Encyclopedia of
WOMEN'S HISTORY IN AMERICA
Second Edition

Encyclopedia of
WOMEN'S HISTORY IN AMERICA
Second Edition

Kathryn Cullen-DuPont

Facts On File, Inc.

Encyclopedia of Women's History in America

Copyright second edition © 2000 by Kathryn Cullen-DuPont

Copyright first edition © 1996 by Kathryn Cullen-DuPont

Facts On File, Inc.
132 West 31st Street
New York, NY 10001

Library of Congress Cataloging-in-Publication Data

Cullen-DuPont, Kathryn.
Encyclopedia of women's history in America / Kathryn Cullen-DuPont.—2nd ed.
p. cm.
Includes bibliographical references and index.
ISBN 0-8160-4100-8 (hc)
1. Women—United States—History—Encyclopedias. 2. Feminism—United States—History—Encyclope-
dias. I. Title: Women's history in America. II. Title.
HQ1410.C85 2000
305.4'0973'03—dc21
99-087498

Facts On File books are available at special discounts when purchased in bulk quantities for businesses,
associations, institutions or sales promotions. Please call our Special Sales Department in New York at
212/967-8800 or 800/322-8755.

Facts On File can be found on the World Wide Web at www.factsonfile.com

Text design by Joan Toro
Cover design by Cathy Rincon

This book is printed on acid-free paper.

Printed in the United States of America

VB Hermitage 10 9 8 7 6 5 4 3 2

For Elizabeth Frost-Knappman

Contents

Preface

Since earliest colonial times, women have contributed to the life of the United States and all its people while striving to better their own situation. This encyclopedia is intended to bring together information about the organizations founded, the books and newspapers published, the speeches given, the documents signed, the demonstrations and conventions held, the legislative actions proposed and enacted, the task forces and committees convened, and the legal rulings rendered—all in the course of "Women's History in America."

In choosing individual women for inclusion, I have not attempted the comprehensiveness possible in a work restricted solely to biographical entries. I have, however, tried to include the women who stand out, almost as landmarks but certainly as central figures, in at least one of several ways: As (1) women who have affected the general course of American history; (2) women important in the struggle for (or, sometimes, against) equal rights; (3) barrier-breaking women, the "firsts" to make their way into the professions and government offices once reserved to men, and the women who, following the "firsts" into these new territories, have made particularly significant contributions; (4) visionary women who created and/or inspired lasting community service organizations, new public policy initiatives, and even religions; and (5) women who have made especially prominent contributions to the cultural and intellectual life of America. I have also and without apology selected some women simply because their accomplishments are pathbreaking within a particular community.

Acknowledgments

I would like to thank many people, organizations, and institutions for their help with this book: first and foremost, my editor, Michelle Fellner, for her thoughtful, intelligent, and rigorous editing, which greatly added to this book, and for her unfailing encouragement throughout this project; Annelise Orleck, for her review of this manuscript on what was not always a convenient schedule and for her generous advice and guidance; Jeanne Jimenez and Jessica Kremen-Kotlen, for their careful research assistance; the staff of the New York Public Library, for providing access to wonderful books and other records of women's history; the support staffs of the many women's and other organizations I contacted with requests for information; my parents, Martin and Arlene Cullen, my mother-in-law, Barbara DuPont, the seven siblings I was lucky enough to grown up with, the thirteen people who've since become siblings-in-law, and my eighteen nieces and nephews, for more extended family support than any one person deserves; my son, Jesse Cullen-DuPont, for keeping me in touch with women's accomplishments in the sports world; my daughter, Melissa Cullen-DuPont, for stimulating conversations about Harriot Stanton Blatch, Ruth St. Denis, and other women in this encyclopedia, which I've enjoyed more than she may ever know; and my husband, Joseph F. DuPont, who has been more encouraging and supportive than any words of mine can adequately express. Finally, I'd like to thank my agent and sometime-coauthor, Elizabeth Frost-Knappman, for her insights into women's history, her enthusiasm, and, especially, her friendship, all of which have been greatly appreciated.

Acknowledgments for the Second Edition

I owe many thanks for the help and support I received while preparing the *Encyclopedia of Women's History in America* for the year 2000. I'd like to thank, in particular, my editor, Nicole Bowen, for both her enthusiasm and her exactitude; she was an editor of the first book I wrote, and it's been a pleasure to work with her again on this one. I'd also like to thank Facts On File's associate editor Terence Maikels, art director Cathy Rincon, project manager Eva Pendleton, and copy editor Laura Magzis, for their generous and careful attention to my book; my agent and friend, Elizabeth Frost-Knappman, to whom I gratefully continue to dedicate the *Encyclopedia of Women's History in America;* the staffs at the New York Public Library, the Library of Congress, the National Archives, the Supreme Court Historical Society, the Seneca Falls Historical Society and, yes, the Baseball Hall of Fame, for prompt and thorough replies to my many requests; my extended family (which now includes twenty nieces and nephews); my husband, Joseph DuPont, for his continued encouragement and support; and our children, Melissa and Jesse Cullen-DuPont, for their continued interest in this book and the progress of American women it attempts to chronicle.

Abortion Counseling Service of Women's Liberation

See JANE.

Abzug, Bella Savitsky (1920–1998) *women's rights leader*

Born on July 24, 1920, in New York City to Esther and Emanuel Savitsky, Bella Abzug became a well-known women's rights leader in the 1960s and 1970s and was the first Jewish woman elected to the House of Representatives.

Abzug attended the Columbia School of Law, where she edited the Columbia *Law Review,* and graduated in 1947. Abzug's clients in the 1950s included members of the civil rights movement and victims of the McCarthy "witch hunts." She worked on behalf of the Civil Rights Act of 1964 and the Voting Rights Act of 1965. She was a member of New York City mayor John Lindsay's advisory committee as well as a founder of WOMEN STRIKE FOR PEACE and the NATIONAL WOMEN'S POLITICAL CAUCUS.

In 1971 Abzug was elected to the House of Representatives, where she worked diligently to secure passage of the Equal Rights Amendment and allocation of funds for the 1977 National Women's Conference. A chairperson of the Subcommittee on Government Information and Individual Rights, she was one of the authors of the Freedom of Information and Privacy Acts and the first person to introduce gay rights legislation into Congress. She was also outspoken against the Vietnam War and against the proliferation of nuclear weapons.

Abzug unsuccessfully ran for Senate after three terms as congresswoman. Her last national governmental position was as co-chair of President Jimmy Carter's National Advisory Council on Women. She subsequently founded and cochaired the Women's Environment and Development Organization, an international organization working to safeguard and improve the environment, enhance social justice, and advance the rights of women. She was inducted into the National Women's Hall of Fame in

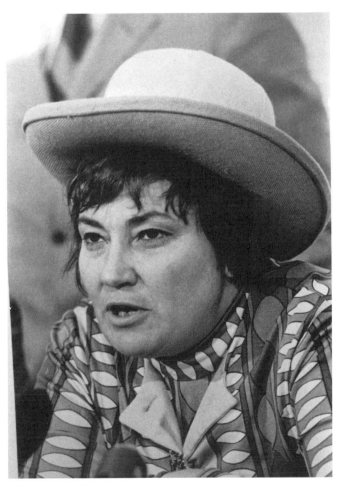

Bella Abzug, feminist activist and the first Jewish woman elected to the U.S. House of Representatives (*Library of Congress*)

September 1994, honored as a leading female environmentalist by the United Nations on March 6, 1997, and named a role model in memoriam by the MS. FOUNDATION FOR WOMEN in December 1998.

Bella S. Abzug died in New York City on March 31, 1998.

Further Reading: Abzug, *Gender Gap;* ———, Nov. 29, 1994 radio interview; Associated Press, March 31, 1998; Clark, *Almanac of American Women;* Davis, *Moving the Mountain;* Hole and Levine, *Rebirth of Feminism;* Reuters, March 3, 1997; *Times Union,* April 1, 1998; *Washington Post,* April 1 and 2, 1998.

Act Concerning the Rights and Liabilities of Husband and Wife, An (1860)

A New York State omnibus bill passed March 20, 1860 and partially rescinded in 1862. The MARRIED WOMAN'S PROPERTY ACT OF 1848, the first act of its kind in the United States, enabled New York's married women to own property. The 1860 act greatly expanded those property rights, and—until the pertinent sections were rescinded—improved inheritance laws with regard to women and recognized mothers as joint guardians of their children.

Section 1 recognized the right of married women to own and retain property. It stated that a married woman's separately held real or personal property could be "used, collected, and invested by her in her own name, and shall not be subject to the interference or control of her husband, or liable for his debts," unless such debts were incurred by the married woman herself, acting as her husband's agent to secure support for herself or her children. Specifically protected property included "that which comes to her by descent, devise, bequest, gift, or grant; that which she acquires by her trade, business, labor, or services, carried on or performed on her sole or separate account; that which a woman married in this State owns at the time of her marriage, and the rents, issues, proceeds of all such property . . ."

Section 2 permitted married women to engage in business on their own and to keep their own earnings as separate property; it also gave them the right to "bargain, sell, assign, and transfer" their separately held personal property.

Sections 3 to 6 dealt with the sale of lands. Section 3 gave married women the right to sell their real estate; however, unlike the sale of personal property, the sale of a married woman's real estate required a husband's written consent. Section 4 permitted women to appeal to county courts for permission to sell their real estate in situations where a husband refused to give his consent; it also permitted women to apply directly to the court for permission in cases involving absent, insane, or otherwise

incapacitated husbands. Sections 5 and 6 outlined the court procedures to be followed in such circumstances: Section 5 described the type of petition a wife could submit. It also required that a husband residing in the same county as his wife and not suffering "disability from insanity or other cause" be served with a copy of his wife's petition and at least ten days' notice of the court's consideration of his wife's request. Section 6 directed the court to authorize a married woman to act alone concerning the sale of her separately held real estate, provided it "satisfactorily appear[s] to such court . . . that the husband . . . has willfully abandoned his said wife, and lives separate and apart from her, or that he is insane, or imprisoned as a convict in any state prison, or that he is a habitual drunkard, or that he is in any way disabled from making a contract, or that he refuses to give his consent without good cause therefor . . ."

Section 7 recognized the right of married women in New York to sue and be sued with respect to their property. (Property received as a gift from a husband was specifically excepted.) It also granted married women the right to bring suits in their own names "for any injury to her person or character." Prior to this, a woman could not bring suit unless her husband joined in the action.

Section 8 stated that a married woman's husband was not responsible for fulfilling bargains and contracts made by a wife in the conduct of her trade or business or with regard to her own property.

Section 9 declared married women the joint guardians of their children, "with equal powers, rights, and duties in regard to them, with the husband." Prior to this, fathers were the sole guardians of their children: So absolute was this guardianship that a father could, in his will, appoint a guardian other than a child's mother to raise that child.

Section 10 and 11 concerned inheritance laws. Section 10 stated that if a husband or wife died without minor children, the surviving spouse would receive "a life estate in one-third of all the real estate" owned by the deceased spouse at the time of his or her death. Section 11 provided widows with the means to care for their children. It stated that if a husband or wife died with minor children and without a will, the surviving spouse would retain all of the deceased spouse's real estate and any resulting rents or profits until the couple's youngest child reached majority. At that point, the surviving spouse would receive one-third.

Elizabeth Cady STANTON's 1860 speech, "A SLAVE'S APPEAL," was instrumental in securing the votes necessary to pass this act. In 1861 the women's rights movement was suspended while its leaders and members involved themselves in the Civil War (see, for example, MILITARY SERVICE, AMERICAN WOMEN AND; NATIONAL WOMAN'S LOYAL LEAGUE; and U.S. SANITARY COMMIS-

SION.) On April 10, 1862—during this wartime suspension of an active women's movement—the New York state legislature amended the Property Act. Some of the changes were beneficial to women: Section 3, as amended, gave married women the right to sell separately held real estate without a husband's consent. (Sections 4, 5, and 6, which had permitted the court to consent in place of a woman's husband, no longer necessary, were repealed.) A new section, requiring a mother's written consent to the apprenticeship of her children, was also added to the act. However, in a serious setback for women, Sections 9, 10, and 11 were repealed. As a result, mothers lost equal guardianship of their children and widows with dependent children lost the use of a deceased husband's estate.

Further Reading: Stanton, Anthony, and Gage, eds., *History of Woman Suffrage,* vol. 1

Adair Act (1854)

An Ohio statute passed in 1854 that permitted the mothers or wives of drunkards to sue alcohol dealers for damages. Eliza Daniel Stewart, a nurse known as "Mother Stewart" during the Civil War, was particularly active and successful in pursuing the statute's application. In January 1872 she gave a speech in which she urged the citizens of Springfield, Ohio to bring this legal remedy to the attention of drunkards' female relatives. By the end of 1873, Mother Stewart had provided a sort of "expert testimony" in two such lawsuits, both of which resulted in convictions.

Further Reading: McHenry, ed., *Famous American Women;* Weisenburger, "Eliza Daniel Stewart," in *Notable American Women,* ed. James, James, & Boyer.

Adams, Abigail Smith (1744–1818) *women's rights supporter*

Later described by Elizabeth Cady Stanton as "the first American woman who threatened rebellion unless the rights of her sex were secured," Abigail Smith Adams was born on November 11, 1744, in Weymouth, Massachusetts, to the Reverend William Smith and Elizabeth Quincy. She grew up without formal schooling but with free access to her family's library. She and John Adams were married on October 25, 1764. The couple had five children.

The letter Abigail Adams wrote to John Adams during his participation in the Continental Congress is well known:

> . . . in the new Code of Laws which I suppose it will be necessary for you to make I desire you would

> Remember the Ladies, and be more generous and favourable to them than your ancestors. Do not put such unlimited power into the hands of the Husbands. Remember all Men would be tyrants if they could. If perticuliar care and attention is not paid to the Laidies we are determined to foment a Rebelion, and will not hold ourselves bound by any Laws in which we have no voice, or Representation.

The dismissive reply of John Adams is not so well known:

> As to your extraordinary Code of Laws, I cannot but laugh. We have been told that our Struggle has loosened the bonds of Government everywhere. That Children and Apprentices were disobedient—that schools and Colledges were grown turbulent—that Indians slighted their Guardians and Negroes grew insolent to their Masters. But your Letter was the first Intimation that another Tribe more numerous and powerfull than all the rest were grown discontented.—This is rather too coarse a Compliment, but you are so saucy, I won't blot it out.
>
> Depend upon it, We know better than to repeal our Masculine systems. Although they are in full Force, you know they are little more than Theory . . . and in Practice you know We are the subjects. We have only the name of Masters . . .

Abigail Adams angrily complained about this letter to her friend Mercy Otis WARREN. In a letter dated April 27, 1776 Adams described the members of her sex as "rather hardly [harshly] dealt with by the Laws of England which gives such unlimited power to the Husband to use his wife Ill" and suggested that Warren "join me in a petition to Congress."

John Adams pondered the question less flippantly with a male colleague, James Sullivan. In a letter devoted primarily to the issue of whether unpropertied men should vote, Adams cited women's "delicacy," reasoned "that nature has made them fittest for domestic cares," and compared both women and children to the unpropertied men under discussion:

> The same reasoning which will induce you to admit all men who have no property, to vote . . . will prove that you ought to admit women and children; for, generally speaking, women and children have as good judgments, as independent minds, as those men who are wholly destitute of property; these last being to all intents and purposes as much dependent upon others, who will please to feed, clothe, and employ them, as women are upon their husbands, or children on their parents . . .

Abigail Adams' threatened petition to Congress never materialized, and her evidently happy marriage survived this difference of opinion. Abigail Adams lived in Europe for the five years in which her husband served his

country abroad, first, as the United States minister at The Hague (1783), second, as the U.S. commissioner in Paris (1784), and, finally, as U.S. minister to Great Britain (appointed 1785). John Adams was elected to serve as second president of the United States (1797–1801), and Abigail Adams became the first First Lady to preside over the newly built White House. Her eldest son, John Quincy Adams, was later elected to serve as the sixth president of the United States (1825–29); during his term, he made a spirited and public defense of women's right to petition Congress, a right that others hotly denied existed.

Abigail Smith Adams died in Quincy, Massachusetts, on October 18, 1818.

Further Reading: Butterfield, "Abigail Smith Adams," in *Notable American Women,* ed. James, James, and Boyer; Evans, *Born for Liberty;* Flexner, *Century of Struggle;* McHenry, ed., *Famous American Women;* Rossi, *The Feminist Papers;* Stanton, Anthony, and Gage, eds., *History of Woman Suffrage,* vol. 1; Withey, *Dearest Friend: A Life of Abigail Adams.*

Addams, Jane (1860–1935) *founder of Hull House, suffragist, and Nobel Peace Prize recipient*
Jane Addams was born on September 6, 1860, in Cedarville, Illinois, to Sarah Weber Addams and John Huy Addams. When Jane was two years old, her mother died. Five years later her father married Anna H. Haldeman, who encouraged Jane to obtain an education.

Jane's father nevertheless refused to allow his daughter to attend Smith College, and she completed her education at the Rockford Female Seminary. When Rockford, due in part to Addams' efforts, became a regular college in 1882, Addams (who had graduated in 1881) was granted a degree.

The next several years were difficult ones; they included the death of her father, enrollment and then withdrawal from the Woman's Medical College of Pennsylvania, and a spinal operation. Following this period, Addams devoted herself to three causes and made a major contribution to each one of them in turn: social reform on behalf of the poor and working classes, women's suffrage, and pacifism.

In 1889, with Ellen Starr, Addams founded Hull House, Chicago's famous settlement house, to serve the city's poor immigrant population. (See SETTLEMENT HOUSE MOVEMENT). This brought her international as well as national renown (and, in some quarters, criticism). As a supporter of women's suffrage, she joined the Chicago municipal suffrage campaign in 1907 and served as first vice-president of the NATIONAL AMERICAN WOMAN SUFFRAGE ASSOCIATION (1911–1914). Addams

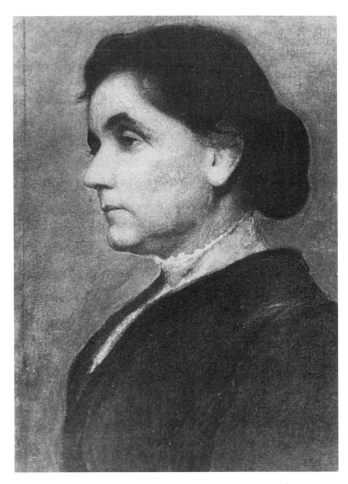

Nobel Peace Prize recipient Jane Addams (*National Portrait Gallery, Smithsonian Institution*)

was prominent at the INTERNATIONAL ALLIANCE FOR WOMEN meeting in Budapest in 1913. She quickly became a prominent and well-respected figure in the peace movement. In January 1915 she was elected chairman of the WOMAN'S PEACE PARTY; in April 1915, president of the International Congress of Women at The Hague; and in 1919, the first president of the Women's International League for Peace and Freedom, a successor organization to the Woman's Peace Party. She was also a strong supporter of the National Committee on the Cause and Cure of War, an organization founded in 1925 by Carrie Chapman CATT. Addams (as well as another recipient) was awarded the Nobel Prize for Peace in 1931; she donated her share of the prize money to the Women's International League for Peace and Freedom.

Addams wrote many articles and books, including: "Ethical Survivals in Municipal Corruption," published in the *International Journal of Ethics* (April 1898); *Democracy and Social Ethics,* a collection of lectures and articles (1902); *The Spirit of Youth and the City Streets* (1909); *Twenty Years at Hull House* (1910); and *The Sec-*

ond Twenty Years at Hull House (1930). She also wrote *Newer Ideals for Peace* (1907) and *Peace and Bread in Time of War* (1922), both of which reflected her views on pacifism.

Jane Addams died in Chicago on May 21, 1935.

Further Reading: In addition to Addams' own works listed above, see Diliberto, *A Useful Woman;* Frost and Cullen-DuPont, *Women's Suffrage in America;* Harper, ed., *History of Woman Suffrage,* vol. 5; Scott, "Jane Addams" in *Notable American Women,* ed. James, James, and Boyer.

Address to the New York State Legislature
Speech given by Elizabeth Cady Stanton on February 14, 1854. It was the first speech made by a woman before this legislative body.

On this occasion, Stanton demanded that the New York State Constitution be revised to provide "a new code of laws" to its female citizens. She then reviewed the present state of law as it affected women.

"We are persons; native, free-born citizens; property-holders, tax-payers," she said, "yet we are denied the exercise of our right to the elective franchise . . . True, the unmarried woman has a right to the property she inherits and the money she earns, but she is taxed without representation . . ." Since women were not allowed to serve on juries, she continued, "among the hundreds of women who are shut up in prisons in this State, not one has enjoyed that most sacred of all rights—the right which you would die to defend for yourselves—trial by a jury of one's peers . . ."

Stanton compared the status of a married woman to that of the slave. "She can own nothing, sell nothing. She has no right even to the wages she earns; her person [women were legally required to accede to their husband's sexual advances], her time, her services are the property of another . . ." As she had in the seventh grievance of the DECLARATION OF RIGHTS AND SENTIMENTS, she accused men of removing any ethical dimension from women's lives:

> She is not held morally responsible for any crime committed in the presence of her husband, so completely is her very existence supposed by the law to be merged in another. Think of it; your wives may be libelers [and] burglars . . . and for crimes like these they are not held amenable to the laws of the land, if they but commit them in your dread presence . . .

And she discussed the force husbands were allowed to exert over their wives: "By the common law of England, the spirit of which has been but too faithfully incorporated into our statute law, a husband has a right to whip his wife with a rod not larger than his thumb, to shut her up in a room, and administer whatever moderate chastisement he may deem necessary to insure obedience to his wishes . . ."

She acknowledged the improvement in women's condition due to passage of the MARRIED WOMAN'S PROPERTY ACT but found many injustices remaining. She decried the fact that widowed women, under New York State law, were awarded only a one-third share of their marital homes while widowed men retained the whole.

She also discussed women's lack of guardianship rights over their children, condemning laws that allowed fathers to apprentice their children (even to "a gamester or rum-seller" or, in the case of a daughter, "to the owner of a brothel") without the consent and over the objections, of mothers; laws providing that a "father, about to die, may bind out all his children wherever and to whomsoever he may see fit, and thus, in fact, will away the guardianship of all his children from the mother"; and laws that granted custody, in every case of separation or divorce, to fathers.

The speech also examined the relationship of the New York State Constitution to its disfranchised female citizens. Since that Constitution's Bill of Rights "says that no authority can, on any pretence whatever, be exercised over the citizens of this State but such as is or shall be derived from, and granted by the people of this State," Stanton told the legislators that "Woman is theoretically absolved from an allegiance to the laws of this State."

Although she had listed the injustices faced by women and carefully examined the suffering so caused, she did not rest her argument upon a desire simply to relieve physical, pecuniary, or even maternal discomfort. Instead, at the end of her speech, she based women's claims upon a natural rights argument and an examination of the pain caused by abrogation of those rights.

> It is impossible to make the Southern planter believe that his slave feels and reasons just as he does—that injustice and subjection are as galling as to him—that the degradation of living by the will of another, the mere dependent on his caprice, at the mercy of his passions, is as keenly felt by him as his master. If you can force on his unwilling vision a vivid picture of the Negro's wrongs, and for a moment touch his soul, his logic brings him instant consolation. He says, the slave does not feel this as I would. Here, gentlemen, is our difficulty: When we plead our cause before the lawmakers . . . they cannot take in the idea that men and women are alike . . . You scorn the thought that she [woman] has any natural love of freedom burning in her breast, any clear perception of justice urging her on to demand her rights.
>
> Would to God you could know the burning indignation that fills woman's soul when she turns over the pages of your statute books, and sees there

how like feudal barons you freedmen hold your women. Would that you could know the humiliation she feels for her sex, when she thinks of all the beardless boys in your law offices, learning these ideas of one-sided justice—taking their first lessons in contempt for all womankind—being indoctrinated into the incapacities of their mothers, and the lordly, absolute right of man over all women, children, and property, and to know that these are to be our future presidents, judges, husbands, and fathers . . .

In conclusion, then, let us say, in behalf of the women of this State, we ask for all that you have asked for yourselves in the progress of your development, since the *Mayflower* cast anchor beside Plymouth Rock; and simply on the ground that the rights of every human being are the same and identical.

No woman suffrage bill or expansion of the Married Woman's Property Act was passed following the speech.

Further Reading: For full speech, see Stanton, Anthony, and Gage, eds., *History of Woman Suffrage,* vol. 1.

Adkins v. Children's Hospital (1923)

The 1923 Supreme Court decision voiding a Washington, D.C. minimum wage law for female workers. The court reasoned that special wage standards for women deprived them of the right to bargain. The decision was cheered by the National Woman's Party, which sought the end of all forms of disparate treatment of the sexes. Other women's organizations, having specifically sought the type of protective legislation struck down in *Adkins,* condemned the decision. Well-known labor organizer Florence KELLEY described the decision as affirming "the inalienable right of women to starve."

Female minimum wage laws were struck down in Arizona, Kansas, and Wisconsin as a direct result of the ruling.

Further Reading: *Adkins v. Children's Hospital of District of Columbia;* Brown, D. M., *American Women in the 1920s;* Chafe, *The American Woman;* Cushman, *Cases in Constitutional Law.*

African-American Benevolent Societies

Mutual aid societies formed by African-American women as early as the 1790s. These societies operated as "insurance" collectives. Members paid what dues they could, when they could. The resulting fund was used to assist members in times of crisis. The Order Book from the Daughters of Africa, for example, records funds granted for medical care and funeral expenses from 1821 through 1829. At the time, white women were complaining in their diaries that they weren't permitted to act as treasurers of their own sewing circles but were required to find a willing male to handle their money. African-American women, for all the hardships they faced, at least escaped this type of male scrutiny: Grace Douglass recorded that she herself "Visited Mrs. Jones with the Committee and gave her 50 cts [cents] worth of groceries. She has been confined 10 days. Grace Douglass." The earliest of these societies to leave records was the Female Benevolent Society of St. Thomas, which was founded in 1793. Other organizations included the African Female Band Benevolent Society of Bethel (dates uncertain); the African Female Benevolent Society of Newport, Rhode Island (founded 1809); Colored Female Religious and Moral Society of Salem (founded 1818); the Colored Female Roman Catholic Beneficial Society (founded in Washington, D.C., 1828); the African Dorcas Association (founded in New York City, 1827, and unusual among African-American women's benevolent societies because it did have male direction); the Colored Female Charitable Society (founded in Boston, 1832); the Female Benevolent Society (founded in Troy, New York, in 1833); and the Female Benevolent Society (founded in Portland, Maine in 1840). Caucasian women also established benevolent societies, and this type of charitable organization remained popular until the end of the nineteenth century.

Further Reading: Frost and Cullen-DuPont, *Women's Suffrage in America;* Sterling, *We Are Your Sisters.*

African-American Women for Reproductive Freedom (1990)

Formed in 1990, African-American Women for Reproductive Freedom was established to provide evidence of support among women of color for *ROE V. WADE.* Faye Wattleton, then the well-known president of Planned Parenthood, was among the organization's first and most vocal supporters.

Further Reading: Davis, *Moving the Mountain.*

Against Our Will: Men, Women and Rape (1975)

Susan Brownmiller's book, *Against Our Will,* was published in 1975 and is widely credited with changing public attitudes about RAPE.

Rape is still sometimes viewed as the victim's fault, but such attitudes were far more common before publication of *Against Our Will.* San Quentin's warden, Clinton Duffy, spoke for many when he wrote in 1965 that women could circumscribe their behavior to avoid rape:

Many [women] break the most elementary rules of caution every day. The particularly flagrant violators,

those who go to barrooms alone, or accept pickups from strangers, or wear unusually tight sweaters or skirts, or make a habit of teasing, become rape bait by actions alone. When it happens, they have nobody to blame but themselves.

Brownmiller analyzed such views of rape and concluded that rape was an institution, "a conscious process of intimidation by which *all men* keep *all women* in a state of fear." As she explained it:

Women have been raped by men, most often by gangs of men, for many of the same reasons that blacks were lynched by gangs of whites: as group punishment for being uppity, for getting out of line, for failing to recognize "one's place," for assuming sexual freedoms, or for behavior no more provocative than walking down the wrong road at night in the wrong part of town . . .

Brownmiller concluded that the ever-present threat of rape was one method used to keep women within traditional bounds.

While female rape victims still must confront stereotyped notions such as Duffy's, many rape laws have been changed in the wake of Brownmiller's book. Many states, for example, have dropped laws requiring the corroboration of up to three witnesses, and all fifty states have eliminated the marital rape exemptions that legally enshrined the once-common belief that a man, "not having to steal what he already owned," could not be charged with raping his nonconsenting spouse.

Further Reading: Brownmiller, *Against Our Will;* Davis, *Moving the Mountain;* Duffy with Hirshberg, *Sex and Crime.*

age of consent
The age at which a girl can be legally presumed to consent to sexual relations, called the age of consent, was originally set at ten by common law. As women became politically skilled during the suffrage movement, they organized to raise the age of consent. In 1864 Oregon raised its age of consent to 14; Wyoming followed in 1882. While raising the age of consent was the general response to women's demands in most states, in other states the issue provoked unexpected developments. Delaware, for example, reduced the age to seven in 1871; it agreed in 1889 to raise the age to fifteen, but on the condition that rape be treated as a misdemeanor. Wisconsin raised the age of consent to fourteen in 1887 in response to women's demands; two years later, in response to male complaint, it reduced both the age (to twelve) and the punishment (five to thirty-five years, rather than the former life imprisonment) and provided a lighter sentence "if the child shall be a common prostitute."

New York's experience with age of consent reform perhaps best illustrates the impact of politically organized women upon this issue. In 1887, that state raised the age of consent to sixteen. Under pressure, New York's legislators then proposed lowering that age to twelve. Mary H. Hunt of the Women's Christian Temperance Union asked for and received permission to address the legislators. "I represent 21,000 women," she warned, "and any man who dares to vote for this measure will be marked and held up to scorn. We are terribly in earnest." New York's age of consent remained unchanged.

At present, the age of consent in most states is sixteen.

Further Reading: Stanton, Anthony, and Gage, eds., *History of Woman Suffrage,* vol. 4.

Albright, Madeleine Korbel (Maria Jana Korbelova) (1937–) *secretary of state*
Born Maria Jana Korbelova on May 15, 1937, in Prague, Czechoslovakia, to Anna ("Mandula") Speigel Korbel and Josef Korbel, Madeleine K. Albright became the United States' first female secretary of state and the highest-ranking woman yet to serve in the country's government. (Korbelova is the feminine version of her father's surname; her mother later rechristened her Madeleine.)

Albright's father was a Czech diplomat who took his family to England when the Nazis arrived in Czechoslovakia in 1938. The family returned to Prague after World War II, but were granted political asylum in the United States after the Communist takeover of Czechoslovakia. Albright arrived in her adopted country in 1948, when she was eleven years old.

Albright became a naturalized U.S. citizen in 1957. She received her B.A. degree from Wellesley College in 1959 and married Joseph Albright the same year. (The couple divorced in 1983.) She received her master's degree in international affairs from Columbia University in 1968, and her doctorate, also from Columbia University, in 1976.

She entered politics as a coordinator for Senator Edmund S. Muskie's unsuccessful presidential campaign in 1976 and afterward became the senator's chief legislative assistant. At the invitation of President Jimmy Carter's National Security Advisor, Zbigniew Brzezinski, who had been one of her professors at Columbia University, Albright joined the staff of the National Security Council as a legislative liaison in 1978. She next joined the faculty of Georgetown University in 1982 as a research professor of international affairs. She was also the director of female students in the foreign service program at Georgetown's School of Foreign Service and a senior fellow in Soviet and Eastern European affairs at

the Georgetown University Center for Strategic and International Studies.

In 1989, she became president of the Center for National Policy, a nonprofit Democratic think tank in Washington, D.C. She was an adviser to several Democratic presidential campaigns, advising both Walter F. Mondale and Geraldine Ferraro in 1984; Michael S. Dukakis in 1988; and Bill Clinton in 1992. She was Clinton's senior foreign policy adviser during the campaign, his foreign policy liaison during the transition period and, after he assumed office, his nominee to represent the United States at the United Nations, both as permanent representative and as head of the U.S. delegation. She was also made a member of the president's cabinet. President Clinton nominated Madeleine Albright to be secretary of state in 1996, and she was unanimously confirmed by the Senate in 1997.

Soon after her appointment as secretary of state, Albright had occasion to reflect in public on some very personal facts of her childhood. While researching a story about her, journalist Michael Dobbs found out from one of Albright's relatives in Czechoslovakia that her family was of Jewish origin and that many of her relatives had died in the Holocaust. Albright, who had been reared as a Roman Catholic, refused to criticize her deceased parents for hiding this information. As she described her feelings in a subsequent *Newsweek* interview:

> My parents did everything in their power to make a good life for their children. They were very protective of us . . . What they gave us children was the gift of life, literally. . . . So I am not going to question their motives . . . I have been and am very proud to be an American . . . I have been proud of the heritage that I have known about and I will be equally proud of the heritage that I have just been given.

Albright has since visited the Old Jewish Cemetary and the Pinkas Synagogue in Prague and invoked her perished relatives' memories in an emotional speech at a conference on the Holocaust.

Albright has often been quoted as saying that it was not Vietnam, but Munich, that formed her political worldview; that is, not the lessons of an ill-advised and ultimately futile intervention in Indochina, but the lessons learned from the West's failure to oppose Adolf Hitler's invasion of Czechoslovakia. However, she objected to suggestions that her personal history was the driving force behind her support for U.S. intervention in Kosovo in 1999. "I know much has been made about my background," she said, "but I think that any American who has the privilege to live in this country, either by birth or coming here as a refugee, understands the importance of standing up for values and not allowing ethnic cleansing to reoccur." The 11-week NATO war in Kosovo, fought largely by NATO troops, was nonetheless widely referred to in Washington and in the media as "Madeleine's War" and was closely associated with her in Kosovo as well: When she visited Pristina, the capital city, at the war's conclusion, she was greeted by two thousand cheering Albanians, some of whom called her "Nona," or mother. Later, at a Serbian Orthodox monastery south of Pristina, Serbian men spit at her passing car, cursed at her, and made rude gestures. In a *Time* magazine interview Albright, reflecting on "Madeleine's War," said, "Well, I don't think it's solely mine. But I feel that we did the right thing, and I am proud of the role I played in it."

Albright has also emphasized women's rights as a component of U.S. foreign policy. Addressing American diplomats at a 1997 International Women's Day ceremony, she stated that "Advancing the status of women is not only a moral imperative, it is being actively integrated into the policy of the United States. It is our mission. It is the right thing to do, and frankly it is the smart thing to do." She serves as chair of the PRESIDENT'S INTERAGENCY COUNCIL ON WOMEN.

Madeleine K. Albright was inducted into the National Women's Hall of Fame in 1998.

Further Reading: Blackman, *Seasons of Her Life: A Biography of Madeleine Korbel Albright;* Cohen, "Albright Encounters Cheers, Jeers in Kosovo"; Corry, "Madeleine's War"; Dobbs, *Madeleine Albright: A Twentieth-Century Odyssey;* Drogin, "Albright Welcomed as Hero in Kosovo but Visit Also Includes Gunshot, Jeering Crowd"; Isaacson, "Madeleine's War"; Raum, "Kosovo Albanians Hail Albright as Liberator"; *USA Today,* April 12, 1999; *Washington Post,* March 25, 1997.

Alcott, Louisa May (1832–1888) *author*

Beloved author of books that inspired generations of girls, Louisa May Alcott was born on November 29, 1832, in Germantown, Pennsylvania, to Abigail May Alcott and Bronson Alcott.

Alcott's parents supported the abolitionist and women's rights movements, and she was schooled by her famous transcendentalist father. Because her father's intellectual life seemed to preclude him from supporting his family in a steady manner, Louisa May Alcott assumed the financial care of the family. At various times, she worked as a domestic servant, governess, seamstress, and teacher. She was eventually able to support the family with the proceeds of her writing career.

Although Alcott published at least 270 works of various length, she is best known for *Little Women* (1868) and its sequels. In *Little Women,* Jo March struggles to grow into a "womanly" sort of woman, while simultaneously testing the limits of female decorum. Well over one

hundred years later, the book remains a favorite of American girls who desire independence.

Another of Alcott's books, *Work: A Story of Experience,* explores the world of a wage-earning nineteenth-century woman, Christie Devon. The novel, written for adult readers, draws on Alcott's own experience as it portrays the difficulties Devon encounters while working as a maid-servant, governess, seamstress, and in other positions, and it concludes with Devon's decision to become a women's rights worker.

In recent years, a number of anonymous and pseudonymous stories have been traced to Alcott and republished under her name; the most complete volume is *Louisa May Alcott Unmasked: Collected Thrillers.* Several previously undiscovered novels have also been published for the first time. These include *The Inheritance,* a romance novel written when Alcott was seventeen, and *A Long Fatal Love Chase,* a novel deemed "too sensational" by Alcott's nineteenth-century publishers but praised by its twentieth-century reviewers. Its protagonist, the young Rosamond Vivian, says she would "gladly sell [her] soul to Satan for one year of freedom." She is subsequently seduced and tricked into a sham marriage by an obsessed (and already married) older man, whom she ultimately leaves. He stalks her, and she flees. Her flight, from one country to another, and from one disguise to another, illustrates the paucity of options available to nineteenth-century women as well as Rosamond's personal desperation. Rosamond remains courageous throughout her search for independence, but the last line of the novel belongs to her tormentor, who claims victory by declaring: "Mine first—mine last—mine even in the grave!"

Although Alcott supported the goals of the women's rights movement, she herself was not an active member of its organizations. As she wrote to Lucy Stone in 1873, "I am so busy just now proving 'woman's right to labor,' that I have no time to help prove 'woman's right to vote.'" Louisa May Alcott cared for various family members until her own death on March 6, 1888.

Further Reading: Alcott, *Work;* ———. *Little Women;* ———. *Jack and Jill;* ———. *Eight Cousins;* ———. *Little Men;* ———. *Jo's Boys;* ———. *Rose in Bloom;* ———. *Louisa May Alcott Unmasked;* ———. *The Inheritance;* ———. *A Long Fatal Love Chase;* ———. *Alternative Alcott;* Cheney, *Louisa May Alcott;* Frost and Cullen-DuPont, *Women's Suffrage in America;* Stern, *Louisa May Alcott.*

All-American Girls Professional Baseball League

A woman's baseball league established in 1943 by Philip K. Wrigley, owner of the Chicago Cubs, the All-American Girls Professional Baseball League (AAGPBL)—founded as the All-American Girls Softball League—originally was intended to keep baseball alive in America in the absence of potential male players during World War II. The women's game quickly evolved from softball into baseball: Overhand pitching replaced the underhanded pitching of women's softball, stealing was permitted, and the size of the ball was reduced. By the end of the first year, "baseball" was an official and accurate part of the league's name.

The teams, all based in the Midwest, were the Fort Wayne Daisies, the Rockford (Illinois) Peaches, the Grand Rapid Chicks, the Racine Belles, the Kenosha Comets, the Minneapolis Millerettes, the South Bend Blue Sox, the Peoria Redwings, the Kalamazoo Lassies, the Springfield Sallies, and the Chicago Colleens.

During its eleven-year history, the league showcased the skill of almost 600 women ballplayers, including Rose Gacioch, Lillian "Tennessee" Jackson, Marie "Red" Mahoney, Dottie Green, Kelly Candaele, Joanne Winter, Dorothy Kamenshek, Connie Wisniewski, and Dottie Wiltse Collins, who successfully pitched until the end of her sixth month of pregnancy. The league was not integrated, however, and one ballplayer who was not invited to join the league was Toni Stone. An African-American woman, Stone in 1949 joined the New Orleans Creoles, a Negro League minors team that was otherwise comprised of men. (In 1953 Stone was signed by the Indianapolis Clowns.)

Like Stone, other women made successful forays into the world of baseball that were independent of the All-American Girls Professional Baseball League. From the early 1890s until 1935, for example, there were several hundred "Bloomer Girl" teams, including the New York Bloomer Girls, the Philadelphia Bobbies, the Boston Bloomer Girls, the Western Bloomer Girls, and the Chicago Bloomers. Referred to as "barnstormers," these teams—which welcomed the occasional male player, some of whom, in the early days, played disguised in wigs and dresses—traveled around the United States to challenge the established minor league and semipro male teams to games. Maud Nelson, the most highly praised of these barnstormer players, was a pitcher and third baseman from at least 1897 through 1913, and afterward the manager and co-owner of her own Bloomer Girl teams.

Between 1904 and 1908 Amanda Clement was a well-paid and highly respected umpire who traveled throughout North and South Dakota, Minnesota, Nebraska and Iowa, earning praise from ballplayers and sportswriters alike. Virne "Jackie" Mitchell was signed to pitch for the Chattanooga Lookouts in 1931, becoming the first woman to join a previously all-male baseball team. On April 2, 1931, the Lookouts played an exhibition game against the New York Yankees, and "Jackie" Mitchell struck out both Babe Ruth and Lou Gehrig.

(Her contract was promptly nullified by baseball commissioner Kenesaw Mountain Landis.) In 1934 Olympic gold medalist Mildred "Babe" Didrikson pitched a no-run inning for the Philadelphia Athletics against the Brooklyn Dodgers. (Sixteen years later she would pitch again and strike out Joe DiMaggio.)

In 1952 shortstop Eleanor Engle was signed to the Interstate League's Harrison Senators, a Class AA (minor league) team. Two days later her contract was nullified by minor league head George M. Trautman. Baseball commissioner Ford Frick quickly and publicly endorsed Trautman's action, and on June 23, 1952—two days after Engle signed her contract—baseball officials issued regulations that prohibited women from becoming members of major league teams. Thus, when the All-American Girls Baseball League was dissolved in 1954, there was no possibility that any of the female players would be considered for spots on the men's teams. (The 1952 ban against women was still in place as of 2000.)

Since the demise of the All-American Girls Professional Baseball League, there have been only a few bright spots for women wishing to play a part in the national pastime. In 1972 the New York State Court of Appeals ruled that Bernice Gera had the right to be one of professional baseball's umpires. (Citing "threats," Gera resigned after her first game.) In 1977 Mary Shane was hired by the Chicago White Sox to provide its play-by-play commentary, thereby becoming the first female television announcer in major league baseball's history. In 1979 Doris Goodwin ended the sex segregation of sports reporters when she conducted interviews in the Boston Red Sox clubhouse.

The future of women in baseball may have been most affected, however, by a United States president's action on Little League: In the early 1970s, parents and daughters in fifteen states brought sex-discrimination suits against the Little League. President Gerald Ford ended the debate in 1974 by signing legislation permitting the entrance of girls into the formerly all-boy program. Young girls have since become an active part of the Little League program and—thanks to Penny Marshall's 1992 movie *A League of Their Own*—devoted admirers of the All-American Girl Professional Baseball League. A professional women's baseball team, the Silver Bullets, was formed in Atlanta in 1994. It played various men's amateur, semipro, and minor league teams across the country, finishing the 1997 season with a 23–22 winning record. Unable to attract corporate sponsorship, the team disbanded in April 1998. In 1997, the Ladies League Baseball Association was founded. A professional women's baseball league with six teams, it disbanded in 1998.

On November 4, 1989, the Baseball Hall of Fame in Cooperstown, New York opened its permanent exhibit honoring the All-American Girls Professional Baseball League. The rights to the league's emblems and name are currently owned by a nonprofit group, the All-American Girls Professional Baseball League Players Association.

Further Reading: Clark, *Almanac of American Women in the 20th Century; Buffalo News,* July 29, 1998; Davis, *Moving the Mountain;* Gregorich, *Women at Play; Los Angeles Times,* July 11, 1997 and January 30, 1998; Rix, ed., *The American Woman 1990–91;* Sparhawk, et al., *American Women in Sport, 1887–1987;* Thomas, "Dottie Green, a Baseball Pioneer in Women's League, Dies at 71."

Alliance for Displaced Homemakers

See WOMEN WORK! THE NATIONAL NETWORK FOR WOMEN'S EMPLOYMENT.

Amalgamated Clothing Workers of America

One of the first trade unions to admit female workers, the Amalgamated Clothing Workers of America (ACWA) was founded in 1914 by Bessie Abramowitz and Sidney Hillman. They later married.

Like the INTERNATIONAL LADIES' GARMENT WORKERS' UNION (ILGWU), the ACWA organized workers throughout an industry rather than by a particular craft. By 1920 fully half of the female garment workers in America were unionized either through the ILGWU (65,000 female members in that year) or the ACWA (66,000 members). The ACWA, in addition to pressing for improved pay and working conditions, was one of the first unions in the country to provide benefits such as health care, educational aid, and children's day-care centers for its members.

The ACWA was merged with the Textile Workers Union of America in 1976, becoming the Amalgamated Clothing and Textile Workers Union. In 1995, it merged with the International Ladies' Garment Workers' Union to form UNITE, (Union of Needletrades, Industrial and Textile Employees). The 350,000-member organization thus became America's fourth largest manufacturing union.

Further Reading: *Buffalo News,* July 9, 1995; Kessler-Harris, *Out to Work;* Wertheimer, *We Were There.*

American Association of University Women

Founded as the Association of Collegiate Alumnae in 1882, this organization was renamed the American Association of University Women upon its merger with the Western Association of Collegiate Alumnae and the Southern Association of College Women in 1921. The first meeting of the Association of Collegiate Alumnae

took place on January 14, 1882, and was attended by sixty-five women—representing Boston University, the universities of Cornell, Michigan, and Wisconsin, and Oberlin, Smith, Vassar, and Wellesley colleges.

In its early years, the organization worked to provide housing for female students and pressed both for the hiring of qualified female professors and the structuring of an equitable pay scale for those professors. In recent years the association has provided financial aid to welfare mothers, supported abortion rights, audited the voting records of congressional representatives on women's educational issues, and lobbied for family and medical leave legislation. Most notably it has conducted a thorough investigation into the disparate treatment of male and female students in United States schools and released what have become influential policy briefs: *How Schools Shortchange Girls: The AAUW Report;* and *Gender Gaps: Where Schools Still Fail Our Children.* The organization's next report, *Voices of a Generation: Girls on Sex, School and Self,* is scheduled for release in the year 2000.

The organization, which maintains its headquarters in Washington, D.C., has 150,000 members and more than 1,500 branches across the country. Sharon Schuster is its president.

Further Reading: Bryant, October 1991 letter; Davis, *Moving the Mountain;* Flexner, *Century of Struggle.*

American Birth Control League

Founded by Margaret SANGER in 1921, this organization encouraged the establishment of birth control clinics and promoted a woman's control of her own fertility.

The Birth Control Clinical Research Bureau, a research group sponsored by the American Birth Control League, established the safety and effectiveness of the diaphragm as a contraceptive in the 1920s. The Birth Control League, in turn, worked to develop a list of physicians willing to prescribe birth control devices.

The organization became Planned Parenthood Federation of America in 1942.

Further Reading: Chesler, *Woman of Valor.*

American Equal Rights Association

An organization formed at the suggestion of abolitionist Theodore Tilton in May 1866 to urge equal rights and "universal suffrage" (suffrage for both women and African-American men), it was created in an attempt to mend the post–Civil War breach between the abolitionist and women's rights movements.

At the end of the Civil War, members of Congress had begun working to extend not just freedom but citizenship and suffrage to African-American men. Robert Dale Owen sent an early draft of what would eventually become the Constitution's FOURTEENTH AMENDMENT to Elizabeth Cady STANTON in the summer of 1865. It proposed enfranchising all men in language that pointedly—and for the first time—defined "citizens" as "male" and specifically excluded women from the voting population. (See Fourteenth Amendment for further discussion, including male abolitionist endorsement, the responses of various women's rights leaders, the amendment's impact upon the nineteenth-century women's movement, and interpretation of the Fourteenth Amendment in twentieth-century Supreme Court cases.)

After some initial disagreement among themselves about whether to support such an amendment, the three most prominent leaders of the women's movement—Stanton, Susan B. ANTHONY, and Lucy STONE—circulated a letter in the fall of 1865 asking women to "unitedly protest" any constitutional amendment that would "exclude women from a voice in the government" and to petition Congress for women's suffrage. They received 10,000 signatures and Theodore Tilton's suggestion regarding a merger of the two movements.

Women's rights conventions had been canceled for the duration of the Civil War in order to free women activists for war work. Now Stanton and Anthony scheduled the first of the postwar conventions for May 10, 1866 and placed Tilton's suggestion on the agenda. At that meeting, participants voted to disband their own women's rights organization and become members of the American Equal Rights Association (AERA). AERA's declared goal was to "secure Equal Rights to all American citizens, especially the right of suffrage, irrespective of race, color, or sex." Stanton and Anthony believed that supporters of female and African-American male suffrage would now unite forces without reservation. Stanton herself wrote the preamble for the AERA's constitution. In it she declared, "we, today . . . bury the woman in the citizen, and our organization in the American Equal Rights Association." Lucretia MOTT was elected president, Stanton, first vice-president, and Anthony, one of three corresponding secretaries. Eleven others, with Stanton and Anthony, formed the executive committee.

Wendell Phillips, who had opposed the merger, was one of the executive committee members. Twenty-one days after the formation of the AERA, the executive committee met in Boston without Stanton or Mott. There Phillips made clear what policy he expected the AERA to follow: ". . . the negro's claim to this right [of suffrage] might fairly be considered to have precedence . . . This hour, then, is preeminently the property of the negro."

"The Negro's Hour" became the standard response of abolitionists, Republicans, and newspaper editors to

any women's rights demand made during reconstruction. When it became clear to women rights leaders that the AERA's purported support of women's equality and suffrage was, as one woman wrote to Stanton, "that sham," the women's rights leaders found themselves increasingly divided. Stanton and Anthony steadfastly refused to support the Fourteenth Amendment and denounced it in their newspaper, the REVOLUTION. Stone and her supporters endorsed it as a partial step toward universal suffrage.

Tension only increased after the ratification of the Fourteenth Amendment in July 1868. The FIFTEENTH AMENDMENT—forbidding the denial of voting rights "on account of race, color, or previous condition of servitude"—was proposed in February 1869. Since it did not include protection for sex, Stanton and Anthony refused to support it. Their attacks sometimes vilified African-American men and appalled former colleagues.

During the AERA's existence, support for the Fifteenth Amendment was often discussed heatedly. At the association's first anniversary meeting, held May 9 and 10, 1867, in New York City, Sojourner TRUTH, a formerly enslaved African-American woman, expressed her views:

> I come from . . . the country of the slave . . . There is a great stir about colored men getting their rights, but not a word about the colored women; and if colored men get their rights, and not colored women theirs, you see the colored men will be masters over the women, and it will be just as bad as it was before . . . I want women to have their rights. In the courts women have no right, no voice . . . You [men] have been having our rights so long, that you think, like a slave-holder, that you own us . . .

Although president Lucretia Mott, Frances D. Gage, and Stanton endorsed Truth's sentiments, the AERA continued to make black male suffrage its clear priority.

The difference of opinion came to a head at an anniversary meeting held in New York City on May 12 and 13, 1869. There abolitionist Stephen Foster criticized Stanton and Anthony's publication of an article entitled "That Infamous Fifteenth Amendment" and accused the two women of betraying the goals of the organization.

A bitter debate followed. Anthony explained that she did not support the Fifteenth Amendment because "it did not mean equal rights; it put 2,000,000 colored men in the position of tyrants over 2,000,000 colored women, who until now had been at least the equals of the men at their side."

Frederick Douglass, the African-American abolitionist, responded. At the SENECA FALLS CONVENTION in 1848, he had been largely responsible for persuading hesitant women to demand the right of suffrage. It was, he had said in forceful language, the right that secured and safeguarded all other rights. What he said now, however, was

> I must say I do not see how anyone can pretend that there is the same urgency in giving the ballot to woman as to the negro. With us, the matter is a question of life and death, at least in fifteen States of the Union. When women, because they are women, are hunted down through the cities of New York and New Orleans; when they are dragged from their houses and hung upon lamp-posts; when their children are torn from their arms, and their brains dashed out upon the pavement; when they are the objects of insult and outrage at every turn; when they are in danger of having their homes burnt down over their heads; when their children are not allowed to enter schools; then they will have an urgency to obtain the ballot equal to our own.

Someone called out, "Is that not true about black women?"

And Douglass gave his answer: "Yes, yes, yes; it is true about the black woman, but not because she is a woman, but because she is black . . . Woman! why she has 10,000 modes of grappling with her difficulties."

Anthony disagreed.

> . . . When Mr. Douglass mentioned the black man first and the woman last, if he had noticed he would have seen that it was the men that clapped and not the women. There is not the woman born who desires to eat the bread of dependence, no matter whether it be from the hand of father, husband, or brother; for any one who does so eat her bread places herself in the power of the person from whom she takes it. Mr. Douglass talks about the wrongs of the negro; but with all the outrages that he to-day suffers, he would not exchange his sex and take the place of Elizabeth Cady Stanton.

Douglass then inquired "whether the granting to woman the right of suffrage will change anything in respect to the nature of our sexes."

And Anthony stated angrily:

> It will change the nature of one thing very much, and that is the dependent condition of woman. It will place her where she can earn her own bread, so that she may go out into the world an equal competitor in the struggle for life; so that she shall not be compelled to take such positions as men choose to accord and then take such pay as men please to give . . . It is not a question of precedence between women and black men; the business of this association is to demand for every man, black or white, and every woman, black or

white, that they shall be enfranchised and admitted to the body politic with equal rights and privileges.

When the question of "free love" was raised, Anthony chose her words carefully: "This howl [of free love] comes from the men who know that when women get their rights they will be able to live honestly and not be compelled to sell themselves for bread, either in or out of marriage."

Lucy Stone is usually quoted as saying during this exchange that "I will be thankful in my soul if *any* body [black and/or female] can get out of the terrible pit." In context, it becomes obvious that her feelings were quite ambivalent. After listening for some time to the debate, Stone told Douglass that

> woman suffrage is more imperative than his own; and I want to remind the audience that when he says what the Ku-Kluxes did all over the South, the Ku-Kluxes here in the North in the shape of men, take away children from the mother, and separate them just as completely as if done on the block of the auctioneer. Over in New Jersey they have a law which says that *any* father—he might be the most brutal man that every existed—*any* father, it says, whether he be under age or not, may by his last will and testament dispose of the custody of his child, born or not born, and that such disposition shall be good against all persons, and that the mother shall not recover her child; and that law in modified form exists over every state in the Union except in Kansas. Woman has an ocean of wrongs too deep for any plummet, and the negro, too, has an ocean of wrongs that cannot be fathomed. There are two great oceans; in the one is the black man, and in the other is the woman. But I thank God for that XV. Amendment and hope that it will be adopted in every State. I will be thankful in my soul if *any* body can get out of the terrible pit.

Frances Ellen Watkins HARPER, herself an African-American woman, also agreed, reluctantly, that black male suffrage should be supported.

Immediately following this meeting, Stanton and Anthony, abandoning their hopes for coalition, founded the NATIONAL WOMAN SUFFRAGE ASSOCIATION (NWSA) to work exclusively for women's rights and, especially, for women's suffrage. Stone did not wish to join NWSA, primarily because its leaders vehemently opposed the Fifteenth Amendment. Before the year ended, she founded the AMERICAN WOMAN SUFFRAGE ASSOCIATION, which worked for women's rights and suffrage while supporting the Fifteenth Amendment. Other disagreements separated the leaders even after the Fifteenth Amendment was ratified, and the women's movement remained divided for two decades.

Further Reading: Harper, *Life and Work of Susan B. Anthony,* vol. 1; Stanton, Anthony, and Gage, eds., *History of Woman Suffrage,* vol. 2.

American Female Moral Reform Society

Founded in May 1834 at New York City's Third Presbyterian Church, the American Female Reform Society was dedicated to the elimination of prostitution and the ending of other male behaviors that it considered denigrating to women.

The society began as a small circle of like-minded women. Within ten years, it had grown to include over 400 chapters, one of which was the New York Moral Reform Society. The New York Moral Reform Society published a newspaper, the *Advocate,* in which it castigated the "predatory nature of the American male." As in the other chapters, members did not condemn prostitutes but reached out to them as fallen or victimized sisters. The society's efforts were supported by evangelical clergy.

The society is known today as the Woodycrest Youth Service.

Further Reading: Evans, *Born for Liberty.*

American Woman Suffrage Association

Founded by Lucy STONE, Julia Ward HOWE, and others in November 1869, the American Woman Suffrage Association (AWSA) was intended as an alternative to Susan B. ANTHONY and Elizabeth Cady STANTON's more radical NATIONAL WOMAN SUFFRAGE ASSOCIATION (NWSA). Its newspaper was the *Woman's Journal.*

Despite their anger at women's exclusion from the FIFTEENTH AMENDMENT (which granted suffrage to African-American males), AWSA leaders supported its ratification. AWSA thereafter tried to get women's suffrage included in every state constitution, and it avoided controversial subjects—such as birth control and divorce law reform—so that women's suffrage might seem a thoroughly respectable and unthreatening prospect. AWSA and NWSA merged in 1890, becoming the NATIONAL AMERICAN WOMAN SUFFRAGE ASSOCIATION.

Further Reading: Stanton, Anthony, and Gage, eds., *History of Woman Suffrage,* vol. 3; Flexner, *Century of Struggle;* Lasser and Merrill, eds., *Friends and Sisters;* Wheeler, ed., *Loving Warriors.*

American Women's Hospitals Service

A committee created in 1917 by the Medical Women's National Association (now the American Medical

Women's Association) to enable female physicians to provide care for those injured in World War I at a time when female doctors were not admitted into the armed forces.

Under the initial leadership of Dr. Rosalie Slaughter and Dr. Mary M. Crawford, the service trained and deployed an all-female team of ambulance drivers, nurses, and physicians to provide care in the hospitals it created in the French war zone. (They also offered care to injured and ill civilians.) When the war ended, the service remained in Europe to provide care during reconstruction.

The committee continued to respond to world crises. Care was provided to the poor in America's Appalachia, to Turkish refugees stranded in Greek islands, and to people in need in Asia and South America.

In 1920 Dr. Esther Pohl Lovejoy became the committee's chairperson, a position she still held when the United States entered World War II. Although female doctors were permitted to serve beginning in 1943, the United States reestablished the prohibition against them once the war ended. Female physicians won full acceptance in the armed forces only in the 1950s.

The American Women's Hospitals Service continues to serve as an international relief service. Its female physicians and nurses currently provide care, including family planning services, in many countries, Bolivia and Haiti among them.

Further Reading: Brennan, ed., *Women's Information Directory;* Lovejoy, *Certain Samaritans;* Thomson, "Esther Pohl Lovejoy," in *Notable American Women: The Modern Period.* Sicherman and Green, eds.

Angelou, Maya (1928–) *poet, author, historian, playwright, actress, producer and director*
Maya Angelou was born Marguerite Johnson on April 4, 1928, in St. Louis, Missouri, to Vivian Baxter Johnson and Bailey Johnson.

She received her education in the California and Arkansas public school systems and then studied both music and dance, working for a time with Martha GRA-HAM. Angelou was, at different times in her youth and young adulthood, a streetcar conductor or "conductorette," a dancer, a journalist, a prostitute, and a madam. Angelou's first book, *I Know Why the Caged Bird Sings,* was the first of six autobiographical volumes that would explore these disparate occupations as part of much larger themes: an African-American girl's growth into womanhood, the struggle of a single mother to rear her son, the need to transcend the damaging effects of rape, bad marriages and ill-fated affairs, the endurance of familial bonds, and the meaning she extracted from participation in the women's and civil rights movements. Angelou's five other autobiographical works are *Gather*

Together in My Name (1974), *Singing and Swingin' and Gettin' Merry Like Christmas* (1976), *The Heart of a Woman* (1981), *All God's Children Need Traveling Shoes* (1986), and *Wouldn't Take Nothin' for My Journey Now* (1993).

Angelou's poetry is collected in five volumes: *Just Give Me a Cool Drink of Water 'fore I Diiie* (1971), *Oh Pray My Wings Are Gonna Fit Me Well* (1975); *And Still I Rise* (1978); *Shaker, Why Don't You Sing?* (1983); *I Shall Not Be Moved* (1990); and *Complete Collected Poems* (1995). In 1993 she read "On the Pulse of Morning," at the inauguration of President Bill Clinton. The poem, composed specifically for the occasion, refers to each American as the "descendant of some passed-/On traveler . . . arriving on a nightmare/Praying for a dream" and offers both a difficult truth and a promise: "History, despite its wrenching pain/Cannot be unlived, but if faced/With courage, need not be lived again."

She was the northern coordinator of the Southern Christian Leadership Conference in the 1960s, a member of the National Commission on the Observance of International Women's Year during the Carter administration, and a member of the American Revolutionary Bicentennial Advisory Council under President Ford.

Angelou's first artistic successes had been in the theater and included participation in a worldwide tour of *Porgy and Bess* sponsored in 1954–55. After the success of *I Know Why the Caged Bird Sings* and other books, Angelou continued to devote time to the performing arts. She directed both the 1974 film *All Day Long* and a production of her own 1976 play, *And Still I Rise,* and she acted in the Broadway production of *Look Away* (1973), the TV miniseries *Roots (1977),* and the film *How to Make an American Quilt (1995).* Her prizewinning documentaries include the PBS special *Afro-Americans in the Arts.* She is a member of the Director's Guild and serves on the board of the American Film Institute.

Her awards and honors include a 1970 Yale University Fellowship, her 1975 selection as a Rockefeller Foundation Scholar in Italy, nominations for the Pulitzer Prize, Emmy Award and the theater community's Tony Award, and the receipt of a 1944 Grammy Award from the music industry—for best spoken word or nonmusical album, in honor of her recording of "On the Pulse of Morning."

Maya Angelou currently holds a lifelong chair at Wake Forest University as the Z. Smith Reynolds Professor of American Studies.

Further Reading: Angelou, *I Know Why the Caged Bird Sings;* ———, *Just Give Me a Cool Drink of Water 'fore I Diiie;* ———, *Gather Together in My Name;* ———, *Oh Pray My Wings Are Gonna Fit Me Well;* ———, *Singing' and Swinging' and Gettin' Merry Like Christmas;* ———,

And Still I Rise; ———, The Heart of a Woman; ———, Why Don't You Sing?; ———, All God's Children Need Traveling Shoes; ———, I Shall Not Be Moved; ———, "On the Pulse of Morning"; Gilbert and Gubar, eds., Norton Anthology of Literature by Women; Meroney, "The Real Maya Angelou"; New York Times, January 21, 1993 and March 2, 1994; Showalter, Baechler, and Litz, eds., Modern American Women Writers.

Anthony, Susan Brownell (1820–1906) *women's rights leader*

One of the nineteenth century's most famous women's rights leaders, Susan B. Anthony was born on February 15, 1820, in Adams, Massachusetts, to Lucy Read Anthony and Daniel Anthony. Daniel Anthony, of Quaker background, firmly believed in equal education for women and provided his daughter Susan with the best schooling he could afford. Anthony became a teacher in 1839 and by 1846 had become headmistress of the Female Department of Canajoharie Academy in Rochester, New York, a position she held for three years.

Anthony became involved in the temperance movement in 1848, when she joined the Daughters of Temperance. In 1852 she founded the WOMAN'S NEW YORK STATE TEMPERANCE SOCIETY. She was also active in the abolitionist movement and was William Lloyd Garrison's primary representative for the American Anti-Slavery Society in New York beginning in 1856.

Over the course of her life, however, it was the women's rights movement that claimed most of her energy. Anthony and Elizabeth Cady STANTON were introduced in 1850, and the pair quickly became the women's movement's most high-profile activists. Anthony collected signatures for the 1854 petition requesting an expansion of the MARRIED WOMAN'S PROPERTY ACT in New York (the law was amended in 1860); in 1866 she again collected signatures—this time petitioning the United States Congress for women's suffrage. During the Civil War and after Lincoln's issuance of the Emancipation Proclamation, Anthony and Stanton formed the NATIONAL WOMAN'S LOYAL LEAGUE to collect signatures to a petition demanding emancipation of *all* slaves in the United States. (The Emancipation Proclamation freed only those slaves in states at war with the Union.) After the war Anthony and Stanton opposed ratification of the FOURTEENTH and FIFTEENTH AMENDMENTS because black male suffrage was addressed in language that excluded women. Other women's rights leaders—notably, Lucy STONE—disagreed with the Anthony/Stanton position, and the movement suffered a twenty-year split as a result.

Anthony voted in the 1872 presidential election in Rochester, New York. She was arrested and stood trial

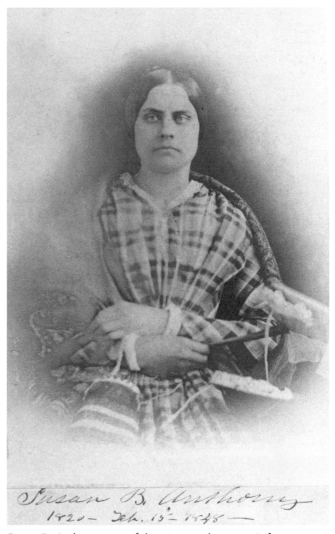

Susan B. Anthony, one of the nineteenth century's foremost women's rights leaders, in 1848 (*University of Rochester Library*)

the following year. Judge Henry Selden wrote his opinion and the jury's verdict before the trial even commenced, and Susan B. Anthony was denied the right to testify because of her sex. She was convicted of illegal voting and fined $100, which she steadfastly refused to pay. (The judge released her anyway.)

Anthony was a founder and officer of the National Woman Suffrage Association (1869–90), proprietor of the women's rights newspaper the *REVOLUTION* (1868–70), and vice president (1890–92) and president (1892–1900) of the NATIONAL AMERICAN WOMAN SUFFRAGE ASSOCIATION. The NINETEENTH AMENDMENT, guaranteeing women's suffrage, is sometimes called the "Susan B. Anthony Amendment." In 1979, Anthony's likeness appeared on the dollar coin; it was the first time a woman's likeness had appeared on any U.S. currency.

Susan B. Anthony died at her home in Rochester, New York, on March 13, 1906.

Further Reading: Barry, *Susan B. Anthony;* Cullen-DuPont, Kathryn, "U.S. v. Susan B. Anthony," *Great American Trials.* Knappman, ed. DuBois, *Elizabeth Cady Stanton/Susan B. Anthony;* Flexner, *Century of Struggle;* Frost and Cullen-DuPont, *Women's Suffrage in America;* Harper, *Life and Work of Susan B. Anthony.*

Antistalking Legislation

The U.S. Department of Justice defines stalking as "conduct directed at a specific person that involve[s] repeated physical or visual proximity, nonconsensual communication, or verbal, written or implied threats." According to 1997 Justice Department figures, one million women and 375,000 men are stalked annually. The National Institute of Justice has also reported to Congress that there is "strong evidence of a link between stalking and domestic violence."

The VIOLENCE AGAINST WOMEN ACT OF 1994 made it a crime to cross state lines to injure or abuse a spouse or partner. The Interstate Stalking Punishment and Prevention Act, introduced by Senator Kay Bailey Hutchinson (R-TX) and signed into law by President Bill Clinton in 1996, significantly strengthened the federal prohibition against interstate stalking: With its passage it became a felony to cross state lines to harass or stalk a person, whether or not the stalker was previously known to the victim, whether or not there had been a preexisting order of protection, and whether or not the stalker committed a violent act.

In 1990, California became the first state to pass legislation criminalizing stalking within its borders. Since then, every other state and the District of Columbia have passed similar antistalking legislation. The laws were upheld as constitutional by the Supreme Court in 1998 when it refused to hear appeals by men convicted of stalking in Virginia and the District of Columbia.

As of 1999, one-third of states have also passed laws prohibiting stalking on the internet or via other forms of electronic communication, and a 1998 federal law protects children from Internet-related stalking. In February 1999, the Clinton administration asked the Justice Department to prepare a report on the advisability of expanding the limited federal cyber-stalking legislation. The report, released in September 1999, recommended that federal laws be broadened to protect all citizens from interstate electronic stalking and urged states without cyber-stalking laws to adopt them.

A 1999 California case provides an example of the type of crime these laws seek to prevent: Gary Steven Dellapenta, whose advances were rebuffed by a 28-year-old woman, posed as that woman on the Internet and placed ads asking for men to rape her, saying it would fulfill her fantasy. Prosecutors claimed that Dellapenta gave various respondents the woman's description and home address, as well as the instructions to disable her home security system, and that six men entered her apartment with intent to rape her. Dellapenta, the first person charged under California's cyber-stalking law, pleaded guilty in April 1999.

Further Reading: Associated Press, November 13, 1977; *Houston Chronicle,* January 23, 1999; Lindlaw, "Gore Attacks Online Stalking"; Miller and Maharaj, "Chilling Cyber-Stalking Case Illustrates New Breed of Crime"; Miller, "Man Pleads Guilty to Using Net to Solicit Rape"; Reuters, September 13, 1996; *Fort Worth Star-Telegram,* September 23, 1996; Violence Against Women Office; *Washington Post,* April 21, 1998.

Arab-Jewish Women's Dialogue for Peace

An organization founded in 1983 as Women for Peace in the Middle East by Susan Ryder, the Arab-Jewish Women's Dialogue for Peace (AJWDFP) is an organization of Arab and Jewish women working to improve their relations and understanding of each other in the United States, with the ultimate goal of helping to bring together Arab and Jewish women in the Middle East and acting as a model for the unification of women around the world, especially across battle lines. As part of its effort to foster understanding, the organization conducts discussion groups, teenager workshops, and cultural programs. The organization also is dedicated to the idea that women are able to influence world events in a peaceful manner. Each of its members has therefore pledged to fast one day per week so long as the enmity in the Middle East continues and a final settlement remains unsigned.

The Arab-Jewish Women's Dialogue for Peace currently maintains its offices in Wheaton, Maryland. It is headed by Susan Ryder, its founder.

Further Reading: Brennan, ed., *Women's Information Directory.*

Arendt, Hannah (1906–1975) *political theorist, twentieth-century philosopher*

Arendt was born on October 14, 1906, in Hanover, Germany, to Jewish parents, Martha Cohn Arendt and Paul Arendt. She received an excellent education, studying at Marburg and Freiburg and then earning her Ph.D. from Heidelberg. In 1933, fleeing Hitler, she moved to Paris. The following year, she became active in Youth Aliyah, an organization and division of HADASSAH devoted to the care of Jewish orphans. When France succumbed to

Hitler's invasion, Arendt relocated to the United States, where she became a naturalized citizen in 1950.

Arendt was a full professor at Princeton and also taught at the University of Chicago, the University of California at Berkeley, Brooklyn College, and the New School for Social Research in New York City. Her most widely read book is *The Origins of Totalitarianism* (1951; revised 1958) in which she examines the basic foundations of totalitarian governments, specifically the Soviet Union and Germany. She isolates "organized loneliness" as the condition necessary for the formation of a totalitarian movement: a loneliness so acute that it is experienced as an extreme fracturing of individuals, one from another and all from the world itself.

Her other works include *The Human Condition* (1958), *On Revolution* (1963), *Eichmann in Jerusalem* (1963) and *The Life of the Mind* (published posthumously in 1977).

Hannah Arendt died on December 4, 1975.

Further Reading: Arendt, *On Revolution;* ———, *The Human Condition;* ———, *On Violence;* ———, *The Life of the Mind;* ———, *The Origins of Totalitarianism;* Young-Bruehl, "Hannah Arendt," in *Notable American Women: The Modern Period.* Sicherman, ed.

Association of Junior Leagues International, The

Founded in New York City in 1900 by Mary Harriman, Nathalie Henderson, Jean Reid, Gwendolyn Books and other members of that year's freshman class at Barnard College, this organization was originally named the Junior League for the Promotion of Settlement Movements. (See SETTLEMENT HOUSE MOVEMENT for further discussion.) Its members, most of whom were middle-class or wealthy young women, worked "for the benefit of the poor and the betterment of the city."

Now known as the Association of Junior Leagues International, this educational and charitable volunteer organization has chapters in every state and works locally to improve and strengthen communities.

In recent years the league has instituted a program to help prevent teenage pregnancy; has worked to upgrade middle and junior high schools in various communities; supported family and medical leave legislation, in particular the FAMILY AND MEDICAL LEAVE ACT; and worked to diminish DOMESTIC VIOLENCE. In addition to its internal magazine, the Association of Junior Leagues International has published a *Report on Parental Leave* and a *Homeless Women and Children's Report.* Clotilde Dedecker is the current president.

Further Reading: Birmingham, *The Grandes Dames;* Brecher and Lippitt, *Women's Information Exchange*

National Directory; Brennan, ed., *Women's Information Directory.*

Association of Southern Women for the Prevention of Lynching

Established in 1930 by Jesse Daniel Ames, the Association of Southern Women for the Prevention of Lynching (ASWPL) organized white Southern women to work through church organizations to stop the lynching of African-American men. Its members felt obligated to act because the "protection of white womanhood" was commonly given as the reason for lynching. These women—many of whom were unaccustomed to political action—held press conferences to refute the notion that African-American men were lynched because they raped white women and denounced the "false chivalry" of white men who would claim otherwise.

Further Reading: Hall, *Revolt Against Chivalry;* ———, "Jesse Daniel Ames," in *Notable American Women: The Modern Period.* Sicherman and Green, eds.

athletics and sport, American women's participation in

Women have participated in athletics and sport throughout American history—Elizabeth Cady STANTON, for example, was an accomplished horsewoman in her youth—but never with the access to training, facilities, and organized competition they enjoy today.

Lawn tennis was popularized in the United States by Mary Ewing Outerbridge in the 1870s, and the first national lawn tennis competition for women was held in 1887 at the Philadelphia Cricket Club. However, when the first modern Olympic Games were held in Athens, Greece in 1896, women were excluded from competition.

From 1900 on the twentieth century has provided ever-increasing opportunities for female athletes. The second Olympic Games, held in 1900, permitted eleven women to compete. (American Margaret Abbot won a gold medal for golf.) The numbers of women competing in the Olympics and the numbers of events open to their competition has since steadily increased. Among the most outstanding of America's Olympic women have been "Babe" Didrikson ZAHARIAS, winner in 1932 of gold medals in the hurdles and javelin throw and a silver medal in the high jump (she later played basketball, softball, tennis and golf and, in a 1950 baseball game, struck out Joe DiMaggio); sprinter Wilma Rudolph who, in 1960, became the first woman to win three gold medals in Olympic track events; Joan Benoit who, in 1984, won the gold in the first Olympic Games marathon for women; Mary Lou Retton who, also in 1984, received

the Olympic gold medal for all-around gymnastics competition; Jackie Joyner-Kersee, who became the 1988 Olympic champion in both the heptathlon and the long jump; Florence Griffith Joyner who, also in 1988, won three gold medals in track events; and speed skater Bonnie Blair who became, in 1992, the most gold-medal winning woman in Olympic history. American women have also won many Olympic medals for figure skating. These athletes include Tenley Albright (silver medal, 1952, and gold medal, 1956); Peggy Fleming (gold medal, 1968); Dorothy Hamill (gold medal, 1976); Kristi Yamaguchi (gold medal, 1992); and Nancy Kerrigan (silver medal, 1994). The United States women's softball and soccer teams won gold medals in 1996, and the U.S. women's hockey team won the gold medal in 1998.

Outside of the Olympic arena, women's success in golf and tennis and their contributions to America's competition in equestrian events around the world have been especially notable. The Ladies Professional Golf Association, established in 1949, has become a solid presence in the athletic world, and female golfers such as Patty Berg, Pat Bradley, Joanne Carner, and Nancy Lopez have enjoyed highly successful and well publicized careers. Women's tennis, dominated by such outstanding athletes as Billie Jean King, Chris Evert, Martina Navratilova, Venus Williams and Serena Williams also has become a vital part of American sports.

The ALL-AMERICAN GIRLS PROFESSIONAL BASEBALL LEAGUE, in existence from 1943 to 1954, gave many female athletes the opportunity to fully develop their competitive talents.

In the 1990s, as the first generation of girls to grow up under Title IX produced an unparalleled number of female college athletes, women's professional sports leagues began to reappear. The American Basketball League (ABL), the Women's National Basketball Association (WNBA), and the Women's Professional Fastpitch softball league debuted in 1996, and the latter two leagues have been successful. (The ABL dissolved in 1998 and many of its players joined WNBA teams.) Countrywide enthusiasm for the U.S. women's soccer team and its win at the 1999 Women's World Cup has prompted the U.S. Soccer Federation to undertake a feasibility study regarding a possible women's team. In the meantime, two professional women's baseball organizations begun in the 1990s—the Silver Bullet team in Atlanta and the Ladies League Baseball Association, based in California—have recently ended operations.

In contrast to many other sports, equestrian events offer men and women the chance to compete against each other. Women have long been part of American equestrian teams, and several women—including Margie Goldstein, Katie Monahan Prudent, Anne Kursinski, and Melanie Smith Taylor—are considered some of America's best riders. On the racetrack Julie Krone won 3,545 races and the jockey championship at Belmont and Monmouth parks, Atlantic City, the Meadowlands, and Gulfstream; in May 2000, following her retirement, she became the first woman inducted into racing's Hall of Fame.

American women in the nonprofessional ranks have also benefited greatly from TITLE IX OF THE EDUCATION AMENDMENTS OF 1972. Its passage required educational institutions that receive federal funds to provide their female and male students with equal access to athletic scholarships, equipment and facilities, and training. In 1972, the year Title IX was passed, only one in twenty-seven high school girls played varsity sports. In 1997, twenty-five years later, that number is one in three.

Further Reading: Anderson, "A Working Golfer, Wife and Mother," *New York Times,* July 11, 1993; Associated Press, July 12, 1999; Durso, "Dead Heat: Krone and Smith Vie for Title." *New York Times,* August 24, 1993; Goldstein, "Few Leagues of Their Own"; Lear, "Julie Krone: Best Female Jockey—or Best Jockey?" *New York Times Magazine,* July 25, 1993; Lewis, "Flood of Talent Buoys WNBA's Third Season;" Morris, George H., *Hunter Seat Equitation;* Sparhawk et al., *American Women in Sport, 1887–1987;* Vecsey, "2-Pound Vest Protected Krone's Life," *New York Times,* September 21, 1993; U.S. Congress, "A resolution honoring the inaugural season"; *Washington Post,* October 20, 1996, February 24, 1997, and August 6, 1998; Yannis, "Women's College Programs Are Enjoying Boom Times," *New York Times,* September 15, 1993.

Austin-Wadworth Bill, the

One of six bills introduced during World War II in the United States Senate to draft civilians, including women, for industrial and/or agricultural jobs within the United States. The Austin-Wadworth Bill (S.B. 666), if passed, would have become the National War Service Act. Intended by Senator Warren Austin (R-VT) to "provide further for the successful prosecution of the war through a system of civilian selective service," the bill proposed mandatory registration of women aged eighteen to fifty, with exemptions for: women who were pregnant, mothers of children below the age of eighteen, and women engaged in caring for disabled family members. The other five bills, all similar, were introduced by Senators Bilbo of Mississippi, Hill of Alabama, McKellor of Tennesse, Reynolds of North Carolina, and Taft of Ohio. In addition, a women's military draft was proposed in the Congress by Representative Joseph C. Baldwin (R-NY).

Baldwin's 1942 bill, H.R. 6806, proposed "the registration of women between the ages of 18 and 65 under the Selective Training and Service Act."

None of these bills was passed. Nonetheless, like the congressional proposal to draft female nurses (see the Nurses Selective Service Act of 1945 in MILITARY SERVICE, AMERICAN WOMEN AND, for further discussion), these proposals to draft women for agricultural and/or industrial work in support of the country's war effort were considered seriously. As a review of the *Congressional Record* shows, whether women could be drafted was not debated as an issue. Instead, other issues were debated: the bill's impact on unionized labor, for example, and whether the United States had a severe enough labor shortage to require a draft.

In the 1970s, opponents of the EQUAL RIGHTS AMENDMENT, such as Phyllis SCHLAFLY, argued that women were exempt from the draft so long as the Equal Rights Amendment was not made part of the Constitution. Despite the historical evidence provided by the Nurses Selective Service Act of 1945, the Austin-Wadworth Bill, and other similar measures, many women were persuaded that Schlafly was correct.

Further Reading: *Congressional Record—House*, 77th Cong., 2d sess., 1942, vol. 88, pt. 2, p. 2691; *Congressional Record—Senate*, "Proposed National War Service Act," 78th Cong., 1st sess., February 8, 1943, vol. 89, pt. 1, p. 666; ———, Part 3, May 10, 1943, p. 4122; ———, Part 1, February 8, 1943, p. 668; ———, March 1, 1943, p. 1375; Mansbridge, *Why We Lost the ERA;* Weatherford, *American Women and World War II*.

Automobile Workers v. Johnson Controls, Inc. (1991)

A 1991 Supreme Court decision that unanimously overturned Johnson's so-called fetus protection policy. Under Johnson's policy, all women of childbearing age were excluded from jobs that might expose fetuses or women's reproductive systems to harm. The Court ruled that such gender exclusion from these well-salaried positions was obviously biased, since it barred only unsterilized women from positions that were hazardous to the reproductive systems of both men and women, in direct violation of the 1978 PREGNANCY DISCRIMINATION ACT.

Further Reading: *Automobile Workers v. Johnson Controls*, 499 U.S. 187 (1991); Carelli, "Court Calls Job Hazard Policies Sex Bias," *San Francisco Examiner*,

March 20, 1991; Faludi, *Backlash;* Marshal, "An Excuse for Workplace Hazard," *The Nation*, April 25, 1987.

Avery, Rachel G. Foster (1858–1919) *suffragist and officer of various women's rights organizations*

Rachel Foster Avery was born on December 30, 1858, in Pittsburgh, Pennsylvania, to Julia Manuel Foster and J. Heron Foster.

After growing up in a household that was sympathetic to the women's rights movement, and following a private school education, Avery became active at a young age in the Citizen's Suffrage Association. She attended the 1879 NATIONAL WOMAN SUFFRAGE ASSOCIATION (NWSA) convention; in 1880 she was elected as NWSA's corresponding secretary. In this capacity, she directed the 1882 suffrage campaign in Nebraska. Avery became a close friend and confidante of Susan B. ANTHONY and, over the years, assumed many of Anthony's organizational responsibilities, including the planning of many states' suffrage campaign strategies. Then, in order to provide financial security for Anthony in her old age, Avery donated her own money, and collected additional monies from other suffragists, to purchase an annuity for Anthony.

Avery helped establish the International Council of Women (see INTERNATIONAL CONGRESS OF WOMEN) and served as its secretary from 1889 to 1893. She also served as secretary to the National Council of Women from 1891 to 1894 and to the Committee of the World's Congress of Representative Women in 1893. She strongly supported the merger between the National Woman Suffrage Association and the AMERICAN WOMAN SUFFRAGE ASSOCIATION. She was secretary of the International Woman Suffrage Alliance (see INTERNATIONAL ALLIANCE FOR WOMEN) from 1904 to 1909. Avery then served as first vice president of the National American Woman Suffrage Association from 1907 until her resignation in 1910. In 1908 she headed the Pennsylvania Woman Suffrage Association and is credited with revitalizing the cause of women's suffrage in that state.

Rachel Avery lived long enough to see the NINETEENTH AMENDMENT passed but not long enough to see it ratified. She died on October 26, 1919, exactly ten months prior to ratification.

Further Reading: Flexner, *Century of Struggle;* Frost and Cullen-DuPont, *Women's Suffrage in America;* Harper, *The Life and Work of Susan B. Anthony;* Stanton, et al., eds., *History of Woman Suffrage*, vols. IV–VI; Willard and Livermore, *A Woman of the Century*.

B

Baby M, In the Matter of (1988)

The first highly publicized trial to examine the ethical questions raised by "reproductive technology," *In the Matter of Baby M* was a battle for parental rights to the child now legally known as "Melissa Stern." The events leading to the case were as follows: Mary Beth Whitehead signed a legal contract agreeing to accept $10,000 to become artificially inseminated by William Stern and give the baby up to him and his wife upon delivery. She neither accepted the money nor relinquished the baby, and William Stern sued.

The case itself spurred a national debate about "surrogate motherhood," as such an arrangement has been termed. Among the issues debated was whether it was ethical to pay a woman to give up a child for adoption. (Although the contract described the $10,000 as "compensation for services and expenses" and specifically stated that the fee should "in no way be construed as a fee for termination of parental rights or a payment in exchange for a consent to surrender the child for adoption," it was actually payable only upon the surrender of a live infant.) Other debated questions included whether a biological mother had more of a claim to their child than did the child's biological father; whether women—or the poor and working classes, from which most surrogate mothers came—were exploited by such arrangements; and whether a child was automatically better off with a wealthier family than a struggling one.

Some feminists felt that a woman's right to do what she wished with her body, including the right to contract out its services in a binding surrogacy arrangement, should be validated by the court with a decision in Stern's favor. Other feminists viewed the case as a maternal rights issue. Mothers must either relinquish their children in writing or be found unfit before their maternal rights can be severed legally, and Whitehead had done neither. (The contract had stipulated that she *would* relinquished her maternal rights, but it was not in itself a legal surrender of those rights.) Feminists in support of Mary Beth Whitehead objected to the termination of maternal rights without such a voluntary surrender, and they also objected to what they perceived as the attempt of the Sterns' lawyers unfairly to portray Whitehead as an unfit mother.

Judge Harvey Sorkow of the New Jersey Superior Court severed all of Mary Beth Whitehead's parental rights to the child, granted exclusive custody to William Stern, and presided over Elizabeth Stern's adoption of the baby on March 31, 1987. On February 2, 1988 a New Jersey Supreme Court Justice reversed Sorkow's decision. He invalidated Elizabeth Stern's adoption of the infant, restored Whitehead's maternal rights, and ordered that custody and visitation be negotiated as if in a divorce case.

The New Jersey Supreme Court decision also prohibited additional surrogacy arrangements in that state unless "the surrogate mother volunteers, without any payment, to act as a surrogate and is given the right to change her mind and to assert her parental rights."

As of early 2000, a few states prohibit surrogacy contracts, while most—either by regulatory statute or lack of any specific prohibition—permit the practice. The states with regulations generally provide that a surrogate birth mother may change her mind within a few days of the birth of a genetically related infant. It has become more common, however, for couples to hire a surrogate to carry and bear a child to whom she is not related. In gestational surrogacy, as this is known, an embryo created with the egg and sperm of anonymous donors or the intended parents, is implanted into the surrogate's uterus. Thus, the surrogate mother in such an arrangement has no genetic tie to the infant she bears.

Since 1979, approximately 10,000 children have been born to surrogate mothers.

Further Reading: Chesler, *Sacred Bond: The Legacy of Baby M;* Cullen-DuPont, "In the Matter of Baby M," in *Great American Trials,* ed. Knappman; *Denver Post,* December 26, 1998; Lodes and Clark, "In Gestational Surrogacies, All Parties Bear Risk"; *Matter of Baby M;* Sack, "New York Is Urged to Outlaw Surrogate Parenting for Pay," *New York Times,* May 15, 1992; Squire, "Whatever Happened to Baby M?" *Redbook,* January 1994; Whitehead, with Schwartz-Nobel, *A Mother's Story: The Truth About the Baby M Case.*

Backlash: The Undeclared War Against American Women (1991)

Published in 1991, *Backlash,* by Susan Faludi, is the Pulitzer Prize–winning journalist's analysis of what she views as "the antifeminist campaign of the [19]80s."

According to Faludi's thesis, the various successes of the women's movement have prompted a surging resentment, or a "backlash," toward women and their demand for equality. This resentment is expressed quite openly by members of the political new right who are alarmed by women's strides toward independence. More alarming to Faludi, though, is evidence that this same "backlash" of resentment has informed the manner in which the popular culture and even the news media have presented women and their concerns in recent years.

She found a pattern of deliberate distortion, a claim she supported with, among other things, a reexamination of studies that were widely cited and rarely questioned during the 1980s. One such study, published in 1985 by a Stanford University sociologist, reported that the implementation of no-fault divorce laws had caused newly divorced women to experience, on average, a 73 percent decrease in their living standards and newly divorced men, on average, a 42 percent increase. Another, published in 1986 by Harvard and Yale researchers, found that only 20 percent of college-educated women who had not married by age thirty would marry during their lifetime, while the probability dropped to only 1.3 percent for those who remained unmarried at forty. Faludi found errors in these and other studies, and she also found, in the media's uncritical attention, a reflection of society's strategy for stemming feminism's impact: Persuade American women to retreat from their demands for equality by convincing them that their hard-won advances have been too costly.

Faludi urged her readers to resist such manipulation and to continue to support the modern women's movement. The book was widely reviewed and read, becoming both a hardcover and a paperback bestseller. Faludi herself was portrayed in the news media as one of feminism's new, young voices, and her book—like Naomi Wolf's FIRE WITH FIRE—was credited with bringing younger members to the women's rights movement.

Further Reading: Carabillo, et al., *Feminist Chronicles: 1953–1993;* Faludi, *Backlash;* Gibbs, "How to Revive a Revolution."

Barnard Center for Research on Women, The

Founded at Barnard College in 1971, the Barnard Center for Research on Women was intended, as its charter describes it, "to assure that women can live and work in dignity, autonomy, and equality."

The center maintains a large research archive on women, including books, periodicals, governmental reports, and organizational newsletters, brochures, leaflets, and publications. It subscribes to more than 120 current periodicals, including the AMERICAN ASSOCIATION OF UNIVERSITY WOMEN's *Outlook,* the *Asian Journal of Women's Studies,* the *Berkeley Women's Law Journal,* the *Duke Journal of Gender Law & Policy, the European Journal of Women's Studies, Feminism & Psychology, International Family Planning Perspectives,* the *Journal of Women's History,* the *National NOW Times,* the OWL *Observer,* the *Women's Art Journal,* and the *Women's Review of Books.* It also archives back issues of defunct periodicals from the early days of the modern women's movement. Its collection of women's resource materials is topically organized and includes material on women's education, employment, health, and legal status, as well as information on lesbian and gay issues, feminist theory, violence against women, and the women's movement. This archive, known as the Myra Josephs/Birdie Goldsmith Ast Resource Collection, is open to the public.

The Barnard Center for Research on Women also sponsors several lecture series, including the "Lunchtime Lecture Series," which features Barnard faculty; the "Rennert Women in Judaism Forum," which explores the historical and current roles of women within Judaism; and "Speaking of Women," which invites writers, activists, and scholars to share their work on women with the Barnard community and guests. The center also hosts the annual, day-long "Scholar and Feminist Conference."

Further Reading: Barnard Center for Research on Women. Available on-line: http://www.barnard.columbia.edu/crow/

Barton, Clara Harlowe (1821–1912) *Founder of the American Red Cross and first woman to head a U.S. government bureau*

Clara Barton was born on December 25, 1821, in North Oxford, Massachusetts, to Sarah Stone Barton and Stephen Barton. She was educated in public schools and then, in 1850, attended the Liberal Institute of Clinton,

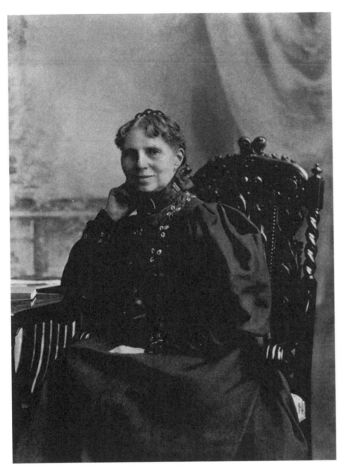

Clara Harlowe Barton, founder of the American Red Cross
(*Library of Congress*)

New York. She became a schoolteacher and founded New Jersey's first free school with six students in Bordentown, in 1852; by the end of Barton's tenure, 600 students were enrolled in the school.

During the Civil War, Barton at times aided the United States SANITARY COMMISSION but worked primarily as an independent nurse, using her own supplies. She offered care to both Union and Confederate soldiers alike at battles such as Cedar Mountain, South Mountain, Antietam, Fredericksburg, Second Bull Run, and Falmouth, as well as through the sieges of Richmond and Petersburg. At the end of the war, Clara Barton traveled to Annapolis to meet exchanged prisoners and set up an office to assist in locating missing soldiers. In July 1865 it was Barton who supervised the meticulous marking of the graves for the 13,000 Union soldiers who had died while imprisoned at Andersonville. Recently discovered documents have shed further light on these years. As head of the Missing Soldiers Office from 1865 to 1868, Barton was the first woman to lead a U.S. government bureau. Working from a two-room office in Washington,

D.C., Barton's Missing Soldiers Office located 22,000 missing Civil War soldiers.

Barton traveled to Switzerland in 1869 and became acquainted with the International Red Cross, founded in 1864. She returned to the United States, determined that her own country should sign the 1864 Geneva Convention and thereby become a member of the International Red Cross. Finally, in March 1882 the United States did so. In 1900 a federal charter establishing the American Red Cross was issued. Barton served as president of the American Red Cross until 1904.

Clara Barton died in Glen Echo, Maryland, on April 12, 1912.

Further Reading: Barton, *The Red Cross;* ———, *The Story of My Childhood;* Curti, "Clara Barton," in *Notable American Women,* ed. James, James, and Boyer; *New York Times,* December 2, 1999; Stanton, Anthony, and Gage, eds., *History of Woman Suffrage,* vol. 2; *Times Union,* November 28, 1997; *Washington Post,* February 25, 1998.

Beach, Amy Marcy Cheney (1867–1944) *composer*
Amy Beach was born Amy Marcy Cheney on September 5, 1867, in Henniker, New Hampshire to Clara Imogene Marcy Cheney and Charles Abbot Cheney. She received an excellent education but little formal instruction in music. At sixteen, she made her debut as a pianist. She married Henry Harris Aubrey Beach on December 1, 1885, and thereafter became widely known as Mrs. H. H. A. Beach.

Beach's *Gaelic Symphony,* which she finished in 1886, is the first symphony known to have been composed by a woman in America. Beach's other works include Mass in E Flat op. 5, Sonata in A Minor for violin and piano op. 34, Piano Concerto in C Sharp op. 45, and *Cabildo* op. 149 (an opera). She made many European and American concert tours, receiving critical acclaim both for her compositions and her performances.

Amy Marcy Cheney Beach died in New York City on December 27, 1944.

Further Reading: Ammer, *Unsung;* Block and Neuls-Bates, eds., *Women in American Music;* Block, *Amy Beach, Passionate Victorian;* Epstein, "Amy Marcy Cheney Beach," in *Notable American Women,* ed. James, James and Boyer; Hughes, *Music Lovers' Encyclopedia.*

Beard, Mary Ritter (1876–1958) *historian and author*
Beard was born Mary Ritter on August 5, 1876, in Indianapolis to Narcissa Lockwood Ritter and Eli Foster Rit-

ter. She attended the DePauw University in Asbury, Indiana, where she met Charles Austin Beard, whom she married in 1900. She attended Columbia University to pursue graduate studies in sociology for two years.

Beard was a member of the NATIONAL WOMEN'S TRADE UNION LEAGUE and helped organize that organization's protest of the TRIANGLE SHIRTWAIST COMPANY FIRE. She was a member of the NATIONAL WOMAN'S PARTY during the last years of the suffrage battle. After the Nineteenth Amendment was adopted in 1920 she supported efforts to gain PROTECTIVE LABOR LEGISLATION for women. During these years she—like many other supporters of protective legislation—opposed the Woman's Party's efforts to secure an EQUAL RIGHTS AMENDMENT (ERA). (These ERA opponents feared that the proposed amendment, by eliminating all forms of discrimination, would eliminate any basis for laws designed to protect women in the workplace.)

Beard championed the creation of women's studies programs at Barnard, Radcliffe, Smith, Vassar, and Syracuse University. Her own works of history continue to set a standard for feminist scholarship. These include *On Understanding Women* (1931), *Woman as a Force in History* (1946), and *The Force of Women in Japanese History* (1953).

Mary Ritter Beard died in Phoenix, Arizona on August 14, 1958.

Further Reading: Beard, *On Understanding Women;* ———, *Women as a Force in History;* ———, *The Force of Women in Japanese History;* Beard and Beard, *Basic History of the United States;* Clark, *Almanac of American Women;* Cott, "Mary Ritter Beard," in *Notable American Women: The Modern Period,* Sicherman, ed.

Beaux, Cecilia (1855–1942) *painter*
Cecilia Beaux was born Eliza Cecilia Beaux on May 1, 1855, to Cecilia Kent Leavitt Beaux and Jean Adolph Beaux, in Philadelphia.

Following the death of her mother, Beaux resided with maternal relatives and was visited frequently by her father. She received her early education from family members before entering Miss Hill's School for Girls, a Philadelphia finishing school, at the age of fourteen. Her artistic training began at age sixteen, when she began studying with Katherine Ann Drinker, a painter of historical subjects and a relative of her uncle. Although her uncle disapproved of life drawing and refused her permission to enter the Pennsylvania Academy of Fine Arts, he supported her studies with Drinker and, later, funded her attendance at the art school of Adolph Van der Whelen in Philadelphia.

Les derniers jours d'enfance (1883–84), a painting of her sister and nephew, is generally considered to be

Beaux's first important work. By 1900 she had become a prominent portraitist, well known for paintings such as *A Little Girl* (1887), *Ernesta with Nurse* (1894), *New England Woman* (1895), and *Dorothea and Francesca* (1899–1900). She traveled frequently to Europe and was well acquainted with the work of Monet, Manet, and other moderns, but she most admired the old masters and continued to develop her own art along traditional lines. Her work is most often compared to John Singer Sargent's, and some—including art historians Ann Sutherland Harris and Linda Nochlin—find Beaux's portraits to be the more objective renderings of subjects, painted with less intent to flatter. Her other paintings include *Sita and Sarita* (1893–94), *The Dreamer* (1894), and *A Lady from Connecticut* (1895) (which were exhibited with three other paintings to international praise at the Paris Salon of 1896), a number of commissioned portraits, including paintings of First Lady Edith Carow Roosevelt with her daughter Ethel (1901) and Louise Whitfield Carnegie, and several portraits of Allied leaders, commissioned by the National Art Committee at the end of World War I: Belgium's Cardinal Mercier, France's premier Georges Clemenceau, and Great Britain's admiral Lord Beatty (1919).

Beaux had fourteen one-woman shows during her lifetime, and her work was exhibited at the Pennsylvania Academy of Fine Arts, the MacBeth and Knoedler galleries in New York City, as well as at the Paris Salon. She became the first female instructor at the Pennsylvania Academy of Fine Arts, and she was honored by that institution with a retrospective exhibit in 1974, thirty-two years after her death. Other honors received during her lifetime include election to the Academy of Arts and Letters, the National Academy of Design, and the Society of American Artists; honorary degrees from the University of Pennsylvania (1908) and Yale (1912); and many prizes and awards for her paintings, including a gold medal at the Paris Exposition of 1900.

In 1924 Beaux fractured her hip and was thereafter somewhat incapacitated. She worked more on her autobiography than on her painting in later years, publishing *Background with Figures* in 1930.

Cecilia Beaux died at her summer home in Gloucester, Massachusetts on September 12, 1942.

Further Reading: Grafly, "Cecilia Beaux," in *Notable American Women,* ed. James, James, and Boyer; Harris and Nochlin, *Women Artists;* McHenry, ed., *Famous American Women;* Rubinstein, *American Women Artists;* Tufts, *American Women Artists 1830–1930.*

Beecher, Catharine Esther (1800–1878) *author and pioneer for the improved education of young women*

Catharine Esther Beecher was born on September 6, 1800, in East Hampton, New York, to Roxana Foote Beecher and Lyman Beecher. The family which included Catharine's sister Harriet Beecher STOWE (and later her half sister Isabella Beecher HOOKER), relocated to Litchfield, Connecticut in 1810. Catharine, the eldest child in her family, assumed many of the household responsibilities upon her mother's death in 1816 and thereafter always believed that a woman's traditional role was an essential and ennobling one.

Beecher attended Miss Sarah Pierce's school for girls but supplemented that less-than-rigorous education with the study of mathematics, Latin, and philosophy at home. She became a schoolteacher in 1821 and—together with her sister Mary—opened in 1823 what became the Hartford Female Seminary. She moved to Cincinnati with her father in 1832 and there established the Western Female Institute, which failed after five years.

In "Female Education" (1827), "Suggestions Respecting Improvements in Education" (1829), and "An Essay on the Education of Female Teachers" (1835), she outlined her views on the education of women as well as the desirability of their employment as teachers. Since she valued women's traditional role, she believed education should increase women's appreciation of its importance, while furnishing them with an improved ability to perform the tasks involved. She also regarded teaching as a natural extension of women's traditional role, and in *The Duty of American Women to Their Country* (1845) urged young women to provide educations to American children. Due to the book's influence, a society was organized in Boston and the Board of National Popular Education created in Cleveland for the purpose of sending young East Coast women to the West as teachers. Beecher established the American Woman's Educational Association in 1852 in order to prepare young Western women to become teachers in their own communities.

Beecher opposed women's suffrage, believing that women already wielded a beneficent, behind-the-scenes influence upon their male relatives and, consequently, upon public policy. In "An Essay on Slavery and Abolitionism, with Reference to the Duty of American Females" (1837), she castigated Angelina Grimké for speaking against slavery in public and warned that behavior which "throws woman into the attitude of a combatant, either for herself or others" removed her from "her appropriate sphere." She did not see herself as opposing the advancement of women, however. She tirelessly sought greater public appreciation of women's special work within their traditional sphere; to have that, Beecher declared in the title of an 1869 work, would be "Something for women better than the ballot."

Beecher wrote more than thirty books, including *A Treatise on Domestic Economy* (originally published in 1841 and revised throughout the next twenty-five years) and *The Evils Suffered by American Women and Children: The Causes and the Remedy* (1846). Catharine Esther Beecher died in Elmira, New York, on May 12, 1878.

Further Reading: Beecher, "An essay on the education of female teachers . . ."; ———, "An essay on slavery and abolitionism, with reference to the duty of American females"; ———, *The Duty of American Females to Their Country*; ———, *The Evils Suffered by American Women and American Children*; ———, "Female Education"; *A Treatise on Domestic Economy*; ———, *Something for Women Better Than the Ballot*; ———, *Woman's Profession as Mother and Educator with Views in Opposition to Woman Suffrage*; Boydston, Kelley, and Margolis, eds., *Limits of Sisterhood*; Cross, "Catharine Esther Beecher" in *Notable American Women*, Sicherman, ed.; Faust, ed., *American Women Writers*; McHenry, ed., *Famous American Women*.

"Beijing Declaration and Platform for Action" (1995)

A 400-paragraph document setting forth the measures agreed to in 1995 by government delegations at the United Nations Fourth World Conference on Women in Beijing, China.

The agreements reached at Beijing were far-reaching ones, prompting Marjorie Margolies-Mezvinsky, former congresswoman from Pennsylvania and deputy chair of the U.S. delegation, to make a comparison to the 1985 World Conference on Women in Nairobi, Kenya, and the "NAIROBI FORWARD-LOOKING STRATEGIES FOR THE ADVANCEMENT OF WOMEN" adopted that year: "People are going to look back and say it all began in Beijing," she said. "If Nairobi was a compass, then Beijing is a detailed map."

The document sets forth that the human rights of women and girls are "an inalienable, integral, and indivisible part of universal rights" and that guaranteeing their rights is in the "interest of all humanity." In thoughtful language, it notes the many circumstances in which these rights have been denied. It notes, for example, that the end of the cold war has not diminished more localized conflict or the "grave violations of the human rights of women [that] occur . . . in times of armed conflict, and include murder, torture, systematic rape, forced pregnancy, and forced abortion, in particular under policies of ethnic cleansing." It notes as well the impact of developing countries' enormous debt burdens on women and their children and states that "the major cause of the continued deterioration of the global environment is the unsustainable patterns of consumption and production, particularly in industrialized countries. . . ." It issues a call for women to continue to work in nongovernmental

organizations—and for governments to grant those organizations the freedom necessary—to influence debates from the community to international level.

The platform itself is, as Margolies-Mezvinsky described it, a detailed map. It identifies a dozen critical areas of concern and lists specific, concrete actions that the signatory countries agreed to implement. If met, these goals would lead to improvements in the poverty levels of women; their access to education; the availability of health care; the prevention of violence; the rate of female victimization during armed conflict; their participation in the economy; their access to decision-making positions; the sensitivity of governments to gender concerns; the inclusion of women's rights in any definition of human rights; the portrayal of women in the media; consideration of women's environmental concerns; and freedom and opportunity for "the girl-child."

The PRESIDENT'S INTERAGENCY COUNCIL ON WOMEN was created in 1995 to implement the Platform for Action in the United States.

Further Reading: *Houston Chronicle,* October 12, 1995; *Beijing Declaration and Platform for Action.*

Belmont, Alva Erskine Smith Vanderbilt
(1853–1933) *suffragist*
Alva Erskine Smith Vanderbilt Belmont was born Alva Erskine Smith on January 17, 1853, in Mobile, Alabama, to Phoebe Ann Desha Smith and Murray Forbes Smith. After an education in French private schools, Belmont returned to the United States. She married William K. Vanderbilt in 1875, divorced twenty years later, and married Oliver Hazard Perry Belmont in 1896.

After her husband's death in 1908, Belmont entered the suffrage movement. She devoted a great deal of her fortune, a militant enthusiasm, and the rest of her life to the women's suffrage campaign. In 1909 she founded the Political Equality League and served as its president. During the New York City shirtwaist makers' strike of 1909–10, she gave money and time to the New York Women's Trade Union League. (See NATIONAL WOMEN'S TRADE UNION LEAGUE). In 1913 she served on the executive board of the Congressional Union, an organization led by Alice PAUL and Lucy Burns. She also served on the executive board of the NATIONAL WOMAN'S PARTY after 1917 and was elected that organization's president in 1921. At The Hague Conference on the Codification of International Law in 1930, Belmont represented the National Woman's Party and, in that capacity, argued for the removal of legal restrictions against women in international law.

Alva Erskine Smith Vanderbilt Belmont died in Paris, France on January 26, 1933.

Further Reading: Flexner, *Century of Struggle,* Frost, and Cullen-DuPont, *Women's Suffrage in America;* Lasch, "Alva Erskine Smith Vanderbilt Belmont," in *Notable American Women,* ed. James, James, and Boyer.

Benedict, Ruth Fulton (1887–1948) *anthropologist*
Ruth Fulton Benedict was born Ruth Fulton on June 5, 1887, to Beatrice Joanna Shattuck Fulton and Frederick Samuel Fulton, in New York City.

Her early childhood was spent in various places—St. Joseph, Missouri, Owatonna, Minnesota, and Buffalo, New York—as her widowed mother traveled from one teaching job to another, but her summers were spent on the farm of her maternal grandparents in Norwich, New York. In 1899 the family settled in Buffalo, New York, where Ruth attended an Episcopal preparatory school on scholarship. She received her A.B. from Vassar in 1909. After three years as a teacher in California, she married biochemist Stanley Rossiter Benedict on June 18, 1914.

In 1919 Ruth Benedict entered the New School for Social Research, where she began to study anthropology. Encouraged by Elsie Clews Parsons and Alexander Goldenweiser, she entered Columbia University and began to study under the prominent anthropologist Franz Boas. She received her Ph.D. in 1923 and remained associated with Columbia University. From 1924 to 1930 she was an instructor; from 1931 to 1947, an associate professor; and, in 1948, just before her death, a full professor.

Her first book, *Tales of the Cochiti Indians* (1931), and the later *Zuni Mythology* (2 vols., 1935) were the result of an eleven-year-long study of Native American folklore and religious belief, particularly that of the Apache, Blackfoot, and Pueblo tribes. One of her most influential works was *Patterns of Culture* (1934). In it she explored the way in which a particular society may value and reward certain expressions of "personality," while regarding members with other characteristics as marginal. Through careful comparison of Dobu, Kwakiutl, and Zuni societies, Benedict showed that the favored cultural personality is fairly arbitrary and that one society's highly valued personality might be another society's pathological personality. (She used the example of the West's aggressive, possession-seeking male.) Just as important, she explored the way in which one society's discarded or unappreciated personalities might, in another society, be invited to blossom.

Benedict revisited the themes of *Patterns of Culture* to a certain degree in 1946, when she wrote *The Chrysanthemum and the Sword: Patterns of Japanese Culture.* In this work, she movingly set forth the traditional cultural patterns of Japanese life and argued persuasively that postwar Japan could return to a peaceful place in the world community only if these traditions were respected.

So influential was this book that the Office of Naval Research in 1947 funded a program at Columbia, headed by Benedict and entitled "Research in Contemporary Cultures." In 1947 Benedict became president of the American Anthropological Association, a position she held until 1948.

Ruth Fulton Benedict died suddenly of a coronary thrombosis on September 17, 1948, in New York City. Her various papers were collected and edited by Margaret MEAD, who was her student, and published as *An Anthropologist at Work: The Writings of Ruth Benedict* in 1959.

Further Reading: Benedict, *The Chrysanthemum and the Sword;* ———, *Patterns of Culture;* ———, *Race, Science, and Politics;* McHenry, ed., *Famous American Women;* Mead, *An Anthropologist at Work: Writings of Ruth Benedict;* ———, "Ruth Fulton Benedict, 1887–1948," *American Anthropologist* 51 (1949): 457–468.

Bethune, Mary McLeod (1875–1955) *educator, civil rights leader, presidential adviser*

Bethune was born Mary McLeod on July 10, 1875, near Mayesville, South Carolina, to Patsy McIntosh McLeod and Sam McLeod, both former slaves. The fifteenth of seventeen children, Bethune grew up with few material advantages but was always encouraged by her family. She received her education first in a mission school and then, on scholarship, at Concord, New Hampshire's Scotia Seminary (which later became Barber-Scotia College) and Chicago's Bible Institute for Home and Foreign Missions (which later became the Moody Bible Institute). She married Albert McLeod Bethune in 1898.

Bethune taught at the Hanes Normal and Industrial Institute in Augusta, Georgia and the Kindell Institute in Sumter. She then opened a mission school in Palatka, Florida and the Daytona Normal and Industrial Institute, a girls' seminary in Daytona Beach, Florida. The Daytona Normal and Industrial Institute became the Bethune-Cookman College in 1932, and Bethune served as its president until 1942.

When women were enfranchised in 1920, Bethune conducted a voter registration drive for African-American women in defiance of Ku Klux Klan threats. One of the founders of the NATIONAL COUNCIL OF NEGRO WOMEN and a leading figure in the NATIONAL ASSOCIATION OF COLORED WOMEN, Bethune was also active in the National Association for the Advancement of Colored People and the National Urban League. In 1935 President Franklin D. Roosevelt appointed Bethune administrator of the newly created Office of Minority Affairs. (Her title later became director of the Division of Negro Affairs.)

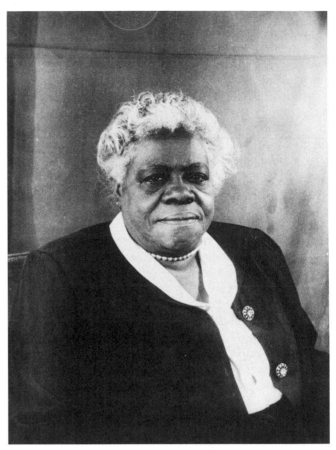

Mary McLeod Bethune, civil rights leader and adviser to President Franklin D. Roosevelt (*Library of Congress*)

Mary McLeod Bethune died at her home in Daytona Beach, Florida, on May 18, 1955.

Further Reading: Clark, *Almanac of American Women;* Holt, *Mary McLeod Bethune;* McHenry, ed., *Famous American Women;* Smith, "Mary McLeod Bethune," in *Notable American Women,* Sicherman, ed.; Sterling, *We Are Your Sisters.*

Bill of Rights for Women (1967)

A document issued by the NATIONAL ORGANIZATION FOR WOMEN in November 1967 at its second national conference held in Washington, D.C., the Bill of Rights for Women was delivered to the 1968 Republican and Democratic platform committees and to all candidates aspiring to election to Congress in 1968. Its introductory section listed the rights demanded:

I Equal Rights Constitutional Amendment

II Enforce Law Banning Sex Discrimination in Employment

III Maternity Leave Rights in Employment and in Social Security Benefits

IV Tax Deduction for Home and Child Care Expenses for Working Parents

V Child Care Centers

VI Equal and Unsegregated Education

VII Equal Job Training Opportunities and Allowances for Women in Poverty

VIII The Right of Women to Control Their Reproductive Lives

The remainder of the document discussed each of the demands in turn. (See Appendix for a copy of the complete document.)

Further Reading: Davis, *Moving the Mountain;* Hole and Levine, *Rebirth of Feminism.*

Bishop, Elizabeth (1911–1979) *poet*

Elizabeth Bishop was born on February 8, 1911, to Gertrude Bulmer Bishop and William Thomas Bishop, both Canadian Americans, in Worcester, Massachusetts. When Bishop was eight months old, her father died; when she was close to school age, her mother was afflicted with an incapacitating mental disorder and institutionalized. The remainder of Bishop's childhood was spent in the homes of various relatives. Near the end of her life, she described her transient upbringing and her reaction to it: "My relatives, I think they all felt so sorry for this child that they tried to do their very best. And I think they did . . . But . . . with my relatives . . . I was always sort of a guest, and I think I've always felt like that."

Bishop attended Vassar College where, with fellow student Mary McCarthy and others, she founded the *Conspirato* as an alternative to the more staid *Vassar Review.* (The two periodicals were later merged.) During her senior year she met Marianne Moore, with whom she was to develop a lifelong bond. Moore dissuaded the young and talented Bishop from attending medical school and urged her to continue writing; in 1935, the year after Bishop's graduation from Vassar, Moore also included several of her poems—including "The Map" and "Three Valentines"—in an anthology entitled *Trial Balances.*

"The Map" was later placed as the opening poem in Bishop's *North & South,* a collection that earned its author the 1945 Houghton Mifflin Poetry Fellowship and was subsequently published in 1946. This collection was later expanded and published as *North & South: A Cold Spring,* winning the 1955 Pulitzer Prize for poetry.

As she had in childhood, Bishop moved frequently during her adult years. She lived in and traveled through Mexico, Brazil, and England as well as in and through various parts of North Africa and Europe; the body of her work offers an overview—almost a catalog—of the world's geographic vastness, while many of the individual poems express an intimate, acquired awareness of the many ways in which a particular locale and specific time's necessities may influence—or even create—individual sensibilities, responses, and methods of living. In addition to the two versions of *North & South,* Bishop's poetry collections included *Questions of Travel* (1965); *Complete Poems* (1969), which won the National Book Award, and *Geography III* (1976).

Bishop was also a consultant in poetry at the Library of Congress (an office that preceded the creation of a Poet Laureate position in America) from 1949 to 1950 and the recipient of the American Academy of Arts and Letters Award in 1950 and of the *Books Abroad* Neustadt International Prize for Literature. She died in Boston, Massachusetts, on October 6, 1979.

Further Reading: Bishop, *The Complete Poems of Elizabeth Bishop, 1927–1979* (New York: Farrar, Straus and Giroux, 1984); ———, *One Art: Letters;* ———, *Collected Prose;* Faust, ed., *American Women Writers;* Gilbert and Gubar, eds., *Norton Anthology of Literature by Women;* McHenry, ed., *Famous American Women;* Miller, *Elizabeth Bishop;* Plimpton, ed., *Writers at Work,* 6th series (New York: Viking Penguin, 1984); Showalter, Baechler, and Litz, eds., *Modern American Women Writers.*

Bitch Manifesto, The

A document of the radical feminist community of the late 1960s, The Bitch Manifesto was written by New York Radical Women member Joreen in 1969 and published in *Notes From the Second Year.* It refutes stereotypical feminine behavior, stating, in part, that

> A true Bitch is self-determined, but the term "bitch" is usually applied with less discrimination. It is a popular derogation to put down uppity women that was created by man and adopted by women. Like the term "nigger," "bitch" serves the social function of isolating and discrediting a class of people who do not conform to the socially accepted patterns of behavior.

"The woman who conducts herself with true self-determination and without regard to making a pleasing impression on observers," Joreen continues, "should be proud to declare she is a Bitch, because Bitch is Beautiful."

Further Reading: Davis, *Moving the Mountain;* Hole and Levine, *Rebirth of Feminism.*

Blackwell, Alice Stone (1857–1950) *suffragist, feminist, editor*

An editor of the WOMAN'S JOURNAL and officer of the NATIONAL AMERICAN WOMAN SUFFRAGE ASSOCIATION, Alice Stone Blackwell was born on September 14, 1857, in Orange, New Jersey, to a remarkable family. Blackwell's mother was Lucy STONE, the suffrage leader, and her father was suffragist and reformer Henry Browne Blackwell. Her aunt Elizabeth BLACKWELL was the United States' first female doctor and her aunt Antoinette Brown BLACKWELL was the country's first ordained woman minister. All of these relatives provided inspirational role models for Blackwell.

After graduating from Boston University, Blackwell became an editor of her mother's feminist publication, the *Woman's Journal.* She was influential in merging the two rival organizations, the NATIONAL WOMAN SUFFRAGE ASSOCIATION and the AMERICAN WOMAN SUFFRAGE ASSOCIATION, into the National American Woman Suffrage Association, of which she became the recording secretary for almost twenty years.

In addition to women's suffrage, Blackwell supported the temperance, pacifists, animal rights, and early civil rights movements. The WOMAN'S CHRISTIAN TEMPERANCE UNION, the National Association for the Advancement of Colored People, the American Peace Party and the Anti-Vivisection Society all counted her among their members.

Blackwell published many articles, including a biography of her mother, *Lucy Stone* (1930), several volumes of poetry translations, and *The Little Grandmother of the Russian Revolution: Reminiscences & Letters of Catherine Breshkovsky* (1917).

Alice Stone Blackwell died in Cambridge, Massachusetts on March 15, 1950.

Further Reading: Blodgett, "Alice Stone Blackwell" in *Notable American Women,* ed. James, James, and Boyer; Flexner, *Century of Struggle;* Stanton, Anthony, and Gage, eds., *History of Woman Suffrage.*

Blackwell, Antoinette Louisa Brown (1825–1921) *minister*

America's first ordained female minister, Blackwell was born Antoinette Louisa Brown on May 20, 1825, in Henrietta, New York, to Abby Morse Brown and Joseph Brown. Antoinette Brown entered Oberlin College, the first American college to admit women, in 1847. There she studied theology instead of the literary course approved for female students; as a result, she was refused graduation at the end of her studies in 1850. (Oberlin awarded Blackwell an honorary A.M. in 1878 and an honorary D.D. in 1908.)

After Oberlin, Brown became a women's rights, abolitionist, and temperance lecturer. She was ordained as a minister of the First Congregational Church in Butler and Savannah, New York on September 15, 1853. On January 24, 1856, she married Samuel Charles Blackwell—brother to America's first female doctor, Elizabeth Blackwell, and brother-in-law to Lucy Stone.

Blackwell was a vice-president of the Association for the Advancement of Women, an early member of the AMERICAN WOMAN SUFFRAGE ASSOCIATION, and a frequent contributor to the WOMAN'S JOURNAL. She was the author of a number of books, including *Studies in General Science* (1868), *The Sexes throughout Nature* (1875), *The Physical Basis of Immortality* (1876), and *The Philosophy of Individuality* (1893); near the end of her life, abridged versions of her work were published as *The Making of the Universe* (1914) and *the Social Side of Mind and Action* (1915). An ardent supporter of women's suffrage, she traveled across the United States to address suffrage and other women's rights meetings. In 1911, at the age of eighty-six, she participated in a widely publicized suffrage parade down New York City's Fifth Avenue. She was a founder of All Souls' Unitarian Church in Elizabeth, New Jersey and served there as pastor emeritus from 1908 until her death.

Antoinette Brown Blackwell died in Elizabeth, New Jersey on November 5, 1921.

Further Reading: Blackwell, *Sex Injustice;* ———, *The Philosophy of Individuality;* ———, *The Social Side of Mind and Action;* ———, *The Physical Basis of Immortality;* ———, *The Sexes Throughout Nature;* Lasser and Merrill, eds., *Friends and Sisters;* Solomon, "Antoinette Louisa Brown Blackwell" in *Notable American Women,* ed. James, James, and Boyer.

Blackwell, Elizabeth and Emily (1821–1910) (1826–1910) *pioneering physicians*

Both pioneering female physicians (Elizabeth was America's first female physician), the Blackwell sisters were born to Hannah Lane Blackwell and Samuel Blackwell, Elizabeth on February 3, 1821, in Counterslip, England, and Emily on October 8, 1826, in nearby Bristol. Elizabeth was the third of twelve children, nine of whom survived childhood; Emily was the sixth. Since Samuel Blackwell was a Dissenter (a member of the English Nonconformist party), his children were unwelcome in English schools and had to be taught at home. Tutors were engaged, and Elizabeth, Emily, and their sisters received the same instruction as their brothers.

The family relocated to America in 1832, settling first in New York City, then in Jersey City, New Jersey. Samuel Blackwell died in 1838, and Elizabeth worked as

a teacher from 1838 until 1847 to help her mother and two elder sisters, Marian and Anna, support and educate the younger children.

In 1847, after failure to gain admission to Bowdoin, Yale, Harvard, and every medical school in the cities of New York and Philadelphia, Elizabeth was admitted to Geneva College in upstate New York. Geneva's student body had been asked to vote upon the unusual application and, believing the application to be a prank, had gleefully agreed to welcome a female student. Elizabeth's hard work and good performance earned her the respect of most of her surprised classmates, and she graduated from Geneva on January 23, 1849. Medical degree in hand, she traveled to Europe for further training. She contracted purulent ophthalmia from a patient, and the resulting loss of sight in one eye ended her planned career as a surgeon. Upon her return to New York in August 1851, Elizabeth was unable to find employment. In 1853 she began in one room what would become the New York Infirmary for Women and Children in 1857.

Emily, meanwhile, had struggled to gain her own medical degree. Geneva and ten other medical colleges refused to admit her. She was finally admitted to Chicago's Rush Medical College in 1852 but, after the State Medical Society objected, was asked to leave at the end of her first year. She worked with her sister Elizabeth during the summer and completed her schooling at the Western Reserve University's medical college in Cleveland. Emily, like Elizabeth, traveled to Europe for further training upon graduation. She worked in Edinburgh with Sir James Young Simpson, who pioneered the use of chloroform during childbirth.

In 1856 Emily returned to work with Elizabeth at the New York Infirmary, where she became that institution's primary surgeon. Together Elizabeth and Emily built the New York Infirmary for Women and Children into a hospital that, by 1860, treated over 3,600 patients a year. A training course for nurses was established at the infirmary in 1858, and the United States' first charitable in-home medical service, the "Out-Practice or Tenement House Service," was established in 1866.

Elizabeth, satisfying a lifelong dream, organized the Woman's Medical College 1868. The college operated until 1898, when Cornell University Medical College began accepting qualified female students; at that point, the Woman's Medical College was closed and its students were transferred to Cornell. (The Blackwell sisters were not alone in encouraging women to become physicians: Other women's medical colleges founded during the second half of the nineteenth century include the Female Medical College of Pennsylvania, established in 1850; the New England Female Medical College, 1856; and the Homeopathic New York Medical College for Women, 1863.)

Emily and Elizabeth coauthored *Medicine as a Profession for Women* (1860). Elizabeth wrote many other books, essays, and articles, including *The Laws of Life, with Special Reference to the Physical Education of Girls* (1852), *Counsel to Parents on the Moral Education of Their Children* (1878), *The Religion of Health* (1878), and *The Human Element in Sex* (1884).

Elizabeth Blackwell died in Argyllshire, Scotland on May 31, 1910. Emily Blackwell died in York Cliffs, Maine on September 7 of that year.

Further Reading: Blackwell, E. and E., *Medicine as a Profession for Women;* Blackwell, *The Laws of Life with Special Reference to the Physical Education of Girls;* ———; *Address on the Medical Education of Women;* ———, *The Religion of Health;* ———, *Counsel to Parents on the Moral Education of Their Children;* ———, *The Human Element in Sex;* ———, *The Influence of Women in the Profession of Medicine;* ———, *Pioneer Work in Opening the Medical Profession to Women;* Evans, *Born for Liberty;* Thompson, "Elizabeth Blackwell," in *Notable American Women,* ed. James, James, and Boyer; ———, "Emily Blackwell," in *Notable American Women,* ed. James, James, and Boyer.

Blatch, Harriot Eaton Stanton (1856–1940)
feminist, suffragist, and founder of the Women's Political Union

Harriot Eaton Stanton Blatch was born on January 20, 1856 in Seneca Falls, New York to women's rights leader Elizabeth Cady STANTON and lawyer and abolitionist Henry B. Stanton. She received an excellent private school education and an early exposure to the suffrage movement.

Blatch began her career when her mother and Susan B. ANTHONY began the voluminous HISTORY OF WOMAN SUFFRAGE. It was she who prepared the 106-page chapter concerning Lucy STONE and the AMERICAN WOMAN SUFFRAGE ASSOCIATION. In 1907, five years after her mother's death and in an effort to reinvigorate the suffrage movement, Blatch formed the Equality League of Self-Supporting Women, which later became the WOMEN'S POLITICAL UNION. This organization introduced suffrage parades into the women's suffrage campaign. Its most influential members were its many female factory workers, who did much to prove that suffrage was not the demand solely of upper-class women. In 1917 the Woman's Political Union merged with the Congressional Union. Later that year Blatch helped to create the NATIONAL WOMAN'S PARTY through the merger of the Congressional Union and the Woman's Party. The National Woman's Party among other things, organized the picketing of the White House that resulted in the imprisonment of many suffragists.

After the United States entered World War I, Blatch continued to support the National Woman's Party but channeled her own energies into the war effort as head of the Food Administration Speakers Bureau and as Director of the Woman's Land Army, a group dedicated to supplying agricultural labor during the war. After the war's end and the ratification of the NINETEENTH AMENDMENT, Blatch was a strong proponent of the National Woman's Party proposed EQUAL RIGHTS AMENDMENT. She wrote *Mobilizing Woman-Power* (1918), *A Woman's Point of View* (1920), *Challenging Years* (with Alma Lutz, 1940), and edited with her brother, Theodore Stanton, *Elizabeth Cady Stanton: As Revealed in Her Letters, Diaries and Reminiscences* (1922).

Harriot Stanton Blatch died in Greenwich, Connecticut on November 20, 1940.

Further Reading: Flexner, "Harriot Eaton Stanton Blatch," in *Notable American Women*, ed. James, James, and Boyer; ———, *Century of Struggle*.

Bly, Nellie
See Elizabeth Cochrane SEAMAN.

Board of Directors of Rotary International v. Rotary Club of Duarte (1987)
A 1987 Supreme Court decision that upheld a California law requiring the Rotary Clubs to accept women as members. The Rotary Club of Duarte challenged California's antidiscrimination law based on the First Amendment's protection of freedom of association, but the Court, as Sandra Day O'Connor later summarized it in a speech, "reasoned that any infringement on the club members' freedom of association was justified by the State's compelling interest in eliminating sex discrimination and in assuring women equal access to leadership skills and business contacts." The Court had earlier ruled, in *ROBERTS V. JAYCEES* (1994), that state anti-discrimination laws applied to male-only clubs. This second and more complete decision on the subject prompted U.S. Kiwanis, Lions, and all chapters of the Rotary Club to accept female members.

Further Reading: *Board of Directors of Rotary International v. Rotary Club of Duarte;* O'Connor, "Women and the Constitution: A Bicentennial Perspective," in *Women, Politics and the Constitution*, ed. Lynn.

Bonnin, Gertrude Simmons (Zitkala-Sa, Zitkala-Sä, Red Bird) (1876–1938) *author, reformer*

Born on February 22, 1876, at the Yankton Sioux Agency in South Dakota, to Ellen Simmons, a Yankton Nakota Sioux woman, and a Caucasian father whose identity has not survived, Gertrude Simmons Bonnin, also known as Zitkala-Sä or Red Bird, was an author and reformer.

Bonnin lived in the traditional Nakota manner until the age of eight, when she entered White's Manual Institute, a boarding school for Indians run by Quaker missionaries. Thereafter, she attended Earlham College in Richmond, Indiana for two years, winning honors for her oratory skills and poetry. In 1898 she became a teacher at the Carlisle Indian School in Carlisle, Pennsylvania. She and Raymond T. Bonnin were married on May 10, 1902.

Bonnin's literary career included the publication, between 1898 and 1901, of four autobiographical essays in the *Atlantic Monthly* and two stories, each containing elements of Indian tales, in *Harper's Monthly;* the 1901 publication of *Old Indian Legends;* the 1921 publication of *American Indian Stories;* her work as editor from 1918 to 1919 on the Bureau of Indian Affairs publication, the *American Indian Magazine;* and, just before her death in 1938, a collaboration with William F. Hanson on *Sun Dances*, a Native American opera.

Bonnin was also an effective reformer. She was a member of the Society of American Indians, founded in 1911 at Ohio State University and considered the first reform organization for Native Americans managed by Native Americans. As a member of this group, Bonnin lobbied for American citizenship for Indians, a goal that was attained in 1924. Bonnin was also instrumental in persuading the GENERAL FEDERATION OF WOMEN'S CLUBS to create its Indian Welfare Committee in 1921. At Bonnin's urging, the committee worked closely with the Indian Rights Association to investigate the treatment of Native American tribes by the U.S. government, secure suffrage for Native Americans, and assist Native Americans in their efforts to improve reservations' educational and health facilities.

Gertrude Simmons Bonnin died on January 26, 1938 in Washington, D.C.

Further Reading: Bonnin, *American Indian Stories;* ———, *Old Indian Legends;* Fisher, "Zitkala Sä: The Evolution of a Writer"; Young, "Gertrude Simmons Bonnin," in *Notable American Women*, cd. James, James, and Boyer; *New York Times*, January 27, 1938.

bra-burning
According to author and feminist Robin Morgan, bra-burning was a form of protest that never actually occurred but that nonetheless was widely reported and

commented on throughout the late 1960s and 1970s. What actually happened, according to Morgan, is that the NEW YORK RADICAL WOMEN, as part of a protest of the 1968 Miss America Pageant, tossed various trappings of femininity into a "Freedom Trash Can." Although "dishcloths, steno pads [and] girdles" were also tossed, the flung bras caught the media's attention. No fire was set, but feminists thereafter were sometimes pejoratively referred to as "bra-burners."

Further Reading: Morgan, *Going Too Far.*

Bradstreet, Anne Dudley (ca. 1612/13–1672) *poet*
The first American poet to have a collection of poetry published, Bradstreet was born Anne Dudley in either 1612 or 1613 in Northampton, England, to Dorothy Yorke Dudley and Thomas Dudley, chief steward to Theophilus Clinton, the Puritan Earl of Lincoln. Growing up in a noble household, Anne was educated by tutors and given access to the earl's extensive library. In 1628, at about the age of sixteen, she married her father's assistant, Simon Bradstreet. Two years later the couple sailed for America. They—and Anne's parents—were among the first Massachusetts Bay Colony settlers. Bradstreet's family brought approximately 800 of their books with them to the New World—possessions that must have softened what Bradstreet at first found a harsh physical existence. (The Bradstreets went two years without a proper house.)

Anne wrote her poetry while bearing and rearing her eight children. Many of her early poems are imitative, especially of the poems of Guillaume DuBartas, a French Calvinist. Bradstreet's brother-in-law, unbeknownst to Bradstreet and without giving her the opportunity for revision or editing, arranged to have these early poems published in London. When *The Tenth Muse Lately sprung up in America, Or Severall Poems, compiled with great variety of Wit and Learning, full of delight . . . by a Gentlewoman of those parts* appeared in 1650, Bradstreet lamented: "Thou ill-sprung offspring of my feeble brain/. . . snatched . . . by friends less wise than true/Who thee abroad, exposed to public view." Bradstreet began revising her poems for the second edition, which was published in the United States in 1678, six years after her death. This edition—whose title omits the description of Bradstreet as "The Tenth Muse"—includes her mature work.

The later poems are startlingly beautiful and the basis of her enduring reputation. Many address concerns of life, death, age, and loss in the voice of a wife or mother. In "Before the Birth of One of Her Children," Bradstreet bids a possible farewell to her husband after reflecting on the nature of mortality:

How soon, my Dear, death may my steps attend,
How soon't may be thy lot to lose thy friend,
We both are ignorant; yet love bids me
These farewell lines to recommend to thee,
That when that knot's untied which made us one,
I may seem thine, who in effect am none.

Three elegies—for the three of four children of her son Samuel and his wife who died in early childhood—record both a grandmother's loss and her sustaining reflection upon her faith. "On My Dear Grandchild Simon Bradstreet, Who Died on 16 November 1669, Being but a Month and One Day Old," marks the loss of the third of these children:

No sooner come, but gone, and fallen asleep.
Acquaintance short, yet parting caused us weep;
Three flowers, two scarcely blown, the last i'th'bud,
Cropped by th' Almighty's hand; yet is He good.
With dreadful awe before Him let's be mute;
Such was His will, but why, let's not dispute;
With humble hearts and mouths put in the dust,
Let's say He's merciful, as well as just.
He will return, and make up all our losses,
And smile again, after our bitter crosses.
Go pretty babe, go rest with sisters twain;
Among the blest in endless joys remain.

Other poems, set outside a familial framework, are ardent meditations upon the interplay of earthly experience and spiritual immortality. "Contemplations," for example, begins with an appreciation of New England's natural beauty. Later in the poem, Bradstreet seems to envy ". . . the earth (though old) still clad in green/The stones and trees, insensible of time/Nor age nor wrinkle on their front are seen/If winter come, and greenness then do fade/A spring returns, and they more youthful made." It is a harsh contrast to the experience of ". . . man [who] grows old, lies down, remains where once laid." The poem examines the building of monuments and other futile attempts of humans to outlive their lives, and ends with the consolation that those who are saved by God "shall last and shine when all of these are gone."

In "The Flesh and the Spirit," the comparative value of heavenly salvation and earthly treasures is argued between two sisters, Flesh and Spirit. Flesh tries to tempt Spirit into the pursuit of honor and wealth. Near the beginning of her winning retort, Spirit tells the Flesh that

Sisters we are, yea, twins we be
Yet deadly Feud 'twixt thee and me:
For from one father are we not,
Thou by old Adam wast begot,
But my rise is from above,
Whence my dear Father I do love.

Spirit, rueful at "How oft thy slave, hast thou made me"—and vowing that the mistake won't be repeated—tells the inferior Flesh that "Mine eye doth pierce the heavens and see/What is invisible to thee." The poem describes the heavenly "city where I [Spirit] hope to dwell" and concludes with a triumphant Spirit:

If I of heaven may have my fill,
Thou take the world, and all that will.

Anne Bradstreet died in North Andover on September 16, 1672.

Further Reading: Bradstreet, *Works of Anne Bradstreet in Prose and Verse,* ed. Ellis; Faust, ed., *American Women Writers;* Gilbert and Gubar, eds., *Norton Anthology of Literature by Women;* Rogers, ed., *Early American Writers;* Winslow, "Anne Bradstreet," in *Notable American Women,* ed. James, James, and Boyer.

Bradwell v. Illinois (1873)

The 1873 Supreme Court decision that held that a woman's right to engage in the livelihood of her choice was not "one of the privileges and immunities of women as citizens" and, therefore, was not protected by Section 1 of the FOURTEENTH AMENDMENT.

In August 1869 Myra Bradwell, editor of the *Chicago Legal News,* passed Illinois' law exam. She received a certificate of qualification that was duly signed by circuit judge E. S. William and state attorney Charles H. Reed, both of whom recommended that she be issued a license to practice law. In September Bradwell applied for admission to the Illinois bar. In addition to the usual papers, she submitted a separate written application that addressed the matter of sex. She acknowledged that the Illinois Revised Statutes discussed attorneys strictly in male terms, "authoriz[ing] *him,*" for example, "to appear in all the courts." (Emphasis added.) But Bradwell also was able to point to Chapter 90, Section 28 of the same Revised Statutes, that stated: "When any party or person is described or referred to by words importing the masculine gender, females as well as males shall be deemed to be included." Then, to illustrate the general acceptance of this principle, she gave several examples of the male pronoun's use, including "Section 3 of our Declaration of Rights, [which] says 'that all men have a natural and indefeasible right to worship Almighty God,' etc. It will not be contended," Bradwell claimed, "that women are not included within this provision." She ended with a request for admission to the bar.

The Supreme Court of the State of Illinois declined to admit her. In his October 6, 1869 letter of denial, the Honorable Norman L. Freeman explained that the decision was based ". . . upon the ground that you would not be bound by the obligations necessary to be assumed where the relation of attorney and client shall exist, by reason of the disability imposed by your married condition—it being assumed that you are a married woman . . ."

The disability referred to arose from the status of married women as FEMMES COVERTS, or as persons who had suffered a civil and legal death. Married women, in most parts of the country—and in Illinois almost right up to the point of Bradwell's application—could own nothing; all property accruing to them automatically belonged to their husbands. A woman under *femme coverte* might have been considered incapable of holding her client's funds in an escrow account, since her husband or his creditors might conceivably seize it at any time. Moreover, husbands had a legal right to their wives' companionship and sexual compliance. Colonial statutes clearly forbade married women to engage in business without the permission of their husbands and just as clearly stated the reason: If women could be held liable for their actions and debts, they might find themselves arrested and incarcerated—events that would leave husbands without the companionship and sexual access that were their legal due. This disabling requirement that a wife be available to her husband still existed in mid-nineteenth-century America; the court may well have viewed it as another potential compromise of a woman's ability to maintain a fiduciary relationship with a client. (For further discussion of women and marriage, see AN ACT CONCERNING THE RIGHTS AND LIABILITIES OF HUSBAND AND WIFE; FEMME SOLE TRADERS; and MARRIED WOMEN'S PROPERTY ACT, 1848, NEW YORK STATE.)

On November 18, 1869 Bradwell filed a spirited brief with the court in which she stated that "Your petitioner admits to your honors that she is a married woman (although she believes the fact does not appear in the record), but insists most firmly that under the laws of Illinois it is neither a crime nor a disqualification." She discussed cases in which married women had been treated as *femme sole* traders (women conducting business as if single) and cited her own case as editor and stockholder of the *Chicago Legal News* and the admission of Arabella Mansfield to the bar in Iowa. She also discussed changes made in Illinois law earlier that same year:

Your petitioner claims that a married woman is not to be classed with an infant since the passage of the Act of 1869. A married woman may sue in her own name for her earnings, an infant can not. A married woman, if an attorney, could be committed for contempt of court the same as any other attorney. If she should collect money and refuse to pay it over, she could be sued for it the same as if she were single. A married woman is liable at law for all torts committed by her, unless under the real or implied coercion of her hus-

band. Having received a license to practice law as an attorney, and having acted as such, she would be estopped from saying she was not liable as an attorney upon any contract made by her in that capacity.

The fees that a married woman receives for her services as an attorney are as much her earnings as the dollar that a sewing-woman receives for her day's work, and are just as much protected by the Act of 1869. Is it for the court to say, in advance, that it will not admit a married woman?

Several weeks later, Bradwell amended her brief to include a claim that her Constitutional rights, especially under the Fourteenth Amendment, were being abridged by the State of Illinois. Specifically, Bradwell claimed that she had the same right as any other citizen to choose a means of employment pursuant to the Fourteenth Amendment.

The Supreme Court of the State of Illinois found otherwise. In its opinion, delivered by Chief Justice Lawrence, the court did not address Bradwell's claims under the Fourteenth Amendment. Instead, it declared that the recent changes in Illinois property law affected only a woman's own separate holdings. Women's "common law disabilities in regard to making contracts," Lawrence said, had not been removed to an extent that would have "invited them to enter, equally with men, upon those fields of trade and speculation by which property is acquired through the agency of contracts." The court also found that Bradwell, even without a woman's traditional legal disabilities, could be considered unfit solely on the grounds of sex: ". . . [A]fter further consultation . . . we find ourselves constrained to hold that the sex of the applicant, *independently of coverture,* is, as our law stands, a sufficient reason for not granting this license." (Emphasis added.) Finally, the court disagreed with Bradwell's reading of male pronouns, saying:

. . . [I]t is said . . . that, whenever any person is referred to in the statute by words importing the masculine gender, females as well as males shall be deemed to be included. But the 36th section of the same chapter provides that this rule of construction shall not apply where there is anything in the subject or context repugnant to such construction. This is the case in the present instance.

Bradwell next appealed to the Supreme Court of the United States. Matthew H. Carpenter, a United States senator from Wisconsin, argued the case. Focusing on Bradwell's Fourteenth Amendment claim, Carpenter asked: ". . . [C]an this court say that, when the XIV. Amendment declares 'the privileges of no citizen shall be abridged,' it meant that the privileges of no male citizen or unmarried female citizen shall be abridged?" If Bradwell's

choice of employment was not protected by this clause, Carpenter reasoned, than neither was anyone else's:

If the Legislature may, under pretense of fixing qualifications, declare that no female citizen shall be permitted to practice law, they may as well declare that no colored citizen shall practice law . . . If this provision does not open all the professions, all the avocations, all the methods by which a man may pursue happiness, to the colored as well as the white man, then the Legislatures of the State may exclude colored men from all the honorable pursuits of life, and compel them to support their existence in a condition of servitude. And if this provision does protect the colored citizen, then it protects every citizen, black or white, male or female. Why may a colored citizen buy, hold, and sell land in any State of the Union? Because he is a citizen of the United States and that is one of the privileges of a citizen. Why may a colored man be admitted to the bar? Because he is a citizen, and that is one of the avocations open to every citizen; and no State can abridge his right to pursue it.

For the same reasons, Carpenter maintained, Myra Bradwell's right to be admitted to the bar could not be abridged by the State of Illinois.

Justice Samuel F. Miller delivered the Court's opinion, which held that Illinois could indeed restrict the practice of law, among other professions, to men. Finding that the Fourteenth Amendment did not protect a person's right to practice law, he wrote:

. . . there are certain privileges and immunities which belong to a citizen of the United States as such; otherwise it would be nonsense for the Fourteenth Amendment to prohibit a state from abridging them, and [plaintiff's counsel] proceeds to argue that admission to the bar of a state, of a person who possesses the requisite learning and character, is one which a state may not deny.

In this latter proposition, we are not able to concur with counsel.

It is the concurring opinion of Justice Joseph P. Bradley that is most often quoted in illustration of the Court's view of women during the nineteenth century. To uphold Bradwell's claim under the Fourteenth Amendment, Bradley wrote, would indicate "that it is one of the privileges and immunities of women as citizens to engage in any and every profession, occupation or employment in civil life."

"It certainly cannot be affirmed, as a historical fact, that this has ever been established as one of the fundamental privileges and immunities of the sex," Bradley declared. He then explained his reasoning:

The harmony . . . which belong[s] or should belong to the family institution, is repugnant to the idea of a

woman adopting a distinct and independent career from that of her husband . . . The paramount destiny and mission of woman are to fulfill the noble and benign offices of wife and mother. This is the law of the Creator. And the rules of civil society must be adapted to the general constitution of things . . .

The Supreme Court would not apply Section 1 of the Fourteenth Amendment to women or their rights until 1971, nearly one hundred years after the amendment's ratification. (See *MINOR V. HAPPERSETT* and *REED V. REED.*)

Further Reading: *Bradwell v. State of Illinois;* Cary and Peratis, *Woman and the Law;* Stanton, Anthony, and Gage, eds., *History of Woman Suffrage,* vol. 2.

Breckinridge, Mary (1881–1965) *nurse, midwife, founder of the Frontier Nursing Service*

Born on February 17, 1881, in Memphis, Tennessee, to Katherine Carson Breckinridge and Clifton Rodes Breckinridge, nurse-midwife Mary Breckinridge founded the Frontier Nursing Service.

Breckinridge's father was a U.S. congressman from Arkansas and later served on and off as American minister to Russia. Breckinridge received her early education from her governess in Washington, D.C. When her parents moved to St. Petersburg, she began to attend boarding schools; from 1896 to 1898 she attended the Rosemont-Dezaley School in Lausanne, Switzerland and from 1898 to 1899 she attended the Low and Heywood School in Stamford, Connecticut. Breckinridge was married to Henry Ruffner Morrison in 1904 and widowed in 1906 when her husband died of appendicitis. Mourning Henry's death, Breckinridge resolved to become a nurse, and she graduated from Saint Luke's Hospital School of Nursing in New York City in 1910. She returned to Arkansas, where her parents lived, to care for her ill mother. There she met and on October 8, 1912 married, Richard Ryan Thompson, president of Eureka Springs' Crescent College and Conservatory for Young Women. The couple had two children, one of whom died when six hours old, the other, at the age of four. The marriage ended in divorce in 1920, and Breckinridge legally resumed use of her original surname.

At the end of World War I, Breckinridge assisted with disaster relief in Vic-sur-Aisne, France, paying particular attention to the needs of children and women who were pregnant or nursing. Breckinridge returned to the United States in 1921, determined to honor the memory of her own two children by "rais[ing] the status of childhood everywhere" and by communicating the idea that nurse-midwives like those she had encountered in Europe could "provide a logical response to the needs of the young child in rural America." She studied public health at Columbia University and then attended the school of the British Hospital for Mothers and Babies, which certified her as an English midwife in 1924. Breckinridge engaged in postgraduate work at the York Road General Lying-in Hospital in London and was admitted to the Midwives Institute in England, in 1924.

In 1925 Breckinridge used the inheritance she had received from her mother to found the Kentucky Committee for Mothers and Babies, which would, three years later, become the Frontier Nursing Service. The organization's nurses rode horses through the mountains to deliver babies and care for the ill. During the service's first year, 1,000 families were served. By Breckinridge's death in 1965, Frontier Service nurses had delivered over 15,000 rural babies and had become a firmly established institution with twenty-nine nurse-midwives on staff and an annual budget of over $300,000.

Breckinridge also helped to establish Leslie County's first hospital, the Hyden Hospital, in 1928, and she established The Frontier Graduate School of Midwifery in 1938. She was awarded the Harmon Fanton Prize for her contributions to the field of public health work in 1926 and received the Mary Adelaine Nutting Award for Distinguished Service, the highest honor of the National League of Nursing, in 1961.

Mary Breckinridge died on May 16, 1965 in Hyden, Kentucky.

Further Reading: Breckinridge, *Wide Neighborhoods;* Faust, "Mary Breckinridge," in *Notable American Women,* Sicherman, ed.; *New York Times,* May 17, 1965; Read and Witlieb, *Book of Women's Firsts.*

Bremer, Edith Terry (1885–1964) *social worker*

Born Edith Terry on October 9, 1885, in Hamilton, New York, to Mary Balswein Terry and Benjamin Stites Terry, social worker Edith Bremer was the leader of the International Institute movement.

Bremer graduated from the University of Chicago in 1907 and then attended the Chicago School of Civics and Philanthropy from 1907 to 1908. She married Harry M. Bremer on September 4, 1912.

Upon completion of her education, Bremer joined the Women's Trade Union League. In Chicago, she devoted herself to a number of tasks. She investigated the problems faced by wage-earning women, worked for the Chicago Juvenile Court as a field investigator, and worked for the U.S. Immigration Commission as a special agent. She became involved in the SETTLEMENT HOUSE MOVEMENT in Chicago and then in New York City, where she had moved prior to her marriage. In 1910, wishing to focus on problems facing immigrant girls, she joined the National Board of the Young Women's Christian Association (YWCA) in New York City and became its national field secretary.

Convinced that women were poorly served by other immigrant social welfare agencies, both public and private, Bremer founded the YWCA's first International Institute in December 1910. The institute employed "nationality workers," or social workers who had themselves entered the United States as immigrants, to help new female immigrants adjust to life in America. Among the services offered were English-language classes, employment counseling and placement, housing referrals, and naturalization assistance.

Bremer's efforts were redirected from the International Institute Movement during World War I. She organized immigrant women for relief work under the auspices of the YWCA's War Work Council. She also supervised the state-side training of the Polish Gray Samaritans, a group of Polish-American women who performed valuable relief work in Poland at the end of the war.

The International Institute movement regained momentum after the war and, by 1925, there were fifty-five International Institutes in various American cities. Bremer was made the head of the YWCA's Department of Immigration and Foreign Communities (which became, in 1932, the Bureau of Immigration and Foreign-Born). She continued to work on behalf of immigrants, testifying about immigration policies before Congress, lobbying for reform of relevant laws, and—well in advance of the current move toward "cultural pluralism"—urging Americans to accept immigrant groups and their languages and customs as valuable contributions to American society.

In December 1933, with the sanction of the YWCA, Bremer established an independent National Institute of Immigrant Welfare (which became, in 1944, the American Federation of International Institutes), which absorbed and effectively replaced the YWCA's Bureau of Immigration and Foreign-Born. Bremer acted as the institute's director until her retirement in 1955. Under Bremer's direction, the institute was an effective advocate of refugees seeking admission to the United States during and following World War II and was of particular assistance in the resettlement of Japanese-Americans who had been held in internment camps during the war.

Edith Bremer died on September 12, 1964 in Port Washington, New York.

Further Reading: Mohl, "Edith Terry Bremer," in *Notable American Women,* Sichermen, ed.; Young Women's Christian Associations, *Foreign-Born Women and Girls.*

Brent, Margaret Reed (ca. 1601–ca. 1671) *suffragist*
Landowner, one-time executor for the colonial governor of Maryland, and perhaps the first American woman to request suffrage, Margaret Reed Brent was born in or about 1601 in Gloucester, England to Elizabeth Reed Brent and Richard Brent, the Lord of Admington and Lark Stoke. She arrived in Maryland on November 22, 1638, with her sister Mary and two brothers, Giles and Fulke. Margaret and Mary received the first land grant made to females in Maryland, seventy and a half acres that became known as "Sisters Freehold." Margaret Brent increased her holdings and became one of Maryland's prominent landowners. She filed suits with the Provincial Court whenever necessary in the course of her business dealings and sometimes appeared in court on behalf of others. When Mary Kitomaquund, daughter of the Piscataway Indian chief, arrived in Maryland for an education, Governor Leonard Calvert and Margaret Brent became her joint guardians.

Brent assisted Calvert in raising troops during the armed Protestant attack against Maryland's Catholic government (1644–46). Some of the soldiers came from Virginia in response to Calvert's promise of payment. In May 1647, after order was restored in Maryland but before the Virginian soldiers had been paid, Governor Calvert lay dying. He appointed Margaret Brent executor of his estate and directed her to "Take all, pay all" to the by-then restless and possibly mutinous Virginian soldiers. When Calvert's assets proved insufficient to pay the troops, Brent sought and received a court order allowing her to exercise, as Calvert's executor, a power of attorney he had held for Lord Baltimore, the colony's proprietor. Brent, without hesitation, sold Lord Baltimore's cattle and used the proceeds to pay the soldiers.

Brent made her demand for suffrage before the House of Burgesses on January 21, 1647/48—and she asked not for one vote in the assembly, but two—one as a freeholder in her own right, the second as Lord Baltimore's attorney. The house refused, and Brent immediately, but without avail, "protested a[gainst] all proceedings in this [a]p[oi]nt[ed] Assembly, unless shee may be appointed? and have vote as aforesaid."

Margaret Brent later moved to Virginia. She is believed to have died in 1671.

Further Reading: Carr, "Margaret Brent," in *Notable American Women,* ed. James, James, and Boyer. Flexner, *Century of Struggle;* McHenry, ed., *Famous American Women.*

Brown, Hallie Quinn (ca. 1850–1949) *educator, temperance worker, suffragist, founder of African-American women's organizations*
Hallie Quinn Brown was born about 1850, in Pittsburgh, Pennsylvania, to Frances Jane Scroggins Brown and Thomas Arthur Brown, both former slaves. She was educated in Pittsburgh and Ontario, Canada before entering Wilberforce University in Ohio.

Upon her graduation in 1873, Brown moved to Mississippi to help teach elementary school during Reconstruction. While teaching, she attended Chautauqua Lecture School, graduating in 1886. She returned to Ohio in 1887 and opened a night school for adults from the South. She again moved south in 1892; there she accepted the position of principal of the Tuskegee Institute in Alabama and later a position as elocution professor at Wilburforce University. In association with the Wilburforce Concert Co. she made extensive trips abroad, lecturing on the subject of African-American life. She was a supporter of the WOMAN'S CHRISTIAN TEMPERANCE UNION and lectured in England and Scotland for the British Women's Temperance Association in 1895. She represented the United States at the meeting of the INTERNATIONAL CONGRESS OF WOMEN held in England in 1899. Brown actively worked for the African Methodist Episcopal Church and attended the World Conference on Missions in 1910. She founded the black women's Neighborhood Club at Wilburforce University, was president of the Ohio State Federation of Colored Women's Clubs from 1905 to 1912, helped found the Colored Woman's League of Washington, D.C. (a predecessor of the NATIONAL ASSOCIATION OF COLORED WOMEN), and served as president of the National Association of Colored Women from 1920 to 1924. Her political involvements included a term as vice president of the Ohio Council of Republican Women during the early 1920s. In 1924 she was named Director of Colored Women's Activities in Chicago. She wrote several books, including *Homespun Heroines and Other Women of Distinction* (1926), *First Lessons in Public Speaking* (1920), and *A Choice Selection of Recitations* (1880).

Hallie Quinn Brown died in Wilberforce, Alabama on September 16, 1949.

Further Reading: Brown, *Homespun Heroines;* Wesley, "Hallie Quinn Brown," in *Notable American Women,* James, James, and Boyer, eds.

Bryn Mawr Summer Schools for Women Workers (1921–1930s)

Two-month summer school sessions for female factory workers, the Bryn Mawr Summer Schools for Women Workers began in 1921 and continued through the mid-1930s.

Such a school was originally the suggestion of Margaret Dreier Robins, president of the Women's Trade Union League from 1907 to 1922. It was established by Bryn Mawr's president, M. Carey Thomas, and two of the college's instructors, Susan Kingsbury and Hilda Smith. After its successful inception at Bryn Mawr, the summer schools were conducted at varying sites.

In order to be considered for the program, a woman generally had to have received at least an eighth-grade education, but exceptions were made. Referrals were made by the Young Women's Christian Association in the South and by unions throughout the rest of the country. Bryn Mawr's first class consisted of seventy-five women; while they were not charged for expenses, they forfeited their normal summer earnings in order to attend.

Students studied economics, history, union organizing, labor law, and the nature of democracy.

Further Reading: Brown, *American Women in the 1920s;* Evans, *Born for Liberty.*

Buck, Pearl Comfort Sydenstricker (1892–1973)
writer

Born Pearl Sydenstricker on June 26, 1892, in Hillsboro, West Virginia, to Caroline Stulting Sydenstricker and Absolom Sydenstricker, author Pearl Buck became the first American woman to win the Nobel Prize for literature.

Buck's parents were missionaries, and Buck lived with them in China from the age of three months until the age of eight, when the Boxer Rebellion forced the family to return to the United States in 1900. Buck received private tutoring and attended boarding and missionary schools until she entered Virginia's Randolph-Macon Woman's College in 1910. Shortly after her graduation in 1914, Buck returned to China to care for her ill mother, who had returned to that country during her daughter's school years.

In May 1917 she married John Buck, a U.S. agricultural expert working in China. The couple had one daughter, who was born in 1920 and diagnosed as retarded in 1925. (In 1950 Buck related the challenges and rewards of raising her daughter in *The Child Who Never Grew.*) Pearl and John Buck divorced in 1935, and Buck subsequently married Richard Walsh.

The Buck family moved between China and the United States during the 1920s. In 1921 Buck taught English literature at China's University of Nanking. She returned to the United States between 1922 and 1925 and published several short stories and articles about China. At that time she also received a master's degree in English from Cornell University. Upon her return to China, she once again taught English literature, this time at the National Southeastern University and Chung Yang University.

In 1930 Buck published her first novel, *East Wind, West Wind,* and her second, *The Good Earth,* the novel for which she would become most famous. *The Good Earth* tells the story of O-Lan, a slave girl, and Wang Lung, the farmer she marries. *The Good Earth* was a Pulitzer Prize winner in 1931, a Howells Medal of the American Academy of Arts and Letters recipient in 1935, and a best-

Buck wrote more than one hundred books, most of which were set in Asia and a number of which dealt with strong women. This latter group includes *Pavilion of Women,* her 1946 novel about an iconoclastic Chinese woman and the spiritual nature of her love for an Italian cleric; *Imperial Woman,* her 1956 novel based on the life of China's dowager empress, Tzu Hsi; and *Command the Morning,* a 1959 novel that details both the atomic bomb's development and a female scientist's struggle to place work above love. Also of particular note is *The Mother,* a 1934 novel that was ground-breaking in its depiction of childbirth and abortion.

In addition to her literary works, Buck founded the Welcome House, an agency that placed Asian-American children for adoption in the United States, and in 1949, The Pearl S. Buck Foundation, to assist Asian children born to and abandoned by American fathers.

Pearl S. Buck died on March 6, 1973, in Danby, Vermont.

Further Reading: Buck, *The Good Earth;* ———, *The Mother;* ———, *This Proud Heart;* ———, *Peony;* ———, *Pavilion of Women;* ———, *Command the Morning;* Cohen, "Pearl Syndenstricker Buck," in *Notable American Women,* Sicherman, ed.; Conn, *Pearl S. Buck: A Cultural Biography;* Faust, ed., *American Women Writers;* McHenry, ed., *Famous American Women;* Read and Witlieb, *Book of Women's Firsts.*

Buck v. Bell (1927)

This 1927 Supreme Court decision upheld a Virginia law permitting the government to order the compulsory sterilization of young women it believed were "unfit to continue their kind."

Carrie Buck grew up in difficult circumstances: Removed from the care of her widowed mother at age three, she lived with the Dobbs family of Charlottesville, Virginia, who withdrew her from school at the end of fifth grade. Carrie satisfactorily performed the family's household work until she turned seventeen. She then became pregnant during what she said was a rape by a Dobbs family member.

The Dobbses responded by having their own and a second doctor testify to Charlottesville justice of the peace Charles D. Shackleford that Carrie was feebleminded, thereby securing an order committing her to the Virginia State Colony for Epileptics and Feebleminded, in Lynchburg on January 24, 1924. (The Dobbses kept Carrie Buck's infant daughter.)

The superintendent of the state colony, Dr. Albert Priddy, believed he could help society limit the number of what he called "mental defectives" by controlling the reproduction of his patients. Dr. Priddy, claiming that he

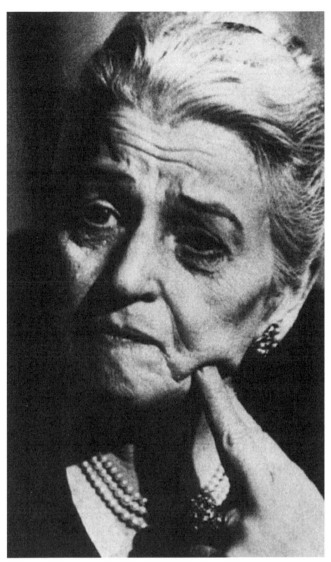

Pearl Buck, the first American woman to win the Nobel Prize in literature (*Library of Congress*)

seller that would ultimately sell over 2 million copies in over thirty languages. Two other novels, *Sons* (1932) and *A House Divided* (1935), follow the family of O-Lan and Wang Lung through two additional generations. In 1936 Buck published a biography of her mother, *The Exile,* in which she explores, among other things, her mother's regret that her marriage had not been an equal partnership. She published a biography of her father in the same year, entitled *Fighting Angel. This Proud Heart,* a fictionalized exploration of her own struggles to balance marriage and work, was published in 1938.

In 1938 Buck became the first American woman to receive the Nobel Prize for literature, awarded in honor of her "rich and genuine portrayals of Chinese life and masterpieces of biography."

operated only to cure "pelvic disease," had sterilized between seventy-five and one hundred young women without their consent before seeing Carrie Buck. The Virginia Assembly soon made Priddy's "pelvic disease" excuse unnecessary: Prompted by Aubrey Strode, a chief administrator of the state colony and a state legislator as well, the assembly in 1924 adopted a bill permitting compulsory sterilization of "feeble-minded" or "socially inadequate person[s]."

The colony decided to use Carrie Buck as a test case and hired Irving Whitehead—formerly a member of the colony's board—to represent Buck. *Buck v. Priddy* was argued on November 19, 1924, before Judge Bennett Gordon of the Circuit Court of Amherst County. Aubrey Strode acted as attorney for Dr. Priddy, who sought to have Buck declared feebleminded and a candidate for enforced sterilization pursuant to Virginia's new law.

Several Charlottesville teachers testified that Carrie's brother, sister, and cousin were less than average students, but no teachers testified about Carrie's abilities. A Red Cross social worker, Caroline Wilhelm, who had been introduced to the Dobbs family and Carrie during Carrie's pregnancy, was asked by Buck's attorney Irving Whitehead: "Judging by the fact that she has already given birth to an illegitimate child, and had an immoral tendency, is it your opinion that by sterilization she would be made less of a liability and more of an asset to the State?"

Wilhelm answered, "I think it would at least prevent the propagation of her kind."

Arthur Estabrook, author of *The Jukes in 1915,* testified as an expert witness that "the result of the study was to show that certain definite laws of heredity were being shown by the [Jukes] family, and that the feeblemindedness was being inherited . . . and . . . was the basis of the anti-social conduct, showing up in the criminality and the pauperism." Estabrook then agreed with Aubrey Strode's characterization of Carrie Buck as "a feebleminded person and the probably potential parent of socially inadequate offspring likewise affected."

In February 1925 Judge Gordon upheld Virginia's compulsory sterilization law and ordered Carrie Buck sterilized. On Buck's behalf, Whitehead appealed to Virginia's Court of Appeals. (The case was renamed *Buck v. Bell* because Dr. Priddy died and was succeeded at the Colony by Dr. J. H. Bell.) Judge Gordon's decision was upheld by the Appeals Court.

The case then went to the Supreme Court. Whitehead argued that the Fourteenth Amendment protected a person's "full bodily integrity." He warned that the country would see the "worst kind of tyranny" if it set no "limits of the power of the state (which, in the end, is nothing more than the faction in control of the government) to rid itself of those citizens deemed undesirable." Strode

took a different view: Compulsory sterilization, he told the justices, was similar to compulsory vaccination.

On May 2, 1927 Justice Oliver Wendell Holmes delivered the court's opinion:

> We have seen more than once that the public welfare may call upon the best citizens for their lives. It would be strange if it could not call upon all those who sap the strength of the state for their lesser sacrifices, often felt to be much by those concerned, in order to prevent our being swamped with incompetence. It is better for all the world, if instead of waiting to execute offspring for crime, or to let them starve for their imbecility, society can prevent those who are manifestly unfit from continuing their kind. The principle that sustains compulsory vaccination is broad enough to cover cutting the Fallopian tubes . . .

Justice Pierce Butler offered the only dissent without a written opinion.

Carrie Buck was sterilized by Dr. Bell on October 16, 1927. Paroled from the colony shortly thereafter, she married, was widowed, and married again. Her minister, neighbors, and later health care providers do not believe she was feebleminded.

Buck v. Bell's implications reached far past Carrie Buck, however. In the United States, over 50,000 people were sterilized in thirty states in accordance with laws modeled on Virginia's. In Europe, following World War II, Nazi lawyers defended the forced sterilization of 2 million people by citing that the U.S. Supreme Court had declared such laws constitutional in *Buck v. Bell.*

Buck v. Bell has yet to be reversed. In 1973 ROE V. WADE guaranteed the right of women to terminate their pregnancies during the first two trimesters. Justice Harry A. Blackmun in that decision, balanced the interests of the woman and the state and found the woman's right of privacy paramount. However, specifically citing *Buck v. Bell,* Justice Blackmun pointedly refuted "the claim . . . that one has an unlimited right to do with one's body as one pleases."

Further Reading: *Buck v. Bell,* 274 U.S. 200 (1927); Cushman, *Cases in Constitutional Law;* Frost-Knappman and Cullen-DuPont, *Women's Rights on Trial;* Knappman, ed., *Great American Trials;* Smith and Nelson, *Sterilization of Carrie Buck.*

Burlington Industries, Inc. v. Ellerth (1998)

One of two Supreme Court decisions that, taken together, enunciate a new standard for holding employers liable for supervisor harassment. (The other case is *FARAGHER V. CITY OF BOCA RATON.*)

In the *Burlington* case, Kimberly Ellerth, a salesperson at Burlington Industries, charged that Theodore

Slovik, vice president of sales, made offensive remarks and unwanted overtures. Three specific incidents contained threats to deny tangible job benefits unless sexual favors were granted. Ellerth granted no favors, however, and the threats were never acted upon; in fact, Slovik promoted her during the course of his objectionable behavior. Ellerth told Slovik that she objected to his behavior, but she never informed anyone else of his conduct while she was at Burlington. She eventually quit and filed a lawsuit in the United States District Court for the Northern District of Illinois. She alleged a violation of Title VII of the CIVIL RIGHTS ACT OF 1964, claiming that Burlington Industries engaged in sexual harassment and thus forced her constructive discharge.

The court noted that Ellerth had suffered no negative job consequences. It also noted that she had been aware of Burlington's policy against sexual harassment, yet had not complained to supervisors about Slovik's behavior. Reasoning that Burlington did not know, and could not be expected to know, of any sexual harassment, the court dismissed Ellerth's claim.

The Seventh Circuit Court of Appeals en banc reversed the lower court's decision, but with eight separate opinions based on divergent rationales. Their opinions raised two central questions. First, should Ellerth's claim be classified as a quid pro quo harassment claim, i.e., one in which tangible job benefits were tied to sexual behavior; and second, whether employers in such a situation should be held to a vicarious liability standard, i.e., one where the employer is directly responsible for the actions of its offending employee, or to a negligence standard, i.e., one where the employer is responsible only if it is negligent or in some way directly blamable for its employee's actions.

As Justice Anthony Kennedy appraised the confusion in the Supreme Court's decision, "[t]he disagreement revealed in the careful opinions of the judges of the Court of Appeals reflects the fact that Congress has left it to the courts to determine controlling agency law principles in a new and difficult area of federal law." The Supreme Court, therefore, granted certiorari "to assist in defining the relevant standards of employer liability."

The Supreme Court's ruling on June 26, 1998, was succinctly summarized as follows:

> Under Title VII, an employee who refuses the unwelcome and threatening sexual advances of a supervisor, yet suffers no adverse, tangible job consequences, may recover against the employer without showing the employer is negligent or otherwise at fault for the supervisor's actions, but the employer may interpose an affirmative defense.

An affirmative defense, if proven, would relieve the employer of liability if it took "reasonable care" to prevent and end harassing behavior, and the employee unreasonably refused to make use of any preventative or curative remedies.

The Supreme Court's decision in *Faragher v. City of Boca Raton* was issued the same day.

Further Reading: Associated Press, June 26, 1998; *Burlington Industries, Inc. v. Ellerth*, 118 S. Ct. 2257 (1998); Castro, "Enforcement Guidance: Vicarious Employer Liability for Unlawful Harassment by Supervisors"; *National Law Journal*, March 22, 1999; *Washington Post*, June 27, 1998.

Cable Act (1922)

Legislation passed by Congress on September 22, 1922, the Cable Act permitted women who married foreigners to retain their United States citizenship. Prior to the act's passage, a woman's citizenship automatically became that of her new husband. Upon her election to Congress in 1916, Jeannette Rankin introduced a bill guaranteeing permanent citizenship to women. In a 1917 speech before the members of the National American Woman Suffrage Association, Rankin explained her view of such an act's importance:

> We . . . must not forget that there are other steps beside suffrage necessary to complete the political enfranchisement of American women. We must not forget that the self-respect of the American woman will not be redeemed until she is regarded as a distinct and social entity, unhampered by the political status of her husband or her father but with a status peculiarly her own and accruing to her as an American citizen. She must be bound to American obligations not through her husband's citizenship but directly through her own.

In 1933 the Cable Act was amended to allow American-born women of Asian descent to regain their American citizenship if their marriages to citizens of other countries ended.

Further Reading: Chafe, *American Woman;* Clark, *Almanac of American Women in the 20th Century;* Stanton, Anthony, and Gage, eds., *History of Woman Suffrage,* vol. 5.

Caraway, Hattie Ophelia Wyatt (1878–1950)
senator

Born Hattie Ophelia Wyatt on February 1, 1878, on a farm outside of Bakerville, Tennessee, to Lucy Mildred Burch Wyatt and William Carroll Wyatt, Hattie Wyatt Caraway became the first woman to be elected to the United States Senate.

Growing up in rural Tennessee, Caraway received a fairly rudimentary elementary education until her enrollment in the Dickson Normal School at the age of fourteen. She received a B.A. from this small academy/college in 1896. She taught school until she married Thaddeus H. Caraway in 1902. The couple made their home in Jonesboro, Arkansas, where Thaddeus pursued a political career and Hattie managed their plantation and reared her children.

Thaddeus Caraway died in November, 1931 during his third term as a Democratic senator from Arkansas. Hattie Wyatt Caraway was appointed by Governor Harvey Parnell to fill her husband's seat. On December 9, 1831, when Caraway was sworn in, she became the second woman to be seated in the U.S. Senate. (Rebecca Latimer Felton of Georgia also served by appointment in the Senate, but for only one day.) Caraway became the first woman to be elected to the Senate on January 12, 1932, when she won a special election in which she ran unopposed. She was elected to serve until March 1933, which would have been the end of her husband's term.

Caraway assumed her late husband's seat on the Agriculture and Forestry Committee and was later made a member of the Commerce Committee. She discharged her duties with diligence, quickly earning a reputation for careful preparation, thorough follow-up, and consistent attendance. On May 9, 1932, at the invitation of Vice President Charles Curtis, Caraway became the first woman to preside over the Senate. With the media gathered to take note of this senatorial "first," Caraway announced that she would seek reelection. Although most senators expressed surprise, Senator Huey Long of Louisiana actively campaigned for Arkansas' "little widow woman." Caraway won a crowded Democratic primary

by an overwhelming majority. In November 1932 she was elected to a full six-year term, which she began to serve in March 1933. She won election to her second full term in 1938.

Caraway supported Prohibition and voted against anti-lynching legislation. She also took progressive positions, actively supporting legislation on behalf of organized labor and veterans, as well as the New Deal policies of President Franklin Roosevelt. In 1940 she became both a cosponsor of the proposed Equal Rights Amendment and the first congresswoman to endorse it. Caraway was also the first female senator to chair a committee (the Committee on Enrolled Bills) and the first woman to serve as president pro tem of the Senate (1943).

Caraway was defeated in the 1944 Arkansas primary by William Fulbright, and she left the Senate—after a standing ovation—on December 19, 1944. She was appointed by President Roosevelt to the Federal Employees' Compensation Commission the following year and to the Employees' Compensation Appeals Board in 1946.

Hattie Wyatt Caraway resigned from public life in January 1950 due to health problems. She died on December 21, 1950, in Falls Church, Virginia.

For a complete list of all the women who have served as U.S. Senators, see Appendix, item 39.

Further Reading: Clark, *Almanac of American Women in the 20th Century;* McHenry, ed., *Famous American Women; New York Times,* numerous stories between 1931 and 1945, as well as obituary, December 22, 1950; Young, "Hattie Ophelia Wyatt Caraway," in *Notable American Women,* ed. James, James, and Boyer; Read and Witlieb, *Book of Women's Firsts.*

Carson, Rachel Louise (1907–1964) *biologist, conservationist, writer*
Born on May 27, 1907, in Springdale, Pennsylvania, to Maria McLean Carson and Robert Warden Carson, Rachel Louise Carson was a biologist, conservationist, and author who brought environmental awareness into the mainstream of American thought.

Carson remembered herself as "a solitary child [who] spent a great deal of time in woods and beside streams, learning the birds and the insects and flowers." She was educated in public schools and then attended the Pennsylvania College for Women (now Chatham College) on scholarship. Originally an English major with the goal of becoming a writer, Carson became a biology major after taking a required course in the subject. Upon her graduation in 1929, Carson attended the Johns Hopkins University, again on scholarship, where she studied genetics. While still a student at Johns Hopkins, Carson became a

member of the zoology department at the University of Maryland. Upon completion of her education, Carson became one of the first two women to be employed by the United States Bureau of Fisheries (later the Fish and Wildlife Service) in other than a support capacity. She remained with the government until 1953, progressing from junior aquatic biologist to biologist and chief editor of Fish and Wildlife publications. During these years she became the sole support of an extended family. When her father died in 1935 and her married sister died in 1936, Carson assumed the support of her mother and her two young nieces.

Carson had not lost her desire to become a writer; as she explained to a friend, "I have always wanted to write, but I know I don't have much imagination. Biology has given me something to write about. I will try in my writing to make animals in the woods and waters where they live as meaningful to others as they are to me." In 1937 she published an essay, "Undersea," in *The Atlantic Monthly.* The essay led to her first book, *Under the Sea-Wind,* published in 1941. Her second book, *The Sea Around Us,* was published in 1951, becoming a Book-of-the-Month Club selection and remaining on the bestseller list for almost two years. Carson's next book, *The Edge of the Sea,* was published in 1955. Each of the three books met Carson's goal of "tak[ing] the seashore out of the category of scenery and mak[ing] it come alive."

Carson's last book, published in 1962, had a tremendous impact on the thought and practices of the latter part of the twentieth century. Entitled *The Silent Spring,* the book stressed the interconnectedness of all life on earth and detailed the damage done to the chain of life by DDT and other pesticides. The book was vigorously denounced by the chemical industry but soundly endorsed by President John F. Kennedy's Science Advisory Committee and read by millions. Its impact was impressive: Within a year, forty bills concerning the regulation of pesticides were pending in state legislatures and Carson was invited to testify before two separate Senate committees. As one newspaper editor put it, "A few thousand words from her, and the world took a new direction."

Carson did not live to see the November 1969 decision of the U.S. government to phase out DDT use by 1971 or the growth of the modern environmental movement—which she helped inspire—to become the formidable political force it is today. Rachel Louise Carson died on April 14, 1964 in Silver Spring, Maryland.

Further Reading: Brooks, *House of Life;* Carson, *The Sea Around Us;* ———, *Silent Spring;* ———, *Under the Sea-Wind;* Gartner, *Rachel Carson;* Lear, *Rachel Carson: Witness for Nature;* McHenry, ed. *Famous American Women.*

Cassatt, Mary Stevenson (1844—1926) *painter*
Born on May 22, 1844, in Allegheny City (now part of Pittsburgh) to Katherine Kelso Johnston Cassatt and Robert Simpson Cassatt, Impressionist painter Mary Cassat was a major American artist.

From 1851 to 1855, Cassatt and her family traveled throughout Europe. Upon their return, the family lived in several locations in Pennsylvania before finally settling on a Chester County farm. Cassatt loved the art museums she had seen in Europe and developed a strong desire to become an artist. She attended the Pennsylvania Academy of the Fine Arts, in which she was disappointed and from which she graduated in 1866. Although her father was unhappy about his daughter's desire to paint—he once shouted, "I'd rather have you dead!"—he allowed her to study art in Europe. Between 1866 and 1874 she lived in and traveled about France, Italy, Spain, and Holland, where she worked on her own painting and studied the works of others.

Cassatt first exhibited her paintings and drawings in the Paris Salon in 1872, 1873, and 1874, but soon gravitated to Edgar Degas' group of "independents," later known as the Impressionists. Cassatt became an important member of the group, exhibiting her work in the Impressionist shows of 1879, 1880, 1881, and 1886.

During the 1870s and toward the middle of the 1880s, Cassatt's paintings were primarily of women in social settings. Examples of these paintings are *The Cup of Tea* (1881), a charming portrait of her sister Lydia attired in pink bonnet and dress and wearing long gloves, and *Young Woman in Black* (1883), an oil on canvas depicting a formal but sportingly attired woman—possibly an equestrienne—seated upon an upholstered armchair.

Lady at the Tea Table (1883) is generally regarded as the painting in which Cassatt's mature style began to emerge. With lightly painted brushstrokes, this painting depicts its subject, Mrs. Robert Riddle, in silhouette and in a manner that gives priority to line over mass, creating a feeling of fluidily.

Cassatt's subsequent paintings, in which she tended to favor a linear emphasis, were often of mothers and children. She had explored this subject before, such as in *Mother about to Wash Her Sleepy Child* (1880), a painting in which the child sprawls backward, limply and with unquestioned trust, across the mother's lap and into the curve of her supporting arm. Examples of her later mother and child paintings are *Two Children at the Seashore* (1884) and *Baby in Dark Blue Suit, Looking over His Mother's Shoulder* (1889). Both in early and late treatments of this subject, Cassatt renders the physical and emotional intimacy engendered by maternity without undue sentimentality.

Toward the end of her career, Cassatt created color prints by combining the techniques of etching, aquatint, and drypoint. Reminiscent of Japanese woodblocks and characterized by delicacy and grace, they drew mixed reaction when shown in 1891 but are now considered among her finest works. These include *The Coiffure, The Fitting,* and *Peasant Mother and Child.*

Throughout her life, Cassatt routinely declined to accept exhibition prizes. Two honors she accepted were an invitation to create a mural for the Woman's Building of the 1893 Columbian Exposition in Chicago (although Cassatt lived in France, she supported the women's rights movement in the United States) and the Chevalier of the Legion of Honor in 1904.

In 1912 cataracts in both eyes began to take their toll on her life and work; the few paintings produced after this point are not among Cassatt's best. By 1920 she was seriously ill from diabetes and almost ablind. Mary Cassatt died on June 14, 1926, at the Château de Beaufresne, France.

Further Reading: Barter, *Mary Cassatt: Modern Woman;* Boyle, *American Impressionists;* Breeskin, *Mary Cassatt: Catalogue Raisonne of the Graphic Works;* ———, *Mary Cassatt: Catalogue Raisonne of the Oils, Pastels, Watercolors and Drawings;* Hale, *Mary Cassatt;* Harris and Nochlin, *Women Artists;* Matthews, *Mary Cassatt: A Life;* McHenry, ed., *Famous American Women;* Roudebush, *Mary Cassatt;* Sweet, *Miss Mary Cassatt;* ———, "Mary Cassatt," in *Notable American Women,* ed. James, James, and Boyer.

Cather, Willa Sibert (Wilella Cather) (1873–1947) *writer*
Born Wilella Cather on December 7, 1873, in the Black Creek Valley of Virginia to Mary Virginia Boak Cather and Charles Fectigue Cather, author Willa Cather made substantial contributions to America's literary heritage with such well-loved novels as *My Ántonia* and *O Pioneers!*

Cather spent her first nine years at Willowshade, a Virginia farm that had long been in her father's family. During these years she was educated at home and given a large measure of freedom outdoors. In 1883 Willowshade was sold and the Cathers became pioneers on the Nebraskan frontier. Realizing quickly that their eastern life had not suited them for such ruggedness, they resettled the following year in the town of Red Cloud, where Charles Cather engaged in banking activities.

In Nebraska, Cather attended school for the first time. At this time she became well acquainted with immigrants from Sweden, Russia, Poland, Germany, and Bohemia. As she witnessed their struggle to prosper in a new land, she also learned of her new friends' homesickness and transplanted customs.

Author Willa Cather (*Library of Congress*)

In 1891 Cather entered the University of Nebraska in Lincoln and, while a student, published her first stories. Upon her graduation in 1896, she embarked upon a literary career, working first as a manager and editor at the Pittsburgh *Home Monthly* and then as a copy editor and cultural reviewer at the *Pittsburgh Daily Ledger.* In 1901, seeking a respite, she briefly became a teacher; an even better respite was granted by Isabelle McClung, a young and wealthy art patron who opened her home to Cather, supplying room, board, and the freedom to write. Her first book-length works were published during this time: *April Twilight,* a book of poems, in 1903, and *The Troll Garden,* a book of tales, in 1905. On the basis of these publications, she was invited by C. S. McClure to join the staff of his magazine, *McClure's.*

By 1908 Cather was *McClure's* managing editor. The next four years were tremendously busy and successful in a business sense, but not particularly fortuitous for Cather's own writing. Sarah Orne JEWETT, a well-respected writer who had become friends with Cather, counseled the younger writer to abandon the commercial world of journalism in order to write fiction both full time and on her most closely held experiences. Cather took Jewett's advice: In 1912 her first novel, *Alexander's Bridge,* appeared in

serial form as "Alexander's Masquerade" in *McClure's;* in that same year, Cather resigned from the magazine and began the work for which she is remembered.

O Pioneers!, published in 1913, and *My Ántonia,* published in 1918, tell the stories of two strong pioneer women—Alexandra and Ántonia, respectively—making lives for themselves against the odds and against convention upon the Nebraskan Great Plains. *The Song of the Lark,* published in 1915, examines the struggle of an artist—in this case, an opera singer—to leave behind geographically and in spirit her resentful neighbors.

Cather's Pulitzer Prize–winning novel, *One of Ours,* was published in 1922. It chronicles a male protagonist's journey from a Nebraskan childhood to a World War I battlefield death in France.

Subsequent novels include *A Lost Lady* (1923), *The Professor's House* (1925), *My Mortal Enemy* (1926), and *Death Comes for the Archbishop* (1927). Cather also published four collections of short stories in addition to the early *Troll Garden* and two volumes of essays, including *Not Under Forty* (1936). In addition to the Pulitzer Prize, Cather received numerous honors, including degrees from more than a half-dozen institutions, including Yale, New York University, and Smith College, and election to the National Institute of Arts and Letters.

Willa Sibert Cather died on April 24, 1947, in New York City.

Further Reading: Cather, *Kingdom of Art;* ———, *Novels and Stories of Willa Cather* (13 vols.); ———, *Old Beauty and Others;* ———, *On Writing;* Edel, "Willa Sibert Cather," in *Notable American Women,* ed. James, James, and Boyer; Faust, ed., *American Women Writers;* Lee, *Willa Cather;* McHenry, ed., *Famous American Women;* O'Brien, *Willa Cather: The Emerging Voice;* Showalter, Baechler, and Litz, eds., *Modern American Women Writers;* Woodress, *Willa Cather: A Literary Life.*

Catt, Carrie Clinton Lane Chapman
(1859–1947) *suffragist, feminist, and peace activist*
Carrie Chapman Catt was born on January 9, 1859, in Ripon, Wisconsin, to Maria Clinton Lane and Lucius Lane.

After graduating from Iowa State College in November 1880, Catt became an educator and then a journalist. By 1887 she had joined the Iowa Woman Suffrage Association. In 1890 she attended the first convention of the newly organized NATIONAL AMERICAN WOMAN SUFFRAGE ASSOCIATION (NAWSA). A superior administrator and organizer, she served as chair of the Organization Committee of NAWSA from 1895 to 1900. She was an excellent platform speaker and participated in twenty hearings before the U.S. Congress on the proposed

NINETEENTH AMENDMENT. In 1900 she succeeded Susan B. ANTHONY as president of NAWSA, and in 1902 she formed the International Woman Suffrage Alliance. She resigned as president of NAWSA in 1904 in order to nurse her ill husband. Upon his death in 1905, Catt devoted her energies to the International Woman Suffrage Alliance (serving as its president until 1923) and to local suffrage organizations in New York City and State. In 1912 she organized two major campaigns in New York State resulting in a 1914 statute that gave women the right to vote.

Catt was reelected to the presidency of NAWSA in 1915 and held that position until her death. She designed a clear, workable and ultimately effective strategy for winning women's suffrage. Entitled the "WINNING PLAN," it focused NAWSA's efforts on securing women's suffrage in thirty-six states—the number needed for ratification of a federal amendment—and then using the influence of those enfranchised women upon their state legislators to secure the constitutional guarantee of women's suffrage in every state. The Nineteenth Amendment was finally adopted in 1920. Anticipating victory in 1919, she founded the LEAGUE OF WOMEN VOTERS to help educate the new voting force.

In addition to her suffrage activities, Catt was involved in the peace movement. She founded the National Committee on the Cause and Cure of War in 1925 and served as its chairman until 1932, when she became honorary chairman. She also was active in support of the League of Nations and relief of Jewish refugees in Germany. Her books include *Woman Suffrage and Politics* (1933) and *Why Wars Must Cease* (1935).

Carrie Chapman Catt died on March 9, 1947.

Further Reading: Catt and Shuler, *Woman Suffrage and Politics;* Flexner, *Century of Struggle;* Fowler, *Carrie Catt;* Frost and Cullen-DuPont, *Women's Suffrage in America;* Peck, *Carrie Chapman Catt;* Van Vooris, *Carrie Chapman Catt.*

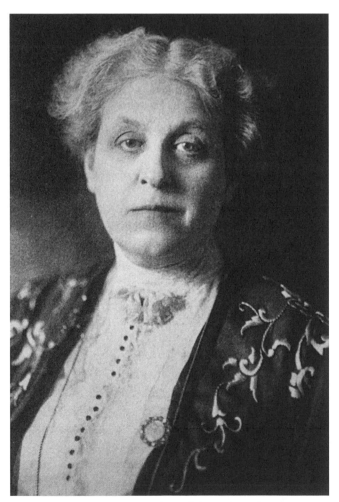

Carrie Chapman Catt, president of the National American Woman Suffrage Association, during the final years of the suffrage campaign (*Library of Congress*)

Chisholm, Shirley Anita St. Hill (1924–)
congressional representative

Born Shirley St. Hill on November 30, 1924, in Brooklyn, New York, to Ruby Seale St. Hill and Charles C. St. Hill, Shirley Chisholm was first African-American woman to win election to United States House of Representatives.

Chisholm's early years were spent with her grandmother in Barbados. Returning to the United States, she graduated from high school and from Brooklyn College in 1945. She received an M.A. in education from Columbia University. On October 8, 1949 she and Conrad Q. Chisholm were married.

Chisholm worked as an administrator of child care centers until she began her political career with her successful 1964 race for a state assembly seat. Reelected in 1965 and 1966, Chisholm was known for support of educational legislation and for her attention to the problems of domestic workers.

In 1968 Chisholm defeated incumbent U.S. representative James Farmer and won a seat in Congress as the representative from New York's twelfth district. She retained her seat until 1982 and, throughout her congressional career, was a vocal advocate of minority, female, impoverished, and undereducated Americans. She was appointed to the House Education and Labor Committee in 1971, and she became both the first African-American and the first woman to serve on the House Rules Committee in 1976.

In 1972, wishing to inspire people with the belief that "Someday, somewhere, somehow, someone other

Shirley Chisholm, the first African-American woman to win election to the United States House of Representatives (*Library of Congress*)

than a white male could be President," Chisholm entered the 1972 primary race in an attempt to win the Democratic Party's presidential nomination. She later said that she had been surprised by the number of campaign attacks based on gender and went so far as to reflect that

> I have met far more discrimination as a woman than being black in the field of politics. Why should black men be any different from white men, brown men, pink men, whatever? They're all a part of the male gender, who for so many years have preconceived notions and stereotypical thinking about women. But in spite of it all, I went to the Democratic convention in 1972 . . . and began to open the way for women to think that they can run.

Chisholm received 28.65 percent of the popular vote and 158 delegate votes.

Shirley Chisholm retired from politics in 1982 and joined the faculty of MOUNT HOLYOKE COLLEGE, where she is presently the Purrington Professor of Political Science. She is the author of several books, including *Unbought and Unbossed* (1970) and *The Good Fight* (1973).

Further Reading: Brownmiller, *Shirley Chisholm;* Clark, *Almanac of American Women in the 20th Century;* Haskins, *Fighting Shirley Chisholm;* Hicks, *Honorable Shirley Chisholm;* Lanker, *I Dream a World.*

Chopin, Kate O'Flaherty (1851–1904) *writer*
Born Kate O'Flaherty on February 8, 1851, in St. Louis, Missouri, to Eliza Faris O'Flaherty and Thomas O'Flaherty, Kate Chopin was the author of *The Awakening* and other works.

Chopin's father, an Irish immigrant who had become prosperous in America, died when she was four years old. She lived in a household that included her mother and her maternal grandmother and great-grandmother, all of whom had been widowed. A devout Catholic from childhood on, Chopin attended the Academy of the Sacred Heart in St. Louis, from which she graduated in 1868. She and Oscar Chopin were married on June 9, 1870.

The couple lived in New Orleans, where Chopin—of French Creole descent on her mother's side—enjoyed the vibrant atmosphere created by the city's Creole culture. They had six children between 1871 and 1880. In the year of the last child's birth, Oscar's business failed, and he moved his family to a family property in Nachitoches Parish, Louisiana. In 1882 Oscar Chopin died and Kate Chopin moved her large family back to St. Louis, to her childhood home, now owned by her mother.

Chopin's first novel, *At Fault,* published in 1890, was the story of a young widow's successful attempt to reconcile her own suitor with his ex-wife, with disastrous consequences to all concerned.

The following two books were collections of stories, *Bayou Folk* (1894) and *A Night in the Acadie* (1897). Among her best-known and most widely praised stories are "Desiree's Baby," the story of a woman whose marriage ends when her husband, realizing their baby has African-American ancestry, concludes that his wife is of mixed blood; "Wiser Than a God," the story of a woman who forsakes what would have been a loving marriage in order to pursue an artistic career; and "The Story of an Hour," the tale of a woman who believes, with growing relief over the course of an hour, that her husband has died.

The novel upon which Chopin's reputation is now solidly fixed, *The Awakening,* was published in 1899 to critical and moral condemnation. Centered on Edna

Pontellier's rediscovery of her own inner desires—both sexual and artistic—as she manages to leave an empty marriage but not the burdens of domestic care or societal conformation, *The Awakening* examines the consequences of a woman's inability to give expression to her truest self in her society. Edna's solution is to maintain the integrity of her being by taking her life in the ocean's waters. As Chopin describes Edna's thoughts as she turns her back on a domestically lived life for the last time, ". . . the children appeared before her like antagonists who had overcome her; who had overpowered her and sought to drag her into the soul's slavery for the rest of her days. But she knew a way to elude them."

Kate Chopin wrote little after *The Awakening*. She died in St. Louis, Missouri, of a cerebral hemorrhage on August 22, 1904.

Further Reading: Chopin, *The Awakening;* ———, *Complete Works of Kate Chopin;* Faust, ed., *American Women Writers;* McHenry, ed. *Famous American Women;* Nissenbaum, ed. "Kate O'Flaherty Chopin," in *Notable American Women,* ed. James, James, and Boyer; Rankin, *Kate Chopin and Her Creole Stories;* Showalter, Baechler, and Litz, eds., *Modern American Women Writers.*

Civil Rights Act of 1964 (Title VII) (1964)

First proposed by the Kennedy administration in 1963, this legislation was originally intended to bar discrimination on account of race, color, creed, and national origin. Women—including Alice PAUL and other members of the NATIONAL WOMAN'S PARTY, Michigan congresswoman Martha Griffiths, and members of the NATIONAL FEDERATION OF BUSINESS AND PROFESSIONAL WOMEN'S CLUBS— successfully lobbied for the addition of "sex" as a category protected from employment discrimination under Title VII of the Act. Representative Howard Smith, a Democrat from Virginia, offered the "sex" amendment; since he was believed to oppose the Civil Rights Act, he may have granted the women's wish in the hopes of killing the entire measure. The act passed both the House and Senate, however, and was signed by President Lyndon Johnson in July 1964. It became effective on July 2, 1965.

Title VII prohibits private employers, unions, and employment agencies from discriminating for reasons of race, color, religion, national origin, or sex, and it originally exempted educational institutions and all levels of government from compliance. The Equal Employment Opportunity Commission (EEOC) was created to investigate violations of Title VII, but it initially lacked enforcement authority. If the EEOC found discrimination that an employer then refused to correct, its only recourse was to recommend that the U.S. Attorney General bring a lawsuit against the offending employer. (The

attorney general was under no obligation to act on the EEOC's suggestion.) Worse, the EEOC itself chose to investigate race, color, religion, and national origin complaints while largely ignoring sex discrimination complaints. So blatant was the commission's lack of interest that Congresswoman Griffiths castigated it from the House floor for its "wholly negative attitude toward the sex provisions of Title VII."

Prompted in part by the lack of response to Title VII, Betty FRIEDAN, Marguerite Rawalt, and thirteen other women founded the NATIONAL ORGANIZATION FOR WOMEN (NOW) in June 1966. NOW members successfully petitioned the EEOC to hold public hearings on Title VII. NOW and other women's groups, emboldened by passage of Title VII, also worked through the courts and the state human rights commissions to end sex discrimination in employment; by 1972 every state had passed it own such legislation. At the same time, the federal courts—citing Title VII—began striking down PROTECTIVE LABOR LEGISLATION for women as a form of sex discrimination. While this disappointed leaders of many women's organizations, which had long supported special working conditions for women, it also served to unite those organizations in support of the EQUAL RIGHTS AMENDMENT, which some had opposed due to fear of its possible legal impact on such protective labor legislation.

A 1972 amendment to Title VII granted the EEOC the right to sue employers directly and also ended the exemptions for educational institutions and state and local governments. The Congressional Accountability Act, passed in 1995, required Congress to comply with the provisions of the Civil Rights Act of 1964 as well.

Further Reading: Chafe, *American Woman;* Davis, *Moving the Mountain;* Evans, *Born for Liberty;* Hole and Levine, *Rebirth of Feminism;* Kessler-Harris, *Out to Work;* U.S. Congress, House of Representatives, *Congressional Record,* 89th Congress, 2nd Session, June 20, 1966; ———, Debate on sex amendment to Title VII. *Congressional Record,* 88th Congress, 2nd session, February 8, 1964.

Clay, Laura (1849–1941) *suffragist, founder of the Citizen's Committee for State Suffrage Amendment*

Laura Clay was born on February 9, 1849, on a sprawling estate near Lexington, Kentucky, to Mary Jane Warfield Clay and Cassius Marcellus Clay, who was a relative of Henry Clay.

Clay was introduced to the women's suffrage movement when her older sister organized the first suffrage club in Kentucky. In 1881 Clay was elected president of the newly organized Kentucky Woman Suffrage Association (which was later renamed the Kentucky Equal

Rights Association). She served in this capacity until 1912. Under Clay's direction this extremely active organization was, by 1900, successful in repealing several statutes of Kentucky law that discriminated against women, including laws that prohibited Kentucky's married women from controlling their incomes, owning property, or making wills. In 1895 she joined the board of the NATIONAL AMERICAN WOMAN SUFFRAGE ASSOCIATION as its first auditor and as the chairman of its membership committee. During this time she also served as a member of the Woman's Club of Central Kentucky. An ardent believer in white supremacy, Clay, like a number of other white Southern suffragists, described women's suffrage as a means of "insur[ing] white supremacy" in the South. She also supported a Mississippi suffragist, Belle Kearney, in her effort to win suffrage for Caucasian but not African-American women. When the national suffrage movement began to increase its emphasis upon a federal amendment, Clay objected, citing fears that federal oversight of any aspect of a state's election laws might ultimately weaken the ability of Southern state legislatures to effectively disfranchise African Americans.

In 1911, Clay lost her bid for reelection to NAWSA's board. She became vice president of the Southern States Woman Suffrage Conference in 1913 and resumed her work on behalf of a state-level suffrage amendment.

From 1915 to 1917 Clay was a member of the WOMAN'S PEACE PARTY. Throughout her life she was a strong supporter of the WOMAN'S CHRISTIAN TEMPERANCE UNION. After resigning in June 1919 from both the National American Woman Suffrage Association and the State Equal Rights Association, she formed the Citizen's Committee for State Suffrage Amendment.

Laura Clay died in Lexington, Kentucky, on June 29, 1941.

Further Reading: Boyer, "Laura Clay," *Notable American Women*, James, James and Boyer, eds.; Frost and Cullen-DuPont, *Women's Suffrage in America;* Kraditor, *The Ideas of the Woman Suffrage Movement.*

Clergy Consultation Service on Abortion, The

Founded by the Reverend Howard Moody of the Judson Memorial Church in New York City, the Clergy Consultation Service on Abortion (CCS) referred pregnant women to skilled abortionists beginning in May 1967, when abortion was illegal. It was originally comprised of one rabbi and twenty-six ministers but quickly became a nationwide referral service with over 1,000 volunteers assisting clergy in approximately twenty-four states.

The existence of the CCS was an outright challenge to antiabortion laws, made by presumably moral and ethical men. When the Reverend Moody announced at a press conference that he, his fellow ministers, and a rabbi were ready to help women with "problem pregnancies" secure abortions, the *New York Times* carried the story on its front page. During the years prior to *Roe v. Wade* (1973), several CCS volunteers were arrested and charged for their actions in what was an illegal activity in most states.

The New York City branch of CCS conducted its work in the basement of the Reverend Moody's church. It continued to act as a referral service following New York State's legalization of abortion in 1970.

Further Reading: Davis, *Moving the Mountain;* Faux, *Roe v. Wade;* ———, *Crusaders.*

Clinton, Hillary Rodham (1947–) *first lady, politician, lawyer*

The only First Lady in American history to be elected to public office, Hillary Rodham Clinton was born Hillary Rodham on October 26, 1947, in Chicago, Illinois, to Dorothy and Hugh Rodham. She grew up within a close Methodist family in Park Ridge, a suburb of Chicago, and received a public school education. In her early teenage years, Hillary Rodham was especially influenced by her church's youth minister, the Reverend Donald Jones, who stressed the responsibility of Christians to act upon their beliefs in this world and who, in 1962, took his young parishioners to hear the Reverend Martin Luther King speak. She was also influenced by her Republican parents; working in Barry Goldwater's campaign during her senior year of high school, she wore a sash emblazoned with the words "Goldwater Girl." She graduated in the top 5 percent of her high school class and then attended Wellesley College. Hugh Rodham later jokingly referred to his daughter's attendance at Wellesley as a "great miscalculation" on his part, since his former "Goldwater Girl," like many others of her generation, spent part of her college career protesting the Vietnam War and, apparently, changing her politics. The first Wellesley student invited to speak at her own commencement in 1968, she used the occasion to gently criticize Republican Senator Edward Brook, who had just completed his own address to the class, and to laud the idealistic aspirations of her own generation.

Hillary Rodham attended Yale Law School, where she met Bill Clinton, who would later become the forty-second president of the United States. On October 11, 1975, a little more than a year after they graduated, Hillary Rodham and Bill Clinton were married. Their daughter, Chelsea, was born five years later.

Hillary Rodham Clinton worked on the 1974 House Judiciary Committee's impeachment inquiry concerning President Richard M. Nixon and, in 1987,

served on the American Bar Association Commission on Women in the Profession. By the time she became First Lady, she was a partner in the Rose Law Firm and a member of various corporate and philanthropic boards. Named one of America's "100 Most Influential Lawyers," by the *National Law Journal,* Rodham Clinton steadfastly continued her separate career during her husband's terms as governor of Arkansas and her own tenure as Arkansas' First Lady. During Bill Clinton's presidential campaign, however, she stated that due to conflict of interest questions and the special public service opportunities afforded to a First Lady, she would discontinue the private practice of law if her husband won the election.

Bill Clinton was the winner of the 1992 presidential election and, when he was inaugurated on January 20, 1993, Hillary Rodham Clinton became First Lady. Confirming the fears of some and the hopes of others, she began to transform what many Americans had viewed as an unchangeable supportive role.

Within weeks of his inauguration, President Clinton named Hillary Rodham Clinton as head of his twelve-member Task Force on National Health Care Reform. As such, she headed a staff of more than 500 and conducted more than fifty congressional meetings in an effort to formulate proposals for a fundamental reshaping of the country's health care system. The task force—which, in addition to Clinton, was comprised of six Cabinet secretaries and other White House officials—met in private. A lawsuit demanding public access to the meetings was brought by the Association of American Physicians and Surgeons, the American Council for Health Care Reform, and the National Legal and Policy Center. The suit centered on the role of an American First Lady, since it contended that Hillary Rodham Clinton was not an official of the government and cited the 1972 Federal Advisory Committee Act. (The act requires advisory panels to meet in public and grant public access to their papers, unless all of the participants are government officials.) On June 22, 1993, the U.S. Court of Appeals for the District of Columbia ruled that Hillary Rodham Clinton was a "de facto officer or employee" of the United States government.

The health reform measures recommended by Hillary Rodham Clinton were not adopted, and she turned her attention to issues affecting women and children. In March 1995, she twice addressed the United Nations. Speaking at a United Nations conference on world poverty in Copenhagen in the first week of March and at the United Nations in New York during the "Women and the United Nations" conference, she addressed the conditions facing women around the world. At the latter conference, she said:

when full economic, social and political opportunities for women too often remain an elusive goal, we should commend the United Nations for inviting serious discussion of the unique obstacles confronting women in every country, rich and poor . . . we must work harder for ways to open opportunities for women . . . The United Nations must play a leadership role, and must play a role by example. Every program, policy and decision that emanates from this building directly or indirectly affects women, as they raise their children, manage households, or work at their jobs.

Hillary Rodham Clinton spent the remainder of March and part of April touring South Asia to learn more about efforts to end poverty and encourage independence among women. She was honorary chairperson of the U.S. delegation to the United Nations' fourth international conference on women, which took place in September 1995. That conference produced the "BEIJING DECLARATION AND PLATFORM FOR ACTION."

Rodham Clinton's public composure during the sex scandals involving her husband and his subsequent impeachment increased her public approval ratings, prompting several key Democratic Party figures to suggest she run for the Senate. In May 2000 the New York State Democratic Party nominated her as its candidate for the U.S. Senate. She won that election in November 2000 and currently serves as the junior senator from New York State.

Further Reading: *Newsweek,* December 28, 1992; *New York Newsday,* July 13, 1992 and January 19, 1993; *New York Times,* June 23, 1993, March 15, 1995, September 23 and 26, 1999; *People* magazine, January 25 and May 10, 1993; *Time* magazine, September 14, 1992 and May 10, 1993.

Clinton v. Jones (1997)

A Supreme Court Decision, *Clinton v. Jones* held that U.S. presidents have no immunity from prosecution for unofficial acts. Specifically, the Court refused to dismiss or postpone Paula Jones' sexual harassment lawsuit against President Bill Clinton.

Paula Corbin Jones, a government clerk, filed the lawsuit on May 6, 1994, in the United States District Court for the Eastern District of Arkansas. She alleged that in May 1991, while at an official conference in Little Rock, Arkansas, a police officer asked her to meet with Clinton (then governor of Arkansas) in a business suite. Jones claimed that Clinton made "abhorrent" sexual advances, which she rejected. She further alleged that she suffered negative job consequences after rejecting those advances. She brought the lawsuit when Clinton was president, after a reporter referred to rumors of the incident in an article and the police officer "implied she had

accepted [Clinton's] alleged overtures, and . . . various persons authorized to speak for the president publicly branded her a liar by denying the incident had occurred."

Clinton filed a motion to dismiss with the Federal District Court on grounds of presidential immunity. The district judge refused to dismiss the case and ruled that discovery and other trial preparation could take place during Clinton's term as president, but that the trial itself would be postponed until he left office.

The Eighth Circuit Court upheld the District Court's refusal to dismiss the case but objected to a delayed trial date. Reversing that part of the lower court's ruling, the Eight Circuit Court described postponing the trial as the "functional equivalent" of temporary immunity to which Clinton had no constitutional claim. The court ruled that the president of the United States, like every other citizen, was subject to the law, and that immunity for official acts did not extend to immunity for personal, private conduct by a president.

The Supreme Court upheld the Eighth Circuit's ruling. The Court's opinion, delivered by Justice John P. Stevens, held that Clinton's claim that "the Constitution affords the president temporary immunity from civil damages litigation arising out of events that occurred before he took office—cannot be sustained on the basis of precedent."

Jones' lawsuit against Clinton was settled in December 1998, but President Clinton was impeached in January 1999 for allegedly giving "perjurious, false and misleading testimony" and obstructing justice in connection with the lawsuit. The articles of impeachment failed in the Senate, and Clinton remained in office. However, in April 1999, the federal judge before whom Clinton was deposed in Jones' lawsuit, found the president in contempt of court for "giving false, misleading and evasive answers that were designed to obstruct the legal process." He was fined $90,000 in July 1999.

Further Reading: *Clinton v. Jones; Denver Post,* July 30, 1999; *Houston Chronicle,* January 15, 1999; *New York Times,* April 13, 1999; Rozell and Wilcox, "The Clinton Scandal in Retrospect."

Coalition of Labor Union Women (1974)
An organization of female members of America's various labor unions, the Coalition of Labor Union Women (CLUW) was established in Chicago in March 1974 by Dorothy Haener, Edith Van Horne and Olga Mader of the United Auto Workers, Addie Wyatt of the Meatcutters Union, and others.

Although the founders anticipated an attendance of about 800 women at the March meeting, 3,500 women attended. The new organization's primary goals were to:

1. Increase affirmative action on the job and women's participation in their unions at every level.
2. Work for passage of legislation important to women workers.
3. Encourage women's involvement in the political process, including election to office.
4. Organize the millions of unorganized women workers in this country, without which the labor movement cannot grow.

Members of the CLUW must be members of another labor union before seeking admission. The organization works to increase the power of women within these other labor unions. It also works to provide a unified voice for labor union women and their concerns, which include child care issues and the inclusion of equal employment opportunity and equal pay provisions in union contracts. The Coalition of Labor Union Women played an important role in persuading the American Federation of Labor-Congress of Industrial Organizations (AFL-CIO) actively to support the Equal Rights Amendment.

Its 20,000 members represent more than sixty American and international unions. Chrystl Lindo-Bridgeforth is the current executive director.

Further Reading: Evans, *Born for Liberty; New York Times,* March 25, 1974, p. 27; Wertheimer, *We Were There.*

Coast Guard Women's Reserves (1942–1978)
Established in November 1942, the Coast Guard Women's Reserves was the female component of the Coast Guard until 1978. They were called SPARS, based on the Coast Guard motto, *Semper Paratus* (Always Ready). Dorothy Constance Stratton was named director with the rank of lieutenant commander. Thirteen thousand SPARS served during World War II. While all women's corps of the other military branches—the WOMEN'S ARMY CORPS, the WOMEN'S RESERVES OF THE NAVY, and the MARINE CORPS, WOMEN'S RESERVES—trained their female soldiers separately from men during World War II, SPAR officer candidates trained alongside men at the U.S. Coast Guard Academy. (Enlisted SPARS, in contrast to officer candidates, were trained separately from men.) During World War II, SPARS filled a number of positions, including, by the end of the war, all positions in Unit 21, the group that supervised the top-secret project called Long Range Aid to Navigation, or LORAN.

The SPARS and the military's other women's corps—the Women's Army Corps, the Women's Reserve of the Navy, and the Marine Corps, Women's Reserve—remained a regular part of the Army until 1978, when all such units were abolished in favor of women's integration into the armed forces.

Further Reading: Clark, *Almanac of American Women in the 20th Century;* Weatherford, *American Women and World War II.*

Coleman, Bessie (1892 or 1893–1926) *aviator*

Born on January 26, 1892 or 1893, to George and Susan Coleman, in Atlanta, Texas, Bessie Coleman became the first black person to receive an aviator's license anywhere in the world and the first American woman to earn an international pilot's license in 1921.

Coleman's role model was Eugene Jacques Bullard, an African American who flew and fought with the French during World War I. When she found no one in the United States willing to instruct a black student, she studied French in preparation for flying lessons abroad.

Toward the end of the World War I, Coleman traveled to France as part of a Red Cross unit. She persuaded members of a French flying squadron to instruct her, and she received her license from the Federation Aeronautique Internationale four years after the end of the war.

During her brief career, Coleman flew some of the largest planes to be piloted by a woman in the early 1920s, including a German LFG with a 220-horsepower Benz engine. She returned to the United States in August 1922 and in September was part of an aviators' event honoring the Fifteenth (Negro) Infantry Regiment of the New York National Guard. Coleman hoped to found an aviation school for African Americans, and she began to give lectures and flying exhibitions across the country in order to raise the necessary funds. In Jacksonville, Florida, April 30, 1926—during one of these exhibitions and before her dream could be realized—she was thrown from the open cockpit of her plane and was killed.

Several years later the Bessie Coleman School was founded in Los Angeles in order to provide aviation instruction to African Americans.

Further Reading: Brooks-Pazmany, *United States Women in Aviation 1919–1929;* Hardesty, and Pisano, *Black Wings: The American Black in Aviation;* Read and Witlieb, *Book of Women's Firsts.*

Collins, Eileen Marie (1956–) *astronaut*

The first woman to command a mission into space, Eileen Marie Collins was born on November 19, 1956, to Rose Marie Collins and James Collins, in Elmira, New York.

Collins' parents separated during her elementary school years. Afterward, Collins and her siblings lived with their mother in public housing and for a time relied on food stamps, something Collins frequently mentions in order to inspire children growing up in similar circumstances. Because her parents could not afford the flying lessons of which she dreamed, she worked at enough part-time jobs to pay for them herself. In 1974, she graduated from Elmira Academy and enrolled at Corning Community College, from which she received an associate's degree in 1976. She received a B.A. degree from Syracuse University in 1978, a master of science degree in operations management from Stanford University in 1986, and a master of arts degree in space systems management from Webster University in 1989.

Upon her graduation from Syracuse University in 1978, Collins was one of 120 women to apply to the Air Force's Undergraduate Pilot Training Program, which had begun to accept women two years earlier. She completed her pilot training in 1979 and became the Air Force's first woman flight instructor. Continuing her own flight education, she became the second woman to train at the Air Force Test Pilot School. NASA selected Collins for astronaut training in 1990 and originally assigned her to orbiter systems support.

In February 1995, she became the first woman to pilot a U.S. space shuttle when she flew as the *Discovery*'s copilot during its rendezvous mission with the Russian *Mir* space station. In May 1997, she was the shuttle pilot for the sixth docking mission with the *Mir* space station.

Collins became the first woman to command a space mission in July 1999. The mission, conducted aboard the space shuttle *Columbia,* delivered the $1.5 billion Chandra X-ray Observatory into orbit. The Chandra, 45 feet long and 50,000 pounds, is the world's most powerful x-ray telescope and the heaviest payload carried to date by a shuttle.

U.S. Air Force Colonel Eileen Collins lives in Houston, Texas with her husband, Pat Youngs, and their daughter. She received several medals from the Air Force for her service in Grenada (Operation Urgent Fury, 1983) and was inducted into the NATIONAL WOMEN'S HALL OF FAME in 1995.

Further Reading: *Aviation Week & Space Technology,* March 9, 1998, Carreau, "Shuttle Puts Down in Rare Night Landing"; Dunn, "Woman to Lead Shuttle Crew"; ———, "First Female Shuttle Commander Has Already Risen Far"; ———, "And She's Off . . .!"; ———, "Message from Space: 'Reach for the Stars'"; ———, "Shuttle Flight Ends in Triumph Despite Fuel Leak"; *Encyclopedia of World Biography.*

Combahee River Collective

A 1970s organization of African-American lesbians, the Combahee River Collective was dedicated to the eradication of heterosexism, racism, sexism, and class exploitation. Its founding members originally belonged to the NATIONAL BLACK FEMINIST ORGANIZATION but felt that lesbian issues—and perhaps even African-American lesbian members—were not completely embraced by that organization. They broke away from the National Black Feminist Organization following its first conference and founded the Combahee River Collective to fill that void.

Further Reading: Davis, *Moving the Mountain;* Tuttle, *Encyclopedia of Feminism.*

Comstock law (1873)

An amendment to the United States criminal code passed by Congress in 1873 at the urging of Victorian-era reformer Anthony Comstock, the so-called Comstock law made it illegal to use the public mails to convey, among other things, information about or articles for use in connection with birth control or abortion information. The law provided the public with a detailed list of what was considered illegal to mail:

> Every obscene, lewd, or lascivious, and every filthy book, pamphlet, picture, paper, letter, writing, print, or other publication of an indecent character, and every article or thing designed, adapted, or intended for preventing conception or producing abortion, or for any indecent or immoral use; and every article, instrument, substance, drug, medicine, or thing which is advertised or described in a manner calculated to lead another to use or apply it for preventing conception or producing abortion, or for any indecent or immoral purpose.

The act further established that violators would be fined $5,000 or incarcerated for five years, or both.

Comstock's first major victory had been the 1868 passage of an anticontraception and antiabortion law, which he supported, in New York State. By the time he began to pressure Congress for a federal measure, he had the full endorsement of the Young Men's Christian Association.

Once the federal law was passed, statutes were adjusted in every state except New Mexico. Twenty-four states decided to prohibit publication and/or advertising in addition to conveyance by mail, and fourteen other states also prohibited speech regarding birth control or abortion. In Connecticut, a law forbidding the use of contraceptives was passed. (This law would be overturned by the Supreme Court in GRISWOLD V. CONNECTICUT.) In New York State, Comstock was made a "special agent" and empowered to search, confiscate, and arrest. Feminist Victoria WOODHULL was charged under New York's Comstock law for speaking of "free love" in the 1870s. Around the same time, Ezra Heywood was charged under the Massachusetts version in connection with the distribution of a periodical containing advertisements for birth control and articles about free love. Comstock also issued an injunction against the performance in the United States of George Bernard Shaw's *Mrs. Warren's Profession* in 1902 and seized drawings of nude women from the Art Student's League in New York City in 1914.

Margaret SANGER also experienced the wrath of Anthony Comstock and his law. Between 1912 and 1913 she wrote a column entitled "What Every Girl Should Know," which was published in the socialist newspaper, *The Call.* Her articles gave women accurate information about the reproductive process and sexuality. When Sanger wrote about venereal disease, Comstock ordered the newspaper to eliminate her column. Sanger's publishers both complied and protested at the same time. The following week, Sanger's column heading—"What Every Girl Should Know"—appeared in its usual spot, along with an answer: "Nothing; by order of the U.S. Post Office."

The birth control provisions were removed from the Comstock law in 1971.

Further Reading: Chesler, *Woman of Valor;* Sanger, *My Fight for Birth Control.*

Congress to Unite Women

The first organized attempt to align the women's rights organizations formed in the Northeast during the 1960s into an effective coalition, the Congress to Unite Women was held in New York City on November 21, 22, and 23, 1969. It was attended by more than 500 women from organizations as varied as the Boston Female Liberation, DAUGHTERS OF BILITIS, NATIONAL ORGANIZATION FOR WOMEN, New Yorkers for Abortion Law Repeal, REDSTOCKINGS, the Stanton-Anthony Brigade, WITCH Resurrectus, Women Lawyers-Boston, and the Women's Liberation Club of the Bronx High School of Science.

Following twelve workshops entitled, among others, "Feminine Image," "Family Structure," and the "Sex Role System," the congress approved resolutions binding the participating organizations to endorse the Equal Rights Amendment and to actively participate in the repeal of restrictive abortion laws and the creation of child care centers and women's studies programs. Nonetheless—and although a second congress was held several years later—no working coalition of these early second-wave feminist organizations actually materialized.

Further Reading: Davis, *Moving the Mountain;* Hole and Levine, *Rebirth of Feminism;* Tanner, *Voices from Women's Liberation.*

Congressional Caucus for Women's Issues

A bipartisan group committed to the improvement of women's status in America, the Congressional Caucus for Women's Issues was established in 1977.

From its formation in 1977 until 1995, the caucus was a congressional legislative service organization with a budget and salaried staff. When the House in 1995 abolished all such groups and their funding, Congresswomen nonetheless maintained their affiliation and became a congressional members association. Two former caucus members formed a nonprofit organization, Women's Policy, Inc., to facilitate the caucus' work. At present, 56 congresswomen are members of the caucus. Representatives Carolyn B. Maloney (D-NY) and Sue W. Kelley (R-NY) are the current cochairs.

The caucus introduced the Economic Equity Act—a package of bills designed to improve the economic lives of women—into every Congress between 1981 and 1995. While it was not adopted in its entirety, several of its component bills became law, including, in 1988, the Women's Business Ownership Act. This bill, coauthored by Representatives Lindy Boggs (D-LA) and John LaFalce (D-NY), then both caucus members, guarantees women and minorities "equality of access to business credit." In recent years, the Congressional Caucus for Women's Issues also has championed the WOMEN'S HEALTH EQUITY ACT, the FAMILY AND MEDICAL LEAVE ACT, and the FEMALE GENITAL MUTILATION Act.

Further Reading: Congressional Caucus for Women's Issues, 106th Congress; The Congressional Caucus for Women's Issues in the 101st Congress, "The Cochairs' Report," in Rix, ed., *American Woman 1990–91;* The Congressional Caucus for Women's Issues in the 102nd Congress. "The Cochairs' Report," in Ries and Stone, eds., *American Woman, 1992–93.*

Consumers Leagues

Established at the end of the nineteenth century, Consumers Leagues provided homemakers with a means of applying pressure on the purveyors and manufacturers of household goods, clothing, and the like to improve the working conditions of their female employees. The success of local Consumers Leagues, such as the New York Consumers League, established in 1890, and those in Massachusetts, Pennsylvania, and several other states, prompted the founding of the National Consumers League in 1899.

An 1895 Consumers League study recognized that store employees and factory workers had little leverage in dealing with their employers. It stated, in part:

> They are young, many being between the ages of fourteen and twenty; and therefore without the wisdom, strength of character, or experience which would enable them to act on their own behalf.
>
> Their trade, although it has highly skilled departments, is mostly unskilled, and therefore there is an almost unlimited supply of applicants for their situations in case they do not accept the conditions offered them.

While the study may have overlooked earlier strikes involving young women, such as the 1824 strike in Pawtucket, Rhode Island (in which male and female factory workers struck together) and the 1828 strike in Dover, Massachusetts (in which women acted alone), it was nonetheless correct in assessing the limited bargaining position of the workers concerned.

At a time when many women were paid $2.00 for a six-day week and granted no lunch breaks or vacations, the National Consumers League urged homemakers to purchase their household goods from companies and stores that met what it called "Standards of a Fair House": Wages of at least $6.00 per week; a work day no longer than 8:00 A.M. to 6:00 P.M.; a forty-five-minute lunch break; a week's vacation, with pay, plus one half-day off each week in July and August; the absence of child labor; and accommodations such as lockers for personal belongings and seating for women working behind counters. The league issued annual "White Lists" of companies that complied. (Only Lord & Taylor, Altman's, and six other stores made the New York Consumers League's first list in 1891.) Later, when its efforts were extended into the factories themselves, the league also gave manufacturers that met with approval the right to affix a certifying "White Label" to products.

The National Consumers League was led, in succession, by presidents Josephine Shaw Lowell, Maud Nathan, and Florence KELLEY. A strong supporter of protective labor legislation, the league lobbied for the passage of such laws at the state and federal level and lent its resources to the successful 1908 legal fight in *Muller v. Oregon.* (See PROTECTIVE LABOR LEGISLATION for further discussion.) The 1923 reversal of the Supreme Court's position on protective legislation in *ADKINS V. CHILDREN'S HOSPITAL* was, however, a major blow to Florence Kelley personally and the league as a whole.

The organization ceased to be a vital force in the 1920s, but is enjoying something of a resurgence in the late 1990s. It conducts consumer advocacy programs

such as the Internet Fraud Watch, and it continues to work on behalf of those who produce consumer goods through programs such as its Child Labor Coalition.

The National Consumers League, which maintains its headquarters in Washington, D.C., has 8,000 members. Linda Golodner is the current president.

Further Reading: National Consumers League, Available online: http://www.fraud.org; Evans, *Born for Liberty;* Flexner, *Century of Struggle;* Wertheimer, *We Were There.*

contraception

In colonial America, women who wished to limit the size of their families relied on sexual abstinence, withdrawal, or induced abortion. These remained the only commonly known and used methods in America through the seventeenth and eighteenth centuries. At least in part because contraceptive methods were so rudimentary, there were approximately seven American children for each woman in America in 1800.

The first book published in America containing advice on how to limit family size was Robert Owen's *Moral Physiology,* which appeared in 1830. Dr. Charles Knowlton's *FRUITS OF PHILOSOPHY; OR, THE PRIVATE COMPANION OF YOUNG MARRIED PEOPLE,* which was more accurate, was published in 1839. An English translation of *Marriage Physiologically Discussed* by French author Jean Du Bois also appeared in the United States in 1839. Other books were published in the 1850s. As result, by the middle of the nineteenth century many Americans learned about the use of condoms and chemically treated sponges. An additional contraceptive method, the diaphragm, also was introduced before the end of the century.

At the same time, two movements championed sexual abstinence, for two very different reasons. Some feminists viewed contraception as a means of freeing men to indulge "base desires" without adequately considering women's health or other concerns. They urged women to refuse to acquiesce to too-frequent sexual demands or to remain unmarried. The other champion of sexual abstinence was the nineteenth-century medical community, which believed that men lost vital energies through ejaculation. Due to the combination of increased birth control knowledge and an emphasis on abstinence, fertility rates fell to 5.42 per woman in 1850 and to 3.56 by 1900.

Access to birth control information was curtailed before the end of the nineteenth century, however. Right after the Civil War, reformer Anthony Comstock began campaigning to prohibit the dissemination of sexually explicit materials. In 1873 Congress amended an 1872 law that prohibited the mailing of obscene materials so that it specifically included contraceptive information. Now known as the COMSTOCK LAW, this statute acted as a model for many state laws prohibiting contraception information.

Beginning in the early 1900s, Margaret SANGER, Mary Coffin DENNETT, and other birth control advocates brought the issue before the public. It was at this time that the term "birth control" was coined by one of Sanger's friends. In 1913, Sanger deliberately flouted the Comstock law and received considerable publicity when the post office refused to circulate an article on contraception she had written.

Sanger continued distributing contraceptive information and founded the National Birth Control League in 1914 and the AMERICAN BIRTH CONTROL LEAGUE in 1921. Dennett became a leader of the National Birth Control League in 1915, and she too ran afoul of the post office. Arrested in 1928 for mailing sex education materials to youth and church organizations, she was tried and convicted of violating New York State's version of the Comstock law. In 1930 the Second Circuit Court of Appeals overturned her conviction and ruled, in *United States v. Dennett,* that Comstock laws should not apply to the provision of accurate sexual information "unless the terms in which the information is conveyed are clearly indecent." This state court decision served as a precedent for other states to loosen their interpretation of Comstock laws. (The federal law was not amended to specifically exclude contraceptive information until 1971.) Both public knowledge and use of birth control increased dramatically during this time, and the birth rate fell to slightly more than two children per woman by 1940.

In 1965 the United States Supreme Court, in *GRISWOLD V. CONNECTICUT,* invalidated all state laws restricting a married person's access to contraceptive information. In 1972, in *Eisenstadt v. Baird,* the High Court also invalidated state laws restricting single persons' access to such information.

Since the 1970s, oral contraceptives ("the Pill") and other methods have given women many options in controlling the size of their families. The ability of women to limit the number of years spent in active maternity has greatly aided women in their attempts to make public as well as private lives for themselves.

While the legal right of women to choose to use contraceptives is now considered settled, the introduction of a new contraceptive, Norplant, has raised a different controversy. In certain child abuse cases, judges have ordered women to use Norplant, a surgically inserted time-released hormonal contraceptive, even against their will, raising questions as to whether or not contraceptive choices will remain entirely up to the woman involved.

Further Reading: Chesler, *Woman of Valor;* Cullen-DuPont, "Griswold v. Connecticut," in *Great American Trials,* ed. Knappman; Gordon, *Woman's Body, Woman's Right.*

Convention for the Suppression of the Traffic in Persons and of the Exploitation of the Prostitution of Others (1949–)

An international agreement sponsored by the United Nations intended to end prostitution, the Convention for the Suppression of the Traffic in Persons and of the Exploitation of the Prostitution of Others has been in force since 1949. It was followed by the 1956 Supplementary Convention on the Abolition of Slavery, the Slave Trade, and Institutions and Practices Similar to Slavery.

Although these international agreements obligate signatory nations to outlaw prostitution and sets an international standard for United Nations member states, few countries have enforced compliance with either treaty. (In the United States, for example, prostitution currently is legal in 12 of Nevada's 17 counties.) The CONVENTION ON THE ELIMINATION OF ALL FORMS OF DISCRIMINATION AGAINST WOMEN also contains prohibitions against prostitution.

Further Reading: United Nations, *Convention for the Suppression of Traffic in Persons and of the Exploitation of the Prostitution of Others;* ———, *Supplementary Convention on the Abolition of Slavery, the Slave Trade, and Institutions and Practices Similar to Slavery.*

Convention on the Elimination of All Forms of Discrimination Against Women (1979)

Adopted on December 18, 1979 by the United Nations General Assembly, the Convention on the Elimination of All Forms of Discrimination Against Women achieved the status of an international treaty upon its ratification by the twentieth country on September 3, 1981.

The convention incorporates many of the recommendations made by the U.N. Commission on the Status of Women from its inception in 1947 through the International Women's Year, 1975. Essentially an international "bill of rights for women," the convention requires participating governments to, among other things, make it possible for women to enjoy fundamental rights and freedoms; maintain affirmative action programs to benefit women, until such time as there is parity between men and women; rid their countries of prostitution and any form of female enslavement; grant women's suffrage and the right of women to hold political and/or public office; permit women, regardless of whether they are married, to make their own decisions regarding a change or retention of citizenship; require equal educational opportunities; require equal employment opportunities for all women, including those who are married, pregnant, or mothers; adopt maternity leave and child care policies; ensure that women receive health care, including prenatal, obstetrical, and postnatal care as well as family planning services, if desired; guarantee the right of women to take part in athletic, cultural, and recreational activities. The concluding section, as summarized in the United Nation's *The World's Women 1970–1990: Trends and Statistics,* commits governments to

> ensur[e] equal rights to choose a spouse, name or occupation; marry and divorce; own, buy, sell and administer property; share patenting, regardless of marital status; and choose the number and spacing of their children, including adoption or guardianship. In addition, governments are committed to establishing a minimum age for marriage and to ensuring that all marriages are entered into freely, by mutual consent.

To date, the convention has been signed by 163 member nations and ratified by 130 of those nations. In 1980 the convention was signed by Sarah T. Weddington on behalf of President Jimmy Carter at the world conference on women held in 1980 in Copenhagen, but the United States has never ratified the convention. The distinction is an important one: While signing a convention prohibits a country from acting in violation of the principles outlined in the document, ratification obligates a government actively to pursue the realization of those principles and regularly report on its progress to the U.N.

President Bill Clinton and Secretary of State Madeleine ALBRIGHT have repeatedly urged Congress to ratify the treaty, as has the FEMINIST MAJORITY FOUNDATION and other women's organizations. In the meantime, the U.N. Commission on the Status of Women has formulated a protocol that would permit women to bring complaints about treaty violations directly to the United Nations if their own countries fail to intercede. The U.N. General Assembly is expected to consider adoption of the protocol in the near future. Ten more countries must ratify the Convention itself before it can be enacted.

Further Reading: Associated Press, December 11, 1996 and March 16, 1999; Riding, "Women Seize Focus at Rights Forum," *New York Times,* June 16, 1993, p. A3; Rix, ed., *American Woman 1990–91;* United Nations, *World's Women 1970–1990;* Wandersee, *American Women in the 1970s; Washington Post,* March 25, 1997.

Cooper, Anna Julia Haywood (ca. 1858–1964)
scholar, educator

Anna Julia Haywood Cooper was born Anna Julia Haywood, to Hannah Stanley, a slave, and George Washington Haywood, who was quite possibly her mother's master at the time. Her birthdate is believed to be August 10, 1858 or 1859.

Still a child when freed from slavery by the Emancipation Proclamation, Haywood attended an Episcopal school dedicated to the training of teachers to staff African-American schools in the South. She progressed through St. Augustine's Normal School and Collegiate Institute quickly, becoming a "pupil-teacher" at the age of eight and ultimately becoming the school's matron. She married the Reverend George C. Cooper, an Episcopal priest and former slave, in June 1877 but was widowed in 1879.

In 1881 Cooper resumed her education at OBERLIN COLLEGE, receiving her A.B. in 1884 and her A.M. in 1888. After teaching for one year at Wilberforce University and for another two years at St. Augustine's, Cooper became a teacher of Latin at the Washington High School. (This became the M Street High School and, later, the Dunbar High School.)

The M Street High School was a college preparatory school for African Americans that offered some business courses but whose fundamental purpose was in providing a primarily classical curriculum for its students. At the time of Cooper's arrival at the high school, Booker T. Washington at the Tuskegee Institute and many Washington, D.C. policymakers were promoting the idea that African Americans would be better served by vocational training than by a classical education. From her position at M Street High School, Cooper publicly objected to this approach. In *A Voice from the South by a Black Woman of the South* (1892), she gave credit to Tuskegee for the successes of its students, but castigated anyone who would steer another person away from higher education on the basis of either race or sex.

Cooper became principal of M Street in 1901. She not only continued the school's tradition of college preparatory and high academic standards, but helped her students to gain admission to the nation's most respected private colleges. Despite the political ascendancy of Booker T. Washington's approach and lack of support from the school administration of Washington, D.C., Cooper gained admissions and scholarship consideration for M Street students from Brown, Harvard, and Yale universities. When local school officials ordered Cooper to cease in her efforts, she refused and was fired in 1906. There is evidence that Tuskegee Institute applied direct pressure for her dismissal.

Cooper returned to M Street High School as a teacher of Latin in 1910. With more time available to her due to her more restricted duties, Cooper continued her own education. She began working toward her doctorate at Columbia University and transferred her credits to the Sorbonne in Paris. Her thesis, *L'Attitude de la France à l'Egard de l'Esclavage pendant la Revolution,* was a study of the French treatment of St. Domingue (now Haiti) during and after the French revolution. Using careful scholarship, Cooper—once enslaved herself—examined the manner in which the French failed to apply their democratic ideals to their slave colony. She was awarded her degree in 1925, at the age of sixty-five.

In 1930 Cooper retired from Dunbar High School and became the president of the Frelinghuysen Group of Schools for Employed Colored Persons—an evening school for adult African Americans that later became Frelinghuysen University. (It ceased operation in 1961.) She served as Frelinghuysen's president until her retirement in 1942, at the age of eighty-three.

Anna Julia Haywood Cooper died on February 27, 1964 in Washington, D.C.

Further Reading: Gabel, "Anna Julia Haywood Cooper," in *Notable American Women,* ed. Sicherman et al.; Sterling, *We Are Your Sisters; Washington Post,* February 29, 1964.

Corbin, Margaret Cochran (1751–1800)
participant in the Revolutionary War battle of Fort Washington

Margaret Cochran was born on November 12, 1751, in what is now Franklin County, Pennsylvania, to Robert Cochran and his wife, whose name is lost. Margaret Cochran and John Corbin were married in approximately 1772.

During the Revolutionary War, John Corbin served in the Continental Army with the First Company of Pennsylvania Artillery. Margaret Corbin, like many women, followed her husband's regiment in order to cook, do laundry, and provide nursing care. During the battle of Fort Washington, New York, on November 16, 1776, John Corbin was killed by Hessians while at his cannon. Margaret Corbin took his place as cannoneer, sustaining three grapeshot wounds and becoming permanently disabled.

The Continental Congress awarded Corbin one-half of a soldier's salary, to be paid for the term of her disability or until her death. She was an official member of the Invalid Regiment, formed in 1777 for those soldiers wounded during the war and disbanded in 1783. She is believed to have died on January 16, 1800. In 1926, at the request of the Daughters of the American Revolution, Margaret Corbin's remains were reinterred at the West Point Cemetery, where a monument now stands beside her grave.

Further Reading: Land, "Margaret Cochran Corbin," in *Notable American Women,* ed. James, James, and Boyer; McHenry, ed. *Famous American Women.*

Cori, Gerty Theresa Radnitz (1896–1957)
biochemist, physician, the first American woman to win a Nobel Prize in the sciences

Gerty Radnitz Cori was born Gerty Radnitz on August 15, 1896, to Martha Neustadt Radnitz and Otto Radnitz, in Prague, then part of the Austro-Hungarian Empire.

She was educated by tutors until she entered a private girls' school at the age of ten. She decided to study medicine at the age of sixteen and spent the next two years studying mathematics and Latin in preparation for medical school. In 1914 she entered the Medical School of the German University of Prague. She received her M.D. in 1920 and, on August 5 of that year, married Carl Ferdinand Cori.

Gerty and Carl Cori had been medical students together, and their joint research project had resulted in the 1920 publication of a paper on the immune properties of blood. Although they were determined to continue their research on a collaborative basis, their first jobs were in separate institutions: Carl became an assistant at the University of Vienna's medical clinic and pharmacological institute, and Gerty, an assistant in the Karolinen Children's Hospital.

When Carl was offered a position as a pathologist in 1922 with the New York State Institute for the Study of Malignant Diseases (later the Roswell Park Memorial Institute), he immigrated to the United States. When the institute offered Gerty a position as assistant pathologist several months later, she immigrated as well. In 1928 they became American citizens.

At the New York State Institute, the Coris began to collaborate once again on their research. Initially, the director at the institute ordered Gerty to end either the research partnership or her employment, but "the storm," as Gerty called it, passed, and the couple's research continued. (Prejudice was not restricted to the New York State Institute. Carl was offered a position with another university during this time, and his potential employer bluntly told Gerty that she was obstructing her husband's career and that it was "un-American" for a woman to work alongside her husband.) Despite the institute's reservations about the Coris' collaborative research, Gerty was made an assistant biochemist in 1925.

As time went on, the couple feared that their primary research interest—carbohydrate metabolism—could not contribute directly to the institute's program of cancer research, and they began to look for another scientific home. Carl Cori joined the Washington University School of Medicine in St. Louis as chairman of its department of pharmacology in 1931. Since Washington University, like other universities at the time, prohibited two family members from becoming faculty members simultaneously, Gerty accepted a research position with only a token salary. In 1947, when Gerty Cori received the Nobel Prize—along with her husband and Argentina's Bernardo Houssay—the university relented and made her a professor of biochemistry.

The research for which Gerty and Carl Cori received the Nobel Prize for medicine and physiology involved the impact of insulin and epinephrine on carbohydrate metabolism; the conversion of liver glycogen to glucose, and of muscle glycogen to lactate; their 1936 discovery of an intermediate stage in the conversion of glycogen, glucose-1-phosphate (generally known as the Cori ester); their 1938 discovery of the catalytic enzyme phosphorylase; and their 1939 synthesis of glycogen in the laboratory.

In 1950 President Harry Truman appointed Gerty Cori to the board of the National Science Foundation. She remained on that board and as professor of biochemistry at the Washington University School of Medicine during a ten-year battle with myelofibrosis, a rare bone marrow disease.

Gerty Cori died on October 26, 1957, in St. Louis.

Further Reading: *Current Biography,* 1947; McHenry, ed., *Famous American Women; New York Times,* October 27, 1957; Opfell, *Lady Laureates;* Parascandola, "Gerty Cori," in *Notable American Women,* ed. Sicherman; Riederman, and Gustafson, *Portraits of Nobel Laureates in Medicine and Physiology.*

Council of Asian American Women
Founded in 1979, the Council of Asian American Women works to increase the impact and participation of Asian American women in entrepreneurial endeavors, politics, and the professions. It also tries to insure that the concerns of Asian-American women are considered during the formation of public policy. The organization maintains its offices in Washington, D.C. Virginia Kee is currently its president.

Further Reading: Brennan, ed., *Women's Information Directory.*

Craig v. Boren (1976)
A 1976 Supreme Court decision that overturned, on Fourteenth Amendment grounds, an Oklahoma law allowing the sale of beer to women at age eighteen but prohibited the sale of beer to men until age twenty-one and, more important, enunciated a new standard of scrutiny for application in sex discrimination cases.

Frank Gilbert argued the case, and Ruth Bader GINS-BURG filed an *amicus curiae* (friend of the court) brief. Ginsburg thought the particular issue at hand was a "non-weighty interest pressed by thirsty boys"; however, she also thought that the disparate age requirements were a violation of the Equal Protection Clause of the Fourteenth Amendment, which stated that "No State shall . . . deny to any person . . . the equal protection of the law."

The opinion, written by Justice William J. Brennan, Jr., overturned the Oklahoma law, stating: "Classifications by gender must serve important governmental objectives and must be substantially related to achievement of those objectives." In most cases the Court will uphold or strike down a discriminatory law based on whether it passes a *rational relationship test*. The Court will permit discrimination if it bears a rational relationship to a state goal that is found to be legitimate. States are permitted, for example, to establish laws regulating the ages at which persons may acquire drivers' licenses. However, when discriminatory laws classify the targeted group by race, creed, or national origin—categories the Court has termed *suspect*—a standard known as *strict scrutiny* is applied. In these cases, the Court will uphold a discriminatory law only if it serves a *compelling state interest*, which cannot be assured by any other means. In presenting her argument in an earlier sex discrimination case, *FRONTIERO V. RICHARDSON* (1973), Ruth Bader Ginsburg had asked the Court to find sex a suspect category entitled to strict scrutiny; had she been successful, the Court thereafter would have had to evaluate sex and race discrimination by the same standards. However, the Court, while nearly unanimous in overturning the sex-biased regulations challenged in *Frontiero*, (the decision overturned a law requiring female army officers to prove their husbands' financial dependency before receiving spousal benefits) had been one vote short of the five needed to establish sex as a suspect category.

Three years later, though, with *Craig v. Boren*, the Court established what is referred to as an "intermediate" or "mid-level" test for application in sex discrimination cases. While the Court would not require states to prove a *necessary* relationship to a *compelling* governmental interest, as was required by the strict scrutiny standards applied to race discrimination cases, it would, in sex discrimination cases, require a *substantial* relationship to an *important* governmental interest.

Further Reading: Cary and Peratis, *Woman and the Law; Craig v. Boren*. 1976. 429 U.S. 190; Cushman, *Cases in Constitutional Law; Frontiero v. Richardson*. 1973. 411 U.S. 677; O'Connor, "Women and the Constitution," in *Women, Politics and the Constitution,* ed. Lynn. Von Drehle, "A Trailblazer's Step-by-Step Assault on the Status Quo."

Crandall, Prudence (1803–1890) *educator*
Educator and founder of the first institution dedicated to the education of young African-American women, Prudence Crandall was born on September 3, 1803, in Hopkinton, Rhode Island, to Esther Carpenter Crandall and Pardon Crandall. A Quaker, Crandall received her education at the New England Friends' Boarding School in Providence.

Crandall opened the Canterbury Female Boarding School in Canterbury, Connecticut in 1831. In 1833 she decided to admit Sarah Harris, an African-American girl, to the school. The parents of Crandall's white students—and, indeed, many of her neighbors—were outraged. When Crandall was ordered by the town to expel Harris, she instead shut down her school. Two months later Crandall reopened the school—as a boarding school for African-American girls.

Townspeople worked hard to undermine Crandall's ability to operate her school. Local doctors refused to treat and shopkeepers refused to sell food or other necessities to her or her students. Stones were thrown through the school's windows and at Crandall and her students.

Connecticut passed a law making it illegal to educate out-of-state students, and, since several of the school's boarders were in this category, Crandall was jailed. She stood trial twice (the first jury was divided) and was convicted at the end of the second trial. When her conviction was overturned by a higher court, Crandall returned to the school. Community outrage continued, however, and Crandall's school was set afire. Afraid that she was endangering the lives of the very girls she wished to help, Crandall finally closed her school in September 1834. When Crandall was 84 years old, the Connecticut legislature formally apologized for the "cruel outrages" that she and her students suffered.

Prudence Crandall died in Elks Falls, Kansas, on January 28, 1890. The building that was Crandall's home and school is now the Prudence Crandall Museum for black and women's history.

Further Reading: Drake, "Prudence Crandall," in *Notable American Women,* James, James, and Boyer, eds.; Flexner, *Century of Struggle;* McHenry, ed., *Famous American Women;* Strane, *A Whole-Souled Woman: Prudence Crandall and the Education of Black Women.*

Cult of True Womanhood (19th century)
A nineteenth-century concept that sentimentalized and romanticized a woman's place within the home, the Cult of True Womanhood was first seriously analyzed for the twentieth century by historian Barbara Welter.

Welter's 1966 article, "The Cult of True Womanhood: 1820–1860," as well as her subsequent book,

Dimity Convictions (1976), examines religious sermons and literature, women's magazines, and newspapers, and identifies a pervasive message—perhaps even a dictum—aimed at Victorian American women. Women were urged to embrace Purity, Piety, Domesticity, and Submission as their primary virtues and to employ these in service of their homes and families, a private realm that was referred to as "Woman's Sphere." Adherents of the Cult of True Womanhood were expected to affect public policy only through the men in their lives. Moral guidance of sons who would later vote or personal pleas directed to husbands or fathers who then acted in the public sphere was referred to as a "Woman's Influence."

Further Reading: Banner, *American Beauty;* Clinton, *The Other Civil War;* Cott, *The Bonds of Womanhood;* Smith Rosenberg, *Disorderly Conduct;* Welter, "Cult of True Womanhood," 151–174; ———, *Dimity Convictions.*

curtesy

The common-law principle that a husband, if he and his wife had children, could, upon his wife's death, have use of his wife's property for the remainder of his life but not the freedom to sell the property or to grant it by will to anyone other than his wife's children. A wife's similar right was called DOWER.

In most states, if a woman dies intestate (without a will) her husband now receives outright and with the right to dispose of at will one-third to one-half of his wife's property rather than the old curtesy use.

Further Reading: Salmon, *Women and the Law of Property in Early America.*

dame school

Conducted by a woman in her own home, a dame school offered instruction in the basics: reading, writing, and arithmetic. Some daughters of wealthy families also received tutoring or went on to female academies but, until the last third of the nineteenth century, most American girls received only a dame school education.

Further Reading: Flexner, *Century of Struggle;* Frost and Cullen-DuPont, *Women's Suffrage in America;* Stanton, *Eighty Years and More;* Stanton, Anthony, and Gage, eds., *History of Woman Suffrage,* vol. 1.

Daughters of Bilitis

Founded in 1955 by several women in San Francisco, Daughters of Bilitis (DOB) began as a social club for lesbians and soon evolved into a civil rights organization with a strong educational outreach program. Within five years of its founding, DOB had chapters in Chicago, Los Angeles, New York City, and Rhode Island. The organization's name was taken from Sappho's poetry, and its first president was Del Martin.

As part of its effort to eliminate stereotyping and prejudice, DOB invited members of the community to participate in regularly scheduled discussions of lesbianism. Eventually its speakers began to address high school, college, radio, and television audiences. DOB also published a newsletter, the *Ladder,* of which Phyllis Lyon was the first editor, and provided access to its library collection.

In December 1970, an article in *Time* magazine criticized Kate Millett for "contribut[ing] to the growing skepticism about the [women's] movement by acknowledging at a recent meeting that she is bisexual. The disclosure is bound to discredit her as a spokeswoman for her cause, cast further doubt on her theories, and rein-

force the views of those skeptics who routinely dismiss all liberationists as lesbians."

Members of the Daughters of Bilitis joined members of the NATIONAL ORGANIZATION FOR WOMEN (NOW) and several other women's rights groups at a press conference at the New York City's Washington Square Methodist Church on December 18, 1970. There Millet read a carefully prepared statement:

> Women's liberation and homosexual liberation are both struggling toward a common goal: A society free from defining and categorizing people by virtue of gender and/or sexual preference. "Lesbian" is a label used as a psychic weapon to keep women locked into their male-defined "feminine role." The essence of that role is that a woman is defined in terms of her relationship to men.

Daughters of Bilitis ceased to exist as a national organization in 1970.

Further Reading: Damon, "The Least of These," in *Sisterhood Is Powerful,* ed. Morgan; Davis, *Moving the Mountain;* Hole and Levine, *Rebirth of Feminism;* "Lesbian Issue and Women's Lib," *New York Times,* December 18, 1970; *Time,* December 14, 1970.

Daughters of Liberty

Loose associations of Colonial American women dedicated to the boycott of British products before and during the Revolutionary War. Members forswore not only tea but English cloth, which they replaced in organized, political "spinning bees." (On the afternoon of December 12, 1769, 290 skeins of yarns were spun by Daughters of Liberty gathered in the home of one clergyman.) By February of 1770, 300 Boston women were members of such an organization, and cities as far apart as Providence and Edenton, North Carolina, had similar associations.

Further Reading: Evans, *Born for Liberty;* Flexner, *Century of Struggle;* Stanton, Anthony, and Gage, *History of Woman Suffrage,* vol. 1.

Daughters of St. Crispin

A trade union of women shoe workers. Founded July 28, 1869, in Lynn, Massachusetts, it soon became the first national organization of women workers, with twenty-four lodges in Massachusetts, California, Illinois, Maine, New Hampshire, New York, Ohio, and Pennsylvania. Carrie Wilson was its president and Abbie Jacques, its secretary. The organization held annual conventions until 1872. At the convention of 1870, the following resolution was adopted:

> Whereas the common idea among employers has been and still is that women's labor should receive a less remuneration, even though equally valuable and efficient, than is paid men even on the same qualities of work; and
> Whereas in every field of human effort the value and power of organization is fully recognized: Therefore be it
> Resolved by this National Grand Lodge of the Daughters of St. Crispin, That we demand for our labor the same rate of compensation for equal skill displayed, or the same hours of toil, as is paid other laborers in the same branches of business; and we regard a denial of this right by anyone as a usurpation and a fraud.
> Resolved, That we condemn and promptly veto one sister's making a percentage on another sister's labor.
> Resolved, That we assure our fellow-citizens that we only desire to so elevate and improve our condition as to better fit us for the discharge of those high social and moral duties which devolve upon every true woman.

The Daughters of St. Crispin sent delegates to the National Labor Union's convention in 1870. In 1872, in three factories in Stoneham, Massachusetts, 300 Daughters staged a strike, which ended unsuccessfully. Another Daughter of St. Crispin strike in 1872—this one in Lynn, Massachusetts—won higher wages for the women. The national union lasted only several years; by 1876 it was again a local organization of Lynn, Massachusetts, workers.

Further Reading: Flexner, *Century of Struggle;* Wertheimer, *We Were There.*

Davey v. Turner (1764)

A 1764 decision of the Supreme Court of colonial Pennsylvania, *Davey v. Turner* was an early and important ruling with regard to the property of married women, since it upheld the joint deed system of conveyance.

While it is true that married women had few property rights prior to the passage of nineteenth-century women's property acts (see MARRIED WOMAN'S PROPERTY ACT, 1848, NEW YORK STATE for further discussion), it is also true that, especially in colonial times, there were regional variations concerning married women's control—if not outright ownership—of property. Pennsylvania, for example, along with Southern colonies such as Maryland, Virginia, and South Carolina, employed a joint deed system. Under this system, a justice of the peace interviewed a married woman or FEMME COVERT to make sure that she did not object to the transfer of family property. The procedure was intended to protect a woman from loss of DOWER rights (the use of one-third of a husband's property following his death) or the transfer of property that came into the marriage through her family.

Further Reading: Salmon, *Women and the Law of Property in Early America.*

Day, Dorothy (1897–1980) *social reformer*

Born on November 8, 1897, in Brooklyn, New York, to Grace Satterlee Day and John Day, Dorothy Day became a cofounder and head of the Catholic Worker Movement.

One of five children, Day was reared in New York City, California, and Chicago. In 1914 she was awarded a scholarship, which enabled her to attend the University of Illinois. Her reading of Upton Sinclair, Jack London, and others, coupled with her growing desire to fight poverty, led her to join the Socialist party.

Day left school in 1916 and returned to New York, where she became a member of the Anti-Conscription League and the Industrial Workers of the World, as well as a reporter for the Socialist *Call.* In addition to espousing socialism, Day supported women's suffrage. In 1917 she picketed the White House to demand suffrage along with Alice PAUL and other suffragists. On November 10, 1917, Day was arrested along with other picketers and sentenced to thirty days in the Occoquan workhouse. During that time, she was one of many suffragists to go on a hunger strike as a means of continued protest.

The years following her release included work at Crystal EASTMAN's newspaper, *The Liberator,* the publication of a novel, *The Eleventh Virgin* (1924), her common-law marriage to anarchist Forster Batterham, and what would be the galvanizing experience of her life: the birth of her daughter, Tamar Theresa, in 1927. In the experience of her pregnancy and delivery of the child, Day found something almost unbearably profound, mysterious, and joyful. The event prompted a religious conversion: To the incomprehension of many to whom she had previously been close, including Tamar's father, Day was baptized a Roman Catholic in December 1927.

Dorothy Day, cofounder and head of the Catholic Worker movement (*Library of Congress*)

Day struggled with the difficulty of reconciling her new faith with her continued desire to change if not the world, then its harsh impact on the poor. The synthesis she finally arrived at was, that "[t]he mystery of the poor is that they are Jesus, and what we do for them we do for him."

In May 1933, four years into the Great Depression, Day founded the *Catholic Worker* with Peter Maurin. The newspaper, which had a circulation of 150,000 people at the end of three years, reflected Day's view that the Bible supported anticapitalism and activist works based on social conscience. Responding to Day's call for "works of mercy, and personalist action," *Catholic Worker* readers formed communities whose members practiced voluntary poverty (both as a matter of spiritual discipline and as a means of joining with the poor) while agitating on behalf of a social justice agenda. In 1934 St. Joseph's House of Hospitality in New York City was founded to offer food and lodging to the homeless and hungry. Before the end of the Depression, Catholic Worker communities had established more than thirty such houses throughout the country.

Day was a pacifist, and her newspaper supported conscientious objectors during World War II. Following the end of World War II and the emergence of the Cold War, Day focused on opposing the use of nuclear weapons. Day also participated in the civil rights demonstrations of the 1950s and 1960s. During the war in Vietnam, she once again supported conscientious objectors and also took part in anti-war demonstrations opposing the war in Vietnam. She was arrested a number of times for acts of civil disobedience and served as an inspiration to Catholic peace activists such as Daniel Berrigan.

In addition to publishing the *Catholic Worker* and *The Eleventh Virgin,* Day published *From Union Square to Rome* (1938), *House of Hospitality* (1939), *On Pilgrimage* (1948), *The Long Loneliness* (1952), *I Remember Peter Maurin* (1958), *Therese* (1960), *Loaves and Fishes* (1963), and *On Pilgrimage: The Sixties* (1972).

Dorothy Day divided her time between the Catholic Workers' farm in Tivoli, New York and one of its New York City houses, in voluntary poverty, until her death in New York City on November 29, 1980. The *Catholic Worker* continues to be published, and its offices on East Third Street, New York City, continue to serve as a soup kitchen and as a center for those trying to live in accord with Day's ideals. John Cardinal O'Connor of New York proposed that Day be canonized a saint of the Roman Catholic Church.

Further Reading: Clark, *Almanac of American Women in the 20th Century;* Coles, *Dorothy Day;* Day, *Long Loneliness;* ———, *Selected Writings;* Ellesberg, ed. *By Little and By Little;* Elie, "Patron Saint of Paradon"; Faust, ed., *American Women Writers;* Forest, *Love Is the Measure;* McHenry, ed., *Famous American Women;* Miller, *Dorothy Day;* ———, *A Harsh and Dreadful Love;* Nekola and Rabinowitz, eds., *Writing Red;* Piehl, *Breaking Bread;* Stevens, *Jailed for Freedom.*

Declaration of Rights and Sentiments (the Declaration of Sentiments and Resolutions) (1848) Consciously modeled after the Declaration of Independence, the Declaration of Rights and Sentiments became the founding document of the American women's movement. It was written by Elizabeth Cady STANTON with input from Lucretia MOTT, Jane Hunt, Mary Ann M'Clintock, and Martha Coffin Wright, and it was adopted at the SENECA FALLS CONVENTION, July 19 and 20, 1848.

The Declaration of Independence had said, "We hold these truths to be self-evident: that all men are created equal." The Declaration of Rights and Sentiments restated this claim as "all men and women are created equal." Then, where the Declaration of Independence had accused King George, the women's Declaration of Rights and Sentiments accused all men: It accused them of denying women the right of suffrage; of forcing them to obey laws that they had not participated in forming; of

causing them to suffer a civil death upon marriage; and of depriving them of property rights and wages. (At the time, married women were not allowed to own property, and married women's wages belonged to their husbands.) The Declaration of Rights further accused men of trying to deprive women of a moral sense; as evidence of this claim, it mentioned laws that empowered husbands to punish their wives with physical force and laws that held women inculpable for crimes committed in the presence of their legally responsible husbands. Men were accused of drafting divorce laws that gave no consideration to women's happiness and that granted custody of the children to their fathers; of barring women from colleges, the ministry, and professions; and of devising two separate moral codes for men and women.

Twelve resolutions, demanding redress of these grievances, followed. One went so far as to state that "such laws [that] conflict, in any way, with the true and substantial happiness of women, are contrary to the great precept of nature and of no validity." Other resolutions demanded education equal to that of men, admission into the professions and trades, the right to speak in public, the right to become religious leaders—and women's suffrage. This last demand (the ninth of twelve resolutions in the document) caused the greatest controversy, both at the Seneca Falls Convention and in newspapers and at the pulpit afterward; while all the other resolutions were passed unanimously, the suffrage resolution passed narrowly and only after an impassioned speech by Frederick Douglass. At the end of the convention, one hundred people (sixty-eight women and thirty-two men) signed the document. However, the public outcry that followed, together with private pressure from male relatives, caused many of the women to remove their names during the weeks that followed. (Harriet Cady Eaton, sister of Elizabeth Cady Stanton, was one such woman.) Two weeks later, the document was adopted for a second time at the ROCHESTER CONVENTION.

The document continues to inspire American women. In Rochester on July 12, 1998, to celebrate the 150th anniversary of the Declaration of Rights and Sentiments and look toward the future, the NATIONAL ORGANIZATION FOR WOMEN adopted the 1998 Declaration of Sentiments of the National Organization for Women. At the same celebration, fifty girls working under the auspices of the Girls International Forum drafted their own Bill of Rights for Girls, modeled after the original Declaration, and the Women's History Project coordinated another such document.

Further Reading: Frost and Cullen-DuPont, *Women's Suffrage in America;* Stanton, Anthony, and Gage, eds., *History of Woman Suffrage,* vol. 1.

Declaration of Rights of Women (1876)

A document written by Elizabeth Cady STANTON and Matilda Joslyn GAGE to mark the occasion of the United States' centennial in 1876 and to jolt the nation into an awareness that women had been without suffrage and many other rights throughout the country's hundred years of independence.

Stanton wrote a polite letter asking that the centennial committee give the NATIONAL WOMAN SUFFRAGE ASSOCIATION (NWSA) permission to present the document during the public celebrations. "We do not ask to read our declaration . . . only to present it, that it may become a historical part of the proceedings," she explained. When permission was refused, NWSA members began planning what one gleefully called an "overt action."

Susan B. ANTHONY, Sara Andrews Spencer, Lillie Devereux Blake, Phoebe Couzins, and Matilda Joslyn GAGE joined an audience of 150,000 people on July 4, 1876. Heads of state from various countries stood on the platform beside U.S. generals and governors as the Declaration of Independence was solemnly read aloud. As the last word was spoken, Susan B. Anthony and Matilda Joslyn Gage, as the New York *Tribune* reported, "pushed their way vigorously through the crowds and appeared upon the speaker's platform . . . Hustling generals aside, elbowing governors . . . they reached Vice President Ferry, and handed him a scroll about three feet long, tied with ribbons of various colors. He was seen to bow and look bewildered . . ."

Thus, the presentation of the Declaration of Rights for Women became, as Stanton wished, an official part of the centennial proceedings.

The document professed "faith . . . firm and unwavering in the broad principles of human rights proclaimed in 1776 . . ." but mourned that "The history of our country the past hundred years has been a series of assumptions and usurpations of power over woman, in direct opposition to the principles of just government, acknowledged by the United States as its foundation . . ." The document summarized those principles as follows:

First—The natural rights of each individual.
Second—The equality of these rights.
Third—That rights not delegated are retained by the individual.
Fourth—That no person can exercise the rights of others without delegated authority.
Fifth—That the non-use of rights does not destroy them.

Continuing, the women's document "arraign[ed] our rulers on this Fourth day of July, 1876, and set forth articles of impeachment." In closing, the declaration stated:

And now, at the close of a hundred years . . . we declare . . . that woman was made first for her own happiness, with the absolute right to herself . . . and we deny that dogma of the centuries, incorporated in the codes of all nations—that woman was made for man—her best interests, in all cases, to be sacrificed to his will . . . We ask justice, we ask equality, we ask that all the civil and political rights that belong to citizens of the United States, be guaranteed to us and our daughters forever.

Further Reading: Frost and Cullen-DuPont, *Women's Suffrage in America;* Stanton, Anthony, and Gage, eds., *History of Woman Suffrage,* vol. 3; Wheeler, ed., *Loving Warriors.*

Defense of Marriage Act (1996)

Signed by President Clinton and enacted into law on September 21, 1996, the Defense of Marriage Act is intended to restrict recognition of same-sex marriages to the states in which such marriages may be permitted and to exempt the federal government from recognizing same-sex marriages.

Specifically, the act made an exception to the "full faith and credit" statutes by permitting individual states to decide whether or not to give their full faith and credit to marriage licenses issued by other states, when those licenses are held by a same-sex couple. (Normally, each state is required to recognize the validity of the others' marriage licenses.) The act further provides that the federal government, for the purposes of its own laws and programs, would construe the terms *marriage* and *spouse* as being applicable only to heterosexual couples. Thus, if a state legalized same-sex marriage, homosexual partners who married could not participate as dependents in the Federal Employees Health Benefits Program or collect Social Security survivors' or other benefits normally accruing to married persons in the United States.

To date, same-sex marriage has not been legalized in any state, although Vermont approved civil unions in 2000.

Further Reading: Baker, "President Quietly Signs Law Aimed at Gay Marriage"; Defense of Marriage Act, Public Law 104–33; Mathis, "President Signs GOP Bill on Gay Marriages"; Robichaud, "Defense of Marriage—Or Attack on Family?"; "Same-Sex Marriage: Federal and State Authority."

De Mille, Agnes George (ca. 1905–1993) *dancer, director, writer, choreographer*

Born on September 18, 1905 (or 1908 or 1909; sources vary), in New York City, to Anna George de Mille and William Churchill de Mille, Agnes de Mille became a dancer, director, writer, and the choreographer of ballets and many of Broadway's best-loved musicals.

De Mille was born into a very accomplished family. Her father was a highly respected playwright, her uncle was film producer Cecil B. DeMille, and her grandfather was noted economist Henry George. She requested and received drama and dance lessons, and she met important figures of the dance world such as Ruth ST. DENIS and Ted Shawn while still a student at the Hollywood School for Girls.

Upon her graduation from UCLA in 1927, de Mille moved to New York City. In 1928 she held a number of dance concerts, which led to an invitation to dance in London. From London, she choreographed *Hamlet* for a Broadway production and the dances in MGM's 1937 *Romeo and Juliet.* Returning to the United States, she became the resident choreographer for the American Ballet Theater in 1939 (a position she held until 1944) and married Walter J. Prude in 1943.

De Mille's many ballets include *Rodeo* (1942), *Tally-Ho* (1944), *Fall River Legend* (1948), *The Harvest According* (1952), *The Bitter Weird* (1962), *The Wind in the Mountains* (1965), and *The Four Marys* (1965). Her choreographic work for Broadway is even more well known, including as it does *One Touch of Venus* (1943), *Oklahoma* (1943), *Bloomer Girl* (1944), *Carousel* (1945), *Brigadoon* (1947), *Gentlemen Prefer Blondes* (1949), *Paint Your Wagon* (1951), *The Girl in Pink Tights* (1954), *Kwamina* (1961), and *110 in the Shade* (1963). Even audiences unable to attend the Broadway shows saw versions of many of these musicals, as quite a few were made into movies; where the change in medium required choreographic alterations, de Mille herself choreographed the new dances. De Mille's Oklahoma set a precedent by omitting the once customary chorus from the Broadway musical and placing song and dance numbers firmly in the context of character development and plot requirements.

In addition to her work on and for the various stages, de Mille has written extensively about the world of dance and her own life and work. Her books include *And Promenade Home* (1958); *To a Young Dancer* (1962); *The Book of the Dance* (1963); *Lizzie Borden: A Dance of Death* (1968); *Russian Journals* (1970); *Dance to the Piper* (1972); *Speak to Me, Dance With Me* (1973); *Where the Wings Grow* (1978); *America Dances* (1980); *Reprieve: A Memoir* (1981); and, most recently, *Martha: The Life and Work of Martha Graham* (1991).

De Mille's later work was accomplished despite a massive stroke that left her without the use of her right side after 1975; as she described the effects of her "physical disabilities and relative helplessness" while expressing gratitude to her assistants (in the acknowledgments prefacing *Martha*), she "could not . . . even open a dictionary."

Agnes de Mille died on October 7, 1993, in New York City.

Further Reading: Clark, *Almanac of American Women in the 20th Century; Dance Magazine* (October 1971; September 1972; November 1974; June 1974); De Mille, *Martha;* ———, *And Promenade Home;* ———, *Dance to the Piper;* ———, *America Dances;* Faust, ed., *American Women Writers;* McHenry, ed., *Famous American Women.*

Dennett, Mary Coffin Ware (1872–1947) *reformer*

Born Mary Coffin Ware on April 4, 1872, in Worcester, Massachusetts, to Livonia Coffin Ames Ware and George Whitefield Ware, Mary Coffin Ware Dennett became a noted birth control reformer.

Dennett attended Miss Capen's School for Girls in Northampton, Massachusetts, and then the school of the Boston Museum of Fine Arts. She taught decoration and design at the Drexel Institute in Philadelphia from 1894 to 1897; the following year she became coproprietor of a Boston handicraft shop with her sister. In 1900 she married architect William Hartley Dennett, with whom she had three children (one of whom died when only several weeks old) and from whom she was divorced in 1913.

Dennett became active in the suffrage movement, serving as field secretary for the Massachusetts Woman Suffrage Association from 1908 to 1910 and acting as corresponding secretary of the NATIONAL AMERICAN WOMAN SUFFRAGE ASSOCIATION from 1910 to 1914. In the years prior to World War I, Dennett joined the Intercollegiate Socialist Society and the Hillquit Nonpartisan League (the latter an organization in support of Socialist Morris Hillquit's New York City mayoral candidacy). She also acted upon her pacifist beliefs by joining the American Union Against Militarism, serving as its field secretary in 1916. Following the United States' entry into World War I, Dennett became a cofounder of the People's Council, an antiwar organization.

At the same time, Dennett had become committed to what would become the primary cause of her life, the reform of birth control laws. Other birth control reformers, led most notably by Margaret SANGER, were engaged in efforts to overturn state and federal legislation, such as the COMSTOCK LAW, which forbade the passage of birth control information through the mail. Sanger favored confrontational methods and the deliberate breaking of laws at the beginning of her career and when in 1915 she took up residence in Europe rather than stand trial for a resultant arrest, Mary Coffin Dennett and others absorbed Sanger's National Birth Control League into a new entity, the Voluntary Parenthood League. Under Dennett's leadership, the Voluntary Parenthood League disavowed militant methods in favor of more mainstream tactics such as lobbying Congress.

When Sanger returned to the United States, she disagreed with Dennett about more than the propriety of Dennett's having taken over the National Birth Control League. Sanger no longer sought an outright repeal of existing birth control laws, but rather their amendment to permit the medical community to provide birth control information. Dennett, suddenly the more radical of the two women, continued to press for the outright repeal of all birth control restrictions. She strongly objected that the medical community, according to Sanger's model, would control women's access to birth control information. "Fancy real live Americans wanting freedom for doctors only, and being willing to let the laws provide that anyone who passes along what the doctor tells, is guilty of obscenity!" is how she expressed her view to a friend.

Dennett, like Sanger, was arrested in the course of her career. In 1918 "The Sex Side of Life"—an essay originally written to explain the "vivifying joy" of human sexuality to her growing sons—was published in the *Medical Review of Reviews.* Church organizations, health departments, and youth organizations had requested and received 25,000 reprinted copies by 1922, when the Postmaster General categorized the essay as obscene. Dennett continued to mail copies upon request and was arrested in 1928. Her conviction in 1929 prompted public support, newspaper editorials on her behalf, and an appeal mounted with the help of the American Civil Liberties Union. In 1930 the Second Circuit Court of Appeals in New York State overturned Dennett's conviction and ruled, in *United States v. Dennett,* that Comstock laws should not apply to the provision of accurate sexual information "unless the terms in which the information is conveyed are clearly indecent." This state decision later served as precedent in other cases, among them the 1934 case involving publication of James Joyce's *Ulysses* in the United States.

The Voluntary Parenthood League eventually accepted Sanger's position that birth control would be legalized in America only as long as it remained within the province of the medical community. In 1925 the organization voted to merge with the AMERICAN BIRTH CONTROL LEAGUE, an organization founded in 1921 by Sanger following Dennett's appropriation of the Birth Control League. Dennett, still refusing to support a medical model of birth control freedom, resigned from the newly merged organization and continued to press for women's direct access to birth control information.

In addition to "The Sex Side of Life," and other essays and pamphlets, Dennett published a newspaper, the *Birth Control Herald,* from 1922 to 1925, and several books, including *Birth Control Laws* (1926), *Who's*

Obscene? (1930), and *The Sex Education of Children* (1931).

Near the end of her life, Dennett again acted upon her pacifist beliefs and in 1941 became the first chairman of the World Federalists, an organization committed to the belief that peace could be attained by a world government that respected international law.

Mary Coffin Ware Dennett died on July 25, 1947, in Valatie, New York.

Further Reading: Chesler, *Woman of Valor;* Dennett, *The Real Point;* ———, *Birth Control Laws;* ———, *Prosecution of Mary Ware Dennett for Obscenity;* ———, *Sex Education of Children;* ———, *Who's Obscene?;* ———, Letter to Alice Park, May 17, 1925; Gordon, *Woman's Body, Woman's Right;* Kennedy, *Birth Control in America;* Sanger, *An Autobiography.*

DES Action, U.S.A.

An organization founded as DES Action, National, in 1977, Des Action, U.S.A., is a national organization composed primarily of DES-exposed women "working to try to ameliorate the problems caused by DES."

DES is a synthetic estrogen, diethylstilbestrol, which was widely used between 1941 and 1971 to prevent bleeding during pregnancy, miscarriage, premature delivery, and gestational diabetes, and, in some cases, to treat women's infertility problems.

DES has since been found to cause severe health problems in the mothers originally involved and in their daughters. The mothers have an increased risk of breast cancer and their daughters have twice the rate of miscarriage and seven times the rate of ectopic pregnancy experienced by the general population of childbearing women. Other consequences experienced by DES daughters are congenital malformations of the vagina or cervix, which may lead to difficulty in conceiving, and, if DES was administered during the mother's first five months of pregnancy, an increased risk of clear-cell adenocarcinoma, a rare form of cancer affecting the vagina or cervix. There have been reported cases of low sperm count, urinary problems, and genital malformation, including undescended testes, in DES sons, but medical research in this area has not yet been conclusive. Both DES daughters and sons are believed to experience higher than normal rates of immune system disorders. (It should be noted that many DES children have experienced no reproductive difficulty or disease.) Until recently, there did not appear to be a third-generation effect. However, studies conducted by the National Institute of Environmental Health Sciences and released in 1998 raise the possibility that DES granddaughters may be at an increased risk for certain cancers, including uterine cancer.

DES Action, U.S.A., is working to secure federal legislation and funding to assist affected persons, to educate the medical community with regard to DES consequences, to offer counseling and physician referral to those affected by DES, and to encourage DES-exposed persons without symptoms to receive regular medical monitoring.

DES Action, U.S.A., as the organization was renamed in 1986, maintains its headquarters in Oakland, California, and has thirty state groups. It publishes the quarterly *DES Action Voice: A Focus on Diethylstilbestrol Exposure* and has published several handbooks, including the *Fertility and Pregnancy Guide for DES Daughters and Sons* and *Reproductive Outcomes in DES Daughters.* Nora Cody is the organization's current executive director.

Further Reading: Apfel and Fisher, *To Do No Harm;* Brennan, ed. *Women's Information Directory;* Fenichell and Charfoos, *Daughters at Risk;* Reuters, October 2, 1998.

Dickinson, Anna Elizabeth (1842–1932) *orator, Lyceum lecturer, playwright*

Anna Elizabeth Dickinson was born on October 28, 1842, in Philadelphia to Mary Edmondson Dickinson and John Dickinson, both Quakers.

At the age of seventeen, she made her first speech before the Pennsylvania Anti-Slavery Society and quickly rose to fame as an eminent orator on political and social issues. Her speeches about African-Americans' rights, the emancipation of women, prison reform, and public assistance for the poor were delivered with intense emotion and described by both audiences and newspapers as "electrifying." She campaigned for Republican candidates during New Hampshire's state elections of 1863 and then for Republican candidates in Connecticut. Later that year she campaigned for Republican candidates in New York and Pennsylvania. She was considered so instrumental in Republican victories that the House of Representatives invited her to speak. President and Mrs. Lincoln, senators, congressmen, and Supreme Court Justices attended the event, which drew national attention.

Dickinson wrote two books conveying her views— *What Answer* (1868) and *A Paying Investment* (1876). Despite support for the cause of women's suffrage and friendship with its leaders, she was not involved in the organized suffrage movement. When public lectures no longer attracted audiences, Dickinson attempted a career in playwriting and acting. She made her acting debut in her play *A Crown of Thorns* in May 1867, but the reviews were not favorable. After many attempts, she wrote a play that achieved reasonable success—*An American Girl* (1880).

Dickinson made a final attempt to regain status as a public speaker in 1888, for the Republican National Committee. The attempt failed, and she resigned from public speaking.

Anna E. Dickinson died in Goshen, New York on October 22, 1932.

Further Reading: Frost and Cullen-Dupont, *Women's Suffrage in America;* Stanton, et. al., eds., *History of Woman Suffrage,* vols. II and III; Willard and Livermore, *A Woman of the Century.*

Dickinson, Emily (1830–1886) *poet*

Born on December 10, 1830, in Amherst, Massachusetts, to Emily Norcross Dickinson and Edward Dickinson, Emily Dickinson became a major American poet.

The facts of Emily Dickinson's life have become well known: She graduated in 1847 from the Amherst Academy, which was cofounded by her grandfather (as was Amherst College). She spent the 1847–48 academic year at the Mount Holyoke Female Seminary (see MOUNT HOLYOKE COLLEGE) but returned home exhausted at its conclusion. Dickinson's father refused to permit her return to Mount Holyoke the following year, and, after 1848, Dickinson left Amherst only four times: once, in 1854, to visit Washington, D.C., with her father during his term in Congress and to visit a school friend in Philadelphia before returning home; and three additional times, between 1851 and 1865, to visit Boston. (The last two of these visits involved medical care.) Except for these few forays from home, Dickinson lived as a recluse in the house of her birth, writing poetry.

Only ten of Dickinson's poems were published during her lifetime, and these were published anonymously. Three volumes of selected poems were published in the late nineteenth century (1890, 1891, and 1896), and what is believed to be her entire body of work—1,775 poems—was published in 1955. Her poems are characterized by a startling compression and exactitude, as evidenced in the well-known lines of poem 258:

> There's a certain Slant of light,
> Winter Afternoons—
> That oppresses, like the Heft
> Of Cathedral Tunes—
>
> Heavenly Hurt, it gives us—
> We can find no scar,
> But internal difference,
> Where the Meanings, are —
>
> None may teach it—Any—
> 'Tis the Seal Despair—
> An imperial affliction
> Sent us of the Air—

> When it comes, the Landscape listens—
> Shadows—hold their breath—
> When it goes, 'tis like the Distance
> On the look of Death.

Dickinson's major themes were spirituality, nature, passion, love, individual integrity, and death. Devoting herself entirely to the exploration of these themes in her remarkably original voice, Dickinson became one of America's most important and enduring poets.

Emily Dickinson died of Bright's disease on May 15, 1886, in Amherst, Massachusetts, leaving her poetry manuscripts carefully prepared and awaiting discovery.

Further Reading: Dickinson, *Complete Poems of Emily Dickinson;* ———, *Letters;* Faust, ed., *American Women Writers;* Gelpi, "Emily Dickinson," in *Notable American Women,* ed. James, James, and Boyer; Gilbert and Gubar, eds., *Norton Anthology of Literature by Women;* Juhaza, *Feminist Critics Read Emily Dickinson;* ———, *Undiscovered Continent;* Martin, *American Triptych;* Sewall, *Life of Emily Dickinson;* Showalter et al., eds., *Modern American Women Writers.*

Dinner Party, The (1973–1979)

Judy Chicago's well-known feminist art project. The project, inspired by Chicago's lingering anger at a college professor's claim that women had made no "intellectual contributions" to history, uses women's traditional domestic crafts to celebrate the achievements of 999 historical and mythical women. Six tapestry banners lead the viewer into *The Dinner Party.* The core of the work consists of a triangular "Heritage Floor" with 2,300 tiles, each bearing the name of one of the 999 women, and a triangular table set with 39 embroidered place mats and 39 painted ceramic plates, each honoring a particularly significant female subject. These "guests of honor," including the Primordial Goddess, the Amazon, Sojourner TRUTH, Susan B. ANTHONY, Mary Wollstonecraft, Virginia Woolf, and Georgia O'KEEFFE, are also profiled in a photo-documentary panel. While Chicago designed each aspect of *The Dinner Party,* it actually was created with the assistance of over 400 needleworkers and other artisans—mostly female—who volunteered to work under the artist's supervision.

The Dinner Party, begun in 1973, opened in 1979 at the San Francisco Museum of Modern Art. It quickly became a beloved cultural icon of the modern women's movement and, during its fifteen exhibitions, has been viewed by more than 1 million people. Nonetheless, its critical reception in the established art world has been mixed, and few of its exhibitions have taken place in major art museums. (For example, in Chicago—the

artist's hometown and namesake city—women conducted a two-year fund-raising drive in order to sponsor an exhibition of the work in a former warehouse.)

Chicago's next major work was *The Birth Project.* First exhibited in 1984, *The Birth Project* uses tapestries to explore the political, mythical, and simply human implications of women's part in creation. *The Holocaust Project,* exhibited in 1993, is her most recent work.

Chicago published her autobiography, *Through the Flower: My Struggle as a Woman Artist* in 1975 and has documented the creation and intent of her work in several other books including: *The Dinner Party: A Symbol of Our Heritage* (1979); *Embroidering Our Heritage: The Dinner Party Needlework* (1980); *The Birth Project* (1985); and *Holocaust Project: From Darkness into Light* (1994). In addition, her work is documented in several films: *Womanhouse; Right Out of History: The Making of The Dinner Party;* and *Holocaust Project: From Darkness Into Light.*

The most recent exhibition of *The Dinner Party* took place in Los Angeles in 1996.

Further Reading: Chicago, *Through the Flower;* ———, *Dinner Party;* ———, *The Birth Project;* ———, *Embroidering Our Heritage;* ———, *Holocaust Project;* ———, *Lecture;* ———, *Beyond The Flower.*

Displaced Homemakers Self-Sufficiency Assistance Act (1990)

Sponsored by Representative Matthew Martinez (D-CA) and passed by Congress in 1990, the Displaced Homemakers Self-Sufficiency Assistance Act (DHSSA) created a federal program to train displaced homemakers (as well as single parents of young children) for entry into the job market. Despite the continued support of Representative Martinez and lobbying by WOMEN WORK! THE NATIONAL NETWORK FOR WOMEN'S EMPLOYMENT, the act has never been funded.

Further Reading: National Displaced Homemakers Network, *Transition Times* 5, no. 1 (Spring 1993); Women Work! The National Network for Women's Employment, *Network News* 16, no. 4 (Winter 1993).

Dix, Dorothea Lynde (1804–1887) *social reformer*

A prominent nineteenth-century humanitarian, worldwide crusader for the improved treatment of the mentally ill, and superintendent of United States Sanitary Commission nurses during the Civil War, Dorothea Lynde Dix was born on April 4, 1802, in Hampden, Maine

(when that village was still part of Massachusetts), to Mary Bigelow Dix and Joseph Dix.

After an early childhood marked by instability at home and several years spent in the custody of her grandmother in Boston and a great-aunt in Worcester, Dix founded a successful DAME SCHOOL for girls in Boston in 1821. She continued her educational career until 1836 and published a popular science textbook for elementary students, *Conversations on Common Things,* in 1824. (She published several other books during this period as well, including: *Hymns for Children,* which she edited and *Evening Hours,* both 1825; *Meditations for Private Hours,* 1828; and *The Garland of Flora,* 1829.)

The turning point in her life came in March 1841, when she was asked to begin a women's Sunday school class in East Cambridge's jail. There Dix found conditions that she vowed to change: mentally ill and insane women thrown naked and filthy among the jail's prisoners, in chains or bearing evidence of repeated whippings. Dix, by then living comfortably on an inheritance from her grandmother, embarked on a two-year fact-finding mission throughout Massachusetts.

In January 1843 she reported her observations to a shocked Massachusetts legislature and demanded change. At the time, society's disturbed members were routinely locked away, either in jails or by their own families in attics. Dix's call for intelligent, humane care of these people in Massachusetts resulted in the expansion and renovation of an asylum in Worcester and the removal of many insane persons from jail. She then spent the next forty years of her life traveling throughout the United States and Canada, documenting abuse and spurring change. She successfully sought legislative reform in fifteen states and personally guided the establishment of thirty-two mental health hospitals in America. She is credited with inspiring the establishment of many more such asylums. As Helen Marshall points out in her essay in *Notable American Women,* there were only thirteen mental health hospitals in America when Dix delivered her 1843 report; by 1880 that number had grown to 123. In addition, in *Remarks on Prisons and Prison Discipline in the United States* (1845), Dix advocated far-reaching reforms of general prison conditions.

In the years prior to the Civil War, Dix traveled to the Channel Islands, Italy, France, Russia, Scotland, and Turkey, where she investigated conditions in jails and hospitals and recommended the necessary reforms. When she faced difficulty in Scotland, she convinced the British government to intervene; in Italy she turned to Pope Pius IX, who pledged his personal and immediate attention.

When the United States Sanitary Commission was formed in response to the Civil War, Dorothea Dix was named superintendent of nurses. She was less successful

as an administrator than she had been as a crusading reformer, and Secretary of War Edwin McMasters Stanton curtailed her responsibilities in 1863. Dix retained her title, served until September 1866, and then returned to her work on behalf of the mentally ill.

In October 1881, at the age of seventy-nine, Dorothea Lynde Dix entered a Trenton, New Jersey, hospital that she had founded more than three decades earlier. She died there on July 18, 1887.

Further Reading: Dix, *Garland of Flora;* ———, *Remarks on Prisons and Prison Discipline in the United States;* Evans, *Born for Liberty;* Flexner, *Century of Struggle;* McHenry, ed., *Famous American Women;* Marshall, "Dorothea Lynde Dix," in *Notable American Women,* ed. James, James, and Boyer; Stanton, Anthony, and Gage, eds., *History of Woman Suffrage,* vol. 2.

Dole, Elizabeth Hanford (1936–) *politician, cabinet member, director of Coast Guard*

Born Elizabeth Hanford on July 20, 1936, in Salisbury, North Carolina, to Mary Ella Cathey Hanford and John Van Hanford, Elizabeth Dole became the first female head of an armed service, the seventh woman to serve in a presidential cabinet, and a candidate for the Republican Party's presidential nomination.

She graduated from Duke University with a B.A. degree in political science in 1958 and pursued graduate study at Oxford University in 1959. Thereafter, she received two degrees from Harvard University: an M.A. in education in 1960, and a J.D. in 1965. She and Robert (Bob) Dole were married on December 6, 1975.

Dole was originally registered as a Democrat. She became a registered Independent during her first few years in Washington and a registered Republican following her marriage to Bob Dole. She entered government service as a staff assistant in the Department of Health, Education, and Welfare during the Johnson Administration, in 1966. She left the administration in 1967 to conduct the private practice of law, but she returned in 1968 to become associate director of the President's Committee on Consumer Interests. (She later became director of the committee.) In 1971, she became deputy director of the Office of Consumer Affairs under President Richard Nixon.

She was one of five commissioners of the Federal Trade Commission (FTC) from 1973 to 1979; her tenure was marked by an FTC investigation into nursing home abuses and enforcement of the EQUAL CREDIT OPPORTUNITY ACT OF 1975. When her husband announced his candidacy for president in 1979, Dole resigned from the FTC to campaign for him. Bob Dole's campaign was unsuccessful, and Ronald Reagan was elected in 1980.

President Ronald Reagan appointed Elizabeth Dole as secretary of transportation in 1983. The first woman to hold this cabinet position, Dole oversaw the U.S. highway, mass transit, air traffic control, and shipping systems. As secretary of transportation, she also automatically became the director of the U.S. Coast Guard and, thus, the first woman to command a U.S. armed service.

When Bob Dole announced that he would run for president a second time, in the late 1980s, Elizabeth Dole resigned as secretary of transportation to campaign for him. That campaign was unsuccessful and the ultimate victor, President George Bush, nominated Elizabeth Dole as secretary of labor in 1989. Among her initiatives as in that position, Dole investigated the "GLASS CEILING" that many felt prevented women and minorities from reaching the highest tiers of corporate management.

Dole resigned as secretary of labor in 1990 and became president of the American Red Cross. In addition to overseeing the organization's international relief efforts, Dole took steps to safeguard the supply of donated blood against the HIV virus. When Bob Dole announced the beginning of another presidential campaign, Elizabeth Dole took a one-year leave of absence to campaign for him. When that campaign failed in 1996, she returned to her position at the American Red Cross and served there until her resignation in early 1999.

Following this resignation, Elizabeth Dole announced her own candidacy for president. Although she was not the first woman to seek the presidency, Elizabeth Dole may properly be described as the first woman whose presidential candidacy was not discussed in the media primarily in terms of gender. She placed third among Republicans in the Iowa straw poll in August 1999, drew solid crowds during her campaign, and received financial contributions as well as volunteer support from people not ordinarily drawn into the campaign process. She did not, however, have the fund-raising success she deemed necessary to run the campaign. Elizabeth Dole dropped out of the Republican primary on October 18, 1999. In January 2000, she endorsed her former rival, George W. Bush.

Elizabeth Dole lives with her husband, Bob Dole, in Washington, D.C.

Further Reading: *Denver Post,* October 21, 1999; *Houston Chronicle,* October 21, 1999; *New York Times,* July 19 and October 13, 1996; January 3 and 4, 2000; *Washington Post,* October 22, 1999.

domestic novels (nineteenth century)

A term used to describe the highly popular novels of nineteenth-century female authors such as Fanny Fern

(Sara Payson Willis Parton), Catharine Maria Sedgwick, and Augusta Jane Evans. These novels often appeared first in serialized and then in book form, and many of their authors made substantial incomes.

The genre accepted a happy home as a woman's ultimate goal and highest blessing. (Much of the writing employed religious phraseology.) However, the books' heroines usually arrived at this state via careful planning, prudent but exciting risk-taking, and hard work—and not simply as a result of marriage. As a result, domestic novels offered their female readership an appealing picture of a new, independent woman, fully capable of succeeding in the world and then finding a way to translate that success into comfort at home.

Domestic novels began to appear in the 1820s and reached the peak of their popularity in the 1850s and 1860s. Some notable examples are: *A New England Tale* (1822), *Redwood* (1824), *Hope Leslie, Clarence* (1830), *The Linwoods* (1835), and *Married or Single?* (1857), all by Catharine Maria Sedgwick; *Ruth Hall* (1855) and *Rose Clark* (1856), by Fanny Fern (Sara Payson Willis Parton); and *Beulah* (1859) and *St. Elmo* (1866) by Augusta Jane Evans.

Further Reading: Faust, ed., *American Women Writers;* Flexner, *Century of Struggle;* Papashvily, *All the Happy Endings;* Parton, *Fanny Fern;* Parton, *Ruth Hall.*

domestic violence

The leading cause of injury to women aged fifteen to forty-four, domestic violence is physical and/or mental abuse inflicted upon a person by a spouse or partner.

While women instigate or dominate a certain portion of violent disputes between intimate heterosexuals, the Justice Department in February 1994 cited figures indicating that females are the victims in such situations eleven times more often than are males. That this is primarily a women's problem was dramatically underscored by U.S. Surgeon General Dr. Antonia Novello who, in 1991, pointed out that one-third of American women murdered in any year are murdered by past or present boyfriends or husbands, and concluded with the assessment that "The home is actually a more dangerous place for American woman than the city streets." The American Medical Association (AMA) concurs: In 1992 the AMA cited figures indicating that one in three American women will suffer domestic violence during their lives and that 4 million women are abused by intimate males each year—domestic violence, the AMA reported, was "a public health problem that has reached epidemic proportions." While some dispute the AMA's figure—2 million women, or one

woman every sixteen seconds, is the figure most frequently cited—no one disputes that, on a yearly average, 1,400 of these beatings result in death for the women involved. These crimes are committed by men from all socioeconomic, educational, racial, and religious backgrounds: In June 1994 Representative Patricia SCHROEDER (D-CO.) emphasized this point by citing a study of one major American city, in which more police officers, whom she would characterize as law-abiding citizens, had killed their wives than had been killed in the line of duty.

Prior to the 1994 enactment of the VIOLENCE AGAINST WOMEN ACT, twenty-six states had laws requiring police officers to arrest perpetrators of domestic violence. In most states the victim was required to press charges in order for the assailant to be charged and prosecuted. For various reasons, including fear of retaliation, hope that the situation would improve, and financial dependence upon the assailant, women often were reluctant to press charges. Evidence also showed that mandatory arrest or report laws often were disregarded. For example, since 1979 New York City law has required police officers to report every instance of domestic violence. Nevertheless, a 1993 report detailed that officers answering approximately 200,000 domestic violence calls filed the required reports in only 30 percent of the cases and arrested only 7 percent of the assailants.

The Violence Against Women Act (VAWA), among other things, designated gender-biased crimes such as domestic violence a violation of a woman's civil rights; required that all states adopt mandatory arrest policies regarding such crimes; and permitted women to sue attackers in federal courts. A May 2000 Supreme Court ruling subsequently invalidated the federal court provision. The 1996 DOMESTIC VIOLENCE OFFENDER GUN BAN, which prevents those convicted of domestic violence (including police officers) from owning or using firearms, has been upheld as constitutional by the U.S. Court of Appeals for the District of Columbia.

Further Reading: Dao, "Albany Set to Require Arrest in Domestic Violence Cases"; Ingrassia et al., "Patterns of Abuse"; Schroeder, Interview with Charles Bierbauer; Smolowe, "When Violence Hits Home."

Domestic Violence Offender Gun Ban (1996)

Introduced by Senator Frank Lautenberg (D-NJ) and signed into law by President Clinton in September 1996, this federal law made it illegal for anyone convicted of a domestic violence crime to possess a gun. That there was no exemption for military personnel or police officers caused immediate controversy. Police chiefs nationwide

began to terminate or reassign officers convicted of misdemeanor domestic violence, and police officer unions filed suits in Washington, D.C.; Los Angeles; Atlanta; and Tallahassee, Florida. In April 1999, the U.S. Court of Appeals for the District of Columbia upheld the ban as constitutional.

The Pentagon responded to the Domestic Violence Offender Gun Ban by requiring affected military employees to relinquish personal and military side arms but letting stand their access to warplanes, tanks, and large-scale weapons.

Further Reading: Associated Press, April 17, 1999; PL 104-208. Omnibus Consolidated Appropriations Act, 1997; Rankin, "Police Union Unsure if It Will Appeal"; Reuters, October 24, 1997; *Washington Post,* September 10, 1997.

Dove, Rita (1952–) *poet*
Born on August 28, 1952, in Akron, Ohio, Rita Dove became the first African American, the second woman, and the youngest person named as the U.S. Poet Laureate.

Dove received her education at Miami University, Universiat Tübingen (West Germany), and the University of Iowa's well-known Writers' Workshop.

Dove's debut volume of poetry, *The Yellow House on the Corner,* was published to critical acclaim in 1980. Her other volumes of poetry include *Thomas and Beulah* (published in 1986 and winner of the 1988 Pulitzer Prize for Poetry); *Grace Notes* (1989); *Museum* (1993); *Selected Poems* (1993); *Mother Love* (1995) and *On the Bus with Rosa Parks* (1999). Dove has published two works of fiction: a collection of short stories entitled *Fifth Sunday* (1985) and a novel, *Through the Ivory Gate* (1992). She also has published a verse play. *The Darker Face of Earth* (1996). In addition, some of her work has appeared in limited edition and/or chapbook form: *Ten Poems* (1977); *The Only Dark Spot in the Sky* (1980); *Mandolin* (1982); and *The Other Side of the House* (1988).

Dove uses exquisitely simple and clear language to create poems of elegiac force. She writes most often about the experiences of African Americans, using historical references and her own family's handed-down stories. In an interview following her 1993 appointment as Poet Laureate, Dove discussed her view of her poem, "Mississippi" and what she hoped would be its meaning for African-American readers. She called the poem "almost a meditation on the Mississippi River and what it has meant in American history," and she hoped her descriptive language of the trip downriver had managed to evoke the feeling of "falling deeper into slavery."

Dove has been a writer-in-residence at Tuskegee Institute and has taught in the English Department at Arizona State University. In addition to her 1988 Pulitzer Prize for *Thomas and Beulah* and her 1993–95 term as poet laureate, Dove has been the recipient of numerous awards and honors, including the Lavan Younger Poets' Prize from the Academy of American Poets and fellowships from the John Simon Guggenheim Memorial Foundation, the Fulbright Foundation, the National Endowment for the Humanities, and the National Endowment of the Arts. She has also received an NAACP Great American Artist Award.

She is currently the Commonwealth Professor of English at the University of Virginia and lives with her husband, Fred Viebahn, and their daughter in Charlottesville.

Further Reading: Dove, *The Yellow House on the Corner;* ———, *Museum;* ———, *Thomas and Beulah;* ———, *Grace Notes;* ———, *Fifth Sunday;* ———, *Through the Ivory Gate;* Molotsky, "Rita Dove Named Next Poet Laureate."

dower
The one-third of a deceased husband's real estate that a widow was entitled to use upon his death, dower was originally part of English common law. (It is distinct from a dowry, which is a gift or payment made by a bride's family to the groom or his family at the time of marriage.)

The right of dower did not extend to holdings other than land, and upon the widow's death, the property reserved for her dower use was then inherited by whomever her husband had indicated in his will (normally, the couple's children). While the widow was unable to sell or bequeath the dower property, she did have the right to monies received as rent from the property and other income, such as the sale of crops, derived from her use of the land. It should also be noted that dower referred to the minimum provision a husband was required to make for his wife, and records indicate that many husbands exceeded these minimum requirements.

Colonial courts vigorously protected a widow's dower rights. However, as the United States began to industrialize in the eighteenth century, real estate and other types of investment were more often offset by mortgage and other debt. As a consequence, a widow's right to use one-third of her deceased husband's lands was increasingly viewed as an impediment to the final settlement of her husband's estate, and dower rights began to be ignored.

Legislation such as the MARRIED WOMAN'S PROPERTY ACT, 1848 guaranteed to married women the right

of outright property ownership and inheritance for the first time, leading many husbands to make arrangements for their wives in addition to or in place of dower. A federal law, Administration of Estates Act, Section 45, abolished dower in 1945. The traditional one-third percentage survives now as the percentage of a husband's estate generally awarded to his widow (on an outright basis) in the event he dies intestate, or without a will. (A husband's corresponding right of inheritance is termed CURTESY.)

An example of a dower statute, "An Act Concerning the Dowry of Widows, 1672," is contained in Appendix A.

Further Reading: Frost and Cullen-DuPont, *Women's Suffrage in America;* Kerber and Mathews, eds., *Women's America: Refocusing the Past;* Salmon, *Women and the Law of Property in Early America;* Spruill, *Women's Life and Work in the Southern Colonies.* Stanton, Anthony, and Gage, eds., *History of Woman Suffrage,* vols. 2–6.

dress reform, nineteenth century

For much of American history, women were virtually imprisoned in their clothing. Nineteenth-century corsets, for example, applied an average of twenty-one pounds of pressure to a woman's abdominal area, and some corsets applied as much as eighty-eight pounds of pressure. The skirts that were anchored to this constricted center weighed, again on average, almost twenty pounds. Prolapsed uteri, broken ribs, and damaged internal organs were common problems in the middle- and upper-class women who wore corsets. Both poor and wealthy women alike were hampered by their long, heavy skirts.

Elizabeth Cady STANTON hoped for dress reform as early as 1844 and corresponded with Lydia Maria Child about it. The French author Helene Marie Weber, who had adopted male attire, sent a letter to American women gathered at the WORCESTER WOMEN'S RIGHT'S CONVENTION in 1850.

> The newspapers . . . have done me great injustice . . . they . . . charge me with a disposition to undervalue the female sex, and to identify with the other. Such calumnies are annoying to me. I have never wished . . . to be anything but a woman . . . I adopted male attire as a measure of convenience . . . and never expect to return to a female toilette.

But it was Cady Stanton's cousin, Elizabeth Smith Miller, who sparked the reform of women's clothing in America.

In the winter of 1851, Elizabeth Smith Miller discarded the customary clothing of the nineteenth-century female and appeared in an outfit of her own design. It was a short skirt worn over pantaloons without corsets or other confining undergarments. When Amelia Bloomer printed the pattern in her newspaper, *THE LILY,* this outfit became known as "bloomers."

Women who adopted bloomers experienced a tremendous increase in physical freedom. Seeing Miller in the outfit for the first time, Cady Stanton marveled at the difference: "To see my cousin, with a lamp in one hand and a baby in the other, walk upstairs with ease and grace, while, with flowing robes, I pulled myself up with difficulty, lamp and baby out of the question . . ."

But bloomer-clad women also experienced hostility and ridicule. Wherever they went, crowds gathered, stared, and jeered. Susan B. ANTHONY always remembered the "rude vulgar men" yelling at her. Lucy STONE, walking one day with Anthony, "Gradually . . . noticed that we were being encircled. A wall of men and boys at last shut us in, so that to go on or to go back was impossible. There we stood. The crowd was a good-natured

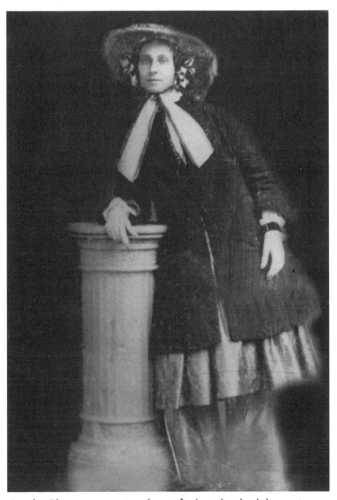

Amelia Bloomer, wearing the outfit that shocked the nation, ca. 1850 (*Seneca Falls Historical Society*)

one. They laughed at us. They made faces at us. Every moment brought added numbers . . ." A passerby finally called a police officer to the scene, and the "wall of men and boys" was broken apart.

Elizabeth Cady Stanton's wardrobe became a New York State election issue. Her husband, Henry B. Stanton, was running for election to the state Senate at the time, and voters repeatedly told him they wouldn't elect a man whose wife wore bloomers. On election day, New Yorkers shouted in the streets:

> Heigh! ho! the carrion crow,
> Mrs. Stanton's all the go;
> Twenty tailors take the stitches,
> Mrs. Stanton wears the breeches.

(Henry Stanton supported his wife's right to reform her attire. He won the election by a very narrow margin.)

This struggle to reform women's dress ended when the women's rights leaders decided it was distracting attention from their other demands. Susan B. Anthony, one of the last of the leaders to return to traditional, restrictive garb, did so in 1854. (However, Harriet TUBMAN later wanted her bloomers back. While acting as a Union spy and scout during the Civil War, she found time to write to her friends, "I want . . . a *bloomer* dress, made of some coarse, strong material, to wear on *expeditions* . . .")

Despite the women's leaders' abandonment of their bloomers, dress reform remained an issue in the United States. Eliza Hurd De Wolfe, for example, was arrested by a police officer in San Francisco in May 1866 for violation of that city's ordinance prohibiting women from wearing "male attire." De Wolfe wore the offending outfit to court, and her husband pointed out that "every article of her clothing, with the exception of her pantalettes, or pantaloons, or, as some might choose to call them, breeches, were precisely the same as those ordinarily worn by ladies." Her hat, furs, and basque (a tightly fitted bodice) were specifically claimed by Mr. De Wolfe as part of his wife's defense, and his reasoning sheds light on at least his perception of the purpose behind San Francisco's ordinance: "There was no concealment of her sex," he said, offering as proof the fact that "boys in the street recognized her at once and showed their illbreeding by shouting, 'There goes the woman in man's dress.'"

After additional testimony from the arresting officer, the district attorney, and De Wolfe's counsel, a Colonel Chapman (but not from De Wolfe herself, since women were not allowed to testify in court at the time), Judge Rix said,

> He was free to admit that the dress worn by Mrs. De Wolfe, was, in his opinion, intrinsically more appropri-

ate and becoming and healthy than that generally worn by ladies, and could it become the fashion and be generally adopted, it would be better for the female sex; but that was not the question here. If her dress tended to excite a mob and thereby disburb the public peace, it must not be permitted to be worn.

> Concluding, he said, "The fault might be in the public and not in the lady—he was inclined to think it was—but so long as public opinion remained as it was now, no person could be permitted to shock the popular sentiment . . . so as to bring on a disturbance of the peace . . ." Mrs. De Wolfe was thereupon ordered to "modify her dress."

Further Reading: Barry, *Susan B. Anthony;* Ehrenreich and English, *For Her Own Good;* Griffith, *In Her Own Right; New York Times,* June 11, 1866; Stanton, *Eighty Years and More;* Stanton, T., and H. Stanton Blatch, *Elizabeth Cady Stanton as Revealed in Her Letters, Diary and Reminiscences.*

Duncan, Isadora (1878–1927) *dancer*
Born on May 27, 1878, in San Francisco, to Dora Gray Duncan and Joseph Charles Duncan, Isadora Duncan was a dancer who seemed, to many women, the embodiment of physical freedom.

Duncan's parents divorced shortly after her birth, and Duncan's life with her musically artistic mother was marked by poverty. She attended school only until the age of ten and then helped to support her family by teaching a free-style form of dance to local children. The family moved to Chicago in 1896 and Isadora, eighteen, joined the theatrical company of Augustin Daly as an actress and dancer. Two years later Duncan rented a Carnegie Hall studio and began staging private performances in the homes of wealthy art patrons.

Duncan, having created a sensation in New York, traveled to Europe in 1900. Between 1900 and 1909, she danced in London, Paris, Vienna, Athens, Budapest, Munich, and Moscow, winning resounding acclaim in some quarters and simply notoriety in others. While no recordings of her dances are known to exist, they made permanent impressions on many other dancers and artists. Duncan chose the music of Beethoven, Brahms, Chopin, and Wagner, and she avoided distortion in favor of "natural" movement in her dances, which she performed in Greek-style tunics, barefoot. As Agnes DE MILLE remembers it, Isadora Duncan

> appeared right at the crest of the release from Victorian sexual restraints, and she was the sensational public advertisement of women's freedom . . . She threw

off her socks and stockings—not the first to do so, but the most public. She threw off corsets and went around like the Pre-Raphaelites . . . And she was imitated everywhere.

Duncan refused to marry and without apology bore two children out of wedlock. The children were accidentally drowned in the Seine River in 1913, and the event marked the beginning of Duncan's artistic and personal decline.

Throughout her career, she had run intermittent dance studios; in the years following her children's death, she taught in the United States, South America, Athens, Paris, and Moscow. While living in Russia during the early 1920s, she reversed her earlier opposition to marriage and married the Russian poet Sergei Yessenin (in 1922). (On subsequent travels in the United States, she was called a Bolshevist.) Yessenin left Duncan when he fell in love with one of Tolstoy's granddaughters, and he committed suicide in 1925.

Duncan's 1927 Paris performance at the Théâtre Mogador, while clearly the effort of a dancer past her creative peak, is remembered as being tremendously evocative. Later that year, as Duncan rode in a car, her long, fringed scarf became tangled in the spokes of a wheel. Isadora Duncan died of a broken neck on September 14, 1927, in Nice, France.

Further Reading: Baxter, "Isadora Duncan," in *Notable American Women*, ed. James, James, and Boyer; Clark, *Almanac of American Women in the 20th Century;* De Mille, *Martha;* Desti, *Isadora Duncan's End;* Duncan, *Duncan Dancer;* Duncan, *My Life;* MacDougall, *Isadora;* Magriel, ed. *Isadora Duncan;* McHenry, ed. *Famous American Women;* Rosemont, ed., *Isadora Speaks;* Steegmuller, ed., *Your Isadora;* Terry, *Isadora Duncan.*

Duniway, Abigail Jane Scott (1834–1915)
suffragist, founder of the Oregon Equal Suffrage Association

Abigail Scott Duniway was born Abigail Jane Scott on October 22, 1834, on a farm in Illinois to Ann Roelofson Scott and John Tucker Scott.

In 1852, over the objections of his wife, Duniway's father decided to resettle his family in the Northwest Territory of Oregon. Duniway's mother and her three-year-old brother died on the 2,400-mile pioneer's journey. Abigail, then seventeen, taught school for a year and married Benjamin Charles Duniway on August 1, 1853.

Abigail Duniway resented the life of drudgery she found in Oregon, and she remembered, with sorrow, the hardships of her own mother's life on the family's Illinois farm. Writing later about the hard physical work she per-

formed while bearing and raising six children on her husband's farm in the forest, Duniway said it was "work for which I was poorly fitted, chiefly because my faithful mother had worn both me and herself to a frazzle with just such drudgery before I was born." In 1862 the Duniway family farm was lost when a friend, for whom Benjamin Duniway had cosigned a note, defaulted on a loan. Abigail Duniway had not been informed of her husband's assumption of such an obligation, and she resented laws that would permit a man to pledge his family's security without the consent of his wife. The situation was compounded when her husband was disabled shortly thereafter, and Abigail Duniway had to assume the support of her family. She returned to work as a teacher and also ran a small shop, becoming with each passing year an ever more ardent supporter of women's rights.

In 1871 Duniway began the publication of a weekly newspaper, *New Northwest,* which prospered for sixteen years. Before long and with the full encouragement of her husband, Duniway was lecturing throughout the Northwest for the suffrage cause. She founded and presided over the Oregon Equal Suffrage Association in 1873 and was, for many years, a faithful lobbying presence at the Oregon legislature. Duniway was honorary president of the Oregon Federation of Women's Clubs and was elected president of the Portland Woman's Club. She was extremely instrumental in gaining women's suffrage in Washington Territory and in Idaho, but her repeated efforts failed to secure women's suffrage in Oregon. This failure prompted national suffrage leaders to assume management of the Oregon Equal Suffrage Association, which caused Duniway to resign from that organization. When the Oregon campaign was finally successful, however, Abigail Duniway's early influence was fully recognized. She was asked to write the suffrage proclamation and was the first female voter in the state of Oregon. She wrote several books, including *Captain Grey's Co.* (1859) and her autobiography, *Path Breaking* (1914).

Abigail Scott Duniway died on October 11, 1915.

Further Reading: Baxter, "Abigail Jane Scott Duniway," *Notable American Women,* James, James, and Boyer, eds.; Duniway, *Path Breaking;* Flexner, *Century of Struggle;* Stanton, Anthony, and Gage, eds., *History of Woman Suffrage,* vol. 5.

Dworkin, Andrea (1946–) *writer, feminist*
Born on September 26, 1946, in Camden, New Jersey, to Sylvia Speigel Dworkin and Harry Dworkin, Andrea Dworkin is one of the women's movement's most radical writers.

As a sixth grader, Dworkin realized that she wanted to work for societal change and considered becoming either a writer or a lawyer. As she recalls, "I thought that either way you could really change society. By writing, you did it by changing people's minds; by law, you did it by changing the social structure." While she did not attend law school, Dworkin has attempted to change society by both literary and legislative means.

Dworkin graduated from Bennington College in 1968. She published *Woman Hating* in 1974 and *Our Blood: Prophecies and Discourses on Sexual Politics,* a collection of essays, in 1976. These books examine what Dworkin considers the means men have used to oppress women around the world and throughout history, including the imposition of physical limitations such as foot binding, political "terrorism" in the guise of religious fervor during witch hunts, and the insidious influence of fairy tales, mythology, and, most dangerously, pornography.

It is around the subject of pornography that Dworkin has united her early ambitions. In 1981 she was a contributing author to the anthology *Take Back the Night: Women on Pornography.* Her 1981 book, *Pornography: Men Possessing Women,* further explores her contention that pornography "creates hostility and aggression toward women, causing both bigotry and sexual abuse" and is an effective tool in men's campaign to dominate women. Dworkin also approached this issue through legislation. With attorney Catharine MACKINNON, Dworkin drafted antipornography ordinances that were passed in Indianapolis, Indiana, and Minneapolis, Minnesota. As Dworkin explained in the ordinance,

> the law can be used by men, women, children, and transsexuals. A person can sue if she has been coerced into a pornographic performance, forced to watch pornography, assaulted or physically injured as a direct result of a specific piece of pornography, or she can bring a complaint against traffickers . . . because they are part of a system of exploitation that keeps women in particular civilly inferior (though men, children, and transsexuals can also sue under this part, if they can show that pornography impacts on their civil status).

The Supreme Court, through 1986 summary affirmation of the lower court opinion in *Hudnut v. American Booksellers Association,* held that such local ordinances were in violation of the First Amendment's guarantee of free speech and therefore unconstitutional.

Andrea Dworkin's other books include *The New Woman's Broken Heart* (a collection of short stories, 1980), *Right-Wing Women* (1983), *Intercourse* (1987), *In Harm's Way* (with Catherine MacKinnon, 1998), and several novels, including *Ice and Fire* (1986); *Mercy* (1991); and *Life and Death* (1997).

Further Reading: *Contemporary Authors,* vols 77–80, 1979; New Revision Series, vol. 16, 1986; Dworkin, *Woman Hating;* ———, *Pornography;* ———, *Right-Wing Women;* ———, *Intercourse;* ———, *Mercy;* ———, *Life and Death;* MacKinnon and Dworkin, *In Harm's Way.*

Dyer, Mary Barrett (early 1600s–1660) *Quaker martyr*
Born Mary Barrett in England in the first quarter of the seventeenth century, Mary Dyer became a Quaker martyr in colonial America.

Mary Dyer and her husband emigrated from England to Massachusetts in 1634 or 1635, and they promptly became members of the Boston church in the Massachusetts Bay Colony. In 1638, when the Boston church excommunicated Anne HUTCHINSON, Dyer walked out of the church at Hutchinson's side. By the early 1650s, Dyer had become a member of the Society of Friends, or a Quaker. Although founded by a group of religious dissenters from England, the Massachusetts Bay Colony—as evidenced by its treatment of Hutchinson—was not noted for its religious tolerance. In 1658 members of the Society of Friends, or Quakers, were banished "on pajne of death," the colony having found that "The doctrine of this sect [Quakers] of people . . . tends to overthrow the whole gospell & the very vitalls of Christianitie . . ." Marmaduke Stephenson and William Robinson, both Quakers, were imprisoned in 1659. Mary Dyer visited them in their Boston jail cell and was herself imprisoned. Banished on September 12, 1659, and threatened with death should they ever return to the Massachusetts Bay Colony, the three returned several weeks later to "look [the] bloody laws in the face."

Arrested, as the governor's records detail, for "theire rebellion, sedition, & presumptuous obtruding themselves upon us," and "as underminers of this government," they stood trial on October 19, 1659, before the General Court. During the proceedings, they "acknowledged themselves to be the persons banished" and previously "convicted for Quakers." Three identical sentences were read by Governor John Endecott: "You shall go from hence to the place from whence you came [jail], & from thence to the place of execution, & there hang till you be dead."

Mary Dyer accepted her sentence as part of a divine plan and said simply, "The will of the Lord be done." Her husband, William Dyer, viewed the situation as a political one. On August 30, 1659, he had notified the

"Court . . . assembled in Boston" that he objected to the attempts to restrict his wife's religious freedom. Pointing out that they were acting as "judge and accusser both," he compared those sitting in the General Court to the thirteenth century's "Popish inquisitors." He reminded the officials of the Massachusetts Bay Colony that they had come to the American colonies in order to escape religious persecution, and he bitterly condemned them for engaging in similar persecution:

> "[S]urely you or some of you, if ever you had the courage to looke a bishop in the face, cannot but remember that the 1. 2 or third word from them was, You are a Puritane are you not, & is it not so in N. England, the magistracy having . . . assumed a coercive power of conscience, the first or next word After appearance is You are a Quaker."

Objections to Mary Dyer's planned execution were also filed by Governor John Winthrop, Jr., of Connecticut, Governor Thomas Temple of Nova Scotia, and Dyer's son.

On the appointed day, drum-beating soldiers marched Dyer, along with Robinson and Stephenson, "to the place of execution, & there [made her] to stand upon the gallowes, with a rope about her necke." Both of the men were hanged but Dyer's noose was never tightened. To her surprise, she was granted "liberty for forty eight howers . . . to depart out of this jurisdiction, after which time, being found therein, she is forthwith to be executed."

Mary Dyer returned after only seven months. On May 31, 1660, before the General Court and Governor Endecott, "she acknowledged herself to be Mary Dyer, . . . denied our lawe, [and said she] came to bear witness against it." In response, "The whole court mett together voted, that the said Mary Dyer, for her rebelliously returning this jurisdiction . . . shall . . . according to the sentence of the General Court in October last, be put to death."

Mary Dyer was hanged in Boston on June 1, 1660. Almost 300 years later, in 1959, the Massachusetts General Court ordered a seven-foot statue of Dyer to stand on the lawn of the Boston State House. The inscription on the statue reads "Witness for Religious Freedom."

Further Reading: Chu, *Neighbors, Friends or Madmen;* Cullen-DuPont, "Mary Dyer Trials," in *Great American Trials,* ed. Knappman; Dyer, *Mary Dyer, Quaker;* McHenry, ed. *Famous American Women;* Shurtleff, ed., *Records of the Governor and Company of the Massachusetts Bay in New England;* Tolles, "Mary Dyer," in *Notable American Women,* ed., James, James, and Boyer.

Earhart, Amelia Mary (1897–ca. 1937) *aviator*

Born on July 24, 1897, in Atchinson, Kansas, to Amy Otis Earhart and Edwin Stanton Earhart, Amelia Earhart became an aviator whose spectacular nine-year career advanced public acceptance of commercial aviation and women's capabilities in the air and other adventurous arenas.

The Earhart family moved frequently, and Amelia Earhart lived in Kansas, Iowa, Minnesota, and Illinois before graduating from Hyde Park High School in Chicago in 1916. Earhart enrolled in the Ogontz School in Rydal, Pennsylvania, but left in December 1917 to become a World War I Red Cross volunteer in Canada. During her service in the dispensary at Spadina Military Hospital, Earhart became enthralled by the risk-taking flights of the Royal Flying Corps.

Earhart's own first ride in a plane was in 1920. Finding in flight a "breathtaking beauty," Earhart asked another female aviator, Neta Snook, for lessons. Earhart set her first record, for women's altitude, in 1921, the year of her first solo flight. She came to national attention in 1928, as the first woman to fly across the Atlantic Ocean, but shrugged off the attention, saying that her passenger position as log keeper was akin to being "a sack of potatoes." Nonetheless, she became known as "Lady Lindy" (an appellation likening her to Charles Lindbergh) and became a vice president of what later became National Airways, Inc. airlines.

In 1931 Earhart married publisher George P. Putnam. Earhart's career, subsequently managed by Putnam, included a 1932 solo flight, the first for a woman, across the Atlantic; a 1935 flight in which she became the first person to fly solo to the U.S. mainland from Honolulu; and another 1935 flight in which she became the first person to fly nonstop to Newark, New Jersey, from Mexico City.

Earhart's most famous flight was her last: a 1937 attempt, with Frederick Noonan as navigator, to fly around the world. On July 2, 1937, during the most arduous segment of the journey—the 2,556-mile stretch from New Guinea to the two-mile-long Howland Island in the mid-Pacific—Earhart's plane lost communication and disappeared. In the years since 1937, the joint fate of Earhart and Noonan has been variously explained; possible scenarios have included Earhart's employment as a

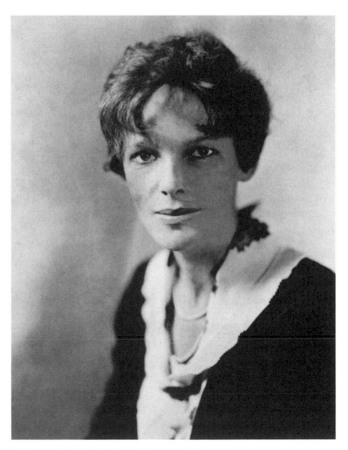

Aviator Amelia Earhart (*Library of Congress*)

spy by Franklin D. Roosevelt and the pair's capture and retention as prisoners by the Japanese. The most recent evidence supports the theory that Earhart's plane either sank near Howland Island or crashed on Nikumaroro Island in the Polynesian Republic of Kiribati.

Earhart took her position as a ground-breaking role model for other women both in and outside the world of aviation very seriously. She was the founder and first president of the Ninety-Nines, an organization of female pilots still in existence; a career counselor to female students at Purdue University; and an outspoken supporter of women's rights who used her many lecture opportunities to call for an end to discrimination against women. She published several books about her experiences, including *Twenty Hours Forty Minutes: Our Flight in the Friendship* (1928); *The Fun of It* (1932); and the posthumous *Last Flight* (1937).

Honors and awards received by Amelia Earhart during her lifetime include the Harmon International Trophy, the gold medal of the National Geographic Society, the Cross of the French Legion of Honor, and, from the U.S. Congress, the Distinguished Flying Cross. The navigational beacon currently in service on Howland Island is named the Earhart Memorial Light.

Further Reading: Bachus, *Letters from Amelia;* Earhart, *Twenty Hours Forty Minutes;* ———, *The Fun of It; Houston Chronicle,* December 2, 1998; Goerner, *Search for Amelia Earhart;* Putnam, *Soaring Wings;* Rich, *Amelia Earhart;* Ware, *Amelia Earhart.*

Eastman, Crystal (1881–1928) *labor leader, suffrage leader*

Born Catherine Crystal Eastman on June 25, 1881, in Marlborough, Massachusetts, to Anna Bertha Ford Eastman and Samuel Elijah Eastman, socialist Crystal Eastman founded organizations that would later become the Women's International League For Peace And Freedom (see the WOMAN'S PEACE PARTY) and the American Civil Liberties Union.

Eastman attended public schools and then entered Vassar College, from which she was graduated in 1903. She received her M.A. from Columbia University in 1904 and her LL.B. degree from New York University Law School in 1907.

Upon completion of her education, Eastman worked on the Russell Sage Foundation's "Pittsburgh Survey," a project whose purpose was to document workplace conditions and accidents. Her final report, *Work Accidents and the Law,* published in 1910, gained Eastman an appointment to the New York State Employers' Liability Commission in 1909 (she served until 1911) and helped to build momentum for worker's compensation legisla-

tion. The only female member of the New York State Commission, Eastman drafted what became both the state's and the country's first worker's compensation law.

Eastman lived for a short time in Milwaukee and, while a resident of Wisconsin, managed the 1912 women's suffrage campaign. She returned to New York following the unsuccessful conclusion of the suffrage drive and, with Alice PAUL, Lucy Burns, and several others, founded the Congressional Union for Woman Suffrage in 1913. (The organization later became the NATIONAL WOMAN'S PARTY). Later that year she represented the Congressional Union at the International Woman Suffrage Alliance convention in Budapest.

After women's suffrage was secured in 1920 by the adoption of the NINETEENTH AMENDMENT, Eastman supported the EQUAL RIGHTS AMENDMENT, introduced in 1923. She opposed PROTECTIVE LABOR LEGISLATION on the grounds that it provided employers with an excuse to discriminate against female workers, since it "protected" women from such opportunities as night work and overtime. She was a strong advocate of birth control reform, writing for *The Birth Control Review* and publicly supporting Margaret SANGER following her 1916 arrest.

Eastman was also an important figure in the women's peace movement. In 1915 she founded the Women's Peace Party, which later became the Women's International League For Peace And Freedom. Following U.S. entry into World War I, Eastman established the National Civil Liberties Bureau and became the organization's head attorney. The bureau, which originally worked to defend conscientious objectors, evolved into the current American Civil Liberties Union.

Crystal Eastman died of nephritis on July 8, 1928, in Erie, Pennsylvania.

Further Reading: Davis, "Crystal Eastman," in *Notable American Women,* ed. James, James, and Boyer; Eastman, *Crystal Eastman on Women and Revolution;* Harper, ed., *History of Woman Suffrage,* vols. 5 and 6; *Nation,* August 8, 1928; *New York Times,* July 29, 1928.

Eddy, Mary Morse Baker (1821–1910) *religious leader*

Born Mary Baker on July 16, 1821, near Bow, New Hampshire, to Abigail Baker and Mark Baker, Mary Baker Eddy was the founder of the Christian Science church.

A frail and frequently ill child, Eddy attended school only sporadically. As an adult, she married three times. Her first husband, married in 1843, died while Eddy was pregnant; ill and poverty-stricken, Eddy later relinquished custody of her son. Eddy's second husband, married in 1853, was a transient dentist, whom Eddy

Mary Baker Eddy, founder of the Christian Science church (Library of Congress)

divorced in 1873. She married her third husband, Asa Gilbert Eddy, on January 1, 1877.

By the time of her unhappy second marriage, Eddy was plagued by chronic spinal problems, hysteria, nervousness, and palsy. She also had become addicted to the morphine used, according to the norms of the time, to relive pain. Seeking a return to health, Eddy answered the advertisement of a Portland, Maine, healer and mesmerizer, Dr. Phineas Parkhurst Quimby. Under Quimby's care, Eddy regained—or perhaps achieved for the first time—full, healthful vigor.

Quimby died in 1866 and a grief-stricken Mary Baker Eddy began to proclaim the dead healer's theories to the public. She published *Science and Health* in 1875. Over the course of Eddy's 381 revisions, the book moved away from Quimby's medical theories and became the central exposition of the Church of Christ (Science), which was chartered in 1877. According to Eddy's interpretation of the Bible, the "Father Mother God," creator of the world and everything in it, did not create illness or death—and, therefore, these two states do not really exist, except in the minds of humans. (Eddy, did, however, believe in the reality of demonology, attributing the 1882 death of her third husband to "Malicious Animal Magnetism" directed at him

by former Christian Scientists.) Christian Scientists who perceived the symptoms of illness were advised to consult with their own practitioners and to shun medical doctors. Most of those who sought training as the religion's healing practitioners and teachers were female. Throughout its history, the church has received negative publicity as a result of its members' attempts to avoid what most other people view as desirable or necessary medical care. As early as 1888, Christian Scientist Abby H. Corner was prosecuted for the deaths of her daughter and granddaughter during a childbirth that Abby Corner, for religious reasons and in preference to a physician, had overseen. (Corner was acquitted but Eddy, to the dismay of many of her followers, publicly distanced herself from the case.)

Eddy published the monthly *Journal of Christian Science* beginning in 1883, the weekly *Christian Science Sentinel* beginning in 1898, and the daily *Christian Science Monitor* beginning in 1908. The church's membership grew from approximately 85,000 members in 1906 to approximately 269,000 members in 1936, according to federal religious census figures. The current membership is estimated at 100,000.

Mary Baker Eddy died in Chestnut Hill, Massachusetts on December 3, 1910, leaving an estate of nearly $2.5 million to the Church of Christ (Science).

Further Reading: Bates and Dittemore, *Mary Baker Eddy;* Eddy, *Science and Health;* Peel, *Mary Baker Eddy: The Years of Authority;* ———, *Mary Baker Eddy: The Years of Discovery;* ———, *Mary Baker Eddy: The Years of Trial;* Roster, *Religions in America;* Wilbur, *Life of Mary Baker Eddy.*

"Edenton Ladies' Tea Party" (1774)

A political meeting of fifty-one women in Edenton, North Carolina, held to support the colonial Nonimportation Association resolves of 1774. The women vowed support and signed petitions that explained that they could not "be indifferent on any occasion that appears nearly to affect the peace and happiness of our country." News of the tea party traveled to England, where it was greeted with derision. A cartoon depicted the endorsement as an act of incredible buffoonery, and Arthur Iredell (British kin to one of the petitioning women) wrote to ask in a patronizing tone, "Is there a Female Congress at Edenton too? I hope not, for we Englishmen are afraid of the Male Congress, but . . . the Ladies . . . since the Amazonian Era, [have] been esteemed the most formidable Enemies."

The full text of the Edenton Resolution is included in the appendix, Document No. 4.

Further Reading: Beard and Beard, *Basic History of the United States;* Evans, *Born for Liberty;* Flexner, *Century of Struggle.*

Edmunds-Tucker Act (1887)

A bill outlawing polygamy, the Edmunds-Tucker Act was passed by Congress in 1887. Women in the territory of Utah had secured suffrage in 1869, but one of the provisions of the Edmunds-Tucker Act stripped them of this right. Utah's women regained suffrage in 1896, when Utah was admitted as a state with women's suffrage as part of its state constitution.

Further Reading: Flexner, *Century of Struggle;* Frost and Cullen-DuPont, *Women's Suffrage in America;* Stanton, Anthony, and Gage, eds., *History of Woman Suffrage,* vol. 2.

Elion, Gertrude Belle (1918–1999) *scientist, Nobel Prize winner*

Born on January 23, 1918, in New York, New York, to Bertha Cohen Elion and Robert Elion, Gertrude Belle Elion was awarded the Nobel Prize for physiology or medicine in 1988.

Elion graduated from Hunter College in 1937 and received her M.S. degree from New York University in 1941. Although initially unable to find work in her chosen field, in 1944, as men's absence due to their conscription in World War II created untraditional job opportunities for American women, Elion was hired by a Tuckahoe, New York, pharmaceutical company, Burroughs Wellcome. She began working as a laboratory assistant to Dr. George H. Hitchings but quickly became his colleague.

Over the next four decades, Hitchings and Elion developed a number of important drugs for use in the treatment of heart disease, leukemia, malaria, and other medical problems. The team's research was also instrumental in the development of acyclovir, used against the herpes virus, and AZT, a drug used in the treatment of AIDS. In 1988 the pair were awarded—along with Sir James Whyte Black, an English pharmacologist—the Nobel Prize for physiology or medicine.

Elion's other honors include the National Medal of Science (1991) and her 1991 induction into the National Inventors Hall of Fame. (Drugs receive patents and are considered inventions.) She was also inducted into the National Women's Hall of Fame.

When Elion retired from her position at Burroughs Wellcome in 1983, she was granted the title of scientist emeritus. Thereafter, she served as a member of the World Health Organization and the National Cancer Advisory Board.

Gertrude B. Elion died in Chapel Hill, N.C., on February 21, 1999.

Further Reading: Altman, "Gertrude Elion"; Read and Witlieb, *Book of Women's Firsts;* Rix, ed., *American Woman 1990–91; Who's Who in America,* 48th ed., 1994.

Emily's List

A donor network that identifies candidates and collects individual donations for forwarding to those candidates, Emily's List was founded in 1984 to provide financial backing to female Democratic candidates. "Emily" is an acronym for Early Money Is Like Yeast, and it reflects the fact that members support selected candidates beginning at the earliest stages of a primary contest—a point in the election process at which women had previously found it difficult to secure financial support. Ellen Malcolm is the organization's founder and president.

Barbara Mikulski (D-MD), during her successful 1986 bid for a seat in the United States Senate, was the first woman to receive support from Emily's List. In 1992, the "YEAR OF THE WOMAN," Emily's List raised $6.2 million—more than any other, fund-raising network in America—from approximately 63,000 people, each of whom donated an average of $100.00. Emily's List's influence on the 1992 campaign was acknowledged by the American Association of Political Consultants, which named Emily's List president Ellen Malcolm its "most valuable player" for that year. Contributions grew since that landmark election, enabling Emily's List to raise $7.5 million for pro-choice Democratic women who ran for election in 1998. Among the women who publicly credited Emily's List with playing a role in their successful campaigns was Democrat Barbara Roberts, governor of Oregon from 1990 to 1994.

Other organizations created to support female candidates include the NATIONAL WOMEN'S POLITICAL CAUCUS, the Women's Campaign Fund, a bipartisan organization founded in 1974, and the more recent WISH List, an organization that supports Republican, pro-choice women.

Further Reading: Roberts, March 1994 letter; Davis, *Moving the Mountain;* "Emily's List Showed What Democracy Can Do," Letters to the Editor of the *New York Times,* March 22, 1993; "Emily's Loophole," *New York Times* editorial, March 10, 1993; Emily's List, http://www.emilyslist.org.

Equal Credit Opportunity Act (1974)

Signed into law in October 1974 by President Gerald Ford, the Equal Credit Opportunity Act (ECOA) prohibited businesses from discriminating because of sex or marital status when extending credit. Banks, credit card companies, home mortgage lenders and/or finance companies, and retail stores were all affected by the act.

Commercial and business loans were exempted under the Equal Credit Opportunity Act. However, on October 25, 1988, President Ronald Reagan signed the Women's Business Ownership Act (H.R. 5050), which extended the antidiscrimination requirements to credit transactions in connection with women's commercial and business endeavors.

Further Reading: Davis, *Moving the Mountain;* Rix, ed., *American Woman 1990–91.*

Equal Employment Opportunity Commission

This federal agency is charged with enforcing Title VII of the CIVIL RIGHTS ACT OF 1964 (forbidding employment discrimination on the basis of race, color, religion, national origin, or sex), the EQUAL PAY ACT of 1963 (requiring equal pay for equal work), and EXECUTIVE ORDER 11375 of 1967 (extending Title VII requirements to companies working under federal contract), as well as Section 501 of the Rehabilitation Act of 1973 (prohibiting the federal government from discriminating against disabled individuals), the Age Discrimination in Employment Act of 1979, and the 1992 Americans with Disabilities Act.

The Equal Employment Opportunity Commission (EEOC) was created by the U.S. Congress and is made up of five people appointed to five-year terms by the President and approved by the Senate. While the EEOC's stated mission is to "seek full and effective relief for each and every victim of employment discrimination, whether sought in court or in conciliation agreements before litigation, and to provide remedies designed to correct the discrimination and prevent its recurrence," the agency's record with regard to discrimination against women is mixed. In its earliest years, the EEOC investigated primarily race, color, religion, and national origin complaints and largely ignored sex discrimination complaints. (Betty FRIEDAN later cited the EEOC's disregard of the sex provision of Title VII as a catalyst for the founding of the NATIONAL ORGANIZATION FOR WOMEN.) Moreover, its effectiveness was questionable even in those cases where it did agree to intervene, since it originally had been granted only investigatory and advisory power over discriminating employers. The situation improved in 1972, when the EEOC was granted the power to sue employers on behalf of employees who had been discriminated against. For example in 1973 the American Telegraph and Telephone Company (AT&T) settled with the EEOC rather than face the conclusion of such a lawsuit, and 13,000 female employees and 2,000 non-Caucasian men received more than $38 million in back wages. (The company had been charged with discrimination against women, African Americans, and His-

panics in the areas of hiring, promotion, and fringe benefits.) Since 1972 the EEOC's effectiveness has fluctuated in response to the commitment—or lack thereof—of each successive administration. During the Reagan and Bush administrations, for example, the EEOC's funding was reduced by 50 percent and its appointed leadership frequently was criticized by minority and women's groups as not being committed to ending employment discrimination. Indeed, a 1987 General Accounting Office study faulted the EEOC's local offices and state agencies for dismissing between 40 and 80 percent of complaints received without adequate or, in some cases, any, investigation.

In recent years, the EEOC has filed several high-profile class-action lawsuits, including a sexual harassment suit against Mitsubishi Motor Manufacturing, which in 1998 resulted in a $34 million settlement. The commission has also been quick to issue new employer guidelines following relevant Supreme Court decisions, such as FARAGHER V. CITY OF BOCA RATON (this 1998 decision held companies liable for the harassing actions of supervisors, under certain conditions).

Ida B. Castro is the EEOC's current chairperson.

Further Reading: Davis, *Moving the Mountain;* Faludi, *Backlash;* Freeman, *The Politics of Women's Liberation;* Castro, "Enforcement Guidance: Vicarious Employer Liability for Unlawful Harassment by Supervisors"; Friedan, *Feminine Mystique;* "President Is Criticized for Delays at E.E.O.C.," *New York Times,* March 25, 1994, p. 19; U.S. Department of Labor, Women's Bureau, *A Working Woman's Guide to Her Job Rights;* U.S. General Accounting Office, "Equal Employment Opportunity"; *Washington Post,* June 12, 1998.

Equal Pay Act (1963)

Debated over the course of nineteen years and finally signed by President John F. Kennedy on June 10, 1963 (effective as of June 11, 1964), the Equal Pay Act of 1963 is actually an amendment to the Fair Labor Standards Act of 1938. As such, it is enforced by the U.S. Labor Department's Wage and Hour and Public Contracts Divisions. The law requires private-sector employers to pay male and female employees the same wages for the same work performed under identical conditions, but it does not cover women employed in executive, professional, or administrative capacities. It was the first federal law to prohibit sex discrimination.

Further Reading: Davis, *Moving the Mountain;* Evans, *Born for Liberty;* Hole and Levine, *Rebirth of Feminism;* Lifton, ed., *Woman in America;* Zophy and Kavenik, eds., *Handbook of American Women's History.*

Equal Rights Amendment

First proposed by Alice PAUL in Seneca Falls, New York, in 1923 on the seventy-fifth anniversary of the Seneca Falls Convention, the amendment, as drafted by Paul, simply stated that "Men and women shall have equal rights throughout the United States and every place subject to its jurisdiction."

The amendment was introduced in Congress in 1923 but failed to pass. The NATIONAL ASSOCIATION OF COLORED WOMEN supported the amendment along with the NATIONAL WOMAN'S PARTY, but many of the other women's organizations, including the NATIONAL FEDERATION OF BUSINESS AND PROFESSIONAL WOMEN'S CLUBS (BPW) and the LEAGUE OF WOMEN VOTERS, did not. The members of these opposing organizations had worked during the last years of the suffrage battle to secure what became known as "protective legislation" for women. Such legislation "protected" employed women from night-shift hours and dangerous working conditions, and ERA opponents feared that these laws would be invalidated by the amendment. (The FAIR LABOR STANDARDS ACT, enacted in 1938, granted many protections previously granted only to women—such as a minimum wage and a limitation on the number of hours required to be worked—to male workers as well, making the workplace more hospitable to workers of both sexes and inducing some previous opponents to support the ERA. A number of other women's organizations, hoping to retain the protective legislation aimed specifically at women, would continue to oppose the ERA until passage of the CIVIL RIGHTS ACT OF 1964, which federal courts began to interpret as invalidating these gender-based laws. Nonetheless, the feared loss of protective legislation caused many women's organizations to remain opposed to the ERA.)

The women's movement remained divided on the issue for nearly forty years. Supporters (including, after 1937, the National Federation of Business and Professional Women's Clubs) were successful in having the amendment introduced in Congress almost every year after 1923. From 1940 to 1960, both the Democratic and Republican parties included an endorsement of the ERA in party platform. ERA opponents proved stronger, however, and during these years the amendment was never sent to the states for ratification.

The National Organization for Women (NOW) was founded in June 1966 and, after a briefing by Alice Paul and several other surviving members of the National Woman's Party, it endorsed the Equal Rights Amendment. In 1970 BPW and several other women's organizations joined NOW to coordinate a lobbying effort on behalf of the ERA.

A Judiciary Committee subcommittee responded by scheduling hearings on the amendment in the same year. Attorney Marguerite Rawalt carefully researched all the Supreme Court's decisions regarding disparate treatment of the sexes. She shocked many when she testified that, in her professional opinion, women were not included in the United States Constitution. As a 1947 Supreme Court decision explained it, women's rights were granted "constitutional compulsion . . . in only one particular—the grant of the franchise by the nineteenth amendment." Rawalt and her colleagues further concluded that women would not be included in all of the Constitution's other guarantees of rights and responsibilities without an Equal Rights Amendment.

In 1972, 5 million letters of support and two years later, Congress passed the ERA. The wording was changed slightly from that proposed by Alice Paul; it now read:

> RESOLVED by the Senate and House of Representatives of the United States of America in Congress assembled (two thirds of each house concurring therein), That the following article is proposed as an amendment to the Constitution of the United States, which shall be valid to all intents and purposes as part of the Constitution when ratified by the legislatures of three-fourths of the several States within seven years from the date of its submission by the Congress:
>
> SEC. 1. Equality of rights under the law shall not be denied or abridged by the United States or any State on account of sex.
>
> SEC. 2. The Congress shall have the power to enforce, by appropriate legislation, the provisions of this article.
>
> SEC. 3. This amendment shall take effect two years after the date of ratification.

Before the end of 1973, thirty of the required thirty-eight states ratified the amendment.

By that time virtually all of the women's organizations endorsed the ERA. However, well-organized, sudden, and effective antifeminist opposition arrived in the form of Stop ERA, an organization established by Phyllis Schlafly, a former Republican congressional candidate. Schlafly and her organization's members claimed, in effect, that the granting of equal rights to women would destroy American families.

The deadline for ratification was extended by three years, to June 30, 1982, but the amendment failed. It was three states short of ratification on the day of its demise. Since 1985, the Equal Rights Amendment has been reintroduced during each session of Congress and held in committee.

Further Reading: Baron, ed., *Soul of America;* Chafe, *The American Woman;* Clark, *Almanac of American Women;* Davis, *Moving the Mountain;* Faludi, *Backlash;* Hole and Levine, *Rebirth of Feminism;* Mansbridge, *Why We Lost the ERA.*

equity courts

In colonial America and through the early nineteenth century, women—and especially married women—approached equity or chancery courts for relief from legal disabilities.

At a time when a married woman was considered a FEMME COVERT (legally absorbed into her husband) without property ownership or other rights, equity courts were known to consider individual cases on their practical merits, rather than on their relationship to common law. Thus, equity courts often upheld antenuptial agreements or marriage settlements—arrangements that permitted a woman to separate some previously owned property from her new husband's control and even bequeath it as she pleased. (It should be noted that the use of antenuptial agreements was rare.)

When various states began to pass married women's property acts in the nineteenth century (see MARRIED WOMAN'S PROPERTY ACT, 1848, NEW YORK STATE for further discussion), the effect of equity courts upon women's lives was greatly diminished.

Further Reading: Norton, *Liberty's Daughters;* Salmon, *Women and the Law of Property in Early America.*

Executive Order 11375 (1968)

Also known as "Executive Order 11246 as amended," this order was signed by President Lyndon B. Johnson on October 13, 1967, and took effect on October 13, 1968. An earlier executive order, 11246, had barred discrimination by federal contractors and subcontractors for reasons of race, color, religion, and national origin. Executive Order 11375 added sex discrimination to the list. It also prohibited the federal government itself from discriminating, as an employer, for reasons of race, color, religion, national origin, or sex.

Further Reading: Hole and Levine, *Rebirth of Feminism.*

Fair Labor Standards Act (1938)

Passed by Congress in 1938 and also known as the Wages and Hours Law, the Fair Labor Standards Act guaranteed to both male and female workers a forty-hour workweek and a minimum wage of 40 cents per hour, provided they were employed in industries subject to interstate commerce regulations. The act also ended child labor by forbidding the employment of children younger than sixteen years of age and further prohibited employers from hiring minors between the ages of sixteen and eighteen for hazardous work. Frances PERKINS, labor secretary under President Franklin D. Roosevelt, helped to draft the legislation. Its constitutionality was upheld by the Supreme Court in its 1941 decision, *United States v. Darby*.

Prior to the passage of the Fair Labor Standards Act, women's movement leaders had been divided in their support of the proposed EQUAL RIGHTS AMENDMENT (ERA), based on their view of PROTECTIVE LABOR LEGISLATION, or labor laws designed to "protect" wage-earning women. Supporters of the ERA generally felt that women would benefit more from equal treatment than from special concessions, such as a workplace exemption from overtime or late-night work. ERA supporters also argued that "protective" legislation simply made women less desirable employees. Supporters of protective legislation generally opposed the ERA because they feared its passage would provide new grounds on which to invalidate these laws, which treated women differently from men. (To the dismay of Florence KELLEY and other supporters of protective legislation, the Supreme Court had already, in 1923, invalidated a separate minimum wage for women and children.) The Fair Labor Standards Act, by extending the idea of protective workplace legislation to both men and women, set the stage for an end to this particularly divisive argument.

The act has been amended a number of times since 1938, resulting in an increased minimum wage and, since 1973, minimum-wage protection for domestic workers. With the passage of the Congressional Accountability Act in 1995, Congress, which had originally been exempted from compliance with the act, became bound by its requirement as well.

Further Reading: Chafe, *American Woman;* Kessler-Harris, *Out to Work;* Steinberg, *Wages and Hours.*

Family and Medical Leave Act

Originally drafted in 1984 and signed by President Bill Clinton in February 1993, this act requires that companies with more than fifty employees grant such employees unpaid leaves of up to twelve weeks to care for a seriously ill member of their immediate family or a newborn or newly adopted child. The same unpaid leave also may be taken by employees who themselves become seriously ill. According to the U.S. General Accounting Office, 908,000 American workers are expected to qualify for family medical leave each year.

Prior to the mid-1970s, women frequently were fired when their pregnancies became obvious, and they enjoyed no legal protection from this practice and in general received no maternity benefits. The issue was studied in a series of 1970s Supreme Court cases, with varying results. *Cleveland Board of Education v. LaFleur,* decided in 1974, found unconstitutional a law requiring schoolteachers to leave their positions when they reached the five-month point in their pregnancies; *Geduldig v. Aiello,* also decided in 1974, found it constitutional for states to deny pregnancy disability benefits to female workers; *Turner v. Department of Employment Security,* decided in 1975, found unconstitutional a law denying unemployment compensation during the last three months of a woman's pregnancy; and *General Electric v. Gilbert,* decided in 1976, found that it was not a violation of

federal law for private employers to deny medical disability benefits to women on maternity leaves. In 1978 the PREGNANCY DISCRIMINATION ACT was passed as an amendment to Title VII of the CIVIL RIGHTS ACT OF 1964, but it simply required employers to treat pregnancy like any other medical disability. In other words, employers who did not permit extended medical leaves for other reasons or illness were not required to provide maternity leaves.

By the end of the 1980s, every industrialized Western country except South Africa and the United States provided a government-mandated leave in the event of childbirth. Support for similar legislation in the United States grew: Organizations as disparate as the NATIONAL ORGANIZATION FOR WOMEN and the U.S. Catholic Conference lobbied for family leave legislation. Polls taken to measure support indicated that up to 74 percent of those queried were also in favor of family medical leave legislation. The Family Medical Leave Act was passed by Congress and vetoed by President George Bush twice: in 1990 and just prior to the 1992 election. During the 1992 campaign, Bill Clinton garnered support among women's rights groups and their supporters by promising, among other things, to sign the act as soon as Congress once again passed it. It was passed and signed during Clinton's first few weeks in office. With passage of the Congressional Accountability Act, Congress, which had originally been exempted from the Act's purview, became an employer charged with compliance.

Further Reading: Davis, *Moving the Mountain; Money* magazine, 22, no. 6 (June 1993); *Ms.* magazine, 3 (May/June 1993); Symons, "Legislation for Women."

Faragher v. City of Boca Raton (1998)
One of two Supreme Court cases that, taken together, enunciate a new standard for employer responsibility for supervisor sexual harassment. (The other case is *BURLINGTON INDUSTRIES, INC. V. ELLERTH.*)

This case was brought against the city of Boca Raton, Florida, by Beth Ann Faragher, who claimed she suffered sexual harassment while employed as an ocean lifeguard. Two of Faragher's lifeguard supervisors, Bill Terry and David Silverman, subjected her to lewd comments, offensive gestures, and unwanted touching. Faragher did not complain to Parks and Recreation Department management but to a third supervisor who never reported it to the city. (He felt, as had Faragher, that the conversation was on a friend-to-friend basis and not a formal complaint.) The District Court ruled in favor of Faragher and against the city of Boca Raton.

The court of appeals reversed that ruling, reasoning that Silverman and Terry were acting outside the scope of

their employment while harassing Faragher, and that the city, knowing nothing of the situation, could not be held negligent for failing to prevent it. Several judges issued a strong dissent, setting forth that employers should be held responsible for the behavior of supervisors and most readily in cases like Faragher's, where she worked far from any management office.

Justice David Souter's opinion for the Court, issued June 26, 1998, made it clear that an employer is always held to a vicarious liability standard for the actions of a supervisor; that is, the employer is always directly responsible for the actions of its supervisory personnel. It also made clear that employers were entitled to make an affirmative defense. A proven affirmative defense would relieve the employer of liability if it took "reasonable care" to prevent or end the harassment, and the affected employee unreasonably refused to make use of any preventive or curative remedies.

The Supreme Court's decision in *Burlington Industries Inc., v. Ellerth* was issued the same day.

Further Reading: Associated Press, June 26, 1998; Castro, "Enforcement Guidance: Vicarious Employer Liability for Unlawful Harassment by Supervisors"; *Faragher v. City of Boca Raton*, 524 U.S. 775 (1998); *National Law Journal*, March 22, 1999; *Washington Post*, November 15, 1997.

female anti-slavery societies
The first female anti-slavery society in America was founded on February 22, 1832, by African-American women in Salem, Massachusetts. Mary A. Bathys was its first president. Abolitionist leader William Lloyd Garrison founded the New England Anti-Slavery Society in the same year, and the Boston Female Anti-Slavery Society, open to women of both African and European descent, was founded by Maria Weston Chapman as a counterpart to Garrison's organization. Similar female anti-slavery societies appeared quickly in Rochester, New York, and Lynn, Massachussetts.

In 1833 Lucretia MOTT attended the founding convention of the American Anti-Slavery Society in Philadelphia. Told that women were not welcome, she joined with nineteen other female abolitionists to found the Philadelphia Female Anti-Slavery Society. Like the Boston Female Anti-Slavery Society, it welcomed Caucasian and African-American women. Four years later female anti-slavery societies existed in twelve states, and eighty-one delegates joined together at the 1837 National Female Anti-Slavery convention in New York City.

Members of these organizations coordinated petition drives, raised funds for the cause, and—to the dismay of

the clergy and many others—began speaking against slavery in public. Due to public opposition to such "unladylike" activities, abolitionist women soon realized that they would have to enlarge their own sphere in order to more effectively work on behalf of others.

The World Anti-Slavery Convention held in London in 1840 was the proverbial "final straw": Delegates from the Philadelphia and Boston Female Anti-Slavery societies traveled from the United States to London, only to be told that women's thoughts and participation were unwelcome. Lucretia Mott, in London as a delegate, and Elizabeth Cady STANTON, present as a guest of her husband Henry Stanton, vowed to organize a woman's rights convention upon their return to the United States. Even though their convention did not take place until 1848, the World Anti-Slavery Convention of 1840 is considered the unofficial beginning of the women's rights movement in the United States.

Further Reading: Flexner, *Century of Struggle;* Frost and Cullen-DuPont, *Women's Suffrage in America;* Griffith, *In Her Own Right;* Stanton, Anthony, and Gage, eds., *History of Woman Suffrage,* vol. 1; Sterling, *We Are Your Sisters.*

female genital mutilation

Illegal in the United States since March 30, 1997, female genital mutilation is a ritual practice intended to eliminate women's sexual pleasure and thus ensure their virginity before marriage and faithfulness afterward.

While female genital mutilation has been practiced for 3,000 to 6,000 years in more than twenty African countries and in some parts of the Middle East and Asia, it is not mandated by any religion. Generally, the operation is performed on groups of female children whose ages vary depending on the culture. Infants as young as two weeks are known to have suffered genital mutilation, but girls most commonly undergo the mutilation near the onset of puberty. In general, no anesthesia is used, and unsterilized knives, razors, and shards of glass are the usual surgical implements.

There are several degrees of mutilation, depending on the cultural norms of a particular village: Circumcision, or *sunna,* removes the hood of a woman's clitoris but leaves the body of the clitoris. Clitoridectomy, or excision, removes a woman's entire clitoris and part or all of her labia minora. An intermediate circumcision, as the practice is also termed, may involve removal of part of a woman's labia majora as well as the removal of her entire clitoris and labia minora. The most extreme form is pharaonic, or infibulation. In this operation, a woman's clitoris, labia minora, and most of the labia majora are removed. What remains of her vulva is then sewed together—with thorns or catgut—to seal her vagina; a sliver of wood is inserted to maintain a small opening for the woman's menstrual flow and urine. Infection, complications, and death can result from the various operations.

The United Nations Population Fund estimates that approximately 2 million women in 28 countries are at risk for female genital mutilation each year and that approximately 120 million women have already suffered such mutilation. As African immigration to Western countries has increased, the practice has spread; in 1997, the U.S. Centers for Disease Control and Prevention estimates that 168,000 girls in America have undergone or are at imminent risk of undergoing the procedure.

Population Action International, the Women's International Network, the FEMINIST MAJORITY FOUNDATION, and the NATIONAL ORGANIZATION FOR WOMEN have been active in alerting the public to the practice and gaining support for its prohibition. Members of the CONGRESSIONAL CAUCUS FOR WOMEN'S ISSUES and, in particular, Representative Patricia SCHROEDER, fought for the better part of a decade to win a legislative end to the practice.

Female genital mutilation was finally banned in the United States in 1996, by an amendment introduced by Senator Harry Reid (D-NV) and passed as part of larger legislative package. The law, which became effective on March 30, 1997, criminalized the performing of female genital mutilation on persons under the age of 18; required the Immigration and Naturalization Service to inform aliens that female genital mutilation is a crime and that sentences of up to five years may be imposed on conviction for that crime; and requires the United States to vote against the use of any international funds for countries that are not engaged in preventing female genital mutilation. (An exception permits the use of such funds to address basic human needs.)

The United States has since granted asylum to two women, Fauziya Kasinga of Togo and Adelaide Abankwah of Ghana, both of whom fled their countries rather than submit to female genital mutilation.

Other countries that have banned the practice include England, France, the Central African Republic, Senegal, Djibouti, and Guinea.

Further Reading: "American Academy of Pediatrics Statement on Female Genital Mutilation"; Associated Press, July 14, 1999; "Country Reports On Human Rights Practices for 1997"; *The Economist,* February 13, 1999; Jones et al, "Female Genital Mutilation/Female Circumcision: Who Is at Risk in the U.S.?"; *Los Angeles Times,* April 11 and 30, 1996; *New York Times,* April 15 and 25, 1996, May 2, 1996, and October 12, 1996; President's Interagency Council on Women, "Update to America's Commitment: Federal Programs Benefitting

Women and New Initiatives as Follow-Up to the U.N. Fourth World Conference on Women, April 1998 Supplement"; Public Law 104–208, Sections 579, 644, and 645; Reuters, May 28, 1997; U.S. Newswire, May 19, 1999; *Washington Post*, March 17, 1996, April 24 and 30, 1996, May 2 and 3, 1996, December 7, 1998, and July 21, 1999.

female literary societies

Reaching the height of their popularity in the early nineteenth century, these female literary societies—along with sewing circles and African-American benevolent societies—were the first "women's organizations" in the United States. Unlike the sewing circles, which were intended to benefit charities or churches (through the sale of women's handiwork), the benevolent and literary societies were intended to benefit the women themselves. The literary societies stressed self-improvement and education, and encouraged independent thought at a time when middle- and upper-class women were expected to live a fairly circumscribed life. The Smithfield Female Improvement Society of Smithfield, Rhode Island (in existence in the 1820s), for example, expected its members to read "useful books" and to write compositions on subjects of interest to each other. Lucy STONE belonged to a literary society in the 1840s and reported that the women involved had begun to question the exclusion of women from public life.

Free African-American women formed their own literary societies in Boston, New York, Philadelphia, and other East Coast cities in the 1830s. One of these societies, the Ohio Ladies Education Society, broadened its agenda to include the improved education of their children and is credited with advancing the creation of schools for African Americans in Ohio.

Feminine Mystique, The

A 1963 book by Betty FRIEDAN, *The Feminine Mystique* helped to ignite the modern American women's movement.

The Feminine Mystique grew out of a questionnaire that Friedan, a Smith alumna, sent to other Smith graduates. Friedan had been unhappy in the years following her own graduation, years in which she had combined writing for women's magazines with a traditional homemaker's role. The responses to her questionnaire indicated that many other women also suffered from "the problem with no name": a feeling of personal worthlessness and lack of self, arising from women's attempts to live through their husbands and children.

In her book, Friedan examined the ways in which society discriminated against women and forced them into homebound, vicarious lives. While it emphasized the plight of the middle-class, college-educated women whose hard-won skills went unused, it found an audience among a wide range of women and became an instant and much-discussed best-seller.

The Feminine Mystique served as a rallying point for American women and made Friedan one of the most prominent spokespersons of the modern women's movement.

Further Reading: Friedan, *Feminine Mystique*.

Feminist Majority Foundation

Founded as the Fund for the Feminist Majority in 1987 by former NATIONAL ORGANIZATION FOR WOMEN (NOW) president Eleanor Smeal, former NOW vice president Toni Carabillo, former NOW board member Judith Meuli, former president of NOW's Los Angeles chapter Katherine Spillar, and theatrical producer Peg Yorkin, the Feminist Majority Foundation is dedicated to "devis[ing] long-term strategies and permanent solutions for the pervasive social, political and economic obstacles women face." It sponsors research and provides the public with information it hopes will "explode myths and expose sources of opposition to women's equality" and ultimately "transform the public debate on issues of importance to women's lives and to empower women." As part of this effort, the organization maintains an on-line archive of international news on women's issues from 1995 to the present and facilitates on-line research through links on its Feminist Research Center page.

In 1987 the Feminist Majority instituted the first of its Feminization of Power campaigns. These campaigns take Feminist Majority leadership all across the country in an effort to identify electable women and persuade them to run for office. At the beginning of 1992 (one of the campaign's most successful years—see Anita HILL and YEAR OF THE WOMAN for further discussion), the Feminist Majority released a report, *The Feminization of Power: 50/50 by the Year 2000*, which examined the unbalanced ratio of male/female representation in United States government and defended the Feminist Majority's aggressive candidacy recruitment drives. As Katherine Spillar, the campaign's national coordinator, summarized the organization's stand, "Our strategy is simple—the more women who run, the more women will win."

The organization has been active in the prevention of DOMESTIC VIOLENCE, including support of the VIOLENCE AGAINST WOMEN ACT and the DOMESTIC VIOLENCE OFFENDER GUN BAN. In 1995, it established the National Center for Women & Policing; the center is currently working with the Violence Against Women Office of the

U.S. Department of Justice to create a training program for police involved in sexual assault investigations. The Feminist Majority has been active in the area of abortion rights as well, including the struggle to have the abortion drug RU-486 introduced into the United States.

The Feminist Majority has also addressed international feminist concerns. In recent years, it has organized a campaign to stop gender apartheid in Afghanistan and to apply pressure on behalf of Afghanistan's women, who have been deprived of basic rights since the fundamentalist Taliban militia captured the capital city of Kabul in September 1996. The Feminist Majority launched a petition drive to persuade President Clinton and Secretary of State Madeleine ALBRIGHT to strengthen U.S. sanctions against the Taliban, and it joined with the European Commissioner for Humanitarian Affairs, international nongovernmental organizations, and expatriate Afghanistan women to sponsor "A Flower for the Women of Kabul" campaign on International Women's Day, March 8, 1998. To create a source of income for Afghan women, it has also organized an ongoing, on-line sale of their craft items.

The Feminist Majority Foundation maintains its national office in Arlington, Virginia. Eleanor Smeal has been the organization's president since its inception.

Further Reading: Associated Press March 16 and 20, 1999; Brecher and Lippitt, *Women's Information Exchange National Directory;* Brennan, ed., *Women's Information Directory;* Carabillo, et al., *Feminist Chronicles 1953–1993;* Feminist Majority, http://www.feminst.org; *New York Times,* April 25, 1996; U.S. Department of State," Afghanistan Country Report on Human Rights Practices for 1998."

femme covert (feme covert)

The common law principle, imported to the American colonies from England, that stripped a woman of her civil existence upon marriage. As *The Lawes Resolutions of Women's Rights* (London, 1603) explains it:

> Man and wife are one person, but understand in what manner. When a small brooke or little river incorporateth with Rhodanus, Humber or the Thames, the poor rivulet looseth its name, it is carried and recarried with the new associate, it beareth no sway, it possesseth nothing during coverture. A woman as soon as she is married, is called *covert*, in Latin, *nupta*, that is, *veiled*, as it were, clouded and overshadowed, she hath lost her streame . . . To a married woman, her new self is her superior, her companion, her master.

Married women could not own property. Their inheritances and any wages earned became the property of their husbands. They had no right to refuse the sexual advances of their husbands, nor did they have joint guardianship of their own children. (A husband could place his children in apprenticeships without the consent of their mother and, in his will, he could name a guardian other than the children's mother.)

There were regional differences in the application of this principle. Some Southern colonies, for example, had very strict laws requiring an independent examination of a wife before a husband could sell property that had originated in his wife's family. DOWER—a widow's right to the use (but not the ownership) of one-third of her husband's real property for the remainder of her own life— was also considered one ameliorating consideration.

The married women's property acts of the nineteenth century (see MARRIED WOMAN'S PROPERTY ACT, 1848, and ACT CONCERNING THE RIGHTS AND LIABILITIES OF HUSBAND AND WIFE) began to grant economic rights, such as the right to own property, to married women. Other rights of married women, such as the right to refuse the sexual advances of their husbands, began to be recognized in the 1970s. (See RAPE for further discussion.)

Further Reading: Flexner, *Century of Struggle;* Salmon, *Women and the Law of Property in Early America;* Stanton, Anthony, and Gage, eds., *History of Woman Suffrage,* vol. 1.

femme sole

A term inherited from English common law, "femme sole" refers to a single woman or widow. In contrast to her married, "FEMME COVERT," counterpart, a femme sole had the right to own property, even prior to passage of the first married women's property acts in the nineteenth century. (See MARRIED WOMAN'S PROPERTY ACT, 1848, NEW YORK STATE for further discussion.) She also was entitled to conduct independent business transactions (although professions that were closed to women in general remained closed to a femme sole) and to retain her own wages. Married and unmarried women in America continued to experience different degrees of economic freedom well into the twentieth century.

Further Reading: Kerber, *Women of the Republic;* Norton, *Liberty's Daughter's;* Salmon, *Women and the Law of Property in Early America.*

femme sole traders

Single women engaged in commerce in colonial America, femme sole traders were entitled to enter into contracts and bring lawsuits on their own. (Married women needed their husbands to join them in either of these

activities and even needed a husband's permission to own a business.) Some colonies, such as Pennsylvania in 1718, passed laws that made married women eligible for femme sole trader status if their husbands deserted the family or otherwise failed to provide financial support. Other states, including South Carolina in 1712, passed laws expressly stating that femme sole traders—and no male members of their families—were responsible for the payment of their business debts. Such statutes reassured the business community as to a femme sole trader's accountability and thus enhanced the ability of colonial businesswomen to conduct business.

Further Reading: Kerber, *Women of the Republic;* Norton, *Liberty's Daughter's;* Salmon, *Women and the Law of Property in Early America.*

Ferraro, Geraldine (1935–) *politician*
Born on August 26, 1935, in Newburgh, New York, to Antonetta Corrieri Ferraro and Dominick Ferraro, Geraldine Ferraro became the first American woman to receive the nomination of a major political party for vice president. Dominick Ferraro died while his children were still young, and Antonetta moved her family to New York City, where she worked in garment factories to support her family. Geraldine Ferraro frequently has described Antonetta's hard work and sacrifice as inspiring her to work hard, do well, and benefit others. Ferraro received her B.A. in English from Marymount College in 1956. After graduation she taught grade school in Queens, New York, while attending Fordham University Law School at night. She received her J.D. degree from Fordham in 1960 and later that year married John Zaccaro.

Ferraro worked in private practice and became involved in the local Democratic Party while raising her three children. She served as assistant district attorney in Queens from 1974 to 1978, working at one point for the Special Victims Bureau. She left the district attorney's office in 1978 and ran as a Democrat for a seat in Congress. She won that election and was reelected to that seat—in the Ninth District of New York (Queens)—in 1980 and 1982. In 1982 she cosponsored the Economic Equity Act; if passed, it would have achieved legislatively many of the aims of the recently defeated Equal Rights Amendment. Ferraro was named chair of the National Platform Committee of the Democratic Party in 1984, the first women to be so appointed. Several months later she was chosen by Walter F. Mondale, the Democratic Party's presidential candidate, as the party's vice-presidential nominee.

During the campaign, Ferraro, a Roman Catholic, was publicly chastised by the archbishop of New York, Cardinal John J. O'Connor, for her support of abortion rights. Ferraro refused to change her position, explaining that she would not act to impose the Catholic church's, teaching on American non-Catholics. (She was also supported publicly by sixty-seven prominent Catholic lay persons, two priests, two brothers, and twenty-six nuns who signed the "Catholic Statement on Pluralism and Abortion," which appeared as a full-page advertisement in the *New York Times.* It began by stating "A diversity of opinion regarding abortion exists among committed Catholics." While most of the religious signatories later retracted the statement under pressure from the Vatican, two nuns—Sisters Patricia Hussey, SND, and Barbara Ferraro, SND [no relation to Geraldine Ferraro]— renounced their vows rather than do so. Candidate Ferraro also had to address questions about the business practices of her husband, who, after the election, pleaded guilty to inflating his net worth on a loan application. Nonetheless, Ferraro was a popular candidate who received $4 million in campaign contributions from women.

The Mondale/Ferraro ticket was defeated by Ronald Reagan and George Bush. In 1992 Ferraro ran a tightly contested primary race for the Democratic Senate nomination in New York State; had she won, she would have faced conservative, antichoice, and incumbent Senator Al D'Amato in the general election. However, she lost to Robert Abrams by a margin of 37 to 36 percent in a race that also included Elizabeth Holtzman (13 percent) and Al Sharpton (14 percent).

On October 22, 1993, President Bill Clinton nominated Geraldine Ferraro to be the U.S. representative to the United Nations Human Rights Commission. The following year, she was made ambassador to the UN Human Rights Commission, a position she held until 1995. She subsequently became a regular guest moderator on the Cable News Network program, *Crossfire,* where she remained an advocate for women and the disadvantaged. She was also the vice chair of the U.S. delegation at the Fourth World Conference on Women, in Beijing, China, in 1995.

In 1998, Geraldine Ferraro ran for the Democratic nomination in the Senate primary race in New York. Following her loss to Charles Schumer, she announced her retirement from elected politics. She has since joined an Arlington, Virginia, accounting firm, where she advises employers on issues concerning women and minorities.

Further Reading: "Catholic Statement on Pluralism and Abortion," *New York Times* (paid advertisement), October 7, 1984; Clark, *Almanac of American Women in the Twentieth Century;* Ferraro with Francke, *Ferraro: My Story;* Ferraro with Whitney, *Framing & Life;* Ferraro, *Changing History; New York Times,* October 23, 1993; O'Reilly et al., *No Turning Back;* Purdum, "Leaders Back Ferraro's Bid for the Senate"; ———, "Abrams,

in Tight Senate Vote, Appears to Edge Out Ferraro";
———, "Ferraro, Looking Back and Ahead"; Read and
Witlieb, *Book of Women's Firsts.*

Fifteenth Amendment

This amendment to the United States Constitution,
which guarantees the right of suffrage to African-
American males, was ratified on March 30, 1870. Its text
reads:

> SEC. 1. The right of citizens of the United States to
> vote shall not be denied or abridged by the United
> States or by any State on account of race, color, or
> previous condition of servitude.
> SEC. 2. The Congress shall have power to
> enforce this article by appropriate legislation.

The response of the women's rights leaders was
divided along the same lines as their earlier response to
the FOURTEENTH AMENDMENT: Elizabeth Cady STAN-
TON and Susan B. ANTHONY bitterly opposed the amend-
ment since it failed to include a protection for sex, and
Lucy STONE supported it only reluctantly.

Following an argument about the Fifteenth
Amendment at a May 1859 meeting of the AMERICAN
EQUAL RIGHTS ASSOCIATION, the women's movement
formally split into two separate factions. By the end of
the year, Stanton and Anthony headed the NATIONAL
WOMAN SUFFRAGE ASSOCIATION and Lucy Stone, the
AMERICAN WOMAN SUFFRAGE ASSOCIATION. The rup-
ture lasted until 1890, when the two organizations were
merged into the National American Woman Suffrage
Association.

Further Reading: Banner, *Elizabeth Cady Stanton;* Baron,
ed., *Soul of America;* Evans, *Born for Liberty;* Flexner, *Cen-
tury of Struggle;* Frost and Cullen-DuPont, *Women's Suf-
frage in America;* Griffith, *In Her Own Right;* Harper, *Life
and Work of Susan B. Anthony;* Stanton, Anthony, and
Gage, eds. *History of Woman Suffrage,* vol. 2.

Fire with Fire: The New Female Power and How It Will Change the 21st Century

Published in 1993, Naomi Wolf's *Fire with Fire* is a cri-
tique of the tactics of the modern feminist movement.
Wolf retraces the struggle for women's equality in Amer-
ica, beginning with the 1848 presentation of the DECLA-
RATION OF RIGHTS AND SENTIMENTS in Seneca Falls,
New York, and continuing through the 1992 election and
the historic leap in female representation that was its most
noted result. (See YEAR OF THE WOMAN for further dis-
cussion.) Wolf is concerned with what she sees as the fail-
ure of women's rights leaders to present the women's

movement as a successful, energizing, and extremely posi-
tive force in American history. She sees instead a constant
presentation of "woman as victim," and she believes that
the unwillingness of many women to identify themselves
as feminists stems from their refusal to identify with this
negative symbol. For feminism to have a vital impact on
American life in the twenty-first century, Wolf argues, the
movement must unapologetically lighten up, emphasize
and even revel in its successes, and coax women into bet-
ter using two of the tools it has already secured to them:
the ballot and their wages. (For a discussion of married
women's ownership of wages, see MARRIED WOMAN'S
PROPERTY ACT, 1848, NEW YORK STATE, and ACT CON-
CERNING THE RIGHTS AND LIABILITIES OF HUSBAND AND
WIFE; for discussion of equal pay, see EQUAL PAY ACT.)

Like Susan Faludi's BACKLASH (1991), Wolf's *Fire
with Fire* was discussed in the media as the work of one of
feminism's new, young voices and was credited with
attracting younger members to the modern women's
movement.

Further Reading: Wolf, *Fire with Fire: The New Female
Power and How It Will Change the 21st Century* (New
York: Random House, 1993).

Flynn, Elizabeth Gurley (1890–1964) *labor organizer, first female national chairperson of the Communist Party in America, a founder of the American Civil Liberties Union*

Elizabeth Gurley Flynn was born on August 7, 1890, in
Concord, New Hampshire, to Annie Gurley Flynn and
Thomas Flynn.

Flynn's parents were both Irish nationalists and
Socialists and her mother, especially, encouraged Eliza-
beth's political activities from the start. Elizabeth deliv-
ered her first public address at the Harlem Socialist Club
in January 1906. Only sixteen at the time, she analyzed
the situation of women under socialism and capitalism.
She became so successful a speaker that, before the year's
end, she was arrested on a street corner for stopping traf-
fic in New York City. Events continued to move quickly
for Flynn: She became a member of the Industrial Work-
ers of the World (IWW) in 1906; took part in her first
labor strike in Bridgeport, Connecticut, in 1907; left high
school with her parents' approval to become a full-time
Socialist agitator and married labor organizer John
Archibald Jones of Minnesota in 1908 (the couple would
divorce in 1920); bore one premature and short-lived
baby in 1909 and her son, Fred, in 1910; and participated
in many important IWW strikes, including the Lawrence,
Massachusetts, textile workers strike of 1912, the Patter-
son, New Jersey, silk workers strike of 1913, and the
Mesabi Range, Minnesota, miner's strike of 1916.

In 1917 a federal grand jury indicted Flynn—along with 168 other IWW members—for violation of the Espionage Act. Since Flynn had not been directly involved with the IWW's decisions during the time investigated, the charges against her were dropped. The following year, 1918, she helped to organize the Workers' Defense Union, which defended immigrants facing deportation from the United States. She was a founding member of the American Civil Liberties Union (ACLU) in 1920. She next joined the Communist Party, U.S.A. (1937) and was elected to its national committee in 1938. The ACLU revoked Flynn's membership in 1940 because of her Communist ties. (It would reinstate her posthumously, in 1976.)

During the 1940s, Flynn returned to the theme of her first public lecture: the situation of women. She ran for New York state congressman-at-large in 1942, addressing many women's rights issues in her campaign; she drew 50,000 votes but lost the election. During World War II she supported the drafting of women into the Women's Army Corps and their recruitment for work in factories and industry; demanded that the government provide day care centers for the children of female workers; and, pointing to women's contribution to the war effort, demanded an end to discrimination against women. After the war's end, Flynn participated in the Women's Congress in Paris (1945), an event dominated by Socialists and ultimately leading to the creation of the women's International Democratic Federation.

In March 1952 Flynn was again indicted, this time under the Smith Act, for conspiring to overthrow the government of the United States with the use of force and violence. She was convicted and served her jail sentence from January 1955 to May 1957 in the Women's Federal Reformatory. In 1961 Flynn became the first woman to be elected as chair of the Communist Party, U.S.A., a position she held for the rest of her life. In 1962 the State Department revoked her passport pursuant to the McCarren Act of 1950, which prohibited members of totalitarian organizations from entering and departing the United States. A lawsuit brought by Flynn and the noted historian Herbert Aptheker (*Aptheker v. Secretary of State*) was eventually heard by the Supreme Court, which ordered that Flynn's passport be returned to her in 1963.

Elizabeth Gurley Flynn died of acute gastroenterocolitis while on a visit to Moscow on September 5, 1964. She was given a state funeral in Red Square.

Further Reading: *Aptheker v. Secretary of State.* 378 U.S. 500,508 (1964). Camp, "Elizabeth Gurley Flynn," in *Notable American Women,* ed. Sicherman et al.; Clark, *Almanac of American Women in the 20th Century;* Flynn, *Rebel Girl;* McHenry, ed., *Famous American Women;* Milkman, ed., *Women, Work & Protest;* Wertheimer, *We Were There.*

foreign correspondents, World War I and II

A woman, Margaret FULLER (Ossoli), was America's first foreign correspondent, and women now fill approximately 20 percent of the foreign correspondent staff positions around the world. The first women to follow in Fuller's steps en masse—and pave the way for the increased coverage of world events by today's women—were the foreign correspondents of World War I and World War II.

When the United States entered World War I in 1917, American women were already engaged in covering its battles. Mary Boyle O'Reilly, daughter of the *Boston Pilot*'s publisher, was present in August 1914 when the Germans invaded Louvain, Belgium, "beat[ing] all the male correspondents sent in from Paris," as scholar George Weller recounts it, "and stay[ing] on after they left." Another of the first correspondents—male or female—to cover World War I from the front was Mary Roberts Rinehart. A novelist and fiction writer for the *Saturday Evening Post,* she turned to journalism at the beginning of the war and was at the front, in Belgium and France successively, at the beginning of 1915. She reported the German use of poisoned gas, but the *Saturday Evening Post* declined to print her eyewitness story. (Will Irwin's report on the poisoned gas was printed by his paper, the *New York Tribune,* and he received the credit for an exclusive story.) In 1917, however, the United States—then a participant in the war—refused accreditation to female reporters wishing to cover combat. Ordered to the rear, three American women instead covered the war from the Russian front: Bessie Beatty, writing for the *San Francisco Bulletin,* Louise Bryant, writing for the *Bell Syndicate,* and Rheta Childe Dorr, writing for the *New York Mail.*

Approximately 150 American women covered World War II as foreign correspondents. Among the best known were Mary Marvin Breckinridge, who, reporting for CBS, became the first foreign female staff correspondent for a radio network; Inez Robb of the International News Service and Ruth Cowan of the Associated Press, who were the first female correspondents to cover the war as uniformed members of the Women's Auxiliary Army Corps; photographer Margaret Bourke-White, who became, on January 22, 1943, the first female correspondent to accompany a bombing mission; Martha Gellhorn, who managed to cover the June 6, 1944, Allied invasion of Normandy by stowing away on a hospital ship; Ann Stringer of the United Press who defied a direct order to retreat to Paris and instead continued her trek to Germany's Elb River, where she wrote the exclusive story of the Soviet army's arrival on April 25, 1945; Helen Kirkpatrick, who reported the war from Africa, France, and Italy for the foreign service of the *Chicago Daily News* (thereby reporting simultaneously to approximately one hundred member newspapers, including the

Daily News) and was one of the first correspondents in Paris on Liberation Day; and Marguerite Higgins, who not only covered the American arrival at Dachau but was awarded the army campaign ribbon for her assistance during the SS guards' surrender and the camp's liberation.

Further Reading: Edwards, *Women of the World;* May, *Witness to War;* "The Rhine Maidens," *Newsweek,* March 10, 1945; Rinehart, *My Story;* Robb, *Don't Just Stand There;* Ross, *Ladies of the Press.*

Fossey, Dian (1932–1985) *ethnologist, primatologist*
Born in 1932 in San Francisco, Dian Fossey became the world's foremost authority on mountain gorillas.

Fossey graduated from San Jose State College in 1954 with a B.A. in occupational therapy and worked for two years in California hospitals. She joined the Kosair Crippled Children's Hospital in Louisville, Kentucky, as director of its occupational therapy department in 1956.

Having developed what she described as "this great urge, this *need* to go to Africa" to study the mountain gorilla, Fossey took out a bank loan and used the proceeds toward a 1963 safari. She visited with anthropologists Louis and Mary Leakey at Olduvai Gorge in Tanzania and with Jane Goodall, the British primatologist, all of whom encouraged her to pursue her dream of studying the mountain gorilla. She traveled to Zaire (then the Democratic Republic of the Congo), where she encountered the gorillas. As she later described it, "Sound preceded sight. Odor preceded sound . . . The air was suddenly rent by a high-pitched series of screams . . . [and] I was struck by the physical magnificence of the huge jet-black bodies blended against the green palette wash of the thick forest foliage." Fossey left Africa determined to return as soon as possible.

In 1966 Fossey took up residence in Zaire's Parc National des Virungas, where she imitated the behavior of mountain gorillas and gained their acceptance. In the midst of her study of three gorilla families, Fossey was ejected from the country by armed guards and warned that she would be shot if caught within Zaire's borders again. Fossey continued her work in adjacent Rwanda and established the Karisoke Research Center in the Parc National des Volcans there in September 1967.

In Rwanda, Fossey lived among fifty-one mountain gorillas belonging to four families. Her research established that these large animals (males are about six feet tall and about 400 pounds) were vegetarians and, for the most part, peaceful. She also established that loss of habitat—and the efforts of big-game hunters—had placed the mountain gorilla in danger of extinction. To her further alarm and despite her protests, the Rwandan government reduced the Parc National by 4,000 acres. While Rwanda—the most densely populated African country—badly needed to increase its farm production, Fossey feared that the move would thin the gorilla's ranks further. A number of altercations between Fossey and the Rwandan tribespeople ensued. Perhaps in an attempt to drive Fossey away, her favorite gorilla, Digit, was killed in 1978, and two other gorillas were killed within the next six months.

Fossey next sought international awareness of and assistance for the mountain gorilla. Having received her Ph.D. in zoology from Cambridge University in 1974, she embarked upon a brief teaching career, becoming a visiting professor at Cornell University in 1980. She established the Digit Fund (named after the gorilla) to raise money for gorilla conservation efforts. She published *Gorillas in the Mist* in 1983, which, although, criticized by some scientists for appealing too blatantly to the general public with anthropomorphic descriptions of her beloved gorillas, was widely reviewed and discussed, and later made into the film by the same name.

In the mid-1980s, Fossey returned to Rwanda, where she was called *Nyiramachabelli,* "the old lady who lives in the forest without a man." Dian Fossey was found murdered in the Parc National des Volcans on December 24, 1985.

Further Reading: Clark, *Almanac of American Women in the 20th Century; Chicago Tribune,* October 3, 1983; *Current Biography Yearbook,* 1985; Fossey, *Gorillas in the Mist; New York Times,* May 1, 1981.

Fourteenth Amendment
An amendment to the United States Constitution designed to secure the enfranchisement of African-American males, the Fourteenth Amendment was passed by Congress on June 13, 1866, and ratified on July 28, 1868. The first two sections were destined to be of particular interest to the women's movement:

> SEC. 1. All persons born or naturalized in the United States, and subject to the jurisdiction thereof, are citizens of the State wherein they reside. No State shall make or enforce any law which shall abridge the privileges or immunities of citizens of the Untied States; nor shall any State deprive any person of life, liberty, or property, without due process of law; nor deny to any person within its jurisdiction the equal protection of the laws.
>
> SEC. 2. Representatives shall be apportioned among the several States according to their respective numbers, counting the whole number of persons in each State, excluding Indians not taxed. But when the right to vote at any election for the choice of electors

for President and Vice President of the United States, Representatives in Congress, the Executive and Judicial officers of a State, or the members of the Legislature thereof, is denied to any of the *male* inhabitants of such State, being twenty-one years of age, and citizens of the United States, or in any way abridged, except for participation in rebellion, or other crime, the basis of representation therein shall be reduced to the proportion which the number of such *male* citizens shall bear to the whole number of *male* citizens twenty-one years of age in such State. [Emphasis added.]

Section 3 barred from state, federal, and military office any person who had "engaged in insurrection or rebellion" against the United States, or provided "aid or comfort" to others who had so engaged; Section 4 acknowledged the "validity of the public debt of the United States" incurred during the Civil War but declared "illegal and void" any debts incurred "in aid of insurrection or rebellion against the United States, or any claim for the loss or emancipation of a slave." Section 5 gave Congress the "power to enforce, by appropriate legislation, the provisions of this article."

Although all of the leaders of the nineteenth-century women's movement had worked for abolition to one degree or another and all supported African-American suffrage, they were outraged by the Fourteenth Amendment's insertion of the word "male" into the U.S. Constitution for the very first time. The Constitution had previously been almost entirely gender free—a document that did not appear to limit its guarantees of rights to men only. For example, the Constitution begins, "WE THE PEOPLE of the United States" and then outlines the citizenship rights of its "People" and "Persons." The president—and only the president—was referred to as "he." Otherwise, the Constitution had never mentioned gender. Women had indeed been disfranchised, but always at the state level: Section 4 of the Constitution stated, "The Times, Places, and Manner of holding Elections for Senators and Representatives, shall be prescribed in each State by the Legislature thereof . . ." Only the various *state* constitutions used the word "male" to limit suffrage and other rights to men. Therefore, the proposed insertion of the word "male" into the U.S. Constitution itself in the Fourteenth Amendment was a serious setback for the women's movement.

Elizabeth Cady STANTON and Susan B. ANTHONY immediately opposed ratification of the Fourteenth Amendment, which caused them to lose the support of many previously sympathetic male abolitionist leaders. Lucy STONE and many other women, while upset about the amendment's specific exclusion of women from Section 2, supported it in the belief that the extension of suffrage to any one of the nation's disfranchised groups was an important step. The AMERICAN EQUAL RIGHTS ASSOCIATION, founded in May 1866 to enlist both factions in securing "universal" suffrage (suffrage for both women and African-American men) was not able to heal the division. By 1869 the women's rights leaders had publicly split into two factions, due primarily to bitterness over the Fourteenth and Fifteenth amendments.

The breach between the suffrage leaders was healed in 1890, upon the merger of Cady Stanton's and Anthony's organization, the NATIONAL WOMAN SUFFRAGE ASSOCIATION, and Lucy Stone's AMERICAN WOMAN SUFFRAGE ASSOCIATION into the unified NATIONAL AMERICAN WOMAN SUFFRAGE ASSOCIATION. The debate over the Fourteenth Amendment's legal impact on American women lasted much longer.

Before the end of 1869, attorney Francis Minor urged women to focus on the first, not the second, section of the amendment. According to Minor's reading, women were indisputably among those "persons born or naturalized in the United States" and thus clearly "citizens of the State wherein they reside." Since Section 1 forbade any state to "make or enforce any law which shall abridge the privileges and immunities of citizens," etc., Minor claimed that women were already entitled to exercise all constitutional rights, including the right to vote. Several women put his thesis to the test.

In August 1869, Myra Bradwell passed the Illinois law exam and, with the proper certificate of qualification and required references, applied for a license to practice law. When she was denied the license because of her sex, she sued, citing, among other things, Section 1 of the Fourteenth Amendment. In 1874 the Supreme Court ruled that a woman's right to engage in the livelihood of her choice was not "one of the privileges and immunities of women as citizens" and, therefore, was not protected by the Fourteenth Amendment.

In 1872 Minor's wife and president of the Woman Suffrage Association of Missouri, Virginia Minor, tried to vote and was turned away from the polls. Her lawsuit also cited the Fourteenth Amendment and also reached the Supreme Court. In 1875 the high Court found that women were citizens of the United States but that the right of suffrage was not one of the privileges and immunities of citizenship; therefore, states were permitted to disfranchise females.

In 1872 Susan B. Anthony was arrested for unlawful voting. The Fourteenth Amendment notwithstanding, she was convicted and fined. (Because her lawyer posted bail during the trial—explaining that he "could not see a lady I respected put in jail"—Anthony lost the right to file a Supreme Court appeal based on the writ of *habeas corpus*.)

The turning point in the interpretation of the application of the Fourteenth Amendment to women came in

1971, in the Supreme Court's decision in REED V. REED. The case was argued by attorney and constitutional scholar Ruth Bader GINSBURG (Supreme Court justice nominated by President Bill Clinton in 1993) in association with the Women's Rights Project of the American Civil Liberties Union; it claimed that Sally Reed had the same right as her husband, Cecil Reed, to be considered for appointment as an administrator of her deceased child's estate, despite an Idaho law that gave preference to men. Ninety-eight years after ruling against Myra Bradwell, the Court ruled in favor of Sally Reed, and sex discrimination was, for the first time, declared a violation of what had become known as the Fourteenth Amendment's equal protection clause.

Further Reading: Baron, ed., *Soul of America;* Cary and Peratis, *Woman and the Law;* Cullen-DuPont, *"Bradwell v. Illinois, et al."* and *"U.S. Circuit Court v. Susan B. Anthony,"* in *Great American Trials,* ed. Knappman; Cushman, *Cases in Constitutional Law;* Davis, *Moving the Mountain;* Flexner, *Century of Struggle;* Frost and Cullen-DuPont, *Women's Suffrage in America;* Stanton, Anthony, and Gage, eds. *History of Woman Suffrage,* vol. 2.

Frankenthaler, Helen (1928–) *artist*

Born on December 12, 1928, in New York City, to Martha Lowenstein Frankenthaler and Alfred Frankenthaler, Helen Frankenthaler is one of the twentieth century's leading artists.

Frankenthaler attended the Brearley School and the Dalton School, both New York City private schools, and Bennington College, where she studied art. Upon her graduation from Bennington in 1949, she returned to New York City to begin her career. Frankenthaler participated in her first show, sponsored by Bennington in New York City, in 1950; in 1951 she participated in both the Ninth Street Show and a New Talent Show. She became a student at the Art Students League under the direction of Hans Hofmann, who stressed nature as an inspirational source, and was influenced by Jackson Pollock. Over the years, however, her sources of inspiration have been varied, ranging "from nature and the unconscious to great artists of the past." One of what critics referred to as a "second generation" of abstract expressionists, Frankenthaler is credited with joining abstract expressionism to a free, lyrical use of color in a landmark painting, *Mountains and Sea* (1952). The method she used to create the work—pouring paint onto an unprimed canvas upon which colors flowed and merged before finally settling in the threads with soft, sensuous effect—was called color-field or stain painting.

Frankenthaler's work inspired other painters, including Kenneth Nolan and Morris Louis; Whitney Chad-wick, in her book *Women, Art and Society,* has pointed out that it was not until these male painters adopted Frankenthaler's methods that she "was accorded status as an 'innovator'" by an art world that is sometimes slow to accord that status to women.

Frankenthaler's work has been exhibited in many American cities as well as Berlin, London, Milan, Montreal, Paris, and Venice, among others. The Whitney Museum in New York City, which has exhibited her paintings on a regular basis for many years, honored her in 1969 with a one-artist retrospective. She has received many prizes and awards for her work, and she has taught at many colleges and universities, including Hunter College, New York University, Princeton University, the University of Pennsylvania, and Yale University.

Further Reading: Chadwick, *Women, Art and Society; Current Biography Yearbook,* 1966; Frankenthaler, *Helen Frankenthaler;* McHenry. ed., *Famous American Women;* Munsterberg, *History of Women Artists;* Rubenstein, *American Women Artists from Early Indian Times to the Present;* Tufts, *Our Hidden Heritage.*

Friedan, Betty Naomi Goldstein (1921–) *author, feminist*

Author of the book that reignited the women's rights movement and a founder of the NATIONAL ORGANIZATION FOR WOMEN, Friedan was born Betty Naomi Goldstein in Peoria, Illinois, on February 4, 1921, to Miriam Horwitz Goldstein and Harry Goldstein. She was a bright student who became valedictorian of her high school class. She attended Smith College, where she majored in psychology and was the award-winning editor of her college newspaper. In 1942 she graduated with honors and received a fellowship at the University of California at Berkeley, where she studied for one year. She married Carl Friedan in 1947. The couple had three children, and Friedan cared for them in their Rockland County, New York, home while writing articles for women's housekeeping magazines.

In 1957, dissatisfied with her life, Friedan sent a questionnaire to other Smith graduates. She found out that many other women also suffered from "the problem with no name": a feeling of personal worthlessness and lack of self, arising from women's attempts to live through their husbands and children. In her book THE FEMININE MYSTIQUE (1963), Friedan examined the ways in which society discriminated against women and forced them into home-bound, vicarious lives. The book, an instant bestseller, became a rallying point for American women and made Friedan their most prominent spokesperson.

Friedan and other concerned women founded the National Organization for Women (NOW) in 1966.

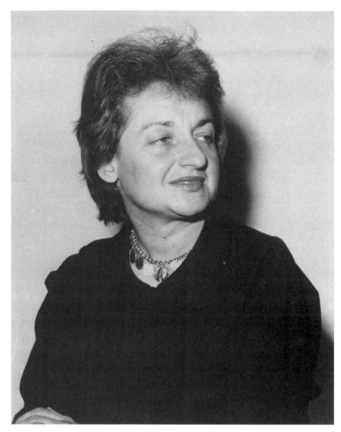

Betty Friedan, author of *The Feminist Mystique* and first president of the National Organization for Women (*Library of Congress*)

NOW's members vowed to "take *action* to bring women into full participation in the mainstream of American society now, exercising all the privileges and responsibilities thereof, in truly equal partnership with men." Friedan served as its president until 1969, advocating passage and ratification of the EQUAL RIGHTS AMENDMENT, legal abortion, child care and maternity leave policies, and increased job opportunities for women.

After her resignation from the presidency of NOW, Friedan organized the WOMEN'S STRIKE FOR EQUALITY to demand increased rights, and set August 26, 1970—the fiftieth anniversary of women's enfranchisement—as the date. To Friedan's delight, the strike was observed in forty cities, with 50,000 women participating in New York City alone. In the days prior to the strike, the U.S. House of Representatives finally passed the Equal Rights Amendment, which had been introduced annually since 1923. (The Senate later passed it as well, but it failed to win ratification by the necessary number of states and expired in 1983.)

In 1976, Friedan published *It Changed My Life: Writings on the Women's Movement*. In *The Second Stage* (1981), Friedan urged men and women to work together

to find an equitable balance between domestic life and public achievement. *The Fountain of Age* (1993) explores the issue of age discrimination as well as the great potential of later life. *Beyond Gender: The New Politics of Work and Gender* (1997) and the memoir *Life So Far* (2000) are her most recent books.

Betty Friedan, now divorced from her husband, lives in New York City.

Further Reading: Friedan, *Feminine Mystique;* ———, *Second Stage;* ———, *It Changed My Life;* ———, *Fountain of Age;* ———, *Beyond Gender.*

Frontiero v. Richardson (1973)

A 1973 Supreme Court decision overturning a federal law that granted unequal benefits to the spouses of military servicemen and women, unless the spouses of military women could prove that they were, in fact, dependent on their wives for more than 50 percent of their support.

Frontiero, was one of a group of landmark decisions that found protection for women's rights in the equal protection clause of the Fourteenth Amendment. That amendment, ratified in 1868, stated in part that "No State shall . . . deny to any person . . . the equal protection of the laws." It was first applied successfully to a woman's rights case more than one hundred years after its passage and just two years prior to *Frontiero,* in REED V. REED, in 1971.

Sharron Frontiero was a lieutenant in the U.S. Air Force. When she applied on behalf of her husband for medical benefits and a housing allowance—benefits wives of servicemen received without question—she was instructed to prove that she was, in fact, supporting her husband. The case was argued before the Supreme Court by Joe Levin of the Southern Poverty Law Center and by Ruth Bader GINSBURG, who had joined the case under the auspices of the American Civil Liberties' Women's Rights Project. Ginsburg—who had argued the 1971 *Reed v. Reed* case and who argued that the law should be struck down because (1) it automatically gave men greater compensation (salary plus family benefits) than it granted women (salary without family benefits) for the same work, and (2) because it did so based on the arbitrary presumption that married women were supported by their husbands.

The decision, delivered by Justice William J. Brennan, Jr., and joined by Justices William O. Douglas, Byron R. White, and Thurgood Marshall, traced the evolution of women's legal status in America:

> There can be no doubt that our Nation has had a long and unfortunate history of sex discrimination. Traditionally, such discrimination was rationalized by an attitude of "romantic paternalism" which, in prac-

tical effect, put women, not on a pedestal, but in a cage. . . .

. . . our statute books gradually became laden with gross, stereotyped distinctions between the sexes and, indeed, throughout much of the 19th century the position of women in our society was, in many respects, comparable to that of blacks under the pre-Civil War slave codes. Neither slaves nor women could hold office, serve on juries, or bring suit in their own names, and married women traditionally were denied the legal capacity to hold or convey property or to serve as legal guardians of their own children. . . . And although blacks were guaranteed the right to vote in 1870, women were denied even that right—which is itself "preservative of other basic civil and political rights"—until adoption of the Nineteenth Amendment half a century later.

Continuing, it found that "the sex characteristic frequently bears no relation to ability to perform or contribute to society. As a result, statutory distinctions between the sexes often have the effect of invidiously relegating the entire class of females to inferior legal status without regard to the actual capabilities of its individual members."

Justices Brennan, Douglas, White, and Marshall held that the disparate tests used to determine the benefits granted to spouses of male and female members of the military violated the equal protection clause of the Fourteenth Amendment. Significantly, the four justices also "conclude[d] that classifications based upon sex, like classifications based upon race, alienage, or national origin, are inherently suspect, and must therefore be subjected to strict judicial scrutiny." Chief Justice Warren E. Burger and Justices Potter Stewart, Lewis F. Powell, Jr., and Harry A. Blackmun concurred that the federal law violated the equal protection clause of the Fourteenth Amendment, but without declaring sex a suspect classification.

The distinction is worth noting. In general, the Court will evaluate a discriminatory law using what is called a "rational relationship test." In other words, in order to be upheld, a discriminatory law must be found to bear a rational relationship to a legitimate state goal. States are permitted, for example, to establish driver licensing laws that discriminate against blind people under the rational relationship test. However, when discriminatory laws classify people by race, creed, or national origin—groupings the Court has categorized as "suspect"—a different standard, known as "strict scrutiny," is used. In such instances, a discriminatory law, in order to be upheld, must be shown to meet a "compelling state interest" that cannot be met in any other way. When Ruth Bader Ginsburg argued Sharron Frontiero's case, she asked for more than the female lieutenant's benefits: She also asked the Court to find sex a

suspect category entitled to strict scrutiny. If the Court had agreed, it thereafter would have had to use the same standards in evaluating race and sex discrimination cases. The Court did not agree, however. It overturned the "male dependency" test faced by Sharron Frontiero and other military women seeking benefits for their family with a nearly unanimous decision (only Justice William H. Rehnquist dissented), but only four of the required five justices voted to establish sex as a suspect category.

To date, the Court has not found sex to be a suspect classification. However, in 1976 the Court, in *Craig v. Boren*, established what is referred to as an "intermediate" or "mid-level" test for application in sex discrimination cases. While the Court would not require states to prove a "necessary" relationship to a "compelling" governmental interest, as was required by the strict scrutiny standards applied to race discrimination cases, it *would* require a "substantial" relationship to an "important" governmental interest—a higher level of scrutiny than the "rational basis" test, which requires a "rational" relationship to a "legitimate" governmental interest.

Further Reading: Cary and Peratis, *Woman and the Law; Craig v. Boren.* 1976. 429 U.S. 190; Cushman, *Cases in Constitutional Law; Frontiero v. Richardson.* 1973. 411 U.S. 677; Mansbridge, *Why We Lost the ERA;* O'Connor, "Women and the Constitution" in *Women, Politics and the Constitution,* ed. Lynn; *Reed v. Reed,* 1971. 401 U.S. 71; Von Drehle, "A Trailblazer's Step-by-Step Assault on the Status Quo."

Fruits of Philosophy; or, The Private Companion of Young Married People

Believed to be the first pamphlet by an American physician on the subject of birth control, the *Fruits of Philosophy* was published by Dr. Charles Knowlton in 1839. Knowlton advocated douching following sexual intercourse and was prosecuted by the Commonwealth of Massachusetts under then-existing obscenity statutes. The tract was nonetheless purchased by thousands of interested persons and was quoted in marriage manuals throughout the 1870s.

Further Reading: Chesler, *Woman of Valor;* Knowlton, *Fruits of Philosophy.*

Fuller, Sarah Margaret (Margaret Ossoli)
(1810–1850) *author, women's rights advocate*
Fuller was born Sarah Margaret Fuller on May 23, 1810, in Cambridgeport, Massachusetts, to Margaret Crane Fuller and Timothy Fuller. Margaret, as she preferred to be called, received a rigorous education from her father, a

Harvard graduate, lawyer, and member of the United States Congress. She studied Latin and English grammar and began reading Horace, Ovid, and Virgil when only seven years old. She spent two years (1824–26) in Groton, Massachusetts, at the Misses Prescott's school, and then resumed her solitary studies.

In 1839 Fuller began what became known as her "Conversations"—discussions with groups of women on subjects such as art, ethics, mythology, and, especially, women's rights, which continued until 1844. During the same period, Fuller helped establish the transcendentalist community, Brook Farm, in West Roxbury, Massachussetts (1841) and joined Ralph Waldo Emerson and others to found the transcendentalist journal *Dial* (1840), of which Fuller was editor for two years. Fuller wrote *Summer on the Lakes* in 1844; the book so impressed Horace Greeley that he hired her as the *New York Tribune's* literary critic. Many of the essays she wrote while at the *Tribune* were collected and published as *Papers on Literature and Art* (1846).

In 1843 Fuller also had published an essay in *Dial*, "The Great Lawsuit. Man *versus* Men. Woman *versus* Women." An expanded version of this essay, published as *Woman in the Nineteenth Century* (1845), stands as one of the most important works of early American feminism. In it Fuller argues for the complete equality of men and women:

> We would have every arbitrary barrier thrown down. We would have every path laid open to women as freely as to Man . . . then and then only will mankind be ripe for this, when inward and outward freedom for Woman as much as for Man shall be acknowledged as a *right*, not yielded as a concession. As the friend of the Negro assumes that one man cannot by right hold another in bondage, so would the friend of Woman assume that Man cannot by right lay even well-meant restrictions on Woman.

Undaunted by anticipated arguments based on traditional social order, Fuller wrote, "if you ask me, what offices the [women] may fill, I reply—any. I do not care what case you put; let them be sea-captains, if you will."

Fuller further insisted that "Woman needs . . . as a nature to grow, as an intellect to discern, as a soul to live freely, and unimpeded to unfold such powers as were given her when we left our common home." Following her own dictum, she accepted Horace Greeley's offer to become a foreign correspondent for the *Tribune*. In April 1847 she reached Italy, where she reported the events and particulars of the revolution to the *Tribune* and subsequently wrote a book on the subject. She also married Giovanni Angelo Marchese d'Ossoli, with whom she had one child.

In July 1850 the family sailed for America to arrange for publication of Fuller's history of the Roman revolution and, possibly, to enable Fuller to accept a May 1850 invitation to assume a leadership position in the women's rights movement. (See WORCESTER WOMEN'S RIGHTS CONVENTION.) The entire family drowned in a shipwreck, on July 19, 1850. Only the child's body was recovered; the bodies of Fuller and her husband—as well as her final manuscript—were lost at sea.

Further Reading: Blanchard, *Margaret Fuller;* Flexner, *Century of Struggle;* Howe, *Margaret Fuller;* Ossoli, *Summer on the Lakes;* ———, *Papers on Literature and Art;* ———, *Memoirs;* ———, *Woman in the Nineteenth Century;* ———, *At Home and Abroad;* ———, *Life Without and Life Within;* ———, *Love Letters of Margaret Fuller, 1845–1846;* Stanton, Anthony, and Gage, eds., *History of Woman Suffrage,* vol. 1.

Gage, Matilda Joslyn (1826–1898) *suffragist, writer, editor of the* HISTORY OF WOMAN SUFFRAGE

Matilda Joslyn Gage was born on March 25, 1826, in Cicero, New York, to Helen Leslie Joslyn and Dr. Hezekiah Joslyn.

Gage entered the woman's rights movement as a speaker at the National Woman's Rights Convention in September 1852. She was critical of woman's subservience to men and advocated equality in educational opportunity and legal status. In 1869 she became a contributor to the *REVOLUTION,* the newspaper of the NATIONAL WOMAN SUFFRAGE ASSOCIATION (NWSA) and became a member of that organization's first advisory council. As a writer and talented organizer, Gage served NWSA as secretary and vice president from 1869 through 1875 and as president from May 1875 to May 1876. In 1875 she became president of the New York State Woman Suffrage Association.

Gage was responsible for editing the NWSA's newsletter, *National Citizen and Ballot Box,* during its publication (1878–81). In 1890 she formed the Woman's National Liberal Union, which advocated opposition to a united church and state. By this point in her career, Gage felt that religious teachings were responsible for the belief that women were inferior to men and that this was by far the greatest obstacle to women's emancipation. Her book, *Woman, Church & State* (1893), reflected this view. She also wrote several pamphlets—"Woman as Inventor" (1870) and "Who Planned the Tennessee Campaign of 1862?" (1880) among them. With Elizabeth Cady Stanton and Susan B. Anthony, Gage produced the first three volumes of the *History of Woman Suffrage* (1881–86). She wrote the chapters entitled "Preceding Causes," "Woman in Newspapers," and "Woman, Church and State" in volume 1 and "Woman's Patriotism in the War" in volume 2.

Matilda Joslyn Gage died in Greenwich, Connecticut on March 18, 1898.

Further Reading: *Chicago Times Herald,* March 19, 1898; *Chicago Tribune,* March 19, 1898; Stanton, Anthony, and Gage, eds., *History of Woman Suffrage;* Willard and Livermore, eds., *Woman of the Century.*

"gender gap"

Coined in the early 1980s, the term "gender gap" refers to measured differences in men's and women's voting patterns (see YEAR OF THE WOMAN for further discussion), employment, and income. In 1980, for example, the income gender gap was $.36 to the dollar, with women earning $.64 for every dollar men earned; by 2000, women were earning $.75 for every dollar earned by men. The income gap had shrunk to $.25.

Further Reading: Ries and Stone, eds., *American Woman, 1992–93.*

General Federation of Women's Clubs

Founded in 1890, the General Federation of Women's Clubs is a women's international volunteer service organization.

In 1889, when the FEMALE LITERARY SOCIETY Sorosis turned twenty-five, its founder, Jane Cunningham Croly, invited members of other literary female societies to the celebration. In 1890 a number of these clubs united as a federation to address social welfare and reform issues, such as the creation of public libraries, the enactment of PROTECTIVE LABOR LEGISLATION, and the improvement of the education system.

The federation has a history of initial opposition followed by endorsement with regard to constitutional amendments affecting women: The organization's pro-suffrage leadership did not convince the general membership to endorse the NINETEENTH AMENDMENT until

1914, and, similarly, the organization did not endorse the EQUAL RIGHTS AMENDMENT (ERA) until 1943, twenty years after its introduction. It was not alone in its late endorsement of the ERA. Like many other women's organizations, the federation feared that the ERA, by prohibiting the discriminatory treatment of women, would remove any basis for the special work conditions created by PROTECTIVE LABOR LEGISLATION. (The federation did, however, endorse the Eighteenth Amendment prohibiting the manufacture, sale, or transportation of alcohol, from the start.)

The General Federation of Women's Clubs recently has established a Women's History and Resource Center to document the history of women's volunteer activities and encourage a continuation of that tradition. (On June 7, 1991, the organization celebrated its 101st year with a symposium headed by Dr. Joyce Brothers and entitled "Forum for the Future: Agenda for Women in the 21st Century." The symposium featured experts from the educational, environmental, and health communities.)

The organization currently has 6,500 clubs in the United States and more than 20 countries. It publishes the quarterly *GFWC Clubwoman Magazine*. Maxine Scarbro currently serves as the federation's president.

Further Reading: Blair, *Clubwoman as Feminist;* Brennan, ed. *Women's Information Directory;* Davis, *Moving the Mountain;* Evans, *Born for Liberty;* Flexner, *Century of Struggle;* O'Neil, *Everyone Was Brave;* Ries and Stone, eds., *American Woman, 1992–93.*

Gilligan, Carol (1936–) *psychologist*

Born Carol Friedman on November 28, 1936, in New York, New York, to Mabel Caminez Friedman and William E. Friedman, psychologist Carol Gilligan sparked a major reevaluation of women's psychological development with the publication of *In a Different Voice: Psychological Theory and Women's Development* in 1982.

Gilligan was educated at Swarthmore College, from which she received her B.A. in 1958; Radcliffe College, from which she received her M.A. in 1960; and Harvard University, from which she received her Ph.D. in 1964. She is married to James Frederick Gilligan, a psychiatrist; the couple has three children.

In *In a Different Voice,* Gilligan sets forth the thesis that ethical standards have evolved to explain and suit male experience, resulting in a system that praises men and their abstract decisions concerning justice while devaluing women, who tend to make decisions by evaluating an action's impact on the people concerned.

Discussing the views of psychologists from Sigmund Freud to the present on "women's inferiority," Gilligan takes particular issue with Lawrence Kohlberg. She explains that Kohlberg, following studies from which women were excluded, sets forth a six-step process of moral development and places women at "stage three," where moral reasoning is based on wishing to please and assist others. Gilligan, citing "two disparate modes of experience," contends that what she sees as women's pattern of moral reasoning is as valid as men's.

In later books, including *Making Connections: The Relational Worlds of Adolescent Girls at Emma Willard School* (1991, with coauthors Nona P. Lyons and Trudy J. Hammer) and *Meeting at the Crossroads: Women's Psychology and Girls' Development* (1992, with coauthor Lyn Mikel Brown), Gilligan has examined the stresses suffered and the accommodations made by girls trying to "resist the 'psychological foot-binding' that is imposed on them by patriarchal social structures."

Gilligan has taught at various institutions, including Harvard and Rutgers universities and the University of Cambridge. She was named "Woman of the Year" by *Ms.* Magazine in 1984 and was awarded the Grawemayer Award in Education in 1992.

Further Reading: Gilligan, *In a Different Voice;* Gilligan with Brown, *Meeting at the Crossroads;* Gilligan with Lyons and Hanmer, *Making Connections;* Gilligan et al., *Mapping the Moral Domain;* Olendorf, *Contemporary Authors,* vol. 142, 1994; Prose, "Carol Gilligan Studies Girls Growing Up."

Gilman, Charlotte Anna Perkins Stetson
(1860–1935) *writer*

Feminist author of the late nineteenth and early twentieth centuries, Gilman was born Charlotte Anna Perkins on July 3, 1860, in Hartford, Connecticut, to Mary A. Fitch Westcott Perkins, whose ancestors had been among the settlers of colonial Rhode Island, and Frederic Beecher Perkins, a nephew of Harriet Beecher Stowe and Henry Ward Beecher. Frederic Perkins left his wife shortly after Charlotte's birth, leaving Mary Perkins to raise Charlotte and an older brother on the funds received through itinerant work and family charity. Despite these difficult circumstances, Charlotte attended the Rhode Island School of Design in Providence in 1878 and 1879. As a teenager, she secured work as an art teacher and governess and began to support herself. In May 1884 she and Charles Walter Stetson, an artist, were married. The couple's daughter and only child, Katherine Stetson, was born in March 1885.

Gilman suffered from despair and finally a total collapse during her marriage, and she spent much of her time in bed, in tears. Deciding that she would lose her sanity if she continued the marriage, Gilman separated from her husband in 1888 and was divorced in 1894. When

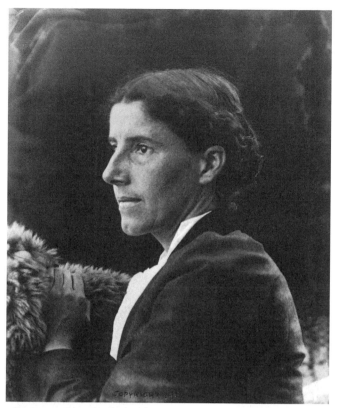

Charlotte Perkins Gilman, feminist author of the late nineteenth and early twentieth centuries, in 1900 (*Library of Congress*)

Charles Stetson thereupon married Grace Ellery Channing, a close friend of Gilman's, Gilman granted the newly married couple custody of her daughter, Katherine.

In 1892 Gilman's short story, "The Yellow Wallpaper," was published in *New England Magazine*. A feminist classic, the story describes the anguish and subsequent nervous breakdown of a female artist torn between her desire to write and the demands of her marriage and maternity. Gilman also had begun writing poetry at the age of twenty-one and, in 1892, she published the poetry collection *In This Our World*. It contained poems commenting on women's position in America and supporting the women's suffrage movement. Reprinted twice, it is notable more for its political content than for its literary merit.

In 1898 Gilman published the work for which she is best known, *Women and Economics,* which was originally titled *Economic Relation of the Sexes as a Factor in Social Development*. In this examination of the "sexuoeconomic relation," Gilman argues that married women do not earn their support through housework or through their worth as mothers but through their sexual relationship with their husbands. According to her analysis, this arrangement results in women's accentuation of "femi-nine" or passive characteristics designed to attract and accommodate men and the impoverishment of the individual women and society. Gilman supported economic independence for women and an end to what she believed was excessive privatization of family life. (One specific suggestion was the building of apartments or communities featuring communal kitchens, child care facilities, and common gardens.)

In 1900 Gilman published *Concerning Children,* in which she elaborated on her proposition for communal day care for the children of employed women. She argued that this would broaden and stimulate the minds of children as well as free their mothers. She returned to this theme again in her 1911 short story, "Making a Change." In this story Julia Gordins, a young music teacher, tries to commit suicide after the birth of her child. Julia's mother-in-law, referred to in the story as "Mrs. Gordins, senior," rescues Julia. The two women then work together to completely reorder their respective lives: Julia resumes her teaching career and Mrs. Gordins, senior, opens a day care nursery for the children of employed parents (including Julia's child and her own grandson, Albert). Frank Gordins is not informed of the changes and notices only the improved dispositions of his mother and wife. When a coworker tells him, in a disapproving tone, that Julia has returned to work, Frank confronts his wife and mother. By the end of the story, he is persuaded that the new arrangement is a wonderful one.

By the time "Making a Change" was written, Gilman herself was happily married—to her cousin, George Houghton Gilman—and had been rejoined by her daughter, Katherine. During this marriage, she continued to work: *The Home; Its Work and Influence,* a critique of the stunting effects of domestic confines upon the lives of women and children, was published in 1903. *Human Work,* which describes useful and meaningful work as a necessary part of a well-lived life for both men and women, was published in 1904. From 1909 to 1916 she published the *Forerunner,* a monthly magazine containing her own poetry, fiction, and political analysis. *Man-Made World,* in which she attributed society's emphasis on war and competition to a lack of political input from women, was published in 1911. *His Religion and Hers: The Faith of Our Fathers and the Work of Our Mothers,* which predicted that female theologians would push existing religions away from what she saw as their preoccupation with punishment, was published in 1923.

Gilman supported women's suffrage and was a speaker at the 1913 International Suffrage Convention in Budapest. (Although a key speaker at a convention for women's suffrage, she always maintained that economic independence was a more important goal for women.) She was also a founder, with Jane ADDAMS and other prominent women, of the WOMAN'S PEACE PARTY.

Gilman was diagnosed with breast cancer in 1932 and fearing the loss of her autonomy, procured enough chloroform with which to commit suicide. Three years later, at her daughter's home in Pasadena, California, on August 17, 1935, when her illness began to interfere seriously with her customary activities, Gilman committed suicide. As she explained in her suicide note—as well as in the manuscript of her autobiography—"I have preferred chloroform to cancer."

Further Reading: Bernikow, *World Split Open;* Clark, *Almanac of American Women in the 20th Century;* Dengler, "Charlotte Perkins Gilman," in *Notable American Women,* ed. James, James, and Boyer; Faust, ed., *American Women Writers;* Gilman, *Women & Economics;* ———, *Concerning Children;* ———, *The Home;* ———, *Human Work;* ———, *The Man-Made World;* ———, *His Religion and Hers;* ———, *Living of Charlotte Perkins Gilman;* ———, *The Yellow Wallpaper;* Solomon, ed., *American Wives.*

Ginsburg, Ruth Joan Bader (1933–) *Supreme Court Justice*

Born Ruth Bader on March 15, 1933, in the Flatbush section of Brooklyn, New York, to Celia and Nathan Bader, Ruth Bader Ginsburg became one the country's foremost gender equality lawyers and its second female Supreme Court justice.

Ginsburg grew up in Brooklyn, attending public schools while her mother—who had not been able to fulfill her own dream of attending college—saved $8,000 in "pin money" toward her daughter's education. During Ginsburg's senior year at James Madison High School, her mother died of cancer. Years later, during the press conference held to announce her appointment to the Supreme Court, Ginsburg spoke lovingly and with obvious emotion about her mother's strong influence on her, saying "I pray that I may be all that she would have been had she lived in an age when women could aspire and achieve and daughters are cherished as much as sons."

Ginsburg attended Cornell University, where she studied pre-law and met her future husband, Martin D. Ginsburg. Ruth Bader Ginsburg graduated and married in June 1954. She attended Harvard Law School for two years, then transferred to Columbia Law School when her husband accepted a job in New York. Although Ginsburg had made law review at two Ivy League schools, upon her graduation in 1960 she was unable to find a job at any top Manhattan law firm, and Supreme Court justice Felix Frankfurter—despite the urging of Albert Sachs, a dean at the Harvard Law School—refused to interview her for a clerkship, explaining, as the *New York*

As a lawyer Ruth Bader Ginsburg successfully argued landmark women's rights cases before the U.S. Supreme Court. In 1993 she became the second female Supreme Court Justice. (*The Supreme Court Historical Society*)

Times summarized, that "he just wasn't ready to hire a woman." Ginsburg found her first job with U.S. District Judge Edmund L. Palmieri. When her clerkship ended, Ginsburg accepted a job offer from a Swedish law firm and the offer of a grant to study the Swedish legal system from the Carnegie Foundation. Upon her return to the United States, Ginsburg became Rutgers' second female law professor and one of the first twenty female law professors in the United States.

While at Rutgers Ginsburg, at the request of the American Civil Liberties Union, joined the legal team handling Sally Reed's successful appeal to the Supreme Court. Reed was a divorced mother whose son had died and whose ex-husband was, as a man, automatically preferred by Idaho law to become executor of the child's estate. REED V. REED (1971) was the first decision in which the Supreme Court applied FOURTEENTH AMENDMENT protection to women. As Ginsburg later acknowledged, it was, for women, "the turning point case."

In 1972 Ginsburg became the first woman hired with tenure by Columbia Law School. In that same year the board of directors of the American Civil Liberties Union established the Women's Rights Project and named Ginsburg director. Between 1973 and the end of the decade, she argued six women's rights cases before the Supreme Court, winning five and establishing important precedents: *FRONTIERO V. RICHARDSON* (1973), *WEINBERGER V. WIESENFELD* (1975), *Edwards v. Healy* (1975), *Califano v. Goldfarb* (1977), *Duren v. Missouri* (1978), and her only loss, *Kahn v. Shevin* (1974).

In 1980 Ginsburg was appointed to the federal bench by President Jimmy Carter. Judge Ginsburg served on the United States Court of Appeals for the District of Columbia for thirteen years and, on June 14, 1993, was nominated for the Supreme Court by President Bill Clinton. Upon her confirmation, she became the second woman and the first Jew in over twenty years to serve on the high Court.

Ginsburg's first opinion as a Supreme Court justice was her concurring opinion in the 1993 sex harrassment case, *HARRIS V. FORKLIFT SYSTEMS, INC.* In her opinion, Ginsburg, as the *The New York Times* put it, "went out of her way to suggest that discrimination on the basis of sex should be taken as seriously by the Court as discrimination on the basis of race." She wrote the majority opinion in the 1996 case *UNITED STATES V. COMMONWEALTH OF VIRGINIA,* which prohibited state-supported schools from excluding women and forced the Virginia Military Institute and The Citadel to admit women or forgo taxpayer support. (Both schools currently admit women.)

Ruth Bader Ginsburg received the American Association of University Women's Achievement Award and the American Bar Association's Thurgood Marshall Award in 1999.

Further Reading: Berke, "Centrist Role Cited"; Frost-Knappman and Cullen-DuPont, *Women's Rights on Trial;* Lewis, "Rejected as a Clerk, Chosen as a Justice"; ———, "High Court Nominee Is Rated Highly by the Bar Association"; Margolick, "Trial by Adversity Shapes Jurist's Outlook"; Von Drehle, "Quiet Revolutionary"; ———, "Trailblazer's Step-by-Step Assault on the Status Quo."

"glass ceiling"

A term coined to describe the failure of women and of male members of minority groups to be promoted to the highest management positions in businesses as a result of an insidious discrimination so subtle that it is difficult to prove outright violation of existing laws.

According to a 1989 survey of Fortune 500 companies, women comprised only 12.7 percent of the membership of corporate boards of directors. At the same time, according to Labor Department statistics, female, Hispanic, and African-American workers composed less than 1 percent of the nation's chief executives and employees reporting directly to chief executives, and about 30 percent of large corporations' middle management ranks. On July 29, 1990, Labor Secretary Elizabeth DOLE announced "a glass ceiling initiative" to attempt to increase the promotions of women and of male members of minority groups to such top positions. Dole said:

> I have made this issue a top priority, and it will remain so during my service as Secretary of Labor. For me, it is a matter of fairness and equity, born of personal experience . . . There can be little doubt that a woman or minority, no matter how well-schooled, what their wage or how thick their portfolio, enters many business organizations with limited or no hope of reaching the top.

Under Dole's direction, the Labor Department's Office of Federal Contract Compliance Programs was especially vigorous in enforcing EXECUTIVE ORDER 11375's prohibition of various forms of discrimination, including sex discrimination, in companies doing business with the federal government.

The glass ceiling remains: In 1999, only three women were CEOs of Fortune 500 companies, and only 11.2% of the executive positions in those companies were held by women.

Further Reading: Kilborn, "Labor Dept. Wants to Take on Job Bias in the Executive Suite"; *New York Times,* July 21, 1999; Rix, ed., *American Woman, 1990–91.*

Godey's Lady's Book

A highly influential women's magazine of the nineteenth century, *Godey's Lady's Book* in its most successful years reached up to 150,000 people, a wide readership for the time.

The magazine was founded by Louis A. Godey in 1831 in Philadelphia and was an insignificant offering until Godey persuaded Sarah Josepha Hale to merge her own magazine, *American Ladies' Magazine,* with *Godey's Lady's Book.* Hale became editor of the expanded periodical in 1837.

The magazine combined illustrations of women's fashions with poetry and fiction that tended to reinforce the values of the "CULT OF TRUE WOMANHOOD," which glorified women's traditional role in the home. At the same time, however, Hale used the magazine to enlarge women's traditional sphere. She advocated higher education for women, praising Catharine BEECHER's school for

female teachers in the West, providing detailed coverage of SEVEN SISTER Vassar's first years, and editorializing about the need for government to fund women's educational institutions. An author of many books herself, she published reviews of books by other female writers. She also included articles on women's history that cast the accomplishments of women such as Dr. Elizabeth BLACKWELL in a positive light, urged acceptance of female nurses and physicians, and encouraged the presence of women in other occupations.

The influence of *Godey's Lady's Book* diminished by the time of Hale's retirement in 1877, and the magazine lost its audience to *Ladies' Home Journal* at the end of the century. Electronic facsimiles of several complete issues are now available on-line.

Further Reading: Boyer, "Sarah Josepha Hale," in *Notable American Women*, ed. James, James, and Boyer; Flexner, *Century of Struggle*; Finley, *Lady of Godey's*; "Godey's Lady's Book on-line"; Hale, *Boarding Out*; ———, *Good Housekeeper*; ———, *Woman's Record*; McHenry, ed., *Famous American Women*; Mott, *History of American Women's Magazines*.

Goeppert-Mayer, Maria (1906–1972) *physicist, Nobel Prize winner*

Born Maria Goeppert on June 28, 1906, in Kattaowitz, Upper Silesia (then part of Germany), to Maria Wolff Goeppert, a musician and schoolteacher, and Friedrich Goeppert, a pediatrician and professor of medicine, Maria Goeppert-Mayer became the first American woman to win the Nobel Prize for physics and only the second woman in the world to do so. (Marie Curie won the prize in 1903).

As a child, Goeppert-Mayer missed much of her formal schooling due to severe headaches, but she entered a private college preparatory school at fifteen. University education at Göttingen followed; there Goeppert-Mayer became a student of mathematics and physics. In 1928 she was awarded a fellowship to Girton College, Cambridge, England, where she spent one term. Back at Göttingen in 1929, she met Joseph E. Mayer, an American chemist, whom she married the following year.

Goeppert-Mayer received her Ph.D. in 1930 and moved to Baltimore with her husband that same year. Joseph Mayer became a professor at Johns Hopkins University but, citing nepotism, the university declined to hire Maria Goeppert-Mayer. She nonetheless used the university's facilities to conduct research with Karl Herzfeld, physical chemist. With Herzfeld and occasionally other collaborators, she published important papers on the benzene molecule's electron states, described by science writer Joan Dash as "the first attempt to predict the electron spectrum of a relatively complicated molecule," and other aspects of molecular physics, including double-beta decay.

The couple's children, Maria Anne and Peter, were born in 1933 and 1938, respectively, and the couple published their coauthored book, *Statistical Mechanics* in 1940. During this time the family moved to New York City, where Columbia University welcomed Joseph Mayer, but not his wife, as a professor. Despite his role in enforcing Columbia's nepotism rule, Harold Urey, the chemistry department's chairperson, developed a friendship with both of the Mayers. When Urey was named the leader of the Manhattan Project (the U.S. government's project to develop the atomic bomb), he asked Maria Goeppert-Mayer to participate.

After World War II and the conclusion of Goeppert-Mayer's work on the Manhattan Project, the University of Chicago extended an unusual offer to the couple. It would hire both: Joseph Mayer as a full professor with salary, and Maria Goeppert-Mayer—because of nepotism rules—as an unpaid associate professor. The couple accepted in 1946. Although Maria Goeppert-Mayer was later made a full professor, no raise in her nonexistent pay accompanied the promotion.

With Edward Teller in 1947, Maria Goeppert-Mayer began work on the origin of elements, which led to the finding that stable elements contained what would become known as "magic numbers," or patterns in the number of particles their nuclei contain. This ultimately led Goeppert-Mayer to the "shell model" of the nucleus—the theory that atomic nuclei owe their stability to the existence of relatively fixed "shells" or orbits upon which protons and neutrons travel. While other physicists also had envisioned a shell model, there was no convincing evidence until Maria Goeppert-Mayer, acting on a suggestion made by Enrico Fermi, and German scientist H. H. D. Jensen, working simultaneously but separately, discovered that spin-orbit coupling occurred within nuclei. "Spin-orbit coupling" refers to particles spinning while they orbit, in all possible combinations of direction: one spinning left, orbiting clockwise, another spinning right, orbiting counterclockwise, and so on. Such coupling increases the routes available for particles to travel. By performing calculations based on the existence of spin-orbiting, Goeppert-Mayer was able to provide both proof of the shell theory and a reason for the existence of magic numbers.

Goeppert-Mayer submitted papers documenting her research to the *Physical Review* in 1949; at the same time, Jensen submitted a paper outlining his own work on the theory to the same review. The two physicists consulted and coauthored a book, *Elementary Theory of Nuclear Shell Structure*, which was published in 1955.

In 1959 the University of California in San Diego offered both Joseph Mayer and Maria Goeppert-Mayer

positions as full professors; breaking precedent, it offered to pay each of them a salary. The couple accepted and relocated once again. In 1963 Goeppert-Mayer won the Nobel Prize for physics, along with Hans Jensen and Eugene Winger.

Maria Goeppert-Mayer died on February 20, 1972 in San Diego.

Further Reading: Carabillo, et al., *Feminist Chronicles;* Dash, "Maria Gertrude Goeppert-Mayer," in *Notable American Women,* Sicherman, ed.; Hall, "An American Mother and the Nobel Prize—A Cinderella Story in Science"; McHenry, ed., *Famous American Women;* Read and Witlieb, *Book of Women's Firsts.*

Goesaert v. Cleary (1948)

A 1948 Supreme Court decision upholding a Michigan law prohibiting women who were not "the wife or daughter of the male owner" of the establishment from working as bartenders. In its 1904 decision *Cronin v. Adams,* the Court ruled that neither a woman's right to work in a saloon nor her right to be served in one was protected by the equal protection clause of the Fourteenth Amendment. Its 1948 decision was essentially the same. Delivered by Justice Felix Frankfurter, it contained fairly patronizing language:

> While Michigan may deny to all women opportunities for bartending, Michigan cannot play favorites among women without rhyme or reason. The Constitution in enjoining the equal protection of the laws upon States precludes irrational discrimination as between persons or groups of persons in the incidence of a law. But the Constitution does not require situations "which are different in fact or opinion to be treated in law as though they were the same." . . . Michigan evidently believes that the oversight assured through ownership of a bar by a barmaid's husband or father minimizes hazards that may confront a barmaid without such protective oversight. This Court is certainly not in a position to gainsay such a belief by the Michigan legislature. If it is entertainable, as we think it is, Michigan has not violated its duty to afford equal protection of the laws . . . we cannot give ear to the suggestion that the real impulse behind this legislation was an unchivalrous desire of male bartenders to try to monopolize the calling . . .

Justice Wiley B. Rutledge, joined by Justices William O. Douglas and Frank Murphy, dissented:

> The statute arbitrarily discriminates between male and female owners of liquor establishments. A male owner, although he himself is always absent from his bar, may employ his wife and daughter as barmaids. A female owner may neither work as a barmaid herself nor employ her daughter in that position, even if a man is always present in the establishment to keep order. This inevitable result of the classification belies the assumption that the statute was motivated by a legislative solicitude for the moral well-being of the women who, but for the law, would be employed as barmaids. Since there could be no other conceivable justification for such discrimination against women owners of liquor establishments, the statute should be held invalid as a denial of equal protection.

Not until 1971, in its decision *REED V. REED,* would the Supreme Court find that the equal protection clause of the Fourteenth Amendment also applied to women.

Further Reading: Cary and Peratis, *Woman and the Law; Cronin v. Adams,* 1904. 192 U.S. 108; Cushman, *Cases in Constitutional Law; Goesaert v. Cleary,* 1948. 335 U.S. 464; O'Connor, "Women and the Constitution," in *Women, Politics and the Constitution,* ed. Lynn; *Reed v. Reed,* 1971. 401 U.S. 71.

Goldman, Emma (1869–1940) *anarchist author and lecturer, feminist, birth control advocate*

Emma Goldman was born on June 27, 1869, in Kovno, Russia (now Kaunas, Lithuania), to Taube Bienowitch Goldman and Abraham Goldman.

Emma's father arranged a marriage when his daughter turned fifteen; rather than submit, she left Russia for America and settled in Rochester, New York, where she met and married Jacob Kershner, a naturalized citizen. She performed factory work and quickly became convinced that the poor were exploited as much under American democracy as in czarist Russia. By the time the infamous Chicago Haymarket conspiracy trial began Goldman had already begun attending socialist meetings in Rochester, N.Y. During the Haymarket trial, eight anarchists were accused of causing a dynamite bomb explosion and killing eight police officers. Following a trial that primarily examined their political beliefs, the eight were convicted; four were hanged. Emma Goldman was radicalized and galvanized by the event: She divorced her husband (the two had not been happy together), moved to New York City, and joined the anarchist movement.

During the 1892 Homestead strike, Goldman helped Alexander Berkman, then her lover, procure a gun for his attempted assassination of the millionaire steel-mill owner Henry Clay Frick. In 1894 she advised the unemployed to feed their families on stolen bread if necessary and spent a year in jail as a result. In 1915 she instructed a New York City audience in the use of contraceptives and was arrested again. At the end of her trial, she was given the choice of paying a $100 fine or

serving fifteen days in the workhouse. Goldman went to jail, prompting Margaret Anderson to write in *The Little Review,* "Emma Goldman was sent to prison for advocating that women need not always keep their mouths shut and their wombs open." When anarchist Leon Czolgosz assassinated President William McKinley in 1901, he claimed that Emma Goldman was his inspiration. (Goldman, by this time, had renounced violence as a means of social change.)

As an anarchist, Goldman opposed all forms of institutionalized authority. She imposed her anarchist views onto marriage—viewing it as simply another form of institutionalized authority to be opposed. As she explained to Berkman in 1889 before they became lovers, "If I ever love a man again, I will give myself to him without being bound by the rabbi or the law, and when that love dies I will leave without permission." She never supported the suffrage movement, which she viewed as a request to participate in a poor system that ought to be overthrown. Women, she felt, could begin their own revolution.

> [T]rue emancipation begins neither at the polls nor in courts. It begins in women's soul. History tells us that every oppressed class gains true liberation from its masters through its own efforts. It is necessary that woman learns that lesson, that she realize that her freedom will reach as far as her power to achieve her freedom reaches . . .

In 1908 the U.S. government had stripped Jacob Kershner (Goldman's former husband) of his citizenship, which cost Goldman her citizenship as well. (See the CABLE ACT for a discussion of women's ties to their husbands' citizenship.) As Richard Drinnon has written, a 1909 letter to the attorney general from Oscar S. Straus, secretary of commerce and labor, indicates that the action against Kershner was specifically motivated by a desire to "quietly strip Goldman of her own citizenship." During World War I Goldman engaged in what would be her last political action in the United States, anticonscription agitation. She was jailed for two years and, upon her release at the age of fifty in 1919, deported to Russia in the company of Berkman and other anarchists.

Goldman found the Bolshevik Revolution in Russia disillusioning and spent her remaining years in Europe and Canada. She published various essays during her lifetime, and her books include *Anarchism and Other Essays* (1910), *My Disillusionment in Russia* (1923), and *Living My Life* (2 vols., 1931). When she died in Toronto on May 14, 1940, the United States government permitted the burial of her remains beside the graves of the men hanged following the Haymarket trial.

Further Reading: Christianson, "Haymarket Trial: 1886," in *Great American Trials,* ed. Knappman; Drinnon, "Emma Goldman," in *Notable American Women,* ed. James, James, and Boyer; ———, *Rebel in Paradise;* Goldman, *The Traffic in Women and Other Essays on Feminism;* ———, *Living My Life* (2 vols.); ———, *Anarchism and Other Essays;* ———, *My Disillusionment in Russia;* McHenry, ed. *Famous American Women;* Shulman, ed., *Red Emma Speaks;* Wexler, *Emma Goldman in America.*

Gordon, Kate M. (1861–1932) *suffragist, founder of the Equal Rights Association, organizer of the Southern States Woman Suffrage Conference*

Kate M. Gordon was born on July 14, 1861, in New Orleans, Louisiana, to Margaret Galiece Gordon and George Hume Gordon.

Gordon supported many social reforms but always believed that the emancipation of women was the most direct route to any other desired reform. In 1896, with the help of her sister, Jean Gordon, she founded the Equal Rights Association, better known as the Era Club, to work for women's suffrage. The organization soon espoused many other eclectic reforms as well, resulting in the formation of satellite organizations, such as the Women's League for Sewerage and Drainage, of which Gordon was president. Gordon entered the national suffrage movement in 1900 and was elected corresponding secretary of the NATIONAL AMERICAN WOMAN SUFFRAGE ASSOCIATION in 1901. From 1901 to 1913 she led the Louisiana State Suffrage Association. A strong believer in white superiority and states' rights, Gordon opposed the adoption of a federal amendment requiring the enfranchisement of women on the basis that a federal amendment would override state voter requirements and would impede the efforts of Southern legislatures to effectively disfranchise African Americans. In 1913 she organized the Southern States Woman Suffrage Conference to work for suffrage on a state-by-state basis.

After ratification of the Nineteenth Amendment, Gordon's energies were devoted to the New Orleans Anti-Tuberculosis League, the Society for the Prevention of Cruelty to Animals, and a Travelers Aid Society. She also helped form New Orleans' first permanent juvenile court and the New Orleans Hospital and Dispensary for Women and Children.

Kate M. Gordon died in New Orleans on August 24, 1932.

Further Reading: Flexner, *Century of Struggle;* Frost and Cullen-DuPont, *Women's Suffrage in America;* Kraditor, *Ideas of the Woman Suffrage Movement;* Zimmerman, "Kate M. Gordon," *Notable American Women,* James, James, and Boyer, eds.

governors

In 1924 America got not only its first but its first *two* female governors—both of whom had previously served their states as first ladies. One was Nellie Tayloe Ross, who was elected in 1924 to complete the term of her husband, who had died two years into his term as governor of Wyoming. (Ross failed to win reelection in 1927.) The other was Miriam Amanda (Ma) Ferguson. Her husband had been governor of Texas several years before; when he was impeached and barred from ever holding that office again, his wife ran and won in his place. Although she was in most cases a proxy for her husband (the two campaigned side by side with the motto "Two Governors for the Price of One"), Ma Ferguson followed her own agenda on one issue: Unlike her husband, Ferguson gave what aid she could to the prohibition forces. A woman also served—for one day—as the first African-American governor in the country when Democrat Barbara JORDAN was appointed, according to Texan custom, "governor for a day" in 1972.

The first woman to be elected governor in her own right was Ella GRASSO, governor of Connecticut from 1974 to 1980, when illness forced her to resign. Subsequent female governors (all elected in their own right), their states, and their years of service include:

Dixie Lee Ray, D-Washington, 1976–80
Madeline M. Kunin, D-Vermont, 1984–91
Martha Lane Collins, D-Kentucky, 1983–87
Joan Finney, D-Kansas, 1990–94
Ann Richards, D-Texas, 1990–94
Barbara Roberts, D-Oregon, 1990–94
Christine Todd Whitman, R-New Jersey, 1993–2001
Jane Hull, R-Arizona, 1997–
Jeanne C. Shaheen, D-New Hampshire, 1996–

Further Reading: *Boston Globe,* November 14, 1996; Clark, *Almanac of American Women in the 20th Century;* Carabillo, et al., *Feminist Chronicles; Christian Science Monitor,* December 23, 1998; Cook, "Lone Star"; Hoffman, ed., *World Almanac and Book of Facts: 1992; Houston Chronicle,* January 3, 1999; Kunin, *Living a Political Life;* McHenry, ed., *Famous American Women;* McLarin, "An Outsider Wins Office"; Ries and Stone, eds., *The American Woman, 1992–93;* Taylor, "Miriam Amanda Wallace Ferguson," in *Notable American Women,* ed. Sicherman et al.; Wandresse, *American Women in the 1970s; Washington Post,* November 7, 1996.

Graham, Katharine Meyer (1917–) *publisher*

Born Katharine Meyer on June 16, 1917, in New York City to Agnes Elizabeth Ernst Meyer and Eugene Meyer, Katharine Graham became the publisher of one of America's most influential newspapers, the *Washington Post.*

Growing up in Washington, D.C., she attended a private preparatory school in Virginia. She began her college studies at Vassar College but transferred after her freshman year to the University of Chicago, from which she graduated in 1938. Her father had purchased the *Washington Post* in 1933, and Graham had held summer jobs at the paper during her summer vacations. Upon graduation, she became a reporter with the *San Francisco News;* after one year, her father persuaded her to join the *Post,* where she became part of the editorial department. On June 5, 1940, she and Philip L. Graham were married.

Philip Graham, who had been a law clerk for Supreme Court justice Felix Frankfurter, went to the Pacific with the army Air Forces during World War II. Upon his discharge in 1945, he joined his father-in-law at the *Washington Post,* as associate publisher. By 1948 Philip Graham had become publisher, and Eugene Meyer had sold all of the paper's voting stock to his daughter and son-in-law.

Philip Graham committed suicide in 1963, and Katharine Graham became president of the *Washington Post.* (She became publisher as well in 1969.) The company's holdings at the time included not only the *Post* but WTOP Radio and WTOP-TV in Washington, WJXT-TV in Jacksonville, Florida, *Newsweek* and *Artworld* magazines, and significant interest in the Los Angeles Times-Washington Post News Service, among other entities. As Graham assumed control, she said that her goals remained the ones her father had expressed in 1935:

> The newspaper's duty is to its readers and to the public at large, and not to the private interests of the owner. In the pursuit of truth, the newspaper shall be prepared to make sacrifice of its material fortunes, if such course be necessary for the public good. The newspaper shall not be the ally of any special interest, but shall be fair and free and wholesome in its outlook on public affairs and public men.

Under Graham's leadership, the *Post* fought judicial restraining orders in the Supreme Court and published voluminous excerpts from the so-called Pentagon Papers. Between 1972 and 1974, *Post* reporters Robert Woodward and Carl Bernstein tracked the Watergate obstruction of justice directly to President Richard M. Nixon. Their stories were published with the express backing of Katharine Graham. (Nixon and Haldeman were so upset with the *Post* that, as one portion of the audio tapes of Nixon indicates, they entertained the possibility of obstructing the relicensing of *Post*-affiliated radio and television stations.)

In 1973 Katharine Graham became chair of the Washington Post Company's board of directors. In that year she also became the first woman to receive the Peter Zenger Award, named in honor of the colonial editor who successfully fought a charge of "seditious libel" by claiming the truth as his defense and awarded to honor distinguished service on behalf of the people's right to information and to a free press.

Further Reading: Jaworski, *Right and the Power;* Knappman, "John Peter Zenger Trial: 1735," in *Great American Trials,* ed. Knappman; McHenry, ed., *Famous American Women; Current Biography Yearbook, 1971;* Read and Witlieb; *Book of Women's Firsts.*

Graham, Martha (1893–1991) *dancer, choreographer*
Born on May 11, 1893, in Pittsburgh to Jane Beers Graham and George G. Graham, dancer and choreographer Martha Graham was, as Agnes DE MILLE expressed it, "a woman who made a greater change in her art—in the idiom, in the technique, in the content, and in the point of view—than almost any other single artist who comes readily to mind."

Graham's family moved to California when Graham turned ten, and she was educated in California public schools. Her father, a physician, wanted Graham to attend Wellesley College. However, shortly before high school graduation, Graham had seen Ruth ST. DENIS dance. From that moment on, Graham—who had not had any dance or acting lessons as a child—knew she would devote her life to the performing arts. Following graduation, she attended the Cumnock School of Expression in Los Angeles (1913–16). In 1916 she became a student at Ruth St. Denis' School of Dance and Related Arts in Los Angeles. In 1920 she moved to New York City, where she attended Denishawn, the famous dance school of Ruth St. Denis and Ted Shawn. Graham made her professional debut in 1920 in Shawn's *Xochitl,* a modern ballet with Aztec influences.

Graham founded the Martha Graham School of Contemporary Dance in New York City in 1927. Among her most famous dances are: *Primitive Mysteries* (1931), *Letter to the World* (1940) (called by John Martin of the *New York Times* "potentially one the most beautiful creations yet to be revealed in American dance" and based on Emily DICKINSON's poetry and an interpretation of the poet's life in which love is deliberately sacrificed to artistic solitude), *Clytemnestra* (1958), *A Time of Snow* (1968) (the last work in which Graham danced (she was then seventy-two)) and *The Rite of Spring* (1984).

Martha Graham died in New York City on April 1, 1991.

Further Reading: Armitage, *Martha Graham;* De Mille, *Martha;* Graham, *Blood Memory;* McDonagh, *Martha Graham;* Stodelle, *Deep Song.*

Grasso, Ella (Ella Rosa Giovanni Oliva Tambussi) (1919–1981) *politician*
Born Ella Rosa Giovanni Oliva Tambussi on May 10, 1919, in Windsor Locks, Connecticut, Ella Grasso became the first women to be elected governor without succeeding her husband into office.

Grasso received her early education in private and parochial schools. She received her B.A. from Mount Holyoke in 1940 and her M.A., from the same institution, in 1942. In August 1942 she and Thomas Grasso, a teacher, were married.

Grasso was assistant director of research for the Federal War Manpower Commission's Connecticut office during World War II. She was elected to the Connecticut state legislature in 1952 and reelected in 1954. Between 1956 and 1958, she served on the Democratic National Committee. She was elected to the first of her three consecutive terms as secretary of state of Connecticut in 1958. In 1970 Grasso was elected to represent the Sixth District in the United States House of Representatives, where she voted primarily along liberal lines. She was reelected to a second term in 1972.

Grasso was elected governor of Connecticut in 1974—the first woman who had not been a governor's wife to win that office. (In 1924 Nellie Ross had been elected to complete the term of her husband, who had died two years into his term as governor of Wyoming [she failed to gain reelection in 1927], and Mariam Amanda [Ma] Ferguson had been elected governor of Texas, an office her husband had held—he had been impeached and barred from holding again—several years before.)

As governor, Grasso worked hard and successfully to improve the financial stability of her state. During her tenure, she also joined her former congressional colleague Bella Abzug on the International Women's Year Commission, which organized the International Women's Year Conference of 1975.

An enormously popular governor, Grasso ran for reelection in 1978 and won in a landslide, winning more than 75 percent of the votes cast in the towns. In the middle of the second term, on December 4, 1980, Grasso announced that she was resigning from office, effective at the month's end, because she had cancer. On February 5, 1981, Ella Grasso died in Hartford, Connecticut. See also GOVERNORS.

Further Reading: Clark, *Almanac of American Women in the 20th Century;* Johnson, "Politics' Old-Girl Network State"; McHenry, ed., *Famous American Women;*

Read and Witlieb, *Book of Women's Firsts*; Taylor, "Miriam Amanda Wallace Ferguson," in *Notable American Women*, ed. Sicherman et al.; Wandersee, *American Women in the 1970s*.

Grimké, Angelina Emily (1805–1879) and Sarah Moore Grimké (1792–1873) *abolitionists*

Abolitionists who found themselves at the forefront of the early women's rights movement in America, the Grimké sisters were born in Charleston, South Carolina, to Mary Smith Grimké and John Faucheraud Grimké, Sarah on November 26, 1792, and Angelina on February 20, 1805. Although both were raised in a wealthy, slave-owning family, they grew to despise slavery. Both sisters were educated by tutors, but primarily in ornamental arts.

Sarah left both her family's home and the Episcopal church in 1821 when she moved to Philadelphia and became a Quaker, largely because she supported the Quakers' prohibition against slavery. In 1829 Angelina—who also had converted to the Quaker faith—followed Sarah to Philadelphia.

Angelina became a member of the Philadelphia Female Anti-Slavery Society and, in 1835, wrote a letter to abolitionist William Lloyd Garrison in which she condemned slavery and supported his efforts to end it. Garrison, to Angelina's surprise, published her letter in his newspaper, the *Liberator*. Angelina then wrote "An Appeal to the Christian Women of the South"; published in 1836, it outlined Grimké's objections to slavery and addressed her former female neighbors:

> But perhaps you will be ready to query, why appeal to *women* on this subject? We do not make the laws which perpetuate slavery. *No* legislative power is vested in *us; we* can do nothing to overthrow the system, even if we wished to do so. To this I reply, I know you do not make the laws, but I also know that *you are the wives and mothers, the sisters and daughters of those who do;* and if you really suppose *you* can do nothing to overthrow slavery, you are greatly mistaken . . . 1st. You can read on this subject. 2d. You can pray over this subject. 3d. You can speak on this subject. 4th. You can *act* on this subject.

The copies that arrived in Charleston were burned by the postmaster, and local police asked the Grimké family to warn Angelina against a return to the South. In that same year, Sarah published the *Epistle to the Clergy of the Southern States*, which denounced the then-popular claim that the institution of slavery was sanctioned by the Bible.

The real controversy began when the sisters began speaking in public—to "mixed" audiences of men and women—under the auspices of the American Anti-Slavery Society. Only Frances WRIGHT and Maria W. STEWART had so addressed American audiences before, and both had faced harsh derision. Now the Grimkés were attacked. The Massachusetts clergy had a *Pastoral Letter of the General Association of Massachusetts to the Congregational Churches Under Their Care* read from the pulpit in the state's orthodox churches in July 1837. The *Letter* warned that when a woman "assumed the place and tone of man as public reformer . . . her character becomes unnatural." Two more "Clerical Appeals" were made. Catharine BEECHER, an advocate of education for women, also opposed the public stance taken by the Grimkés. In *An Essay on Slavery and Abolitionism with reference to the Duty of American Women,* published in 1837, Beecher warned Angelina in particular that activity which "throws women into the attitude of a combatant, either for herself or others" took her out of the "woman's sphere."

The Grimkés fought back. Sarah's letters on the subject were published in the *Spectator* and later formed the basis of her 1838 book, *Letters on the Equality of the Sexes and the Condition of Women*. Flatly contradicting the Massachusetts clergymen, she described women as naturally endowed with equal rights and unnaturally suppressed by men. Without hesitation, she demanded a male retreat: "I ask no favors for my sex," Sarah wrote. "I surrender not our claim to equality. All I ask our brethren is, that they will take their feet from off our necks and permit us to stand upright on the ground which God designed us to occupy." Angelina's retort, *Letters to Catharine Beecher,* also appeared in 1838.

Angelina became the first American woman to speak before a legislative body on February 21, 1838, when she presented an antislavery petition signed by 20,000 women to the Massachusetts state legislature. Opposition to the idea of a public life for women remained strong, however: On May 15, 1838, the Anti-Slavery Convention of American Women was held in Philadelphia's Pennsylvania Hall, and Angelina Grimké was among the participants. On May 17, an angry mob burned down the hall.

Angelina married abolitionist Theodore Dwight Weld on May 14, 1838, and the couple had three children. Sarah moved in with her sister and helped to raise her niece and nephews. Domestic cares seem to have come close to ending the public careers of both women, but the debate they began continued well into the next century.

Sarah Grimké died in Hyde Park (now Boston) on December 23, 1873. Angelina Grimké Weld died in Hyde Park on October 26, 1879.

Further Reading: Flexner, *Century of Struggle;* Frost and Cullen-DuPont, *Women's Suffrage in America;* Grimké, *Appeal to the Christian Women of the South;* ———, *Letters*

to Catharine E. Beecher; ———, *Letter from Angelina Grimké Weld;* Grimké, *An Epistle to the Clergy of the Southern States;* Hadas, *Letters on the Equality of the Sexes;* Lerner, *The Grimké Sisters;* Stanton, Anthony, and Gage, eds., *History of Woman Suffrage.*

Griswold v. Connecticut (1965)

The 1965 Supreme Court decision that invalidated state anti–birth control laws, *Griswold v. Connecticut* enunciated the constitutional "right to privacy" that served as the basis for the Court's 1973 decision in *Roe v. Wade.*

Estelle T. Griswold, executive director of the Planned Parenthood League of Connecticut, and Dr. Charles Lee Buxton, chair of Yale University's obstetrics department, were arrested on November 10, 1961, and charged with operating a New Haven birth control clinic, for married women only, in violation of Connecticut's strict anti–birth control law. As of 1940, only Connecticut and Massachusetts prohibited the distribution of contraceptive information to married women.

Connecticut's law, passed in 1879, stated:

> Any person who uses any drug, medicinal article or instrument for the purpose of preventing contraception shall be fined not less than fifty dollars or imprisoned not less than sixty days nor more than one year or be both fined and imprisoned. (General Statutes of Connecticut, Section 53-32.)
>
> Any person who assists, abets, counsels, causes, hires or commands another to commit any offense may be prosecuted and punished as if he were the principal offender. (Section 54-196.)

In January 1962 Griswold and Buxton were tried in the Sixth Circuit Court; they were convicted and fined $100 each. A three-judge panel of the Appellate Division of the Sixth Connecticut Circuit Court upheld the convictions on January 18, 1963, but certified the case for review by the State Supreme Court of Errors, explaining that it concerned questions "of great public importance." That court upheld the conviction on May 11, 1964, explaining in its opinion that "the courts may not interfere with the exercise by a state of the police power to conserve the public safety and welfare, including health and morals . . ." The case was appealed to and accepted by the Supreme Court.

Oral arguments began on March 29, 1965. Thomas Emerson, representing Griswold and Buxton, argued that the 1879 birth control law prevented his clients and their patients from exercising their right to free speech, which was guaranteed by the First Amendment, and their right to liberty, which the Fourteenth Amendment guaranteed could not be abridged "without due process of law." He also argued that the law violated his clients' right to privacy, which he claimed was protected by the Ninth Amendment, which reserves to "the people" all rights not specifically granted by the Constitution to the government. Finally, he described the law as an attempt to maintain as "a principle of morality" the position that it was "immoral to use contraceptives even within the married relationship." This "moral judgment," he summarized, no longer "conform[ed] to current community standards."

Thomas Clark, representing Connecticut, defended the state law as an attempt "To reduce the chances of immorality" and "as a deterrent to sexual intercourse outside marriage." Justice Potter Stewart pointed out that "The trouble with that argument is that . . . [the clinic serves] only married women." Justice Arthur J. Goldberg also questioned the law's use in ensuring marital fidelity. He asked Clark whether or not Connecticut's antifornication and antiadultery statutes could sufficiently address the issue; Clark answered that "it's easier to control the problem" with additional laws banning the use of contraceptives. Clark also argued that prohibiting birth control was a legitimate exercise of a state's right to ensure its own "continuity."

In a 7–2 ruling, the Supreme Court overturned Griswold's and Buxton's convictions, invalidated the anti–birth control laws of Connecticut and all other states, and found that a constitutional "right to privacy" did indeed exist. William O. Douglas wrote the majority opinion. It stated that the "specific guarantees in the Bill of Rights have penumbras, formed by emanations from those guarantees that help give them life and substance . . ." While the Constitution's First, Third, Fourth, Fifth, and Fourteenth amendments were cited, the Ninth was quoted in its entirety: "The enumeration in the Constitution, of certain rights, shall not be construed to deny or disparage others retained by the people." Connecticut could not enforce its law without violating the "right to privacy," a right that was one "retained by the people." Douglas asked, "Would we allow the police to search the sacred precincts of marital bedrooms for telltale signs of the use of contraceptives?" Declaring this an action "repulsive to the notions of privacy surrounding the marriage relationship," the opinion overturned the lower court convictions.

Justices Hugo L. Black and Potter Stewart issued the two dissenting opinions.

Douglas' opinion marked a change in the high Court's interpretation of the Ninth Amendment. Previously, the amendment had been construed to mean that any right not specifically granted to the federal government remained the right of the state governments. Douglas' literal reading, that *the people* themselves retained all rights not otherwise and specifically granted to the government, was central to two other reproductive-law cases: *Eisenstadt v. Baird* (1972) and *ROE V. WADE* (1973).

In *Eisenstadt,* the right to use birth control was extended to unmarried persons. The majority opinion was written by Justice William J. Brennan, who had concurred with Douglas in *Griswold.* Among other things, the decision stated that "If the right to privacy means anything, it is the right of the *individual,* married or single, to be free from unwarranted governmental intrusion into matters so fundamentally affecting a person as the decision whether or not to bear or beget a child."

In *Roe v. Wade,* the Court found that the "right of privacy . . . is broad enough to encompass a woman's decision whether or not to terminate her pregnancy."

Further Reading: Carey and Peratis, *Woman and the Law;* Countryman, ed., *The Douglas Opinions;* Cullen-DuPont, *"Griswold v. Connecticut* and *Eisenstadt v. Baird,"* in *Great American Trials,* ed. Knappman; Cushman, *Cases in Constitutional Law;* Davis, *Moving the Mountain; Eisenstadt v. Baird;* Faux, *Roe v. Wade; Griswold v. Connecticut; New York Times,* October 27, 1961; November 3, 4, 11, 13, and 25, 1961; December 2 and 9, 1961; January 3 and 13, 1962; October 20, 1962; January 18, 1963; May 17 and 19, 1963; May 12, 1964; December 9, 1964; March 30 and 31, 1965; and June 8, 9, 10, 13, and 15, 1965.

Hadassah, The Women's Zionist Organization of America

Founded on February 24, 1912, in New York City, by Henrietta SZOLD and a dozen other women, Hadassah is now America's largest volunteer women's organization.

Named Daughters of Zion until 1914, the organization is dedicated to the cultivation and preservation of Jewish social and religious values, to the forging of strong ties between Israel and the American Jewish community, and to the provision of necessary services, such as medical care, in Israel. Within its first year, Hadassah opened its first medical facility in what was then Palestine. To help ensure future medical staffing in the area, the Henrietta Szold Hadassah School of Nursing was established in 1918 and the Hebrew University-Hadassah Medical School was established in 1949. Hadassah erected and continues to maintain the Hadassah Medical Organization, which comprises the Hadassah University Hospital at Mt. Scopus, Israel, and the Hadassah Hebrew University Medical Center at Ein Karem, Israel. Hadassah's medical institutions provide care without regard to the religious background of those in need.

Hadassah also supports education. Guided by the principle that "basic Jewish education [is] a background for intelligent and creative living in America," Hadassah maintains an educational department in the United States that, among other endeavors, publishes study guides on Jewish culture and history as well as other relevant topics. In Israel, the organization operates the Hadassah College of Technology in Jerusalem, which offers training in dental and medical technology, computer sciences, printing, and graphics.

In 1934, prompted by violence toward Jews in Germany, Henrietta Szold cofounded Hadassah's Youth Aliyah division with Recha Freier and several others in Germany. Youth Aliyah has relocated many thousands of endangered Jewish children, from those born in Ger-

many prior to World War II to those threatened with starvation in the Ethiopian famine of the 1980s.

Hadassah publishes two triannual publications, *The American Scene* and *Textures: Hadassah National Jewish Studies Bulletin;* two quarterlies, *Hadassah Associates Medbriefs* and *Hadassah Headlines;* and its monthly *Hadassah Magazine.* The organization has continued to maintain its headquarters in New York City. Beth Wohlgelernter is Hadassah's current executive director, and there are presently 385,000 members nationwide.

Further Reading: Brecher and Lippit, eds., *Women's Information Exchange National Directory;* Brennan, ed., *Women's Information Directory;* Dash, *Summoned to Jerusalem: the Life of Henrietta Szold;* Fineman, *Woman of Valor.*

Harper, Frances Ellen Watkins (1825–1911)
author, lecturer, reformer

Born on September 24, 1825, in Baltimore, Maryland, to free African-American parents, Frances Ellen Watkins Harper was an author, lecturer, and reformer.

Both of Harper's parents died before her third birthday, and she was brought up by her abolitionist uncle, the Reverend William Watkins. She attended her uncle's school with other free African-American children until she turned thirteen, at which point she became a live-in domestic servant for a Baltimore family. Harper continued to read widely on her own, and published her first volume of prose and verse, *Forest Leaves,* in 1845, at the age of twenty. (No copies are known to survive.) She became a sewing teacher in 1850, teaching first in Columbus, Ohio, and then, in 1852, in Little York, Pennsylvania.

In 1853 a law was passed in Maryland that allowed the capture and sale into slavery of free African Ameri-

cans who entered the state from the North. Harper, roused to action by laws such as this and by her frequent contact with abolitionists involved with the Underground Railroad, turned her talents and energies to the antislavery movement. In 1854 she published *Poems on Miscellaneous Subjects,* a collection of antislavery poetry, and made what would be her first antislavery speech, "Education and Elevation of the Colored Race," in New Bedford, Massachusetts. From 1854 to 1860 she traveled widely throughout the North, speaking about the need for abolition. Prior to the Civil War, her poetry was featured prominently in antislavery newspapers, and her short story "The Two Officers," which appeared in the *Anglo-African Magazine* in 1859, is believed to be the first short story published by an African American. Harper donated the majority of her income from these endeavors to the Underground Railroad.

She and Fenton Harper, a widowed farmer, were married in 1860. They settled in Columbus, Ohio, where they had a daughter, Mary. Fenton Harper died in 1894.

After the Civil War, Harper tried to persuade Susan B. ANTHONY, Elizabeth Cady STANTON, and their followers to support the FOURTEENTH and FIFTEENTH AMENDMENTS, despite these amendments' failure to address women's suffrage alongside the enfranchisement of African-American men. At a May 1869 meeting of the AMERICAN EQUAL RIGHTS ASSOCIATION, she told the primarily Caucasian membership that "[i]f the nation could only handle one question, she would not have the black women put a single straw in the way, if only the men of the race could obtain what they wanted." When the women's movement formally divided over the question, Harper aligned herself with Lucy STONE's organization, the AMERICAN WOMAN SUFFRAGE ASSOCIATION, which had endorsed the Fourteenth and Fifteenth amendments. She continued to press for women's enfranchisement, specifically addressing African-American men with such poems as "Dialogue on Woman's Rights," which was published in the *New York Freeman* in 1885. The poem is set as an argument about women's suffrage between two men, both former slaves, and contains the following stanza:

> The masters thought before the war
> That slavery was right;
> But we who felt the heavy yoke
> Didn't see it in that light.
> Some thought that it would never do
> For us in Southern lands,
> To change the fetters on our wrists
> For the ballot in our hands.
> Now if you don't believe 'twas right
> To crowd us from the track
> How can you push your wife aside
> And try to hold her back?

Harper also worked with the National Woman's Christian Temperance Union and directed its activities among African Americans from 1883 to 1890. In 1894 she became a director of the American Association of Education of Colored Youth. In 1896 she was an organizer of the NATIONAL ASSOCIATION OF COLORED WOMEN, an organization for which she served as vice president in 1897.

Harper's later published works include *Sketches of Southern Life* (1872), *The Martyr of Alabama and Other Poems* (1894), *Moses: A Story of the Nile* (1892), and *Iola Leroy, or Shadows Uplifted* (1892). In addition, three novels that were serialized in the nineteenth century but never published in book form were recently rediscovered by Frances Smith Foster. These three novels, *Minnie's Sacrifice, Sowing and Reaping,* and *Trial and Triumph,* have recently been published by Beacon Press.

Frances Ellen Watkins Harper died on February 22, 1911, in Philadelphia.

Further Reading: Bernikow, ed., *The World Split Open;* Faust, ed., *American Women Writers;* Filler, "Frances Ellen Watkins Harper," in *Notable American Women,* James, James, and Boyer, eds.; Foster, *A Brighter Coming Day;* Gilbert and Gubar, eds., *The Norton Anthology of Literature by Women;* Harper, *Sketches of Southern Life;* ———, *Minnie's Sacrifice;* ———, *Sowing and Reaping;* ———, *Trial and Triumph;* Lyall, "Book Notes," *New York Times;* McHenry, ed., *Famous American Women;* Rogers, ed., *The Meridian Anthology of Early American Women Writers;* Stanton, Anthony, and Gage, eds., *History of Woman Suffrage,* vols. 2 and 6; Sterling, ed., *We Are Your Sisters: Black Women in the Nineteenth Century.*

Harper, Ida A. Husted (1851–1931) *suffragist, journalist, biographer, an editor of the* History of Woman Suffrage

Ida A. Husted Harper was born on February 18, 1851, in Fairfield, Indiana, to Cassandra Stoddard Husted and John Arthur Husted.

Harper began her career in journalism in 1872 by contributing articles to the *Terre Haute Saturday Evening Mail,* initially under a male pseudonym. She continued to contribute articles and eventually wrote a column under her own name for about twelve years. From 1884 to 1893 she edited a section of the Locomotive Firemen's Magazine, and for a brief period in 1890 she was editor-in-chief of the *Terre Haute Daily News.* Moving in that same year to Indianapolis, she joined the editorial staff of the *Indianapolis News.*

Harper was always a sympathizer of the women's movement, but she did not become actively involved in the suffrage cause until 1887, when she became secretary

of the state suffrage society formed by Helen Mar Gourgar. Moving to California in 1896, Harper spearheaded a press campaign during California's attempt to secure a suffrage amendment to its constitution. In 1897 she moved to Rochester, New York, to write Susan B. ANTHONY's biography, the three-volume *Life and Work of Susan B. Anthony*. During this time she also began working with Anthony on volume 4 of the HISTORY OF WOMAN SUFFRAGE (1902). After passage of the NINETEENTH AMENDMENT, Harper worked on volumes 5 and 6 of the *History* (1922).

Throughout her career as a suffragist, she put her journalistic talents to great use. She wrote numerous articles and letters to newspapers and journals across the United States in defense of the feminist cause. In 1916, at the request of Carrie Chapman CATT, she became head of national publicity for the Leslie Bureau of Suffrage Education. During the last years of her life, she lived in Washington, D.C., at the headquarters of the AMERICAN ASSOCIATION OF UNIVERSITY WOMEN, an organization in which she remained active until her death.

Ida A. Husted Harper died in Washington, D.C., on March 14, 1931.

Harris v. Forklift Systems, Inc. (1993)

A 1993 Supreme Court decision broadly defining workplace sexual harassment, *Harris v. Forklift Systems, Inc.* was the Court's second on the subject.

In 1964 Congress passed the Civil Rights Act. Designed as a comprehensive attack on discrimination, the act contained a number of sections, or "titles," each of which addressed a different type of discrimination. Title I, for instance, forbids discrimination with regard to voting rights; Title II, with regard to places of public accommodation; and Title VI, with regard to federally assisted programs. All titles but Title VII forbid discrimination only on the basis of race, religion, or national origin; Title VII alone—forbidding employment discrimination—includes sex as a protected category. Section 703 of Title VII reads as follows:

(a) It shall be unlawful employment practice for an employer—

(1) to fail or refuse to hire or to discharge any individual, or otherwise to discriminate against any individual with respect to his compensation, terms, conditions, or privileges of employment, because of such individual's race, color, religion, sex or national origin . . .

The Court, in its 1986 decision in MERITOR SAVINGS BANK, FSB V. VINSON, found that sexual harassment could "alter the conditions of . . . employment" and concluded that a "plaintiff may establish a violation of Title VII by proving that discrimination based on sex has created a hostile or abusive work environment." In the years between *Meritor* and *Harris*, lower courts frequently required that the victim of sexual harassment prove psychological harm and/or an inability to maintain her job performance in the face of such harassment. However, the *Harris v. Forklift Systems, Inc.* opinion, written by Justice Sandra Day O'CONNOR, emphatically states that Title VII protection "comes into play before the harassing conduct leads to a nervous breakdown."

Teresa Harris' work environment and the actions she took in response were summed up by Justice O'Connor in her opinion:

Teresa Harris worked as a manager at Forklift Systems, Inc., an equipment rental company, from April 1985 until October 1987. Charles Hardy was Forklift's president.

. . . throughout Harris's time at Forklift, Hardy often insulted her because of her gender and often made her the target of unwanted sexual innuendos. Hardy told Harris on several occasions, in the presence of other employees, "You're a woman, what do you know" and, "We need a man as the rental manager"; at least once, he told her she was "a dumb ass woman." Again in front of others, he suggested that the two of them "go to the Holiday Inn to negotiate [Harris's] raise." Hardy occasionally asked Harris and other female employees to get coins from his front pants pocket. He threw objects on the ground in front of Harris and other women, and asked them to pick the objects up. He made sexual innuendos about Harris's and other women's clothing.

In mid-August 1987, Harris complained to Hardy about his conduct. Hardy said he was surprised that Harris was offended, claimed he was only joking, and apologized. He also promised he would stop, and based on this assurance Harris stayed on the job. But in early September, Hardy began anew: While Harris was arranging a deal with one of Forklift's customers, he asked her, again in front of other employees, "What did you do, promise the guy . . . some [sex] Saturday night?" On Oct. 1, Harris collected her paycheck and quit.

Harris then sued Forklift . . .

The United States District Court for the Middle District of Tennessee ruled that Harris had not worked in an abusive environment. While acknowledging that Hardy's statements "offended [Harris] and would offend the reasonable woman," the court did not find them "so severe as to be expected to seriously affect [Harris'] psychological well-being. A reasonable woman manager under like circumstances would have been offended by Hardy, but his conduct would not have risen to the level of interfering with that person's work performance." Continuing, the lower court judge stated: "Neither do I believe that

[Harris] was subjectively so offended that she suffered injury . . . Although Hardy may at times have genuinely offended [Harris], I do not believe that he created a working environment so poisoned as to be intimidating or abusive to [Harris]."

When the United States Court of Appeals for the Sixth Circuit in Cincinnati upheld the District Court decision, the Supreme Court grated certiorari, a discretionary review of a federal question, in order, as Justice O'Connor explained in her opinion, to settle the pressing question of "whether conduct, to be actionable as 'abusive work environment' harassment . . . must 'seriously affect [an employee's] psychological well-being' or lead the plaintiff to "suffe[r] injury . . ." The Court unanimously ruled that Title VII protection was violated "so long as the environment would reasonably be perceived, and is perceived, as hostile or abusive" and that psychological injury is "an element Title VII does not require." It then returned Harris' case to the appeals court for reconsideration pursuant to these guidelines. (In February 1995, the parties settled out of court and refused to release the terms of their agreements.)

Justices Antonin Scalia and Ruth Bader GINSBURG each filed a separate concurring opinion. Justice Ginsburg's, her first opinion issued as a Supreme Court justice, was especially interesting, since it seemed to reopen arguments she had presented to the Court as an attorney in the 1970s, *CRAIG V. BOREN* and *FRONTIERO V. RICHARDSON*. In a footnote, Justice Ginsburg shifted from consideration of Title VII to the Equal Protection Clause of the Fourteenth Amendment, stating that

> . . . even under the Court's equal protection jurisprudence, which requires an exceedingly persuasive justification for a gender-based classification, *KIRCHBERG V. FEENSTRA* (1981), it remains an open question whether classifications based upon gender are inherently suspect. See *MISSISSIPPI UNIVERSITY FOR WOMEN V. HOGAN* (1982).

At present, laws that discriminate by categorizing people by race, creed, or national origin are considered "inherently suspect" by the Court and can be upheld only if they are proven to serve a "compelling state interest" that cannot be assured in any other way. Discriminatory laws that categorize by sex are not subject to the same "strict scrutiny," something Ginsburg, as an attorney, repeatedly asked the Court to change (see *Frontiero v. Richardson* and *Craig v. Boren*).

By recalling *Mississippi University for Women* and raising questions about the level of scrutiny applied in that case, Justice Ginsburg seems to have used her first Supreme Court opinion to signal her continued view, as Linda Greenhouse of the *New York Times* summarized it,

". . . that discrimination on the basis of sex should be taken as seriously by the Court as discrimination on the basis of race . . ."

Further Reading: Baron, ed., *Soul of America;* Cary and Peratis, *Woman and the Law;* Greenhouse, "Court, 9–0, Makes Sex Harassment Easier to Prove: A Standard Is Set"; *Harris v. Forklift Systems Inc.,* 510 U.S. 17 (1993); Hoffman, "Plaintiffs' Lawyers Applaud Decision"; *Meritor Savings Bank, FSB v. Vinson.* 1986. 106. S. Ct. 2399; *New York Times,* February 10, 1995; O'Connor, "Women and the Constitution," in *Women, Politics and the Constitution,* ed. Lynn.

Hellman, Lillian Florence (1905–1984) *writer*

Born on June 20, 1905, in New Orleans, to Julia Newhouse Hellman and Max Hellman, Lillian Hellman was one of America's leading female playwrights.

Hellman attended public schools in New Orleans and New York City. She attended New York University from 1922 to 1924, leaving after two years to work as a reader of plays and film scenarios in the publishing and film industries. She married playwright and author Arthur Kober in 1925; following the couple's divorce in 1932, Hellman began living with detective-fiction writer Dashiell Hammett. Their relationship lasted thirty-one years (though on an off-and-on basis), and Hammett is often credited with helping Hellman to master her craft.

The Children's Hour, Hellman's first produced play, was first performed at Maxine Elliot's Theatre in New York City, on November 20, 1934. Based on a nineteenth-century Scottish libel suit, the play centers on the plight of Karen Wright and Martha Dobie, proprietors of a successful private girls' school who are accused of lesbianism by a spoiled, bored student. Widely acclaimed, the play was performed 691 times on Broadway and then taken on national tour.

The next play, *The Little Foxes,* was first produced on February 15, 1939, at the National Theatre in New York City. A tale of extreme greed and manipulation, this play revolves around the efforts of Ben and Oscar Hubbard and their sister, Regina Giddens, to extract money from Regina's husband, Horace, and ends with Regina coldly engineering Horace's death from a heart attack. *Another Part of the Forest,* first produced on April 12, 1944, at the Fulton Theatre in New York City, explores the childhoods of Ben, Oscar, and Regina Hubbard.

Hellman traveled to France and Russia in 1936, to Spain in 1937, and—as a guest of Stalin's government—to the Soviet Union in 1945. These trips and her well-known leftist politics brought Hellman before Senator Joseph McCarthy's House Un-American Activities Committee in 1952. She disdainfully told the committee that

she had no intention of cutting her conscience to fit the current fashion. She was not imprisoned during this time as Hammett was, but she was blacklisted and saw her income drop from $150,000 per year to nearly zero. Hellman discussed her experience during this period of American history in her memoirs, *Scoundrel Time* (1976).

Hellman's last two plays were *The Autumn Garden* (1951) and *Toys in the Attic* (1960). Each centers on people in midlife who confront both the despair of their lives and the seeming impossibility of effecting significant change.

Other plays include *Days to Come* (1936); *Watch on the Rhine* (1941); *The Searching Wind* (1944); and several adaptations of others' plays. Memoirs in addition to *Scoundrel Time* include *An Unfinished Woman* (1969); *Pentimento: A Book of Portraits* (1973); and *Maybe* (1980). Hellman also wrote for the film industry, including an adaptation of her own *The Little Foxes*. (Serious questions have been raised as to the accuracy of details in several of Hellman's memoirs.).

Hellman received many honors and awards, including two New York Drama Critics Circle Awards (1941 for *Watch on the Rhine* and 1960 for *Toys in the Attic*), two Academy Award nominations for screenplays (1941 for *The Little Foxes* and 1943 for *The North Star*), a National Book Award in Arts and Letters (in 1969 for *An Unfinished Woman*), and honorary degrees from a number of colleges and universities—including, in 1974, one from New York University.

Lillian Hellman died on June 30, 1984 in Martha's Vineyard, Massachusetts.

Further Reading: Clark, *Almanac of American Women in the 20th Century; Contemporary Authors,* vol. 33, 1984, and vol. 112, 1985; *Current Biography,* 1941 and 1960; Hellman, *An Unfinished Woman;* ———, *Collected Plays;* ———, *Pentimento: A Book of Portraits;* ———, *Scoundrel Time;* ———, *Maybe;* McHenry, ed., *Famous American Women; New York Times,* July 1, 1984 and November 12, 1998; Wright, *Lillian Hellman.*

Hesse, Eva (1936–1970) *artist*

Born on January 11, 1936, in Hamburg, Germany, to Ruth Marcus Hesse and Wilhelm Hesse, sculptor Eva Hesse was the first woman to receive a retrospective exhibit of her work at the Solomon R. Guggenheim Museum.

In November 1938 her parents, who feared for their Jewish daughters' safety during the Nazis ascent to power, hid the two girls with a Catholic family in Amsterdam. In 1939 the Hesses retrieved their children and fled with them to America. In New York, Ruth and Wilhelm

Hesse divorced. When her father remarried, Eva chose to join his household; her mother committed suicide in 1946.

Hesse attended New York City public schools and graduated from the School of Industrial Arts in 1952. She studied at Cooper Union from 1954 to 1957 and received her B.F.A. from Yale in 1959. She and sculptor Tom Doyle were married on November 21, 1961.

Hesse's first one-woman show featured her drawings and was held in March 1963 at the Allen Stone Gallery in New York City. The following year she accompanied her husband to Kettwig-am-Ruhr, Germany, where he had been offered space in which to work.

In 1965 Hesse returned to New York. Before the year was over, she had lost her father and faced the end of her marriage. She also had begun an incredible period of artistic development. In 1968 she had her first one-woman show of her sculptures at the Fischbach Gallery in New York City, and in 1969 the Museum of Modern Art, also in New York City, added one of her sculptures, *Repetition Nineteen,* to its collection.

Just as Hesse began to achieve success, she was diagnosed as having a cancerous brain tumor. She continued to work with unabated passion throughout a course of three operations and chemotherapy. On May 29, 1970, Eva Hesse died in New York City. A retrospective memorial exhibit of her work was held at the Solomon R. Guggenheim Museum in 1972.

Further Reading: Gula, "Eva Hesse"; Lippard, "Eva Hesse," in *Notable American Women,* ed. Sicherman et al.; *New York Times,* May 30, 1970.

Hill, Anita Faye (1956–) *lawyer*

Born in 1956, Anita Hill brought the issue of sexual harassment to unprecedented national attention when she claimed, in October 1991, that Supreme Court nominee Clarence Thomas had so harassed her in prior years.

Hill received her B.S. in psychology from Oklahoma State University in 1977 and her J.D. from Yale University in 1980. She was Thomas' assistant at the Office for Civil Rights of the U.S. Education Department from 1981 to 1982. When Thomas became the chairman of the EQUAL EMPLOYMENT OPPORTUNITY COMMISSION, Hill followed him there and worked with him until 1983, when she began to teach law at the Oral Roberts University. Hill began teaching at the University of Oklahoma in 1986 and became a tenured full professor in 1990.

When President George Bush nominated Thomas to the Supreme Court on July 1, 1991, Anita Hill was contacted by Senate staffers and aides in mid-August. She stated that she had been sexually harassed by Thomas but that she did not want her name cited. On September 19

Hill inquired as to the Judiciary Committee's disposition of her charges. Hill was told that, while Senators Joseph Biden, Howard Metzenbaum, and Ted Kennedy had been informed of the allegations, no other committee members would be informed unless she supported her claims with the use of her name. Hill authorized an FBI investigation and the internal use of her name on September 23; on September 26, Hill was told that her charges would be circulated among all members of the committee only upon her public disclosure of the alleged events. Hill refused to allow public disclosure. The Judiciary Committee, with only three of its members having knowledge of Hill's charges, then voted on September 27, 1992, 7–7 to send Thomas' nomination to the full Senate for confirmation.

The story of Hill's charges broke on National Public Radio on October 6, and the Senate canceled its vote on Thomas' confirmation. The following week, fully televised public hearings on Hill's charges began. According to Hill, Thomas badgered her for dates, described pornographic movies to her in great detail, and bragged about his sexual prowess. Thomas denied the charges and questioned the right of the Judiciary Committee to sit as a judge in the matter. Both Hill and Thomas brought believable character witnesses to the hearing. Americans argued passionately, not only about which of the parties they believed, but also about the severity of SEXUAL HARASSMENT as a problem for wage-earning women.

In the end, Thomas was confirmed by the slimmest of margins and on November 1, 1991, became the country's 106th associate justice. The fact that Hill's charges had not been fully aired within the committee—followed by the televised questioning of Anita Hill by an all-male Judiciary Committee—prompted many women to run for office in 1992. (See YEAR OF THE WOMAN for further discussion.)

Anita Hill is currently a professor of law, social policy and women's issues at Brandeis University.

Further Reading: *Times Union*, February 27, 1999; *Who's Who in America*, 48th ed., 1994.

Hishon v. King & Spalding (1984)

A 1984 Supreme Court decision which held that, as Sandra Day O'Connor later summarized it, "once a law firm makes partnership consideration a privilege of employment, the firm may not discriminate on the basis of sex in its selection of partners." The case centered on Title VII of the CIVIL RIGHTS ACT OF 1964, which makes it unlawful for any employer "to fail or refuse to hire or to discharge any individual, or otherwise to discriminate against any individual with respect to his compensation, terms, conditions, or privileges of employment, because

of such individual's race, color, religion, sex or national origin . . ."

Further Reading: Cary and Peratis, *Woman and the Law; Hishon v. King and Spalding*, 1984. 467 U.S. 69; O'Connor, "Women and the Constitution," in *Women, Politics and the Constitution*, ed. Lynn.

History of Woman Suffrage

A six-volume, 5,703-page history of the women's suffrage movement in the United States and other countries, which also incorporates chapters on the history of women generally.

The *History* was written and edited over the course of forty-one years by women who were themselves participants in the suffrage struggle. Elizabeth Cady STANTON, Susan B. ANTHONY, and Matilda Joslyn GAGE edited volumes 1, 2, and 3; Susan B. Anthony and Ida Husted HARPER, volume 4; and Harper, alone, volumes 5 and 6. These women represented the NATIONAL WOMAN SUFFRAGE ASSOCIATION (NWSA) and not the more conservative AMERICAN WOMAN SUFFRAGE ASSOCIATION (AWSA) during the early years of the *History*'s writing and the NATIONAL AMERICAN WOMAN SUFFRAGE ASSOCIATION rather than the more radical NATIONAL WOMAN'S PARTY during the writing of the last volumes. For this reason and because Lucy STONE, president of AWSA, cooperated only minimally with requests for information about her organization's activities, the *History* is a very full account of only half the story. It is nevertheless the fundamental primary source for the women's suffrage campaign, containing, in many instances, full minutes of meetings and copies of letters, speeches, court transcripts and decisions, congressional hearings and reports, and newspaper reports and editorials.

Volume 1, published in 1881, begins with a section entitled "Preceding Causes," written by Matilda Joslyn Gage. It examines, among other things, the negative impact of organized religion on women around the world; the accomplishments of women in England from 200 B.C. to the nineteenth century; the contributions of women both to the American Revolution and to the formation of what became the United States; women's attempts, in the early nineteenth century, to secure educational opportunities equal to men's; women's involvement in the abolitionist and temperance movements; and the cumulative, inspirational impact of the work of women writers such as Margaret FULLER, George Sand, and Charlotte Brontë on members of their own sex. Chapter 2, also written by Gage, explores women's work in the newspaper industry from 1702 to the middle of the nineteenth century in the United States and Europe. In Chapter 3, Gage traces the women's suffrage movement

in America from 1840 to 1861. Both the WORLD ANTI-SLAVERY CONVENTION and the SENECA FALLS CONVENTION are fully documented, and relevant events in New York, Ohio, Massachusetts, Indiana, Wisconsin, Pennsylvania, and New Jersey are recorded. Volume 1 also contains a copy of the eulogy delivered by Elizabeth Cady Stanton at NWSA's memorial service for Lucretia MOTT, and Stanton's and Clarina Howard Nichols' personal reminiscences of the suffrage movement during the years discussed. The volume concludes with another chapter written by Matilda Joslyn Gage entitled "Woman, Church and State," which examines women's position in pagan religions, describes the burning of witches as a political action against women, and, generally "show[s] woman's position under the Christian Church for the last 1,500 years."

Volume 2, published in 1881, picks up the suffrage struggle in 1861, just prior to the Civil War, and ends in 1876. Its chapters provide detailed information on women's contributions to the war effort, including the formation of the U.S. SANITARY COMMISSION, The Freedman's Bureau, and the NATIONAL WOMAN'S LOYAL LEAGUE; the formation and subsequent meetings of the AMERICAN EQUAL RIGHTS ASSOCIATION; the Kansas State Suffrage Campaign of 1867; the introduction of the FOURTEENTH and FIFTEENTH AMENDMENTs and the proposal of a women's suffrage amendment as a Sixteenth Amendment to the Constitution; the New York Constitutional Convention of 1867; the national Women's Rights Conventions of 1866, 1867, 1869, 1873, 1874, and 1875; a discussion of Francis Minor's resolutions stating that women were entitled to vote pursuant to the Fourteenth Amendment, Victoria WOODHULL's presentation of that viewpoint to Congress in 1871, Virginia MINOR's unsuccessful attempt to vote, and the Supreme Court decision, *MINOR V. HAPPERSETT*, which stated that the United States Constitution granted neither Minor nor any other American woman the right of suffrage. Susan B. Anthony's casting of a ballot in 1872 (along with 150 other women) and Anthony's subsequent arrest and trial also are described in detail, as are Illinois' refusal to admit Myra Bradwell to the bar and the Supreme Court decision, *BRADWELL V. ILLINOIS*, which stated that the Constitution granted Bradwell no right that Illinois had abridged. This volume concludes with a chapter concerning the American Woman Suffrage Association, compiled by Elizabeth Cady Stanton's daughter, Harriot Stanton BLATCH, from accounts published in AWSA's *WOMAN'S JOURNAL* and its predecessor, *The Agitator.*

Volume 3, published in 1886, begins in 1876 with the Centennial of the United States and the DECLARATION OF RIGHTS OF WOMEN written for that occasion, and concludes in 1885. With regard to activities on a federal level, NWSA's annual national conventions of 1877 through 1883 are recorded in detail, as are congressional hearings and debates and the many petition drives with regard to women's suffrage during these years. Activities and summaries of laws concerning women within the states of Massachusetts, Connecticut, Rhode Island, Maine, New Hampshire, Vermont, New York, Pennsylvania, New Jersey, Ohio, Michigan, Indiana, Illinois, Missouri, Iowa, Wisconsin, Minnesota, Dakota, Nebraska, Kansas, Colorado, California, and Wyoming (including the enfranchisement of women in 1870, when Wyoming was still a territory) are given in separate chapters. Another chapter outlines activities in fifteen other, less active states and the District of Columbia. Activities in the territories of Oregon, Washington, Idaho, and Montana are combined into one chapter. The International women's rights and suffrage movements are addressed as well, in chapters concerning women's situation in Canada, Great Britain, and Continental Europe. Volume 3 concludes with Elizabeth Cady Stanton's personal reminiscences of the years 1876 to 1885.

Volume 4, published in 1902, begins in 1884 and ends in 1900. It reviews some of the material presented earlier; records the speeches and proceedings at national conventions and other women's rights gatherings (including the successful negotiation of a merger of NWSA and AWSA into the National American Woman Suffrage Association [NAWSA]); notes the death of early suffragists, including Lucy Stone; outlines the activities of the American Woman Suffrage Association from 1884 to the 1900 merger; summarizes congressional hearings and actions; gives a state-by-state overview of the "Status of woman at close of the century," as evidenced by laws, progress toward political equality, and educational and employment opportunity. The founding, in 1888, of the INTERNATIONAL CONGRESS OF WOMEN is fully documented, and the situation of women at the close of the nineteenth century in great Britain, New Zealand, Tasmania, and many other countries is outlined. This volume concludes with a listing of the various women's rights organizations in existence by 1900 and a discussion of their goals and activities.

Volume 5, published in 1922, two years after ratification of the NINETEENTH AMENDMENT, focuses on the last twenty years of the suffrage struggle on a national and international level. In addition to the recording of NAWSA's convention proceedings during these years, it contains an overview of the struggle to have the Nineteenth Amendment passed by Congress and ratified by the necessary three-fourths of the states. It also describes the activities of other organizations both in support and in opposition to women's suffrage; the services rendered by the women's rights organizations during World War I; the efforts made during these years to make support for women's suffrage become part of the Democratic and

Republican party platforms; and the evolution of the National American Woman Suffrage Association into the LEAGUE OF WOMEN VOTERS.

Volume 6, also published in 1922, examines the same years—1900 to 1920—and the ratification of the Nineteenth Amendment on a state-by-state basis. It provides an update to volume 4's survey of the position of women in the various states, describes the ratification campaign waged in each state, and tallies each state legislature's final vote for or against ratification of the Nineteenth Amendment. It also outlines the status of women's rights and suffrage as of 1920 in the U.S. Territories and the Philippines; in Great Britain and its colonies; and in thirty other countries, including New Zealand, Australia, Canada, South Africa, India, Finland, Norway, Iceland, Sweden, Belgium, China, Japan, and Mexico. Finally, it documents in full the history of International Woman Suffrage Alliance and its congress and prints the complete text of the "MANIFESTO OF THE NEBRASKA MEN'S ASSOCIATION OPPOSED TO WOMAN SUFFRAGE."

Further Reading: Barry, *Susan B. Anthony;* Flexner, *Century of Struggle;* Frost and Cullen-DuPont, *Women's Suffrage in America;* Griffith, *In Her Own Right;* Harper, *The Life and Work of Susan B. Anthony;* Stanton, et. al., eds., *History of Woman Suffrage,* vols. I–VI.

Hispanic Women's Council

A Montebello, California–based organization working to empower Hispanic women, the Hispanic Women's Council (HWC) focuses on educational and career assistance. It conducts one-day seminars, entitled "Horizons," for teenagers and tries to provide these young women with role models or mentors before they enter the business world. For Hispanic women already involved in careers, the council conducts leadership training and career development seminars. In addition, the council maintains a scholarship program and publishes a quarterly report, *Hispa-News.*

Unlike many other organizations, the council requires each of its members to take a very active part in volunteer work; due in part to this strict requirement, the council currently is comprised of only 250 members.

Vice President Mary George is the current contact person for Hispanic Women's Council.

Further Reading: Brennan, ed., *Women's Information Directory.*

Homemakers Equal Rights Association

Founded in 1973 as Housewives for ERA, the Homemakers Equal Rights Association (HERA) is an organization of homemakers—some of whom also work for pay outside their homes—who support ratification of the EQUAL RIGHTS AMENDMENT (ERA). The organization emphasizes the importance of women's work within homes and demands that laws be changed where necessary to treat homemakers as full marital partners entitled to an equal share in marital assets.

HERA's other goal is to inform legislators and the public—and especially other homemakers—about the Equal Rights Amendment. Toward this end, it holds workshops and seminars and sponsors an active speakers' bureau. It also maintains a library devoted to Equal Rights Amendment information and publishes a quarterly *Newsletter.*

HERA maintains its offices in Voorhees, New Jersey, home of one of its cochairs, Nancy Jean Siegle, and has 2,000 members.

Further Reading: Brennan, ed., *Women's Information Directory.*

Hooker, Isabella Beecher (1822–1907) *suffragist*

Isabella Beecher Hooker was born on February 22, 1822, in Litchfield, Connecticut, to Lyman Beecher and his second wife, Harriet Porter Beecher. The family moved to Boston when Isabella was four years old, then relocated again, to Cincinnati, when Isabella was ten. She was educated in schools run and/or founded by her sister, Catharine BEECHER. On August 5, 1841, she married Thomas Hooker.

Hooker opposed her sister Catharine's antisuffrage views. In 1868 she helped to form the New England Woman Suffrage Association; the following year she organized the Hartford convention that led to the founding of the Connecticut Woman Suffrage Association, over which she presided as president until 1905. She published "A Mother's Letters to a Daughter on Woman's Suffrage," anonymously in 1868 and under her name in 1870, and was instrumental in passage of a Connecticut married woman's property bill in 1877.

Hooker traveled frequently to Washington, D.C., where she spoke in favor of women's suffrage before congressional hearings, at National Woman Suffrage Association conventions, and before the International Council of Women.

Isabella Beecher Hooker died in Hartford, Connecticut on January 25, 1907.

Further Reading: Boydston, Kelley, and Margolis, eds., *Limits of Sisterhood;* Frost and Cullen-DuPont, *Women's Suffrage in America;* Hooker, *Constitutional Rights of the Women of the United States;* ———, *Womanhood.*

Horney, Karen (Clementine Theodore Danielsen)
(1885–1952) *psychoanalyst*
Born Clementine Theodore Danielsen on September 16,
1885, in Hamburg, Germany, to Clotilde van Ronzelen
Danielsen and Berndt Danielsen, psychiatrist Karen Horney challenged the traditional Freudian biases against
women.

Horney received her medical degree from the University of Berlin in 1911. In 1909, before completing her
medical training, she and Oscar Horney were married;
the couple had three children and divorced in 1937.

Karen Horney briefly practiced medicine, but turned
in 1913 to the study of psychoanalysis under Karl Abraham, a disciple of Freud. She began working with clients in
1919 and in 1920 began a series of lectures on women's
psychology at the Berlin Psychiatric Clinic and Institute,
where she was later made the supervising analyst.

Horney treated many women and came to doubt
that their problems stemmed from the causes postulated
by Freud, most notably penis envy. In articles such as
"The Flight from Womanhood" (1926), "Distrust
Between the Sexes" (1931), and "The Dread of Woman"
(1932), Horney argued that women's psychological difficulties were more logically the result of male domination.
She also theorized that male envy of women's ability to
give birth was far more likely than female envy of the
male penis.

Immigrating to the United States in 1932, Horney
joined the Chicago Institute of Psychoanalysis as associate director. She returned to private practice in 1934 and
simultaneously became an instructor at the New York
Psychoanalytic Institute and the New School for Social
Research. In 1938 Horney became a naturalized citizen
of the United States. The following year she published
New Ways in Psychoanalysis, a book that was extremely
critical of Freudian psychology. As a result she was disqualified as an instructor by the New York Psychoanalytic Institute. In 1941, with Erich Fromm, Clara
Thompson, and Harry Stack Sullivan, Horney founded
the Association for the Advancement of Psychoanalysis
and its affiliated American Institute for Psychoanalysis;
she headed the latter until her death in 1952. Horney
was also the founding editor of the *American Journal of
Psychoanalysis.*

In addition to *New Ways in Psychoanalysis,* Horney's
works include *The Neurotic Personality of Our Time*
(1937); *Self-Analysis* (1942); *Our Inner Conflicts: A
Constructive Theory of Neurosis* (1945); *Neurosis and
Human Growth: The Struggle Towards Self-Realization*
(1950); and two posthumously published works, a collection of her papers entitled *Feminine Psychology* (1966)
and *The Adolescent Diaries of Karen Horney* (1980).

Karen Horney died on December 4, 1952, in New
York City.

Further Reading: *Contemporary Authors,* vol. 114,
1953; *Current Biography,* 1941 and 1953; Horney, *Neurotic Personality of Our Time;* ———, *New Ways in Psychoanalysis;* ———, *Our Inner Conflicts; New York Times,*
December 5, 1952; Schultz, *History of Modern Psychology.*

Hosmer, Harriet Goodhue (1830–1908) *artist*
Born on October 9, 1830, in Watertown, Massachusetts,
to Sarah Watson Grant Hosmer and James Hosmer, Harriet Goodhue Hosmer was one of the first recognized
female sculptors of the nineteenth century.

When Hosmer's mother and sister died of tuberculosis, her father insisted that she protect her health by
engaging in rigorous outdoor exercise; she quickly
learned to swim, shoot, skate, and jump horses. Upon
graduation from Mrs. Charles Sedgwick's School at
Lenox in the Berkshires, she studied anatomy with a St.
Louis physician. In 1852 she traveled to Rome to study
sculpture under John Gibson.

Her first commissioned work, *Oenone,* was completed
in 1856; her second, *Beatrice Cenci,* was completed in
1857 and delivered to the St. Louis Mercantile Library.
Her third work, a charming statue entitled *Puck,* was enormously popular: Fifty people, including the Prince of
Wales, purchased copies at a cost of $1,000 each. Her other
works include *Zenobia in Chains* (1859); *Sleeping Faun*
(1865); *Heroine of Gaeta* (1871); and a statue of Queen
Isabella (1894). As Hosmer's fame spread, so did rumors
that the quality of her work should properly be credited to
her workmen; when two English periodicals published
these rumors, Hosmer sued for libel, and received retractions. In December 1864—wishing to document her creative process and further stifle the rumors—she published
"The Process of Sculpture" in the *Atlantic Monthly.*

Hosmer's many friends and patrons included Robert
Browning and Elizabeth Barrett Browning, the actress
Fanny Kemble, members of the English aristocracy and
the continent's royal families. While her neo-classical
sculptures never lacked acclaim during the nineteenth
century, today's critics admire their deft execution more
than their creative vision.

Harriet Goodhue Hosmer died on February 21,
1908, in Watertown, Massachusetts.

Further Reading: Gerdts, *The White Marmorean Flock;*
Hosmer, *Letters and Memories;* McHenry, ed., *Famous
American Women;* Read and Witlieb, *Book of Women's
Firsts;* Thorp, "Harriet Goodhue Hosmer," in *Notable
American Women,* ed. James, James, and Boyer.

Howe, Julia Ward (1819–1910) *writer, suffragist*
First woman to be elected to the American Academy of
Arts and Letters, author of the "Battle Hymn of the

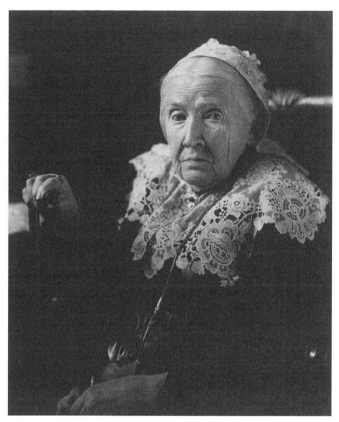

Julia Ward Howe, the first woman to be elected to the American Academy of Arts and Letters (*Library of Congress*)

Republic," and suffrage leader, Julia Ward Howe was born Julia Ward on May 27, 1819, in New York City to Julia Rush Cutler Ward and Samuel Ward, Jr. Educated by governesses, at schools for young ladies, and, after age sixteen, by a tutor, on April 23, 1843, she married Samuel Gridley Howe.

Her first book of poems, *Passion-Flowers,* was published anonymously in 1854. Her second, *Words for the Hour* (1857), was also published anonymously. She wrote two plays in 1857: *Leonora, or the World's Own,* which was produced to scathing reviews, and *Hippolytus,* which was not published until 1941. During the Civil War, Howe's "Battle Hymn of the Republic" was published in the *Atlantic Monthly* (February 1862); the poem, set to music and sung throughout the North, brought Howe a measure of fame.

After the Civil War, Howe helped Lucy STONE and others establish the AMERICAN WOMAN SUFFRAGE ASSOCIATION (1869). From 1870 to 1878 and from 1891 to 1893, she was president of the Massachusetts Woman Suffrage Association; she served as president of the New England Woman Suffrage Association from 1868 to 1877 and from 1893 to 1910. She was instrumental in

founding both the Association of Advancement of Women and the GENERAL FEDERATION OF WOMEN'S CLUBS.

She founded and edited the literary magazine *Northern Lights* (1867) and was a founder and assistant editor of the suffrage newspaper the *WOMAN'S JOURNAL* (1870). Her final publications were her biography of Margaret FULLER (1883) and her *Reminiscences* (1900). She was elected to the American Academy of Arts and Letters in 1908.

Julia Ward Howe died on October 17, 1910.

Further Reading: Boyer, "Julia Ward Howe," in *Notable American Women,* ed. James, James, and Boyer; Flexner, *Century of Struggle;* Frost and Cullen-DuPont, *Women's Suffrage in America;* Howe, *Julia Ward Howe and the Women's Suffrage Movement;* ———, *Mrs. Howe on Equal Rights;* ———, *Reminiscences;* ———, *Margaret Fuller;* Stanton, Anthony, and Gage, eds., *History of Woman Suffrage,* vol. 3.

Hoyt v. Florida (1961)

A 1961 Supreme Court decision that upheld a Florida law requiring women to register in order to be considered for jury duty. Since relatively few women took this step, all-male juries were the norm in Florida. Gwendolyn Hoyt was tried by one such all-male jury for the assault and murder of her husband with a baseball bat; her defense was that she had been enraged and driven temporarily insane by her husband's adultery. When Hoyt was found guilty, she appealed on the basis that Florida's female registration requirement had deprived her of a jury of her peers, in violation of the Fourteenth Amendment's equal protection clause.

The Supreme Court had ruled in 1880 that a state may "confine the selection [of jurors] to males" (*STRAUDER V. WEST VIRGINIA*) and in 1961 it declined to question the "continuing validity of this dictum . . . which has gone unquestioned for more than eighty years in the decisions of this Court." As Justice John Marshall Harlan's opinion explained:

"Despite the enlightened emancipation of women from the restrictions and protection of bygone years, and their entry into many parts of community life formerly considered to be reserved to men, woman is still regarded as the center of home and family life. We cannot say that it is constitutionally impermissible for a State, acting in pursuit of the general welfare, to conclude that a woman should be relieved from the civic duty of jury service unless she herself determines that such service is consistent with her own special responsibilities."

Thus, as Justice Sandra Day O'Connor later summarized the case, "the Court upheld the blanket excuse of all women from jury service."

The Supreme Court's 1975 decision in TAYLOR V. LOUISIANA finally reversed both *Strauder v. West Virginia* and *Hoyt v. Florida,* "put[ting] to rest the suggestion that all women should be exempt from jury service based solely on their sex and the presumed role in the home."

Further Reading: Cary and Peratis, *Woman and the Law;* Cushman, *Cases in Constitutional Law; Hoyt v. Florida.* 1961. 368 U.S. 57; O'Connor, "Women and the Constitution," in *Women, Politics and the Constitution,* ed. Lynn; *Strauder v. West Virginia.* 1880. 100 U.S. 303; *Taylor v. Louisiana.* 1975, 419 U.S. 522.

Huntington, Anne Vaughn Hyatt (1876–1973)
artist

Sculptor Anne Vaughn Hyatt Huntington was born on March 10, 1876, in Cambridge, Massachusetts, to Audella Bebe Hyatt and Alphueus Hyatt II.

Huntington received her education in private schools in Cambridge and, during the early 1900s, studied at the Art Students League. In 1923 she and Archer Milton Huntington were married.

Anna Hyatt Huntington's work was first shown in 1900 at the Boston Arts Club. While she sculpted many subjects found in nature, she was probably best known for her outstanding equestrian works, including two of a mounted Joan of Arc (one was placed alongside Riverside Drive in New York City), a wall sculpture of St. Joan for the Cathedral of St. John the Divine, also in New York City, and the *El Cid Campeador,* placed in Seville, Spain. Huntington disapproved of the abstraction she saw in modern art and continued to sculpt in a traditional manner throughout the 1950s and 1960s. One of her last works—unveiled in 1966 when she was ninety years old—was a monumental equestrian monument to the Revolutionary war hero General Israel Putnam.

Anna Hyatt Huntington died on October 4, 1973 in Redding Ridge, Connecticut.

Further Reading: *Current Biography,* 1953; Eden, "Anna Vaughn Hyatt Huntington," in *Notable American Women,* ed. Sicherman et al.; McHenry, ed., *Famous American Women; New York Times,* October 5, 1973.

Hurston, Zora Neale (1891–1960) *anthropologist, writer*

Born on January 7, 1891 (a recently discovered birth certificate has resolved long-standing confusion as to Hurston's actual date of birth), in Eatonville, Florida, to Lucy Potts Hurston and John Hurston, Zora Neale Hurston was an anthropologist and one of the foremost African-American writers of the 1930s and 1940s.

Hurston's early childhood in Eatonville—America's first incorporated all-black town—was a secure one. Her father, previously a tenant farmer in Alabama, was a leading figure in Eatonville, drafting its laws and serving three terms as mayor. She received her elementary education at the Hugerford School, which was directed by followers of Booker T. Washington and dedicated to fostering self-reliance as well as academic development.

This period of security came to a close when Hurston's mother died and her father remarried. Hurston was shuffled from one relative to another, and she soon went to live on her own, supporting herself through domestic service. She later managed to attend the Morgan Academy in Baltimore for a year (1917) and to study part time at Howard University from 1921 to

Author Zora Neale Hurston (*Library of Congress*)

1924. Awarded a scholarship to Barnard College, Hurston studied anthropology under Franz Boas and became the college's first African-American graduate when she received her B.A. in 1928.

Between 1927 and 1932 Hurston worked in America's Southern states and in the Caribbean as a social scientist and wrote several ethnographies. She was awarded a fellowship to pursue graduate studies at Columbia University in 1928, which she completed in 1930, and held teaching positions at two colleges, the Bethune-Cookman College of Daytona Beach, Florida (spring 1934) and the North Carolina College for Negroes (now North Carolina Central University) in Durham (1939).

In the end, however, Hurston devoted herself to the writing of fiction. Her first novel, *Jonah's Gourd Vine* (1934), combines her anthropologic knowledge of folklore with elements of her own early life. Hurston's second novel, *Their Eyes Were Watching God* (1937), is widely acclaimed as her best work. It follows a young black woman, Jamie, through her widowhood at forty and second marriage to a younger man.

Hurston's other works include *Mules and Men* (1935); *Tell My Horse* (1938); *Moses, Man of the Mountain* (1939); *Seraph on the Surwanee* (1948); and her autobiography, *Dust Tracks on a Dirt Road* (1942). During the 1950s, Hurston published essays—and one widely reprinted letter to a newspaper—in which she decried the move toward integration as a development that would cost the African-American community its own distinct culture.

Zora Neale Hurston died in poverty on January 18, 1960 in Ft. Pierce, Florida.

Further Reading: Faust, ed. *American Women Writers;* Hemenway, *Zora Neale Hurston;* Hurston, *Their Eyes Were Watching God;* ———, *I Love Myself When I'm Laughing;* McHenry, ed. *Famous American Women;* Showalter, Baechler, and Litz, eds. *Modern American Women Writers;* Walker, "In Search of Zora Neale Hurston"; ———, "Zora Neale Hurston: A Cautionary Tale and a Partisan View" and "Looking for Zora," both in *In Search of Our Mother's Gardens;* Wall, "Zora Neale Hurston," in *Notable American Women,* ed. Sicherman et al.

Hutchinson, Anne (ca. 1591–1643) *religious agitator*

Anne Marbury Hutchinson was born Anne Marbury ca. 1591 in Alford, England, to Bridget Dryden and Francis Marbury, an Anglican priest who had been imprisoned over religious matters. Anne and William Hutchinson were married on August 9, 1612; during the next twenty-one years, the couple had fourteen children,

twelve of whom survived. Anne Hutchinson's Puritan minister, John Cotton, left England and a hostile Anglican clergy for America in 1633. In 1634 the Hutchinsons followed. Their fifteenth child was born in Massachusetts Bay Colony in 1636.

Although the Puritans had left England and founded the Massachusetts Bay Colony in order to achieve religious freedom for themselves, they did not necessarily envision religious freedom and tolerance for others. The colony was, as historian Barbara Ritter Dailey aptly terms it, a "wilderness theocracy," with rigid, doctrine-driven rules. Women were expected to be circumspect and obedient. Anne Hutchinson was neither.

Shortly after her arrival in the colony, Hutchinson began to hold religious meetings of up to eighty men and women in her home. Puritan doctrine generally accepted "good works" as justification, or evidence, of an individual's election by God for salvation. Hutchinson outlined an alternate view that was loosely based on the "covenant of grace" preached by John Cotton—the idea that one might divine one's own selection for salvation through a spiritual consciousness that one felt saved. Angered by both Hutchinson's dissension and her religious meetings, the church elders conceded that "women might meet (some few together) to pray and edify one another" but rebuked the "one woman . . . [who] took upon her the whole exercise . . ." as "disorderly, and without rule." Hutchinson continued to hold her meetings and was summoned before the General Court in November 1637.

Although the actual charge was "Traducing the ministers and their ministry," it is clear from the surviving records that Hutchinson was tried for her "unwomanly" behavior as well as for her theological views. Outlining the charges, Governor John Winthrop said:

> Mrs. Hutchinson, you are called here as one of those that have troubled the peace . . . you have spoken of divers[e] things . . . very prejudicial to the honour of the churches and ministers thereof, *and you have maintained a meeting . . . that hath been condemned . . . as a thing not tolerable nor comely in the sight of God nor fitting for your sex . . .* [Emphasis added.]

Winthrop dismissed Hutchinson's extended and impassioned defense of her theological views, saying simply "We do not mean to discourse with those of your sex . . ." He then focused on the impropriety of a religious meeting led by a woman. Hutchinson objected, citing a "clear rule in Titus, that the elder women should instruct the younger . . ." Winthrop said Hutchinson should "take it in this sense that elder women must instruct the younger about their business and to love their husbands and not make them to clash." Hutchinson rejected that interpretation, declaring "it is meant for some publick

times," only to have Winthrop blame her for the undone housework in the Massachusetts Bay Colony: ". . . it will not well stand with the commonwealth that families should be neglected for so many neighbors and dames and so much time spent, we see no rule of God for this . . . And so what hurt comes of this you will be guilty of and we for suffering you."

In the end, Hutchinson was convicted largely due to her concluding—and heretical—statement that she knew through immediate revelation that God was preparing to vanquish her inquisitors. She was ordered banished, but permitted to stay within the colony until winter had passed.

Hutchinson continued to expound her views. She was tried a second time, before the Church of Boston. Cotton testified against her and outlined what he saw as the consequences of a woman's dissent: ". . . though I have not herd, nayther do I thinke, you have bine unfaythful to your Husband in his Marriage Covenant, *yet that will follow upon it*" (emphasis added). He ordered the other women of the colony to disregard Hutchinson's example and teaching, explaining "she is but a Woman and *many unsound and dayngerous principles are held by her*" (emphasis added). Hutchinson's theological views were denounced and she was excommunicated.

Unrepentant, Hutchinson moved first to Aquidneck Island in Narragansett Bay and, later, to New York, where she was killed by Indians in August 1643. However, as evidenced by Lyle Koehler's research, Hutchinson's removal did not end the Massachusetts Bay Colony's "problems" with its women: Katherine Finch "spoke against the magistrates, against the Churches, and against the Elders," and on October 10, 1638, was ordered whipped. Finch was later reprimanded for failure to perform "dutifully to her husband." Phillip[a] Hammond said in public that "Mrs. Hutchinson neyther deserved the Censure which was putt upon her in the Church, nor in the Common Wale" and was excommunicated in 1639. Sarah Keayne was excommunicated in 1646 for conducting her own religious meetings, with both sexes in attendance, and for "irregular[ly] prophesying." And in 1655 Joan Hogg was excommunicated for "disorderly singing and . . . saying she is commanded of Christ to do so."

Further Reading: Battis, "Anne Hutchinson," in *Notable American Women,* ed. James, James, and Boyer; Cullen-DuPont, "Anne Hutchinson's Trials," in *Great American Trials.* Knappman, ed., 232; Dailey, "Anne Hutchinson," in *Reader's Companion to American History,* ed. Foner and Garraty; Evans, *Born for Liberty;* Flexner, *Century of Struggle;* Hutchinson, *History of the Colony and Province of Massachusetts Bay,* rpt. in Cott, *Root of Bitterness;* Koehler, "Case of the American

Jezebels: Anne Hutchinson and Female Agitation during the Years of the Antinomian Turmoil, 1636–1640," rpt. in *Women's America,* ed. Kerber and Mathews; Morgan, *The Puritan Dilemma;* Winthrop, *Winthrop's Journal.*

Huxtable, Ada Louise Landman (1921–)
writer, journalist, Pulitzer Prize winner
Born Ada Louise Landman on March 14, 1921 in New York City, to Leah Rosenthal Landman and Michael Louis Landman, architecture critic Ada Louise Huxtable won the first Pulitzer Prize for distinguished criticism.

As she recalled during a 1969 interview for the *Christian Science Monitor,* she "always loved cities" and, even as a child, was "always . . . concerned about them." She attended the Wadleigh High School, a Manhattan school for art and music, and then Hunter College, from which she graduated magna cum laude. She did graduate work at New York University's Institute of Fine Arts, but left without the advanced degree when her proposal for a master's thesis on nineteenth- and twentieth-century Italian architecture was rejected. On March 19, 1942, she and industrial designer Garth Huxtable were married.

Ada Huxtable worked at the Museum of Modern Art as assistant curator of architecture and design from 1946 to 1950. She resigned from the museum to study in Italy on a Fulbright scholarship in 1950. In that year, she also became a contributing editor and writer for *Art in America* and *Progressive Architecture,* affiliations that lasted until 1963, when she became the *New York Times'* first architecture critic, a position she held for a decade. In 1973 she was appointed to the *Times* editorial board and began writing an architecture column for the paper's Sunday edition.

In 1965 Huxtable helped to create the Landmarks Preservation Commission for New York City. While she opposed the careless tossing aside of American heritage as evidenced by the tearing down of the original Pennsylvania Station, she just as strongly opposed efforts to freeze history in places such as the colonial re-creation at Williamsburg. "What preservation is really all about," she wrote in a July 14, 1968, article, "is the retention and active relationship of the buildings of the past to community's functioning present."

Huxtable published several books, including *Classic New York* (1964); *Will They Ever Finish Bruckner Boulevard?* (1970); *Kicked a Building Lately?* (1976); *The Tall Building Artistically Reconsidered: The Search for a Skyscraper Style* (1984); *Goodbye History, Hello Hamburger: An Anthology of Architectural Delights and Disasters* (1986); *Architecture Anyone?* (1986); and *The Unreal America* (1998). She received the newly created Pulitzer Prize for distinguished criticism in 1970. Among her other honors and awards are honorary membership in the

Royal Institution of British Architects, the Front Page Award of Newspaper Women's Clubs of New York for feature writing (1965), the New York State Council on the Arts Award (1967), and the Woman of the Year Award from the AMERICAN ASSOCIATION OF UNIVERSITY WOMEN.

Further Reading: *Art in America,* November 1998; *Architecture,* November 1998; *Christian Science Monitor,* April 9, 1969; *Current Biography,* 1973; *The Economist,* August 22, 1998; Huxtable, *Will They Ever Finish Bruckner Boulevard?;* ———, "On Design"; *New York Times,* May 7, 1970; Read and Witlieb, *Book of Women's Firsts.*

Illinois Women's Alliance

Established at the prompting of trade union women in 1888, the Illinois Women's Alliance was a coalition of thirty women's groups that sought to improve the working conditions of employed women and the educational prospects of their children. The alliance arranged for women "responsible to women's organizations" to inspect factories and demanded an improvement in sweatshop conditions. It also supported the elimination of child labor and the establishment of compulsory education programs. The alliance was particularly instrumental in the passage of an 1892 women's and children's eight-hour-day law that was also strongly endorsed by the GENERAL FEDERATION OF WOMEN'S CLUBS.

The organization was dissolved in 1894.

Further Reading: Evans, *Born for Liberty.*

Indigenous Women's Network

Founded in 1989, the Indigenous Women's Network (IWN) is dedicated to providing a public forum not only for Native American women but for indigenous women throughout the Western Hemisphere. It strives to bring the traditional cultural values of native women to the discussion of modern-day problems. The 300-member network sponsors a speakers' bureau, conducts research and educational programs, and publishes a semiannual maga zine, *Indigenous Woman.*

The Indigenous Women's Network maintains offices in Rapid City, South Dakota. Sandra Lopez is the organization's current contact person.

Further Reading: Brennan, ed., *Women's Information Directory.*

International Alliance for Women, The

Founded by Elizabeth Cady Stanton, Susan B. Anthony, and Carrie Chapman Catt in 1902, the International Alliance for Women was its leaders' response to what they considered a growing conservatism within the International Council of Women. The stated goal of the alliance was "to secure the enfranchisement of the women of all nations and to unite the friends of woman suffrage throughout the world in organized cooperation and fraternal helpfulness." Anthony, then eighty-four, was elected honorary president. The alliance's other original officers were: Catt, president; Anita Augspurg, first vice president; Millicent Garett Fawcett of London, second vice president; Rachel Foster Avery, secretary; Dr. Kathe Schirmacher of Paris, first assistant secretary; Johanna A. W. Naber of Amsterdam, second assistant secretary; and Miss Rodger Cunliffe of London, treasurer.

The alliance drafted, discussed, and adopted a Declaration of Principles reflecting its goals for women of all nations:

1. Men and women are born equally free and independent members of the human race, equally endowed with intelligence and ability and equally entitled to the free exercise of their individual rights and liberty.
2. The natural relation of the sexes is that of interdependence and cooperation and the repression of the rights and liberty of one sex inevitably works injury to the other and hence to the whole race.
3. In all lands those laws, creeds and customs which have tended to restrict women to a position of dependence, to discourage their education, to impede the development of their natural gifts and to subordinate their individuality have been based upon false theories and have produced an artificial and unjust relation of the sexes in modern society.

4. Self-government in the home and the State is the inalienable right of every normal adult and the refusal of this right to women has resulted in social, legal, and economic injustice to them and has also intensified the existing economic disturbances throughout the world.

5. Governments which impose taxes and laws upon their women citizens without giving them the right of consent or dissent which is granted to men citizens exercise a tyranny inconsistent with just government.

6. The ballot is the only legal and permanent means of defending the right to "life, liberty and the pursuit of happiness" pronounced inalienable by the American Declaration of Independence and accepted as inalienable by all civilized nations. In any representative form of government, therefore, women should be vested with all the political rights and privileges of electors.

The alliance was sometimes called the International Woman Suffrage Alliance. Subsequent conferences and congresses of the alliance were held in Copenhagen, 1906; Amsterdam, 1908; London, 1909; Stockholm, 1911; Budapest, 1913; and Geneva, 1920.

The delay between the 1913 and 1920 conventions was due to World War I. Because of the transport demands of returning U.S. soldiers, only twelve American women were granted passports and permission to attend in 1920. Carrie Chapman Catt's personal papers reflect her anguish at the drawn faces and apparent ill health of some of her alliance colleagues who had opposed the United States and its allies during the war; in her president's address, she said, "I believe had the vote been granted to women twenty-five years ago, their national influence would have so leavened world politics that there would have been no world war."

Delegates from thirty-six countries participated. As one reporter characterized it:

> from the first day to the last no sign or mark of ill-feeling or enmity was to be found. Not that the delegates forgot or disregarded the recent existence of the war . . . Their differences and their nations' differences were plain in their minds and they neither forgot nor wished to forget the ruined areas, the starving children and the suffering peoples of the world. They met differing perhaps profoundly in their national sentiment, their memories and their judgments but determined to agree where agreement could be found; to understand where understanding could be arrived at and to cooperate with the very best of their will and their intelligence in assuring the future stability of the world.

The alliance's stated goals for the women of the world were "equality, international understanding, and peace." As Sara Rix points out in *The American Women*

1990–91, those words found an echo years later in the "United Nations Decade for Women: Equality, Development and Peace."

Further Reading: Catt, Papers; Flexner, *Century of Struggle;* Frost and Cullen-DuPont, *Women's Suffrage in America;* International Alliance of Women, Constitution; Rix, ed., *American Woman 1990–91;* Stanton, Anthony, and Gage, eds., *History of Woman Suffrage,* vol. 6.

International Congress of Women

Founded in 1888 as part of the celebration of the fortieth anniversary of the Seneca Falls Convention, the International Council of Women, as the organization renamed itself in the early twentieth century, was the first attempt to forge "universal sisterhood."

The first congress was organized by Elizabeth Cady STANTON and Susan B. ANTHONY, leaders of the NATIONAL WOMAN SUFFRAGE ASSOCIATION. It was held on March 25, 1888, in Washington, D.C., and was attended by delegates from Canada, Denmark, England, Finland, France, India, Ireland, and Norway. Female representatives from American "Literary Clubs, Art Unions, Temperance Unions, Labor Leagues, Missionary, Peace and Moral Purity [anti-prostitution] Societies, Charitable, Professional, Educational and Industrial Associations" also attended. Lucy Stone and members of her American Woman Suffrage Association—long estranged from the Cady Stanton/Anthony faction of the women's movement—also attended.

Delegates gave a country-by-country report on the progress made by women and the difficulties facing them. Anthony gave an optimistic summary of American women's progress, saying that

> From a condition, as many of you can remember, in which no woman thought of earning her bread by any other means than sewing, teaching, cooking, or factory work, in these later years the way has been opened to every avenue of industry . . . Men have granted us . . . everything but the pivotal right . . . the right to vote.

Cady Stanton discussed the common, root experience of women from differing cultures:

> Whether our feet are compressed in iron shoes, our faces hidden with veils and masks; whether yoked with cows to draw the plow through its furrows, or [as in the United States] classed with idiots, lunatics, and criminals in the laws and constitutions of the State, the principle is the same . . . With the spirit forever in bondage, it is the same whether housed in golden cages with every want supplied, or wandering in the dreary deserts of life . . .

At the close of the first Congress, the delegates unanimously ratified sweeping resolutions, most of which were far ahead of the state of law or custom in the countries represented:

> . . . all institutions of learning and of professional instruction, including schools of theology, law and medicine, should . . . be as freely opened to women as to men, and . . . opportunities for industrial training should be as generally and as liberally provided for one sex as the other. The representatives of organized womanhood in this Council will steadily demand that . . . equal wages shall be paid for equal work; and . . . an identical standard of personal purity and morality [shall apply] for men and women.

The next several meetings of the International Council of Women took place in Berlin, 1896; London, 1899; Berlin, 1904; Toronto, 1909; Paris, 1913; and Rome, 1914. Its 100th anniversary meeting was held in Washington, D.C., in 1988.

Further Reading: Flexner, *Century of Struggle;* Frost and Cullen-DuPont, *Women's Suffrage in America;* International Congress for Women, London 1899; ———, "Report of the International Congress"; ———, "What is the International Council of Women?"; Rix, ed., *American Woman 1990–91;* Stanton, Anthony, and Gage, eds., *History of Woman Suffrage,* vol. 6.

International Ladies' Garment Workers' Union

Founded in 1900 in New York City, the International Ladies' Garment Workers' Union (ILGWU) was an American Federation of Labor (AFL) union with 173,000 members today.

Originally comprised of the women employed in the Triangle Shirtwaist factory, the ILGWU was dedicated to improving conditions in the garment-center sweatshops. It proved itself a formidable force in 1909, when 20,000 to 30,000 New York City shirtwaist workers—80 percent of whom were women—went on strike. Referred to as the Uprising of the 20,000 or, more simply, the Great Uprising, the strike brought its participants increases in their wages and the ILGWU a new prominence. (However, as the TRIANGLE SHIRTWAIST COMPANY FIRE of 1911 would demonstrate, the strike did not result in improved safety conditions.) By 1920 fully half of America's female garment workers were unionized, either through the AMALGAMATED CLOTHING WORKERS OF AMERICA (66,000 female members in that year) or the ILGWU (65,000 members).

One of the first successful and enduring unions to organize women, the ILGWU was at times less than even-handed in its treatment of men and women. For example, in 1913 (a year in which fully 50 percent of its membership was female), the ILGWU approved a contract between management and labor entitled "Protocol in the Dress and Waist Industry." The protocol institutionalized the division of labor that had evolved within the garment industry, reserving the most highly skilled and well-paying positions for men and opening only the less-skilled and lower-paying positions to women. (As a result, the most highly paid female worker earned less than the lowest-paid male.)

In general, however, the ILGWU has been an extremely positive ally of women working within the garment industry, securing to them both increased remuneration and improved safety conditions. Among its most recent activities were its 1989 protest of a U.S. Labor Department rule permitting home-based work in five garment industries, a rule that was upheld by a federal judge on December 7, 1989, but that the ILGWU feared would result in the exploitation of immigrant women, and its 1991 organization of a strike of Hispanic and predominantly Spanish-speaking workers at four El Paso, Texas, garment factories.

In 1995, the ILGWU merged with the Amalgamated Clothing Workers of America to form UNITE (UNION OF NEEDLETRADES, INDUSTRIAL AND TEXTILE EMPLOYEES). The new, 350,000-member organization is America's fourth largest manufacturing union.

Further Reading: Brennan, ed. *Women's Information Directory; Buffalo News,* July 9, 1995; Foner, *Women and the American Labor Movement: From Colonial Times to the Eve of World War One;* ———, *Women and the American Labor Movement: From World War One to the Present;* Kessler-Harris, *Out to Work;* Ries and Stone, eds., *The American Woman, 1992–1993;* Wertheimer, *We Were There.*

International Tribunal on Crimes Against Women

Intended to "reach and raise the consciousness of as many women in the world as possible regarding the extent and depth of the oppression that women suffer in a male dominated world," the International Tribunal on Crimes Against Women was held March 4–8, 1976, at the Palais des Congres in Brussels, Belgium. More than 2,000 women representing forty countries, including a delegation from the United States, participated.

Throughout four days, women from around the world testified about the oppression faced by female citizens in their respective countries. For example, women from Ireland, Portugal, Belgium, Italy, and France testified about the absence of legalized birth control and/or abortion—which they termed "forced motherhood"—

while the Puerto Rican delegation presented testimony about forced sterilization. Other women testified about the "persecution of nonvirgins and unmarried mothers" in Portugal and Brazil; "compulsory heterosexuality" and the "persecution of lesbians" in Norway, Germany, Mozambique, and other countries; "crimes within the patriarchal family" in Ireland, Tunisia, Canada, and other countries; "dual oppression by family and economy" in Austria, Northern Ireland, Canada, and other countries; "double oppression of third world women" in South Africa, the Middle East, and among the Aboriginal communities of Australia, the Vietnamese communities of France, and the Native and African-American communities of America; the "double oppression of immigrant women" in England and Switzerland; and the "double oppression of women from religious minorities" in Northern Ireland.

The largest block of testimony concerned violence against women, including rape, which was addressed by women from France, Denmark, Portugal, Holland, and Norway; battering, which was addressed by women from Scotland, England, and Holland; "forced incarceration in marriage," which was addressed by a woman from Ireland, a country in which divorce was then nearly impossible; clitoridectomy, excision, and infibulation, which was addressed by a woman from Guinea; and many other forms of violence suffered by women.

The tribunal condemned all oppression or control of women as a crime, regardless of any supposed cultural justification for the form of such oppression or control. The tribunal was concluded on INTERNATIONAL WOMEN'S DAY, March 8, 1976.

Further Reading: Russell and Van de Van, eds., *Crimes Against Women.*

International Women's Day

Initially inspired by women's struggles in the U.S. labor movement, March 8, International Women's Day, was established in 1911 and honored primarily in socialist countries until the late 1960s, when American celebrations reappeared on a grassroots level. In the United States, it is now incorporated into NATIONAL WOMEN'S HISTORY MONTH.

Two strikes inspired the day's creation. The first occurred on March 8, 1857, in New York City, when hundreds of female clothing workers protested against their working conditions and were summarily—and forcefully—disbanded by the police. On March 8, 1908, another group of female clothing workers took to the street with their own demand for improved working conditions, suffrage, and an end to child labor. Fifteen thousand strong, their slogan was "bread and roses," chosen

to signal a desire for more than the meager necessities of life. In their honor, the Socialist Party of America sponsored the first National Women's Day in America; Clara Zetkin, editor of *Die Gleichheit* (Equality), a socialist women's magazine in Germany, then proposed its adoption as International Women's Day. For the next fifty years, it was mostly celebrated in socialist countries.

Women's groups in the United States reintroduced International Women's Day locally in the late 1960s and early 1970s. Women's History Week in Sonoma County, California, first celebrated in 1978, was created around International Women's Day. That history week has since evolved into National Women's History Month, which is set in March in honor of International Women's Day.

Further Reading: Wertheimer, *We Were There: The Story of Working Women in America;* National Women's History Project, "March is Women's History Month"; Tuttle, *Encyclopedia of Feminism.*

International Women's Year

Upon suggestion of various women's groups with consultative status at the United Nations and upon subsequent recommendation of the U.N. Commission on the Status of Women, the U.N. General Assembly in 1973 declared 1975 International Women's Year (IWY).

A major outcome of IWY was an international women's conference, the first gathering of women from different countries to take place with government sponsorship. Attended by delegates representing 150 countries, the U.N. Conference of International Women's Year was held in Mexico City in 1975 and presided over by Kathryn Clarenbach. It exposed to the glare of the media some very fundamental differences between the goals of American feminists and their counterparts from other countries, many of whom sought improvements in their countries' economies and advances in family and child welfare prior to addressing the issue of women's equality. Common ground also was established, however, and both the Women's Voluntary Fund (since renamed the UNITED NATIONS DEVELOPMENT FUND FOR WOMEN, UNIFEM, it funds women's projects in the Third World) and the *International Women's Tribune* center (a clearinghouse for information regarding Third World women's projects, U.N. resolutions concerning women, and other international women's issues) grew out of the conference and surrounding events. Delegates also convinced the U.N. to designate 1976 to 1985 the Decade for Women and secured U.N. sponsorship of two additional conferences for the world's women: the 1980 conference held in Copenhagen and the 1985 conference held in Nairobi. A third conference was held in Beijing, China, in September 1995.

The NATIONAL WOMEN'S CONFERENCE of 1977, which was attended by 20,000 Americans, also was inspired by International Women's Year.

Further Reading: Davis, *Moving the Mountain;* Rix, ed., *American Woman 1990–91; Houston Chronicle,* October 1995; United Nations, *World's Women 1970–1990;* Wandersee, *American Women in the 1970s.*

Interstate Stalking Punishment Act of 1996

See ANTISTALKING LEGISLATION.

Jane (The Abortion Counseling Service of Women's Liberation)

Formed in 1969 as an outgrowth of the Chicago Women's Liberation Union and officially known as the Abortion Counseling Service of Women's Liberation, this group, code-named Jane, originally referred women to physicians willing to perform abortions, which were then illegal in the United States. When group members discovered that many of the so-called physicians were not licensed doctors, they began to train volunteers to perform the abortions themselves. This was intended as an act of political defiance as well as an effort to take fuller responsibility for the welfare of the pregnant women involved. In the years prior to legalized abortion, women in search of someone to perform the procedure would call the current contact, always named "Jane." Women received counseling and a thorough description of the abortion process before any final arrangements were made. Jane's 100 members performed approximately 11,000 abortions without a single fatality and disbanded in 1973, when the Supreme Court decision in ROE V. WADE legalized abortion.

Further Reading: Blakely, "Remembering Jane"; Garrow, *Liberty and Sexuality: The Right to Privacy and the Making of Roe v. Wade"*; Kaplan, *The Story of Jane: The Legendary Underground Feminist Abortion Service.*

Jane Club

A cooperative housing facility for young working women in Chicago, the Jane Club was established under the auspices of the Hull House Settlement on May 1, 1891.

Jane ADDAMS, a founder of Hull House, later wrote that the Jane House was inspired by an overheard conversation between two young women on strike from a shoe factory. Upset that workers' unpaid rent bills would soon force an end to the strike, one of the young women wished for "a boarding club . . . and then we could stand by each other in times like this." Hull House officials immediately rented and furnished two apartments and sublet them to young working women. Although Hull House refused to be reimbursed for the first month's occupancy and during times of extreme difficulty (such as a strike or layoff), it expected its young tenants to pay rent under ordinary circumstances.

Within three years, fifty women made their homes in Jane Club residences. In 1903 a private-sector benefactor had a new, modern building built for the club.

Further Reading: Addams, *Twenty Years at Hull-House.*

Jewett, Sarah Orne (1849–1909) *writer*

Born Theodora Sarah Orne Jewett on September 3, 1849, in South Berwick, Maine, to Frances Perry Jewett and Theodore Herman Jewett, Sarah Orne Jewett became a noted author of the nineteenth century.

Although she attended school sporadically due to frequent illness, she graduated from the Berwick Academy in 1865. Much of her time was spent with her father, a physician whom she accompanied on his rounds through the countryside. Jewett's observations of and empathy with her father's patients resulted in the fully felt characterization of everyday New Englanders that so marked her stories and novels.

Jewett published a short story, "Jenny Garrow's Lovers," in *The Flag of Our Union*, a Boston periodical, when she was just eighteen years old. Her first book-length collection of stories, *Deephaven* (1877), concerns two young women vacationing together in Maine. Her first novel, *A Country Doctor,* appeared in 1884; this novel—the story of a young women who declines a

marriage proposal in order to pursue a medical career—is Jewett's most overtly feminist work.

While Jewett made time to act as mentor for younger female writers, including Willa CATHER, and maintained many friendships, including her friendship with Annie Adams Fields, with whom she traveled and sometimes lived, she also was firm about creating the solitude necessary for her work: She once explained that a "cold selfishness of the moment for one's work sake" required that "you must throw everything and everybody aside at times." Her firmness resulted in a prolific output: *A Marsh Island* was published in 1866; *A White Heron, and Other Stories*, in 1886; *The Story of the Normans*, in 1887; the *King of Folly Island*, in 1888; *Betty Leicester: A Story for Girls*, in 1890; *Tales of New England*, in 1890; *Strangers and Wayfarers*, in 1890; *A Native of Wonby, and Other Tales*, in 1893; *Betty Leicester's Xmas*, in 1894; *The Life of Nancy*, in 1895; *The Country of the Pointed Firs*, in 1896; *The Queen's Twin, and Other Stories*, in 1899; and *The Tory Lover*, in 1901.

The Country of the Pointed Firs was classified by Willa Cather as one of three books (the other two were *The Scarlet Letter* and *Huckleberry Finn*) that would endure throughout American history, and it has since been acknowledged as Jewett's masterpiece. An evocative, lyrical work centered around an elderly herbalist, the book has both the qualities of a novel and a short story collection and, in Cather's words, contains "living things caught up in the open, with light and freedom and airspaces about them," stories that "melt into the land and the life of the land until they are not stories at all, but life itself."

Sarah Orne Jewett died on June 24, 1909, in the South Berwick house in which she had been born.

Further Reading: Berthoff, "Sarah Orne Jewett," in *Notable American Women*, ed. James, James, and Boyer; Carey ed. *Appreciation of Sarah Orne Jewett*; ———, *Sarah Orne Jewett*; Farrant, *Sarah Orne Jewett*; Faust, ed., *American Women Writers*; Gilbert, and Gubar, eds., *Norton Anthology of Literature by Women*; Jewett, *A Country Doctor*; ———, *The Country of the Pointed Firs*; Matthieson, *Sarah Orne Jewett*; Showalter, Baechler, and Litz, eds. *Modern American Women Writers*.

Johnson v. Transportation Agency, Santa Clara County (1987)

A 1987 Supreme Court decision finding that voluntary affirmative action plans that include sex in an effort to increase the numbers of women in traditionally male job categories do not violate Title VII of the 1964 Civil Rights Act. In its ruling in *Johnson*, the Court stressed that Santa Clara's affirmative action program was intended to "'attain' a balanced work force," rather than "to maintain [the type of] permanent racial and sexual imbalance" that Title VII was designed to combat. Title VII makes it unlawful for any employer "to fail or refuse to hire or to discharge any individual, or otherwise to discriminate against any individual with respect to his compensation, terms, conditions, or privileges of employment, because of such individual's race, color, religion, sex or national origin . . ."

Further Reading: Cary and Peratis, *Woman and the Law; Johnson v. Transportation Agency;* 1987. 197 S. Ct. 1442; O'Connor, "Women and the Constitution," in *Women, Politics and the Constitution*, ed. Lynn.

Jones, Mary Harris ("Mother") (1830–1930) *labor leader*

Born Mary Harris on May 1, 1830, in Cork, Ireland, to Helen Harris and Richard Harris, "Mother" Jones, as she became known, was an effective and widely known labor agitator and organizer of the late nineteenth and early twentieth centuries.

Richard Harris immigrated to the United States in 1835, and his family followed shortly thereafter. Jones attended public schools before engaging in work as a schoolteacher and dressmaker. In 1861 she and George Jones—a "staunch member" of the Iron Moulders' Union—were married; the couple had four children. Mary Jones lost her husband and all of her children in a yellow fever epidemic in 1867. Four years later, having struggled to support herself by working as a seamstress for wealthy families, she lost all her material belongings in the Chicago Fire of 1871.

Jones had become convinced while working as a dressmaker that America's labor conditions—and the gap between its rich and poor—were intolerable, and she began to offer assistance to organizing and striking workers in the late 1870s. From that point on, she lived on the move and, as she testified before Congress in 1903, with "no abiding place, but wherever a fight is on against wrong." She was involved in many significant strikes, including the American Railway Union's Pullman strike in 1894, the United Mine Workers coal miners' strike of 1894, the United Mine Workers anthracite (hard coal) strikes of 1900 and 1902, the strike of West Virginian coal miners in 1911–12, the garment and streetcar workers' strikes in New York City in 1915 and 1916, and the 1919 steel strike.

Her methods of providing support while garnering publicity were tremendously effective. During the 1897 strike, for example, she organized local women to supply food for the strikers and their families. During the same strike, she also organized the children of strikers into

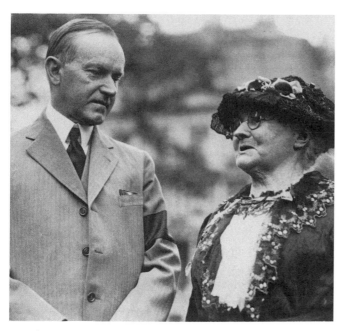

"Mother" Mary Harris Jones, a well-known labor agitator and organizer of the late nineteenth and early twentieth centuries, with President Calvin Coolidge (*Library of Congress*)

parades of visible supporters; one such parade was headed by a delegation of fifty young girls who carried signs with declarations such as "Our Papas Aren't Scared."

Jones repeatedly used dramatic tactics to bring the children of America's working class to national attention. In 1903, for example, seeking support for child labor legislation, Jones led child mill workers—many of whom were obviously malnourished or the victims of workplace accidents—on a weeklong march from the textile mills of Kensington, Pennsylvania, to President Theodore Roosevelt's Oyster Bay, New York, home.

Jones was arrested many times for her activities and served several jail sentences. She also came close to spending the last two decades of her life in prison: Following her threat to call in armed miners during the 1912–13 coal miners' strike, she was convicted of conspiracy to commit murder by a state militia court. When her sentence of twenty years' imprisonment was announced, a Senate investigation was instigated, but the governor, without waiting for the results, released the eighty-three-year old Jones.

On her one hundredth birthday, Jones summed up her life for the *New York Times* by saying "I wouldn't trade what I've done for what John D. Rockefeller has done. I've done the best I could to make the world a better place for poor, hard-working people."

"Mother" Mary Harris Jones died in her 100th year on November 30, 1930. On December 8, 10,000 to 15,000 people (counts vary) surrounded the Mount Olive, Illinois Roman Catholic church wherein her funeral services were conducted.

Further Reading: Fetherling, *Mother Jones;* Jones, *Mother Jones Speaks*, ed. Foner; ———, *Autobiography of Mother Jones.*

Jordan, Barbara (1936–1996) *congressional representative*

Born on February 21, 1936, in Houston, Texas, to Arlyne Jordan and Benjamin M. Jordan, Barbara Jordan became the first African-American woman from the South to win election to the United States House of Representatives.

As Jordan described her childhood in a *Washington Post* interview, "We were poor, but so was everyone around us, so we did not notice it. We were never hungry and we always had a place to stay." She attended the Phyllis Wheatley High School and was inspired to become a lawyer when Edith Sampson, an African-American lawyer, addressed the Wheatley students. Upon her graduation from high school in 1952, Jordan attended Texas Southern University, from which she graduated in 1956. In 1959 she received her LL.B. degree from Boston University and was admitted to the bar in Texas and Massachusetts. Jordan practiced law from her parents' dining room for three years before saving enough money for a more traditional office.

Jordan was unsuccessful in her first two political races, both attempts to win a seat in the Texas House of Representatives (1962 and 1964). In 1966 she ran as a candidate of the Democratic Party for election to the Texas Senate. She won, becoming the first African-American since 1883 and the first African-American woman to win admission to that body. During her first year as state senator, Jordan was chosen outstanding freshman senator. She became senate president pro tempore in 1972. In keeping with the Texan custom of "governor for a day," Jordan served in that position for twenty-four hours; following an official swearing in, Jordan became—however, briefly—the first African-American governor in the United States.

Jordan was elected to the United States House of Representatives in 1972. She became a member of the House Judiciary Committee and, as such, was one of thirty-eight representatives responsible for deciding whether articles of impeachment should be drawn up against President Richard M. Nixon in connection with what became known as Watergate. During this difficult but "cleansing" time, as Jordan referred to it, she

developed a reputation as a person of forceful intellect and iron-clad integrity.

Jordan once described her idea of "substantive" issues as questions concerning "how a person eats and sleeps and lives." Her record reflects these concerns and includes support for civil rights, educational, environmental, and health measures as well as for reduced military spending. She and Representative Martha W. Griffiths (D-MI) were the sponsors of a failed bill that would have granted Social Security coverage to American housewives based on their own domestic labor rather than their husbands' contributions to the Social Security system.

In 1976 Jordan became the first woman and the first African American to open the Democratic Convention and deliver its keynote address. She retired from Congress, after three terms, in 1978. Barbara Jordan next became a professor at the Lyndon Baines Johnson School of Public Affairs at the University of Texas in Austin in 1979. She was also involved in the "Teaching Tolerance" project of the Southern Poverty Law Center, which is designed to "honor diversity . . . reject both white and black racism . . . [and] teach our children tolerance." To do this, the project produces the "highest quality tolerance education materials" and provides them free of charge to elementary and secondary schools. In 1994, she advised the Clinton administration on immigration policy and received the Medal of Freedom from President Bill Clinton.

The Barbara Jordan Award, so named to honor Jordan, is bestowed annually by the Hollywood Women's Political Caucus.

Barbara Jordan died on January 17, 1996 in Austin, Texas.

Further Reading: *Christian Science Monitor,* March 18, 1974; *Current Biography Yearbook,* 1974; Jordan, Letter; Lanker, *I Dream a World;* Robinson, "Women Lawmakers on the Move"; Rogers, *Barbara Jordan; Ebony,* October 1972; *Washington Post,* October 22, 1972.

Joy Luck Club, The (1989)

Published in 1989, *The Joy Luck Club* is Amy Tan's novel about the lives of four Chinese-born women and their American daughters. The novel beautifully illuminates the bonds, misunderstandings, and distances that exist between mothers and daughters. It simultaneously charts a generational journey of women not only from China to America but across time: from a life in which a two-year-old girl may be promised in marriage, to one in which a daughter may grow to make her own—perhaps equally imperfect—choice.

A best-seller for nine months and the basis for a successful motion picture, *The Joy Luck Club,* like Maxine Hong KINGSTON's *The Woman Warrior,* helped to make Asian Americans and in particular Asian-American women and their story more visible in the media.

Further Reading: Tan, *Joy Luck Club.*

Junior Leagues

See ASSOCIATION OF JUNIOR LEAGUES INTERNATIONAL, THE.

Keller, Helen Adams (1880–1968) *crusader for the handicapped, writer, lecturer, feminist*

Born on June 27, 1880, in Tuscumbia, Alabama, to Kate Adams Keller and Arthur H. Keller, Helen Adams Keller was a writer, lecturer, and crusader for the handicapped as well as a feminist.

At nineteen months of age, Keller contracted an illness—probably scarlet fever—that left her blind and deaf. Alexander Graham Bell advised Keller's parents to contact the Perkins Institute for the Blind in Boston when Keller was six years old, and the institute arranged for Anne Mansfield Sullivan to become Keller's private teacher.

A remarkable individual, Anne Sullivan may be one of the few women in American history to become famous for assisting one other individual to reach his or her potential. Sullivan, a woman of twenty who had spent part of her life after being orphaned in a poorhouse—and who herself had been, and would again be, blind—arrived in the Keller household on March 3, 1887, a day Helen Keller would later refer to as her "soul's birthday." Sullivan was a gifted teacher. From her Keller learned to use Braille for reading and writing and to communicate with others by spelling words into their hands.

Keller entered Radcliffe College in 1900, accompanied by Sullivan, who spelled professors' lectures and the contents of textbooks into her student's hands. While still a college student, Keller published her autobiography, *The Story of My Life* (1903). By the time she graduated cum laude from Radcliffe in 1904, Keller was internationally perceived as an extraordinary example of the ability of humans to triumph over difficulties.

Keller was an ardent supporter of women's rights and endorsed the militant methods of British suffragist Emmeline Pankhurst over the more mainstream methods of Carrie Chapman CATT. Explaining her views in the New York *Call* in 1915, she said:

there are no such things as divine, immutable, or inalienable rights. Rights are things we get when we are strong enough to make good our claim to them. Men spent hundreds of years and did much hard fighting to get the rights they now call immutable and inalienable. Today women are demanding rights that tomorrow nobody will be foolhardy enough to question . . .

She also supported Margaret SANGER's efforts to reform birth control laws.

Helen Keller, seated on the left, with her teacher and friend Anne Sullivan (*Library of Congress*)

133

In 1924, shortly after the American Foundation for the Blind was established, Keller became the foundation's adviser and one of its most successful fund-raisers. She lobbied Congress for legislation beneficial to the blind and was instrumental in securing passage of the Pratt Bill, which established and funded reading services for the blind. In addition to her autobiography, Keller wrote a number of poems and essays as well as several other books. They include *Optimism* (1903), *The World I Live In* (1909), *Midstream* (1929), *Helen Keller's Journal* (1938), and her tribute to Anne Sullivan, *Teacher* (1955).

Helen Keller died on June 1, 1968 in New York City.

Further Reading: Keller, *Story of My Life*; ———, *World I Live In*; ———, *Optimism*; ———, "Modern Woman"; Lash, "Helen Keller," in *Notable American Women*, ed. James, James, and Boyer; McHenry, ed., *Famous American Women*; Payne, *Between Ourselves*.

Kelley, Florence Molthrop (1859–1932) *social reformer*

Born on September 12, 1859, in Philadelphia, to Caroline Bartram Kelley and William Darrah Kelley, Florence Molthrop Kelley became an important social reformer.

Kelly suffered ill health as a child, and her early education was received at home. Kelley gained an early and strong sense of social justice from her father, a founding member of the Republican party, a staunch abolitionist, and a member of Congress.

Kelley graduated from Cornell University in 1882 but because of her sex, was refused admission to the University of Pennsylvania, where she wished to pursue graduate work. Denied the chance to fulfill her own educational goals, she began to teach evening classes for Philadelphia's working women. During travel through Europe in 1883, Kelley met M. Carey Thomas, who would later become the president of "SEVEN SISTER" college Bryn Mawr. Inspired by Thomas to explore all possible means of continuing her education, Kelley enrolled at the University of Zurich (the first European university to admit women). She continued to pursue educational goals even after becoming an active reformer: She attended Northwestern University law school, graduating and gaining admission to the bar in 1894.

Her career as a reformer began in 1891, when she joined Jane ADDAMS at the Hull House settlement. In 1898 she became the secretary-general and head of the National Consumers' League (see CONSUMERS LEAGUES), a position she retained until her death in 1932. In that capacity, she helped to create sixty-four local leagues—all of which were dedicated to purchasing household goods manufactured and sold under safe conditions—and maintained close ties with each association through extensive annual travel. Kelley and the consumers leagues were also strong supporters of PROTECTIVE LABOR LEGISLATION, or legislation designed to provide special work conditions for women. Kelley worked closely with the consumers' league in Oregon to help defend a challenge to the ten-hour-day for women in 1908. The case, *Muller v. Oregon*, was heard by the Supreme Court which, to Kelley's delight, upheld restricted work hours for women as constitutional. Later, in the 1920s, Kelley was bitterly angry that the Supreme Court began to find protective legislation for women unconstitutional on the grounds that women's newly won right to suffrage negated their need for special workplace protection (see ADKINS V. CHILDREN'S HOSPITAL). At that point, an exasperated Kelley demanded to know why "seals, bears, reindeer, fish, wild game in the national parks, buffalo, migratory birds, [are] all found suitable for federal protection; but not the children of our race and their mothers?"

Florence Kelley was instrumental in introducing the minimum wage to America, beginning her campaign of published articles and public addresses in 1909 and attracting national attention with a 1911 speech on the subject before the National Conference of Charities and Corrections. To her gratification, and in large measure as a result of her efforts, nine states passed minimum wage laws by 1913.

A tireless opponent of child labor, Kelley, with Lillian WALD, organized the New York Child Labor Committee in 1902. She and Wald also helped to establish the National Child Labor Committee in 1904 and were instrumental in the 1912 creation of the federal Children's Bureau. A strong supporter of accessible prenatal and maternal care, she helped to secure passage of the SHEPPARD-TOWNER MATERNITY AND INFANCY PROTECTION ACT OF 1921. In addition to her other activities and accomplishments, Kelley was a founder of the National Association for the Advancement of Colored People (1909), a member of Eugene V. Debs Socialist Party of America (from 1912 to her death in 1932), a founder of the Women's International League For Peace And Freedom (1919; see WOMAN'S PEACE PARTY); and, for a number of years, the vice president of the NATIONAL AMERICAN WOMAN SUFFRAGE ASSOCIATION.

Florence Kelley died on February 17, 1932 in Philadelphia.

Further Reading: Blumberg, *Florence Kelley*; Goldmark, *Impatient Crusader*; Kelley, *Some Ethical Gains Through Legislation*; ———, *Persuasion or Responsibility*; ———, *Twenty-Five Years of the Consumers' League Movement*; ———, *Wage-Earning Women in War Time*; ———, *What Women Might Do With the Ballot*; ———, *Women in Industry*; ———, *Women in Trade Unions*; ———, *Woman Suffrage*; McHenry, ed., *Famous American Women*; Wade, "Florence Kelley," in *Notable American Women*, ed. James, James, and Boyer.

Kingston, Maxine Hong (1940–) *writer*

The author of the ground-breaking and award-winning autobiography, *The Woman Warrior*, was born Maxine Hong in 1940 to immigrant Chinese parents. Her parents, as depicted in *The Woman Warrior*, owned a laundry and were suspicious of all non-Asians, whom they referred to as "ghosts." Kingston spent her childhood enclosed in this world, which was defined by her parents' transplanted Chinese culture. In 1958 she attended the University of California, from which she graduated with a bachelor's degree. Hong married Earll Kingston in 1962.

The Woman Warrior beautifully chronicles Kingston's journey from her parents' past to her own chosen present, mingling old stories that become Kingston's own with her life as an American woman. Published in 1976, it was awarded the 1976 National Book Critics Circle Award for nonfiction.

China Men was published in 1980, *Tripmaster Monkey*, in 1989.

See also *JOY LUCK CLUB, THE*.

Further Reading: Kingston, *The Woman Warrior*; ———, *China Men*; ———, *Tripmaster Monkey*.

Kirchberg v. Feenstra (1981)

In 1981 the Supreme Court overturned, on Fourteenth Amendment grounds, a Louisiana law granting husbands the right to manage and sell jointly held property without their wives' approval, based on this case, which involved a woman whose husband had mortgaged their jointly owned home without her consent.

Further Reading: Cary and Peratis, *Woman and the Law;* Cushman, *Cases in Constitutional Law;* Goldstein, *The Constitutional Rights of Women; Kirchberg v. Feenstra*, 1981. 450 U.S. 455; O'Connor, "Women and the Constitution," in *Women, Politics and the Constitution*, ed. Lynn.

Kirkpatrick, Jeane J. (1926–) *ambassador*

Born Jeane Jordan on November 19, 1926 in Duncan, Oklahoma, Jeane Kirkpatrick became the United States' first female ambassador to the United Nations.

Kirkpatrick graduated from Stephens College with an A.A. in 1946 and from Barnard with a B.A. in 1948. She received both her master's and doctoral degrees from Columbia University in 1950 and 1968, respectively. In February 1955 she and Dr. Evron M. Kirkpatrick were married.

From 1956 to 1962 Kirkpatrick worked as a research associate with the Fund for the Republic, specializing in the study of communism. During this time she also acted as a consultant to the U.S. departments of Defense,

Jeane Kirkpatrick, the United States' first female ambassador to the United Nations (*Library of Congress*)

State, and Health, Education, and Welfare. She became an assistant professor of political science at Trinity College in 1962 and became an associate professor of political science at Georgetown University in 1967. In 1978 she became Georgetown's Leary Professor in the Foundation of American Freedom.

Kirkpatrick expressed strong anti-Communist views in articles published in the *APS Review*, the *New Republic*, and other publications. In 1972 she ran as a candidate of the Democratic Party for election to the House of Representatives from Maryland. She was defeated, but later made a close examination of fifty women who were elected in that year to *state* legislatures. In 1974 that study, *Political Women*, was published. *The New Presidential Elite* was published in 1976 and *Dismantling the Parties*, in 1978. In the latter book, Kirkpatrick described what she saw as the negative impact of single-issue

groups upon the country's major political parties and, ultimately, on America's political system itself.

During the presidency of Jimmy Carter, Kirkpatrick—herself a Democrat and originally a supporter of Carter—drew wide notice with a 1979 article published in *Commentary*. The article, entitled "Dictatorships and Double-Standards," gave a scathing review of Carter's handling of foreign policy. She then broke with other Democrats to support Ronald Reagan in his successful campaign for the presidency. She would become a registered Republican in 1985.

In January 1981 President Reagan appointed Kirkpatrick the United States' chief delegate to the United Nations. During her hearing before the Senate Foreign Relations Committee, Kirkpatrick said that she planned to present the new administration's views and decisions without "bluster" at the United Nations. She was confirmed on January 29, 1981.

During her tenure, Kirkpatrick opposed the imposition of economic sanctions against South Africa as a method of ending its practice of apartheid, and she endorsed the administration's support of the military junta in El Salvador. Others within Reagan's administration disagreed with Kirkpatrick's views, and strife between Kirkpatrick and other members of Reagan's administration became chronic by 1983. Although differences of opinion on foreign policy matters were certainly central to the widely reported disagreements, sexism also played a part. When other, male members of the administration characterized Kirkpatrick as "too temperamental," she said she viewed it as a "classic male sexist charge." She elaborated at a meeting of the Women's Forum, a New York political and women's group, saying that "sexism is alive in the U.N., in the U.S. government, in American politics." (In 1995, charges of sex discrimination made by women at the United Nations were investigated, and the secretary-general's office subsequently issued targets for the improved appointment and promotion of women.)

On January 30, 1985, Kirkpatrick announced her resignation from her post as U.S. ambassador to the United Nations and her return to Georgetown University. In 1996, she served as an adviser to Bob Dole's presidential campaign; most recently she served as the principal foreign policy adviser to Elizabeth Dole's 1999 primary campaign. Jeane J. Kirkpatrick is currently a senior fellow at the American Enterprise Institute.

Further Reading: Associated Press, June 25, 1999; Clark, *Almanac of American Women in the 20th Century; Current Biography,* 1982; Davis, *Moving the Mountain;* Kirkpatrick, *New Presidential Elite;* ———, *Dismantling the Parties; New York Times,* January 30, 1981; August 21, 1991.

Kreps, Juanita Morris (1921–) *secretary of commerce, director of the N.Y. Stock Exchange*
The first female director of the New York Stock Exchange and the first woman to serve as secretary of commerce, Kreps was born on January 11, 1921 in Lynch, Kentucky. She graduated from Berea College (Kentucky) in 1942 and received her M.A. and Ph.D. in economics from Duke University in 1944 and 1948, respectively. She married fellow economist Clifton H. Kreps in 1944.

From 1945 to 1955, Kreps taught economics at several institutions, including Hofstra College and Queens College. In 1955, she began teaching at Duke University. She became a full professor at Duke in 1968 and the James B. Duke professor of economics in 1968. She was the university's assistant provost from 1969 to 1972, and its vice president from 1973 to 1977. From 1972 to 1977, she was also chairperson of the New York Stock Exchange Board of Directors, the first woman to so serve.

Kreps published *Sex in the Marketplace: American Women at Work* in 1971 and *Sex, Age and Work* in 1975. Both books examined women's evolving place in the workforce, a subject she explored further by organizing the 1975 conference entitled "Women and the American Economy." The year after this conference, she edited a collection of writings on the subject, entitled *Women and the American Economy* (1976). Her other books include *Principles of Economics* (with Charles E. Ferguson, 1962), *Taxation, Spending, and the National Debt* (1964), *Lifetime Allocation of Work and Leisure* (1971), *Economics of Stationary Populations* (1977), and *Contemporary Labor Economics and Labor Relations* (1980).

President Jimmy Carter appointed Kreps secretary of commerce and she was confirmed by the U.S. Senate on January 20, 1977. Kreps described her goals in terms of making an economic policy contribution, and "maybe one that made a difference in the image of professional women." She established the President's Interagency Task Force on Women Business Owners and encouraged women—who then owned only 4.6% of U.S. businesses—to become entrepreneurs. An early proponent of family-friendly policies, Kreps publicly urged businesses to support flextime and maternity and paternity leaves.

Kreps' husband had not been able to follow her to Washington; citing personal reasons, she resigned in 1979 and returned to her professorship at Duke University. Although she has since retired from teaching, she continues to serve at Duke University as vice president emeritus.

Further Reading: Clark, *Almanac of American Women in the 20th Century; Encyclopedia of World Biography;* "Her Own Woman," *Time;* Langway and Thomas, "The Cabinet"; *Los Angeles Times,* July 24, 1977.

labor movement, women's participation in

Women's participation in the United States labor movement began in 1824 when 102 female textile workers in the Pawtucket, Rhode Island, mills, angered by wage cuts and increased work hours, walked out with their male coworkers and became the first women to join a strike. In 1828, 400 women employed in a Dover, New Hampshire, cotton mill, in opposition to tardiness fines, became the participants in the first all-female strike in America. Female factory workers in Lowell, Massachusetts, struck twice in two years: In 1834 a woman objected to a wage cut of 25 percent; she was disciplined for her protest, and almost 1,000 girls and women followed when she walked out. In 1836 Lowell's female textile workers again marched through the streets, this time singing

> Oh, isn't it a pity
> that such a pretty girl as I
> Should be sent into the factory
> to pine away and die?

During the 1830s the first known women's labor unions were formed, the UNITED TAILORESSES SOCIETY of New York and the Shoe Binders of Lynn, Massachusetts among them. These early unions failed to thrive, but a later Lowell organization, the LOWELL FEMALE LABOR REFORM ASSOCIATION (LFLRA), founded in 1844 by Sarah Bagley, was active until 1947. In response to petitions collected by LFLRA, the Massachusetts House of Representatives Committee on Manufacturing held the first government investigation of labor conditions in the United States. The investigation commenced on February 13, 1845, and Sarah Bagley and other textile workers testified on behalf of a ten-hour work week. When the committee did not endorse a ten-hour work day (see appendix no. 11 for the committee report), LFLRA

organized another petition drive in 1846, which also was unsuccessful. (Massachusetts finally enacted a ten-hour work week law thirty years later, in 1874.)

Following the Civil War, the African-American washerwomen of Jackson, Mississippi, organized in an attempt to secure higher wages. They published a letter to the mayor in the *Daily Clarion* in June 1866 that stated:

> . . . That on and after the foregoing date, we join in charging a uniform rate for our labor, and any one belonging to the class of washerwomen, violating this, shall be liable to a fine regulated by the class. We do not wish in the least to charge exorbitant prices, but desire to be able to live comfortably if possible from the fruits of our labor . . . The prices charged are:
> $ 1.50 per day for washing
> $15.00 per month for family washing . . .

No record of the washerwomen's success or failure exists.

It was also after the Civil War that the first national unions to include women were established. A cigar makers union was founded in 1867 and a printers union in 1869. Beginning on a local level, the female shoemakers of Lynn, Massachusetts, unionized separately from the town's male shoemakers; their union, the DAUGHTERS OF ST. CRISPIN, was founded in 1869 and was a national organization for several years.

In 1881, 3,000 washerwomen in Atlanta, Georgia, called the "Washing Amazons" by the editors of the *Atlanta Constitution,* struck for higher wages. Although they were joined by some of the city's cooks and other domestic workers, their strike was unsuccessful. The following year, however, there was a breakthrough for laboring women. In 1882 the Knights of Labor, which had begun as a clandestine fraternal organization, began working for reform in the open and invited women to join.

These labor union strikers won a forty-hour work week and a minimum weekly pay of $20.00 in 1937. (*Library of Congress*)

In the second half of the nineteenth century, it was common for workers of both sexes and all ages to work from ten to sixteen hours per day. Eight Hour Leagues, which included thousands of women, worked to reduce the workday to eight hours. They were more successful than their predecessors in the Lowell Female Reform Association: On May 1, 1886 (now International Workers Day), 350,000 workers nationwide temporarily abandoned their positions and won, in many cases, reduced work hours.

The early twentieth century saw the establishment of garment-industry unions, the INTERNATIONAL LADIES' GARMENT WORKERS' UNION, founded in 1900, and the AMALGAMATED CLOTHING WORKERS OF AMERICA, founded in 1914, both of which prominently included women in their membership. In 1909 New York City shirtwaist workers, beginning with those in the Triangle Shirtwaist Company, conducted a thirteen-week strike in which 20,000 (or even 30,000, depending on the source) took part. Eighty percent of the participants in what became known as the Uprising of the 20,000, or

simply as the Great Uprising, were female. (Some women were beaten by the police, and 600 were arrested.) During the strike, members of the NATIONAL WOMEN'S TRADE UNION LEAGUE, a labor-support coalition of middle-, upper-, and working-class women formed in 1903, furnished bail, court testimony regarding police abuse, and other assistance to the strikers. When the strike ended, the International Ladies' Garment Workers' Union had unionized workers in about 300 garment factories, and many workers had won reduced hours and higher wages. (Safety conditions were not improved, however; see TRIANGLE SHIRTWAIST COMPANY FIRE.)

Strikes of textile workers followed in Philadelphia (1910), Chicago (1911), and, most notably, in Lawrence, Massachusetts. The Lawrence strike began on January 12, 1912, and involved more than 23,000 workers, half of whom were women and children. The strike drew national attention when Elizabeth Gurley FLYNN and Margaret SANGER, both affiliated at the time with the Industrial Workers of the World, helped the mothers of Lawrence find temporary homes in Philadelphia for their hungry and frightened children. The strike lasted two months and won its participants a 20 percent increase in wages.

Following both world wars, there was an increase in unionization and in the number of strikes involving women. These strikes included an April 1919 strike of 8,000 telephone employees; a 1937 strike of the predominantly female Woolworth Retail Clerks Local 1250; and the 1974–75 strike of immigrant Chinese workers, including 135 women, against the Great American Sewing Company.

Unionized workers have become a smaller portion of the workforce over the last quarter of the century, and strikes have become a less frequent means of trying to improve worker compensation and employment conditions. However, one primarily female union, the Flight Attendants Union, seems to have won concessions as a result of its November 1993 strike; following the intervention of President Bill Clinton, the parties held negotiations and resolved the union's complaints of low wages and inferior security.

Further Reading: Flexner, *Century of Struggle;* Foner, *Women and the American Labor Movement: From Colonial Time to the Eve of World War I;* ———, *Women and the American Labor Movement: From World War I to the Present;* Frost and Cullen-DuPont, *Women's Suffrage in America;* Kessler-Harris, *Out to Work;* Sterling, *We Are Your Sisters;* Wertheimer, *We Were There.*

Ladies Association of Philadelphia
The earliest-known women's relief organization of the new American nation, this organization was established

by Esther De Berdt Reed in 1780 to provide clothing and other supplies to soldiers fighting under George Washington in the American Revolution. What began as Reed's locally circulated request for an "offering of the Ladies" became a national sewing and fund-raising effort. The wives of eminent revolutionary men—including the wife of Thomas Jefferson, Martha Wayles Jefferson—were among the most active members of the Association. In Pennsylvania, after asking General Washington what his troops most needed, the Ladies made 2,005 linen shirts for the colonial patriots. (Each woman embroidered her name on the result of her handiwork.) The association quickly became known as George Washington's Sewing Circle.

Esther De Berdt Reed died in 1780, before the war's end. Benjamin Franklin's daughter, Sarah Franklin Bache, became the next leader of the Ladies Association.

The full text of a Ladies Association of Philadelphia broadside, dated 1780, is included in the appendix, document no. 6.

Further Reading: Adelman, *Famous Women;* Bruce, *Women in the Making of America;* Ellet, *Women of the American Revolution,* vol. 1; Leonard, Drinker, and Holden, *American Women in Colonial and Revolutionary Times;* Logan, *Part Taken by Women in American History;* Norton, *Liberty's Daughters.*

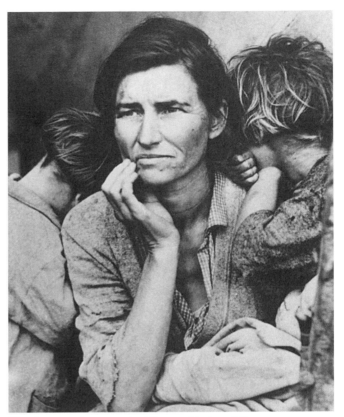

This famous photograph, *Migrant Mother, Nipomo, California,* taken by Dorothea Lange in 1936, helped bring migrant workers to national attention during the Great Depression. (*Library of Congress*)

Lange, Dorothea Nutzborn (1895–1965)
photographer

Born Dorothea Nutzborn on May 26, 1895 in Hoboken, New Jersey, to Joanna Lange Nutzborn and Henry Martin Nutzborn, Dorothea Lange was the photographer who brought the terribly hard lives of migrant workers to national attention during the Great Depression.

Lange's father abandoned his family while Lange was still young, and her mother resumed the use of her maiden name, both for herself and her children. The family move to New York City's Lower East Side. Fascinated by the city, Lange frequently skipped school in order to walk through the streets, simply observing the visual feast of New York City life. She graduated from Wadleigh High School in 1913 and, although she had never used a camera, decided to become a photographer. She worked with various photographers, took a photography class at Columbia University, and then, in 1919, became a portrait photographer.

Lange was successful until the Great Depression hit. Then, as she described it, "The discrepancy between what I was working on in the printing frames and what was going on in the street was more than I could assimilate." Lange's photographs of the unemployed led to her employment in 1935 by the Historical Section of the federal government's Resettlement Administration (which became the Farm Security Administration in 1937). The photographs she took under the administration's auspices were used successfully to create support for President Franklin D. Roosevelt's New Deal legislation. Many of her images—such as *Migrant Mother,* a photograph of a female pea-picker, destitute, and the two weary children who rest their heads upon her shoulders—have become the Great Depression's most emblematic images.

In later years Lange used her camera to document the internment of Japanese Americans during World War II. Although she was hired by the War Relocation Authority to do this work, the government suppressed her empathetic photographs until after the war; they were not generally available for viewing until their 1972 publication in a posthumously published book, *Executive Order 9066.* (The title refers to the number of the government order that resulted in the internment camps.)

Dorothea Lange died on October 11, 1965, in San Francisco. The Museum of Modern Art in New York City held a retrospective exhibit of her work in 1966.

Further Reading: Lange, *Farm Security Administration photographs,* Library of Congress; ————, *War Relocation Authority photographs,* National Archives; Meltzer, *Dorothea Lange;* Ohrn, *Dorothea Lange and the Documentary Tradition;* Ware, *American Women in the 1930s.*

Lanham Act (1943)

Passed in 1943, this act was used to authorize the building of federally supported day care facilities during World War II. These federal funds were appropriated because women's labor was needed in the ammunitions and other defense-related factories during the war and there was no large-scale, preexisting system of child care. Less than 10 percent of the working mothers had access to the government-sponsored child care.

After the war, Frances PERKINS, President Franklin Roosevelt's secretary of labor (and the first woman to serve in any president's cabinet), opposed the continued operation of the Lanham Act child care centers and called on employed mothers to vacate their jobs for returning soldiers and unemployed men.

Further Reading: Chafe, *American Woman;* Clark, *Almanac of American Women in the 20th Century.*

Lavender Menace

First used by Betty FRIEDAN in 1969 as a derogatory description of lesbians and their impact on public perception of the women's movement, the phrase "Lavender Menace" was appropriated by twenty women who organized a lesbian rights protest at the second Congress to Unite Women, held May 1–3, 1970, in New York City.

As approximately 400 women settled in for the first evening of the congress, the lights were suddenly turned off. When they came on again, the room had been decorated with posters bearing legends such as "Take a Lesbian to Lunch." Twenty women—wearing lavender T-shirts with the proclamation "Lavender Menace"—had lined up in the front of the room and commandeered the microphone. One woman read from an essay prepared by the group, "The Woman-Identified Woman," which stated, in part:

> . . . A lesbian is the rage of all women condensed to the point of explosion. She is the woman who, often beginning at an extremely early age, acts in accordance with her inner compulsion to be a more complete and freer human being than her society . . . cares to allow . . . As long as the label "dyke" can be used to frighten a woman into a less militant stand, keep her separate from her sisters . . . to that extent she is controlled by the male culture. Until women see in each other the possibility of a primal commit-
>
> ment which includes sexual love, they will be denying themselves the love and value they readily accord to men. . . , As long as male acceptability is primary . . . the term lesbian will be used effectively against women.

Thirty women joined the Lavender Menace members in a show of support at the front of the room. On the last day of the congress, the group presented its own resolutions:

1. Be it resolved that Women's Liberation is a Lesbian plot.
2. Resolved that whenever the label "Lesbian" is used against the movement collectively, or against women individually, it is to be affirmed, not denied.
3. In all discussions on birth control, homosexuality must be included as a legitimate method of contraception.
4. All sex education curricula must include Lesbianism as a valid, legitimate form of sexual expression and love.

The Lavender Menaces later became the Radicalesbians. Betty Friedan later reversed her position.

Further Reading: Davis, *Moving the Mountain;* Hole and Levine, *Rebirth of Feminism;* Wandersee, *American Women in the 1970s.*

Lazarus, Emma (1849–1887) *writer*

Born on July 22, 1849, in New York City, to Esther Nathan Lazarus and Moses Lazarus, Emma Lazarus became a poet and author. Her most famous poem is the sonnet "The New Colossus," which is emblazoned on the base of the Statue of Liberty.

Lazarus' parents, both descendants of Sephardic Jews who had come to America from Portugal in the seventeenth century, provided their daughter with an excellent private education. Her first book of poetry, *Poems and Translations,* was published in 1867, when Lazarus was eighteen. Subsequent volumes of poetry included *Admetus and Other Poems* (1871) and the verse tragedy, *The Spagnoletto* (1876). In 1874 she published a novel, *Alide;* based on an event in Goethe's life, it depicts an artist's difficult choice between everyday human happiness and the sacrifices necessary to the creation of art.

In 1881 she published what is still the major English translation of Heinrich Heine's work, *Poems and Ballads of Heinrich Heine.* That same year, in which the assassination of Czar Alexander II of Russia led to pogroms against the Jews in that country and their mass immigration into the United States, marked both a personal and artistic turning point for Lazarus. Identifying as never before with her Jewish heritage, she changed direction in her work and sought to "arouse sympathy and to empha-

size the cruelty of the injustice done to our unhappy people." She wrote prose pieces such as those published in the *Century Magazine* in April 1882 and February 1883, the first condemning Christianity's historical nonintervention during the persecution of Jews and the second calling for the creation of national Jewish homeland in Palestine, a demand that was ten years in advance of the Zionist movement. In 1882 she also published serially *The Dance to Death;* a blank verse drama that is considered one of her best works, it depicts the execution of Thuringian Jews during a fourteenth-century plague.

In 1883, when a "literary auction" was held on behalf of the Statue of Liberty fund, Lazarus submitted "The New Colossus," which was subsequently inscribed on the pedestal of the statue and, just as permanently, in the minds of many Americans. Its concluding word are:

Give me your tired, your poor,
Your Huddled masses yearning to breathe free,
The wretched refuse of your teeming shore.
Send these, the homeless, the tempest-tost to me,
I lift my lamp beside the golden door!

Emma Lazarus died at the age of thirty-eight on November 19, 1887 in New York City.

Further Reading: Faust, ed., *American Women Writers;* Hurwitz, "Emma Lazarus," in *Notable American Women,* ed. James, James, and Boyer; Jacob, *World of Emma Lazarus;* McHenry, ed. *Famous American Women;* Merriam, *Emma Lazarus;* Schappes, ed. *Emma Lazarus;* Vogel, *Emma Lazarus.*

League of Women Voters

An outgrowth of the NATIONAL AMERICAN WOMEN SUFFRAGE ASSOCIATION (NAWSA), the nonpartisan League of Women Voters was established at NAWSA's national convention held March 24–29, 1919, in St. Louis, Missouri. Carrie Chapman CATT, then NAWSA's president, first discussed the possibility of such an organization in 1917, when women in eighteen states had secured the right to vote in presidential elections. As envisioned by Catt, NAWSA members in full-suffrage states would be the league's original members, and new members would be added as additional states granted women's suffrage. The enfranchised members of the league, Catt reasoned, would be able to exert especially meaningful pressure on their elected members of Congress to pass the NINETEENTH AMENDMENT.

By 1919—the fiftieth anniversary of the founding of the NATIONAL WOMAN SUFFRAGE ASSOCIATION (predecessor to NAWSA) and the fiftieth anniversary of women's suffrage in Wyoming—the women of twenty-eight states had secured suffrage and the sixty-sixth Congress seemed ready to pass a federal women's suffrage amendment. That year Catt opened NAWSA's national convention with a speech entitled "The Nation Calls," in which she envisioned final success for women's suffrage and pondered what type of memorial would best befit "the memory our brave departed leaders . . . [and] the sacrifices they made for our cause." She established the League of Women Voters to "finish the fight," as proposed in 1917, but also as "the most natural, the most appropriate and the most patriotic memorial [to the early suffrage leaders] that could be suggested." Catt asked NAWSA members, "What could be more appropriate than that such women should do for the coming generation what those of a preceding [generation] did for them? What could be more patriotic than that these women should use their new freedom to make the country safer for their children and their children's children?" Then she outlined the goals of the new League of Women Voters:

1. To use its influence to obtain the full enfranchisement of the women of every State in our own republic and to reach out across the seas in aid of the woman's struggle for her own in every land.
2. To remove the remaining legal discriminations against women in the codes and constitutions of the several States in order that the feet of coming women may find these stumbling blocks removed.
3. To make our democracy so safe for the nation and so safe for the world that every citizen may feel secure and great men will acknowledge the worthiness of the American republic to lead.

The league specifically rejected the idea of forming a "woman's party" or acting as an outside pressure group. Instead, it encouraged its members to work inside whichever of the existing political parties most reflected their individual views. During the 1920 election immediately following ratification of the Nineteenth Amendment, the League of Women Voters supported fifteen specific measures. The Republican party placed five of these measures in its platform, the Democratic party, twelve. There were other victories in the 1920s for the League of Women Voters and its constituents: Congress passed the Packers and Stockyards Bill in 1921 (which mandated measures that protected consumers); the CABLE ACT in 1922 (enabling married women to retain or change their citizenship, regardless of the citizenship of their husbands—prior to the passage of this act, a woman's citizenship automatically followed her husband's); and the SHEPPARD-TOWNER ACT in 1924 (which provided funding for programs designed to improve maternal and infant health).

However, perhaps because the "woman's vote" did not become a unified force, women's issues and the

League of Women's Voters lost much of its original influence in Washington. Since the 1940s, the league has emphasized its role as a nonpartisan educator of the voting public. Toward that end, it publishes *The National Voter* magazine and sponsors debates among local, state, and federal-level candidates. It was, until recently, the expected sponsor of televised debates among presidential candidates.

As of 2000, the league had 110,000 members, almost 5,000 of whom were male. It maintains its headquarters in Washington, D.C., and its president is Carolyn Jefferson Jerkins.

Further Reading: Brown, *American Women in the 1920s;* Chafe, *American Woman;* Clark, *Almanac of American Women in the 20th Century;* Davis, *Moving the Mountain;* Evans, *Born for Liberty;* Frost and Cullen-DuPont, *Women's Suffrage in America;* Hartman, *American Women in the 1940s;* Stanton, Anthony, and Gage, eds., *History of Woman Suffrage,* vol. 6.

Lee, Mother Ann (1736–1784) *religious leader*
Born on February 29, 1736, in Manchester, England, to John Lees and a mother whose name has been lost, Ann Lee (she changed the spelling of her surname) was the founder of the United Society of Believers in Christ's Second Appearing, more widely known as the Shakers.

Lee had no schooling and worked in the textile mills during her teenage years and through her twenties. Near the end of this period, she joined the John and Jane Wardely's sect of Quakers. This sect was known as Shaking Quakers due to their incorporation of dancing, shouting, shaking, and other innovations into their worship services. On January 5, 1762, Lee was married—somewhat against her will, in compliance with family wishes—to Abraham Standering, known as Stanley. She bore four children, all of whom died following extremely difficult births. Lee became convinced that her children's deaths were due to her own "violation of God's laws," and she subjected herself to sleep deprivation and severe fasting. At the end of this time, she had a sense of being spectacularly "broke[n] forth to God" and welcomed "into the spiritual kingdom." She also was certain that "cohabitation of the sexes" was the source of all earthly troubles and a serious sin.

By 1770 Lee became a leader in the Shaking Quaker sect. When the Shakers began in 1772 to worship more publicly, even on English streets and on Anglican church property, they faced arrest and imprisonment. Lee was jailed twice, in 1772 and 1773. Lee believed in a Mother/Father God, and, in prison, she came to believe that Christ was especially present in her. Her followers endorsed this view and interpreted it as the Second Coming of Christ in a female form.

Lee and a number of her followers immigrated to the American colonies in 1774 and settled near Albany, New York. The Shakers faced physical persecution from their new neighbors, including stonings, whippings, and being dragged behind horses as well as charges (resulting from their pacifism during the Revolution) that they were British spies.

Ann Lee died on September 8, 1784 in Niskeyuna (later Watervliet), New York, as a result of a beating. The church Lee left behind reflected its Quaker heritage with a strong opposition to slavery and an equally strong endorsement of equality between the sexes. Its own laws included strict regulation of dress and domestic affairs (the simple, clean lines of their architecture and furniture reflect these codes), communal ownership of property, and the celibacy of its adherents. There were, at Lee's death, about 2,500 Shakers and eleven Shaker communities. The Shakers gained new members and, at their peak in the nineteenth century, maintained fifty communities. However, the church fell into drastic decline in the twentieth century; there is one remaining Shaker community, run by a small number of elderly Shaker women, in Sabbathday Lake, Maine.

Further Reading: Andrews, "Ann Lee," in *Notable American Women,* ed. James, James, and Boyer; Campion, *Ann the Word;* McHenry, ed. *Famous American Women;* Wells, *Testimonies of the Life, Character, Revelation and Doctrine of Our Blessed Mother Ann Lee.*

Liliuokalani (Lydia Dominis) (1838–1917) *queen of Hawaii*
Born on September 2, 1838, in Honolulu to high chief Kapaake and chiefess Keohokalole, members of a high-ranking family with close ties to King Kamehameha III, Liliuokalani became Hawaii's queen. Pursuant to a Hawaiian tradition intended to prevent divisions among tribal members, Liliuokalani was adopted by Konia Paki, a granddaughter of the king who had brought the Hawaiian islands together under one ruler, and her husband, Abner Paki, an adviser to the king. Lydia Kamakaeha Paki, as she was named during this time, received her education in the Royal School maintained by American missionaries. She married John Owen Dominis, an official of the Hawaiian government and son of a Boston sea captain, on September 16, 1862, and became known as Lydia Dominis.

In 1874 King Lunalilo, a king in the line of King Kamehameha III, died childless and without having named a successor. The legislator chose David Kalakaua (Lydia Dominis' birth brother) as the successor. The new King Kalakaua was also childless; when his younger brother died in 1877, he formally named his sister heir to the throne. Liliuokalani, as she then became known to

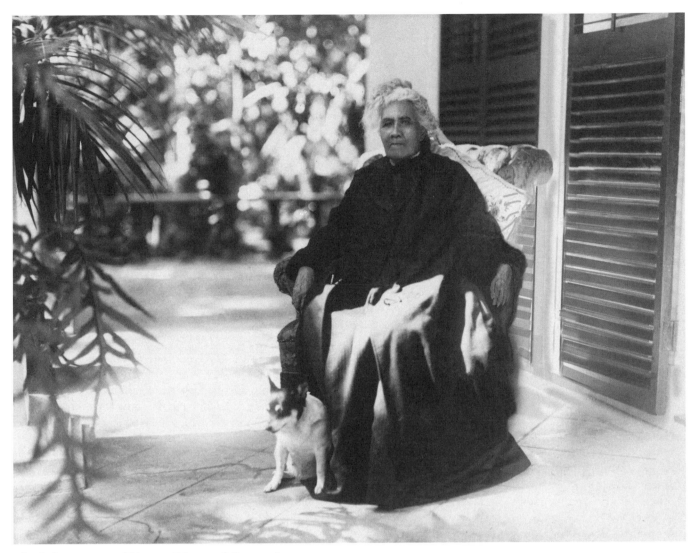

Liliuokalani, queen of Hawaii (*Library of Congress*)

Hawaiians and in history, began her participation in Hawaiian government immediately. She traveled among the country's islands to monitor conditions; she served as regent in her brother's absence from Hawaii; she helped to establish and oversee the Kamehameha Schools for Hawaiian girls and boys (which were funded by a bequest from a member of Liliuokalani's early adoptive family); and she made a state visit to Queen Victoria's court in England, followed by a visit to President Grover Cleveland.

When King Kalakaua died in January 1891, Liliuokalani become the first woman to ascend the Hawaiian throne. Hawaii was at that time a constitutional monarchy with well-established diplomatic relations with the United States, England, Japan, and many other countries. However, the U.S.-Hawaiian Reciprocity Treaty, renewed in 1887, had granted substantial business privileges to U.S. citizens and access to the Pacific, via Pearl Harbor on the Hawaiian Island of Oahu, to the United

States military. Liliuokalani, upon becoming queen, quickly indicated that she wished to strengthen the monarchy's exercise of Hawaiian sovereignty. American businessmen—led by America's minister to Hawaii—just as quickly staged a coup and asked the United States legislature to annex Hawaii. One hundred sixty-eight marines were sent to support the coup, and Liliuokalani was placed under house arrest. She formally abdicated her throne in 1895, in return for the release of her followers, who had been imprisoned after an unsuccessful revolt against the imposed provisional government. Hawaii was annexed to the United States by a joint congressional resolution in 1898.

Liliuokalani continued to live in Honolulu, where she wrote songs, including the national favorite, "Aloha Oe." She received a pension and many tokens of respect from her former subjects until her death on November 11, 1917.

On the one hundredth anniversary of Hawaii's overthrow, Governor John Waihee the Third—the state's first governor of Hawaiian descent—ordered all American flags removed for five days from state buildings, and Senator Daniel K. Akaka declared that Hawaii's state flag would be flown on Capitol Hill in Washington, D.C., at half staff. Approximately 12,000 Hawaiians gathered in protest and in memory at the statue of Queen Liliuokalani in Honolulu. On November 16, 1993, the U.S. House of Representatives and Senate issued a joint, formal apology to Hawaii's native people for the American overthrow of Queen Liliuokalani.

Further Reading: "Anniversary Stirs Hawaii Sovereignty Movement," *New York Times,* January 18, 1993; "Apology for 1893 Rebellion," *New York Times,* November 17, 1993; Greer, "Bernice Pauahi Bishop," in *Notable American Women,* ed. James, James and Boyer; Korn, "Emma," in *Notable American Women,* ed. James, James, and Boyer; ———, "Liliuokalani," in *Notable American Women,* ed. James, James, and Boyer; "Late Bow to Hawaii Queen Overthrown 100 Years Ago," *New York Times,* January 15, 1993; Liliuokalani, *Hawaii's Story;* McHenry, ed., *Famous American Women.*

Lily, The

A six-page monthly newspaper advocating temperance (see also WOMAN'S CHRISTIAN TEMPERANCE UNION) and women's rights, with a national circulation of just over 6,000 copies. It was founded in January 1849 by Amelia Bloomer in Seneca Falls, New York, six months after she had attended the SENECA FALLS CONVENTION. Elizabeth Cady STANTON, an organizer and leader of that convention, published many of her earliest women's rights articles in *The Lily.* The first of these appeared under bylines such as "Sunflower" and "J.V.N." They concerned motherhood and temperance and—in articles such as "Lowell Girls" (see also LOWELL FEMALE LABOR REFORM ASSOCIATION)—reported on women's employment opportunities. Later articles, such as one entitled "Why Women Must Vote," appeared under Stanton's own name, as did reprints of her controversial speeches and letters. One reprinted letter, written by Stanton as president of the WOMAN'S NEW YORK STATE TEMPERANCE SOCIETY to that society's members and insisting that women had both the right and obligation to divorce drunkard husbands, inspired outraged editorials in other newspapers. Bloomer's publication of such articles by Stanton and others made her paper one of the earliest forums for women's rights leaders. *The Lily* was also responsible for the popularization of what became known as "the bloomers." (See also DRESS REFORM, NINETEENTH CENTURY.)

In 1855 Bloomer moved to Council Bluffs, Iowa, which was then part of the western frontier. She found the printing and rail facilities insufficient to support proper publication and nationwide distribution of *The Lily* and, the following year, she sold the paper to Mary B. Birdsall in Richmond, Indiana. The paper ceased publication in December 1856. At the end of 1994, 138 years later, it was announced that *The Lily* would soon resume publication under the auspices of the Women's Rights National Historic Park, in Seneca Falls, New York, a national park founded in 1984 to preserve and restore sites associated with the Seneca Falls Convention.

Further Reading: Lewis, "Amelia Bloomer," in *Notable American Women,* ed. James, James, and Boyer; *New York Times,* Nov. 18, 1984; Stanton, Anthony, and Gage, *History of Woman Suffrage,* vol. 1; Stanton and Blatch, *Elizabeth Cady Stanton: Letters and Reminiscences,* vol. 2.

Lin, Maya Ying (1959–) *architect, sculptor*

Born on October 5, 1959, in Athens, Ohio, to Julia Chang Lin and Henry Huan Lin, architect and sculptor Maya Lin designed what has become one of the best-loved memorials in the United States, the Vietnam Veterans Memorial.

Lin's parents left China shortly before the Communist revolution in 1949. In the United States, her father became dean of fine arts at Ohio University and her mother, a professor of Asian literature at the same university. A co-valedictorian at her high school graduation, Lin enrolled after high school in the architecture program at Yale University.

When a nationwide competition for the design of a Vietnam veterans' memorial was announced in October 1980, Lin decided to prepare a submission and have that serve as her senior project at Yale. Her now-famous design—a V-shaped wall of polished black granite bearing the names of the 58,000 killed and missing service men and women—was one of 1,421 blind submissions.

Jury chairman Grady Clay and the other members of the unanimous jury were delighted to realize that a young student had created the winning entry, and public reaction to the design—including that of many Vietnam veterans—was generally positive. However, a small group of veterans thought the absence of traditional warrior statuary represented the Vietnam War as a less-than-noble chapter in American history, and they organized in opposition. One of the veterans, Tom Cashart, went so far as to call the design "a black gash of shame." The memorial committee also received letters questioning the appropriateness of Lin herself—as a woman and as a person of Asian descent—to serve as the memorial's

designer. Rep. Henry Hyde (R-IL) and conservative commentator Patrick Buchanan insisted that Lin's memorial should not be built. A bitter, year-long debate ensued, during which Lin defended her design as an apolitical "place for private reckoning," where the names of the dead and the missing, arranged chronologically rather than alphabetically, might read "like an epic Greek poem" to those forced by the arrangement to actively search for their own loved ones' names. In the end, a second competition design was selected to stand 120 feet from Lin's, at the entrance to her memorial.

By the time the Vietnam Veterans Memorial was dedicated on Veterans Day, 1982, Lin had graduated cum laude from Yale (1981) and begun graduate studies in architecture at Harvard. Exhausted by her experience with the memorial, she left Harvard to work for an architectural firm in Boston. She returned to Yale in the fall of 1983 and received a master's degree in architecture in 1895. The following year, she received an honorary doctorate of fine arts from the same university.

Lin's work since the Vietnam Veterans Memorial includes the Civil Rights Memorial in Montgomery, Alabama; the Museum for African Art in lower Manhattan; The Women's Table at Yale University in New Haven, Connecticut; Eclipsed Time, at the Long Island Rail Road/Pennsylvania Station terminal in Manhattan; Groundswell at the Wexner Center for the Arts in Ohio; a line of furniture for Knoll entitled "The Earth is (Not) Flat"; and a number of private residences.

Maya Lin currently lives in Manhattan with her husband, Daniel Wolf, and their daughter.

Further Reading: *Architectural Record,* June 1998; *Encyclopedia of World Biography;* Heartney, "The Distillations of Landscape"; *Maya Lin: A Strong Clear Vision;* Rowan, "Maya Lin Finds Inspiration in the Architecture of Nature"; Stein, "Space and Place"; *U.S. News and World Report,* November 6, 1989; Zinsser, "I Realized Her Tears Were Becoming Part of the Memorial."

Lockwood, Belva Ann Bennett McNall

(1830–1917) *lawyer, women's rights activist*

Born Belva Ann Bennett on October 24, 1830, in Royalton, New York, to Hannah Green Bennett and Lewis Johnson Bennett, Belva Bennett McNall Lockwood was a lawyer, women's rights and peace advocate, and the first woman admitted to practice before the United States Supreme Court.

Lockwood was educated in local schools until she turned fifteen, at which point she became a teacher. In November 1848 she and Uriah H. McNall married. Before Uriah McNall's death—due to an accident, in 1853—the couple had a child. Lockwood returned to

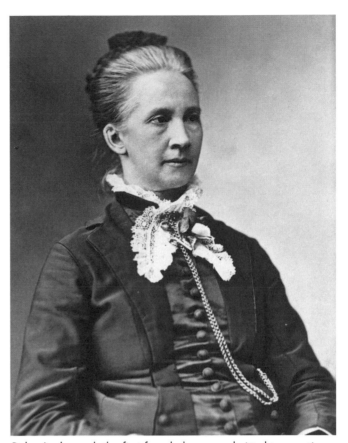

Belva Lockwood, the first female lawyer admitted to practice before the United States Supreme Court (*Library of Congress*)

teaching while simultaneously attending Genesee College (a predecessor of Syracuse University), from which she graduated in 1857. Lockwood continued to teach in New York for a time, then moved to Washington, D.C., where she established her own school. On March 11, 1868, she married Ezekiel Lockwood.

Ezekiel Lockwood eventually assumed his wife's responsibilities at her school, freeing Belva Lockwood to attend law school. After Georgetown University, Howard University, and what is now George Washington University refused to admit her because she was a woman, Lockwood won admission to the National University Law School in 1871. Upon her graduation in 1873, she was admitted to the District of Columbia bar, which had begun to admit women two years prior to Lockwood's application. Although her practice was based on pension claims, Lockwood volunteered her legal talents to the women's movement; she testified on behalf of women's issues before congressional committees and was the author of many of the movement's bills and resolutions.

At the end of 1873, Lockwood was denied the right to plead one of her cases before the federal Court of Claims because of her sex. She petitioned the Supreme

Court of the United States for admission and was denied. Turning to Congress and especially to two senators known to be sympathetic to women's rights, George F. Hoar of Massachusetts and Aaron A. Sargent of California, Lockwood was instrumental in gaining passage of an 1879 bill that required the Supreme Court to admit qualified women. On March 3, 1879, Lockwood became the first woman admitted to practice before the highest court.

Lockwood was an effective champion of people and groups suffering from discrimination. She acted as sponsor for Samuel R. Lowery when he successfully sought to become the first African American from the South admitted to practice before the U.S. Supreme Court in 1880. She also successfully argued a 1906 case on behalf of the Eastern Cherokee Indians before the Supreme Court, winning the tribe an award of $5 million.

She remained active in women's rights, serving as an officer in the NATIONAL and the NATIONAL AMERICAN WOMAN SUFFRAGE ASSOCIATIONS as well as in the LEAGUE OF WOMEN VOTERS. In 1884 she accepted a nomination spontaneously made by several Californian women to run for president of the United States. Although the national suffrage leaders distanced themselves from her candidacy, fearing an ineffective spectacle, Lockwood used the occasion to speak persuasively about the rights of women, Native Americans, and African Americans. (She received 4,149 votes.)

In later years she turned her attention to the world peace movement, attending the International Peace Congress of 1889 and involving herself in the International Council of Women, a predecessor organization to the INTERNATIONAL CONGRESS OF WOMEN, which she viewed as a forum for facilitating world peace as well as championing international women's rights.

Belva Ann Bennett McNall Lockwood died on May 19, 1917 in Washington, D.C.

Further Reading: Flexner, *Century of Struggle;* McHenry, ed., *Famous American Women; New York Times,* May 20, 1917; Read and Witlieb, *Book of Women's Firsts;* Reigel, "Belva Ann Bennett McNall Lockwood," in *Notable American Women,* ed. James, James, and Boyer; Stanton, Anthony, and Gage, eds. *History of Woman Suffrage,* vols. 2, 3, and 4. Stern, *We the Women.*

Los Angeles Department of Water and Power v. Manhart (1978)

A 1978 Supreme Court decision that held that women and men had to receive equal treatment with regard to retirement benefits and, specifically, that women could not be required to make larger contributions than men toward the same retirement benefits. The employer, the Los Angeles Department of Water and Power, based its practice, which was not uncommon prior to this decision, on the fact that "[a]s a class, women live longer than men." The opinion, delivered by Justice John P. Stevens, found the discriminatory practice a violation of Title VII of the CIVIL RIGHTS ACT OF 1964, as amended.

Further Reading: *Los Angeles Department of Water and Power v. Marie Manhart,* 98 Sct 1370 (1978); Goldstein, *Constitutional Rights of Women.*

Lowell Female Labor Reform Association

A labor organization founded in 1844, its 600 members were female workers in the Lowell, Massachusetts, textile mills. Sarah Bagley was its president.

The organization successfully protested a planned increase in the amount of work assigned to the mills' female weavers. When mill owners threatened to "blacklist" employees associated with the Female Labor Reform Association, Bagley was ready with her response:

> What! Deprive us, after working thirteen hours, of the poor privilege of finding fault—of saying our lot is a hard one! Intentionally turn away a girl unjustly persecuted . . . for free expression of honest political opinions! We will make the name of him who dares the act, stink with every wind, from all points of the compass . . . he shall be hissed in the streets, and in all the cities of this widespread republic; for our name is legion though our oppression be great.

The Reform Association also worked for "ten-hour-day" legislation in Massachusetts. Two thousand signatures were collected on a petition, which was presented to the state legislature. An investigative committee was formed, and six female and two male mill workers were called to testify at public hearings, which began on February 13, 1845. Bagley and others testified with force and poise about conditions, such as 150 people doing close work in a room lit—and fouled—by 354 continually burning lamps. (Reportedly up to thirty women per day were made ill by the fumes.) The committee refused to recommend ten-hour-day legislation, explaining in part that the "intelligent and virtuous men and women" who had testified were obviously capable of protecting themselves without such legislation. (see Appendix for Committee report.)

In January 1847 the organization became the Lowell Female Industrial Reform and Mutual Aid Society, with Mary Emerson as president and Huldah Stone as secretary. Although the society continued to petition the state legislature, reform activities gradually were replaced with the offering of assistance to members facing extreme financial hardship or illness.

Further Reading: Flexner, *Century of Struggle;* Frost and Cullen-DuPont, *Women's Suffrage in America;* Robinson, *Loom and Spindle;* Wertheimer, *We Were There.*

Lowell *Offering*

A literary magazine published between 1840 and 1845, the Lowell *Offering* contained poems, essays, and stories written by the "mill girls" who lived and worked at the Lowell Textile Mill. Its first editor was A. C. Thomas (1840–42) and its second was Harriet Farley (1842–45), a mill worker. The magazine gained an international readership and, at the time, was viewed generally as evidence that the female mill workers benefited greatly from their life at Lowell. The *Offering* never mentioned wages of approximately $2.00 per week, long hours, or the crowded housing conditions offered to the workers. Its pages instead extolled the women's Improvement Circles (literary societies) and the self-reliance gained by salaried workers. Many new workers were drawn to the Lowell Mills by the *Offering.*

Sarah Bagley, one of America's first female labor organizers, shocked an audience of 2,000 people at an 1848 Independence Day celebration in Woburn, Massachusetts, by announcing that the *Offering* routinely rejected her more critical articles. By the end of the summer, Bagley had also accused editor Harriet Farley of acting as a management "mouthpiece."

Not all of Lowell's workers shared Bagley's opinion. For example, Lucy Larcom, a frequent contributor to the *Offering* and a poet later included in Rufus W. Griswold's *Female Poets of America,* was always grateful for the opportunities she received during her ten years at Lowell. Bagley had her share of supporters, and with them she introduced a more independent and less salutary paper, the *Voice of Industry.* The Lowell *Offering* suspended publication at the end of 1845.

Further Reading: Eisler, ed., *The Lowell Offering;* Flexner, *Century of Struggle;* Frost and Cullen-DuPont, *Women's Suffrage in America;* Larcom, *New England Girlhood;* Robinson, *Loom and Spindle;* Wertheimer, *We Were There.*

Luce, Ann Clare Boothe (1903–1987) *ambassador, writer*

Born Ann Clare Boothe on April 10, 1903, in New York City to Ann Clare Snyder Boothe and William F. Boothe, Clare Boothe Luce was the first woman to become an American ambassador to a major power.

Boothe Luce graduated from Miss Mason's School, "The Castle," in Tarrytown, New York, in 1919 and then studied drama for a brief time. In 1919 she became secretary to Alva BELMONT, a financial benefactor of the suffrage movement, and became, through her, active in that movement. She and George T. Brokaw were married in 1923 and divorced in 1929.

Resuming her maiden name, she worked at *Vogue* from 1930 to 1931 and at *Vanity Fair,* first as associate editor and then as managing editor, from 1931 to 1934. Her first book, *Stuffed Shirts,* was published in 1931.

In 1935 she and magazine publisher Henry Luce were married. The first of her plays, *Abide with Me,* also appeared on Broadway in that same year. Her next and perhaps best-known play, *The Women,* opened in 1936. A castigating appraisal of wealthy, leisured women who take from, rather than give to, society, it was later described by Luce in 1973 as "show[ing] what I didn't like—idle, parasitical women. I didn't approve then and I don't approve now. The women who inspired this play deserved to be smacked across the head with a meat ax and that, I flatter myself, is exactly what I smacked them with."

Luce's own life was far from idle or unproductive. In addition to her work as a writer—she covered the German invasion of Belgium in 1940, reported on Japan's invasion of China in 1941 as a correspondent for *Life* magazine, and continued to write for the theater such plays as *Kiss the Boys Goodbye* (1938), *Margin for Error* (1940), and her 1971 feminist play, *Slam the Door Softly*—Luce served in several public offices. In 1942 she ran as the Republican candidate for election to the House of Representatives for the Fourth District of Connecticut. She won and was reelected in 1944. During her terms in Congress, she served on the Military Affairs Committee and the Joint Committee on Atomic Energy, and took a hard anti-Communist stance.

In 1944, during Luce's service as a congresswoman, her only daughter was killed in an auto accident. Luce's grief led her to decline to run for reelection in 1946 and also contributed to her conversion to Roman Catholicism. From 1946 to 1952 she wrote a number of religiously oriented articles and, in the latter year, edited *Saints for Now,* a collection of essays by prominent British and American authors.

In 1952 Luce returned to politics as a delegate to the Republican National Convention and as a strong supporter of Dwight D. Eisenhower's candidacy. Following his election, Eisenhower nominated Luce as ambassador to Italy in 1953.

In response to questions raised about her Roman Catholicism by the executive director of Protestants and Other Americans United for Separation of Church and State, Luce testified before the Senate Foreign Relations Committee on February 17, 1953, that she fully believed in "the American tradition of separation of church and state" and that she would have no ties with the Vatican, "formal or informal, open or secret." When

she was confirmed by the Senate on March 2, 1953, she became the second woman to hold the rank of ambassador and the first to represent the United States to a major power. (Helen Eugenie Moore Anderson was ambassador to Denmark from 1949 to 1953.)

Luce returned to private life in 1956 but was again nominated as ambassador—this time to Brazil—in 1959. Her staunch anti-Communist position proved so controversial both during and following the confirmation hearings that she resigned shortly after her confirmation.

In 1964 Luce seconded Barry Goldwater's nomination for president, and in 1973 she served on President Richard Nixon's Foreign Intelligence Advisory Board. She received many honors and awards, including the Presidential Medal of Freedom, awarded by President Ronald Reagan in 1983.

Clare Boothe Luce died on October 9, 1987, in Washington, D.C.

Further Reading: Clark, *Almanac of American Women in the 20th Century; Contemporary Authors,* vols. 45–48 and vol. 123; *Current Biography,* 1953 ed.; McHenry, ed., *Famous American Women; New York Times,* February 8, 1953, October 10 and 14, 1987.

MacKinnon, Catharine Alice (1946–) *lawyer, feminist*

Groundbreaking feminist attorney Catharine Alice Mac-Kinnon was born in 1946, in Minneapolis, Minnesota, to Elizabeth Valentine Davis and George E. MacKinnon, a member of the United States Court of Appeals for the District of Columbia. She graduated from Smith College, as had her mother and her grandmother, in 1969. She graduated from Yale Law School in 1977 and ten years later earned a Ph.D. in political science from Yale University.

MacKinnon's career has been dedicated to changing the way the law views women and crimes against them. In 1977, just out of law school and at a time when sexual harassment was not considered discrimination but a fact of life, MacKinnon and several former Yale classmates filed a lawsuit, *Barnes v. Costle*. The young attorneys argued that, according to federal law, a female student and work-study program participant who charged that she had been sexually harassed by a professor could take legal action against the university in question. A three-judge panel of the United States Court of Appeals for the District of Columbia in 1977 rendered a decision recognizing not only the right of the student in question to sue but the broader issue that a woman coerced into sexual relations in exchange for continued employment would not have been approached in such a manner "but for her womanhood." Although this unanimous decision marked the beginning of a legal reevaluation of sexual harassment, a narrow concurring opinion written by MacKinnon's own father, George E. MacKinnon, one of the deciding judges, also illustrated the deeply ingrained notions MacKinnon sought to challenge. In his separate opinion, he cautioned the court against attempting to legislate social behaviors that, he wrote, were somewhat "normal and expectable."

Catharine MacKinnon published *Sexual Harassment of Working Women* in 1979. In 1986 she prepared a brief for and acted as cocounsel in MERITOR SAVINGS BANK, FSB V. VINSON, the first sexual harassment case accepted by the U.S. Supreme Court. The Court ruled that sexual harassment in the workplace constituted sex discrimination and a violation of Title VII of the Civil Rights Act of 1964.

MacKinnon has also assailed pornography, which she views as a form of terrorism against women. With writer Andrea DWORKIN, she drafted antipornography ordinances that were passed in Indianapolis, Indiana, and Minneapolis, Minnesota. The ordinances permitted a woman to sue the creators and sellers of pornography—which was defined in the Minneapolis version as the "graphic sexually explicit subordination" of women—provided she could prove that she or women as a class had been injured by the pornography. In 1985 the United States Court of Appeals for the Seventh Circuit ruled MacKinnon's ordinance unconstitutional; in 1986 the Supreme Court in *Hudnut v. American Booksellers' Association* affirmed the Seventh Circuit ruling, and the law was invalidated. In 1988 MacKinnon and Dworkin published *Pornography and Civil Rights: A New Day for Women's Equality* to encourage the continued opposition to pornography. In 1998, they published *In Harm's Way*.

MacKinnon's other books include *Feminism Unmodified: Discourses on Life and Law* (1986); *Toward a Feminist Theory of the State* (1989); and *Only Words* (1993).

In 1993, MacKinnon filed a lawsuit against Radovan Karadzic, the wartime Bosnian Serbian leader, charging him with responsibility for the rapes suffered by Muslim and Croatian women during the conduct of warfare in Bosnia-Herzegovina. (Separately, the United Nations began to treat RAPE as a war crime in 1996, when it indicted Bosnian Serb Radomir Kovic and four others on charges of enslaving and raping Muslim women during 1992 and 1993. Karadzic has also been indicted by the U.N., but has never been arrested.) MacKinnon also filed

a brief on behalf of the male plaintiffs in *ONCALE V. SUN-DOWNER OFFSHORE SERVICES, INC.* (1998). The Supreme Court's decision in that case extended Title VII's sexual harassment protection to same-sex situations.

Further Reading: *Boston Globe*, May 28, 1999; *Detroit News*, March 6, 1993 and October 22, 1997; *Contemporary Authors*, vol. 132; MacKinnon, *Sexual Harassment of Working Women*; ———, *Feminism Unmodified*; ———, *Toward a Feminist Theory of the State*; ———, *Only Words; New York Times*, February 24, 1989; Smith, "Love Is Strange"; Strebeigh, "Defining the Law on the Feminist Frontier," *The New York Times Magazine*, October 6, 1991; *Time*, March 10, 1986 and April 17, 1989; *Washington Post*, March 5, 1998.

MANA, A National Latina Organization

Founded in 1974 in Washington, D.C., as the Mexican-American Women's National Association, MANA quickly became one of the best-known organizations of Latina women. Although it originally represented Mexican-American women, it evolved into an organization of women from many different Hispanic backgrounds. In recognition of this the organization in 1994 changed its name to MANA, A National Latina Organization.

MANA supported the EQUAL RIGHTS AMENDMENT and the FAMILY AND MEDICAL LEAVE ACT. It takes a twofold approach to reproductive rights, supporting legalized abortion but putting an equal emphasis on the elimination of sterilization abuse. The organization testified before Congress about sterilizations performed on Spanish-speaking women who had not understood the explanation—delivered in English—of the operation's results. Its leaders were thereupon asked to participate in the Department of Health, Education, and Welfare's revision of sterilization regulations.

The organization maintains a *Hermanitas* (little sisters) projects, which pairs adults women mentors with junior and high school girls in an effort to increase the high school graduation and college enrollment rates of young Hispanic women. MANA also maintains a college scholarship program.

As of 1999, MANA has 4,000 members nationwide. Elisa Sanchez is its president.

Further Reading: Brennan, ed. *Women's Information Directory;* Davis, *Moving the Mountain.*

Manhattan Trade School for Girls

One of the first institutions to provide vocational training for the daughters of working-class parents, the Manhattan Trade School for Girls was established in 1902 under director Mary Schenk Woolman. Twenty girls attended the Manhattan Trade School in its first year.

Further Reading: Clark, *American Women in the 20th Century.*

"Manifesto of the Nebraska Men's Association Opposed to Woman Suffrage"

Issued in Omaha, Nebraska, on July 6, 1914, the "Manifesto of the Nebraska Men's Association Opposed to Woman Suffrage" was selected by Ida Husted Harper, after woman's suffrage was won, as being "in language and in the business interests of the signers . . . thoroughly typical of the open opposition to woman suffrage." Harper printed the manifesto and the names of the signatories "almost in full" in the final volume of *HISTORY OF WOMAN SUFFRAGE,* published in 1923.

The manifesto's consideration of women and suffrage begins with lavish, sentimental praise for females operating within their traditional sphere, "recogniz[ing] in her admirable and adorable qualities and sweet and noble influences . . ." The Nebraska Men's Association also declares itself "ever . . . willing and ready to grant to woman every right and protection, even to favoritism in the law . . . that makes for development and true womanhood."

The manifesto quickly turns, however, to a discussion of suffrage, and the reasons suffrage is among the rights men are not willing to grant to women. First, it states that female property owners have no automatic right of suffrage, since if suffrage "attach[ed]" itself "of right to the owners of property . . . all other persons would be disfranchised." Next, the manifesto states that suffrage "is not a fundamental right of tax-payers, for a great body of men [eligible to vote] are not taxpayers . . ." Finally, echoing the Supreme Court's 1875 decision *Minor v. Happersett,* the manifesto states that suffrage "is not an inherent right of citizenship" but "a privilege of government granted only to those to whom the Government sees fit to grant it."

Having arrived at this point, the Nebraska Men's Association offers its central argument against the enfranchisement of women. It claims that the greatest danger to a democratic government is "an excitable and emotional suffrage" and insists that women do not "always think coolly and deliberate calmly . . ." It requests that readers "Open that terrible page of the French Revolution and the days of terror, when the click of the guillotine and the rush of blood through the streets of Paris demonstrated to what extremities the ferocity of human nature can be driven by political passion." It asks, "Who led those bloodthirsty mobs? Who shrieked loudest in that hurricane of passion?" And it answers in one word: "Woman."

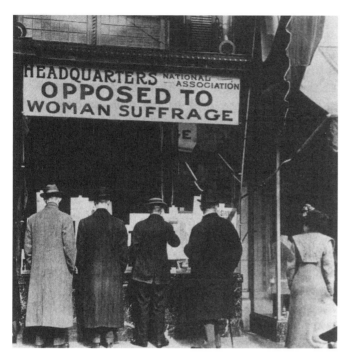

Nineteenth Amendment opponents (*Library of Congress*)

York State Association Opposed to Woman Suffrage, and the National Association Opposed to Woman Suffrage.

As Ida Husted Harper notes in the *History of Woman Suffrage,* these organizations specialized in "open opposition" to women's suffrage, but some politicians and business concerns preferred to work behind the scenes. The liquor interests, for example, opposed women's suffrage because it would empower the temperance movement—during the last few state campaigns for ratification of the Nineteenth Amendment, they tried to block the amendment by getting legislators drunk prior to the scheduled vote.

Further Reading: Bok, "Real opponents to the suffrage movement"; Bronson, "Woman Suffrage and Child Labor Legislation"; Brown, "Woman Suffrage"; Caswell, "Address in Opposition to Woman Suffrage"; Catt and Shuler, *Woman Suffrage and Politics;* Flexner, *Century of Struggle;* Frost and Cullen-DuPont, *Women's Suffrage in America;* Stanton, Anthony, and Gage; eds., *History of Woman Suffrage,* vol. 6.

Mankiller, Wilma (1945–) *principal chief of the Cherokee Nation*
The first woman to serve as principal chief of the Cherokee Nation or, indeed, of any major Native American tribe, Wilma Mankiller was born on November 18, 1945, in Tahlequah, Oklahoma, to Clara Irene Sitton Mankiller, a Caucasian, and Charlie Mankiller, a full-blooded Cherokee. The family's surname was adopted by a male ancestor and signifies Cherokee military ranking.

Mankiller spent her early childhood in Adair County, Oklahoma, on 160 acres of land awarded by the United States government to her grandfather as part of its settlement with the Cherokee for their forced 1838 relocation from ancestral lands in the American Southeast to the newly declared "Indian Territory" in Oklahoma. During the march along what is now known as the Trail of Tears, several thousand Native Americans perished. In 1907 the United States disbanded the Cherokee Nation's government and divided their lands. In 1971 the Cherokee Nation was legally reinstated on 7,000 square miles of sovereign land in northeastern Oklahoma.

When Mankiller was twelve, her family was removed from their Oklahoma land to San Francisco, as part of a relocation program designed by the Bureau of Indian Affairs to "mainstream" Native Americans. In 1969, during her first marriage and while raising two young daughters, Mankiller was galvanized by the young Indians who seized the former Alcatraz prison—and held it for eighteen months—in protest of wrongs suffered by Native Americans. She raised funds for the support and defense of the protesters, later explaining in a *Chicago Tribune*

Following further discussion of the potential impact of women voters on the public, including revolutions and the ending of the republican form of government, the manifesto returns to the subject of women within the home:

> There are kingdoms in which the heart should reign supreme. That kingdom belongs to woman—the realm of sentiment, the realm of love, the realm of gentler and holier and kindlier attributes that make the name of wife, mother and sister next to the name of God himself, but it is not in harmony with suffrage and has no place in government.

The Manifesto concludes by noting that "the decision of this question at the polls is a man's question" and asking the "cooperation" of their male peers in denying women's suffrage. It was addressed to the Electors of the State of Nebraska and was signed by thirty men, including one former senator, one former member of the House of Representatives, two Episcopal ministers, and several men who confidently described themselves as "prominent lawyers."

In addition to the Nebraska Men's Association Opposed to Woman Suffrage, there were many other groups organized throughout America to prevent women's suffrage (and, in many of these, women joined or held leadership positions). A brief sampling of the antisuffrage organizations includes the Man Suffrage Association, the Massachusetts Association Opposed to the Further Extension of Suffrage to Women, the New

interview, "I was a mother, so I couldn't join them, but I did fundraising and got involved in the activist movement." During the next decade, she earned a B.A. in social work from the Flaming Rainbow University in Stilwell, Oklahoma; ended her marriage; and returned with her daughters to reclaim her grandfather's 160 acres.

Mankiller became the Cherokee Nation's program development specialist in 1979 and founded the Cherokee Nation's Community Development Department in 1981. As director of the Community Development Department, she designed and implemented projects such as the nationally praised Bell Water and Housing Project. That project brought fresh running water for the first time into many Native American homes and resulted in the complete rehabilitation of many of these homes, using methods that involved and uplifted the entire community: Each family was given the responsibility for laying one mile of pipe and for raising the funds to accomplish the task. The community succeeded in so stunning a fashion that CBS featured its story on "CBS Sunday Morning." Wilma Mankiller, whose "goal has always been for Indians to solve their own economic problems," was selected by then-Principal Chief of the Cherokee Nation, Ross Swimmer, to run as his deputy principal chief in the 1983 tribal elections. The pair won election. In 1985 Swimmer became head of the Bureau of Indian Affairs and Mankiller became the Principal Chief of the Cherokee Nation. In 1987 she won election to the position in her own right.

Mankiller pointed out that since the Cherokee afforded high position to women and were matrilineal in descent prior to contact with European men, "my election was a step forward and a step backward at the same time." She was aware that her actions reflect on women as well as Native Americans. As she explained to John Hughes during a *New York Times* interview, "I'm conscious of the fact that I'm the first female chief and people are watching me, and I want to make sure I do a good job."

During her tenure, Chief Wilma Mankiller signed a 1990 landmark self-governance agreement between the United States and the Cherokee Nation, which gave the Cherokee Nation the right to directly control federal funds previously administered on its behalf by the Bureau of Indian Affairs; established in 1990 a tax commission for the Cherokee Nation; and vastly improved the operations of the Cherokee Nation's tribal police force and courts. In 1992 she was chosen by President-elect Bill Clinton to attend a preinauguration national economic summit in Little Rock, Arkansas, as the official representative of all Native Americans. Her autobiography and history of the Cherokee Nation, *Mankiller: A Chief and Her People*, was published in 1993.

Despite her tremendous effectiveness and popularity (she won election to her third term in 1991 with 82 per-

cent of the votes cast), Mankiller announced before the end of 1994 that she would not seek reelection in 1995. Health concerns may well have played a part in the decision: Mankiller received her first kidney transplant in 1990 and wrote, in the epilogue of the 1994 paperback edition of her autobiography, that her final decision "just to rest for a while" was made during a month-long hospital stay in 1993. In retirement, she learned that she had lymphoma, which eventually caused her body to reject the transplanted kidney. She then underwent a second transplant, which was successful.

Wilma Mankiller currently lives in Oklahoma with her second husband, Charlie Soup. She was inducted into the NATIONAL WOMAN'S HALL OF FAME in 1994 and received the Presidential Medal of Freedom in 1998.

Further Reading: *Chicago Tribune*, May 14, 1986, and January 20, 1988; *Current Biography Yearbook*, 1988; *Los Angeles Times*, March 5, 1999; Mankiller and Wallis, *Mankiller; Ms.* magazine, January 1988; *New York Times*, December 15, 1985, and May 28, 1987; Steinem, *Revolution From Within, U.S. News and World Report*, February 17, 1986.

Mann Act
Legislation passed by the United States Congress on June 25, 1910, the Mann Act prohibited foreign or interstate transport of women for "immoral purposes." Also known as the White Slave Traffic Act, it was intended to combat prostitution and, especially, forced prostitution.

Further Reading: Clark, *American Women in the 20th Century*.

Marine Corps, Women's Reserve
Established in February 1943, the Women's Reserve of the Marine Corps was the female component of the marines until 1978. Marine Corps officials announced that their female soldier would be referred to simply as "marines." (This was in contrast the Army's WACS, the Navy's WAVES, and the Coast Guard's SPARS.) Major Ruth Cheney Streeter was named director.

During World War II, 23,000 women served under Streeter, who devised a rigorous training course at Camp Le Jeune, North Carolina. Enlistees were told to expect six weeks of boot camp during which "they will receive instruction similar to that given men. In addition, they will be shown all phases of marine combat training to give them a better understanding of their tasks." Female marines instructed male pilots, packed parachutes, supervised photography departments and film libraries, acted

as mechanics, and performed many other noncombat tasks.

The women's reserve of the Marine Corps—as well as the military's other women's corps—remained a regular part of the army until 1978, when all such units were abolished in favor of women's integration into the armed forces.

Further Reading: Clark, *Almanac of American Women in the 20th Century;* Weatherford, *American Women and World War II.*

Marriage Protest of Lucy Stone and Henry Blackwell

For most of the nineteenth century, a woman suffered the equivalent of civil death upon marriage since, as it was commonly put, "the two become one and that one is the husband." When Lucy STONE and Henry Blackwell married on May 1, 1855, they issued a statement that illustrates, as well as protests, the state of marriage law at the time:

> While acknowledging our mutual affection by publicly assuming the relationship of husband and wife, yet in justice to ourselves and a great principle, we deem it a duty to declare that this act on our part implies no sanction of, nor promise of voluntary obedience to such of the present laws of marriage, as refuse to recognize the wife as an independent, rational being, while they confer upon the husband an injurious and unnatural superiority, investing him with legal powers which no honorable man would exercise, and which no man should possess. We protest especially against the laws which give to the husband:
> 1. The custody of the wife's person. [A woman was not allowed to refuse her husband's sexual advances.]
> 2. The exclusive control and guardianship of their children.
> 3. The sole ownership of her personal, and use of her real estate, unless previously settled upon her, or placed in the hands of trustees, as in the case of minors, lunatics, and idiots.
> 4. The absolute right to the product of her industry.
> 5. Also against laws which give to the widower so much larger and more permanent interest in the property of his deceased wife, than they give to the widow in that of the deceased husband.
> 6. Finally, against the whole system by which "the legal existence of the wife is suspended during marriage," so that in most States, she neither has a legal part in the choice of her residence, nor can she make a will, nor sue or be sued in her own name, nor inherit property.

> We believe that personal independence and equal human rights can never be forfeited, except for crime; that marriage should be an equal and permanent partnership, and so recognized by law; that until it is so recognized, married partners should provide against the radical injustice of present laws, by every means in their power . . .

The protest was signed by both Henry B. Blackwell and Lucy Stone, and approved by the presiding minister, Thomas Wentworth Higginson, who circulated it with a letter suggesting that other couples follow suit.

Further Reading: Stanton, Anthony, and Gage, eds., *History of Woman Suffrage,* vol. 1.

Marriage Protest of Robert Dale Owen (1832)

One of the earliest recorded protests of the laws governing married couples in nineteenth-century America, this was the statement issued by Robert Dale Owen upon his marriage to Mary Jane Robinson:

> Of the unjust rights which in virtue of this ceremony an iniquitous law gives me over the person and property of another, I cannot legally, but I can morally, divest myself. And I hereby distinctly and emphatically declare that I consider myself, and earnestly desire to be considered by others, as utterly divested, now and during the rest of my life, of any such rights, the barbarous relics of a feudal, despotic system.

As noted in Owen's protest, the law gave him not only the right to Robinson's property but also to her person—in other words, a wife had no legal right to refuse the sexual advances of her husband. When Lucy Stone and Henry Blackwell married more than two decades after Owen and Robinson, they would find it necessary to protest essentially the same points.

While women began to gain property rights in the mid-1850s, RAPE continued to be defined in most states as "the forcible penetration of the body of a woman *not the wife of the perpetrator*" until the late 1970s. By 1999, all fifty states classified marital rape as a crime.

Further Reading: Davis, *Moving the Mountain;* Flexner, *Century of Struggle;* Stanton, Anthony, and Gage, eds., *History of Woman Suffrage,* vol. 1.

Married Woman's Property Act (1848)

An act granting limited property rights to married women in New York State, this served as a model for subsequent married women's property acts passed across the country between 1848 and 1895. Prior to the passage of this act, the property of a New York State woman (like women in

every other state) became her husband's to control after their marriage. A husband's right to manage his wife's property was so complete that it in effect stripped her of her right to its ownership: She was not legally entitled to make contracts, bring lawsuits, keep her own wages or her property's rents, or sell or transfer her property.

Section I of the Married Woman's Property Act entitled a woman, marrying after its passage, to keep any real and personal property she had owned as a single woman as well as the rents and profits from the same, and prohibited her husband or his creditors from seizing these monies.

Section II stated that the real and personal property of any women already married were now her sole and separate property, as were any proceeds from that property, except that husbands' debts incurred before the act's passage might still be settled by seizure of her property.

Section III stated that it was now legal for a married woman to inherit or be given property (but not by her husband) for her own use, which, with its proceeds, would be safe from the claims of her husband or his creditors.

Section IV stated that "All contracts made between persons in contemplation of marriage shall remain in full force after such marriage takes place."

There were various legislative attempts prior to 1848 to ensure that a woman's property remained within her family if she so wished. In colonial New York an Act to Confirm Certain Conveyances and Directing the Manner of Proving Deeds To Be Recorded was enacted in 1771; it required that a married woman sign the deed to her property before her husband sold or mortgaged it and that she also meet with a judge in private to assure him that the transfer met with her approval. In general, this type of law existed in southern colonies and, later, southern states. Maryland, for example, passed a law requiring such private examinations in 1674; its 1782 decision in *Flannagan's Lessee v. Young* invalidated a husband's transfer of his wife's property simply because the woman's consent had not been properly recorded. Other early but isolated measures to address women's property rights include a 1787 Massachusetts law allowing married women, in certain circumstances, to act as FEMME SOLE TRADERS and an 1809 Connecticut law permitting married women to execute wills. In a number of states, equity or chancery courts also recognized the validity of marriage or antenuptial settlements, enabling a woman to place lands owned prior to marriage (referred to as her "separate estate") in a trust to be managed by a man other than her husband. By the end of the eighteenth century, some states permitted the creation of separate estates without a third-party trustee.

The first married woman's property act, passed in Mississippi in 1839, was extremely limited. (It was concerned largely with a married woman's ownership of her slaves.) In contrast, the married woman's property act

passed by the New York State legislature in 1848 was a comprehensive, landmark measure that granted married women in New York rights no other married women in the United States had been granted as yet.

Among the women who had worked especially hard to secure passage of such an act were Ernestine ROSE, Elizabeth Cady STANTON, and Paulina Wright Davis. It was amended in 1860. (See ACT CONCERNING THE RIGHTS AND LIABILITIES OF HUSBAND AND WIFE.) By 1900, married women's property acts had been passed in every state.

Further Reading: Schneir, ed., *Feminism;* Stanton, Anthony, and Gage, eds., *History of Woman Suffrage,* vol. 1.

Martin, Anne Henrietta (1875–1951) *suffragist, politician, women's rights activist*
Born on September 30, 1875, in Empire City, Nevada, to Louise Stadtmuller Martin and William O'Hara Martin, Anne Martin was the first woman to run for election to the United States Senate.

Martin received one B.A. from the University of Nevada in 1894 and another B.A. and a master's degree from Stanford University, both in 1896. In 1897 she founded the University of Nevada's history department, of which she served as head until 1901.

In England from 1909 to 1911, Martin participated in that country's suffrage movement under the militant leadership of Emmeline Pankhurst. While there she was arrested for demonstrating for women's suffrage on November 18, 1910.

Returning to the United States, Martin was elected president of the Nevada Equal Franchise Society in 1914. In this capacity, she led the women of her native state in a successful campaign to ratify a woman's suffrage amendment to the state constitution. She then turned her attention to the campaign for an amendment to the United States Constitution, serving as an executive member of the NATIONAL AMERICAN WOMAN SUFFRAGE ASSOCIATION and the Congressional Union. In June 1916, when the NATIONAL WOMAN'S PARTY was founded, Martin became its first vice chairman.

Along with other women, Martin was arrested for picketing the White House on July 14, 1917. Upon her release from the Occoquan workhouse, she became the first woman in America to run for election to the Senate. She ran in both 1918 and 1920, losing both elections but securing at least 20 percent of the vote on each occasion.

Martin moved to Carmel, California, in 1921. In addition to writing articles about women's issues, she was an active member of the Women's International League for Peace and Freedom. (See WOMAN'S PEACE PARTY.) She was critical of the National Woman's Party for its emphasis on

lobbying the male political establishment in lieu of running its own female candidates, and she also questioned Carrie Chapman CATT's decision to make the LEAGUE OF WOMEN VOTERS into a primarily educational organization. Martin supported the EQUAL RIGHTS AMENDMENT and especially advocated "sex solidarity," the organization of women into a strong voting block. From 1926 to 1936 she was a national board member of the Women's International League for Peace and Freedom (see Women's Peace Party), and she was a delegate for that organization to world conferences in Dublin (1926) and Prague (1929).

Anne Martin died on April 15, 1951, in Carmel, California.

Further Reading: Anderson, "Anne Henrietta Martin," in *Notable American Women,* ed. Sicherman et al.; McHenry, ed., *Famous American Women;* Read and Witlieb, *Book of Women's Firsts;* Stevens, *Jailed for Freedom.*

McCauley, Mary Ludwig Hays (Molly Pitcher) (ca. 1754–1832) *participant in the Revolutionary War Battle of Monmouth*

Hays, better known by her nickname, "Molly Pitcher," was born on October 13, 1754(?), near Trenton, New Jersey, to John George Ludwig and his wife, whose name has been lost. Mary Ludwig and John Casper Hays were married on July 24, 1769.

John Hays served in the Continental Army during the Revolutionary War, first with Thomas Proctor's First Company of Pennsylvania Artillery and then with the Seventh Pennsylvania Regiment. Mary Hays, like many women, followed her husband's regiment in order to cook, do laundry, and provide nursing care. Hays earned her salutary nickname by bringing pitchers or pails of water to the exhausted and thirsty soldiers.

During the Battle of Monmouth, on June 28, 1778, John Hays was wounded or otherwise incapacitated while loading cannon. He fell to the ground, and "Molly" became the regiment's cannoneer for the remainder of the battle. The Pennsylvania legislature later introduced a bill "for the relief of Molly M'Kolly" (Mary had married John McCauley, also spelled M'Kolly, upon John Hays' death), which would have awarded funds to Molly only as the "widow of a soldier of the revolutionary army." The act was amended and, as passed on February 21, 1822, specifically granted compensation "for the relief of Molly M'Kolly, *for her services during the Revolutionary War*" (emphasis added).

Mary Ludwig Hays McCauley died in Carlisle, Pennsylvania on January 22, 1832.

Further Reading: Cometti, "Mary Ludwig Hays McCauley," in *Notable American Women,* ed. James, and Boyer; Flexner, *Century of Struggle;* McHenry, ed., *Famous American Women.*

McClintock, Barbara (1902–1992) *geneticist, Nobel Prize winner*

Born on June 16, 1902, in Hartford, Connecticut, to Sara Hady McClintock and Thomas Henry McClintock, geneticist Barbara McClintock became the third woman in the world to receive an unshared Nobel Prize in the sciences when she received the award for medicine or physiology in 1983.

In 1908 McClintock's family moved to Flatbush, Brooklyn, which was then a rural area. She attended public schools and graduated from Erasmus Hall High School in 1918. She spent 1919 working at an employment agency and working—successfully—to overcome her mother's disapproval of higher education for women. She received her B.S. from Cornell University in 1923, her M.A. from Cornell in 1925, and her Ph.D. from the same institution in 1927. She taught at Cornell from 1927 to 1936 and at the University of Missouri from 1936 to 1941 but, due to sex discrimination, found herself marginalized in both institutions. She accepted an offer to work at the Cold Spring Harbor Laboratory on Long Island in 1941, and conducted research there for over fifty years.

McClintock began her research on maize, popularly known as Indian corn, while still a student at Cornell. By the 1940s she was on the path to discovering transposable or movable genetic elements, or "jumping genes," as they were later nicknamed. When she published her results in 1951, they were dismissed by the scientific community as entirely implausible. In the 1970s, however, the genetic engineering experiments of molecular biologists confirmed McClintock's conclusions of twenty years prior. She thereupon received a number of honors and awards, including the National Medal of Science in 1970 and—in 1983 at the age of eighty-one—the Nobel Prize for medicine or physiology. She died on September 2, 1992 in Huntington, N.Y.

Further Reading: *Current Biography Yearbook,* 1984 ed.; Keller, *A Feeling for the Organism; Newsweek,* October 24, 1983; *New York Times,* November 18, 1991; *Time,* October 24, 1983.

Mead, Margaret (1901–1978) *anthropologist*

One of the foremost anthropologists of the twentieth century, Margaret Mead was born on December 16, 1901, in Philadelphia, Pennsylvania, to Emily Fogg Mead and Edward S. Mead.

Mead began her college education at DePauw University and, after her freshman year, transferred to Barnard, from which she graduated in 1923. She did her

graduate work at Columbia University under the guidance of Franz Boas and Ruth BENEDICT, two of America's most noted anthropologists. She received her M.A. in 1924 and, in 1929, became one of the first American women to earn a Ph.D. in anthropology. Mead was married several times: in 1923, to Luther Cressman, from whom she was divorced in 1926; in 1928, to Reo Fortune, with whom she conducted collaborative fieldwork until 1933 and whom she divorced in 1935; and, in 1935, to Gregory Bateson with whom she conducted fieldwork, published several works, and had one child, Mary Catherine Bateson. Margaret Mead and Gregory Bateson were divorced in 1943.

Mead began the first of her many anthropologic field trips in 1925, when she studied the progress of girls through adolescence in the South Sea island of Taue in Samoa. Her ensuing book, *Coming of Age in Samoa* (1928), concluded that Samoan girls were afforded an easier, less stressful adolescence by their culture than girls in industrialized countries such as the United States, but that they frequently matured with a less highly wrought individuality. The book brought Margaret Mead—and the new field of anthropology—recognition throughout the United States. Subsequent works include what was possibly her most influential book, *Male and Female: A Study of the Sexes in a Changing World* (published in 1949, the book is a study of gender socialization among different peoples), as well as a number of other important works: *Growing up in New Guinea* (1930); *Sex and Temperament in Three Primitive Societies* (1935); *Cooperation and Competition among Primitive Peoples* (1937); *The School in American Culture* (1951); *Soviet Attitudes toward Authority* (1951); *Cultural Patterns and Technical Change* (1954); *New Lives for Old* (1956); *People and Places* (1959); *Communities in Cultural Evolution* (1964); *Anthropology: A Human Science* (1964); *Culture and Commitment: A Study of the Generation Gap* (1970); and *A Rap on Race* (with James Baldwin, 1971). She edited *An Anthropologist at Work: Writings of Ruth Benedict* in 1959 and published her own autobiography, *Blackberry Winter,* in 1972.

Throughout her working years, Mead was strongly associated with the American Museum of Natural History. She was named that museum's assistant curator of ethnology upon her return from Samoa in 1926, its associate curator in 1942, and its curator emeritus in 1969, a position she held until her death. She also served as president of a number of organizations, including the World Federation of Mental Health (1956–57), the World Society for Ekistics, the multidiscipline scientific study of human settlements (1969–71), the Scientists' Institute for Public Information (1972–73), the Society for Research in General Systems (1972–73), and the American Association for the Advancement of Science (1975).

Mead was also an adjunct professor at Columbia University from the early 1950s and, from 1968 to 1971, the chair of Fordham University's social sciences division.

Margaret Mead died on November 15, 1978, in New York City.

Further Reading: Bateson, *With a Daughter's Eye;* Howard, *Margaret Mead; Coming of Age in Samoa;* ———, *Sex and Temperament in Three Primitive Societies;* ———, *Male and Female: A Study of the Sexes in a Changing World;* ———, *Blackberry Winter.*

Meritor Savings Bank, FSB v. Vinson (1986)

A 1986 Supreme Court decision that held unanimously—and for the first time—that Title VII of the CIVIL RIGHTS ACT OF 1964 prohibited sexual harassment in the workplace. Catharine MACKINNON acted as cocounsel for Mechelle Vinson, a female employee of Meritor Savings Bank. Vinson claimed that her supervisor had demanded sexual favors, which she had granted over four years for fear that she might otherwise lose her job. (Vinson was fired in 1978.)

Title VII makes it "an unlawful employment practice for an employer . . . to discriminate against any individual with respect to his compensation, terms, conditions, or privileges of employment, because of such individual's race, color, religion, sex or national origin . . ." The *Meritor* opinion, delivered by Chief Justice William H. Rehnquist, held that these words are "not limited to 'economic' or 'tangible' discrimination. The phrase 'terms, conditions or privileges of employment' evinces a Congressional intent 'to strike at the entire spectrum of disparate treatment of men and women' in employment." Continuing, he stated that a workplace containing "discriminatory intimidation, ridicule, and insult" that is "sufficiently severe or pervasive to alter the conditions of the victim's employment and create an abusive working environment" is in violation of Title VII.

In its 1993 decision in *HARRIS V. FORKLIFT SYSTEMS, INC.,* the Court further enunciated its definition of sexual harassment actionable under Title VII.

Further Reading: Greenhouse, "Court, 9–0, Makes Sex Harassment Easier to Prove"; *Meritor Savings Bank, FSB v. Vinson,* 1986, 106. S. Ct. 2399; O'Connor, "Women and the Constitution," in *Women, Politics and the Constitution,* ed. Lynn.

Michael M. v. Superior Court (1981)

A 1981 Supreme Court decision that upheld a California statutory rape law that implicated male but not female participants in consensual sex acts.

The California government argued that its law was intended to discourage teenage pregnancies and that this was a legitimate state goal. It further claimed that the possibility of pregnancy already discouraged young females from engaging in sexual activities, and pregnancy, when it did occur under such circumstances, inflicted a consequence upon the young woman from which her male partner was exempt.

The Supreme Court upheld the law, 5–4, in an opinion that granted "great deference" to California's goals and reasoning. Justices Brennan, Marshall, and White dissented, reasoning that a gender-neutral law that punished both young women and men would be at least as effective as California's male-only statute. Justice Stevens issued his own separate dissent, stating that it was "totally irrational" to spare the one most likely to bear the consequences from a punishment intended to deter the act.

Further Reading: Cushman, *Cases in Constitutional Law;* Mezey, "When Should Difference Make a Difference," *Women, Politics and the Constitution,* ed. Lynn.

military service, American women and

Women are an undeniable presence in the American armed forces of today, constituting 14 percent of enlisted military personnel. The armed forces these women have joined are more open to their participation—on increasingly equal terms with men—than ever before: The Pentagon, in 1993, made national headlines by deciding to open selected combat positions to women. However, women have a long history of involvement in the military and have been present in the American military—and in the line of fire—from the Revolutionary War to the present.

WOMEN AND THE AMERICAN REVOLUTION Hordes of women accompanied male relatives on their battle rounds. George Washington considered them both a distraction and a burden, but these women informally assumed responsibility for many necessary tasks. They prepared meals, tended to the laundry, and offered assistance at the military hospitals. Mary Ludwig Hays MCCAULEY ("Molly Pitcher") and Margaret Cochran CORBIN were two camp followers who gained fame because they took over the battle duties of their wounded husbands; just as noteworthy, though, is the fact that they were on the battlefield because they already were actively engaged in supporting the revolution.

Other women disguised themselves as men and enlisted. Deborah SAMPSON, for example, fought bravely for one and one-half years before her sex was discovered and she was honorably discharged. Still other women acted as spies, among them (at least according to persistent legend), the Irish immigrant Lydia Barrington Darragh, who is credited with warning the Continental Army

to be prepared for British General William Howe's December 4, 1777 attack on George Washington. (Washington's troops were prepared, and Howe was forced to retreat.)

CIVIL WAR PARTICIPATION That women acted as spies during the Civil War is amply documented. Harriet TUBMAN, wearing bloomers, served the Union army as both scout and spy; Rose O'Neal Greenhow and Belle Boyd were two of the South's most famous female spies. (En route aboard a British ship to Confederate president Davis in 1864, Greenhow refused to leave her many gold sovereigns behind when difficulties forced passengers into lifeboats. When her lifeboat capsized she sank and drowned. She was buried with full military honors when her body washed ashore; upon Boyd's death much later in 1900, four veteran Union soldiers placed her coffin in its Wisconsin grave.)

As in the Revolution, women disguised themselves as men to enlist as soldiers. One of these women, Sarah Emma Edmonds, served in the Second Michigan Regiment of the Union's Volunteer Infantry and was later granted a pension and inducted into the Civil War's veteran organization, the Grand Army of the Republic. Although she was the only woman to receive such recognition, Edmonds was not the only armed member of her sex on the battlefield: According to contemporary sources, including Mary Livermore's *My Story of the War* (1887), approximately 400 women were known to have served as soldiers in the Civil War.

At the instigation of women during this war, an official nursing corps began to be seen as an essential component of the armed forces. The United States SANITARY COMMISSION, as this nursing corps was named, was approved by President Abraham Lincoln on June 13, 1861. Sanitary Commission nurses, under the guidance of Dorothea DIX, worked in military camps, on battlefields, and in hospital ships. Other northern nursing organizations, unaffiliated with the U.S. government but equally welcome on the battlefield, included the Christian Sanitary Commission and the Western Sanitary Commission. It should also be noted that many other women—most notably, Clara BARTON, who would later found the American Red Cross—donated their services outside the auspices of any formal organization.

Confederate women established private hospitals in their homes and other buildings. The most successful of these was Robertson Hospital, established and operated by Sally Louisa Tompkins in a donated home in Richmond, Virginia. When the Confederate surgeon general ordered private hospitals closed in favor of five newly established Confederate military hospitals, President Jefferson Davis promptly relived Tompkins of her "private" status by commissioning her a cavalry captain. Her hospital, which was thereafter operated under Tompkins'

Civil War nurse *(Engraving by G. E. Perine & Co. for Frank Moore's* Women of the War *[1866])*

military authority, lost only 73 out of its 1,333 wounded patients. The only woman to be commissioned into the Confederate army, Tompkins was buried with full military honors upon her death on July 26, 1916.

WOMEN IN WORLD WAR I By the 1917 entry of the United States into World War I, physical exams were administered to enlisting soldiers, and women were unable to serve as soldiers in the guise of men. Nonetheless, women made significant contributions to the U.S. war effort—and, according to the tally published by the Women's Overseas Service League on November 11, 1922, 161 American women lost their lives in so doing.

The U.S. Army Nurse Corps had been established by the federal government in 1901 with Dita H. Kenney as its first head; the Navy Nurse Corps was established in 1908 with Esther Voohees Hanson as its first superintendent. Many thousands of these military nurses served within the United States, on hospital ships, and in Europe. (Other nurses served outside the military, under the auspices of the Red Cross.)

Nursing was just one aspect of women's participation in World War I, however. Toward the end of the war, the navy—facing a critical clerical shortage—investigated enlistment laws and found a loophole that permitted the admission of women to its ranks. During this war, the marines also decided to open its ranks to women. Opha May Johnson became the first woman to join the U.S. Marine Corps on August 12, 1918, when she enlisted in the Reserves. By the end of World War I, nearly 13,000 women had served as "Yeomen (Female)" in the Navy and Marine Corps (the latter dubbed "Marinettes") on equal status with male yeomen. While many of these female soldiers performed clerical work and provided support services in military kitchens and laundries, there were exceptions. Abby Putnam Morrison, for example, became the first woman naval electrician on October 12, 1917, when she was assigned to the U.S. Navy's Radio Bureau. Approximately 1,000 women also were hired as independent contractors by the armed forces to work overseas as telephone operators, translators, and in other capacities for the American Expeditionary Forces.

As in earlier wars, women made substantial contributions outside the purview of the military itself. In this case, however, the U.S. government tried to lend its support: As women on the home front replaced men in factories, on farms, and even in the country's mines and

steel mills, the federal government created the Women in Industry Service Bureau to oversee the employment conditions of women. (The WOMEN'S BUREAU of the U.S. Department of Labor was a direct outgrowth of this wartime organization.) In addition, President Woodrow Wilson and the Council of National Defense appointed Dr. Anna Howard SHAW to lead the Women's Committee of the Council of National Defense, which coordinated the volunteer efforts of American women's organizations during the war.

In 1925, Congress passed a law barring women from military service outside the nursing corps. When women were needed in World War II, Congress would find it necessary to draft new legislation to permit and redefine their military participation.

WOMEN AND WORLD WAR II American women's efforts and sacrifices in World War II began even before formal U.S. entry into the war. American Red Cross nurses volunteered to go to the aid of European soldiers, and seventeen of these nurses were aboard the Dutch ship *Maasdam* when it was torpedoed; two of them died. When another ship was torpedoed, two American nurses spent nineteen days in a lifeboat in the Atlantic, caring for the seven injured male soldiers with whom they awaited rescue. (Two of the seven men died during the ordeal.) On December 7, 1941, when Pearl Harbor was attacked by the Japanese, Captain Annie Fox, though injured herself, responded so valiantly to the destruction and injury around her that she was later awarded the Purple Heart, the first nurse to be so honored.

Once the United States entered the war, nurses in the Navy Nurse Corps (NNC) served on hospital ships; forbidden to serve on combat ships themselves, they were responsible for training male medics to provide onsite emergency treatment. Nurses in the Army Nurse Corps (ANC) served wherever there were soldiers and sometimes suffered the same consequences: Sixty-six nurses, for example, were taken as prisoners of war and held by the Japanese for three years in prison camps at Bataan and Corregidor. Finally, NNC nurses served for the first time aboard military aircraft. These flight nurses, responsible for caring for the war's most seriously wounded soldiers as they were evacuated from battlefields to hospitals in safer places, were trained rigorously in survival tactics at the School of Air Evacuation at Bowman Fields, Kentucky. Since military reinforcements arrived on the same planes used to evacuate the injured, the protective Red Cross that normally marked medical sites and rescue vehicles was not permitted—effectively placing flight nurses in the line of fire. Nurses were considered so vital to the successful conduct of the war that Congress responded to a nursing shortage with the Nurses Selective Service Act of 1945—a proposal to draft nurses for military service. (The measure was dropped in May 1945 when the Germans surrendered.)

Medically trained women were not alone in their World War II military service. Congress, having passed laws after World War I that prohibited women's military service except as nurses, now passed legislation creating the WOMEN'S ARMY CORPS (WACS), the WOMEN'S RESERVES OF THE NAVY (WAVES), the COAST GUARD WOMEN'S RESERVES (SPARS), and a women's reserve in the MARINES. The women who served in these corps became clerical workers, parachute packers, pilot instructors, airplane mechanics, record keepers, and more. It is also important to note that these women and the uniformed nurses—350,000 women in all—were the first military women for whom veteran's compensation and benefits were provided. Finally, 1,000 female pilots flew U.S. planes out of American Air Force bases in a paramilitary capacity during World War II. These members of the Women's Auxiliary Ferrying Squadron (WAFS) and the WOMEN'S AIRFORCE SERVICE PILOTS (WASPS) flew military aircraft from factories to bases, tested and repaired planes, and taught flight and gunnery to male students. Since they were civilians, they received no veteran's compensation or benefits until 1977 when Congress, prodded by Senator Barry Goldwater (R-AZ), bestowed veteran's status on them.

THE WOMEN'S ARMED SERVICES INTEGRATION ACT AND THE KOREAN WAR The women's Armed Services Integration Act, passed after World War II by Congress (May 1948), granted women a regular, permanent status in the military. The act placed (now obsolete) restrictions on the service of women: They could not attain ranks higher than lieutenant, commander, or colonel; they could not exceed 2 percent of military personnel; and they could not enlist if married unless they were returning veterans. They also were barred from combat duty. However, thanks largely to the efforts of Senator Margaret Chase SMITH, who was instrumental in the act's passage, women who did serve were guaranteed equal pay and privileges. Women served abroad in the U.S. military during the Korean War (1950–53) in nursing and hospital positions as well as in administrative capacities, but their numbers—perhaps due to an interpretation of the Integration Act—were not compiled separately.

WOMEN IN THE VIETNAM WAR During the Vietnam War 265,000 women served in the armed forces. Of the 11,500 women who were stationed in Vietnam itself, the vast majority were nurses. Other military women stationed in Vietnam interpreted photographs for military intelligence, performed various administrative functions, and acted as advisers and consultants to the South Vietnamese Women's Army Corps. In the late 1960s, Congress removed its 1948 restrictions on women's numbers in and attainable rank in the military, enabling military women to achieve many "firsts" during the Vietnam War:

The army appointed its first female general officer in 1970; the air force appointed its first female brigadier general in 1971; and the navy appointed its first female rear general and declared its intention to assign women to general sea duty in 1972.

GENDER INTEGRATION IN THE U.S. ARMED FORCES? In 1978 the separate women's corps of the armed forces—the WACS, WAVES, SPARS, and the women's reserve of the Marine Corps—were abolished in favor of establishing gender integration in the U.S. Armed Forces. Women remained barred from combat duty, by policy in the army and by law in the air force, marines, and navy, for the next fifteen years.

Those fifteen years constituted a period of debate about women's exact position in the now-integrated armed forces. During the 1983 U.S. invasion of Grenada, for example, four military policewomen traveled with their unit to the island, only to be arbitrarily ordered home by the 82nd Airborne Division's commander. In contrast, during the 1989 invasion of Panama by the United States, a number of women were deployed in what the *New York Times* referred to as "combat *area* roles." Captain Linda L. Bray, for example, led her military police unit in the successful capture of a guard dog kennel belonging to and guarded by the Panama Defense Forces. President George Bush stated at a news conference, however, that "these were not combat roles." Brigadier General Peter T. Barry, deputy director of military personnel management for the army, while agreeing that Bray's mission was not a direct combat one, added that "no one thinks she wasn't in combat." During the invasion of Panama, three women came under enemy fire while flying UH-60 helicopters in support functions, such as ferrying troops to landing zones. They became the first women to be nominated for the army's Air Medal and prompted considerable debate in Congress as to whether the combat exclusion should be lifted.

WOMEN IN AND SINCE THE PERSIAN GULF WAR When the United States entered the Persian Gulf War in the beginning of 1991, 40,000 of the 540,000 deployed soldiers were women. They were present in all participating branches of the military. The lines between women's "direct combat roles" and "combat area roles" remained blurred: Women were permitted, for example, to fly reconnaissance planes, but not the planes that flew behind to defend them. They shot down incoming Scuds and a few flew into hostile areas, but they were not officially "in combat." Two women were taken prisoner of war (both were later released), and five women died as a result of hostile action.

On May 23, 1991, the House of Representatives voted in favor of a military budget that contained a measure ending restrictions on women flying combat planes. Representative Patricia SCHROEDER, sponsor of the com-

bat flight measure, viewed its passage as a direct response to women's service in the Persian Gulf War: "There were a lot of cowardly lions roaring in the cloakroom, but they wouldn't go out on the floor to vote against it," she said. "The Persian Gulf helped collapse the whole chivalrous notion that women could be kept out of danger in a war. We saw that the theater of operations had no strict combat zone, that Scud missiles were not gender-specific— they could hit both sexes and, unfortunately, did." The Senate approved similar legislation on July 31, 1991, and in April 1993 Defense Secretary Les Aspin ordered all branches of the military to permit women to fly combat planes. On January 13, 1994, he further ordered the armed forces to review all ground combat positions that were closed to women and to open all positions except those in which a woman would have, as the *New York Times* summarized it, "a high probability of fighting enemy forces in close combat under hostile fire near or at the front lines." At present, women fly in combat helicopters and aircrafts, and the navy is preparing to assign women to submarines on a test basis.

In 1993, President Bill Clinton ordered a new policy toward lesbians and gays in the military. Commonly known as "don't ask, don't tell," the policy requires homosexuals to "keep quite" about their sexual orientation and to refrain from homosexual conduct. (Previously, homosexuals were officially barred from service on any terms.) To date, the Supreme Court has refused to hear challenges against the policy brought by those who claim it violates their right to freedom of speech and/or freedom of association. Abusive behavior toward lesbians and gays in the military has also been reported; to counter this, the Pentagon in August 1999 ordered that antiharassment training be provided to all troops.

Although approximately 1.8 million women have served in the armed forces from the Revolution to the present, it seems that they have not yet won full acceptance. During the spring of 1991, the navy received two complaints of rape from female marines returning from the Gulf War, and the army received two complaints of attempted rape from returning female soldiers—and all of the allegations involved male members of the U.S. Armed Forces. In September 1991, at a Las Vegas convention of the Tailhook Association, a navy aviators' group, 83 female officers and other women were physically and sexually abused by some 140 navy and Marine Corps officers. In 1996, drill instructors at the Aberdeen Proving Ground in Maryland and several other army boot camps were accused of severe sexual misconduct toward young female recruits.

In response, Secretary of Defense William Cohen in 1997 appointed former Senator Nancy Kassebaum Baker (R-KS) to head a panel investigating the merits of mixed-gender military training. Kassebaum Baker's panel unani-

mously recommended that men and women be segregated during training, but Cohen—supported by the air force, army and navy chiefs—rejected that advice. Congress then appointed its own panel, the Congressional Commission on Military Training and Gender-Related Issues, to study the same question. The commission, headed by Anita Blair of the conservative Independent Women's Forum, recommended in August 1999 that mixed-gender training continue.

The Women in Military Service for America memorial at Arlington National Cemetery was dedicated on October 18, 1997.

Further Reading: Associated Press, March 11, 1998; Beck et al., "Our Women in the Desert"; Benton, "What Women Did for the War"; Chestnut, *Mary Chesnut's Civil War;* "Citadel Plans Appeal of Ruling on Woman," *New York Times,* August 18, 1993; Clark, *American Women in the 20th Century;* Cunningham, "Sally Louisa Tompkins," in *Notable American Women,* ed. James, James, and Boyer; Curti, "Clara Barton," in *Notable American Women,* ed. James, James, and Boyer; Dannett, *She Rode With the Generals;* Drinker, "Lydia Barrington Darragh" in *Notable American Women,* ed. James, James, and Boyer; Edmonds, *Nurse and Spy in the Union Army;* Elshtain, *Women and War;* "Female Pilots Recall Bullets," *New York Times,* February 9, 1990; Fladeland, "Sarah Emma Evelyn Emonds," in *Notable American Women,* ed. James, James, and Boyer; Flexner, *Century of Struggle;* Franke, *Ground Zero;* Frost and Cullen-DuPont, *Women's Suffrage in America;* Goostray, "Julia Catherine Stimson," in *Notable American Women,* ed. James, James, and Boyer; Hartmann, *American Women in the 1940s;* Hay, "Belle Boyd", in *Notable American Women,* ed. James, James, and Boyer; Korb, "A Woman's Place Is in the Pentagon"; Livermore, *My Story of the War;* "Male Bastion Finding Fewer Good Men," *New York Times,* October 20, 1993; McHenry, ed., *Famous American Women;* Moore, *Women of the War;* Nelan, "Annie Get Your Gun"; *New York Times,* March 17, 1998; Nordheimer, "Women's Role in Combat"; Palmer, "The Nurses of Vietnam, Still Wounded"; Ralston, "Women's Work"; Rayman, "War Heroines"; Read and Witlieb, *Book of Women's Firsts;* Ross, *Rebel Rose;* ———, "Rose O'Neal Greenhow" in *Notable American Women,* ed. James, James, and Boyer; Schmitt, "Senate Votes to Remove Ban on Women as Combat Pilots"; ———, "Pentagon Plans to Allow Combat Flights by Women"; ———, "Belated Salute to the Women Who Served"; ———, "Aspin Moves to Open Many Military Jobs to Women"; Sciolino, "Battle Lines Are Shifting on Women in War"; ———, "Female P.O.W. is Abused, Kindling Debate"; Shabecoff, "Report of Woman's Role is Called into Question"; Shaw, "What the War Meant to Women"; Sigaud, *Belle Boyd;* Stanton, Anthony, and Gage eds., *History of Woman Suffrage,* vols. 2 and 5; Sterling, *We Are Your Sisters;* "Virginia Military Institute to Establish Courses at Women's Colleges," *New York Times,* September 26, 1993; Weatherford, *American Women and World War II;* Willenz, *Women Veterans;* "Woman Registers at Citadel, Then Is Barred," *New York Times,* January 13, 1994; *USA Today,* June 30, 1997 and August 11, 1999; *Washington Post,* December 16, 1997; and Women in Military Service for America Memorial Foundation.

Mink, Patsy Takemoto (1927–) *congressional representative*
The first Asian-American woman elected to Congress and the first Asian American to run for the presidency, Patsy Takemoto Mink was born on December 6, 1927, in Paia, Maui, Hawaii to parents of Japanese descent.

She attended the European American Kaunoa English Standard School, one of the few Hawaiian Asians to do so. During World War II, unlike others of Asian descent, Hawaiian Asians were not sent to concentration camps, but Mink was isolated by her Caucasian classmates and ultimately transferred to Maui High School. She was valedictorian of her graduating class in 1944 and afterward attended the University of Hawaii. She transferred to Wilson College and the University of Nebraska for part of her college career, but she returned to the University of Hawaii to graduate in 1948. She then attended law school at the University of Chicago and, following her graduation in 1951, became the first Japanese-American woman to pass Hawaii's bar exam. She and John Mink were married on January 27, 1951; the couple have one child.

Mink entered politics as an organizer for the local Young Democrats chapter and quickly became the organization's national vice president. She was elected to the House of Representatives for the Territory of Hawaii on November 7, 1956 and to the territorial Senate in 1959. When Hawaii became America's fiftieth state later that year, the territorial government was suspended.

Mink ran for a seat in U.S. Congress but lost. She was more successful in 1962, when she ran for and was elected to a seat in the Hawaii Senate. In 1964, Mink again ran for a seat in the U.S. House of Representatives. She won that election and the next five, retaining her congressional seat until 1977.

Mink ran unsuccessfully for the presidency in 1972 and for election to the U.S. Senate in 1976. When her term in the House of Representatives expired in 1977, President Jimmy Carter appointed her assistant secretary for Oceans and Environmental Affairs. She served in that position from 1977 to 1978 and then returned to

Hawaii. She spent the next dozen years in private law practice, teaching law at the University of Hawaii, and serving two terms on the Honolulu City Council. In 1990, Mink was reelected to the U.S. Congress, where she continues to serve.

Mink's record has been a distinguished one. She was a founder of the Congressional Asian Pacific Caucus and has served as its chair since 1995. In that capacity, she has been a champion of affirmative action and immigration, and a strong opponent of "English-only" legislation. An equally strong proponent of women's rights, she has been a longtime member of the CONGRESSIONAL CAUCUS FOR WOMEN'S ISSUES and was a sponsor of TITLE IX OF THE EDUCATION AMENDMENTS OF 1972. In 1996, she voted against the federal DEFENSE OF MARRIAGE ACT, which was introduced when Hawaiian courts were preparing to rule on same-sex marriage. (To date, same-sex marriage has not been legalized in Hawaii or in any other state—although Vermont approved civil unions in 2000.)

Further Reading: *Encyclopedia of World Biography;* Estrada, "How Much is Owed to Latin Japanese-Americans"; Jackson, "Patsy Mink Holds Many Political Firsts"; Somerville, "Sponsors Defend English-As-Official-Language Proposals"; Spitzer, "Gay and Lesbian Group Gives Hawaii Delegation Top Marks."

Minor v. Happersett (1875)

A 1875 Supreme Court decision that found women were not entitled to the right of suffrage under the United States Constitution as amended by the FOURTEENTH AMENDMENT.

Although the language of the Fourteenth Amendment was opposed by many nineteenth-century women's rights leaders, Francis Minor, a lawyer and husband of Virginia MINOR, president of the Woman Suffrage Association of Missouri, argued that Section I of the amendment represented an advance for women. Section I states that

> All persons born or naturalized in the United States, and subject to the jurisdiction thereof, are citizens of the United States and of the State wherein they reside. No State shall make or enforce any law which shall abridge the privileges or immunities of citizens of the United States; nor shall any State deprive any person of life, liberty, or property, without due process of law; nor deny to any person within its jurisdiction the equal protection of the laws.

Minor drafted resolutions for consideration and discussion by members of the Woman Suffrage Association of Missouri, resolutions that outlined his conclusion that the Constitution already granted the right of suffrage to women:

> Resolved, 1: That the immunities and privileges of American citizenship, however defined, are National in character and paramount to all State authority.
>
> 2: That while the Constitution of the United States leaves the qualifications of electors to the several States, it nowhere gives them the right to deprive any citizen of the elective franchise which is possessed by any other citizen—to regulate, not including the right to prohibit the franchise.
>
> 3: That, as the Constitution of the United States expressly declares that no State shall make or enforce any laws that shall abridge the privileges or immunities of citizens of the United States, those provisions of the several State Constitutions that exclude women from the franchise on account of sex, are violative alike of the spirit and letter of the Federal Constitution.
>
> 4: That, as the subject of naturalization is expressly withheld from the States, and as the States clearly have no right to deprive of the franchise naturalized citizens, among whom women are expressly included, still more clearly have they no right to deprive native-born women of this right.

Virginia Minor and the members of her association endorsed the resolutions. At the end of 1869, Elizabeth Cady STANTON and Susan B. ANTHONY published them in their newspaper, the *REVOLUTION,* and presented them to the NATIONAL WOMAN SUFFRAGE ASSOCIATION, which also endorsed them. Stanton was, by this time, in the midst of her public battles against the Fifteenth Amendment, but she adopted the Minors' interpretation of the Fourteenth and advocated its tenets to the Congressional Committee on the District of Columbia in an 1870 speech. Victoria WOODHULL next championed what was becoming known among women's rights activists as "the New Departure." Woodhull petitioned Congress to recognize the right of women to vote under the Constitution and, especially, under the Fourteenth Amendment. In response to an invitation of the House Judiciary Committee, Woodhull appeared before it on January 11, 1871, to explain the position. Her "bare legal argument" (as suffragist Isabella Beecher HOOKER approvingly referred to Woodhull's expansion of Minor's view), was well reasoned, fully researched, and admired by many of the 1,400 spectators who crowded the room to hear it. It did not persuade the members of the Judiciary Committee. On February 1, 1871, the committee issued a negative report, declaring that the Fourteenth Amendment would not confer voting privileges upon American women.

Women refused to give up the idea that they were entitled to suffrage under the Constitution. In 1871 and 1872 they tried to vote in various states. About 150 women succeeded, Susan B. ANTHONY among them. (She was arrested, tried, and convicted.) Women who

were turned away in 1871 brought suit unsuccessfully, including Ellen Rand Van Valkenburg of Santa Cruz, California, Carrie S. Burnham of Philadelphia, and Catherine V. Waite of Illinois. Virginia Minor was one of the women turned away from the polls in 1872. She and her husband (since married women were not allowed to bring legal action on their own) sued St. Louis registrar Reese Happersett. The case ultimately reached the Supreme Court.

In their December 1872 lower court petition, Virginia Minor, Francis Minor, and two other attorneys, John M. Krum and John B. Henderson, argued that Virginia Minor's constitutional rights had been abridged and specifically cited Article I, Section 9 ("Which declares that no Bill of Attainder shall be passed"); Article I, Section 10 (prohibiting the states from passing bills of attainder and outlawing "any title of nobility"—a status that "male citizens" appeared to have been granted); Article IV, Section 2 ("The citizens of each State shall be entitled to all privileges and immunities of citizens in the several States"); Article IV, Section 4 ("The United States shall guarantee to every State a republican form of government"); and the Fifth Amendment's guarantee that "No person shall be . . . deprived of life, liberty, or property without due process of law." It also cited the Ninth Amendment (granting all rights not expressly the province of the government to the people, from which the right to privacy is derived). (This amendment would be used with greater success in two landmark twentieth-century cases, GRISWOLD V. CONNECTICUT [1965] and ROE V. WADE [1973].) Last, they cited Section 1 of the Fourteenth Amendment.

Plaintiffs' argument and brief, presented to the Supreme Court in 1874, claimed, in addition, that "There can be no half-way citizenship. Woman, as a citizen of the United States, is entitled to all the benefits of that position, and liable to all its obligations, or to none." Among other Supreme Court decisions, it cited *Dred Scott v. Sandford*, the notorious 1857 response to the question of whether "the class of persons who had been imported as slaves, [or] their descendants . . . *free or not,*" were or ever could be citizens. Chief Justice Roger Taney found that they could not (a decision that was later invalidated by the adoption of the Fourteenth Amendment), but he also made clear that such citizenship would confer rights no state could refuse to recognize:

> if persons of the African race are citizens of a State, and of the United States, they would be entitled to all of these privileges and immunities in every State, and the State could not restrict them; for they would hold these privileges and immunities under the paramount authority of the Federal Government, and its courts would be bound to maintain and enforce them, the

Constitution [of an individual state] and the laws of the State to the contrary notwithstanding . . .

The Minors' attorneys pointed out that Section 1 of the Fourteenth Amendment granted citizenship to women as well as to African-American males. They argued that the members of both groups, by the standards set in *Dred Scott*, were now in possession of a citizen's "privileges and immunities." And they cited the Supreme Court's 1873 *Slaughter-House* decision as evidence that the Court considered suffrage a right of citizenship: "The negro having by the Fourteenth Amendment been declared a citizen of the United States, is thus made a voter in every state of the Union." Therefore, they claimed, Missouri's state constitution, which abridged its female citizens' right of suffrage, was in violation of the United States Constitution.

In a unanimous decision, the Supreme Court found otherwise. Chief Justice Morrison R. Waite declared in his opinion that women born or naturalized in the United States were indeed—and had been even before the adoption of the Fourteenth Amendment—citizens. However, he also declared that the right of suffrage was not one of the privileges and immunities of citizenship and that states could therefore continue to disfranchise their female citizens.

The Supreme Court did not apply any provision of the Fourteenth Amendment to women until 1971, almost 100 years after the amendment's adoption. (See *REED V. REED.*)

Further Reading: Cary and Peratis, *Woman and the Law;* Cushman, *Cases in Constitutional Law;* Goldstein, *The Constitutional Rights of Women; Minor v. Happersett,* 88 U.S. 162 (1875). Stanton, Anthony, and Gage, eds., *History of Woman Suffrage,* vol. 2.

Minor, Virginia Louisa (1824–1894) *founder of the Woman Suffrage Association of Missouri and plaintiff in the Supreme Court case* Minor v. Happersett

Virginia Louisa Minor was born on March 27, 1824, in Caroline County, Virginia, to Maria Timberlake Minor and Warner Minor.

Upon her marriage to a distant cousin, Francis Minor, Virginia Minor moved to St. Louis, Missouri. Despite her Southern background, she was a member of the St. Louis Ladies Union Aid Society, which was organized in 1861 to help Union soldiers and their families during the Civil War. This society later became a branch of the Western Sanitary Commission. After the war, Minor's energies were redirected to the rights of women when in 1865 the St. Louis Ladies Union Aid Society was dissolved. Minor believed that women, as well as

African-American males, deserved the right to vote. She was the first woman to speak out for women's rights in Missouri, and in 1867 she petitioned the Missouri State Legislature to include women in a proposed constitutional amendment to enfranchise black males. When this effort failed, she and others formed the Woman Suffrage Association of Missouri in the same year. She was elected president and subsequently reelected for five consecutive yearly terms. When this organization voted in 1871 to join the AMERICAN WOMAN SUFFRAGE ASSOCIATION, which had supported ratification of the FOURTEENTH AMENDMENT, Minor resigned her position and aligned herself with the NATIONAL WOMAN SUFFRAGE ASSOCIATION (NWSA), which had opposed ratification of that amendment. She later became president of the St. Louis branch of NWSA.

After the Fourteenth Amendment was adopted, Minor and her husband insisted that women, as citizens, were included within its provisions and therefore entitled to vote. When Minor tried to vote in 1872, however, her ballot was refused. With her husband (women could not bring legal action on their own), Minor sued the registrar. The case, *MINOR V. HAPPERSETT*, was eventually heard by the Supreme Court. Its 1874 decision found, unanimously, that women were not entitled to vote under the Fourteenth Amendment.

When the National Woman Suffrage Association and the American Woman Suffrage Association merged, Minor was elected president of the Missouri branch of the NATIONAL AMERICAN WOMAN SUFFRAGE ASSOCIATION. She held this position for two years and then retired.

Virginia Louisa Minor died in St. Louis on August 14, 1894.

Further Reading: Chandler, "Virginia Minor," *Notable American Women*, eds. James, James, and Boyer; Flexner, *Century of Struggle;* Frost and Cullen-DuPont, *Women's Suffrage in America;* Stanton, Anthony, and Gage, *History of Woman Suffrage*, vol. 2.

Mississippi University for Women v. Hogan (1982)

A 1982 Supreme Court decision that held, by a vote of 5–4, that Mississippi University's policy of excluding men from its nursing school was a violation of the Equal Protection Clause of the Fourteenth Amendment.

In 1979 Joe Hogan, a registered nurse without a baccalaureate degree, applied for admission to Mississippi University for Women. The university, originally founded in 1884 as the Mississippi Industrial Institute and College for the Education of White Girls of the State of Mississippi, was, as Justice Sandra Day O'Connor noted in her majority opinion, "the oldest state-supported all-female college in the United States." The School of

Nursing, created by the university in 1971, denied admission to Hogan based on his sex, although he "was otherwise qualified." Hogan was thereupon invited to audit classes without the possibility of earning credit.

The opinion pointed out that discrimination against males as well as females was subject to scrutiny under the Equal Protection Clause of the Fourteenth Amendment, which provided that "No State shall . . . deny to any person within its jurisdiction the equal protection of the laws." It then reviewed the "intermediate" or "midlevel" standard of scrutiny that the Court, in *CRAIG V. BOREN,* found appropriate for application to sex discrimination cases: "Classifications by gender must serve important governmental objectives and must be substantially related to achievement of those objectives."

The opinion cautioned against the application of stereotyped assumptions:

> Although the test for determining the validity of a gender-based classification is straightforward, it must be applied free of fixed notions concerning the roles and abilities of males and females. Care must be taken in ascertaining whether the statutory objective itself reflects archaic and stereotyping notions. Thus, if the statutory objective is to exclude or "protect" members of one gender because they are presumed to suffer from an inherent handicap or to be innately inferior, the objective itself is illegitimate.

In *Mississippi University v. Hogan,* the state claimed that its all-female policy was an educational affirmative action that compensated for sex discrimination suffered by women. This argument was thrown out by the Court, which stated that women suffered no lack of available nurses' training either in 1971, when the nursing school was established by the university, or at the time of Hogan's suit. The opinion also pointed out that the school's offer to allow Hogan's attendance as an uncredited auditor invalidated any possible claim that "women, at least those in the School of Nursing, are adversely affected by the presence of men." An expansion of this point might be read as containing guidelines to what type of situation might be legally remedied by a single-sex classroom policy:

> . . . The uncontroverted record reveals that admitting men to nursing classes does not affect teaching style, that the presence of men in the classroom would not affect the performance of the female nursing students, and that men in coeducational nursing schools do not dominate the classroom. In sum, the record in this case is flatly inconsistent with the claim that excluding men from the School of Nursing is necessary to reach any of MUW's educational goals.

Justice O'Connor also objected to the school's view that training only women to be nurses was, in fact, helpful

to women. In O'Connor's view, as expressed in the majority opinion, the nursing school, by training only women, contributed to the continuation of sexual stereotypes and reduced women's wages by helping to ensure that the nursing profession remained a primarily female one.

This decision was cited as precedent in UNITED STATES V. VIRGINIA (1996), which compelled the last two state-supported all-male colleges to admit women or do without state funding. (Both colleges, the Virginia Military Institute and The Citadel, chose to admit women.)

See also HARRIS V. FORKLIFT.

Further Reading: Cushman, *Cases in Constitutional Law;* Frost-Knappman and Cullen-DuPont, *Women's Rights On Trial;* Greenhouse, "Court, 9–0, Makes Sex Harassment Easier to Prove"; *Mississippi University for Women v. Hogan,* 1982. 458 U.S. 718; O'Connor and Segal, "Justice Sandra Day O'Connor and the Supreme Court's Reaction to Its First Female Member," in *Women, Politics and the Constitution,* ed. Lynn.

Mitchell, Maria (1818–1889) *astronomer*

Born on August 1, 1818, on Nantucket Island, Massachusetts, to Lydia Coleman Mitchell and William Mitchell, astronomer Maria Mitchell was the first woman elected to the American Academy of Arts and Sciences.

Mitchell attended DAME SCHOOLS and later a school run by her father. She frequently assisted her father with another of his responsibilities, the rating (or checking by stellar observation) of the chronometers used by Nantucket whalers. Upon completion of her education, Mitchell initially became a schoolteacher and then, for twenty years, a librarian in Nantucket.

Over the years, Mitchell's father had engaged in stellar research that earned him a place in the United States Coast Survey project. Maria worked alongside her father and used his equipment, including a two-inch Dollond telescope, on her own.

Mitchell became an international celebrity when she discovered a new comet on October 1, 1847. The comet was named "Miss Mitchell's Comet" in her honor, and the King of Denmark presented her with a gold medal for her discovery. Other honors and opportunities for work followed: Mitchell was elected to the American Academy of Arts and Sciences in 1843, the first woman to be so honored and, until 1943, the academy's only female member. She began to work for the United States Nautical Almanac Office in 1849 and continued the association until 1868 (while retaining her position as librarian). In 1850 she was elected to the American Association for the Advancement of Science. In 1858 a group of women organized by Elizabeth Peabody expressed their pride in

Mitchell's achievements by presenting her with an Alvin Clark five-inch telescope.

When Matthew Vassar established Vassar Female College (see "SEVEN SISTERS"), he offered Mitchell a place on the faculty and, as an enticement, built an observatory and outfitted it with a twelve-inch telescope, then the third largest telescope in the United States. When Vassar Female College opened in 1865, Maria Mitchell was its professor of astronomy.

In 1873 Mitchell helped to found the Association for the Advancement of Women, a group of women in public and professional life who met annually to discuss the progress of and challenges facing women.

Maria Mitchell died on June 28, 1889, in Lynn, Massachusetts.

Further Reading: Kendall, *Maria Mitchell;* McHenry, ed. *Famous American Women;* Read and Witlieb, *Book of Women's Firsts;* Wright, Sweeper in the Sky; ——— "Maria Mitchell," in *Notable American Women,* ed. James, James, and Boyer.

"mommy track"

A term that came into use following the 1989 publication of Felice Schwartz' controversial article, "Management Women and the New Facts of Life."

In the article, published in the *Harvard Business Review,* Schwartz argued—from her position as president of Catalyst, a nonprofit research organization focused on women in the workforce—that women had become more expensive employees than their male counterparts, due to the expense of providing maternity leaves and other benefits. She suggested that employers place their "career-primary" and "career-and-family" female managers on two different career tracks; the latter group of women, according to Schwartz' proposal, could "trade some career growth and compensation for freedom from the constant pressure to work long hours."

Critics questioned the accuracy of Schwartz' claim that women were the more expensive employees, and they objected to the absence of fathers from any discussion of how to resolve conflicts between family and work obligations. They also coined the phrase "mommy track" to describe the path Schwartz would assign to the "career-and-family" woman, describing it as a route to dead-end employment because companies would not invest as heavily in women who chose the "career-and-family" track, and a reinforcement of the traditional belief that women bear all the responsibility for homemaking and child rearing.

Schwartz reasserted her position on the "op ed" page of the *New York Times,* stressing that the costs of employing women "pale[d] beside the payoffs" of having

the best possible employees regardless of gender and asserting that "[t]he flexibility companies provide for women now will be a model in the very near future for men—thus women will not be forced to continue to take primary responsibility for child care."

In 1990 a Virginia Slims poll questioned women about their view of "mommy tracking" and found it was viewed as discriminatory and "just an excuse for paying women less than men" by 70 percent of respondents.

Further Reading: Carabillo, et al., *Feminist Chronicles 1953–1993;* Faludi, *Backlash;* Rix, ed., *American Woman 1990–91;* Schwartz, "Management Women and the New Facts of Life," *Harvard Business Review,* January/February 1989; ———, "The 'Mommy Track' Isn't Anti-Woman," *New York Times,* March 22, 1989.

Moore, Marianne Craig (1887–1972) *poet*

Born on November 15, 1887, in Kirkwood, Missouri, to Mary Warner Moore and John Milton Moore, Marianne Moore was an important American poet.

Early in Moore's life her father had a breakdown following a business failure. As she later recalled, "Our mother lost him early, and we never saw him." She was raised by her mother and grandfather, the Reverend John Riddle Warner, a Presbyterian pastor. When John Warner died in 1894, Mary Moore became a teacher at the Metzger Institute of Carlisle, Pennsylvania, which her daughter attended. Marianne Moore received her B.A. from Bryn Mawr college in 1909 and moved with her mother to Greenwich Village in New York in 1914.

The first of Moore's poems to be published, "To a Man Working His Way Through the Crowd" and "To the Soul of Progress," appeared in 1915 in the London periodical *Egoist.* Five more of her poems appeared in America at the end of the year in the journal *Others.* Among her early admirers was T. S. Eliot, who described Moore's poetry as a "dance of the intelligence among words and ideas," and the poet H.D., who, with others, published in 1921 a collection of Moore's work without her knowledge or her permission in England. *Observations,* as Moore's admirers entitled the collection, was expanded by Moore and published under the same title in the United States in 1924. Moore received the Dial award (named for the transcendentalist journal) of 1924 and, in 1926, began a three-year stint as the acting editor of the venerable magazine. In 1929 Moore and her mother moved to Cumberland Street, Brooklyn.

Among her subsequent volumes of poetry were *Selected Poems* (1935), *The Pangolin and Other Verse* (1936), *What Are the Years* (1941), *Nevertheless* (1944), *Like a Bulwark* (1956); *O To Be a Dragon* (1959), and *A Marianne Moore Reader* (1961). In addition to the Dial

Award, Moore received the National Book Award, the Bollingen Prize, and the Pulitzer Prize (all in 1952 for *Collected Poems*), as well as the Gold Medal for Poetry from the National Institute of Letters in 1953. In 1955, she was elected to the American Academy of Arts and Letters. She also received the National Medal for Literature in 1968.

Marianne Moore died on February 5, 1972, in New York City.

Further Reading: Baum, "Marianne Moore," in *Notable American Women,* ed. Sicherman et al.; Faust, ed., *American Women Writers;* Hadas, *Marianne Moore;* Hall, *Marianne Moore; New York Times,* February 6, 1972; Nitchie, *Marianne Moore;* Showalter, Baechler, and Litz, eds., *Modern American Women Writers.*

Morgan, Julia (1872–1957) *architect*

Born January 26, 1872, in San Francisco, to Eliza Parmalee Morgan and Charles Morgan, Julia Morgan was an architect whose many accomplishments broke ground for women in that field.

Morgan had several female predecessors:

- In 1848 Louisa Caroline Tuthill published *A History of Architecture from the Earliest Times,* believed to be the first architectural history by an American woman and dedicated "To the Ladies of the United States of America, the Acknowledged Arbiters of Taste."
- In 1869, Harriet Morrison Irwin of North Carolina, with no formal training in architecture, suggested the building of a hexagonal-shaped house in her "Improvement in the Construction of Houses," and received a patent for the plan from the United States Patent Office. (She also had the house built; as of 1994, it still stood on West 5th Street, Charlotte, North Carolina.)
- Louise Bethune became the first female associate of the American Institute of Architects in 1888 and was a founding partner of Bethune, Bethune & Fuchs, of Buffalo, New York.
- Sophia Hayden became the first woman to complete the architecture course at the Massachusetts Institute of Technology (MIT), but her major commission— the Woman's Building of the Columbian Exposition in Chicago, 1893—was a temporary structure.
- Marion Mahony Griffin became the second woman to complete the MIT course. She became a delineator and designer in Frank Lloyd Wright's office and later an associate of her architect husband. Although she did not take credit for her work during her lifetime, the David Amberg house in Grand

Rapids, Michigan (1909–11) and the Adolph Mueller house in Decatur, Illinois (1910)—both commissioned during her employment with Wright—have been established as her designs.

Julia Morgan, whose work resulted in some 800 standing structures before her death in 1957, moved women to a new sphere of architectural accomplishment. She became, in 1902, the first woman to graduate from the Ecole des Beaux-Arts of Paris and, upon her return to the United States, became the first woman to be licensed as an architect in California.

She was employed by John Galen Howard to work on a project sponsored by Phoebe Apperson Hearst, the addition of a Greek theater and another building to the University of California. Her work there earned her not only a commission for a complete remodeling of Hearst's Pleasanton home, but also the long-term patronage of Hearst and her son, William Randolph Hearst. Among her commissions were the bell tower, library, and other buildings at Mills College; the reconstruction of the landmark Fairmont Hotel following its destruction in the 1906 earthquake and fire, the Hearst Castle compound utilizing transported portions of European monasteries and castles; Principia College, Elsah, Illinois (in collaboration with Bernard Maybeck); a number of industrial buildings utilizing steel-reinforced concrete; and a number of red-shingled houses that played a part in setting California's Bay area style.

Other women noted Morgan's accomplishments and commissioned her for their special projects: She designed YWCA buildings and residence halls in Honolulu, Salt Lake City, and all across California. Morgan, in turn, supported the aspirations of women in her field: She supplied financial aid for female architecture students, and she hired female draftsmen and architects to work in her office.

Julia Morgan retired in 1946. She died in San Francisco on February 2, 1957.

Further Reading: Berkon and Kay, "Marion Mahony Griffin, Architect"; Brooks, *Prairie School;* Gilchrist, "Louisa Caroline Huggins Tuthill," in *Notable American Women,* ed. James, James, and Boyer; Gutheim, "Marion Lucy Mahony Griffin," in *Notable American Women,* ed. Sicherman, et al.; Hayden, "Sophia Gregoria Hayden," in *Notable American Women,* ed. Sicherman et al.; Richey, "Julia Morgan," in *Notable American Women,* ed. Sicherman et al.; Stern, *We the Women.*

Morgan, Robin (1941–) *feminist, editor*
Born on January 29, 1941, in Lake Worth, Florida, to Faith Berkeley Morgan, Robin Morgan is a feminist writer and the former editor of *MS.* magazine.

Upon Morgan's graduation from Columbia University, she became, in 1960, an associate literary agent with the Curtis Brown agency. She left the agency in 1962 to become a freelance editor and writer. A self-described radical feminist, she gained prominence with her 1970 publication of "Goodbye to All That," in the *Rat,* a 1960s journal. In her article, Morgan castigated the civil rights and peace movements of the 1960s—two movements in which she had been active—for operating within a sexist hierarchy.

Her subsequent books about the feminist movement include *Sisterhood Is Powerful: An Anthology of Writings from the Women's Liberation Movement* (1970); *Going Too Far: The Personal Chronicles of a Feminist* (1978), in which she explored her own experiences with feminism; *Sisterhood Is Global: The International Women's Movement Anthology* (1984); *The Demon Lover: On the Sexuality of Terrorism* (1989); and *The Word of a Woman* (1992). She was a contributing editor to *Ms.* magazine from 1977 until the magazine's publication was suspended in 1989 for financial reasons. When the magazine was resurrected in 1990 as a bimonthly periodical supported entirely by its readers, Morgan became its editor, a position she held until 1993.

In addition to her nonfiction, Morgan has published a novel, *Dry Your Smile* (1987), and several volumes of poetry: *Monster: Poems* (1972), *Lady of the Beasts: Poems* (1976); *Depth Perception: New Poems and a Masque* (1982); *Upstairs in the Garden* (1990) and *A Hot January* (1999). She has also written a children's book, *The Mer-child* (1991).

Consistently in the forefront of the modern women's movement, Morgan was a founding member of NEW YORK RADICAL WOMEN, the Women's International Terrorist Conspiracy from Hell, and WOMEN AGAINST PORNOGRAPHY. In an interview for *Contemporary Authors,* Morgan reflected upon the difficulties of merging her literary and political leadership roles: "I am an artist and a political being as well," she said. "My aim has been to forge these two concerns into an integrity which affirms language, art, craft, form, beauty, tragedy, and audacity with the needs and visions of women, as part of an emerging new culture which could enrich us all."

Robin Morgan currently lives in New York City.

Further Reading: *Contemporary Authors,* vol. 29; Morgan, *Monster: Poems;* ———, *Lady of the Beasts;* ———, *Going Too Far;* ———, *Demon Lover;* Morgan, ed., *Sisterhood Is Powerful;* ———, *Sisterhood Is Global;* ———, *The Word of a Woman.*

Morrill Land-Grant Act (1862)
Passed by Congress on July 2, 1862, the Morrill Land-Grant Act provided states and territories with public

lands upon which to establish agricultural and mechanical colleges, as well as adjunct facilities for institutions that awarded liberal arts degrees. Each state or territory not in a "condition of rebellion or insurrection against the government of the United States" was awarded federal lands based on each state's proportionate representation in Congress; the formula was 30,000 acres per member of Congress. Many of the new institutions were located in the West and Midwest and many admitted women. Today 13 million acres of land are home to universities built on Morrill Land-Grant plots.

Further Reading: Baron, ed., *Soul of America;* Flexner, *Century of Struggle.*

Morrison, Toni (1931–) *writer, Nobel Prize winner*

Born Chloe Anthony Wofford on February 18, 1931, in Lorain, Ohio, to Ramah Willis Wofford and George Wofford, author Toni Morrison in 1993 became the first African-American woman to win the Nobel Prize in literature.

Morrison graduated from high school with honors in 1949 and attended Howard University, in Washington, D.C. graduating in 1953. She received her M.A. from Cornell University in 1955 and began teaching, first at Texas Southern University in Houston and later, as a member of the faculty at Howard University. In 1958 she and Harold Morrison were married; the couple had two children and divorced in 1964.

Following her divorce, Morrison relocated to New York and became an editor at Random House. Her first novel, *The Bluest Eye,* was published in 1969. The story of a "black girl who wanted blue eyes," the novel has been described by Morrison as "the absolute destruction of human life because of the most superficial thing in the world—physical beauty." Her other books include *Sula* (1973), which chronicles the complicated, four-decade-long friendship between two women; *The Song of Solomon* (1977), Morrison's first novel to center on a male protagonist; and *Tar Baby* (1981), which lays bare racial and sexual tensions in the course of examining the love affair of two blacks.

Beloved, published in 1987, originated in Morrison's discovery of a historical event: A runaway and recaptured slave mother's murder of her infant, whom she could not bear to imagine living under slavery. A novel of incredible, aching beauty even as it depicts in almost unbearable fullness the agonies of slavery, *Beloved* prompted effusive critical praise. It was made into a film in 1998.

Morrison's subsequent works include two novels, *Jazz* (1992) and *Paradise* (1998); two works of nonfiction, *Playing in the Dark: Whiteness and the Literary Imagination* (1992); and, as editor, *Race-ing Justice, En-*

Gendering Power: Essays on Anita Hill, Clarence Thomas, and the Construction of Social Realty (1992).

In addition to the Nobel Prize for literature, Morrison has been the recipient of numerous other awards, including the National Book Critics Circle Award and the American Academy and Institute of Arts and Letters Award (both in 1977, for *Song of Solomon*), the Robert F. Kennedy Award and the Pulitzer Prize for fiction (both in 1988, for *Beloved*), and the National Organization for Women's Elizabeth Cady STANTON Award.

Toni Morrison is currently the cochair of the Schomburg Commission for the Preservation of Black Culture and a professor at Princeton University.

Further Reading: *Contemporary Authors,* vol. 42; *Current Biography Yearbook,* 1979; Grimes, "Toni Morrison is '93 Winner of Nobel Prize in Literature"; Morrison, *The Bluest Eye;* ———, *Sula;* ———, *Song of Solomon;* ———, *Tar Baby;* ———, *Beloved;* ———, *Jazz;* ———, *Playing in the Dark;* ———, *Nobel Lecture in Literature, 1993;* Morrison, ed., *Race-ing Justice, En-Gendering Power;* ———, *Paradise;* ———, *Conversations with Toni Morrison.*

Mott, Lucretia Coffin (1793–1880) *women's rights leader, abolitionist*

Born Lucretia Coffin on January 3, 1793, in Nantucket, Massachusetts, to Anna Folger Coffin and Thomas Coffin, Mott was an abolitionist, Quaker minister, and women's rights activist. Raised by an independent Quaker mother in a community of equally independent women (many of Nantucket's male residents spent months at a time on whaling voyages), Lucretia Coffin later recalled that she "grew up so thoroughly imbued with women's rights that it was the most important question of my life from a very early day." She was educated at public, private, and Quaker boarding schools. When she was fifteen, she became an assistant teacher at Nine Partners, a boarding school near Poughkeepsie, New York. She soon realized that male teachers were paid much more than their female counterparts, and she resolved that she would one day work for women's equality.

On April 10, 1811, she married James Mott, and the couple had six children between 1812 and 1828.

In 1821, while still engaged in raising her children, Lucretia Mott was recorded as a Quaker minister. Like most Quakers Mott had strong objections to slavery. She attended William Lloyd Garrison's founding meeting of the American Anti-Slavery Society in 1833; informed that women would not be permitted to join, she helped establish the Philadelphia Female Anti-Slavery Society. (When Garrison's society changed its policy, Mott became a member of the Pennsylvania branch's executive

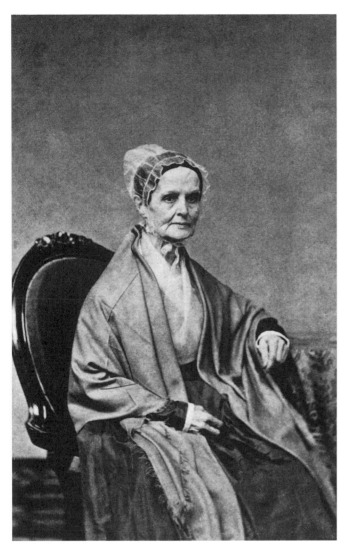

Lucretia Coffin Mott, abolitionist, Quaker minister, and women's rights activist (*Library of Congress*)

committee.) FEMALE ANTI-SLAVERY SOCIETIES proliferated and, on May 15, 1838, Mott and others held an Anti-Slavery Convention of American Women in Pennsylvania Hall, Philadelphia. Two days later an angry mob burned down the hall.

In 1840 Mott, by now a member of the American Anti-Slavery Society, was elected to serve as one of the society's delegates to the World Anti-Slavery Convention in London. In London, Mott and her female colleagues were told they could not participate because of their sex. Elizabeth Cady STANTON who had accompanied her abolitionist husband, Henry Stanton, to the convention, and Mott were outraged by the treatment accorded to women in London, and they vowed to hold a women's rights convention upon their return to the United States.

For various reasons, the SENECA FALLS CONVENTION was not held until 1848. The convention inaugurated the

beginning of an organized women's movement in the United States. Lucretia Mott presided over this movement with grace, attending and addressing conventions through the next three decades. In her 1850 *Discourse on Woman,* she traced the creation of what some considered a woman's natural inferiority to the stunting effects of poor education, limited employment opportunity, and meager wages.

After the Civil War, abolitionists and women's rights activists (who had long been allies) began to clash over the question of whether African-American male suffrage should be supported above women's suffrage. The AMERICAN EQUAL RIGHTS ASSOCIATION was founded in 1866 in order to press for equal rights for all Americans. Although this was a doomed peacemaking attempt, it is certainly noteworthy that the person asked to represent both of the arguing factions as president of this organization was Lucretia Mott.

Lucretia Mott died near Philadelphia on November 11, 1880.

Further Reading: Bacon, *Valiant Friend;* Flexner, *Century of Struggle;* Frost and Cullen-DuPont, *Women's Suffrage in America;* Mott, *Discourse on Woman;* ———, *Sermon to the Medical Students;* Tolles, "Lucretia Mott," in *Notable American Women,* ed. James, James, and Boyer; Tolles, ed., *Slavery and "The Woman Question."*

Mount Holyoke College

Founded by Mary Lyon in 1837, Mount Holyoke is referred to as America's first women's college. It was begun as Mount Holyoke Seminary, however, and did not actually become a college until 1893 (by which time Bryn Mawr, Smith, Vassar, and Wellesley were already open). Lyon struggled for four years before finally raising the $27,000 required to establish her school in South Hadley, Massachusetts; most of the donations were $5.00 or less, and Lyon was criticized for traveling throughout the countryside asking for money. However, because she provided Mount Holyoke with a sound financial foundation, the school was able to grow and provide educational opportunity to young women of varied financial backgrounds.

Under Lyon's direction, Mount Holyoke offered its students a three-year course of instruction (other female seminaries had two-year programs) that included English grammar, geography, ancient and modern history, algebra, philosophy, astronomy, chemistry, geology, theology, calisthenics, and French. In a move that both cut costs and assuaged fears that Mount Holyoke was turning out "strong-minded" women, Lyon instituted a system whereby the female students performed most of the necessary domestic functions, such as cleaning, cooking, and serving meals. Many Mount Holyoke graduates became

teachers during the nineteenth century, and almost two dozen became doctors. The school was renamed Mount Holyoke College in 1893 and is today considered one of America's top liberal arts colleges.

Further Reading: Evans, *Born for Liberty;* Flexner, *Century of Struggle;* Mount Holyoke College, "General view of the principles and designs of the Mount Holyoke Female Seminary"; ———, *Female Education;* ———, *Memorial. Twenty-Fifth Anniversary;* ———, *Historical Sketch of Mount Holyoke Seminary;* Rury, "Mount Holyoke Seminary," in *Handbook of American Women's History,* ed. Zophy and Kavenik; *U.S. News and World Report,* August 30, 1999.

Mourning Dove (Hum-Ishu-Ma, Humishuma, Christine/Christal Quintasket) (ca. 1885–1936) *writer*
Also known as Hum-Ishu-Ma (of which Mourning Dove is a translation) and as Christal Quintasket, Mourning Dove was born ca. 1885 near Bonner's Ferry, Idaho, to Joseph Quintasket and Lucy Stukin and was a member of the Okanogan tribe. She is believed to be the first Native American woman to publish a novel.

Mourning Dove attended the Sacred Heart Convent school in Ward, Washington, and several government-run schools for Native American children. While writing her novel, *Cogewea the Half Blood: A Depiction of the Great Montana Cattle Range,* Mourning Dove supported herself by working as a migrant laborer alongside her Wenatchee husband, Fred Galler. She received encouragement from Lucullus V. McWhorter, an ethnographer and Indian rights reformer, whom she had met in Walla Walla at a Frontier Days Celebration in 1914. Mourning Dove later provided a description of her working conditions to McWhorter in a letter, writing that "after working for ten hours in the blazing sun, and cooking my meals, I know I shall not have the time to look over very much mss. . . . between sand, grease, campfire, and real apple dirt I hope I can do the work."

In 1916 Mourning Dove completed *Cogewea* and, with McWhorter, began the work of finding a publisher. After a long and difficult search, Four Seas, a Boston publishing house, agreed to take on the work if Mourning Dove would pay part of the publication costs. Mourning Dove increased her hours as a laborer and operated a lunch stand to fulfill this obligation, and *Cogewea the Half Blood* was finally published in 1927.

Unfortunately, McWhorter seems to have been a rather paternalistic and proprietary champion; as scholar Dexter Fisher has ascertained, McWhorter rewrote much of the book, replacing Mourning Dove's "direct and simple" style with his own "stiff, formal, and highly rhetorical" one. Whether despite or due to this veneer, Mourning Dove's work was heralded in the press as an outstanding Native American achievement.

Mourning Dove's *Coyote Stories* was published in 1933, and it too passed through McWhorter's hands. Scholar Donald M. Hines, believing that Mourning Dove was a "remarkable woman: poorly educated, working under impossible conditions . . . [and] bridg[ing] two cultures," worked to remove McWhorter's additions from the stories contained in this collection. Her own style is perhaps best characterized by the opening lines of "Coyote Takes His Daughter as a Wife":

Coyote (Sim-ka'-lip) had a beautiful daughter, and the warriors came far and near from the surrounding tribes to ask for her hand. She refused them all. One day, as she stretched out her foot, Coyote saw that she had a shapely leg, which made him fall in love with his daughter . . .

Mourning Dove's work suffered long neglect prior to its inclusion in *The Norton Anthology of Literature by Women: The Tradition in English,* an important collection of women's literary contributions from the Middle Ages to the present in the English language. Mourning Dove died in 1936.

Further Reading: Gilbert and Gubar, eds., *Norton Anthology of Literature by Women;* Miller, Jay, ed. *Mourning Dove: A Salishan Autobiography;* Mourning Dove, *Cogewea: The Half Blood;* ———, *Coyote Stories.*

Ms. Foundation for Women
Founded by Gloria Steinem in 1973, the Ms. Foundation for Women describes itself as "a national, multi-issue, public women's fund, support[ing] the efforts of women and girls to govern their own lives and influence the world around them." It works toward this goal by providing funds and assistance to "women's self-help organizing efforts," while "pursu[ing] changes in public consciousness, law, philanthropy and social policy." Its annual "TAKE OUR DAUGHTERS TO WORK DAY," begun April 28, 1993, attracted national support and attention.

Organizations and projects that have been supported by the foundation include:

- The Aroostook Micmac Council, of Presque Isle, Maine, created by the Micmac Indians in 1982. In this "'traditional' girls council," current concerns such as birth control and career planning are explored, along with the history of Micmac traditions and the role of women within this culture. While Micmac medicine women provide much of the instruction, "expert" speakers also are invited to lecture.

- Women Employed, in Chicago, Illinois. Created in 1973, this grass-roots organization works to "increase women's and girls' access to higher-paying jobs." The foundation specifically funded Career Links, a project of Women Employed, which identifies at-risk teenage girls and provides them with mentors, career counseling, and other assistance designed to diminish the odds of early pregnancy.
- Madre, based in New York City. Founded in 1983, this national, multicultural network tries to encourage social justice and peace through programs that stress "the common needs of women and children" in Central America, the Middle East, and the United States. The foundation specifically funded Madre's Visual and Performing Artists in Residence Program for pregnant girls and teenage mothers. The program, housed in the Martha Neilson School in the South Bronx, provides vocational training and the coursework necessary for a high school diploma while simultaneously helping its students to achieve the independence and maturity required of good parents.
- White Buffalo Calf Women Society, of Mission, South Dakota. A battered women's shelter for Native American women and children on the Lakota's Rosebud Reservation, the society was founded in 1977. The foundation specifically funded the Teen Women's Society, which addresses violence against women and health issues while simultaneously educating the teens about their Lakota heritage and culture.
- The Girls After School Academy, in San Francisco, California. A project of The Girls Leadership Project, the academy is an after-school and summer program serving forty-five girls from economically disadvantaged families residing in San Francisco's public housing. The program assists the girls with their schooling, offers vocational and career counseling, addresses violence against women and health issues, and provides self-defense training.
- Seattle Rape Relief (SRR), of Seattle, Washington. Established in 1972 as one of America's first rape crisis centers, SRR both assists survivors of rape and sexual assault and provides preventative community outreach. The foundation specifically funded a project stressing school-based education about violence against women.

The Ms. Foundation for Women maintains its headquarters in New York City; its current president is Marie Wilson.

Further Reading: Wilson, president of the Ms. Foundation for Women, letter to prospective contributors, June 1993; *New York Newsday,* April 29, 1993; *New York Times,* April 29, 1993; *USA Today,* April 29, 1993; *Wall Street Journal,* April 29, 1993.

Ms. Magazine

Founded in 1972 by Gloria STEINEM, who was its chief editor until 1987, *Ms.* is a well-known women's rights magazine that reports on national and international news of importance to women, publishes fiction and poetry by female writers, and includes articles about women's history.

The magazine's first issue, which included articles such as "Down with Sexist Upbringing" and a list of fifty noteworthy women, including Steinem, who publicly admitted to having abortions, clearly broke the restrictive "women's magazine" mold, which had centered on fashion, homemaking, and child-rearing concerns. Despite its 350,000 subscribers, the magazine had difficulty attracting advertisers; in one case, a well-known cosmetics company pulled its advertising after a *Ms.* cover story featured women who were interviewed about their accomplishments but then were photographed without lipstick.

The magazine has had several owners since 1989. In that year, it was purchased by the Lang Corporation, which almost immediately discontinued publication. When readers refused to accept the magazine's demise, it was resurrected in 1990 as an advertising-free, 100 percent reader-supported bimonthly. In 1996, it was purchased by MacDonald's Communication Corp., which publishes two magazines for women in the workforce: *Working Woman* and *Working Mother.* Citing the wider market for *Ms.,* MacDonald's in September 1998 suspended publication and offered the magazine for sale. A group of feminists, including Gloria Steinem and Marcia Ann Gillespie (*Ms.* magazine's editor-in-chief from 1993 to 1998), formed a media company, Liberty Media for Women, to purchase and publish the magazine.

Ms. made its newest debut with its April/May 1999 issue. Marcia Ann Gillespie is the editor-in-chief of *Ms.* and president of Liberty Media for Women. Gloria Steinem is Liberty Media's chairperson.

Muncy Act (1913)

An act passed in Pennsylvania in 1913, the Muncy Act required that any woman convicted of a crime punishable by imprisonment of a year or more had to be sentenced for an open-ended, or indefinite, period of time. Moreover, if a woman was convicted of a crime punishable by more than three years' imprisonment, the Muncy Act mandated that the woman must receive the maximum sentence possible. Several other states had similar laws at the time.

A supporter of Pennsylvania's Muncy Act, explaining the state's reasoning in a 1913 issue of the *Journal of Criminal Law and Criminology,* wrote that "women delinquents . . . belong to the class of women who lead sexually immoral lives. [Passage of the act] would . . . rid

the streets . . . of soliciting, loitering, and public vice . . . There is nothing the common prostitute fears so greatly as . . . the possibility of prolonged confinement." According to attorney Marguerite Rawalt, women sentenced under Pennsylvania's Muncy Act were incarcerated for 50 percent longer than men who had been convicted of identical crimes.

The NATIONAL ORGANIZATION FOR WOMEN and Marguerite Rawalt participated in the appeal of Jane Daniel, a women sentenced under the Muncy Act to up to ten rather than up to four years' imprisonment for a robbery. The Pennsylvania Supreme Court's July 1968 decision in *Commonwealth of Pennsylvania v. Daniel* invalidated the Muncy Act as discriminatory and freed many women who were unjustly incarcerated pursuant to its terms. (In February 1968 a Federal District Court also had stuck down a similar Connecticut law in its decision in *U.S. ex. rel. v. Robinson.)*

Further Reading: Carabillo, et al., *Feminist Chronicles 1953–1993;* Davis, *Moving the Mountain;* Hole and Levine, *Rebirth of Feminism.*

Murray, Judith Sargent Stevens (1751–1820)
writer

Poet and author of the earliest published American women's right essays, Judith Sargent Murray was born on May 1, 1751, in Gloucester, Massachusetts, to Judith Saunders Sargent and Winthrop Sargent. As a young girl, Judith was permitted to join her brother Winthrop as he studied with a tutor. Afterward, Winthrop is said to have acted as his sister's tutor during his own college vacations. In October 1769 Judith Sargent and John Stevens were married. After Steven's death, Judith married the Universalist minister John Murray. The couple had two children, one of whom survived infancy.

Judith Sargent Murray began writing poetry in the 1770s, while she was in her twenties. During the American Revolution, Murray—like Abigail Adams and Mercy Warren—was struck by the disparity between the rights the male colonists claimed for themselves and the rights they granted to women. Her essay, "Desultory Thoughts upon the Utility of Encouraging a Degree of Self-Complacency, Especially in Female Bosoms," was written in 1779. In it she stated that men and women were intellectually equal and that women were entitled to a far more comprehensive education than the one routinely provided. She decried the early marriages common among girls and predicted that an increased sense of self-worth, gained from an improved education, would enable young women to resist rushing into such unions. The essay was published under the pseudonym "Constantina" in a 1784 issue of the *Gentleman and Lady's Town and Country Magazine.*

Murray continued to publish her work under pseudonyms. As "Constantina," she published her poems and an essay column, "The Gleaner," in the *Massachusetts Magazine* in the early 1790s. Her first play, *The Medium, or a Happy Tea-Party,* was performed on March 3, 1795, by the Federal Street Theater; another play, *The Traveller Returned,* was performed on March 9, 1796. Neither play was well received, and Murray returned her attention to her essays and poetry. A three-volume collection of her essays, *The Gleaner,* was published in 1798. George Washington was among those who purchased the collection, and it is still considered an integral part of America's earliest literature. Between 1802 and 1805, her last poems, published under the pseudonyms, "Honora-Martesia" and "Honora," appeared in various Boston magazines. Murray also edited the *Letters and Sketches of Sermons, 1812–1813* of her second husband, John Murray, and the *Records of the Life of the Rev. John Murray, Written by Himself, with a Continuation by Mrs. Judith Sargent Murray,* in 1816.

Widowed in 1815, Murray spent her last years in Natchez, Mississippi, in her daughter's care. She died on July 6, 1820.

Further Reading: Evans, *Born for Liberty;* Field, *Constantina;* Flexner, *Century of Struggle;* James, "Judith Sargent Murray," in *Notable American Women,* ed. James, James, and Boyer; McHenry, ed., *Famous American Women;* Rossi, *Feminist Papers.*

"Nairobi Forward-looking Strategies for the Advancement of Women"

A document adopted by the World Conference to Review and Appraise the Achievements of the United Nations Decade for Women: Equality, Development, and Peace, the "Nairobi Forward-looking Strategies for the Advancement of Women" was endorsed on December 13, 1985, by General Assembly Resolution 40/108. The conference was held July 15–26, 1985, in Nairobi, Kenya. It was attended by approximately 16,000 women representing about 130 countries, including a delegation from the United States.

Among other things, the document called for an end to all forms of discrimination against women; equal rights under the law, including the right to marry and divorce, to own and administer property, and to secure credit; a recognition of women's unpaid labor, including its reflection in government statistics (see UNRENUMERATED WORK ACT OF 1993); the sharing of child rearing and household labor between parents; equal employment opportunities and equal pay for work of equal value; a guarantee of a woman's right to determine both the number and spacing of her children; equal educational opportunity; and the ending of female illiteracy.

Further Reading: Davis, *Moving the Mountain;* Rix, ed., *American Woman 1990–91;* United Nations, *World's Women 1970–1990.*

Najda: Women Concerned About the Middle East

Najda, an Arabic word that translates as "assistance in time of need," is an organization that brings together Arab Americans and American spouses of Arabs (as well as concerned non-Arabs) to work, in the United States, toward increased understanding of Arab traditions and, in the Middle East, toward increased opportunities for Arab women. It was founded in 1960.

In the United States, Najda sponsors educational programs focusing on Arabic art and literature as well as history and contemporary political developments.

Najda's assistance in the Middle East is primarily financial: It awards scholarships to women in the West Bank and the Gaza Strip, donates money directly to those areas' schools, and furnishes humanitarian relief to Palestinian women and their children.

Najda has published *The Arab World Notebook for the Secondary School Level* and provides a quarterly report for use by teachers, the *Middle East Resources.* It has also published *The Arabic Cookbook.* Another publication, the quarterly *Najda Newsletter,* is designed to keep the organization's members informed about activities and developments.

Founded in 1960, Najda currently maintains offices in Berkeley, California, and has 100 members. Paula Rainey is the organization's president.

Further Reading: Brennan, ed., *Women's Information Directory.*

Nation, Carry Amelia Moore (1846–1911)
temperance leader

Born Carry Moore on November 25, 1846, in Garrard County, Kentucky, to Mary Campbell Moore and George Moore, Carry Nation became perhaps the most visible symbol of the nineteenth-century temperance movement.

Moore grew up in a home characterized by poverty, frequent changes in location, and intermittent schooling. On November 21, 1867, she married Charles Gloyd, an alcoholic who soon died, leaving Carry as the sole support of their one child and also leaving her with a permanent bitterness toward liquor. In 1877 she and David Nation were married. This union also proved unhappy. Carry Nation soon came to believe that God had not

Carry Nation, perhaps the best-known temperance advocate, considered herself a "Home Defender." (*Library of Congress*)

planned for her to have her own happy home but to become a "Home Defender" for other women.

In 1892 Nation established the Barber County chapter of the WOMAN'S CHRISTIAN TEMPERANCE UNION in Medicine Lodge, Kansas. Kansas was a "dry" state by law, but liquor was widely available and there was an active movement to legalize its sale. Believing that it was permissible to take illegal action against illegal activities, in 1899, Nation began her famous "Hatchetation" missions. Accompanied by psalm-singing followers, Nation stampeded through the saloons of Kansas, berating their liquor-consuming occupants while swinging her hatchet and destroying considerable amounts of property. Nation sold souvenir hatchets to pay the fines that followed her frequent arrests.

Nation frequently was assaulted physically by those she had interrupted. Her efforts were unappreciated by the established temperance movement, which distanced itself from the Hatchetation campaign, and by David Nation, who, citing desertion, divorced her.

Carry Nation died on June 9, 1911, in Leavenworth, Kansas.

Further Reading: McHenry, ed., *Famous American Women;* Messbarger, "Carry Nation," in *Notable American Women,* ed. James, James, and Boyer; Nation, *Use and Need of the Life of Carry A. Nation.*

National Abortion and Reproductive Rights Action League (NARAL)

The Washington, D.C.-based National Abortion and Reproductive Rights Action League (NARAL) is the successor organization to the NATIONAL ASSOCIATION FOR THE REPEAL OF ABORTION LAWS and the National Abortion Rights League. The first was founded in 1969 to reform or repeal state anti-abortion laws. When *ROE V. WADE* overturned all prohibitive state laws in 1973, the organization renamed itself the National Abortion Rights Action League and redefined its mission as "keep[ing] abortion safe, legal, and accessible for all women." The latest name change reflects an expanded mission: to continue defending a legal right to abortion, while helping to "make abortion less necessary."

The National Abortion and Reproductive Rights Action League maintains a lobbyist in Washington; provides testimony for congressional hearings on abortion and other reproductive issues; maintains an active speakers' bureau; trains field representatives and organizes local chapters around the country; and supports prochoice candidates for political office.

The NARAL publishes the quarterly *NARAL Newsletter.* It has 500,000 members and 30 state affiliates. Kate Michelman is its current executive director.

Further Reading: Brecher and Lippitt, *Women's Information Exchange National Directory;* Brennan, ed. *Women's Information Directory;* Davis, *Moving the Mountain;* Hole and Levine, *Rebirth of Feminism;* National Abortion and Reproductive Action League.

National American Woman Suffrage Association

Formed as a result of a merger between the AMERICAN WOMAN SUFFRAGE ASSOCIATION and the NATIONAL WOMAN SUFFRAGE ASSOCIATION in 1890, the National American Woman Suffrage Association (NAWSA) became the suffrage movement's mainstream organization. Former National Woman Suffrage Association officials Elizabeth Cady STANTON and Susan B. ANTHONY served as the organization's first president and vice president, respectively. Lucy STONE, a founder of the American Woman Suffrage Association, served as the first chairperson of NAWSA's executive committee while her

daughter, Alice Stone BLACKWELL, was its first corresponding secretary.

Under the leadership of its last president, Carrie Chapman CATT (1900–04 and 1915–20), the National American Woman Suffrage Association successfully pressed for women's suffrage amendments in various state constitutions and then enlisted the new women voters to press for a women's suffrage amendment to the United States Constitution. NAWSA sponsored suffrage parades but disavowed the more militant tactics of the NATIONAL WOMAN'S PARTY. When the Nineteenth Amendment finally was ratified, the NAWSA became the LEAGUE OF WOMEN VOTERS.

Further Reading: Catt and Shuler, *Woman Suffrage and Politics;* Flexner, *Century of Struggle;* Frost and Cullen-DuPont, *Women's Suffrage in America;* Lasser and Merrill, eds., *Friends and Sisters;* Stanton, Anthony, and Gage, eds., *History of Woman Suffrage,* vol. 4; Stanton and Blatch, eds., *Elizabeth Cady Stanton.*

National Association for the Repeal of Abortion Laws

A coalition formed in February 1969 in Chicago, the National Association for the Repeal of Abortion Laws specifically rejected the "reform" of restrictive abortion laws as a goal and instead committed itself to work for the outright *repeal* of such laws in every state in the country.

Three hundred fifty people, including representatives from twenty-one organizations that had worked to reform or repeal various state abortion laws as well as a number of physicians, legislators, and law school professors attended the founding meeting. Larry Lader was the first chairperson of the association, which, after its founding meeting in Chicago, was located in New York. In 1973, following *ROE V. WADE* and the legalization of abortion, the organization became the National Abortion Rights Action League. It is currently known as the NATIONAL ABORTION AND REPRODUCTIVE RIGHTS ACTION LEAGUE.

Further Reading: Davis, *Moving the Mountain;* Hole and Levine, *Rebirth of Feminism.*

National Association of Colored Women's Clubs

This organization was formed by the merger of the nineteenth-century Colored Women's League and the National Federation of Afro-American Women (founded in Boston in 1895) at a convention held in Washington, D.C., in July 1896. The founders of the National Association of Colored Women's Clubs (NACWC) were from two generations of women: those who came of age under slavery and those who had been born since. Harriet TUBMAN, Frances E. W. HARPER, and Charlotte Forten Grimké were among the association's senior founders; Ida B. Wells (see Ida WELLS-BARNETT), Mary Church Terrell, and Josephine St. Pierre Ruffin were among the junior founders. During what many participants agreed was a moving "moment in which a torch was passed," the eldest woman present at the meeting, "Mother Harriet [Tubman]," introduced "the Baby of the Association," Ida B. Wells' newborn son.

First president Mary Church Terrell and vice presidents Frances E. W. Harper, Josephine Ruffin, and Fanny J. Coppin worked to exemplify the association's motto, "Lifting As We Climb." The organization's leaders supported the African-American women's clubs that had given rise to the association (at the time, the GENERAL FEDERATION OF WOMEN'S CLUBS did not welcome African Americans) as members of these clubs worked to improve their own communities across the United States. NACWC members organized kindergartens, safe housing for young working girls, and child and elder care programs.

The National Association of Colored Women's Clubs supported the temperance and suffrage movements in the nineteenth century; in the twentieth century, it was one of the first organizations to endorse the EQUAL RIGHTS AMENDMENT. The NACWC currently has a membership of 45,000 women. Carole A. Early is the current contact person.

Further Reading: Evans, *Born for Liberty;* Flexner, *Century of Struggle;* Sterling, *We Are Your Sisters;* Zophy and Kavenik, eds., *Handbook of American Women's History.*

National Black Feminist Organization

Founded in 1973, the National Black Feminist Organization had ten chapters by the end of its first year. One of its major accomplishments was the organization of a conference to examine the relationship between the struggle for women's rights and the problems of women of color.

Further Reading: Davis, *Moving the Mountain.*

National Coalition of 100 Black Women

Founded in 1981 and headquartered in New York City, the National Coalition of 100 Black Women is an organization of African-American women dedicated to addressing the cultural, economic, familial, health, political, and social issues of concern to African-American women.

The coalition facilitates the career and political development of African-American women by setting up

networking opportunities, leadership development seminars, and mentor programs for women in various states of transition, including teenage mothers, high school women in the midst of planning for either college or work, and recent college graduates embarking on a career.

Despite its name, the National Coalition of 100 Black Women now has 6,000 members. It publishes the semi-annual *National Coalition of 100 Black Women—Statement,* and it confers its Candace awards on outstanding African Americans of both sexes. Jewell Jackson-McCabe is the organization's current chairperson.

Further Reading: Brecher and Lippitt, *Women's Information Exchange National Directory;* Brennan, ed., *Women's Information Directory;* Ries and Stone, eds., *American Woman 1992–93.*

National Conference of Puerto Rican Women

Founded in 1972 and based in Miami Springs, Florida, the National Conference of Puerto Rican Women is dedicated to helping Puerto Rican and other Hispanic women gain full access to the economic, cultural, social, and political life of the United States and Puerto Rico. It works with other women's rights organizations to promote equal rights for women, and it maintains both a speakers' bureau and an extensive biographical archive.

The National Conference of Puerto Rican Women publishes the triannual *Ecos Nacionales* and the periodic *Fact Sheet.* It has 3,000 members; Lydia Sosa is its current president.

Further Reading: Brecher and Lippitt, *Women's Information Exchange National Directory;* Brennan, ed., *Women's Information Directory.*

National Congress of Neighborhood Women

Founded in 1975 and based in Brooklyn, New York, the National Congress of Neighborhood Women brings together women of diverse ethnic, racial, religious, and economic backgrounds to work locally on issues of neighborhood stability and women's rights. In particular, the organization wishes to "provide a voice for a new women's movement that reflects family and neighborhood values while promoting women's empowerment." It conducts Project Prepare, which offers a broad array of employment-related services, including adult education classes, job counseling, child care, and résumé writing. It researches and compiles statistics on poverty and women, and it also maintains a speakers' bureau and an extensive library.

The National Congress of Neighborhood Women publishes the bimonthly *Neighborhood Women Network News.* It has twenty-six regional groups; Janice Peterson is its current executive officer.

Further Reading: Brennan, ed., *Women's Information Directory.*

National Council of Jewish Women

Founded by Hannah Greenbaum Solomon in 1893 and based in New York City, the National Council of Jewish Women "aims to improve the quality of life for individuals of all ages, races, religions, and socioeconomic levels." Toward this end, the organization supports programs to benefit social welfare, advocates the protection of constitutional rights and civil liberties, and endorses the equality of women. In Israel, one of its primary projects is the Research Institute for Innovation in Education, which it maintains at Hebrew University in Jerusalem. In the United States, one of its more important endeavors has been its establishment and maintenance of the Center for the Child, a research institute, in New York. The center researches issues concerning children and proposes policies that it believes would have a positive impact on their lives. Current areas of investigation are women in the workplace and the impact of women's employment on their families. The organization also helps to develop community service projects in many localities.

The National Council of Jewish Women publishes the quarterly *NCJW Journal,* in which it reports on the status of constitutional rights, child welfare, and Jewish life in the United States and Israel as well family issues such as aging. The organization has 100,000 members; Susan Katz is its current executive director.

Further Reading: Brennan, ed., *Women's Information Directory;* Solomon, *Fabric of My Life.*

National Council of Negro Women

Established by Mary McLeod BETHUNE, Mary Church Terrell, and twenty-eight other women in December 1935 in New York City, the National Council of Negro Women (NCNW) united more than a dozen African-American women's organizations and provided its members with a means of addressing broad societal questions and influencing national domestic policy. Bethune considered the new organization a necessary counterpart to the NATIONAL ASSOCIATION OF COLORED WOMEN (of which she was an active member), which was deeply involved in local affairs and projects.

Bethune served as the council's president from 1935 to 1949 and, sometime after the council's inception, moved its headquarters to Washington, D.C. *The*

Aframerican Woman's Journal was created to keep members informed of council initiatives and successes.

The council has combated racism as well as sexism. During Bethune's tenure as president, the council facilitated the formation of the Co-ordinating Committee for Building Better Race Relations, an interracial coalition comprised of women's organizations such as the NATIONAL WOMEN'S TRADE UNION LEAGUE and the Young Women's Christian Association. The reputation of Bethune and the council earned her, on behalf of the council, a seat at the United Nations founding conference in 1945.

The council originally opposed the EQUAL RIGHTS AMENDMENT because it feared its adoption would undermine PROTECTIVE LABOR LEGISLATION (it was a supporter by 1977) and has steadfastly objected to feminism's attack on the structure of the family and its frequent claims that sexism is similar to racism. Despite these differences, the council often works in tandem with representatives of other women's organizations to improve the lives of women. For example, after the 1977 NATIONAL WOMEN'S CONFERENCE in Houston, the council worked with the National Women's Conference Committee and proposed Plan of Action networks in an attempt to secure ratification of the Equal Rights Amendment.

The National Council of Negro Women remains one of the country's most influential organizations of African-American women. Dorothy I. Heights is its current president.

Further Reading: Clark, *Almanac of American Women in the 20th Century;* Davis, *Moving the Mountain;* Evans, *Born for Liberty;* Rix, ed., *American Woman 1990–91;* Smith, "Mary McLeod Bethune," in *Notable American Women: The Modern Period,* ed. Sicherman et al.

National Day of Demonstration Against the EEOC

One of the first truly national protests on behalf of women's rights, the National Day of Demonstration Against the EEOC was organized by the NATIONAL ORGANIZATION FOR WOMEN (NOW) and held on December 14, 1967. Its purpose was to draw attention to the EQUAL EMPLOYMENT OPPORTUNITY COMMISSION's failure to enforce the sex discrimination provisions of Title VII, including the commission's failure to ban sex segregation of help-wanted ads, that is, the once-common practice of advertising for either male or female job applicants, as the employer preferred. Women picketed in at least six major cities, and NOW members stormed the EEOC's regional office in New York with armloads of sex-segregated classified ads.

At the press conference that followed, Betty Friedan, then president of NOW, announced that the organization planned to sue the EEOC. When the EEOC agreed to improve its enforcement of Title VII, NOW's lawsuit, which had been filed promptly, was dismissed.

In August 1967 the EEOC released guidelines relating to the sex discrimination provisions of Title VII, and sex-segregated want ads were declared discriminatory. The commission was powerless to enforce its guidelines, however; while most New York City newspapers ended sex segregation of want ads, other newspapers continued the practice. NOW's Pittsburgh chapter sued the *Pittsburgh Press* over its discriminatory classified advertising practices in October 1969. When the Supreme Court ruled in NOW's favor in 1973, sex-segregated want ads finally were outlawed.

Further Reading: Davis, *Moving the Mountain;* Hole and Levine, *Rebirth of Feminism.*

National Federation of Business and Professional Women's Clubs, Inc. of the United States of America (BPW/USA)

This organization was founded by Lena Madeson Phillips in 1919 to support women employed outside the home. The organization endorsed the EQUAL RIGHTS AMENDMENT in 1937.

Until the 1950s, members were primarily office workers; as the ranks of professional women increased, so did its membership. Today, with 150,000 members, BPW is the world's largest organization of employed women dedicated to the advancement of women's rights and business opportunities.

Following the formation of the PRESIDENT'S COMMISSION ON THE STATUS OF WOMEN, BPW pressured governors and state legislatures to establish similar commissions to study the impact of state laws on women. By 1967 every state had formed such a commission. BPW also formed its own commission, the National Council on the Future of Women in the Workplace, to examine the impact of child rearing on women's careers, the causes of wage inequality, and other employment issues.

Local chapters are also active and still retain the "club" atmosphere of the organization's founding days. For example, the "Fortune 500 Business and Professional Women's Club," as a New York City chapter was christened, held fund-raising events to support the 1980 senatorial candidacy of Elizabeth Holtzman and endorsed the formation of the National Business Council for the ERA (led by the president of Equitable Life Assurance Society, the chairman of the Bendix Corporation, and the president of the League of Women Voters) while providing business seminars and networking opportunities for its members.

Further Reading: Davis, *Moving the Mountain;* Fortune 500 BPW Club, *Fortune 500 Report;* Lemons, *Woman Citizen.*

National Museum of Women in the Arts, The

Founded by Wilhelmina C. Holladay and Wallace F. Holladay in 1981, the National Museum of Women in the Arts opened its collections to public viewing on April 7, 1987 in Washington, D.C. It is housed in a former temple of the Masonic Order.

The museum was established both to compensate for the paucity of space granted to female artists in America's major art museums and to educate the public about the wealth of art created by women throughout time. Wilhelmina and Wallace Holladay donated more than 500 of the museum's central works of art themselves. The collection includes work from the Renaissance period through the present, and features work by Mary CASSATT, Berthe Morisot, Georgia O'KEEFFE, and Lilla Cobot Perry among many others. The museum also maintains an invaluable library and research center on female artists.

The National Museum of Women in the Arts is supported, in large part, by donations from its more than 75,000 members.

Further Reading: Abbott, Rebecca Phillips, director of administration, The National Museum of Women in the Arts, undated letter to prospective members; Wood and McWilliams, *National Museum of Women in the Arts.*

National Organization for Women (NOW)

America's most visible women's rights organization, the National Organization for Women (NOW) was founded by Betty FRIEDAN, Kathryn Clarenbach, and others when, during a luncheon meeting in 1966, Friedan scrawled the word "NOW" on a paper napkin and each woman present placed an impromptu dollar's dues on the table. The chosen name, as Friedan explains in the epilogue to the tenth-anniversary edition of her book *Feminine Mystique,* was not the National Organization *of* Women but the National Organization *for* Women, because the founders thought "men should be part of it."

The women were motivated specifically by their anger at the reluctance of the EQUAL EMPLOYMENT OPPORTUNITY COMMISSION (EEOC) to enforce the sex discrimination provisions of Title VII of the CIVIL RIGHTS ACT OF 1964. Nonetheless, they founded an organization with broad goals: "to take the actions needed to bring women into the mainstream of American society *now,* exercising all the privileges and responsibilities in truly equal partnership with men." In the years immediately following its formation, NOW and its legal

defense committee successfully challenged the gender classification of jobs in newspaper listings; successfully pressured the EEOC to issue sex discrimination guidelines; won the invalidation of Pennsylvania's MUNCY ACT, which required women convicted of a crime to serve longer prison sentences than men convicted of the same crime (*Commonwealth v. Daniels,* July 1, 1968); and successfully challenged protective labor laws that kept women from well-paying jobs (*Weeks v. Southern Bell,* March 4, 1969). After endorsing the EQUAL RIGHTS AMENDMENT in 1967, NOW worked diligently for its passage in Congress, which occurred in 1972, and for its ratification, which failed by three states in 1982.

In recent years, the National Organization for Women has championed legislation such as the FAMILY AND MEDICAL LEAVE ACT (1993), the VIOLENCE AGAINST WOMEN ACT (1994), the DOMESTIC VIOLENCE OFFENDER GUN BAN (1996) and the prohibition against FEMALE GENITAL MUTILATION (1997), and it has successfully sued violent abortion clinic protestors under U.S. antiracketeering laws (see *NATIONAL ORGANIZATION FOR WOMEN V. SCHEIDLER*).

Honoring the past while setting goals for the future, the National Organization for Women in July 1998 marked the 150th anniversary of the SENECA FALLS CONVENTION with an updated version of the DECLARATION OF RIGHTS AND SENTIMENTS.

The National Organization for Women itself currently has more than 260,000 members and is organized into nine regional groups, fifty state organizations, and more than 800 local chapters. Patricia Ireland is its current president.

Further Reading: Davis, *Moving the Mountain;* Friedan, *Feminine Mystique;* Huerta, "The 21st Century Party Holds Founding Meeting," in *National NOW Times* 24, no. 6, (August 1992); Hole and Levine, *Rebirth of Feminism.*

National Organization for Women v. Scheidler (1994)

A 1994 Supreme Court decision that ruled, 9–0, that abortion clinics and providers can sue violent opponents for damages using the Federal Racketeer-Influenced and Corrupt Organizations Act. The federal law, passed in 1970 and known as RICO, made it illegal for groups to use violence or extortion in an attempt to close down a business. Compelling evidence of two or more criminal acts are required to establish an illegal pattern.

The National Organization for Women (NOW) brought the suit on behalf of Milwaukee's Summit Women's Health Organization and the Delaware Women's Health Organization. It named Joseph Schei-

dler and the Pro-Life Action League, Inc., which he leads; Randall A. Terry and the organization he founded, OPERATION RESCUE; antichoice organizations Project Life and the Pro-Life Direct Action League; and other antichoice activists as the defendants. NOW charged that these organizations conspired, through illegal and violent actions such as bombings, property damage, trespassing, and harassment of providers and staff, to shut down abortion clinics. In 1992 the United States Court of Appeals for the Seventh Circuit, in Chicago, dismissed the lawsuit, ruling that Operation Rescue and related groups did not violate RICO because they were not motivated by profit-making or other economic concerns. The court did, however, agree that NOW's charges, if sustained, could be found to violate the federal Hobbs Act (an extortion law).

When the case was argued before the Supreme Court, the justices ruled unanimously in favor of NOW. In the majority opinion, Chief Justice William H. Rehnquist found that Congress had "neither expressed, nor, we think, fairly implied" that any profit motive was a RICO requirement. In ruling that the anti-choice organizations fell within the statute's reach, Rehnquist said the Court ". . . believe[s] the statutory language [of RICO] is unambiguous."

NOW v. Schiedler also raised concerns about the possible violation of anti-abortionists' First Amendment rights. This issue had been addressed during the trial by NOW's attorney, Fay Clayton, who stressed that RICO would not restrict the right of anti-choice groups or individuals to engage in lawful protest: "When they picket, when they pray, when they leaflet, when they petition Congress," she had told the Court, they certainly enjoyed First Amendment protection. Although Chief Justice Rehnquist stated that no First Amendment decision was required by the Court in the case at hand, Justice David H. Souter wrote a concurring opinion, specifically stating that the Court's decision in *National Organization for Women v. Scheidler* "does not bar First Amendment challenges to RICO's application in particular cases." The Souter opinion, in which Justice Anthony M. Kennedy joined, included a specific warning: "I think it prudent to notice that RICO actions could deter protected advocacy and to caution courts applying RICO to bear in mind the First Amendment interests that could be at stake."

Randall Terry denounced the ruling as "a vulgar betrayal of over 200 years of tolerance toward protest and civil disobedience," while leaders of pro-choice groups were comforted by the thought that the possibility of RICO lawsuits—in which triple damages could be applied—might deter further violence at abortion clinics. In a subsequent case, *Madsen v. Women's Health Center* (1994), the Supreme Court more directly confronted the First Amendment issue. In *Madsen* the Court upheld a Florida judge's injunction that created a protest-free area, or buffer zone, around an abortion clinic.

Further Reading: Greenhouse, "Court Rules Abortion Clinics Can Use Rackets Law to Sue," *New York Times,* January 25, 1994; Lewin, "Anti-Abortion Protests to Continue, Groups Say," *New York Times,* January 26, 1994; *National Organization for Women v. Scheidler,* No. 92-780.

National Task Force on Prostitution

Founded by Margo St. James in 1973 as Coyote Howls and also known as COYOTE (Call Off Your Old Tired Ethics), the National Task Force on Prostitution, as it was renamed in 1977, is an organization based in San Francisco that seeks to improve working conditions for prostitutes.

The organization's ultimate goal is the legalization of prostitution and "the removal of stigmas associated with female sexuality." In the meantime, since the exchange of sexual intercourse for money is illegal in all states except Nevada, the task force works to aid and protect prostitutes in conflict with the law. It tries to prevent loitering arrests, works to eradicate the vice squad entrapment methods currently used to secure prostitute arrests, and, in cases where prostitutes are arrested, provides referrals to qualified lawyers. The task force also tries to improve the daily life of prostitutes by helping them to apply for any social services or assistance for which they may be eligible and by providing AIDS and other health counseling.

In order to influence public policy and opinion, the task force lobbies the various state legislatures and maintains a library and speakers' bureau. Among the organization's members are prostitutes, former prostitutes, social service professionals, and lawyers. Sharon Kiser is the task force's current executive director.

Further Reading: Brennan, ed., *The Women's Information Directory;* Tuttle, *Encyclopedia of Feminism.*

National War Service Act

See AUSTIN-WADWORTH BILL.

National Woman's Loyal League

An organization of Northern women formed on May 14, 1863, to organize support for the passage of the Thirteenth Amendment, abolishing slavery, to the United States Constitution.

The Emancipation Proclamation, issued by President Abraham Lincoln on January 1, 1863, freed enslaved people only in the states "in rebellion against the United

States." When the Thirteenth Amendment—intended to end slavery in *all* of the United States—was introduced, Elizabeth Cady STANTON and Susan B. ANTHONY responded by issuing a "call for a meeting of the Loyal Women of the Nation" to be held May 14, 1863, in New York City.

Women from states as far away as Wisconsin traveled to New York to attend, and many other women sent letters expressing their support and willingness to work as the proposed organization directed. Lucy STONE was elected president of the founding meeting; Stanton, Angelina GRIMKÉ and six women from six separate states, vice presidents; Martha Coffin Wright and Lucy N. Colemen, secretaries; and Anthony, Ernestine ROSE, Antoinette B. BLACKWELL, Amy Post, and Annie V. Mumford, the meeting's business committee.

After speeches by Stanton and Grimké, Anthony introduced resolutions for discussion and adoption. They included an approval of the Emancipation Proclamation and a plea that enslaved people be emancipated throughout the United States; a statement that the Union must win the war "at whatever cost" so that the promise of freedom made to the slaves might become a reality; a statement extending to the former slaves a "welcome to legal freedom" and a condemnation of any legislation "exclud[ing] them from any locality, or debar[ring] them from any rights or privileges as free and equal citizens. . .."; a declaration that "There never can be a true peace in this Republic until the civil and political rights of all citizens of African descent and all women are practically established"; and a resolution praising women's contributions to the American Revolution and dedicating their nineteenth-century Northern counterparts to the "final and complete consecration of America to freedom."

It quickly became clear, however, that these goals did not enjoy unanimous support. At the beginning of the Civil War, the leaders of the women's rights movement had agreed among themselves and over the objections of Susan B. Anthony to suspend their activities until the war's end. Now women objected to including women's rights in the league's resolution concerning civil and political rights. One woman, Mrs. Hoyt from Wisconsin, expressed her belief that an organization dedicated to "assist[ing] the Government in its struggle against treason" would be handicapped by its support of "an *ism* [women's rights] obnoxious to the people."

Sarah Halleck, of Milton, New York, also objected to the women's rights resolution, but for another reason: "The negroes have suffered more than the women," she said, "and the women, perhaps can afford to give them preference. . .." Then she added that "It may possibly be woman's place to suffer. At any rate, let her suffer, if, by that means, *man*kind may suffer less." A voice called out,

"You are too self-sacrificing," and a lengthy discussion of the league's—and its constituents'—goals ensued.

Ernestine Rose defended the women's rights resolutions, saying she refused "to throw woman out of the race for freedom" because she believed that "in a republic based upon freedom, woman, as well as the negro, should be recognized as an equal with the whole human race." Angelina Grimké spoke about the many discriminations that she has faced in her life and said that "I can not be a true woman, a full-grown woman, in America." Susan B. Anthony also urged the women to agree to the inclusion of their sex in the resolution concerning civil and political rights.

Another objection—that of equating support of the Union with the adoption of specifically abolitionist goals—also was raised. "We women of the North were invited here to meet in convention. . . not to hold an Anti-Slavery meeting, not to hold a Woman's Rights Convention, but to consult as to the best practical way for the advancement of the loyal cause," Mrs. Hoyt complained.

By the end of the day, however, the National Woman's Loyal League was formed officially and its support of the Union defined formally in abolitionist and women's rights terms. Elizabeth Cady Stanton was elected president and Susan B. Anthony, secretary. The controversial resolution regarding women's rights was adopted by a large majority. Most of the league's members signed a pledge that linked their support of the war to the Union's use of that war to end slavery: "That we, loyal women of the nation, assembled in convention in New York, this 14th day of May, 1863, do hereby pledge ourselves one to another in a Loyal League, to give support to the Government *in so far as it makes the war for freedom*" (emphasis added). And, finally, in an address to President Lincoln, the league emphasized the effects of slavery upon women:

> Our special thanks are due to you, that by your Procla-
> mation two millions of women are freed from the
> foulest bondage humanity ever suffered. Slavery for
> man is bad enough, but the refinements of cruelty must
> ever fall on the mothers of the oppressed race . . . the
> slave-mother, in her degradation, rejoices not in the
> future promise of her daughter, for she knows by expe-
> rience what her sad fate must be . . .

The league asked Lincoln to emancipate all the slaves so that "nowhere under our national flag shall the motherhood of any race plead in vain for justice and protection." Its members agreed to canvass their respective states with a petition to Congress, which stated, "The undersigned, women of the United States above the age of 18 years, earnestly pray that your honorable body will pass at the earliest practicable day an act emancipating all

persons of African descent held to involuntary service or labor in the United States." (A separate petition was prepared for the signatures of men.)

The women set a goal of 1 million signatures. On February 9, 1864, the first installment—100,000 signed petitions—was presented to Senator Charles Sumner, who had introduced the Thirteenth Amendment. The petitions were too heavy for the young Senate pages to carry, so they were carried to the table by two free adult African Americans. Presented with tangible support for the sweeping action proposed by the Thirteenth Amendment, Senator Sumner turned to his colleagues and said people "from all parts of the country and from every condition of life . . . ask nothing less than universal emancipation; and this they ask directly at the hands of Congress."

The league did not abandon its interest in women's rights issues. At its May 1864 anniversary meeting, it proposed "That women now acting as nurses in our hospitals, who are regular graduates of medicine, should be recognized as physicians and surgeons, and receive the same remuneration for their services as men," and "urge[d] our countrywomen who have shown so much enthusiasm in the war—in SANITARY [COMMISSION] and Freedmen's Associations—now to give themselves to the broader, deeper, higher work of reconstruction [of the South at the war's end]."

The *New York Herald*, intending criticism, called the league a "revolutionary women's rights movement." Senator Sumner and abolitionist leaders such as Frederick Douglass, Wendell Phillips, and Theodore Weld were more appreciative. The league's 5,000 members collected 400,000 signatures to petitions in support of the Thirteenth Amendment. It ceased its activities after the amendment's ratification on December 18, 1865, and disbanded shortly thereafter.

Further Reading: Flexner, *Century of Struggle;* Frost and Cullen-DuPont, *Women's Suffrage in America;* Griffith, *In Her Own Right;* Stanton, *Eighty Years and More;* Stanton, Anthony, and Gage, eds., *History of Woman Suffrage,* vol. 2.

National Woman's Party

This organization was formed in 1917 by a merger of the Congressional Union (which began as a committee within the NATIONAL AMERICAN WOMAN SUFFRAGE ASSOCIATION) and the Woman's Party, both of which were headed by Alice PAUL and Lucy Burns. During the last years of the suffrage battle, members of the National Woman's Party picketed the White House and were repeatedly jailed. They went on hunger strikes, endured force feedings, and were the first American citizens to claim that they were being held by their government as political prisoners. In 1923, after ratification of the NINETEENTH AMENDMENT and on the seventy-fifth anniversary of the SENECA FALLS CONVENTION, the National Woman's Party members introduced an EQUAL

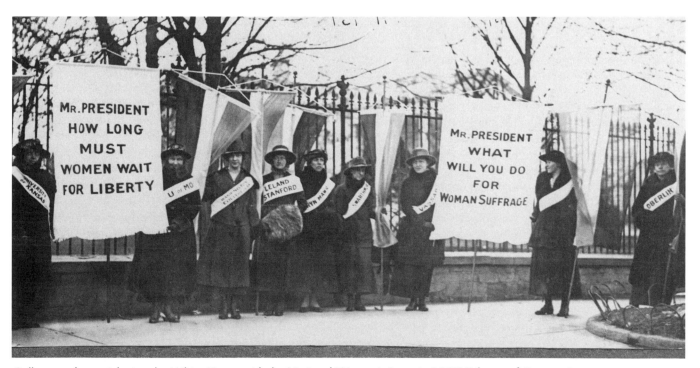

College students picketing the White House with the National Woman's Party in 1917 (*Library of Congress*)

RIGHTS AMENDMENT, which was drafted by Alice Paul. The organization campaigned for the amendment until 1982, when it failed to win ratification by just three states. The National Woman's Party continues to support an Equal Rights Amendment. It maintains its offices in Washington, D.C.; Dorothy Ferrell is its current president.

Further Reading: Brennan, ed. *Women's Information Directory;* Flexner, *Century of Struggle;* Frost and Cullen-DuPont, *Women's Suffrage in America;* Hole and Levine, *Rebirth of Feminism;* Irwin, *The Story of Alice Paul;* Lunardini, *From Equal Suffrage to Equal Rights;* Paul, *Conversations With Alice Paul;* Stevens, *Jailed for Freedom.*

National Woman Suffrage Association (NWSA)

This organization was founded in May 1869 by Elizabeth Cady STANTON and Susan B. ANTHONY when the AMERICAN EQUAL RIGHTS ASSOCIATION—a post-Civil War organization of abolitionists and women's rights activists working to "secure Equal Rights to all American citizens, especially the right of suffrage, irrespective of race, color, or sex"—refused to extend equal support for women's and black male suffrage. The newspaper of NWSA was the *REVOLUTION,* edited by Stanton and Parker Pillsbury. The founding of the National Woman Suffrage Association (NWSA) marked the beginning of a bitter twenty-year split in the women's movement, prompted by differences over the FOURTEENTH and FIFTEENTH AMENDMENTS. (See entries for those amendments and American Equal Rights Association for discussion.) The NWSA opposed ratification of the Fifteenth Amendment, which guaranteed the voting rights of African-American males but not women and which its rival organization, the AMERICAN WOMAN SUFFRAGE ASSOCIATION (AWSA), supported. NWSA, again unlike AWSA, never tried to avoid controversy. Its leaders favored discussion of every aspect of women's liberty, including birth control and divorce law reform, and they staged "overt actions," such as interrupting the vice president on stage and visiting heads of state during the 1876 celebration of the United States' centennial. NWSA sought amendments to state constitutions but focused primarily on a women's suffrage amendment to the United States Constitution. As time passed, AWSA's leader Lucy STONE was somewhat reconciled with Stanton and Anthony. In 1890, shortly after the fiftieth Anniversary celebration of the SENECA FALLS CONVENTION, NWSA and AWSA were merged into the National American Woman Suffrage Association.

Further Reading: Barry, *Susan B. Anthony;* Flexner, *Century of Struggle;* Frost and Cullen-DuPont, *Women's Suffrage in America;* Griffith, *In Her Own Right;* Stanton, Anthony, and Gage, eds., *History of Woman Suffrage.*

National Women's Conference

Organized by the National Commission on the Observance of International Women's Year, which was inaugurated by President Gerald Ford on January 9, 1975, the National Women's Conference was held November 18–21, 1977, in Houston, Texas. Jill Ruckelshaus and Elizabeth Athanasakos served as successive chairpersons of the commission during President Ford's term. President Jimmy Carter, after taking office in January 1977, appointed Bella ABZUG as chair of the committee. To prepare for the conference, between 130,000 and 150,000 women participated in conferences held in all the states and territories of the United States, helping to devise a "National Plan of Action" to be voted upon at the conference.

During the two months prior to its opening day, 1,000 people participated in a Torch Relay, passing a lighted torch from Seneca Falls, New York—site of the first American women's rights convention in 1848—to Houston, Texas, 2,600 miles away. When the conference opened, it was attended by more than 20,000 people, including First Lady Rosalyn Carter, former first ladies Betty Ford and Lady Bird Johnson, and 2,005 voting delegates.

The "National Plan of Action," offering concrete suggestions for government action in areas such as education, employment, childcare, battered women, RAPE, the EQUAL RIGHTS AMENDMENT, reproductive rights, and prejudice toward lesbians and minority women, passed—but not without much soul-searching and dissent. When delegates voted in a ratio of approximately five to one to support ratification of the Equal Rights Amendment, some ERA opponents openly wept. The vote in favor of the reproductive freedom resolution was also in a ratio of about five to one in support of a women's right to abortion, and here too, a serious and heart-felt division was apparent.

Another resolution that faced opposition was the one concerning lesbian rights. In 1969 Betty FRIEDAN had publicly opposed the inclusion of lesbian rights in the agenda of the women's movement. Now, when a participant in the 1977 conference characterized the lesbian rights resolution as an "albatross," Friedan responded differently. She acknowledged that "I have had trouble with this issue," but added, "Now my priority is in passing the ERA. And because there is nothing in it that will give any protection to homosexuals, I believe we must help the women who are lesbians." The resolution was passed.

On March 22, 1978, President Carter received the "National Plan of Action" along with the conference report, *The Spirit of Houston.*

Further Reading: Davis, *Moving the Mountain;* Evans, *Born for Liberty;* Rix, ed., *American Woman 1990–91;* Wandersee, *American Woman in the 1970s.*

National Women's Hall of Fame

Established in 1968 in Seneca Falls, New York, the National Women's Hall of Fame is a not-for-profit membership corporation dedicated "to honor[ing] in perpetuity those women, citizens of the United States of America, whose contributions to the arts, athletics, business, education, government, the humanities, philanthrophy and science have been of the greatest value for the development of their country." The location itself—Seneca Falls was the site of the first women's rights convention in America and the place where the DECLARATION OF RIGHTS AND SENTIMENTS was first presented in 1848—was chosen in tribute to the contributions of women to American history. Among the first women to be included in The National Women's Hall of Fame were Jane ADDAMS, Susan B. ANTHONY, Clara BARTON, Mary McLeod BETHUNE, Pearl BUCK, Rachel CARSON, Mary CASSATT, Emily DICKINSON, Amelia EARHART, Helen KELLER, Eleanor ROOSEVELT, Margaret Chase SMITH, Helen Crooke TAUSSIG, and Harriet TUBMAN.

In addition to permanent exhibits relating the contributions of the women honored, the National Women's Hall of Fame creates traveling exhibits for use by organizations throughout the United States.

Further Reading: Brennan, ed., *Women's Information Directory;* National Women's History Project, *Women's History Resources.*

National Women's History Month

Since 1987, the month of March has been recognized as National Women's History Month in the United States.

A time to study and celebrate women's history, National Women's History Month began in 1978 as Women's History Week in Sonoma County, California. The Education Task Force of the county's Commission on the Status of Women scheduled this first observance for the week of March 8, specifically to include INTERNATIONAL WOMEN'S DAY. The creation of the NATIONAL WOMEN'S HISTORY PROJECT in 1980 greatly facilitated the adoption of Women's History Week in California; among other things, it developed the curriculum and classroom materials necessary to bring women's history more fully into the classroom. An increasing number of schools participated in each successive year.

In 1981, Senator Orrin Hatch (R-UT) and Representative Barbara Mikulski (D-MD) introduced the Joint Congressional Resolution that turned Sonoma County's annual celebration into National Women's History Week. It was celebrated as such every March, during the week of International Women's Day, until 1986; at that point, the National Women's History Project successfully petitioned Congress to declare all of March National Women's History Month. In every year since then, March—by congressional resolution and presidential proclamation—has been Women's History Month.

It is widely observed in schools, many of which assign special women's history projects, sponsor essay contests, and otherwise highlight women in the curriculum. It is also observed by various organizations and agencies, such as the American Association of Retired Persons, the National Park Service, and the Small Business Administration, as well as many women's organizations, which sponsor educational and cultural programs.

Further Reading: Bomann, "Project Recognizes Women in History"; Miniclier, "Homesteader's Story Told in Women's History Month"; "March is National Women's History Month," National Women's History Project, available on-line: http://www.nwhp.org; Quattlebaum, "Girls Have a Blast Visiting the Past"; Dungee, "SBA Salutes Women's History Month."

National Women's History Project

A nonprofit organization founded in 1980 in Sonoma County, California, the National Women's History Project was instrumental in the creation of National Women's History Month and today serves as the event's primary resource organization.

The project acts as a clearinghouse for women's history information, reviewing and evaluating educational materials to select and recommend the best possible curriculum materials to schools. (A catalog, distributed to a mailing list of several hundred thousand people, makes project selections available to the general public as well.) The National Women's History Project also conducts in-service teacher training sessions and produces it own videos, curriculum guides, and other materials for use in the classroom. Its Women's History Network works to bring together community organizers, historians, librarians, parents, teachers, and others interested in "the movement to write women back into history." Recently, Molly Murphy MacGregor, a founder and executive director of the National Women's History project, was appointed by President Bill Clinton as one of the heads of the Women's Progress Commemoration Commission. (The commission will make recommendations to the secretary of the interior as to which historic sites in American women's history should be preserved.)

In addition to its catalog, the Women's History Project publishes the quarterly "Network News." Its offices are in Windsor, California.

Further Reading: National Women's History Project Available online: http://www.nwhp.org; U.S. Newswire, June 3, 1999.

National Women's Political Caucus

Founded in Washington, D.C. on July 10, 1970, by Bella ABZUG, Shirley CHISHOLM, Betty FRIEDAN, Gloria STEINEM (all of whom were members of the organization's first board of directors), and others, the National Women's Political Caucus is dedicated to increasing women's representation in government.

The bipartisan organization identifies women with the ability to succeed in politics, trains them to run a campaign, and assists with funding. In January 1986, in response to the particular difficulties faced by women of color seeking political office, the caucus added a "Minority Women Candidates Training Program." In July 1988, a presidential election year, the caucus joined forty-four other women's organizations (with a combined membership of over 5 million) in the Coalition for Women's Appointments; the coalition, hoping to secure the appointment of women to upper-level federal positions, prepared lists of qualified women, both Democratic and Republican. The caucus also maintains an active lobby and encourages noncandidate women to at least become active voters and supporters of female candidates.

As of 1999, the organization has more than 300 affiliates across the country and 75,000 members.

The caucus' effectiveness was publicly praised by many of the female candidates who won election in what became known as the YEAR OF THE WOMAN: 1992. Anita Perez Ferguson is the organization's current executive director.

Further Reading: Hole and Levine, *Rebirth of Feminism; New York Times,* November 5, 1992; Ries and Stone, eds., *American Woman 1992–93;* Rix, ed., *American Woman 1991–92.*

National Women's Trade Union League

Founded in 1903 by Mary Kennedy O'Sullivan, acting on a suggestion from William E. Walling and in response to the American Federation of Labor's neglect of women workers, the National Women's Trade Union League was a coalition of employed working women and women from outside the workforce with the means and empathy necessary to support working women's demands for reform.

The first three leagues were established in Boston, Chicago, and New York. Margaret Dreier Robins was president of the New York Women's Trade Union League, and Mary Anderson (later the head of the WOMEN'S BUREAU) was also a vital force in the organization. The league's logo set forth as goals "The Eight Hour Day, [and] A Living Wage to Guard the Home," but it also supported women's suffrage, improved working conditions, PROTECTIVE LABOR LEGISLATION, and equal pay for equal work. The nonemployed members of the league, called "allies" by fellow members and, scoffingly, "the mink brigade" by their critics, lent much more than moral support and verbal encouragement to their wage-earning sisters. During the labor strikes of the early nineteenth century—including the New York City shirtwaist workers strike of 1909 or, as it is better known, the Uprising of the 20,000—the allies provided striking women with bail money, testified as witnesses to police brutality, and raised strike relief funds for the workers and their families.

The league was present in eleven cities by 1911 and continued to be active until the end of the 1950s.

Further Reading: Dye, *As Equals and Sisters;* Flexner, *Century of Struggle;* Frost and Cullen-DuPont, *Women's Suffrage in America;* Payne, *Reform, Labor, and Feminism;* Wertheimer, *We Were There.*

Nevelson, Louise (ca. 1899/1900–1988) *artist*

Born Louise Berliawsky on September 23, in either 1899 or 1900, in Kiev, Russia, to Minna Sadie Smolerank Berliawsky and Isaac Berliawsky, noted artist Louise Nevelson is widely regarded as the founder of environmental sculpture, or the use of discarded materials or trash in the creation of art.

The Berliawsky family immigrated to America when Nevelson was five years old and moved in with an already settled family member in Rockland, Maine. Nevelson attended Rockland public schools, where she took art classes and drama. She married Charles Nevelson in 1920, two years after her high school graduation. The couple had one child and later divorced.

The couple settled in New York City, where Nevelson studied at the Art Students League from 1928 to 1930. Nevelson continued her artistic education by studying with Hans Hofmann in Germany and later by becoming an assistant to painter Diego Rivera.

Nevelson began showing her own work toward the end of the 1930s. Art critic Emily Genauer, reviewing Nevelson's work at a 1933 competition-exhibition, said the artist should have won more than an honorable mention. As she wrote later, she thought Nevelson's "five wood sculptures conceived abstractly and with special concern for the tensions of planes and volumes" made her "the most interesting" of the placing exhibitors.

Nevelson found no purchasers for her work during her first solo show (Karl Nierendorf's Gallery, New York

City) in 1940. In despair, she destroyed the exhibited work. During the following decade, however, her work began to find its place in important collections. In 1956 *Black Majesty* from "The Royal Voyage" was purchased by the Whitney Museum; in 1957 *First Personage* from "The Forest" was purchased by the Brooklyn Museum; and in 1958 *Sky Cathedral* from "Moon Garden + One" was purchased by the Museum of Modern Art. She was soon hailed, again in Genauer's words, "no longer just [as] an extremely talented . . . sculptor . . . [but as] one of the handful of truly original, major artists in America."

During Nevelson's early days, she used furniture remnants and other castoffs, materials she characterized as "found," and explained their use by saying "I never could afford much else." As her reputation and access to resources expanded, so did the range of materials used in her work. At various times, Nevelson's work has employed wood, terra cotta, various metals, and Plexiglass. The recurring use of one color for all components of an ensemble sculpture (most frequently black as in "Moon Garden + One", but sometimes also white as in "Dawn's Wedding" or gold as in "Royal Game") creates an emphasis on shadow and space, which Nevelson has described as the two most crucial elements in her work.

Nevelson's "Moon Garden + One," is considered one of the first environmental sculptures. Comprised of a set of rooms whose enclosing walls are collages of 116 black, wooden boxes situated in proximity to circular vessels that are filled with pieces of wood and placed according to pattern, the work has been described as having a "silent, mysterious, brooding, and dream-like quality."

In 1979 an entire "outdoor environment" of black sculptures was established as the Louise Nevelson Plaza at the World Trade Center in New York City. While she is perhaps best known for her sculptures, Nevelson also created many etchings, prints, drawings, and paintings.

Louise Nevelson died on April 17, 1988 in New York City.

Further Reading: *Current Biography Yearbook,* 1967 and 1988; Glimcher, *Louise Nevelson; New York Times,* April 18, 1988; New York *World Journal Tribune* mag., March 12, 1967; *Time,* February 3, 1958, August 31, 1962, March 31, 1967.

New York Radical Women

Founded by Pam Allen and Shulamith Firestone in 1967 in New York City as an offshoot of the Stanton-Anthony Brigade, a short-lived women's group of the late 1960s, New York Radical Women (NYRW) introduced consciousness-raising into the women's movement, staged media-attracting protests, and published radical

feminist writings of the late 1960s in its *Notes From the First Year* and *Notes From the Second Year.*

One of its more memorable protests took place in 1968. The Jeannette Rankin Brigade—founded by the first woman elected to serve in the United States Congress and the only member of Congress to vote against entry into both world wars—organized a march and convention, which drew 5,000 women to Washington, D.C., to protest the Vietnam War. The NYRW members took umbrage at what it considered the brigade's timeworn depiction of women as the vulnerable mothers and wives of beloved soldiers; therefore they staged their own counterprotest of the Jeannette Rankin Brigade protest. A leaflet distributed to the antiwar protesters praised them for "refus[ing] to hanky-wave boys off to war with admonitions to save the American Mom and Apple Pie . . . [and] refus[ing] your roles of supportive girl friends and tearful widows, receivers of regretful telegrams and worthless medals of honor . . ." The leaflet also invited the brigade women to join NYRW later that evening; between 300 and 500 accepted the invitation. That night a large doll, which was dubbed "Traditional Womanhood," was carried in a torch-lit funeral procession to Arlington Cemetery, where it was laid out for public viewing and, if one so chose, lamentation. The eulogy, written and delivered by Kathie (Sarachild) Amatneik, was entitled "Funeral Oration for Traditional Womanhood."

Further Reading: Amatneik, "Funeral Oration for Traditional Womanhood," in *Voices from Women's Liberation,* ed. Tanner; Davis, *Moving the Mountain;* Hole and Levine, *Rebirth of Feminism.*

Nineteenth Amendment (1920)

The amendment to the United States Constitution that guarantees the right of women to suffrage, or to vote, the Nineteenth Amendment was ratified on August 26, 1920. Its text reads:

> The right of citizens of the United States to vote shall not be denied or abridged by the United States or by any States on account of sex.
>
> The Congress shall have power by appropriate legislation to enforce the provision of this article.

The first official demand that women be granted suffrage was made at the SENECA FALLS CONVENTION organized by Elizabeth Cady STANTON, Lucretia MOTT, and others in July 1848. The seventy-two-year-long fight absorbed the energies—and, indeed, the lives—of many talented and devote women, including Stanton, Susan B. ANTHONY, Carrie Chapman CATT, and Alice PAUL. The organizations within which they worked for suffrage

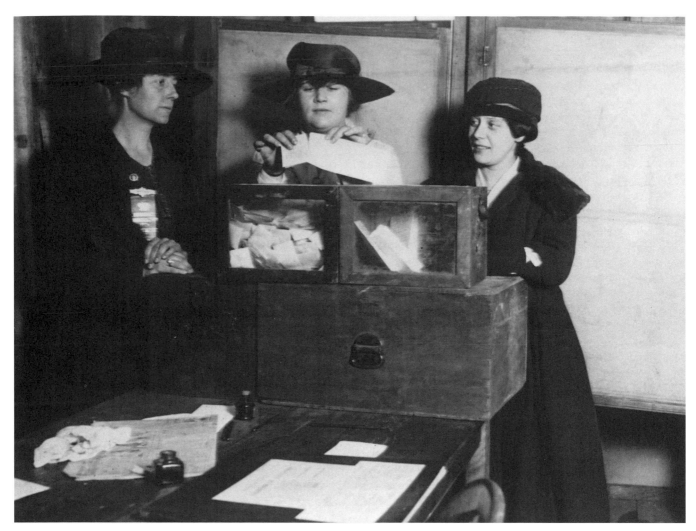

Women voting in New York City in 1917, three years before passage of the Nineteenth Amendment (*Library of Congress*)

included the NATIONAL WOMAN SUFFRAGE ASSOCIATION, or NWSA (which focused, from the start, on obtaining a federal amendment enfranchising the women of all the states); the AMERICAN WOMAN SUFFRAGE ASSOCIATION, or AWSA (which sought women's suffrage on a state-by-state basis); the NATIONAL AMERICAN WOMAN SUFFRAGE ASSOCIATION (the result of a merger in 1890 between NWSA and AWSA); the WOMAN'S CHRISTIAN TEMPERANCE UNION; and the NATIONAL WOMAN'S PARTY.

The state-by-state fight, while slow and probably not destined to secure suffrage for the women of all fifty states, had successes that gave the women's movement leverage with Congress. By June 4, 1919, when Congress submitted the Nineteenth Amendment to the states for ratification, women had already won full suffrage, entitling them to vote in local and federal elections, in Wyoming (1869); Colorado (1893); Utah (1896; Utah Territory had previously granted women's suffrage, from 1869 to 1887, but the EDMUNDS-TUCKER ACT, passed by Congress in 1887, contained provisions that stripped Utah's women of suffrage; when Utah became a state women's suffrage was granted in the new state's constitution); Idaho (1896); Washington (1910); California (1911); Arizona, Oregon, and Kansas (1912); Montana and Nevada (1914); New York, Arkansas, and Rhode Island (1917); and Michigan and South Dakota (1918). Women also had won the right to vote in presidential elections but in no other elections in Minnesota, Iowa, Missouri, Wisconsin, Indiana, Ohio, Kentucky, and Maine. In Illinois, Nebraska, North Dakota, Tennessee, and Vermont, women had won the right to vote in presidential and municipal elections. Voting women therefore were able to exert pressure on their elected officials, both to pass the Nineteenth Amendment in Washington and to ratify it at the state level.

By 1920 the power of public opinion was also strong. Alice Paul and members of the National Woman's Party had begun to picket the White House, stand trial, and serve

jail sentences, all in an effort to raise support for women's suffrage. At the same time, women served their country in World War I, just as they had in every other war—something Carrie Chapman Catt and members of the National American Woman Suffrage Association worked to bring to the attention of President Wilson and the country.

When the House of Representatives passed the Nineteenth Amendment, President Woodrow Wilson personally addressed the U.S. Senate to urge its passage in that house as well. In his September 18, 1918, speech, Wilson expressed the sentiments of many Americans:

> Are we . . . to ask and take the utmost that our women can give—service and sacrifice of every kind—and still say we do not see what title that gives them to stand by our side in the guidance of the affairs of their nation and ours? We have made partners of the women in this war. Shall we admit them only to a partnership of suffering and sacrifice and toil and not to a partnership of right?

The Senate declined to pass the amendment in 1918. However, it was passed once again by the House on May 19, 1919, passed by the United States Senate on June 4, 1919, and finally adopted on August 26, 1920.

Further Reading: Beard and Beard, *Basic History of the United States;* Catt and Shuler, *Woman Suffrage and Politics;* Flexner, *Century of Struggle;* Frost and Cullen-DuPont, *Women's Suffrage in America;* Stanton, Anthony, and Gage, eds., *History of Woman Suffrage;* Stevens, *Jailed for Freedom.*

9 to 5, National Association of Working Women

Founded in 1973 as the Working Women Organizing Project and known from 1978 to 1982 as Working Women, National Association of Officeworkers, 9 to 5 is an association of women office workers dedicated to improving the working conditions of the largely female support staffs of American businesses. Among its specific goals are the elimination of SEXUAL HARASSMENT and race, sex, and pregnancy discrimination in the workplace, improvements in clerical workers' wages, and the safe introduction of office automation technology into the workplace. In connection with this last concern, for example, 9 to 5 conducted research on the reproductive dangers posed by video display terminals (VDTs) and has worked to encourage states to safeguard workers through regulations of laws governing employee use of VDTs. 9 to 5 also runs a summer school for wage-earning women and a "job survival hotline."

9 to 5, National Association of Working Women, publishes the *9 to 5 Newsletter* five times each year, and it has published titles such as *Hidden Victims: Clerical Workers, Automation, and the Changing Economy* and *9 to 5: Working Women's Guide to Office Survival.* The organization has 13,000 members and maintains offices in Milwaukee, Wisconsin. Ellen Bravo is its current executive director.

Further Reading: Brecher and Lippitt, *Women's Information Exchange National Directory,* Brennan ed., *Women's Information Directory.*

Noether, Emmy (1882–1935) *mathematician*

Born in 1882 in Erlangen, Germany, to Jewish parents Max Noether and his wife, whose name has not survived, Emmy Noether was an important mathematician of the pre-World War II era.

Noether received her advanced education at the University of Erlangen, where her father was a mathematics professor. She completed her doctoral dissertation in 1907 and began to work with mathematicians Felix Klein and David Hilbert at the University of Göttingen, Germany, in 1916.

In 1933 Noether immigrated to the United States to escape Hitler's regime. She became a visiting professor of mathematics at Bryn Mawr College, a position she retained for two years. She died in 1935, after surgery.

During Noether's all-too-brief career, she worked in the area of abstract algebra and was a pioneer in the creation of the axiomatic approach. As Albert Einstein wrote after her death:

> In the judgment of the most competent living mathematicians, Fraulein Noether was the most significant creative mathematical genius thus far produced since the higher education of women began. In the realm of algebra, in which the most gifted mathematicians have been busy for centuries, she discovered methods which have proved of enormous importance in the development of the present-day younger generation of mathematicians.

Further Reading: Dick, *Emmy Noether, 1882–1935; New York Times,* May 4, 1935; Osen, *Women in Mathematics.*

Non-Traditional Employment for Women Act (1991)

Passed in 1991, the Non-Traditional Employment for Women Act (NEW) is a federal law, enacted by Congress as an extension of a prior federal employment law, the Job Training Partnership Act (JTPA).

In 1978 President Jimmy Carter, while banning sex discrimination by employers working pursuant to federal contract, specifically targeted the construction trades and

ordered such employers to raise their percentage of female workers to 6.9 percent by 1980. Compliance was almost nonexistent: according to the Bureau of Labor Statistics, only 2 percent of building trade workers were female throughout the 1980s; that figure fell to 1.9 percent (or 81,000 women) in 1991. The Non-Traditional Employment for Women Act renewed the government's effort to encourage the training and inclusion of women in apprenticeships and their subsequent employment in traditionally male areas such as the construction trades, but its ultimate impact is hard to assess. According to the law, states must report the numbers of women trained and hired in the trades to the U.S. Department of Labor. However, states are free to set their own goals for female employment, and penalties for noncompliance—as well as prospects for the act's funding—are unclear.

Further Reading: Bishop, "Scant Success for California Efforts to Put Women in Construction Jobs"; Deutsch, "Getting Women Down to the Site," *New York Times,* March 11, 1990; "Hard Times for Women in Construction," *New York Times,* September 29, 1992; Kilborn, "Putting Up Office Tower, Women Break Sex Barrier."

Norton, Eleanor Holmes (1937–) *lawyer, politician*

Born Eleanor Holmes on June 13, 1937, in Washington, D.C., to parents who strongly stressed the value of an education, Eleanor Holmes Norton became the first woman to chair the EQUAL EMPLOYMENT OPPORTUNITY COMMISSION.

Norton attended segregated public schools in Washington, D.C., for her early education, and the Dunbar High School, then the only Washington, D.C., college preparatory high school open to African-American children. Upon her graduation from Dunbar in 1955, Norton entered Antioch College, from which she graduated in 1960. She received her M.A. in American studies from Yale University in 1963. In 1964 she received her J.D. degree from Yale Law School and became a clerk for a federal judge. On October 9, 1965, she and Edward Norton were married.

The couple settled in New York City, and in 1965 Norton became the assistant legal director of the American Civil Liberties Union (ACLU). During her tenure, which lasted until 1970, Norton specialized in First Amendment freedom-of-speech cases and represented Vietnam War protesters, feminists, politician George Wallace, and Ku Klux Klansmen, among others. While some have questioned Norton about the propriety of an African American representing a Ku Klux Klan member, Norton says she has always been comfortable defending freedom of speech for all: "There's no way to argue," she has said,

"nor should there be, that black people ought to have freedom of speech but racists shouldn't. If the principle is going to live at all, it's got to live for anybody who wants to exercise it." And the principle must live at all cost, Norton explains, because freedom of speech was instrumental in "almost every social change in the twentieth century."

In April 1970 Mayor John V. Lindsay appointed Norton as chair of the New York City Commission on Human Rights. During a press conference held following her assumption of the office, Norton put city residents on notice that she intended, among other things, "to see that the principle of nondiscrimination becomes a reality for women . . ." Charged with responding to individual complaints, Norton won impressive victories for women such as: the liberalization of the maternity leave and other policies at various places of employment, including blue-collar establishments, an airline, and a bank; the continued employment of a pregnant secretary whose private-sector employer had originally ordered her to leave her job by the end of her seventh month of pregnancy; and the order that the 21 Club serve female patrons on the same basis as male patrons. In 1974 newly elected Mayor Abraham D. Beame reappointed Norton to another term as chairman.

President Jimmy Carter appointed Norton chair of the Equal Employment Opportunity Commission in 1977. Upon her arrival, she found 130,000 unresolved cases. Increasing the EEOC's productivity by 65 percent, Norton managed to cut the backlog by half while dealing with new complaints on a timely basis. Her tenure as chair of the EEOC ended in 1981, when Ronald Reagan became president and appointed Clarence Thomas head of the EEOC.

From 1982 to 1990 Norton was a professor of law at Georgetown University Law Center. She currently serves as the District of Columbia's nonvoting delegate to the House of Representatives, a position she was first elected to in 1990. She was co-chair of the CONGRESSIONAL CAUCUS FOR WOMEN'S ISSUES during the 105th Congress.

Further Reading: *Current Biography,* 1976; Lanker, *I Dream a World; USA Today,* April 29, 1993.

Notable American Women (1607–1950)

Published in 1971, *Notable American Women* is an exhaustive, three-volume biographical dictionary of, as the title suggests, American women from 1607 through the end of 1950. As its editors, Edward T. James, and Janet Wilson James, pointed out upon its publication, it was "the first large-scale scholarly work in its field."

Historians W. K. Jordan and Arthur M. Schlesinger, the president of Radcliffe College and a member of its

college council, respectively, helped to establish a Women's Archives at Radcliffe by 1950; the cornerstone of its collection was suffragist Maud Park Wood's 1943 donation of papers from the women's rights movement. (The Women's Archives was renamed the Arthur and Elizabeth Schlesinger Library in 1965, upon Schlesinger's death.) In 1955 Schlesinger suggested that the Advisory Board of the recently established Women's Archives undertake the preparation of a biographical dictionary of American women. To illustrate the need for such a work, Schlesinger pointed out that, although the *Dictionary of American Biography* contained almost 15,000 entries, only 700 entries were on women.

The project was begun, with Schlesinger serving as chairman of the Committee of Consultants until his death. Edward James—associate editor of the *Dictionary of American Biography*—supervised the editorial work, and Radcliffe College funded the project when other financial support failed to materialize. The entire project took sixteen years from inception to publication and contains 1,337 articles written by 738 contributing authors.

Notable American Women: The Modern Period, published in 1980 and edited by Barbara Sicherman and Carol Hurd Green with Ilene Kantrov and Harriette Walker, also was prepared under the auspices of Radcliffe College. This volume was undertaken, as its editors note, "[i]n response to public and scholarly demand" that followed the publication of the original three volumes. It includes the biographies of 442 American women of outstanding achievement, all of whom died between January 1, 1951, and December 31, 1975.

Further Reading: James, James, and Boyer, eds., *Notable American Women;* Sicherman et al., eds., *Notable American Women.*

Nurturing Network, The

Founded by Mary Cunningham-Agee in 1986 and based in Steubenville, Ohio, the Nurturing Network is a charitable organization dedicated to helping women find alternatives to abortion in the event of an unwanted pregnancy. It offers "a professional medical, counseling, and residential network across the country which enables a college or working woman to continue the life of her unborn child without sacrificing her own educational or career goals." Steps taken in the past have included the finding of welcoming, temporary homes; prenatal care; help with adoption procedures, when such help is requested; assistance with college transfers; and financial aid, which it offers to middle-class as well as poorer women on the basis that middle-class women have little chance of securing aid from the government. The Nurturing Network is supported by both "pro-choice" and "pro-life" organizations and individuals; it has 22,000 members. Founder Mary Cunningham-Agee is its current executive director.

Further Reading: Brennan ed., *Women's Information Directory.*

Oberlin College

Oberlin was the first American institution to provide a college-level education to women, and its 1833 founding was therefore called "the grey dawn of our morning" by Lucy STONE, one of its female graduates. It opened as the Oberlin Collegiate Institute, a "seminary" (a term first used by Emma WILLARD to describe an institution less rigorous than a college but more ambitious than an "academy"), and quickly became an actual college. Although its founders, John Shipherd and Philo Stewart, hoped for "the elevation of the female character, bringing within the reach of the misjudged and neglected sex all the instructive privileges which hitherto have unreasonably distinguished the leading sex from theirs," Oberlin originally offered one curriculum to its male students and another, abridged curriculum to its female students. The dual-track approach was abolished in 1841. Still, much to the chagrin of Lucy STONE and another future women's rights leader, Antoinette Brown BLACKWELL, female students originally were responsible for cleaning the rooms and laundering the clothes of Oberlin's male students. (It should be noted that Oberlin's male students had chores as well, including maintaining a farm and helping with various construction projects.) Women also were expected to conform to nineteenth-century standards concerning feminine behavior. Honor student Lucy Stone, for example, was asked to write a commencement speech for her 1847 graduating class but was told that a male student would have to read it publicly in her place. (Stone declined the invitation.) Oberlin adapted to social changes, however, and in 1883 made Stone a keynote speaker during the celebration of its fiftieth anniversary. Today, Oberlin is recognized as one of America's finest liberal arts colleges.

Further Reading: Fletcher, *History of Oberlin College;* Flexner, *Century of Struggle;* Filler, "Lucy Stone," in *Notable American Women,* ed. James, James, and Boyer; Zophy and Kavenik, eds., *Handbook of American Women's History.*

"Observations on the Real Rights of Women, with their appropriate duties, agreeable to Scripture, reason and common sense" (1818)

Pamphlet published in 1818 by Hannah Mather Crocker. Crocker, writing in her sixty-sixth year, acknowledged that she had been influenced by Mary Wollstonecraft's *Vindication of the Rights of Woman* but claimed less than Wollstonecraft's "total independence of the female sex." Crocker emphasized women's education, stating that

> although there must be allowed some moral and physical distinction of the sexes agreeable to the order of nature, still . . . the powers of the mind are equal in the sexes . . . There can be no doubt but there is as much difference in the powers of each individual of the male sex as there is of the female; and if they received the same mode of education, their improvement would be fully equal.

With such an education, Crocker argued in her "Observations," only "local circumstance and domestic cares" would keep women from a public life similar to men's. However, she believed it was women's responsibility to "soothe and alleviate the anxious cares of men" and stated "For the interest of their country, or in the cause of humanity, we shall strictly adhere to the principle and the impropriety of females ever trespassing on masculine ground."

Although Crocker thought that girls should be trained to support themselves in the event of severe hardship, she envisioned "the union and right understanding of the sexes" as the most important result of improved education for women. She then predicted that such mar-

riages would be the best foundation for "a free federal, republican government."

Further Reading: Crocker, "Observations on the real rights of women"; Evans, *Born for Liberty;* Faust, ed., *American Women Writers;* Flexner, *Century of Struggle;* James, "Hannah Mather Crocker," in *Notable American Women 1607–1950,* ed. James, James, and Boyer.

O'Connor, Flannery (1925–1964) *writer*

Born Mary Flannery O'Connor on March 25, 1925, in Savannah, Georgia, to Regina Cline O'Connor and Edward Francis O'Connor, Flannery O'Connor was, during her short lifetime, the author of many award-winning stories and two highly acclaimed novels.

O'Connor received her early education at the Peabody High School, from which she graduated in 1942. She attended the Georgia State College for Women (now Georgia College), where she was a frequent contributor, of cartoons as well as text, to the college's literary magazine. Graduating from an accelerated program in 1945, she next attended the Graduate School of Fine Arts at the University of Iowa, participating in the school's well-known writer's workshop and receiving her M.F.A. in 1947.

During her first year at Iowa, O'Connor sold her first story, "The Geranium," to *Accent* magazine. During her second year, she was awarded the Rinehart-Iowa prize for what would become her first novel, *Wise Blood.* Although the prize gave Holt, Rinehart the right to publish O'Connor's novel, she so disagreed with her editor's viewpoint that she secured a legal release. *Wise Blood* was published in 1953 by Harcourt, Brace. It was edited by Robert Giroux, who became O'Connor's close friend as well as her most trusted reader.

In December 1950 O'Connor came close to dying before she finally was diagnosed as having lupus erythematosus, a disease that had killed her father when she was twelve. She went to live with her mother at a farm near Milledgeville and remained there under her mother's care for the rest of her life, writing.

O'Connor was a Catholic author whose faith was central to her work. Her characters are often grotesque misfits who fall to increasingly abject levels as they search, wittingly or not, for salvation. O'Connor once explained her use of such characters by saying that "for the hard of hearing you shout; for the almost blind, you draw large and startling figures." Her tales of "the action of grace in territory held largely by the devil," as she once described them, won critical acclaim and, more slowly, an audience. In addition to *Wise Blood,* her writings include the short story collections *A Good Man Is Hard to Find and Other Stories* (1955) and, *Everything That Rises Must Converge*

(posthumously published in 1965), and a second novel, *The Violent Bear It Away* (1959). *The Complete Stories of Flannery O'Connor,* which include O'Connor's previously published stories and work prior to her graduation from Iowa, was published in 1972 and was awarded the National Book Award.

Flannery O'Connor died on August 3, 1964.

Further Reading: Asals, *Flannery O'Connor;* Faust, ed., *American Women Writers;* Fitzgerald, "Flannery O'Connor," in *Notable American Women: The Modern Period,* ed., Sicherman et al.; May, *The Pruning Word;* McHenry, ed., *Famous American Women;* O'Connor, *Wise Blood;* ———, *A Good Man Is Hard to Find;* ———, *The Violent Bear It Away;* ———, *Everything that Rises Must Converge;* ———, *The Habit of Being;* ———, *Collected Works by Flannery O'Connor;* Showalter, Baechler, and Litz, eds., *Modern American Women Writers.*

O'Connor, Sandra Day (1930–) *Supreme Court Justice*

The first woman to serve on the United States Supreme Court, Sandra Day O'Connor was born Sandra Day on March 26, 1930, in El Paso, Texas, to Ada Wilkey Day and Harry A. Day. She received her elementary education in a private girls' school and her secondary education at Austin High School. She graduated cum laude from Stanford University with a B.A. in economics in 1950 and earned her LL.B from the same institution in 1952. In June 1952 she and John J. O'Connor, a fellow student at Stanford Law School, were married.

O'Connor became a deputy attorney for San Mateo County, California, largely because private law firms were reluctant to hire women in the 1950s. By the end of the decade, she had moved to Arizona, become a mother, and established her own law practice. She was appointed in 1965 to the Governor's Committee on Marriage and Family, and served as assistant attorney general of Arizona until 1969.

O'Connor served in the Arizona state senate from 1969 to 1974 and voted in favor of the EQUAL RIGHTS AMENDMENT's ratification during her tenure there. In 1974 she was appointed a judge for the Arizona Court of Appeals and was on the court in July 1981 when President Ronald Reagan appointed her to the Supreme Court. Leading opponents and supporters of abortion rights expressed concern about her unknown stance on the subject, but her participation in the majority opinion in *PLANNED PARENTHOOD V. CASEY* (1992) seemed firmly to establish her position: She will uphold woman's right to an abortion prior to fetal viability but allow states to place restrictions on that right, so long as these restrictions do not constitute an "undue burden" upon the woman.

Sandra Day O'Connor, the first woman to serve on the U.S. Supreme Court (*The Supreme Court Historical Society*)

It was widely noted the O'Connor acted as a powerful consensus builder during the Court's consideration of *Planned Parenthood v. Casey.* In the 1990s, she has emerged as one of the Court's major figures, forming centrist coalitions on issues such as abortion rights, sexual harassment protection, and separation of church and state. As legal scholar Thomas Merrill describes her impact, "You could argue she's the most powerful justice on the court. She has been like a rock adhering to her positions and prevailing all over the place." In 1997, she was awarded the American Bar Association's highest award, an honor she shares with Supreme Court Justices Oliver Wendell Homes, Felix Frankfurter, and Thurgood Marshall.

Further Reading: Clarke, *Almanac of American Women in the 20th Century; Current Biography Yearbook,* 1982; Elasser, "O'Connor Makes Mark as Key Influence on Court"; Greenhouse, "Surprising Decision"; O'Connor, "Women and the Constitution," in *Women, Politics and the Constitution,* ed. Lynn; "The Supreme Court: Retaining the Constitutional Right to Abortion," *New York Times,* June 30, 1992.

O'Keeffe, Georgia (1887–1986) *artist*

Born on November 15, 1887, in Sun Prairie, Wisconsin, to Ida Totto O'Keeffe and Francis O'Keeffe, Georgia O'Keeffe was an important figure among the first generation of American modern artists.

O'Keeffe graduated from the Chatham Episcopal Institute in Virginia in 1904 and entered the Art Institute of Chicago that same year. O'Keeffe contracted typhoid and was forced to abandon her studies in 1905. In 1907, having recovered, she went to New York City for a year's study at the Art Students' League. She attended Teacher's College at Columbia University and the University of Virginia. In 1916 O'Keeffe became an art teacher at West Texas State Normal College (now West Texas State University).

During those years, O'Keeffe sent several of her drawings to a friend in New York City. Without her knowledge, they were shown to Alfred Steiglitz, the photographer and founder of the avant-garde 291 Gallery. Steiglitz was impressed and captivated by what he saw as O'Keeffe's daring, original, and completely modern expression of a woman's sensibility. He included O'Keeffe's work in 1916 and 1917 shows, and sponsored the first of what became his nearly annual one-artist exhibits of her work in 1923. O'Keeffe and Stieglitz were married on December 11, 1924.

O'Keeffe's painting during the late 1910s and early 1920s were predominately abstractions intended to express intense emotion. While her other paintings include renderings of New York City, O'Keeffe was deeply inspired by nature and created a large body of paintings (those for which she is most famous) that mixed natural elements—such as flowers and the skeletal remains of animals—with abstract images. As Laurie Lisle has pointed out, she also was influenced by photographic techniques and created the effect of having either cropped her paintings or painted "close-ups."

In 1929 O'Keeffe visited New Mexico and fell in love with its desert landscape. She spent most of her summers there during her marriage and, upon Stieglitz's death in 1946, made her permanent residence in Abiquiu.

Georgia O'Keeffe's work was made a part of important museum collections fairly early in her career, finding a home at the Whitney Museum of American Art and at the Metropolitan Museum of Art as early as 1932, and in many other museums since. There have been several major retrospective exhibits of her work, including those at the Art Institute of Chicago, the Museum of Modern Art, the Whitney Museum of American Art, and the National Gallery of Art, which traveled to four cities

between 1987 and 1989. She received numerous awards and honors during her lifetime, including election to the National Institute of Arts and Letters in 1949 (and its gold medal for painting in 1970), election to the American Academy of Arts and Letters in 1962, and the Medal of Freedom, awarded by President Jimmy Carter in 1977.

Georgia O'Keeffe died in Santa Fe on March 6, 1986.

Further Reading: Clark, *Almanac of American Women in the 20th Century;* Lisle, *Portrait of an Artist;* McHenry, ed., *Famous American Women;* O'Keeffe, *Georgia O'Keeffe;* ———, *Georgia O'Keeffe: Art and Letters;* Robinson, *Georgia O'Keeffe.*

Older Women's League

Founded as the Older Women's League Educational Fund in 1978 by Tish Sommers and Laurie Shields, who earlier had founded the Alliance for Displaced Homemakers (see WOMEN WORK! THE NATIONAL NETWORK FOR WOMEN'S EMPLOYMENT), the Older Women's League (OWL), as it was known after 1980, has vigorously championed legislation designed to combat poverty among America's elderly women.

The organization's constant lobbying of Congress has had measurable results. The Retirement Equity Act, passed by Congress in 1984, required that both husband and wife approve, in writing, a wage-earner's decision to waive survivor benefits. Congress passed another OWL-supported law in 1986, giving a divorced woman the right to continue for a time whatever health insurance coverage she had had under her former husband's policy. (The individual woman was, however, required to pay the premiums involved.)

OWL continues to lobby for additional improvements. As of 2000, the organization had 120 chapters and 21,000 members. It maintains its headquarters in Washington, D.C.; Deborah Briceland-Bretts is its current executive director.

Further Reading: Brennan, ed., *Women's Information Directory;* Davis, *Moving the Mountain.*

Oncale v. Sundowner Offshore Services, Inc. (1998)

A 1998 Supreme Court decision, *Oncale v. Sundowner Offshore Services* extends workplace SEXUAL HARASSMENT protection to same-sex situations.

The case was filed by Joseph Oncale who, in 1991, worked aboard an oil platform in the Gulf of Mexico with seven other men, two of whom acted as supervisors. The two supervisors, on more than one occasion, sexually assaulted Oncale and forced him to endure "sex-related, humiliating actions . . . in the presence of the rest of the crew." One of the supervisors also threatened to rape him.

When Oncale's complaints were ignored, he quit and filed a complaint in the United States District Court for the Eastern District of Louisiana. He claimed employment discrimination based on sex, citing Title VII of the CIVIL RIGHTS ACT OF 1964. Since the Supreme Court's decision in MERITOR SAVINGS BANK V. VINSON (1986), that law had been interpreted as prohibiting sexual harassment in the workplace. The District Court, however, ruled that "Mr. Oncale, a male, has no cause of action under Title VII for harassment by male coworkers." Oncale appealed, and the Fifth Circuit Court upheld the District Court's ruling.

The Supreme Court found otherwise. Justice Antonin Scalia, in the Court's opinion, quoting from Title VII, stated that "[i]t shall be an unlawful employment practice for an employer . . . to discriminate against any individual with respect to his compensation, terms, conditions, or privileges of employment, because of such individual's race, color, religion, sex, or national origin." He traced the history of the Court's decisions from the finding in *Meritor* that this "evinces a congressional intent to strike at the entire spectrum of disparate treatment of men and women in employment," to the 1993 ruling in HARRIS V. FORKLIFT SYSTEMS, INC.: "When the workplace is permeated with discriminatory intimidation, ridicule, and insult that is sufficiently severe or pervasive to alter the conditions of the victim's employment and create an abusive working environment, Title VII is violated."

Scalia reviewed several other cases before emphatically stating that men subjected to such treatment were entitled to bring suit: "If our precedents leave any doubt on the question," he wrote, "we hold today that nothing in Title VII necessarily bars a claim of discrimination 'because of . . . sex' merely because the plaintiff and the defendant (or the person charged with acting on behalf of the defendant) are of the same sex." He stressed that sexual harassment did not necessarily include unwanted sexual advances or evidence of sexual desire but was also recognized to mean conduct arising from hostility toward women in the workplace, a concept that was equally applicable to a man's complaint. He also pointed out that not every sexually charged incident equaled sexual harassment, stressing that the plaintiff "must always prove that the conduct at issue was not merely tinged with offensive sexual connotations, but actually constituted 'discrimina[tion] . . . because of . . . sex.'"

Finally, he cautioned against the reading of sexual harassment case law as the imposition of a "general civility code" for the American workplace. The Court's decision "requires neither asexuality nor androgyny in the workplace; it forbids only behavior so objectively

offensive as to alter the 'conditions' of the victim's employment." Behavior that would be commonplace on a field constituting a football player's workplace might well be unacceptable in an office, Scalia pointed out. "Common sense, and an appropriate sensitivity to social context," he wrote, "will enable courts and juries to distinguish between simple teasing or roughhousing among members of the same sex, and conduct which a reasonable person would find severely hostile or abusive."

The Court of Appeals' decision was reversed, and *Oncale v. Sundowner* was remanded for further proceedings.

Further Reading: *Detroit News,* October 22, 1997; *Oncale v. Sundowner;* 523 U.S. 75 (1998); *U.S.A. Today,* December 17, 1996; *Washington Post,* March 5, 1998.

Operation Rescue

Founded by Randall Terry in 1984 in response to what his friends and colleagues describe as a religious vision, Operation Rescue is a militant "pro-life" organization dedicated to preventing women from having abortions.

Under Terry's direction, members descend on selected cities, conduct large-scale demonstrations, and blockade targeted abortion clinics, which they refer to as "aboratoriums." A woman seeking an abortion at a surrounded clinic generally is intercepted by one or more Operation Rescue volunteers who, in Terry's words, "physically intervene" to keep her from the clinic. (The volunteers also offer some financial support to women who decide to continue their pregnancies. One teenager, interviewed for the *New York Times* on June 22, 1993, said that she had been given a place to live during her pregnancy and a baby shower prior to delivery. She also noted, however, that all support disappeared as soon as her baby was born.)

The group's primary objective is to shut down as many abortion clinics within a city as possible. To date, the group has traveled to several dozen cities and towns, including Atlanta, Georgia; Baton Rouge and New Orleans, Louisiana; Binghamton and Buffalo, New York; Boston, Massachusetts; Charlotte, North Carolina; Chicago, Illinois; Fargo, North Dakota; Indianapolis, Indiana; Little Rock, Arkansas; Los Angeles, California; Milwaukee, Wisconsin; Missoula, Montana; New York City; and Wichita, Kansas.

By the beginning of 1989, approximately 9,500 arrests of Operation Rescue volunteers had taken place, with many volunteers being arrested several times. In 1989 Randall Terry and others stood trial on misdemeanor trespassing charges for activities during what Randall termed a "Holy Week of Rescues" in southern California. Judge Richard Paez refused to allow Terry, who represented himself, to use the "necessity defense." This common-law principle permits a person to break a law in order to accomplish a public good. (A law dictionary example is the intentional setting of fire to "real property of another for the purpose of preventing a raging forest fire from spreading into a densely populated community.") Terry was visibly disappointed to have the trial focus simply on the charge of trespassing in violation of a prior statewide injunction issued by a U.S. District Judge, but he was acquitted nonetheless. Several weeks later, however, he was tried on the same charges for activities in Atlanta and found guilty. On October 5, 1989, the judge gave Terry a choice: Pay two $500 fines and serve two one-year sentences concurrently, or agree to be banned from Atlanta and the surrounding area for a two-year period. Stating that he couldn't, in good conscience, pay the fine, Terry chose jail. An unnamed benefactor subsequently paid the fine, and Terry was freed on January 31, 1990.

The Legal Defense and Education Fund of the National Organization for Women (NOW), together with other women's organizations, has tried to put a legal end to Operation Rescue. In *Bray v. Alexandria Women's Clinic, Now, et al.,* the women's organizations argued that Operation Rescue's attempts to deprive women of their constitutional right to an abortion violated a law commonly referred to as the Ku Klux Klan Act. (This law was passed during Reconstruction to prevent the Klan from depriving African-American men of their constitutional right to vote.) The administration of President George Bush entered *Bray* on behalf of Operation Rescue and several other antichoice organizations that were named in the suit, including the Pro-Life Action League and the Pro-Life Direct Action League. The Supreme Court ruled in January 1993 that Operation Rescue efforts did *not* deprive women of their civil rights.

Following *Bray,* Congress passed the Freedom of Access to Clinics Act. The act, which was signed into law by President Bill Clinton in 1994, prohibits the blockade of abortion clinic protesters. Later that same year, the Supreme Court's decision in NATIONAL ORGANIZATION FOR WOMEN V. SCHEIDLER gave abortion rights' advocates another tool with which to fight Operation Rescue and similar organizations.

In this case, NOW sought to apply the Racketeer Influenced and Corrupt Organizations (RICO) Act to the activities of the militant antichoice organizations, arguing that their nationwide blockade strategy constitutes a conspiracy to eliminate abortion clinics using tactics of intimidation and extortion. Two lower courts had dismissed *NOW v. Scheidler* on the grounds that "economic motivation" was necessary for the application of the RICO racketeering act. The Clinton administration characterized that interpretation as "narrow and grudg-

ing," and filed a brief in support of NOW and its appeal. The Supreme Court ruled 9–0 in NOW's favor in 1994. Also in 1994, the Supreme Court decided in *Madsen v. Women's Health Center* that protesters had to respect a buffer zone established by a Federal judge to protect clinic patients and workers.

These advances for abortion rights have been accompanied by a new round of violence, carried out by individuals who seem to have acted alone. In March 1993 Dr. David Gunn, who performed abortions in Pensacola, Florida, was murdered. In July 1993 Dr. John B. Britton, who also performed abortions in Pensacola, was murdered along with a clinic volunteer, James H. Barrett. In the last week of 1994, two members of the support staff of a Brookline, Massachusetts, clinic—Shannon Lowney and Leanne Nichols—were murdered.

Following these events, two highly visible leaders of the Roman Catholic church—one a long-time supporter of anti-abortion efforts—publicly discussed the future of the abortion protest movement. Bernard Cardinal Law, the archbishop of Boston, called for a moratorium on all protests near abortion clinics. John Cardinal O'Connor, the archbishop of New York, disagreed: During a sermon at St. Patrick's Cathedral on Sunday, January 8, 1995, he said he would call for such a moratorium only "on condition that a moratorium be called on abortions."

In April 1999, Operation Rescue changed its name to "Operation Save America," and announced a broader mission to combat child pornography, homosexuality, teenage sex, and the absence of religion in the schools, as well as abortion.

Further Reading: Associated Press, April 26, 1999; Davis, *Moving the Mountain;* Faux, *Crusaders;* Garrow, *Liberty and Sexuality;* ——, "A Deadly, Dying Fringe"; Greenhouse, "Supreme Court Roundup"; Neuborne, June 1993 letter; *New York Times,* April 19, 1999; Niebuhr, "Anti-Abortion Tactics Debated by Nation's Christian Leaders"; Quindlen, "Public & Private."

Operation Save America

See OPERATION RESCUE.

Organization of Chinese American Women

Founded in 1977 and based in Washington, D.C., the Organization of Chinese American Women is dedicated to advancing the interests of Chinese American women in the United States and increasing public awareness of issues relating to them. In particular, it works to encourage equal employment opportunity in professional and other areas; to combat racial discrimination and stereo-

types as well as "restrictive traditional beliefs"; and to provide financial and other aid to new Chinese immigrants, Among its programs is an exchange program between women in Asian Pacific Rim countries and the United States.

The Organization of Chinese American Women publishes the quarterly newsletter, *OCAW Speaks*. It has 2,000 members; Pauline W. Tsui is its current acting executive director.

Further Reading: Brecher and Lippitt, *Women's Information Exchange National Directory;* Brennan, ed. *Women's Information Directory.*

Orr v. Orr (1979)

A 1979 Supreme Court decision that overturned, on FOURTEENTH AMENDMENT grounds, an Alabama law requiring men to pay alimony following a divorce, but not women.

The legal essence of marriage, as inherited from English common law, was a union in which women contributed sexual and homemaking services to their husbands, and men supported their wives. As attorney Leslie Freidman Goldstein has pointed out, these responsibilities usually were not enforced by the state during the course of a marriage but became matters of legal dispute only during a divorce. In this particular case, William H. Orr challenged the award of alimony to his wife, Lillian Orr, on the basis that a similarly situated woman would not have been ordered to pay the alimony an Alabama court had extracted from him. At the time Alabama, like many other states, had rules stating that men, but not women, could be ordered to pay alimony.

In delivering the Court's opinion, Justice William J. Brennan, Jr., quoting *REED V. REED* (1971), wrote that "the Alabama statutory scheme 'provides that different treatment be accorded . . . on the basis of . . . sex; it thus establishes a classification subject to scrutiny under the [Fourteenth Amendment's] Equal Protection Clause.'" Citing *CRAIG V. BOREN*, he also pointed out that "the fact that the classification expressly discriminates against men rather than women does not protect it from scrutiny."

The Court refused to support Alabama's possible "preference for an allocation of family responsibilities under which the wife plays a dependent role." The Court also refused to be swayed by Alabama's stated argument that such laws "compensate the wife for the discrimination she suffered at the hands of the common law." In conclusion, Brennan wrote that "Where, as here, the State's compensatory and ameliorative purposes are as well served by a gender-neutral classification as one that gender-classifies and therefore carries with it the baggage

of sexual stereotypes, the State cannot be permitted to classify on the basis of sex."

Further Reading: Cushman, *Cases in Constitutional Law;* Goldstein, *Constitutional Rights of Women,* Mansbridge, *Why We Lost the ERA;* O'Connor, "Women and the Constitution," in *Women, Politics and the Constitution,* ed. Lynn; *Orr v. Orr,* 1979. 440 U.S. 268.

Our Bodies, Ourselves (1970)

Published in 1970, *Our Bodies, Ourselves* was a landmark book that discussed women's medical needs and problems in an accessible manner, enabling many women to take the initiative on matters relating to their own health.

The book had its origins in a 1969 women's health workshop at the Boston Woman's Conference at Emmanuel College. Following the conference's conclusion, some participants continued to meet in order to research women's health issues. They began mimeographing their findings for other women and, prompted by demand, paid to have a printed and bound edition published by the New England Free Press. When demand outpaced the ability of the small (and now defunct) press to produce copies, the group found a commercial publisher in Simon & Schuster. The ensuing book, *Our Bodies, Ourselves,* put a basic education regarding birth control, pregnancy, menopause, diseases of the reproductive organs, and the actual techniques used during abortion in the hands of any woman willing to buy or borrow it. The book sold several million copies, and its authors, known as the Boston Women's Health Book Collective, became incorporated as a nonprofit organization "devoted to education about women and health." *Our Bodies, Ourselves* was revised and reissued several times. *The New Our Bodies, Ourselves* was published in 1984 and *Our Bodies, Ourselves: A Book by and for Women, 25th Anniversary Edition,* in 1996. The most recent edition is *Our Bodies, Ourselves for the New Century: A Book for and by Women* (1998).

Further Reading: Boston Women's Health Book Collective, *Our Bodies, Ourselves;* ———, *The New Our Bodies, Ourselves;* ———, *Our Bodies, Ourselves: A Book by and for Women, 25th Anniversary Edition;* ———, *Our Bodies, Ourselves for the New Century: A Book for and by Women.*

Ovington, Mary White (1895–1951) *writer, civil rights leader*

Born on April 11, 1895, in Brooklyn, New York, to Anne Louise Ketcham Ovington and Theodore Tweedy Ovington, civil rights reformer Mary White Ovington was a founder of the National Association for the Advancement of Colored People and, during its early years, one of the organization's few Caucasian members.

Ovington received her education at the Packer Collegiate Institute, from which she graduated in 1891, and Radcliffe College, from which she was forced to withdraw in 1893 for financial reasons. She worked at the Pratt Institute in Brooklyn as a registrar and, in 1895 and under Pratt's auspices, founded and became the head social worker at the Greenpoint Settlement.

In 1903 Ovington heard Booker T. Washington speak and was made painfully aware of the discrimination faced by African Americans. She left the Greenpoint Settlement, where she had assisted European immigrants, to become a fellow at the Greenwich House, which served an African-American community. In 1904 she began a study of the housing and other problems of African Americans, which she published in 1911 as *Half a Man: The Status of the Negro in New York.*

By the time of *Half a Man*'s publication, Ovington had become a friend a sympathizer of black scholar W. E. B. DuBois, catalyst and leader of the Niagara Movement. In 1909, along with Jane ADDAMS, editor Oswald Garrison Villard (a grandson of abolitionist William Lloyd Garrison), and other Caucasian reformers, Ovington founded the National Association for the Advancement of Colored People (NAACP), of which DuBois became publicity director. The NAACP adopted many of DuBois' and the Niagara Movement's demands, including an end to segregation. The organization was seen as a radical challenge to the leadership of Booker T. Washington, whom DuBois criticized for agreeing to maintain segregation in return for economic progress.

Ovington was a significant policymaker and official of the NAACP for more than forty years. In 1919, by which time the NAACP had established 165 branches and enrolled 44,000 members, Ovington became the organization's chair. She resigned that position in 1932 and became the NAACP's treasurer; she remained a board member until her retirement in 1947.

Near the end of the women's suffrage battle—a time when some of the movement's leaders attempted to gain Southern support for the NINETEENTH AMENDMENT by downplaying the enfranchisement of African-American women (see, for example, Laura CLAY)—Ovington pressed women's suffrage leaders openly to demand suffrage for black and white women in tandem. She also opposed the United States' occupation of Haiti and European colonization of Africa and supported NAACP efforts to end both.

In 1934 DuBois began to support what he described as a "voluntary segregation" within which African Americans could concentrate on economic survival (rather than legal advancement) during the Great Depression. Oving-

ton and the rest of NAACP board continued to insist that integration was a valuable goal to be pursued regardless of economic circumstances, prompting DuBois to leave the organization. (He returned from 1944 to 1948.)

In addition to *Half a Man,* Ovington wrote several other books, including a collection of profiles of African-American leaders, *Portraits in Color* (1927), and her autobiography, *The Walls Come Tumbling Down* (1945).

Mary White Ovington died on July 15, 1951, in Newton Highlands, Massachusetts.

Further Reading: Clark, *Almanac of American Women in the 20th Century;* Cryer, "Mary White Ovington," in *Notable American Women,* ed. Sicherman et al.; Harlan, *Booker T. Washington;* Rampersad, *Art & Imagination of W. E. B. DuBois;* Spingarn, Papers.

P

Paglia, Camille Anna (1947–) *writer, feminist*
Born on April 2, 1947, in Endicott, New York, to Lydia
and Pasquale Paglia, writer Camille Paglia is known for
her iconoclastic stance within the feminist community.

Paglia received her B.A. from the State University of
New York at Binghamton in 1968 and her M.Phil. and
Ph.D. from Yale University in 1971 and 1974, respec-
tively. She was a faculty member in the Literature and
Languages Division of Bennington College from 1972 to
1980; a visiting lecturer in English at Wesleyan Univer-
sity in 1980; a fellow of Ezra Stiles College at Yale Uni-
versity in 1981; and a visiting lecturer at Ezra Stiles
College between 1981 and 1984. She joined the faculty
at the Philadelphia College of Performing Arts (now the
University of the Arts) as an assistant professor in 1984
and was made an associate professor in 1987 and a pro-
fessor of humanities in 1991.

Paglia attracted national attention with the 1990
publication of her first book, *Sexual Personae: Art and
Decadence from Nefertiti to Emily Dickinson*. In it Paglia
discusses the primal nature of sex present in art and
rejects the idea that sex can be cleansed of its Dionysian
elements to become an intimate, friendly, and/or safe
endeavor. From this position, Paglia argues that femi-
nism is a movement that "has exceeded its proper mis-
sion of seeking political equality for women and has
ended by rejecting contingency, that is, human limita-
tion by nature or fate." She supports the legalization of
prostitution and drugs and opposes efforts to eliminate
pornography. In "Rape and the Modern Sex War," an
essay contained in Paglia's second book, *Sex, Art, and
Modern Culture* (1992), mainstream feminism is casti-
gated for misleading young women about the sexual
nature of men. In the essay, Paglia contends that date
rape on campuses could be better prevented if college
women understood the nature of the act from a man's
point of view and warned that women should use com-

mon sense. More recently, Paglia published *Vamps and
Tramps: New Essays* (1994).

Sexual Personae was nominated for the National
Book Critics Circle Award for criticism in 1991. Camille
Paglia is currently a professor of the humanities at the
University of the Arts in Philadelphia.

Further Reading: *Contemporary Authors,* vol. 140;
Newsweek, September 21, 1992; Paglia, *Sex, Art, and
American Culture; Time,* January 13, 1992.

Parkhurst, Helen (1887–1973) *educator*
Born on March 7, 1887, in Durand, Wisconsin, to Ida
Underwood Parkhurst and James Henry Parkhurst,
Helen Parkhurst was the founder of the Dalton Plan of
Education.

Parkhurst wanted to be a teacher from a very young
age. She received her B.S. in 1907 from the River Falls
Normal School of Wisconsin State College. She became a
teacher while still a student herself when, in 1904, she
accepted a position in a one-room schoolhouse in Pepin
County, Wisconsin. Parkhurst divided her classroom into
separate areas for the study of each subject and encour-
aged older students—there were forty students of various
ages, all of them boys—to assist younger ones. Following
her own graduation, she taught at the Edison School in
Tacoma, Washington (1901–10) and refined her teach-
ing method.

Parkhurst formalized and explained her approach in
the Laboratory Plan of 1910. (The plan later became the
Dalton Plan, named after the Massachusetts town that in
1918 became the first to adopt it for use in public
schools.) The plan envisioned schools in which children
of mixed ages would study together, each at his or her
own pace and according to his or her own interest, in a
classroom devoid of assigned seating and organized

according to subject areas. Structure was to be provided, in part, by monthly contracts between students and teacher, in which students agreed to meet certain goals.

Following the release of the Laboratory Plan, Parkhurst became a teacher of teachers: She taught at the Central State Teachers College in Ellensburg, Washington, from 1911 to 1913, and at the Central State Teachers College in Stevens Point, Wisconsin, from 1913 to 1915. In 1914 she was given a leave of absence from teaching and sent to Italy by the Wisconsin State Department of Education to research the Montesorri method of teaching. Parkhurst studied under Maria Montessori and in 1917 became the first person Montessori permitted to train teachers in the method.

In 1916, with help from New York City's business community, Parkhurst established the Children's University School, a private school that became the Dalton School in 1920. The school was a tremendous success and drew interested educators from around the world. Parkhurst's book, *Education on the Dalton Plan,* was published in 1922 in England and translated into more than fifty languages. Although her recommendations were fully implemented in America in only two schools—the Dalton, Massachusetts, school, and New York City's Dalton School—they were widely used in Japan and England and influential in many other countries. Among the honors accorded her from around the world were decorations by the Chinese Republic and the emperor of Japan.

After twenty-five years as the headmistress of the Dalton School, Parkhurst resigned and attended Yale University, receiving her M.A. in 1943 and becoming the first Yale Fellow in Education. Parkhurst's next projects, conducted between 1947 and 1950, were radio and television shows for children and teenagers. She returned to teaching from 1952 to 1954, when she taught at the College of the City of New York.

Helen Parkhurst died on June 1, 1973, in New Milford, Connecticut.

Further Reading: Feldman, "Helen Parkhurst," in *Notable American Women,* ed. Sicherman et al.; *New York Times,* June 4, 1973.

Parks, Rosa (1913–) *civil rights leader*

Born on February 4, 1913, to Leona Edwards McCauley and James McCauley in Tuskegee, Alabama, Rosa Parks inspired a 381-day bus boycott that, in turn, ignited the civil rights movement.

Growing up in the segregated South, Parks was raised by a mother who, as she later recalled, "believed in freedom and equality even though we didn't know it for reality during our life in Alabama." Parks attended Alabama State Teachers College for a year and a half,

leaving at the beginning of 1933 to marry Raymond Parks.

Following her marriage, Parks lived in Montgomery, where she was an officer of the National Association for the Advancement of Colored People and an active participant in the Montgomery Voters League, a group dedicated to increasing the number of African Americans registered to vote.

Parks entered the pages of history on December 1, 1955, when, at the end of a day's work at her job as an alterations tailor, she refused to relinquish her seat on a bus for a white passenger. The bus driver called the police to the scene. Asked by an officer, "Why don't you stand up?" Parks simply said, "I don't think I should have to." Parks was arrested and charged with disobeying Montgomery's racial segregation laws. With support from her husband and mother, Parks decided to "use my case as a test case challenging segregation on the buses." She was convicted and fined $10.

On December 5, under the auspices of the Montgomery Improvement Association and the direction of Dr. Martin Luther King, Jr., Montgomery's African-American community, inspired by Parks and outraged at her arrest, began a boycott of the city's bus service. The boycott was very well organized, with African-American taxi drivers lowering their rates to match those of buses, private car owners establishing car pools, and those unable to afford or gain a ride walking back and forth to work for 382 days. The boycott ended when Montgomery, in response to the boycott and a federal court order, integrated its bus service.

In 1957 Parks moved to Detroit with her family to become a special assistant to Congressman John Conyers, a position she held for twenty-five years. In 1988 she founded the Rosa and Raymond Parks Institute for Self-Development, an organization of which she is currently president. In her honor, the Rosa Parks Freedom Award is awarded annually by the Southern Christian Leadership Council.

Rosa Parks herself has been inducted into the NATIONAL WOMEN'S HALL OF FAME. In 1999, she was awarded a Congressional Gold Medal, the 121st American to be so honored.

Further Reading: Dove, *The Torch-bearer;* King, *Stride Toward Freedom;* Lanker, *I Dream a World;* McHenry, ed., *Famous American Women; New York Times,* June 16, 1999.

Pastoral Plan for Pro-Life Activities

Organized by the National Conference of Catholic Bishops in 1975, the Pastoral Plan for Pro-Life Activities was a plan for engaging American Roman Catholics to work

toward an end of legalized abortion. A central component of the plan was the election of "pro-life" candidates to the Senate and House of Representatives in order to secure a constitutional amendment prohibiting abortion.

Further Reading: Davis, *Moving the Mountain;* Faux, *Roe v. Wade.*

Patterson, Eleanor Medill (1881–1948) *editor, publisher*

Born Elinor Josephine Patterson on November 7, 1881, in Chicago to Elinor Medill Patterson and Robert Wilson Patterson, Jr., Eleanor Medill Patterson (she changed her name in adulthood) was an editor and publisher of the *Washington Times-Herald.*

Patterson was born into a powerful newspaper family: Her grandfather, Joseph Medill, a founder of the Republican party, built the *Chicago Tribune* into a powerful force; her father became the *Tribune*'s editor and head in 1899; her brother, Joseph Medill Patterson, became the founder of the *New York Daily News;* her niece, Alicia Patterson, became a founder of *New York Newsday* in 1940; and a cousin, Robert Rutherford McCormick, also headed the *Tribune.*

Eleanor Patterson was not expected to become the first woman in her family to join the world of journalism. Expected instead to excel socially, she received her education at Miss Hershey's School in Boston and at Miss Porter's School in Farmington. She was married on April 14, 1904, to a Polish count, Josef Gizycki. Although the couple had one daughter, Felicia, it soon became clear that Patterson had been married for her fortune. When she fled to England with Felicia in 1908, the count had the child seized and sent to Russia; at the urging of Patterson's father, President-elect William Henry Taft successfully negotiated with Czar Nicholas II for Felicia's return to the United States. Patterson's divorce from Gizycki was not finalized until 1917.

On April 11, 1925, Patterson married Elmer Schlesinger. Her novel, *Glass Houses,* published in France in 1923, appeared in the United States in 1926 and was followed two years later by *Fall Flight,* her second novel.

When Patterson was widowed in 1929, she decided to enter the world of journalism. She had previously written a few pieces for the Hearst newspapers. With this limited experience, she became editor and publisher of William Randolph Hearst's *Washington Herald* on August 1, 1930.

Patterson's innovative journalism and altruism became especially apparent during the Depression. For instance, she stood disguised among the jobless in the Depression and wrote about it. She advocated a hot lunch program for schoolchildren in Washington, D.C., and—

anonymously—funded such a program while awaiting congressional action. The *Herald*'s reporting on Appalachian destitution, entitled "Dixie's Dead End," preceded New Deal attention to the area and its residents.

Hearst ran into financial difficulties toward the end of the 1930s, and Patterson leased, with an option to buy, his two Washington papers: the *Herald* and the *Times.* She purchased both papers on January 28, 1939, and merged the papers into the *Times-Herald.* Known for its extremely lively reporting, the *Times-Herald* became Washington's most widely circulated paper by 1943.

Eleanor Medill Patterson died on July 24, 1948, near Marlboro, Maryland. She left the *Times-Herald* to several of its executives, who sold the paper to the *Chicago Tribune,* headed by Patterson's cousin, Colonel Robert R. McCormick. In 1954 the *Times-Herald* was sold to Eugene Meyer and merged with the *Washington Post.*

Further Reading: Denker, "Eleanor Medill Patterson," in *Notable American Women,* ed. James, James, and Boyer; McHenry, ed., *Famous American Women;* Tebbel, *American Dynasty.*

Paul, Alice (1885–1977) *suffragist, feminist*

Six times "jailed for freedom," as one of her fellow prisoners described it, Alice Paul was born on January 11, 1885, in Moorestown, New Jersey, to Tacie Perry Paul and William M. Paul, and was the descendant of a Quaker who died in an English prison rather than renounce his faith.

After receiving her early education in private schools, Paul received her A.B. degree from Swarthmore College in 1905. She spent 1906 in study at the New School of Philanthropy. In 1907 she went to live in England, where she continued graduate work at the Universities of London and Birmingham. She was awarded a master of arts in absentia from the University of Pennsylvania in 1907 and, following her return to the United States, received her Ph.D. from the same university in 1912. In England Paul became involved with the women's suffrage cause. She participated in several suffrage demonstrations organized by Emmeline Pankhurst and, as a result, was arrested and imprisoned three times.

After her return to the United States, Paul served as chairman of the Congressional Committee of the NATIONAL AMERICAN WOMAN SUFFRAGE ASSOCIATION (NAWSA) in 1912. In 1913 she and the most militant members of that committee left NAWSA and founded the Congressional Union for Woman Suffrage. Paul served as national chairman until 1917. This organization merged in 1917 with the Woman's Party to form the NATIONAL WOMAN'S PARTY, and Paul served as chair of the National Executive Committee of the new organization from 1917

Alice Paul led the National Woman's Party and drafted the Equal Rights Amendment. (*Library of Congress*)

to 1921. She introduced militant methods such as the picketing of the White House into the American suffrage campaign and was imprisoned three more times. In the Occoquan Workhouse in Virginia, she suffered extremely harsh treatment, including force-feeding.

After passage of the NINETEENTH AMENDMENT, Paul earned several law degrees. Paul drafted the EQUAL RIGHTS AMENDMENT in 1923, and she campaigned tirelessly on its behalf until her death. (The ERA eventually was defeated in 1983.) She also advocated an international equal rights treaty. From 1927 to 1937 Paul served as chair of the Woman's Research Foundation and from 1930 to 1933 as a member of the Nationality Committee of the Inter-American Commission of Women. She was a member of the Women's Consultative Committee on Nationality of the League of Nations. She helped found the World's Woman's Party and was instrumental in having a reference to gender equality included in the preamble to the U.N. Charter.

Alice Paul died in Moorestown, New Jersey, on July 9, 1977.

Further Reading: Frost and Cullen-DuPont, *Women's Suffrage in America;* Kleiman, "Alice Paul, a Leader for Suffrage and Women's Rights, Dies at 92," *New York Times,* July 10, 1977; Kraditor, *Ideas of the Woman Suffrage Movement;* Stevens, *Jailed for Freedom.*

Perkins Act (1984)

Passed by Congress in 1984, the Perkins Act, as the Carl D. Perkins Vocational and Applied Technology Education Act became known, allocates funds for the vocational training of school-age girls, with special set-asides for displaced homemakers and single parents of young children. Unlike the 1990 DISPLACED HOMEMAKER SELF-SUFFICIENCY ASSISTANCE ACT, the Perkins Act has been funded consistently since its inception. Augusta Kappner, assistant secretary for Vocational and Adult Education, currently administers the act for the Clinton administration.

Further Reading: National Displaced Homemakers Network, *Transition Times;* Women Work! The National Network for Women's Employment, *Network News.*

Perkins, Frances (1880–1965) *cabinet member*

The first American woman to serve as a cabinet member, Perkins was born Fannie Coraline Perkins on April 10, 1880, in Boston, Massachusetts, to Susan Bean Perkins and Frederick Perkins. She received her education at the Classical High School in Worcester, Massachusetts, where she was one of only several girls in attendance, and at MOUNT HOLYOKE COLLEGE, from which she graduated in 1902. On September 26, 1913, Frances Perkins and Paul Wilson were married. The couple had one child, a daughter, Susanna.

In the years following her graduation from Mount Holyoke, Perkins taught biology and physics. She also performed volunteer work at Hull House in Chicago, became a member of the Philadelphia Research and Protection Agency, and attended Columbia University, earning an M.A. degree in 1910.

After completing her studies at Columbia, Perkins continued to engage in numerous endeavors. In 1910 she became executive secretary of the New York Consumer's League and, in that capacity, conducted investigations of working conditions faced by women and children. She led the successful fight for New York's 1911 law setting standards for factory safety and for the state's 1913 wage and hour law. She also became an active supporter of women's suffrage during this time and taught at Adelphi College.

Perkins' governmental career began in 1918, when Governor Al Smith appointed her to New York's State Industrial Commission. She served at the State Industrial Commission and the State Industrial Board, as it was

later renamed, with only one interruption between 1920 and 1933. (In 1920 and 1921 she left the commission to serve as executive secretary of New York's Immigration Education Council.) She was chair of the State Industrial Board in 1926 and in 1929 was appointed State Industrial Commissioner by Governor Franklin D. Roosevelt.

Shortly after Roosevelt's 1933 inauguration as President of the United States, he named Frances Perkins as his secretary of labor. When Perkins was sworn in on March 4, 1933, she became the first woman cabinet member in American history. She served throughout Roosevelt's twelve-year presidency (only one other appointee did so) and participated in the formation of many New Deal programs, including the Civilian Conservation Corps, the Federal Emergency Relief Act, and the National Labor Relations Act. She was particularly instrumental in the successful passage of the FAIR LABOR STANDARDS ACT and the Social Security Act.

Women's rights leaders, while undoubtedly pleased to have a woman serve in such a high position, were nonetheless disappointed by some of her views. For example, she suggested that employed married women give up their jobs to male applicants during the Depression; opposed the LANHAM ACT's creation of day care centers during World War II; and, throughout her tenure, opposed the EQUAL RIGHTS AMENDMENT.

Following President Roosevelt's death, Perkins published *The Roosevelt I Knew* and served President Harry Truman as a member of the Civil Service Commission. She later joined the faculty of the School of Industrial and Labor Relations at Cornell University.

Frances Perkins died in New York City on May 24, 1965.

Further Reading: Clark, *Almanac of American Women in the 20th Century;* McHenry, ed., *Famous American Women;* Martin, *Madam Secretary;* Perkins, *The Roosevelt I Knew;* Trout, "Frances Perkins," in *Notable American Women,* ed. Sicherman et al.

Pitcher, Molly
See MCCAULEY, MARY LUDWIG HAYS.

Planned Parenthood Federation of America, Inc.
Founded as the American Birth Control League by Margaret Sanger in November 1921, Planned Parenthood Federation of America, as it was renamed in 1942, is a multifaceted organization dedicated to reproductive freedom.

The medical community vacillated in its support for Planned Parenthood's pro-contraceptive position for decades, but in 1959 the American Medical Association finally endorsed the availability of birth control. Nineteen years later all but two states had legalized the dissemination of birth control information to married women. The Supreme Court decision in GRISWOLD V. CONNECTICUT invalidated these last anticontraceptive laws in 1965.

By then the Planned Parenthood Federation of America had begun its attempt to overturn restrictive abortion laws. In 1955 Mary Calderone, Planned Parenthood's medical director, convened a secret conference on abortion. Three years later Planned Parenthood published *Abortion in the United States,* which presented a broad spectrum of opinions on the subject and sparked considerable debate. Planned Parenthood continued to advocate reform and filed an *amicus curiae* ("friend of the court") brief in ROE V. WADE.

Since that case, Planned Parenthood has been in the forefront of many legal battles to keep abortion safe and legal, including PLANNED PARENTHOOD V. CASEY and PLANNED PARENTHOOD V. DANFORTH, while at the same time providing gynecological services to women from all backgrounds.

Planned Parenthood currently provides low-cost birth control and abortion services, prenatal care, and the treatment of sexually transmitted diseases in more than 700 clinics across the country; conducts research on sexuality and reproduction; and maintains an active lobby. In 1992, it began its Clinician Training Initiative, to train New York City's medical residents in abortion techniques. Only 12 percent of the country's medical programs require such training, and Planned Parenthood's program was created both to fill this gap and, in the words of Alexander C. Sanger, president of Planned Parenthood of New York City, "embarrass medical administrators by having Planned Parenthood do their job for them." Twenty other physician training programs are being implemented around the country.

A more recent initiative has been to raise awareness of emergency contraception, which can be used for up to 72 hours after unprotected intercourse. The campaign addressed both the medical community and the public at large.

The national organization's central offices are in New York City, and its current president is Gloria Feldt.

Further Reading: Associated Press, October 11, 1997 and September 2, 1998; Brown, *American Women in the 1920s;* Chesler, *Woman of Valor;* Hartman, *American Women in the 1940s;* Hole and Levine, *Rebirth of Feminism;* Kaledin, *American Women in the 1950s; New York Times,* May 14, 1999; *Philadelphia Inquirer,* March 28, 1998; Planned Parenthood of New York City, *Annual Report,* 1998; Reuters December 18, 1997 and February 26, 1999. Ware, *American Women in the 1930s;* Witchell, "In His Grandmother's Footsteps: At Work

with Alexander C. Sanger," *New York Times,* March 15, 1995.

Planned Parenthood v. Casey (1992)

The Supreme Court decision in this case, delivered on June 29, 1992—almost twenty years after the *Roe v. Wade* decision and near the end of the Reagan/Bush administrations' twelve-year effort to overturn it—reaffirmed by a vote of 5–4 a woman's right to an abortion, while letting stand many of the restrictive Pennsylvania laws at issue in the case.

The opinion, signed by Justices Sandra Day O'Connor, Anthony M. Kennedy, and David H. Souter, states that

> . . . the essential holding of *Roe v. Wade* should be retained and once again reaffirmed.
>
> It must be stated at the outset and with clarity that Roe's essential holding, the holding we reaffirm, has three parts. First is a recognition of the right of the woman to choose to have an abortion before viability and to obtain it without undue interference from the State. Before viability, the state's interests are not strong enough to support a prohibition of abortion or the imposition of a substantial obstacle to the woman's effective right to elect the procedure. Second is a confirmation of the state's power to restrict abortions after fetal viability, if the law contains exceptions for pregnancies which endanger a woman's life or health. And third is the principle that the state has legitimate interests from the outset of the pregnancy in protecting the health of the woman and the life of the fetus that may become a child. These principles do not contradict each other; and we adhere to each.

The opinion further states that "the liberty of the woman is at stake in a sense unique to the human condition and so unique to the law. The mother who carries a child to full term is subject to anxieties, to physical constraints, to pain that only she must bear."

Justices O'Connor, Kennedy, and Souter emphasize in their opinion, however, "that *Roe v. Wade* speaks with clarity in establishing not only the woman's liberty but also the state's 'important and legitimate interest in potential life,'" and they state that "That portion of the decision in Roe has been given too little acknowledgment and implementation by the Court in its subsequent cases." On this basis, and in accordance with the "guiding principle" that "Regulations which do no more than create a structural mechanism by which the state, or the parent or guardian of a minor, may express profound respect for the life of the unborn are permitted, if they are not a substantial obstacle to the woman's exercise of the right to choose," the Court let stand most of the provisions of the Pennsylvania law at issue. It permitted a waiting period of twenty-four hours between a woman's initial visit to a physician or clinic and the actual abortion procedure; a requirement that clinics provide women with state-prepared materials about fetal development and the abortion procedure; a requirement that minor girls receive the permission of one parent or a judge before obtaining an abortion; and a requirement that physicians or clinics keep statistical abortion records for the state. The decision finds unconstitutional provisions of a Pennsylvania law requiring women to notify their husbands of intended abortions.

Justices John Paul Stevens and Harry A. Blackmun, in separate opinions, concurred with the affirmation of *Roe v. Wade* but argued that all provisions of the Pennsylvania law were unconstitutional. Chief Justice William H. Rehnquist and Justice Antonin Scalia, in separate dissenting opinions that were each joined by Justices Byron R. White and Clarence Thomas, argued that *Roe v. Wade* should have been found unconstitutional.

Further Reading: Faux, *Roe v. Wade;* Greenhouse, "Surprising Decision"; "The Supreme Court: Retaining the Constitutional Right to Abortion," *New York Times,* June 30, 1992.

Planned Parenthood v. Danforth (1976)

The Supreme Court decision in this case, delivered July 1, 1976, declared unconstitutional a Missouri law that gave a husband the right to override his wife's decision to have an abortion and declared that the parents of unwed, minor girls could not be given an absolute veto power over their daughters' decisions.

The prohibition against a husband's control over his wife's reproductive decisions remains. Declaring that "husbands may not exercise the control over their wives that parents exercise over their children," the Court, in *Planned Parenthood v. Casey* (June 12, 1992), struck down provisions of a Pennsylvania law requiring women to notify their husbands of intended abortions.

The right of minor, unwed girls to obtain abortions on their own has been brought before the high Court several times since *Danforth.* In *Bellotti v. Baird* (July 2, 1979), the Court expanded on the parental-consent section of its 1976 decision and ruled, 8–1, that states could require minors to obtain parental consent, as long as they were given the option of seeking a judge's permission instead. In *H. L. v. Matheson* (March 23, 1981), the court upheld the right of states to impose criminal penalties on doctors who failed to inform a dependent minor's parents before performing an abortion. On December 14, 1987, the Court, with eight sitting justices, split 4–4 in *Hartigan v. Zbaraz,* invalidating the Illinois law, which would have limited access of minor

girls to abortion services. In *Hodgson v. Minnesota* and *Ohio v. Akron Center for Reproductive Health* (June 25, 1990), the Court upheld two state laws regulating the abortions of minor girls: a Minnesota law requiring that both parents of a minor girl be informed about her planned abortion and offering a judicial hearing as an alternative, and an Ohio law requiring that one parent of a minor girl be informed about the planned abortion and also offering a judicial hearing as an alternative. Finally, in *Planned Parenthood v. Casey* (June 29, 1993), the Court—while emphatically prohibiting laws requiring married women to seek the consent of their husbands—upheld a Pennsylvania law requiring minor girls to have the permission of either one parent or a judge before seeking an abortion.

In its 1990 decision in *Hodgson v. Minnesota* and *Ohio v. Akron Center for Reproductive Health,* the Court declined to consider the question of whether a state could require minor girls to notify one parent and offer no judicial consent alternative. As of 2000, forty states had laws requiring parental consent or notification for minor girls seeking abortions.

Further Reading: "The Court's Major Abortion Decisions Since *Roe v. Wade,*" *New York Times,* June 26, 1990; Greenhouse, "Surprising Decision"; Lewin, "Long Battles Over Abortion Are Seen"; "Since *Roe v. Wade:* The Evolution of Abortion Law," *New York Times,* January 22, 1992.

Plath, Sylvia (1932–1963) *writer*
Born on October 27, 1932, in Boston, to Aurelia Schober Plath and Otto Emil Plath, Sylvia Plath became a poet whose work and life informed the imaginations of subsequent generations of women.

Plath spent her childhood in Winthrop and Wellesley, Massachusetts, and was raised by her mother following the death of her father in 1940. Her first poem was published in *Seventeen* magazine before her graduation from the Bradford High School in 1950.

Plath entered Smith College in 1950. In 1953 she won a guest editorship at *Mademoiselle* magazine in New York. The experience precipitated a severe depression: Plath attempted suicide, endured several electroshock treatments, and was hospitalized in a private facility.

She managed to return to Smith College in 1954, from which she graduated in 1955. She then went to Mewnham College, Cambridge, England, as a Fulbright scholar.

On June 16, 1956, she and the English poet Ted Hughes were married. Returning to the United States with Hughes, Plath taught at Smith College (1957–58) and then took several courses at Boston University.

In 1959 Plath and Hughes returned to England. The following year Plath's first volume of poetry *The Colossus* was published to critical acclaim in that country, and the couple's first child was born. In 1963 Plath published *The Bell Jar* in England; a coming-of-age novel based on Plath's 1953 emotional collapse, it appeared under the pseudonym Victoria Lucas.

Her later poems, written during times of emotional difficulty (including her divorce from Ted Hughes) are filled with harsh, compelling imagery and move with a brutal energy that, in Hughes' words, "ignores metre and rhyme for rhythm and momentum."

In London on February 11, 1963, Sylvia Plath committed suicide by turning on the gas in her oven and placing her head inside it. Her last, extraordinarily intense poems began to appear in England in October of that year. In America, they were collected under the title *Ariel* in 1966. *The Bell Jar* was published in the United States in 1971.

Further Reading: Kroll, "Sylvia Plath," in *Notable American Women,* ed. Sicherman et al.; Faust, ed., *American Women Writers;* Gilbert and Gubar, eds. *Norton Anthology of Literature by Women;* McHenry, ed., *Famous American Women;* Plath, *Bell Jar;* ———, *Collected Poems;* Showalter, Baechler, and Litz, eds. *Modern American Women Writers.*

Pocahontas (ca. 1595/96–1617) *peacemaker*
Born and named Motoaka, most probably in 1595 or 1596, and, it is believed, in what is now Virginia, to the Algonquin chief Powhatan (her mother's name is not recorded), Pocahontas, the pet name by which she was known, is the "Indian princess" famous for her rescue of John Smith from the wrath of her father. (Many historians now believe, however, that part or all of this story are not true.)

The English colonizer John Smith was captured by the Algonquins in 1607. As Smith described it in his 1624 *General Historie of Virginia, New England, and the Summer Isles,* he was about to be executed when the twelve-year-old Pocahontas successfully pleaded with her father to spare his life. The young girl remained a friend to the colonists, bringing food and information about Powhatan's planned hostilities.

In 1613 the English captain Samuel Argall held Pocahontas hostage aboard his ship in order to persuade her father to release several Englishmen being held by the Algonquins. During her captivity, she was converted to Christianity and took the baptismal name Rebecca. She and colonist John Rolfe were married in 1614, and Powhatan reluctantly entered a truce with his daughter's new relatives.

Pocahontas and her husband had a son, Thomas, in 1615. In 1616 the family traveled to England, where Pocahontas was presented at court and contracted an illness from which she did not recover.

Pocahontas died in March 1617 on board ship and is buried in Gravesend, England.

Further Reading: Barbour, "Pocahontas," in *Notable American Women,* ed. James, James, and Boyer; McHenry, ed., *Famous American Women;* Mossiker, *Pocahontas;* Read and Witlieb, *Book of Women's Firsts;* Woodward, *Pocahontas.*

Pregnancy Discrimination Act (1978)

A 1978 amendment to Title VII, the Pregnancy Discrimination Act required all private employers to treat pregnancy in the same manner as any other medical disability. Thus, employers granting medical leaves for other reasons were required also to grant maternity leaves, while employers without medical leave policies were not required to grant maternity leaves. These provisions were superseded by the FAMILY AND MEDICAL LEAVE ACT OF 1993.

Further Reading: Davis, *Moving the Mountain.*

President's Commission on the Status of Women

Proposed by Esther Peterson, assistant secretary of labor and director of the Women's Bureau, and established by President John F. Kennedy on December 14, 1961, the commission investigated the "prejudices and outmoded customs act[ing] as barriers to the full realization of women's basic rights."

Neither Kennedy nor Peterson (a staunch advocate of protective labor legislation) supported the EQUAL RIGHTS AMENDMENT (ERA). According to Peterson's June 1961 memo to Kennedy, she hoped that the commission might formulate and "substitute constructive recommendations" in place of the sweeping ERA. Of the twenty-six people appointed to the commission (fifteen women and eleven men), only Eleanor Roosevelt and Marguerite Rawalt supported the ERA.

Notwithstanding this anti-ERA bias, the commission was given complete authority to investigate the realities of all aspects of women's lives and to propose all concrete steps it deemed necessary to create equality for women. Eleanor Roosevelt served as chair until her death in 1962 and was succeeded by Esther Peterson. Seven separate committees carried out the study: Civil and Political Rights, Education, Federal Employment, Home and Community, Private Employment, Protective Labor Legislation, and Social Security and Taxes.

The commission delivered its report, *American Women,* to the president on October 11, 1963 (the anniversary of Eleanor Roosevelt's birth). Despite the efforts of lawyer Marguerite Rawalt, the commission's report declared that the ERA "need not *now* be sought." It suggested that the Fourth Amendment (which states, in part, that "The citizens of each state shall be entitled to all privileges and immunities of citizens in the several states") and the Fourteenth Amendment (which states, in part, that "No State shall make or enforce any law which shall abridge the privileges or immunities of citizens of the United States" and which had been cited unsuccessfully in defense of women's rights in the *Bradwell* and *Minor* cases in the 1870s) could be used in the courts to win fully equality for women.

The commission did, however, recommend far-reaching changes, including: recognition of women's house and child-rearing work as contributions to a marriage partnership and an acknowledgment that any assets acquired by a couple during the marriage belong to *both* parties; paid maternity leave; accessible and affordable child care, with tax deductions for same; and equal pay, not just for "equal [or the same] work" but for work of comparable value.

In July 1962, during preparation of the commission's report, President Kennedy ordered all federal agencies to hire, train, and promote their employees on a gender-blind basis. On June 10, 1963, he signed the EQUAL PAY ACT, requiring private-sector employers to pay their male and female employees equal wages for equal work performed under identical conditions. In the six weeks between the report's release and his own assassination, President Kennedy also set up a Citizen's Advisory Council on the Status of Women (which, by 1970, was replicated in each of the fifty states to examine women's status in state law and policy) and the Interdepartmental Committee on the Status of Women, a cabinet-level committee that advised Presidents Johnson, Nixon, Ford, and—in a slightly changed format—Carter, but which was disbanded by President Reagan.

The President's Commission on the Status of Women was widely discussed in Congress as well as among the 64,000 individuals who ordered copies of its report. It is one of the events credited with bringing the issue of women's rights back into mainstream political consideration.

Further Reading: Baron, ed., *Soul of America;* Cushman, *Cases in Constitutional Law;* Davis, *Moving the Mountain;* Evans, *Born for Liberty;* Hole and Levine, *Rebirth of Feminism;* President's Commission on the Status of Women, *American Women.*

President's Committee on Recent Social Trends

Created by President Herbert Hoover, the President's Committee on Recent Social Trends issued a report that claimed, among other things, that women worked for "pin money" and not in order to support themselves and/or their families.

As the author of the report, Ralph G. Hurlin, explained it, women sought employment "as only semi-casuals, seeking pin-money, commonly receiving subsidies" from other members of their families. Such a view of women's motivation for working enabled employers to justify the meager wages and lack of advancement offered to women. The Women's Bureau refuted the theory with studies indicating that in the 1920s, 90 percent of employed women applied their wages toward the actual support of their families and themselves; 25 percent of employed women were primary wage earners in a family unit; and 66 percent of single employed women contributed their wages toward household support. Women's Bureau president Mary Anderson summed up her view of Hurlin's theory as follows: "a woman's so-called pin money is often the family coupling pin, the only means of holding the family together and making ends meet."

Further Reading: Chafe, *American Woman.*

President's Interagency Council on Women

(1995)

Established by President Bill Clinton in August 1995, just prior to the U.N. Fourth World Conference on Women, the President's Interagency Council on Women is charged with implementing the "BEIJING DECLARATION AND PLATFORM FOR ACTION" adopted by delegates to that convention. Composed of ranking members of each federal agency, it is currently chaired by Secretary of State Madeleine ALBRIGHT. Hillary Rodham CLINTON has served as honorary chair since the council's inception.

Further Reading: *Houston Chronicle,* October 12, 1995; President's Interagency Council on Women, available on-line: http://secretary.state.gov.www.picw/index.html.

President's Task Force on Women's Rights and Responsibilities

Established by President Richard Nixon in September 1969 and publicly announced on October 1, the President's Task Force on Women's Rights and Responsibilities met in secret to produce its controversial report, "A Matter of Simple Justice." Virginia R. Alan, a business-woman and past president of the Business and Professional Women's Club, served as chairperson. Its twelve other members (ten female, two male) included Elizabeth Athanasakos, a Municipal Court judge in Fort Lauderdale, Florida; Evelyn Cunningham, director of the Women's Unit in the Office of the Governor of New York State; Katherine B. Massenburg, chair of the Maryland Commission on the Status of Women; Sister Ann Ida Gannon, B.V.M., president of Mundelein College; and Dr. Alan Simpson, president of Vassar College.

"A Matter of Simple Justice" was delivered to President Nixon on December 15, 1969. The covering letter urged the president to use his leadership on behalf of "the more than half our citizens who are women and who are now denied their full constitutional and legal rights . . ." It stressed that "An abiding concern for home and children should not, in [women's] view, cut them off from the freedom to choose the role in society to which their interest, education, and training entitle them . . ." Echoing the NATIONAL ORGANIZATION FOR WOMEN's founders, the task force informed the president that it "recommend[ed] . . . a national commitment to basic changes that will bring women into the mainstream of American life . . ." Moreover, it warned that "Without such [basic change] . . . there is danger of accelerating militancy or the kind of deadening apathy that stills progress and inhibits creativity."

The report made specific recommendations, including passage of the EQUAL RIGHTS AMENDMENT; the release of guidelines necessary for the implementation of EXECUTIVE ORDER 11375; and the participation of the attorney general in Title VII cases and in cases charging sex discrimination under the FOURTEENTH AMENDMENT.

To the consternation of the task force and women's groups, the report was not released to the public. Pirated copies were distributed, and the *Miami Herald* published it in installments, beginning on April 22, 1970. Newspapers in other cities quickly provided their own readers with installments of the report, and charges of "suppression" and "cover-up" were made. On June 9, 1970, "A Matter of Simple Justice" was officially released to the public.

Further Reading: Hole and Levine, *Rebirth of Feminism.*

Price, Florence Beatrice Smith (1888–1953)

composer

Born Florence Beatrice Smith on April 9, 1888, in Little Rock, Arkansas, to Florence Gulliver Smith and James H. Smith, composer Florence Price was the first African-American woman to have a symphony performed by a major American orchestra.

Price's father was a dentist, the son of free African Americans, and her mother was an elementary school-teacher with a musical background. Price attended Little

Rock's black schools and was valedictorian of her class. She studied at Boston's New England Conservatory, from which she graduated in 1906. From 1906 to 1910 she taught at Shorter College in North Little Rock. She then taught at Clark University in Atlanta until her September 12, 1912, marriage to Thomas J. Price. The couple had three children, one of whom died in infancy.

Following her marriage, Price became a private music teacher while simultaneously continuing her own musical education at the American Conservatory, the Chicago Musical College, and other institutions.

Price's musical compositions began to gain attention in the 1920s. "Memories of Dixieland" won second place in *Opportunity* magazine's Holstein competition in 1925, and "In the Land of Cotton" won second place in the same competition in 1927. In 1932 Price won, among other prizes, the symphonic division's first place in the Wanamaker Prize competition. Her winning composition, Symphony in E Minor, was performed by the Chicago Symphony under the direction of Frederick Stock in 1933 at the Century of Progress Exposition. In subsequent years her Piano Concerto in F Minor was performed by the Chicago Women's Symphony and her spiritual "Songs to a Dark Virgin" and "My Soul's Been Anchored in the Lord" have been sung by Marian Anderson.

Florence Smith Price died on June 3, 1953, in Chicago.

Further Reading: Arvey, "Outstanding Achievements of Negro Composers"; Graham, "Spirituals to Symphonies"; Jackson, "Florence Beatrice Smith Price," in *Notable American Women*, ed. Sicherman et al.

Pride

Founded in 1978 and currently operating out of the United Way offices of Minneapolis, Pride—from Prostitution to Independence, Dignity, & Equality—is a support and advocacy organization dedicated to assisting women wishing to escape prostitution. Pride offers housing assistance and child protection services as well as counseling and access to its educational and job-training programs. The organization also conducts a speakers' bureau.

Susan Battles is the current coordinator for Pride.

Further Reading: Brecher and Lippitt, *Women's Information Exchange National Directory;* Brennan, ed., *Women's Information Directory.*

protective labor legislation

State laws passed during the nineteenth century to regulate the working conditions and hours of women employed outside the home, protective labor legislation was supported by one faction of the twentieth-century women's movement and condemned by another.

Nineteenth-century efforts to gain limited working hours, improved safety conditions, and a guaranteed minimum wage for both sexes were routinely ruled unconstitutional on the basis that such legislation was, as the Supreme Court declared in *Lochner v. New York,* "an illegal interference with the rights of individuals to make contracts." (This 1905 case involved a New York state law restricting bakers to ten-hour days.) Reformers from both the labor and women's movements were successful, however, in arguing that the general welfare was served by "protecting" women from occupations or conditions that might interfere with their maternal or domestic responsibilities. Thus, states passed laws restricting women to ten-hour days (Ohio passed the first such law in 1852) or employment only during daytime hours (Massachusetts passed the first of this type of law in 1890) as well as laws forbidding the employment of women in what were deemed unsuitable occupations (messenger work, mining, and taxi driving were among the jobs closed to women in various states at different times).

Protective labor legislation for women was upheld as constitutional by the Supreme Court in 1908 in *Muller v. Oregon.* That case concerned an Oregon state law restricting women employed in "mechanical establishments" such as factories to ten-hour days. Louis D. Brandeis (later to serve as a Supreme Court associate justice) successfully defended the Oregon law. Justice David J. Brewer delivered the opinion of a unanimous court: Referring to women's health as "an object of public interest and care in order to preserve the strength and vigor of the race," the decision upheld what it acknowledged were restrictions "upon her contractual powers" since they were "not imposed solely for her benefit but also largely for the benefit of all."

Muller v. Oregon ushered in a decade of protective labor legislation for women. By 1917, for example, all but nine states restricted women's hours of employment. As time went on, however, women disagreed about the benefits of such "protection." The LEAGUE OF WOMEN VOTERS, the U.S. Women's Bureau, and many other women's rights organizations opposed the EQUAL RIGHTS AMENDMENT (ERA) when it was introduced by Alice Paul and the NATIONAL WOMEN'S PARTY primarily because they feared passage of such an amendment would invalidate protective legislation. Other women, however, viewed protective legislation as an obstacle to their full participation in the workplace.

The two views of protective legislation effectively split women's rights organizations into pro- and anti-ERA factions for forty years. The FAIR LABOR STANDARDS ACT of 1938 began to improve working conditions for *all* employ-

ees and caused some women's organizations to abandon their anti-ERA stance. Finally Title VII of the CIVIL RIGHTS ACT OF 1964 prohibited sex discrimination in employment, a provision that gradually was interpreted by the federal courts as invalidating protective legislation.

Only during the late 1960s and early 1970s, with the demise of protective labor legislation, did most major women's rights organizations unite in their support of the Equal Rights Amendment.

Further Reading: Chafe, *American Woman;* Cushman, *Cases in Constitutional Law;* Davis, *Moving the Mountain;* Flexner, *Century of Struggle;* Hole and Levine, *Rebirth of Feminism;* Kessler-Harris, *Out to Work.*

Qoyawayma, Polingaysi (1892–1990) reformer of Native American education

Polingaysi Qoyawayma was born in 1892 to Hopi parents in the Oraibi village, Arizona. During the 1800s, the U.S. Bureau of Indian Affairs, frequently assisted by Christian missionaries, established boarding schools for Native American children. With the stated goal of "Americanizing" future generations, these schools took young children from their homes—often without parental consent—to teach the English language, Christian religion, and Western dress, manners, and values to them.

Qoyawayma received such an education and, when grown, refuted it in several ways. She became a teacher of Native American children and developed a curriculum that included information about Native American cultures. Moreover, she instructed her students not only in English but also in their native Hopi and Navaho. After much effort, Qoyawayma succeeded in convincing the commissioner of the Bureau of Indian Affairs, John Collier, to support this type of education for all Native American children whose families desired it. Finally, Qoyawayma conveyed her concerns to all Americans with the publication of her autobiography, *No Turning Back* (1964), which eloquently describes the pain of begin forcibly alienated from one's heritage and customs.

The Indian Child Welfare Act, passed in 1978, ended the government's ability to remove Native American children from their families without consent. Qoyawayma died in 1990.

Further Reading: Qoyawayma, *No Turning Back;* Snider, "Polingaysi Qoyawayma," in *Handbook of American Women's History,* ed. Zophy and Kavenik.

Queler, Eve (1936–) conductor

One of the twentieth century's most accomplished female conductors, Queler was born Eve Rabin on January 1, 1936, in New York City to Harriet Hirsch Rabin and Benjamin J. Rabin. Her musical training commenced with piano lessons begun at age five. At the age of twelve, she was awarded a full scholarship to the Curtis Institute of Music in Philadelphia. Queler's family could not afford other expenses involved with her attendance at the Curtis Institute; the scholarship was declined and Queler attended the High School of Music and Art in New York City, from which she graduated in 1954. She continued her education in an episodic fashion, taking classes at the City College of New York, the Manes College of Music, and Hebrew Union School of Education and Sacred Music. On December 23, 1956, she married law student Stanley N. Queler. In order to support herself and her husband, Eve Queler interrupted her own academic career to work as an opera coach and organist for several religious institutions. Upon her husband's graduation, Queler began her studies in what was then the predominantly male preserve of symphonic literature. She worked first with Carl Bamberger at Manes College, to which she had returned, and then with the Metropolitan Opera's Joseph Rosenstock.

Rosenstock, although impressed by Queller's obvious talent, predicted that a woman would have difficulty gaining acceptance as a conductor. Indeed, Queler's rise was a slow one: She joined the New York City Opera in 1958 and worked first as an audition and rehearsal pianist and then as one of the company's performing pianists, before finally becoming assistant conductor. In 1966 she conducted her first public performance, Mascagni's *Cavalleria Rusticana,* staged outdoors in Fair Lawn, New Jersey. In subsequent years she has worked with the Opera Orchestra of New York (founded by Queler in 1967, this group has performed at New York City's Carnegie Hall and Lincoln Center's Alice Tully Hall and has featured guest soloists from the Metropolitan Opera company); been associate conductor of Indiana's Fort

Wayne Philharmonic (1970–71); conductor of New York's Lake George Opera Festival (1971–72); conductor of New York City's renowned Mostly Mozart Festival (1972); conductor of London's New Philharmonia orchestra (1973); and conductor of both the Montreal and San Antonio symphonies (1975).

Queler has endured the discrimination that Rosenstock predicted, as, for example, this 1970 New York *Sunday News* summary of her abilities: "Eve Queler had the edge on all other music conductors because she's shapelier then Leonard Bernstein and has better legs than William Steinberg." However, Maestra Eve Queler also has earned the appreciation of critics such as the *New York Times'* Theodore Strongin, who described her as a "knowing and sensitive conductor." She is the first American woman to have conducted a major European orchestra; the first American woman to have become a major metropolitan orchestra's associate conductor in the United States; and the first woman to appear on the stage of New York's Philharmonic Hall, in Lincoln Center for the Performing Arts, in the capacity of conductor of a concert.

Most recently, in the spring of 1995 Queler's Opera-Orchestra of New York performed Massenet's 1881 opera *Hérodiade* at Carnegie Hall. Queler's conducting of the opera won rave reviews.

Further Reading: *Christian Science Monitor,* January 25, 1972; *Current Biography,* 1972; McHenry, ed., *Famous American Women; National Observer,* May 11, 1970; *New York Sunday News,* November 22, 1970; *Opera News,* March 18, 1972.

Quimby, Harriet (ca. 1874–1912) *pilot*

Born most probably on May 1, 1874 in either Coldwater, Michigan, or Arroyo Grande, California, Harriet Quimby became the first American woman and the second woman in the world to become a licensed airline pilot.

After receiving her education in public schools, Quimby became a journalist and worked for the San Francisco *Dramatic Review* and New York City's *Leslie's Weekly,* among other publications. In 1910 she witnessed her first air show and instantly resolved to become an aviator herself. She took lessons in Hempstead, Long Island, at the Moisant School of Aviation. On August 1, 1911, she received license no. 37 from the American branch of the Federation Aeronautique Internationale. Among her noted exploits were her October 1911 flight during the inauguration celebration for Mexico's president Francisco Madero and her April 1912 flight in which she became the first woman to fly across the English Channel.

Harriet Quimby—and a passenger—died in an airplane accident over Boston Harbor, on July 1, 1912.

Further Reading: Clark, *Almanac of American Women in the 20th Century;* McHenry, ed. *Famous American Women;* Read and Witlieb, *Book of Women's Firsts.*

Rand, Ayn (1905–1982) *writer, founder of objectivism*
Born on February 2, 1905, in St. Petersburg, Russia, Ayn Rand was the founder of the Objectivism movement and the author of *Atlas Shrugged* and other works.

Rand lived fairly comfortably in Russia until the Russian Revolution, after which her family's business was nationalized. Rand graduated from the University of Leningrad in 1924 and immigrated to the United States in 1926.

Settling in Hollywood, Rand wrote five screenplays before the *Red Pawn* was purchased in 1932. Her first play, *The Night of January 16th*—set as a murder trial, in which the audience plays the part of jury—opened in 1936 in New York City's Ambassador Theater, where it enjoyed a long run.

The first of Rand's novels, *We the Living*, also appeared in 1936. An indictment of Russian collectivism as an arrangement that violates human integrity, *We the Living* received fairly indifferent reviews. *Anthem*, Rand's second novel, was published in 1938.

The Fountainhead, published in 1943, became a best-seller and now is generally regarded as Rand's best novel. The book examines the clash of an individual's creativity with a society's collective goals as played out in the architectural career of Howard Roark.

Atlas Shrugged, published in 1957 and another best-seller, is the book that established Rand as something of a cult figure. Its female protagonist, Dagny Taggart, discovers a utopian community in a Colorado valley. Called Galt's Gulch, it is populated by people who react to the Communist guideline of "From each according to his ability, to each according to his need" by making a vow of their own: "I swear by my life and my love of it that I will never live for the sake of another man nor ask another man to live for mine."

Atlas Shrugged was Rand's last novel. Thereafter, she detailed her philosophical beliefs without the filter of fic-tion, in such books as: *For the New Intellectual* (1961), *The Virtue of Selfishness* (1965), *Capitalism: The Unknown Ideal* (1966), *Introduction to Objectivist Epistemology* (1967), and *The New Left: The Anti-Industrial Revolution* (1971). Her philosophy, which she named "Objectivism," is characterized by a "morality of rational self-interest" that negates "collectivist" activities such as charitable undertakings as "incompatible with a free society."

Ayn Rand died on March 6, 1982, in New York City.

Further Reading: *Current Biography Yearbook*, 1982; Faust, ed., *American Women Writers;* McHenry, ed., *Famous American Women; New York Times*, March 8, 1992.

Rankin, Jeannette Pickering (1880–1973)
politician, suffragist
The first woman elected to serve in the United States House of Representatives, Rankin was born on June 11, 1880, in what was then the Montana Territory, to Olive Pickering Rankin and John Rankin. Rankin attended Montana's public schools and graduated from the University of Montana in 1902.

Rankin worked as a social worker before becoming active in the women's suffrage movement. On February 2, 1911, she requested that the Montana legislature extend suffrage to women. She then aligned herself with experienced women from California, New York, and Ohio suffrage organizations. She was appointed a National American Woman Suffrage Association field secretary in 1913 and traveled to fifteen states, including her native Montana, to press for women's suffrage.

Montana's women were enfranchised in 1914. Rankin, a Republican, ran for Congress in 1916 on a platform designed to win the women's vote: She called

for child welfare legislation, Prohibition, a women's suffrage amendment to the Constitution, and "preparedness that will make for peace."

Rankin won the election and was introduced as the first female member of Congress on April 1, 1917. On April 6, just five days later, she joined fifty-six members of Congress in voting against the United States' entry into World War I.

During the war and her own first term, Rankin continued to support a federal women's suffrage amendment and legislation designed to benefit women and children. She also made an unsuccessful bid to become Montana's first female senator.

Returning to private life in 1919, Rankin became active in the National Consumers' League and the Women's International League for Peace and Freedom. She participated in the Second International Congress of Women, held in 1919 in Zurich, and lobbied her former colleagues in Congress for passage of the SHEPPARD-TOWNER bill, implementing a mother and child health program.

Rankin was reelected to the House of Representatives in 1940. During this term she opposed the military draft and government spending on armaments. She cast the only vote in opposition to a U.S. declaration of war on Japan on December 8, 1941, becoming the only member of Congress to oppose involvement in both world wars. The action ended her career in electoral politics, but not her pacifist activism: In 1967 Rankin formed the Jeannette Rankin Brigade, which opposed the Vietnam War, and organized a January 1968 demonstration in Washington, D.C.

Jeannette Rankin died in Carmel, California on May 18, 1973.

For a complete list of all the women who have served as U.S. Congressional Representatives see item 39 in the Appendix.

Further Reading: Clark, *Almanac of American Women;* Hole and Levine, *Rebirth of Feminism;* McHenry, ed., *Famous American Women;* Wilson, "Jeannette Pickering Rankin," in *Notable American Women,* ed. James, James, and Boyer.

rape

The term *rape* is currently defined in most states as engaging in sexual relations with a woman without her consent.

Rape is nothing new and has been a problem for American women from colonial times (indeed for women everywhere since the dawn of history): There are records of complaints from as early as 1768 and through the Revolutionary War that British soldiers were raping colonial American women, and George Washington on July 22,

1780, sentenced one of his own soldiers to death for raping a woman. Since this time, however, the legal definition of rape has changed in many states and even among the international community.

From the nation's establishment until the 1970s, most state rape laws covered only those situations in which (1) a man forced a woman who was not his wife into sexual intercourse through threats of bodily harm; (2) the woman physically and vigorously resisted; *and* (3) outside corroboration—usually a witness' testimony—was available. In addition, a victim's dress, behavior, or past sexual history—if considered provocative—frequently was viewed as a defense for the rapist. In the 1970s, following publication of Susan Brownmiller's *AGAINST OUR WILL: MEN, WOMEN AND RAPE* and in response to lobbying by the NATIONAL ORGANIZATION FOR WOMEN and other feminist organizations, resistance to threatened or actual bodily harm and the presence of a witness or other corroboration began to be dropped from the legal definition of rape. The marital exemption was dropped from Oregon's rape law in 1977 and, in 1978, nationally discussed when John Rideout was charged with raping his wife Greta (*People v. Rideout*). Although John Rideout was acquitted, Greta Rideout's painful testimony about her experience spurred many states to drop their own marital exemption clauses. As of 2000, all fifty states classify marital rape as a crime.

In 1978, Congress passed Rule of Evidence 412, which barred evidence concerning a woman's prior sexual history from federal courts. The argument that a woman's behavior at the time in question could justify a rape suffered a major and widely discussed blow with the New Bedford rape trial of 1984. In that case, six defendants were charged with raping a twenty-one-year-old woman in a bar. The fact that the events occurred was never seriously in doubt, since the bar's other patrons had stood by and even cheered. The outcome of the case hung largely upon whether the woman's behavior (she had entered the bar alone and engaged in flirting with some of the bar's patrons) would be construed as an adequate defense for the men charged. Following the conviction of four of the six men, a woman's dress and past sexual history were increasingly seen as inadmissible evidence in state courts.

Although rape law in general has been greatly reformed, it still varies considerably from state to state. Pennsylvania, for example, still requires "forcible compulsion" for a conviction of rape and categorizes "lack of consent" attacks as second-degree misdemeanor offenses. Wisconsin, at the other end of the spectrum, classifies as rape those cases in which a man has had intercourse with a woman without her affirmative agreement, even if he has used no force and she has raised no verbal objection.

Cases in which a woman is acquainted with or even involved in a dating relationship with the man charged with

raping her have been especially hotly debated in recent years, giving rise to two new phrases, "date rape" and "acquaintance rape." Some feminists, including Camille PAGLIA and Katie Roiphe, view the present alarmed discussion of these issues as limiting women's sexual and other freedoms. Roiphe takes issue with the growing acceptance of the idea that a woman can be raped easily without force by a man known to her. As she writes in *The Morning After: Sex, Fear and Feminism on Campus* (1993), ". . . viewing rape as encompassing more than the use or threat of physical violence to coerce someone into sex . . . reinforce[s] traditional views about the fragility of the female body and will. Today's definition of date or acquaintance rape stretches beyond acts of violence or physical force . . . even verbal coercion or manipulation constitutes rape." While she makes it clear that she finds rape a "terrible thing," she also sees many current charges of date rape as relying too much on subjective interpretation. "There is," she insists, "a gray area in which someone's rape may be another person's bad night." Linda A. Fairstein, assistant district attorney in New York County and the director of its Sex Crimes Prosecution Unit, has another view.

As Fairstein writes in *Sexual Violence: Our War Against Rape* (1993), "It *is* real rape. And to the many millions of women who have been victimized by a known, trusted assailant, it is every bit as traumatic as an attack by a stranger." Despite the current controversy over date or acquaintance rape and the difficulty of securing convictions in such cases, most states, in Fairstein's words, view "stranger and acquaintance rape [as] legally equal in terms of the seriousness of their criminality."

The VIOLENCE AGAINST WOMEN ACT, among other things, classified rape as a civil rights violation in the United States and gave women the right to sue attackers in federal courts, but a Supreme Court ruling in May 2000 invalidated that provision. In 1998, rape was classified as a war crime by the International War Crimes Tribunal prosecuting war crimes in Bosnia.

Further Reading: Brownmiller, *Against Our Will;* Cullen-DuPont, "New Bedford Rape Trial," in *Great American Trials,* ed. Knappman; "Date Rape: The Story of an Epidemic and Those Who Deny It," *Ms.,* October 1985; Fairstein, *Sexual Violence;* Fox-Genovese, *Feminism Without Illusions;* Lewin, "Courts Struggle Over How Much Force It Takes to Be a Rape"; "A New Recognition of the Realities of Date Rape," *New York Times,* October 23, 1985 and June 16, 1998; Roiphe, *The Morning After: Sex, Fear and Feminism on Campus.*

Redstockings

A radical feminist organization, Redstockings was founded by Shulamith Firestone, Kathie Sarachild, and Ellen Willis in New York City in January 1969. During the first suffrage wave of feminism women often were mocked as "Bluestockings" by their detractors, a term adopted as slang in the eighteenth century to connote a woman with intellectual or literary interests. In taking the name "Redstockings," Firestone, Sarachild, Willis, and the organization's other members intended to honor their feminist forebears while adding the "red of revolution."

In 1969 the New York State legislature scheduled a panel composed of one nun and fourteen men to testify at a hearing on proposed abortion law reform. Sarachild interrupted the proceedings and asked to testify, declaring that only women who had experienced illegal abortions were qualified to speak on the subject. When permission to speak was denied, Redstockings organized a public abortion speakout at a sympathetic local church. With 300 witnesses and much of the media in attendance, twelve women made public their own personal experiences with unwanted pregnancies and abortion. Over the next several decades, the speakout tactic was used to prompt public discussion of other once-taboo issues such as sexual harassment and rape.

Redstockings and its members promulgated what became the first classics of this period of feminism, including "Resistances to Consciousness," "The Personal Is Political," "The Pro-Woman Line," "The Politics of Housework," and the "Redstockings Manifesto."

Among "Resistances to Consciousness," author Irene Peliskis lists "Thinking that individual solutions are possible, that we don't need solidarity and a revolution for our liberation," along with "Thinking that women's liberation is therapy . . . This impl[ies] that when women get together to study and analyze their experience it means they are sick but when Chinese peasants or Guatemalan guerrillas get together and use identical methods they are revolutionary" and "Thinking that only institutions oppress women as opposed to other people. This implies that you have not identified your enemy, for institutions are only a tool of the oppressor. When the oppressor is stopped he can no longer maintain his tools and they are rendered useless."

In "The Politics of Housework" (1968, revised 1970), Pat Mainardi describes a "dialogue that's been going on for years" and offers translations of "some of the high points" of male argument. For example,

> *"We used to be so happy."* (Said whenever it was his turn to do something.)
> MEANING [the man] used to be so happy.
> *"We have different standards, and why should I have to work to your standards? That's unfair."*
> MEANING If I begin to get bugged by the dirt and crap I will say, "This place sure is a sty" or "how can anyone live like this?" and wait for your reaction. I know that all women have a sore called "guilt over a

messy house" or "Household work is ultimately my responsibility." I know that men have caused that sore—if anyone visits and the place is a sty, they're not going to say, "He sure is a lousy housekeeper." You'll take the rap in any case. I can outwait you.

ALSO MEANING I can provoke innumerable scenes over the housework issue. Eventually doing all the housework yourself will be less painful to you than trying to get me to do half. Or I'll suggest we get a maid. She will do my share of the work. You will do yours. It's women's work.

The "Redstockings Manifesto," issued on July 7, 1969, in New York City, declared in part that

Because we have lived so intimately with our oppressors, in isolation from each other, we have been kept from seeing our personal suffering as a political condition. This creates the illusion that a woman's relationship with her man is a matter of interplay between two unique personalities, and can be worked out individually. In reality, every such relationship is a *class* relationship, and the conflicts between individual men and women are *political* conflicts that can only be solved collectively.

The original Redstockings disbanded by 1971.

Further Reading: Davis, *Moving the Mountain;* Hole and Levine, *Rebirth of Feminism;* Morgan, *Going Too Far;* Tanner, ed., *Voices from Women's Liberation.*

Reed v. Reed (1971)

The Supreme Court decision in this case in 1971 found, for the first time, sex discrimination to be a violation of the Fourteenth Amendment's equal protection clause.

The Fourteenth Amendment was proposed on June 13, 1866, and ratified on July 28, 1868. Section 2 penalized states that failed to enfranchise all male citizens over the age of twenty-one and was intended to make the ballot available to African-American males. Its wording pointedly excluded women and defined "voters" and "citizens" as "male." This marked the first introduction of gender into the Constitution, and women's rights leaders split over whether to support this—and, later, the Fifteenth—amendment. (See AMERICAN EQUAL RIGHTS ASSOCIATION, FIFTEENTH AMENDMENT, and FOURTEENTH AMENDMENT for further discussion.)

After ratification of the Fourteenth Amendment, women's rights leaders turned their attention to the amendment's Section 1, which stated:

All persons born or naturalized in the United States, and subject to the jurisdiction thereof, are citizens of the United States and of the State wherein they reside. No State shall make or enforce any law which shall abridge the privileges or immunities of citizens of the United States; nor shall any State deprive any person of life, liberty, or property, without due process of law; nor deny to any person within its jurisdiction the equal protection of the laws.

As attorney Francis Minor, husband of Virginia MINOR (president of the Woman Suffrage Association of Missouri), pointed out, women were not excluded from this clause. For almost one hundred years after the amendment's adoption, however, the Supreme Court refused to extend the clause's protection to women. In the 1873 decision *BRADWELL V. ILLINOIS,* the Court refused to overturn an Illinois state law barring women from the practice of law in its state courts. In a sweeping opinion, the Court found that "the right of females to pursue any lawful employment for a livelihood (the practice of law included)" was not "one of the privileges and immunities of women as citizens." The following year Virginia Minor, citing Section 1 of the Fourteenth Amendment, sued a St. Louis registrar who refused to let her vote. When *MINOR V. HAPPERSETT* reached the Supreme Court, the opinion was unanimous: Women were citizens of the United States, but the right of suffrage was not one of privileges and immunities of citizenship; therefore, states need not extend suffrage to their female citizens.

Sally Reed fared better in the last third of the twentieth century. When Reed's son died intestate, both Sally Reed and her estranged husband, Cecil Reed, petitioned to become administrators of their child's estate. Pursuant to Idaho state law, Cecil Reed was appointed automatically because of his sex, and Sally Reed lost the privilege automatically because of hers. (The Idaho law gave preference to men but did not entirely exclude women; Sally Reed would have been considered a qualified administrator in the absence of a competing man.)

Sally Reed sued. Attorney and constitutional scholar Ruth Bader GINSBURG was part of the legal team assembled by the American Civil Liberties Union to press Reed's claim. When the Idaho Supreme Court decided that Reed's Fourteenth Amendment rights had not been violated, Sally Reed appealed.

Chief Justice Warren E. Burger, delivering the opinion of the Supreme Court, stated that "We have concluded that the arbitrary preference established in favor of males by the Idaho Code cannot stand in the face of the Fourteenth Amendment's command that no State deny the equal protection of the laws to any person within its jurisdiction." This decision marked the beginning of the Court's acceptance of the applicability of the Fourteenth Amendment to women and their rights.

Further Reading: Cary and Peratis, *Woman and the Law;* Davis, *Moving the Mountain.*

Reno, Janet (1938–) *attorney general*
Born on July 21, 1938, in Miami, Florida, to Jane Wood Reno and Henry Reno, Janet Reno in 1993 became the first female United States attorney general and the longest-tenured attorney general of the twentieth century.

Reno's childhood home was constructed of cypress logs on a 21-acre wooded plot in Dade County by her mother. (Forty-three years and a number of hurricanes later, it still stands.) Described at the time of her nomination by Miami Beach mayor Seymour Gelber as "an outdoorswoman who is at home with nature," Reno grew up surrounded by peacocks, cows, goats, geese, and ponies, and alligators, which her mother wrestled. All of the women in her mother's family provided strong role models: Her aunt Daisy Wood was among the nurses who landed in North Africa during General George Patton's World War II march on Italy, her aunt Winnie was a member of the World War II Women's Air Force Service Pilots (see MILITARY SERVICE, AMERICAN WOMEN AND), and her mother was an investigative reporter who, in the 1950s, testified before a Senate committee about her undercover research into black-market baby sales. Reno's father was a police reporter at the *Miami Herald*. When Reno graduated from Cornell University, both of her parents encouraged her plans to attend Harvard Law School.

Reno received her J.D. from Harvard in 1963. She had been one of only fifteen women in the class of 500 and faced difficulty finding a job. After she was rejected as a summer clerk at one law firm, she later recalled, "I was . . . told by a partner who'd been very supportive that it was because I was a woman." She became a partner in that very same firm fourteen years later.

Reno lost a 1972 race for the Florida Legislature but was invited to assist with court reform and a revision of the judicial code in the state capital, Tallahassee. In 1978 she was appointed Florida State Attorney. During her fifteen years' service as Florida's chief prosecutor, Reno developed a reputation for the thorough prosecution of child abusers and for her strong advocacy of disadvantaged children, whom she saw as being at risk for future criminal behavior. She also attracted national attention for her office's successful prosecution of William Lozano, a police officer who allegedly killed two African-American men in 1989, prompting riots in Miami. (To Reno's disappointment, the conviction later was overturned.)

Reno was nominated as U.S. attorney on February 11, 1993, and she assumed office on March 12, 1993, having been unanimously confirmed by the Senate.

Her tenure has been marked with controversy. In 1993, the federal government tried to end a 51-day standoff at the Branch Davidian compound in Waco, Texas. Under Reno's direction, federal agents moved in, and the fire that ensued killed eighty people, including twenty-four children, all members of a fringe Christian sect the FBI believed was stockpiling weapons. Reno took responsibility for the tragedy but claimed nothing the federal agents had done could have caused the fire. Documents that surfaced during the summer of 1999 indicate, however, that the agents used flammable tear gas in their assault.

The Justice Department's handling of events at Waco is currently being investigated by a five-member Senate task force, as are two other issues: China's alleged theft of nuclear secrets through espionage at U.S. weapons laboratories and the plea bargains of several 1996 Clinton-Gore campaign contributors charged with illegal fund-raising activities.

Less often reported are Reno's efforts to implement the VIOLENCE AGAINST WOMEN ACT; her work to expand ANTISTALKING LEGISLATION; her support for the Brady gun-conrol law and assault weapons ban; and her support for affirmative action.

As the year 2000 began Janet Reno was overseeing a Justice Department antitrust suit against the Microsoft Corporation and the dispute over custody of the Cuban child, Elián Gonzalez. Reno's decision to have Elián taken by force from his Miami relatives in April 2000 sparked great controversy.

Reno was one of the inductees for the year 2000 into the NATIONAL WOMEN'S HALL OF FAME.

Further Reading: Associated Press, November 13, 1997, and June 25, 1999; Bendavid, "Keeping a High Profile"; Berke, "Clinton Picks Miami Woman"; Boyer, "Senate Panel to Probe Justice Department"; Cloud, "Standing Tall"; Gibbs, "Truth, Justice, and the Reno Way"; Gordon, "Will She Be a Force for Change?"; *New York Times*, December 8, 1995; Reno, interview with Elaine Shannon; Rother, "Tough 'Front-Line Warrior'"; *St. Louis Post-Dispatch*, November 28, 1999.

Revolution, The
A six-page women's rights newspaper published in New York City by Elizabeth Cady STANTON, Susan B. ANTHONY, and Pillsbury Parker, its first issue appeared on January 8, 1868.

The newspaper caused controversy even prior to its publication. In 1867 Kansas held a state referendum to allow its voters to decide whether women, African-American males, or both, should be granted suffrage. Stanton and Anthony campaigned for women's suffrage in Kansas and were joined by George Francis Train, a wealthy Democrat who supported women's suffrage but opposed the enfranchisement of male African Americans. Train was criticized for his racist, even pro-slavery, views—and remarked upon for his wildly theatrical style—by

abolitionists, Republicans, and members of the AMERICAN EQUAL RIGHTS ASSOCIATION, some of whom actually were responsible for his appearance in Kansas. As Train provided the financial backing for the newspaper, many in the reform community condemned the *Revolution* outright.

Anthony was the *Revolution*'s proprietor, and Stanton and Parker were its editors. The newspaper was published weekly; at its height, it was read at the White House and by 3,000 other subscribers. For $2.00 a year, these subscribers received a weekly, undiluted dose of Stanton's and Anthony's views, including their opposition to the FOURTEENTH and FIFTEENTH AMENDMENTS. After Stanton and Anthony's founding of the NATIONAL WOMAN SUFFRAGE ASSOCIATION (NWSA), the paper just as enthusiastically reported on and endorsed that organization's activities and positions.

Its motto was uncompromising: "Men, their rights, and nothing more; women, their rights, and nothing less!" Stanton wrote most of the women's rights editorials and articles during the newspaper's first year, but she later was joined by such other writers and commentators as Lillie Devereaux Blake, Mary Clemmer, Phoebe and Alice Cary, and Celia Burleigh. Pillsbury Parker wrote about national politics, and George Train (until he was arrested and imprisoned in England for his support of the Irish rebellion) contributed a page of eclectic opinions. There was also a section devoted to Wall Street activities written by David Melliss, the *New York World*'s financial editor and Train's friend.

The *Revolution* was published during a time of abolitionist equivocation with regard to women's rights, and it ridiculed and denounced former friends of the movement without hesitation. For example, the abolitionist William Lloyd Garrison found his private correspondence with Anthony—in which he had complained about her relationship with Train—published and lampooned in the *Revolution*. (Garrison, as editor of *The Liberator*, often had published the private correspondence of his opponents, but he found Anthony's and Stanton's use of the strategy offensive.) Stanton's own cousin, the abolitionist Gerrit Smith, fared no better when he refused to oppose passage of the Fifteenth Amendment. As Stanton wrote to his daughter, Elizabeth Smith Miller, "your father refuses to sign our petition. I am dissecting him in the next *Revolution*."

The *Revolution* also investigated hiring and employment discrimination against women; explored the organizing efforts of women laundry workers, tailors, and typesetters; printed notices for women's clubs; endorsed and reported changes in divorce law beneficial to women; applauded women who entered traditionally male fields of employment; criticized the view of women enshrined in America's dominant religions; championed the right of female criminals to appear before juries containing women; and advocated women's suffrage.

Editors of other newspapers, such as Horace Greeley of the *New York Tribune* and Wendell Phillips, Garrison's successor as editor of *The Liberator*, largely ignored the *Revolution* and refused to print its notices. More damaging to the health of the newspaper was the absence of financial benefactors: Many reformers claimed they were unwilling to support the paper because Train was associated with it, but few of these reformers contributed once Train's relationship with the paper came to an end. Stanton's refusal to accept advertising for what she considered "quack cures" and dangerous abortifacients also contributed to the paper's financial difficulties. When fiscal matters became particularly precarious, David Melliss invested $7,000 and Anthony's cousin, Anson Lapham, loaned her $4,000. Stanton worked without a salary, and Pillsbury Parker received only a nominal one. Nonetheless, Stanton and Anthony could not keep the paper afloat.

In May 1870 Susan B. Anthony personally assumed liability for all of the *Revolution*'s debts. Laura Curtis Bullard became the proprietor of the newly unencumbered paper and paid $1.00 for the privilege. The *Revolution*'s motto was changed to "What God has joined together, let no man put asunder." Stanton, Anthony, and Parker were asked to leave, and the *Revolution* became a literary and society journal under the editorship of Paulina Wright Davis and her successor, Theodore Tilton. It survived in this guise for one and half years and was then absorbed into the *New York Christian Enquirer*. Susan B. Anthony struggled for six years, to finally repay—with interest—the $10,000 debt accrued by the newspaper during her proprietorship.

Further Reading: Flexner, *Century of Struggle;* Griffith, *In Her Own Right;* Barry, *Susan B. Anthony;* Harper, *Susan B. Anthony,* Stanton, Anthony, and Gage, eds., *History of Woman Suffrage,* vol. 2.

Rich, Adrienne Cecile (1929–) *writer*

Born on May 16, 1929, in Baltimore, Maryland, to Helen Jones Rich and Arnold Rice Rich, Adrienne Rich is an award-winning poet who has refused to separate her art from her politics.

Rich graduated from Radcliffe College in 1951 and married Alfred Haskell Conrad in 1953. The couple, who had three children, divorced after thirteen years. Conrad later committed suicide, an event Rich explored in her poem "From a survivor." Since 1976 Rich has lived with her partner, the writer and historian Michelle Cliff.

In 1951 Rich's first volume of poetry, *A Change of World,* was selected by W. H. Auden as the winner of the Yale Younger Poets Award. These poems, written before the emergence of the modern women's movement, were described by Auden in his preface as poems that are "neatly and modestly dressed, speak quietly but do not

mumble, respect their elders but are not cowed by them, and do not tell fibs." Rich's second volume, *The Diamond Cutters,* was published in 1955.

It was *Snapshots of a Daughter-in-Law* (1963) that marked the change in direction of Rich's work. Containing poems such as "A Marriage in the 'Sixties" and the poem of the title, *Snapshots* explored the painfully wasted potential of women's lives. Reviewers who had previously praised Rich now recoiled.

The negative criticism was replaced with critical acclaim during the course of Rich's career. Subsequent volumes of poetry include *Focus* (1966), *Necessities of Life* (1966), *Diving into the Wreck: Poems, 1971–1972* (1973), *Poems: Selected and New, 1950–1974* (1974), *The Dream of a Common Language: Poems, 1974–1977* (1978), *A Wild Patience Has Taken Me This Far: Poems, 1978–1981* (1981), *The Fact of a Doorframe* (1984), *Your Native Land, Your Life* (1986); and *Midnight Salvage: Poems 1995–1998.*

The work in these volumes is characterized by an elegant strength and clarity, and it has won Rich many honors, including the National Book Award of 1974. (She refused to accept this prestigious award for herself but, accompanied by poet Audre Lorde, accepted it on behalf of all women and donated the financial part of the award to charity.)

Rich also has addressed the intertwined political and personal concerns of women in several nonfiction works, including *Of Woman Born: Motherhood as Experience and Institution* (1976), *On Lies, Secrets and Silence: Selected Prose, 1966–1978* (1979), *Blood, Bread and Poetry: Selected Prose, 1979–1986.* (1986); and *What is Found There: Notebooks on Poetry and Politics* (1993).

Adrienne Rich currently lives in California.

Further Reading: Cooper, *Reading Adrienne Rich; Current Biography Yearbook,* 1976; Keyes, *Aesthetics of Power;* Faust, ed., *American Women Writers;* Rich, *A Change of World;* ———, *The Diamond Cutters and Other Poems;* ———, *Snapshots of a Daughter-in-Law;* ———, *Necessities of Life;* ———, *A Wild Patience Has Taken Me This Far;* ———, *Diving Into the Wreck;* ———, *Poems;* ———, *Of Woman Born;* ———, *On Lies, Secrets, and Silence;* ———, *Fact of a Doorframe;* ———, *Your Native Land, Your Life;* ———, *Blood, Bread, and Poetry;* ———, *Midnight Salvage;* ———, *What is Found There.*

Ride, Sally Kristen (1951–) *astronaut*
Born on May 26, 1951, in Encino, California, to Joyce Ride and Dale B. Ride, Sally Ride became the first American woman and the third woman in the world to fly in space.

As a young girl, Ride focused more intently on athletics than academics and was ranked eighteenth on the junior tennis circuit. Her strong tennis game won her a partial scholarship to the private Westlake School for Girls. Ride credits her junior-year physiology teacher, Dr. Elizabeth Mommaerts, with instilling in her a love of the sciences. No longer a lackluster student, Ride now excelled in both her studies and her tennis career. Upon her 1968 graduation from Westlake, she had difficulty choosing a direction for her life. She attended Swarthmore College in Pennsylvania, majoring in physics, but dropped out in her sophomore year to become a professional player. Then, while training for a professional tennis career, she attended physics class at the University of California. In 1970 Ride—ignoring champion Billie Jean King's advice to pursue her tennis career—entered Stanford University. She received both a B.A. and a B.S. in 1973. Ride did her graduate work in astrophysics, receiving her Ph.D. from Stanford in 1978, after joining the National Aeronautics and Space Administration (NASA). She and John Hawley, an astronomer and fellow astronaut, were married on July 26, 1982. They later divorced.

Ride applied to NASA on impulse and was surprised to become one of five women to join the astronaut class of 1978. In 1982 navy captain Robert Crippen announced that he had chosen Ride as part of the crew for the seventh scheduled shuttle mission. In response to the intense publicity, Ride announced that while she understood the symbolic importance of the event, "I didn't come into the space program to be the first woman in space. I came in to get a chance to fly as soon as I could."

When the space shuttle *Challenger* lifted off at 7:33 A.M. (EST) on June 18, 1983, from Cape Canaveral, Florida, Dr. Sally Ride—mission specialist and flight engineer—was part of the team, making history and, in her own words, having "the most fun I'll ever have in my life." She was part of another *Challenger* crew in October 1984.

Ride was slated to make her third flight when the *Challenger* exploded in January, 1986, and future missions were put on hold. She was then made a member of the Rogers Commission, established to investigate the disaster and make recommendations. Ride was particularly adamant that astronauts should be involved in NASA's management; afterward, Robert Crippen became the deputy director for space shuttle operations.

To date, twenty-seven American women have followed Sally Ride into space, including EILEEN COLLINS, the first woman to pilot and command a space shuttle; Shannon Lucid, who in 1996 set a record with her six-month stint aboard the Russian space station *Mir;* and Mae Jemison, who in 1992 became the first black woman in space. Christa McAuliffe, an American teacher selected to go to space and bring the experience into the classroom,

died on the *Challenger* in 1986, as did Judith Resnik, who had been America's second woman in orbit.

Ride left NASA in 1987 and joined Stanford's Center for International Security and Arms Control. In 1989, she became director of the California Space Institute and a physics professor at the University of California at San Diego. She currently lives in California.

Further Reading: *Current Biography Yearbook,* 1983; Dunn, "From One Woman to Another"; *Encyclopedia of World Biography; Ms.* magazine, January 1983; *Newsweek,* June 13, 1983; *New York Times,* June 19, 1983; *Time* magazine, June 13, 1983.

Roberts v. U.S. Jaycees

The 1984 Supreme Court decision in this case upheld a Minnesota law requiring that the Jaycees, a business organization originally open to men age eighteen to thirty-five without any other criteria, admit women to full voting membership.

The Minnesota state court ruled that the Jaycees, as a non-selective organization, fitted the description of a "place of public accommodation" in the state's civil rights law and had to admit women. The Jaycees appealed to the Supreme Court, arguing that their First Amendment rights of free association and freedom of expression had been abridged. The Supreme Court agreed with the Minnesota state court that the Jaycees, in accepting any male member of a certain age, was more a "place of public accommodation" than an organization enlisting careful selection according to its freedom of association rights. However, the Jaycees also argued that the message conveyed by the organization would be changed if women were admitted and that this would violate the male members' guarantee of freedom of expression under the First Amendment. The Court found that any "incidental abridgement" of this right was justified by the state's compelling interest in ending discrimination against women. Justice Sandra Day O'CONNOR wrote a separate opinion on this point, stating that the Jaycees were a business organization and not "an expressive association," and that this made the freedom of expression question an irrelevant one in this case.

Roberts v. U.S. Jaycees, together with a similar case, *BOARD OF DIRECTORS OF ROTARY INTERNATIONAL V. ROTARY CLUB OF DUARTE* (1987), prompted other all-male associations, including the Lions and Kiwanis clubs, to admit women.

Further Reading: O'Connor, "Women and the Constitution," in *Women, Politics and the Constitution,* ed. Lynn; *Roberts v. Jaycees,* 1984. 468 U.S. 609.

Rochester Convention, The

The second women's rights convention in the United States, it was held August 2, 1848, just two weeks after the SENECA FALLS CONVENTION.

Unlike that first convention, and over the objections of Elizabeth Cady STANTON and Lucretia MOTT, the Rochester Convention was presided over by a woman, Abigail Bush. Women did not lead "promiscuous" meetings in the first half of the nineteenth century, and Bush, in doing so, deeply felt the break with custom. The history of this prohibition against women speaking in public was also discussed during the meeting and the Pastoral Letter of the General Association of Massachusetts (Orthodox) to the Churches under Their Care, issued by Boston clergy in an attempt to silence the GRIMKÉ sisters, was refuted. By the end of the meeting Stanton and Mott agreed that women should conduct their own meetings. Mott embraced a relieved Bush at the convention's end, and, as Bush later recalled, "my strength seemed to leave me and I cried like a baby."

The concerns of wage-earning women also were addressed at this meeting. A Mrs. Roberts (first name unknown) had been asked to invite the working-class women in the area and also to prepare a report regarding women's working conditions and wages. Seamstresses, she reported, made only "from 31 to 38 cents a day, and board from $1.25 to $1.50 per week to be deducted therefrom, and they were generally obliged to take half or more in due bills, which were payable in goods at certain stores, thereby obliging them many times to pay extortionate prices."

Other wage-earning women were hailed as role models: Elizabeth BLACKWELL, enrolled that year in a medical college, was pronounced a "pioneer for woman," and Mrs. Gifford (first name unknown), a Rochester woman engaged in "the mercantile business," was held up as "a noble example" of a woman "mak[ing] for herself an independent living."

Since the Rochester Convention was held after the Seneca Falls Convention and because of the largely negative publicity that had followed, the convention drew many opponents of the new movement. A number of men in the audience had come to discuss what they believed would be the impossibility of marriage if the woman's movement achieved its goals. A Mr. Pickard (first name unknown) "asked who, after marriage, should hold the property, and whose name should be retained. He thought an umpire necessary. He did not see but all business must cease until the consent of both parties be obtained. He saw an impossibility of introducing such rules into society . . ."

Despite the disruptive presence of others with Mr. Pickard's views, the DECLARATION OF RIGHTS AND SENTIMENTS was adopted at the Rochester Convention. Sep-

arate resolutions were drafted, discussed, and adopted as well. They included a resolution to petition the state legislature annually until women's suffrage was granted; a denunciation of the practice of taxing women without granting them representation; a denouncement of inheritance laws applicable to husbands but not to wives; a pledge to convince women "no longer to promise obedience in the marriage covenant"; a statement that "those who believe the laboring classes of women are oppressed ought to do all in their power to raise their wages, beginning with their own household servants"; and a declaration that "it is the duty of woman, whatever her complexion, to assume, as soon as possible, her true position of equality in the social circle, the Church, and the State."

Further Reading: Barry, *Susan B. Anthony;* Frost and Cullen-DuPont, *Women's Suffrage in America;* Stanton, Anthony, Gage, eds., *History of Woman Suffrage,* vol. 1.

Roe v. Wade (1973)

The Supreme Court's decision in *Roe v. Wade* guaranteed a woman's right to an abortion during the first trimester of pregnancy and permitted government regulation of second-trimester abortions only in the interest of a pregnant woman's health.

The class-action suit was brought in 1969 by Norma McCorvey (under the alias "Jane Roe") on behalf of herself and all pregnant women against Texas district attorney Henry B. Wade. McCorvey and her attorneys, Linda Coffee and Sarah Weddington, charged that Texas' 1859 antiabortion law—which permitted abortion only in order to save a woman's life—was unconstitutional. Coffee and Weddington based their argument partly on the FOURTEENTH AMENDMENT's due process clause. This clause guarantees all citizens equal protection under the law and also requires that laws be clearly written. When physicians were charged with performing illegal abortions, they usually claimed that laws outlawing abortions except to preserve the life of the mother were too vague to be interpreted with certainty and, thus, violated the Fourteenth Amendment. However, since Coffee and Weddington were interested in asserting a woman's inviolable right to make her own decision about a pregnancy, they based their argument primarily on the Ninth Amendment, which states that "[t]he enumeration in the Constitution, of certain rights, shall not be construed to deny or disparage others retained by the people."

For most of the country's history, the courts had interpreted this as granting to the states any rights that the Constitution did not award specifically to the federal government. In 1965, however, Justice William O. Douglas' decision in the GRISWOLD V. CONNECTICUT birth control case had stated clearly that *the people* (rather than the states) retained all rights not specifically enumerated in the Constitution and that the right to privacy was one such right.

Coffee and Weddington argued that this right to privacy should protect a woman's right to make her own decision about whether to continue a pregnancy and become a mother. The state's position, as it was summarized for the Fifth Circuit Court by Wade's attorney, John Tolles, was "that the right of a child to life is superior to that woman's right to privacy." The Fifth Circuit Court issued its decision in favor of Roe on June 17, 1970: "On the merits, plaintiffs argue as the principal contention that the Texas abortion laws must be declared unconstitutional because they deprive single women and married couples, of their right, secured by the Ninth Amendment, to choose whether or not to have children. We agree."

While the Fifth Circuit Court declared the Texas anti-abortion law unconstitutional, it did not order Texas to cease enforcing the law. This enabled Coffee and Weddington to appeal immediately to the U.S. Supreme Court, which agreed to hear their case.

Forty-two organizations, ranging from the American College of Gynecologists and Obstetricians and the New York Academy of Medicine to PLANNED PARENTHOOD and the California chapter of the NATIONAL ORGANIZATION FOR WOMEN, filed *amicus curiae* ("friend of the court") briefs in support of a woman's right to end her pregnancy. Moreover, women as prominent as feminist theologian Mary Daly, Barnard College president Millicent McIntosh, anthropologist Margaret Mead, and former U.S. senator from Oregon Maurine Neuberger joined in the signing of a "woman's brief." This document set forth the position, as author Marian Faux summarizes it, "that even if a fetus were found to be a legal person, a woman still could not be compelled to nurture it in her body against her will."

On January 22, 1973, Justice Harry Blackmun's majority opinion was read aloud. In his opening sentences, Blackmun acknowledged that there were vast differences of opinion on the subject of abortion. He next outlined the history of U.S. abortion practices and law, emphasizing that abortion had not always been against the law and that antiabortion laws seemed to have been enacted primarily to safeguard women from a procedure that was, given nineteenth-century medical techniques and standards, notoriously unsafe. That basis for antiabortion laws was no longer sound, Justice Blackmun declared, because twentieth-century medical advances had made abortion as safe as or safer than childbirth.

Next, Blackmun reviewed the High Court's recognition of a "right of personal privacy" in several of its decisions, including *Griswold*. This formed the crux of the

decision: "This right of privacy, whether it be founded in the Fourteenth Amendment's concept of personal liberty and restrictions on state action . . . or . . . in the Ninth Amendment's reservation of rights to the people, is broad enough to encompass a woman's decision to terminate her pregnancy." Blackmun then specifically refuted Texas' contention that it was entitled to "infringe Roe's rights" in order to protect "prenatal life":

> Texas urges that apart from the Fourteenth Amendment, life begins at conception and is present throughout pregnancy, and that, therefore, the State has a compelling interest in protecting that life from and after conception. We need not resolve the difficult question of when life begins . . .
>
> It should be sufficient to note briefly the wide divergence of thinking on this most sensitive and difficult question. There has always been strong support for the view that life does not begin until live birth. This was the belief of the Stoics. It appears to be the predominant, though not the unanimous, attitude of the Jewish faith. It may be taken to represent also the position of a large segment of the Protestant community, insofar as can be ascertained. . . . [The Roman Catholic Church] would recognize the existence of life from the moment of conception . . . [and] as one brief *amicus* discloses, this is a view strongly held by many non-Catholics as well, and by many physicians . . .

Blackmun then pointed out that "In areas other than criminal abortion, the law has been reluctant to endorse any theory that life, as we recognize it, begins before live birth or to accord legal rights to the unborn . . ." He concluded his consideration of this question by writing "In view of all this, we do not agree that, by adopting any one theory of life, Texas may override the rights of the pregnant woman that are at stake."

A woman's right to privacy was not declared absolute, however. Blackmun continued:

> . . . the State does have an important and legitimate interest in preserving and protecting the health of the pregnant woman . . . and . . . it has still *another* important and legitimate interest in protecting the potentiality of human life. These interests are separate and distinct. Each grows in substantiality as the woman approaches term and, at a point during the pregnancy, each becomes "compelling."

Last, Blackmun's *Roe v. Wade* decision gave the states a set framework within which to balance these separate interests. Before the end of a woman's first trimester of pregnancy, the decision to grant a woman's request for an abortion would be "left to the medical judgment of the pregnant woman's attending physician." Before the end of a woman's second trimester of pregnancy, states would be permitted to "regulate the abortion procedure in ways that are reasonably related to maternal health." During the third trimester "subsequent to viability," the states would be permitted to "regulate, and even proscribe, abortion except where it is necessary, in appropriate medical judgment, for the preservation of the life or health of the mother . . ."

Justices White and Rehnquist dissented and wrote separate briefs detailing their views. Justice Rehnquist "agree[d] with the statement . . . that 'liberty' embraces more than the rights found in the Bill of Rights. But that liberty is not guaranteed absolutely against deprivation, but only against deprivation without due process of law . . ." Justice White explained his opposition to *Roe v. Wade* differently:

> At the heart of the controversy in these cases are those recurring pregnancies that pose no danger whatsoever to the life or health of the mother but are nevertheless unwanted for any one or more of a variety of reasons—convenience, family planning, economics, dislike of children, the embarrassment of illegitimacy, etc.
>
> The common claim before us is that for any such reasons, or for no reason at all . . . any woman is entitled to an abortion at her request if she is able to find a medical advisor willing to undertake the procedure.
>
> The Court for the most part sustains this position: . . . during the period prior to the time the fetus becomes viable, the Constitution of the United States values the convenience, whim or caprice of the putative mother more than the life or potential life of the fetus.

Roe v. Wade was challenged many times during the following two decades. As the Supreme Court's liberal proponents of *Roe v. Wade* retired, they were succeeded by the conservative appointees of Presidents Ronald Reagan (1981–89)—Sandra Day O'Connor (1981), Anthony Kennedy (1988); Antonin Scalia (1986)—and George Bush (1989–93)—David Souter (1990) and Clarence Thomas (1991). Even before this reconfiguration, the court ruled in *Harris v. McRae* (June 30, 1980) that the federal and state governments are not obligated to pay for welfare recipients' abortions, even in cases where such abortions are medically necessary. Decisions in which the Reagan and Bush appointees participated included *Webster v. Reproductive Health Care* (July 3, 1989), which gave states new authority to restrict abortions, and *Rust v. Sullivan* (May 21, 1991) which declared constitutional the newly imposed federal regulations that ended Title X funding to family planning facilities which provided information about abortion. But in *Planned Parenthood v. Casey* (June 29, 1992), the High Court by a vote of 5–4 declared that "the essential holding of *Roe v. Wade* should be retained and once again reaffirmed."

President Bill Clinton, elected on November 3, 1992, acted quickly on pro-choice campaign promises.

On January 22, 1993, the twentieth anniversary of the *Roe v. Wade* decision, he signed an order reversing President Reagan's 1988 ban on federal funding of research concerning medical use of fetal tissue; ordered that privately funded abortions be permitted to take place in military hospitals; restored financial aid to international organizations that offer abortion and family planning assistance; and announced a review of government policy prohibiting Americans from importing RU-486 (commonly called the French abortion pill) for their own use. He also permitted federally funded family-planning clinics to resume the dispensing of abortion-related information. Clinton described these measures as an effort to "free science and medicine from the grasp of politics"; abortion-rights advocates viewed them as signaling at least a temporary end to federal efforts to weaken or discard *Roe v. Wade*.

Further Reading: Abraham, *Judicial Process;* Cary and Peratis, *Woman and the Law;* Cushman, *Cases in Constitutional Law;* Cullen-DuPont, *"Roe v. Wade,"* in *Great American Trials,* ed. Knappman; Davis, *Moving the Mountain;* Ehrenreich and English, *For Her Own Good;* Faux, *Roe v. Wade;* Greenhouse, "Surprising Decision: Majority Issues Warning on White House Effort to Overturn Roe"; ———, "A Telling Court Opinion"; Petchesky, *Abortion and Women's Choice;* Phelps, "Abortion Rules Eased"; *Roe v. Wade,* 410 U.S. 113 (1973); Rosten, *Religions of America: Ferment and Faith in an Age of Crisis;* "The Supreme Court: Retaining the Constitutional Right to Abortion, Excerpts from the Justices' Decision in the Pennsylvania Case," *New York Times,* June 30, 1992.

Roosevelt, Eleanor (1884–1962) *first lady, reformer, diplomat, author*

Anna Eleanor Roosevelt was born on October 11, 1884, in New York City, to Anna Hall Roosevelt and Elliott Roosevelt. The niece of President Theodore Roosevelt, Eleanor Roosevelt was orphaned by the age of ten and reared by her grandmother. In 1899 she was sent to Allenswood, a girls' boarding school in England. She returned to New York two years later and made her debut, a formal entrance into society, at seventeen, after which she volunteered to work as a calisthenics and dance teacher to underprivileged children at the College Settlement in New York City's Lower East Side. In 1903 she became a member of the CONSUMERS LEAGUE and, along with "an experienced, older woman," investigated the working conditions of department stores and factories that employed women. Eleanor Roosevelt and her cousin Franklin Delano Roosevelt were married on March 17, 1905. The couple had six children.

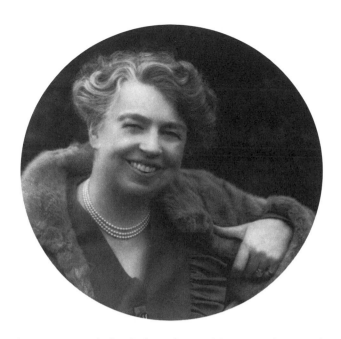

Eleanor Roosevelt, first lady and U.S. delegate to the United Nations (*Library of Congress*)

Eleanor Roosevelt worked with the Red Cross during World War I, was an active member of the LEAGUE OF WOMEN VOTERS and the Democratic party, and became an especially active member of the Women's Trade Union League, which she joined in 1922.

Franklin D. Roosevelt was elected governor of New York in 1928 and president of the United States in 1932, an office he would hold for twelve years. Throughout her tenure as first lady, Eleanor Roosevelt continued to work for improvements in the lives of women and minorities. She gave her views on women's and general political issues on her own regularly scheduled radio program and in her own syndicated newspaper column, entitled "My Day." When the Daughters of the American Revolution refused to allow the African-American opera singer Marian Anderson to sing at its Constitution Hall, Eleanor Roosevelt publicly resigned from the organization and suggested the Lincoln Memorial as a fitting site for Anderson's concert. The concert took place on Easter Sunday, 1939, and 75,000 people attended. She argued strongly for civil rights legislation and her husband's New Deal programs, both in public and in the more behind-the-scenes manner expected of first ladies. During World War II, she was an advocate for Jewish refugees and supported an increased sphere of action for women in the war effort.

After the death of Franklin D. Roosevelt, Eleanor Roosevelt was appointed U.S. delegate to the United Nations by her husband's successor, President Harry S.

Truman. There she was instrumental in the drafting of the Universal Declaration of Human Rights, which was passed by the General Assembly on December 10, 1948. In December 1961 she was appointed by President John F. Kennedy to head his Commission on the Status of Women. Although she did not live to see the commission's work completed, its final report, *American Women,* was delivered to the president on October 11, 1963—the seventy-ninth anniversary of Roosevelt's birth.

Eleanor Roosevelt died in New York City on November 7, 1962.

Further Reading: Chafe, "Anna Eleanor Roosevelt," in *Notable American Women,* ed. James, James, and Boyer; Clark, *Almanac of American Women in the 20th Century;* Cook, *Eleanor Roosevelt, Volume One;* Lash, *Eleanor and Franklin;* ———, *Eleanor;* ———, *Love, Eleanor Roosevelt and Her Friends;* McHenry, ed., *Famous American Women;* Roosevelt, *It's Up to the Women;* ———, *My Day: Her Acclaimed Columns, 1936–1945;* ———, *My Day: Her Acclaimed Columns, 1945–52; Autobiography of Eleanor Roosevelt.*

Rose, Ernestine Louise Siismondi Potowski
(1810–1892) *suffragist, reformer*
Suffragist and driving force behind the MARRIED WOMAN'S PROPERTY ACT (1848) Rose was born on January 13, 1810, to Jewish parents in Poland. By her own description, she was "a rebel at the age of five." When she was sixteen and still living in Poland, her mother died. Although the estate was left to Rose, her father promised it all to the son-in-law of his choice. Outraged, Rose sued him. The court granted Rose her inheritance and her freedom. She gave the money to her father after all, renounced her faith, and immigrated—first to Germany, then to Holland, France, and England (where she met and, in 1836, married her husband, William Ella Rose) and, finally, with her husband in 1836, to the United States.

Once in America, she was shocked by its laws concerning women. Deciding immediately to change those laws, she drew up a petition to the legislature of her new home state, New York. In 1836 she could find only five women willing to sign the petition. She added her own, for a total of six names, and sent it anyway.

In 1840 Elizabeth Cady STANTON and Paulina Wright (later Paulina Wright Davis) joined Rose in what became her annual petition drive. Petition drives continued to be held every year. Finally, on April 6, 1848, New York passed the Married Woman's Property Act, making it the first state in the nation in which a married woman could own property.

Rose attended the WORCESTER WOMAN'S RIGHTS CONVENTION of 1850 and remained active in the organized woman's rights movement during the following decades. She attended many state and national women's rights conventions and lectured throughout the country. She was instrumental in the petition drives preceding Elizabeth Cady Stanton's 1854 and 1860 addresses to the New York State Legislature. In 1860, New York passed AN ACT CONCERNING THE RIGHTS AND LIABILITIES OF HUSBAND AND WIFE, further expanding the rights she had helped to secure for married women in that state. Rose was a member of the NATIONAL WOMAN'S LOYAL LEAGUE during the Civil War and of the AMERICAN EQUAL RIGHTS ASSOCIATION afterward. She was also a founding officer of the NATIONAL WOMAN SUFFRAGE ASSOCIATION.

At the end of their lives, Ernestine and William Rose returned to England, where they had originally met. Ernestine Rose died there on August 4, 1892.

Further Reading: Flexner, *Century of Struggle;* Frost and Cullen-DuPont, *Women's Suffrage in America;* Stanton, Anthony, and Gage, eds., *History of Woman Suffrage,* vol. 1; Tyler, "Ernestine Louise Siismondi Potowski Rose," in *Notable American Woman,* ed. James, James, and Boyer.

Ross, Betsy (1752–1836) *heroine of Revolutionary War legend*
Betsy Ross was born Elizabeth Griscom on January 1, 1752, in Philadelphia, to Rebecca James Griscom and Samuel Griscom. In 1773 she married John Ross, an upholsterer. Upon her husband's death, Ross maintained the upholstery business and also began to make flags for the state of Pennsylvania. According to the story told in 1870 to an audience at the Historical Society of Pennsylvania by her grandson William Canby, Ross was visited by George Washington and several members of the Continental Congress—including an uncle of Ross' late husband—in June of 1776 or 1777. Asked to design a flag for the new nation, Ross is said to have proposed a five-point rather than the suggested six-point star, citing the ease with which a single scissor snip could create the former.

Although little evidence exists to support this tale, Betsy Ross' purported contribution to American history will likely keep its place in children's textbooks. In April 1976 the Betsy Ross Bridge—the first bridge in the United States to be named in honor of a woman—was opened, joining Pennsauken, New Jersey, and Philadelphia, Pennsylvania.

Further Reading: Cometti, "Betsy Ross," in *Notable American Women,* ed. James, James, and Boyer; McCan-

dless, "Story of the American Flag"; McHenry, ed., *Famous American Women;* Read and Witlieb, *Book of Women's Firsts;* Wilcox, "National Standards and Emblems."

RU-486 (Mifepristone)

A drug developed in France to induce abortion without surgery, RU-486 has been the cause of much controversy in the United States.

Mifepristone (RU-486's trade name), if taken during the early stages of pregnancy, stops the female body from making the preparations for pregnancy that usually follow conception. The embryo has its blood supply cut off, and the woman experiences contractions and bleeding during which the embryo is expelled. Mifepristone alone would require several weeks to accomplish the abortion; a second drug, a prostaglandin, therefore is prescribed two days after the Mifepristone in order to strengthen the contractions and end the process within a few days. In France the drug is administered to women only until the forty-ninth day of pregnancy; in England, the cutoff day is sixty-three days. The abortion is painful and necessitates up to four visits to a physician. In all but one-half of 1 percent of women, the induced bleeding is about as severe as that experienced during a heavy menstrual period, but approximately one in 500 women requires a transfusion due to extreme loss of blood and approximately six in 500 women suffer a marked drop in blood pressure.

The drug has been widely used in several countries since its 1989 introduction in France: By 1994, 150,000 to 200,000 European women and between 10,000 and 20,000 Chinese women had abortions induced by RU-486. The drug also has shown promise as a contraceptive, as a "morning-after pill" to prevent pregnancy, and in the treatment of endometriosis, breast cancer, fibroid tumors, and benign brain tumors. However, because of the bitter and well-publicized campaigns of American antiabortion organizations, Roussel Uclaf (the French patent-holder and manufacturer) feared that other products of its American subsidiary Hoechst Celanese would be boycotted if it marketed RU-486 in the United States, and the company refused to make the drug available in this country.

No one in the antichoice Reagan or Bush administrations sought to intervene on behalf of RU-486's manufacture in the United States, but President Bill Clinton and members of his administration strongly supported the importation of the drug into the country. Following a year-long campaign of administration political pressure upon the French government, negotiations among Dr. Donna E. Shalala, Clinton's secretary of health and human services, Dr. David A. Kessler, commissioner of Food and Drugs at the time, and Roussel Uclaf executives, and the strong advocacy of Representative Ron Wyden (D-OR), who threatened that the United States simply would seize the drug's patent rights, agreement began to emerge. On May 16, 1994, it was announced that Roussel Uclaf would relinquish the patent rights—and responsibility for product liability—to the Population Council, an American organization founded by John D. Rockefeller 3rd in 1952 that has since specialized in making contraceptives and family planning services available in developing countries. Clinical trials are currently under way, and the drug is expected to become more widely available in the United States in the year 2000.

Dr. Kessler has characterized RU-486 as "a safe and effective alternative to surgical abortion," but its introduction into the United States will have more than a medical impact. While the overturn of ROE V. WADE seems unlikely, OPERATION RESCUE and other antiabortion organizations have made the operation of abortion clinics increasingly difficult and the experience of entering an abortion clinic one fraught with anxiety for many women. Moreover, 83 percent of women living outside of cities (and 31 percent of women nationwide) reside in counties without abortion providers. What abortion opponents so fear—and what supporters of legalized abortion so look forward to—is the prospect that RU-486, which can be prescribed by any physician trained to deal with pregnancy and its complications, may make the abortion decision a truly private one.

Further Reading: "French Abortion Pill Will Be Tested in U.S.," *New York Times;* Hilts, "When Medical Reliability Adds Political Sensitivity"; Leary, "Maker of Abortion Pill Reaches Licensing Pact With U.S. Group"; ———, "Broader Uses Seen for Abortion Pill"; Lewin, "Plans for Abortion Pill Stalled in U.S."; Seelye, "Accord Opens Way for Abortion Pill in U.S. in Two Years"; Talbot, "The Little White Bombshell."

Sacajawea (Sacagawea) (ca. 1786–1812) *Native American interpreter, legendary guide for the Lewis and Clark expedition*

Sacajawea was born in about 1786 into the Lemhi band of the Shoshone Indians (also known as Snake Indians) in what is now Idaho.

In 1800 Sacajawea was captured by the Hidatsa Indians and sold, traded, or lost in a gamble to the French Canadian fur trader Toussaint Charbonneau, to whom she was later married. The couple, along with their two-month-old son, joined the Lewis and Clark expedition as interpreters for the North Dakota–Pacific Coast leg of the journey. Sacajawea was an invaluable member of the team, both as a sign of peaceful intent and as a speaker of several Indian languages. During a storm, she also saved "equipment and documents" and, according to some accounts, "the lives of the party." Moreover, during the course of the trip, she found her own people and discovered that her brother was now chief; due to Sacajawea's intercession, the Lemhi provided Lewis and Clark with horses, provisions, and directions. In 1806 Sacajawea guided the returning expedition through the Rocky Mountains and surrounding areas.

Her legendary role as the expedition's primary guide has been exaggerated. It was first popularized by Oregon novelist Eva Emery Dye in her 1902 novel, *The Conquest: The True Story of Lewis and Clark*. Dye later became the president of Oregon's Sacajawea Association, which commissioned a bronze statue of the Indian guide by Alice Cooper; it was unveiled following speeches by Susan B. ANTHONY, Anna Howard SHAW, and Carrie Chapman CATT in 1905.

Sacajawea died on December 20, 1812, near what is now Omaha, Nebraska. She was honored with her likeness appearing on a new United States dollar coin in the year 2000.

Further Reading: Clark and Edmonds, *Sacagawea of the Lewis and Clark Expedition;* McHenry, ed., *Famous American Women;* Harper, *History of Woman Suffrage,* vol. 6; Schultz, *Bird Woman;* Wells, "Sacajawea," in *Notable American Women,* ed. James, James, and Boyer.

St. Denis, Ruth (1879–1968) *dancer, choreographer*

Born Ruth Dennis on January 29, 1879, in New Jersey to Ruth Emma Hull Dennis and Thomas Laban Dennis, Ruth St. Denis was a cofounder of America's first major dance school.

St. Denis' mother graduated from the University of Michigan Medical School in 1872 but, following a nervous breakdown, was unable to practice medicine. Ruth Hull became pregnant with her daughter while Thomas Dennis' first marriage to another woman was unraveling; her own marriage to Thomas Dennis, begun with rushed vows in a studio at an artist's colony, was also a stormy one.

St. Denis was educated in a one-room schoolhouse in Adamsville, New Jersey. She found solace and respite from her parents' volatile relationship in play-acting and the study of dance in Somerville. In 1893, with the financial aid of relatives, St. Denis entered Dwight Moody's Northfield Seminary in Massachusetts. It was a short-lived experience: When Moody castigated St. Denis' beloved theater, St. Denis withdrew from school.

Her stage career began during the week after her fifteenth birthday, when she appeared as a dancer at Worth's Museum in New York City. For the next ten years, she participated as a dancer and actress in musical comedies and the vaudeville theater, contributing financial support to her parents (who had separated) and managing to attend to Packer Collegiate Institute in Brooklyn, New York, for one year (1896–97).

In 1904, while appearing on tour with David Belasco's *Madame DuBarry*, she saw a poster for Egypt-

ian Deities cigarettes; mesmerized by the effect of the woman posed as the goddess Isis, St. Denis began incorporating what was referred to as Oriental style in her own dance repertoire.

There were also religious influences at work during this time. St. Denis was a deeply spiritual person, drawn to mysticism. She was interested in and sympathetic to Mary Baker EDDY's Christian Science church, and she also was involved in the study of ancient religions.

On January 28, 1906, "Radha" was premiered at the New York Theater. The dance of a virginal goddess, it combined both religious mysticism and Oriental influences and launched St. Denis' career.

St. Denis toured Europe from 1906 to 1909. Returning to the United States, St. Denis found herself in demand as a teacher. Ted Shawn, a former divinity student, was one of her students; on August 13, 1914, they were married. The couple moved to Los Angeles and in 1915 founded Denishawn, the famous dance company and school in which Doris Humphrey, Martha GRAHAM, and, indeed, the art form known as modern dance would take root. Denishawn toured America during the 1920s and, in mid-decade, the Orient. A second school also was established in New York City.

Both Denishawn and the marriage of its two primary dancers ended in the early 1930s. Ruth St. Denis and Ted Shawn had an intense relationship complicated by affairs, artistic jealousies, Shawn's bisexuality, St. Denis' extreme fear of pregnancy, and her unfulfilled desire for a "proper" life. They separated in 1931 but were never divorced and maintained a lifelong relationship. In 1964 the couple held a public Golden Wedding celebration concert.

St. Denis was, indisputably, the incandescent element of the dances she created. In 1986 three of her solos were performed by the Martha Graham Company; faithfully executed by fabulously trained and talented dancers, without St. Denis they seemed, as De Mille described it, "nothing but a bit of decoration." Although St. Denis had techniques such as her famous "arm ripple," which Graham described as "one of the treasures of the world . . . [a movement that] went from the spine through the entire body and . . . was in touch with all the vibrations of the universe" (and which, by St. Denis' own judgment, other dancers had mastered before her death), St. Denis' absence resulted in more than an absence of one individual's technique. "[T]he secret of her power," De Mille wrote, "was that when she performed she worshipped, and the audience recognized this and shared with her the devotion."

Ruth St. Denis died on July 21, 1968, in Hollywood.

Further Reading: De Mille, *Martha;* McHenry, ed., *Famous American Women;* Read and Witlieb, *Book of* *Women's Firsts;* St. Denis, *Unfinished Life;* Shelton, "Ruth St. Denis," in *Notable American Women,* ed. Sicherman et al. ———, *Divine Dancer;* Terry, *"More Living Life" of Ruth St. Denis.*

Salem witchcraft trials

Witch-hunts were not uncommon in Europe prior to or during the seventeenth century, and charges of witchcraft were not unknown in colonial Massachusetts: Approximately 100 residents of the colony were formally charged with witchcraft—and fifteen executed—in the years prior to 1692 in what are now known as the Salem Witchcraft Trials. The year 1692, however, was spectacularly marked by frenzied accusations of witchery levied against more than 200 people, mostly women.

The trial record is fairly clear. In February 1692 several adolescent and teenage girls fell into a series of fits. Upon questioning by adults who assumed the Devil was at fault, they implicated Sarah Good, Sarah Osburn, and, especially, Tituba, a slave in one of the girls' families who had been amusing the girls with tales of magic and fortune-telling games. Warrants were issued and the three women arrested on February 29, 1692.

At the public hearing that began on March 1 in Salem Village (now Danvers, Massachusetts), magistrates John Hawthorne and Jonathan Corwin severely interrogated the accused women. The pregnant and impoverished Sarah Good declared herself innocent but cast suspicion upon Sarah Osburn. Osburn, who would die in prison before trial, said she was not a witch but suggested that she, like the young girls, might have suffered symptoms of bewitchment; she cited a dream of a figure "like an Indian all in black, which did pinch her in the neck." Tituba at first declared herself innocent, but finally described "[f]our women and one man [who] . . . tell me, if I will not hurt the children, they will hurt me." She identified Good and Osburn as two of her threateners but refused to identify the remaining three. The number of accused widened until hundreds of alleged witches occupied the jails of Salem Town and eastern Massachusetts.

Sarah Bishop was the first woman to stand trial. A neighbor testified that Bishop's "spector" (i.e., the Devil in Bishop's form and image, an appropriation thought to require Bishop's consent) had been seen near the cradle of a child who subsequently succumbed to illness and death. Convicted, Bishop was hanged on June 10, 1692. During an eighteen-day recess, ministers advised the court that "spectral evidence" should be viewed as suspect, since the "demon may assume the shape of the innocent." Nonetheless, trials resumed on June 28, and the first five women brought to court were convicted. Among them was Rebecca Nurse, a well-regarded and deeply religious woman. Ultimately, twenty-nine people were convicted of witchcraft and nineteen executed.

The hysteria was brought to an end by the arrival of a new royal governor, William Phips, who suspended the witchcraft court, forbade further executions of the convicted, and released those held in prison. Five years later, in January 1697, the General Court mandated a day of penitent prayer and fasting and, in 1703 and 1710, descendants of the convicted persuaded the legislature to reverse most of the convictions.

Historians continue to debate the true causes of this event. Some believe that the young girls, a fairly powerless part of Puritan society, simply relished too well their sudden center-stage status and allowed their small fiction to escalate. Others suggest ergot fungus, a hallucinogenic chemical possibly present in rye flour, may have been responsible. Another faction points to the stress caused by shifts in Massachusetts' political situation between 1684 and 1688: During these years, the colony lost its charter and became, with other colonies, part of the Dominion of New England; had the validity of its land titles questioned by the dominion's imported governor; and then, when James II was deposed during England's Glorious Revolution, awaited the evolution of William and Mary's policies toward the American colonies.

Since at least 1881, however, feminist scholars have offered a divergent view. In that year, Matilda Joslyn GAGE, in the "Woman, Church, and State" chapter of the *HISTORY OF WOMAN SUFFRAGE*, found "three striking points for consideration" in her examination of the history of European and colonial American witchcraft trials:

> *First.* That women were chiefly accused, a wizard being seldom mentioned.
> *Second.* That man, believing in woman's inherent wickedness, and understanding neither the mental nor the physical peculiarities of her being, ascribed all her idiosyncrasies to witchcraft.
> *Third.* That the clergy inculcated the idea that woman was in league with the devil, and that strong intellect, remarkable beauty, or unusual sickness, were in themselves a proof of that league.

Gage cited accounts of no-longer-loved wives "dragged by their husbands before the arch-Inquisitor, Sprenger, by ropes around their necks," and the suspicions suddenly cast by the church upon women's carefully cultivated healing skills as evidence that "for 'witches' we [should] read 'women,' [to] gain a more direct idea of the cruelties inflicted by the Church upon women."

Many modern feminists also view the witchcraft trials as arising from gender issues. Anne Llewellyn Barrow and Carol Karlsen, for example, point out that those most in danger of accusation were successful businesswomen, female inheritors, unmarried women, and those who had passed childbearing age without producing a son. Barrow in particular stresses that the unusual right of Salem widows to hold title to their own property may have played a role in the Salem witch hunts.

Further Reading: Barrow, *Witchcraze;* DiCanio, Teddi, "Salem Witchcraft Trials," in *Great American Trials,* ed. Knappman; Gragg, "Under an Evil Hand"; Hansen, *Witchcraft at Salem;* Karlsen, *Devil in the Shape of a Woman;* Stanton, Anthony, and Gage, eds., *History of Woman Suffrage,* vol. 1; Starkey, *Devil in Massachusetts;* Upham, *Salem Witchcraft.*

Sampson, Deborah (1760–1827) *soldier*

A soldier in the Revolutionary War, Sampson was born on December 17, 1760, in Plympton, Massachusetts, to Deborah Bradford Sampson and Jonathan Sampson. On her maternal side, Sampson was a descendant of Governor William Bradford; on her paternal side, of John Alden and Miles Standish.

Her mother was either widowed or abandoned by her husband, and Deborah grew up primarily in the homes of other families. At the age of nineteen, she became a teacher in Middleborough, Massachusetts.

On May 20, 1782, Sampson disguised herself as a man and enlisted in the Continental Army as Robert Shurtleff (which was also sometimes spelled as "Shirtliff"). She served in the 4th Massachusetts Regiment under Captain George Webb for over a year, receiving saber wounds in a fight outside of Tarrytown, New York, and musket-ball wounds in a battle near East Chester, Massachusetts. Although Sampson treated battle injuries herself to avoid a doctor's examination and discovery, later she was hospitalized due to illness and found to be female.

Sampson was discharged at West Point on October 25, 1783, by General Henry Knox. She married Benjamin Gannett two years later; the couple had three children. Sampson's (somewhat exaggerated) biography, *The Female Review,* was published by Herman Mann in 1797. Sampson thereafter toured the Northeast, giving accounts of her service in the war. In 1792 the Massachusetts Legislature awarded Sampson 34 pounds, plus interest computed from the day of her discharge. In 1805, at the urging of Paul Revere, Congress included Sampson in the United States pension list. Sampson died in 1827. On July 7, 1838, following the death of Benjamin Gannett, Congress passed "An Act for the relief of the heirs of Deborah Gannett, a soldier of the Revolution, deceased." A sum equal to the full amount Benjamin Gannett would have received during his life as the widowed spouse of a Revolutionary War soldier subsequently was paid to his and Sampson's children.

Further Reading: Cometti, "Deborah Sampson," in *Notable American Women*, ed. James, James, and Boyer; McHenry, ed., *Famous American Women*.

Sanger, Margaret (1879–1966) *birth control reformer*
Margaret Sanger was born Margaret Higgins on September 14, 1879, in Corning, New York, to Irish-American parents, Anne Purcell Higgins and Michael Higgins.

Sanger's mother was a devout Roman Catholic who obeyed her church's injunction against birth control (see FRUITS OF PHILOSOPHY for an example of contraceptive information available at the time); as Sanger would later remember in the dedication of one of her books, Anne Purcell Higgins "gave birth to eleven living children." The family endured great financial hardship, but managed to send Margaret through two years at the Claverack College and Hudson River Institute (a secondary boarding school in Hudson County, New York). When funds ran out, Margaret secured a teaching position in New Jersey. When Margaret was nineteen, her mother, then fifty, died of consumption, and Margaret was forced to abandon her teaching position in order to help care for the family's youngest children. Thereafter, she received nurse's training at the White Plains Hospital and the Manhattan Eye and Ear Clinic. She and William Sanger were married in 1902, and the

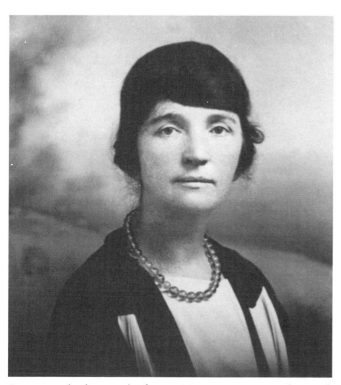

Pioneering birth control reformer Margaret Sanger (*Library of Congress*)

couple had three children. Although the marriage ended in divorce and Sanger remarried, she retained Sanger's surname throughout her life.

Sanger worked among New York City's poor as a visiting nurse and witnessed many women suffering from the effects of unlimited childbearing. She spoke often of the catalytic experience of treating Sadie Sachs, a poor Jewish resident of Hester Street, for the aftereffects of a self-induced abortion. The young woman reportedly told Sanger that a physician had dismissed her request for contraceptive information with the cavalier advice that her husband should "sleep on the roof." When Mrs. Sachs later died following yet another self-induced abortion, Sanger vowed to leave "the palliative career of nursing in pursuit of fundamental social change."

Believing that access to birth control was imperative if women were ever to achieve true autonomy and control over their lives, Sanger set about providing contraceptive information in violation of a then-existing federal law, the COMSTOCK LAW of 1873. She began publishing *The Woman Rebel* in 1914 and, because the information it provided was considered "indecent" and "obscene," she was arrested. She fled to Europe under an alias, leaving behind for distribution 100,000 copies of a candid and informative contraceptive guideline, *Family Limitation*. Returning to stand trial the following year, Sanger was devastated by the sudden death of her daughter, Peggy. Partly in response to public sympathy, charges were dropped on February 14, 1916.

In 1917 Sanger opened America's first birth control clinic in Brooklyn, New York, and was arrested and incarcerated in a workhouse for thirty days for violating obscenity laws. Her conviction was upheld by both an intermediate appellate court and New York's highest court.

The opinion of New York's Superior Court, however, included a specific exemption for physicians prescribing contraceptive devices for married women in order to protect them from "disease." Thereafter, Sanger framed birth control as a medical issue and sought nationwide legalization of birth control information within a "medically supervised" context. The AMERICAN BIRTH CONTROL LEAGUE (ABCL), founded by Sanger in 1921, and the National Committee on Federal Legislation for Birth Control, founded by her in 1931, both worked toward this goal. (This was in contrast to the strategy pursued by Mary Coffin Ware DENNETT, who rejected the need for medical intermediaries and instead urged the outright repeal of all federal and state laws limiting an individual's access to birth control information.)

In 1921, the same year in which she founded the ABCL, Sanger organized the 1921 Birth Control Conference in New York City. Two years later, with the help of a

female physician, Sanger proudly opened America's first doctor-run birth control clinic, the Birth Control Clinical Research Bureau in New York City. She was just as active on behalf of women outside the United States: She organized the 1925 International Birth Control Conference in New York, the 1927 World Population Conference in Geneva, and the 1930 International Contraceptive Conference in Zurich, among others, and worked to foster the use of birth control in India and Japan.

Sanger testified on the subject of contraception before the United States Senate Judiciary Subcommittee in 1932. Her view of medical privilege with regard to birth control was at least partially vindicated when the U.S. Supreme Court, in its 1936 decision *United States v. One Package,* held that Comstockian laws could not interfere with public health by forbidding the mailing of contraceptive information and materials to physicians. (In subsequent rulings, however, many state courts applied the *United States v. One Package* precedent only to doctors involved in the care of existing and endangered patients, refusing to protect clinics on the same basis. Not until GRISWOLD V. CONNECTICUT [1965] and *Eisenstadt. v. Baird* [1972] would access to birth control information and devices be a settled constitutional issue.)

In 1942 the Birth Control Federation of America—a successor to Sanger's American Birth Control League—became the Planned Parenthood Federation, with Margaret Sanger as its honorary chairman. The International Planned Parenthood Federation was founded in 1953, in Bombay, India, and Sanger became that organization's first president.

In addition to *Family Limitation,* Sanger wrote a number of other works, including *The Case for Birth Control* (1917); *Pivot of Civilization* (1922); *Women, Morality, and Birth Control* (1922); *Woman and the New Race* (1923); and *Happiness in Marriage* (1926).

Margaret Sanger died on September 6, 1966, in Tucson, Arizona. Her grandson Alexander Sanger currently heads Planned Parenthood of New York City.

Further Reading: Chesler, *Woman of Valor;* Garrow, *Liberty and Sexuality;* Gordon, *Woman's Body, Woman's Right;* Kennedy, *Birth Control in America;* Lader, *The Margaret Sanger Story and the Fight for Birth Control;* Reed, *From Public Vice to Private Virtue;* Sanger, *My Fight for Birth Control;* ———, *"Family Limitation";* ———, *An Autobiography* (foreword, Kathryn Cullen-DuPont); ———, *Woman and the New Race.*

Sanitary Commission, U.S.

A nursing organization founded to give aid to Northern soldiers during the Civil War.

The first steps toward its organization were taken just days after the first shots were fired on Fort Sumter. On April 17, 1861, women in Cleveland, Ohio, formed the Soldier's Aid Society. Women throughout the North formed similar societies, one of which was the Ladies' Central Relief in New York, founded by Dr. Elizabeth BLACKWELL on April 25. On April 29, these societies united as the Women's Central Association of Relief and made their headquarters in New York City. Members of the Women's Central Association of Relief and two medical associations met with the secretary of war in May. They outlined a plan to train, deploy, and support women nurses. President Abraham Lincoln gave his approval, and, on June 13, 1861, the United States Sanitary Commission was formed. Among its leaders were Frederick Law Olmstead, George Templeton Strong, and Dr. Henry Bellows. Elizabeth Blackwell served for a time as chair of the Registration Committee, but she resigned because, according to the editors of the *HISTORY OF WOMAN SUFFRAGE,* the prejudice then confronting a female doctor made it impossible for her to discharge her responsibilities properly.

In order to provide immediate medical attention to the wounded, the Sanitary Commission's female nurses staffed hospital ships, rode horseback into battle, and camped alongside soldiers. The commission also established and ran forty "Soldiers' Homes," which provided over 800,000 soldiers with free meals and lodging as they went back and forth from their regiments; maintained a "Back Pay Agency" to help collect pay due to soldiers (according to Mary Livermore, it collected up to $20,000 per day); established "Hospital Directories" in Louisville, Philadelphia, New York, and Washington, each of which contained the names and updated conditions of soldiers in 233 army hospitals as well as lists of soldiers reported missing or "fate unknown."

The Sanitary Commission was privately funded and supplied, primarily by women. Their fairs, bake sales, and other fund-raising efforts raised, according to a *Harper's Weekly* estimate, about $500,000 for the Sanitary Commission and other similar organizations, such as the Christian Commission. Women also made the bandages, blankets, socks, and shirts the nurses required. When the Battle of Shiloh ended, Sanitary Commission nurses were able to furnish the wounded with "11,448 shirts; 3,686 pairs of drawers; 3,592 pairs of socks; 2,777 bed-sacks; 543 pillows; 1,045 bottles of brandy, whisky and wine; 799 bottles of porter; 941 lemons; 20,316 pounds of dried fruit; 7,577 cans of fruit; and 15,323 pounds of farinaceous [starch-containing] food."

Prior to the Civil War, four soldiers died from disease or illness for every one soldier who died in battle or as a result of wounds. In the Civil War, efforts such as the Sanitary Commission's reduced that ratio to two to one and saved an estimated 180,000 lives.

Further Reading: Benton, "What Women Did for the War"; Flexner, *Century of Struggle;* Frost and Cullen-DuPont, *Women's Suffrage in America;* Guernsey and Alden, eds., *Harper's Pictorial History of the Civil War;* Livermore, *My Story of the War;* Moore, *Women of the War;* Stanton, Anthony, and Gage, eds., *History of Woman Suffrage,* vol. 2.

Santa Clara Pueblo v. Martinez (1978)

The ruling in these 1978 Supreme Court case declared that the United States government had no right to interfere in Native Americans' intratribal relations, even in order to protect women's rights. In this case, a Pueblo woman who had married a non-Pueblo man was denied tribal disability payments, since the tribe refused to recognize the tribal identity of women (but not men) who married outside of the Pueblo community. The Supreme Court ruled that in matters involving tribal sovereignty, Native American tribes could not be sued for discriminatory violations of the FOURTEENTH AMENDMENT.

Further Reading: *Santa Clara Pueblo v. Martinez;* 1978. 436 U.S. 49.

Schlafly, Phyllis (1924–) *opponent of ERA and abortion*

The most visible female proponent of the defeat of the EQUAL RIGHTS AMENDMENT (ERA) and a staunch public opponent of legalized abortion, Phyllis Schlafly was born Phyllis Stewart on August 15, 1924, in St. Louis, Missouri, to Odile Dodge Stewart and John B. Stewart. She received her elementary and high school educations in Roman Catholic schools. Thereafter, she earned a bachelor's degree from Washington University in 1941 and an M.A. in government from Radcliffe College in 1945. She and John F. Schlafly, Jr., a politically conservative attorney, were married on October 20, 1949.

Prior to her marriage, Schlafly had worked as a congressional campaign manager and editor of a financial institution's newsletter. She ran for Congress in 1952 and 1970, without success. Between 1964 and 1978 she worked on five books with Rear Admiral Chester Ward, including *Kissinger on the Couch* and *Ambush at Vladivostok,* and wrote her own *Power of the Positive Woman.* When Congress passed the ERA, Schlafly founded Stop ERA. She organized opposition by making such dubious claims as that upon ratification of the amendment, men and women would have to share public toilets, equality for women would destroy the American family, and homemakers would lose their right to the financial support of their husbands. She also pointed out that both men and women would have to serve in the event of a

draft, a point feminists conceded. She was appointed to President Ronald Reagan's Defense Policy Advisory Group in 1980.

When the ERA failed, Schlafly turned her attention to the crusade against legalized abortion. She founded the Eagle Forum, a group originally dedicated exclusively to overturning *Roe v. Wade.* The 80,000-member organization has since become a more broadly defined conservative group that presses for tax cuts, sustained military spending, and close parental oversight of the schools, as well as an end to legalized abortion.

Phyllis Schlafly is president of the Eagle Forum. Her syndicated newspaper column appears in 100 newspapers, and her daily radio show is broadcast on more than 200 stations. Now widowed, she lives in Illinois.

Further Reading: Clark, *Almanac of American Women in the 20th Century;* Davis, *Moving the Mountain;* Eagle Forum Available online: http://www.eagleforum.org.; Evans, *Born for Liberty;* Faludi, *Backlash;* Schlafly, *Power of the Positive Woman.*

Schlesinger Library

Begun in 1943 with the donation of suffragist Maud Wood Park's papers to her alma mater, Radcliffe College (now the Radcliffe Institute for Advanced Study), the Schlesinger Library is a research library dedicated to preserving the history of American women.

Arthur M. Schlesinger, a member of Radcliffe's College Council, was instrumental in establishing the archive's mission and was chairman of its advisory board until 1962. After his death, the Women's Archives, as it was then known, was renamed the Schlesinger Library in honor of Arthur Schlesinger and his wife, Elizabeth Bancroft Schlesinger. The library's current holdings include books, diaries, manuscripts, periodicals, audiovisual material, oral histories, and ephemera relating to women's history in America, with a special emphasis on women in the nineteenth and twentieth centuries. Its papers include those of Betty FRIEDAN, Charlotte Perkins GILMAN, and Harriet Beecher STOWE; its organizational records include those of the NATIONAL ORGANIZATION FOR WOMEN; and its photography collection begins with the year 1839 and exceeds 50,000 images.

The board of the Schlesinger Library recommended to Radcliffe that it sponsor the landmark biographical dictionary of women in American history, NOTABLE AMERICAN WOMEN. The original three volumes, including biographical entries on 1,337 women who lived between 1607 and 1950, was published in 1971. A second volume, including entries on 442 women who died between 1951 and 1975, was titled NOTABLE AMERICAN WOMEN: THE MODERN PERIOD and published in 1980.

The Schlesinger Library also houses the Radcliffe archives, a repository for materials relating to Radcliffe College and female students at Harvard University.

Further Reading: Schlesinger Library. Available online: http://www.radcliffe.edu/schles/index/html

Schroeder, Patricia Scott (1940–) *politician, president of the Association of American Publishers*
A United States Representative from Colorado and Congress' most senior female member for many years, Patricia Schroeder was born Patricia Scott on July 30, 1940, in Portland, Oregon, to Lee Combs and Bernice Scott.

She attended public elementary and high schools in Portland and then entered the University of Minnesota from which she was graduated *magna cum laude* and Phi Beta Kappa in 1961, after only three years of study. She then entered Harvard Law School, from which she received her J.D. degree in 1964.

On August 18, 1962, Patricia Scott married James White Schroeder, a fellow Harvard classmate. Upon the couple's graduation from Harvard, they made their home in Denver, Colorado. Pat Schroeder, as she prefers to be known, worked in a variety of legal and political positions, including National Labor Relations Board field attorney (1964–66), Democratic precinct committeewoman (1968), and law lecturer and instructor at the Community College of Denver (1969–70), the University of Denver (1969), and Regis College (1970–72). The Schroeders' two children, Scott William and Jamie Christine, were born in 1966 and 1970, respectively.

James Schroeder stood for election to the Colorado state legislature in 1970. Upon his defeat, he decided to focus on his strengths as a campaign manager, engineering a 1972 liberal Democratic challenge to his district's congressional incumbent, Republican James D. McKevitt. When no established politician would agree to run against the supposedly invincible McKevitt, Schroeder enlisted his wife. As Pat Schroeder later described it, "I never saw myself as a candidate. But . . . I was the only person [Jim] could talk into it!" She ran a candid campaign in which she cheerfully aired her views, stressing an end to the Vietnam War, increased environmental protection, improvement in the quality of education, and better access to medical services and child care.

She won both the Democratic primary and, on November 8, 1972, the general election. Taking office in 1973, Schroeder confronted clear evidence of discriminatory attitudes. As she recalled in a 1978 interview for *People* magazine, a male member of Congress, upon introduction, baldly asked how it was possible to be "the mother of two small children and a member of Congress at the same time." Schroeder's response was lauded by feminists: "I have a brain and a uterus," she said, "and I use them both."

Schroeder sought and gained membership to the House Armed Services Committee, an unexpected move given her known antiwar sentiments during the Vietnam War.

Her highly publicized opposition to what she termed the "unreasonable redundancy" of U.S. weapons systems and her many votes against military appropriations bills gained her the animosity of some (early 1970s committee chairperson F. Edward Herbert, while unsuccessfully trying to keep Schroeder from a SALT disarmament conference in Geneva, went so far as to declare, "I wouldn't send you to represent this committee at a dogfight") and the unreserved respect of others.

A member of the Armed Services Committee throughout her tenure and chair of its subcommittee on military installations, Schroeder was a strong advocate for women in the military. Referring to all-male combat troops as a barrier to women seeking experience needed for promotion to the military's highest ranks and, more colorfully, as "the ultimate tree house—no girls allowed," Schroeder supported full gender integration of the armed forces. (For further discussion, see MILITARY SERVICE, AMERICAN WOMEN AND.)

Schroeder championed the rights of women in all walks of American life. She introduced the FAMILY AND MEDICAL LEAVE ACT, opposed female genital mutilation, and has been an unwavering supporter of abortion rights. In 1990, with Representatives Olympia Snowe (R-ME) and Henry A. Waxman (D-CA), Schroeder prompted a General Accounting Office study that concluded that the National Institutes of Health—in violation of their stated policies—routinely failed to include female subjects in medical research projects. She also chaired the House Select Committee on Children, Youth and Families.

During the summer of 1987, Schroeder prepared to enter the Democratic presidential primary, raising almost $500,000 and placing third in the preliminary polls. She withdrew from that race, however, and remained, as Senator Barbara Boxer has referred to her, "the dean of the women of the House" for another nine years. During that time, she saw FEMALE GENITAL MUTILATION criminalized in the United States, a protection she had worked for twenty years to secure.

Patricia Schroeder retired from Congress in 1996. She is currently president and chief executive officer of the Association of American Publishers.

Further Reading: Beck et al., "Our Women in the Desert"; Boston Globe, March 4, 1997; Boxer, Barbara with Boxer, *Strangers in the Senate;* Carabillo, Meuili and Csida, *Feminist Chronicles 1953–1993; Current Biography Yearbook,* 1978; *Quill,* November 1997 Ralston,

"Women's Work"; *Redbook,* November 1973. Ries and Stone, eds., *American Woman 1992–1993;* Rix, ed., *American Woman 1990–1991;* Schroeder, *24 Years of House Work . . . and The Place is Still a Mess.*

Seaman, Elizabeth Cochrane ("Nellie Bly")
(1865/67–1922) *journalist, social reformer*

The pioneering and intrepid journalist known as "Nellie Bly," Seaman was born Elizabeth Cochrane on May 5, 1865 or 1867, in Cochran Mills, Pennsylvania, to lawyer and mill owner Michael Cochran and his second wife, Mary Jane Kennedy Cochran. (Elizabeth herself added the "e" to her surname.)

Her parents' third child and one of ten siblings and half siblings, Elizabeth received only one year of formal schooling, at boarding school in Pennsylvania. Upon Michael Cochran's death, his family moved to Pittsburgh and Elizabeth's legendary career began.

Reading an 1885 editorial in opposition to the goals of the nineteenth-century women's movement, Elizabeth, then nineteen and a strong supporter of women's rights, sent a rebuttal to the *Pittsburgh Dispatch.* The paper's editor, George A. Madden, was so impressed with her arguments that he requested an interview and promptly hired her. Fearing family disapproval should she use her own name, Elizabeth chose a by-line from a famous Stephen Foster song, "Nellie Bly."

Nellie Bly did not become the first newspaperwoman in America; in 1767 Anna K. Greene had founded the *Maryland Gazette,* that colony's first newspaper. Neither did she become America's youngest newspaperwoman; in Penfield, New York, the thirteen-year-old Nellie Williams had earlier founded the *Penfield Enterprise.* (Written, set up, and published by Williams, it had a circulation of 3,000 at the end of its three-year life.) But if she was neither the first nor the youngest newspaperwoman, she was, with Margaret FULLER and the New York *Mail's* Rheta Childe Dorr, one of the women who set the stage for this century's noted female correspondents and photo-journalists, including Margaret Bourke-White, Martha Gellhorn, Marguerite Higgins (see FOREIGN CORRESPONDENTS OF WORLD WAR I AND WORLD WAR II) Dorothea LANGE, and Dorothy Thompson.

Bly helped to break ground by refusing to write the "feminine" articles her new editor had envisioned. Instead, she investigated and described the exploitive working conditions faced by many women, the living conditions of Pittsburgh's poorest citizens, and the consequences to women of unfair divorce laws. She went on assignment for six months to Mexico, at a time when few other American journalists were reporting about the country based on firsthand observation. Her stories concerning political corruption and the disparate lives of Mexico's rich and poor were published in the *Pittsburgh Dispatch;* she wrote, among other things, that "Mexico is a Republic in name only. It is the worst monarchy in existence." Bly's assignment ended with her expulsion by the Mexican government.

In 1887 Bly secured a position with Joseph Pulitzer's *New York World.* With the *World's* backing and the help of attorney Henry D. Macdona, Bly managed to get herself committed to the "lunatic" asylum on Blackwell's Island. Pulitzer, as previously arranged, disclosed Bly's identity and secured her release, and Bly wrote a dramatic exposé of the asylum's horrific conditions. An investigation and a number of reforms followed.

Bly, appreciating a journalist's ability to work for change, continued to write stories that are described both as stunt reporting and as early examples of "muckraking" journalism. Disguised, she worked in a sweatshop alongside exhausted, underpaid workers and then quit to write about it. Disguised again, she staged a theft; her story of internment in a female penitentiary resulted in yet another series of investigation and reform.

From November 14, 1889, to January 26, 1890, Bly was absorbed with the story for which she would be most remembered and caricatured: Her dash to beat the fictional eighty-day record of Jules Verne's imaginary character, Phileas Fogg, in a trip around the world. (Bly made the trip in seventy-two days, six hours, and eleven minutes.)

Among the last Nellie Bly stories to appear in the nineteenth century were interviews of Susan B. ANTHONY and anarchist Emma GOLDMAN. In March 1895 Bly married the seventy-two-year-old Robert L. Seaman, a man she had met just several days before. For the next fifteen years, she lived a settled, quite life in New York. Robert Seaman died in 1910; Bly made an unsuccessful attempt to continue his manufacturing business and then went to live in Austria-Hungary. Her last years were spent back in the United States, as a reporter for the *New York Journal.*

Elizabeth Cochrane Seaman was the author of three books, *Ten Days in a Mad-House; or Nellie Bly's Experiences on Blackwell's Island* (1887); *Six Months in Mexico* (1888); and *Nellie Bly's Book: Around the World in Seventy-two Days* (1890). She died on January 27, 1922, in New York City.

Further Reading: Belford, *Brilliant Bylines;* Bly, Interview of Susan B. Anthony; Edwards, *Women of the World;* Marzolf, *Up From the Footnote;* Rittenhouse, *Amazing Nellie Bly;* Robertson, *The Girls in the Balcony;* Ross, *Ladies of the Press;* Schilpp, *Great Women of the Press;* Stanton, Anthony, and Gage, eds., *History of Woman Suffrage,* vol. 1; Weisberger, "Elizabeth Cochrane Seaman," in *Notable American Women,* ed. James, James, and Boyer.

Seneca Falls Convention, The (1848)

Held July 19 and 20, 1848, in Seneca Falls, New York, this was the first woman's rights convention held in the United States and the event that marked the official beginning of the organized women's rights movement in America. Lucretia MOTT and Elizabeth Cady STANTON had first envisioned such a convention while at the WORLD ANTI-SLAVERY CONVENTION in London eight years earlier. When the two women met again on July 13, 1848, in the home of Jane Hunt, Stanton was ready to act. Distressed by domestic experiences that seemed to her to have political roots, she "poured out . . . the torrent of my long accumulated discontent with such vehemence and indignation that I stirred myself, as well as the rest of the party, to do and dare anything." In addition to Stanton, Mott, and Hunt, the party included Mary Ann M'Clintock and Martha Coffin Wright, a sister of Lucretia Mott.

The five women decided that the convention would be held within the week. That very afternoon, they arranged for the use of the Wesleyan Chapel in Seneca Falls, delivered a notice to the *Seneca Falls Courier*, and began drafting the DECLARATION OF RIGHTS AND SENTIMENTS. Although Mott had worried that attendance would be slight, as she wrote to Stanton, "owing to the busy time with the farmers' harvest," more than 100 people attended. The crowd included men as well as women (despite the first day having been listed as "for women only"). Since it was considered highly improper for a woman to lead a "promiscuous" meeting, James Mott, husband of Lucretia Mott, was asked to act as chairperson.

The Declaration of Sentiments and Resolutions was seriously debated for two days. By the end of the convention, it had been adopted and signed by 100 people. The demands contained in the document and agreed to at the Seneca Falls Convention set the agenda for the women's rights movement in America. As Stanton summed them up in 1881, they were:

> equal rights in the universities, in the trades and professions; the right to vote; to share in all political offices, honors and emoluments; to complete equality in marriage, to personal freedom, property, wages, children [women had no right to guardianship of their children at this time; a father could apprentice his children out against their mother's wishes, and even leave their care to someone other than their mother in his will]; to make contracts; to sue, and be sued; and to testify in courts of justice.

Two abolitionist newspapers, Frederick Douglass' *North Star* and William Lloyd Garrison's *Liberator*, gave favorable accounts. (Douglass had attended the convention and been instrumental in persuading the crowd to vote in favor of the woman suffrage resolution, the most controversial of the demands made at Seneca Falls.) At the *New York Tribune*, Horace Greeley at least treated the matter seriously. Most other newspapers, however, responded with scorn. "They should have resolved at the same time that it was obligatory also upon the lords [men] to wash dishes, scour up, be put to the tub, handle the broom, darn stockings, patch breeches, scold the servants, dress in the latest fashion, wear trinkets, [and] look beautiful . . ." one newspaper declared, ridiculing woman's sphere while consigning her to it. Others branded Stanton, Mott, M'Clintock, Hunt, and Wright "sour old maids," "childless women," and "divorced wives," although they were none of these; the implications were that such "marginal" women could not speak for their sex. Underlying all this commentary was the clear assumption that women were of value only insofar as they were of use (or of potential use) to men. As the *Philadelphia Public Ledger and Daily Transcript* explained, "A woman is nobody. A wife is everything. A pretty girl is equal to ten thousand men, and a mother is, next to God, all powerful . . . The ladies of Philadelphia therefore . . . are resolved to maintain their rights as Wives, Belles, Virgins, and Mothers, and not as Women."

Although she would have preferred to see the Seneca Falls Convention commented upon respectfully as well as widely, Stanton welcomed all mention of the event: Thanks to the controversy, she wrote to one editor, there was "no danger of the Woman Question dying for want of notice."

A 150th anniversary celebration of the Seneca Falls Convention resulted in 1998 in the adoption of a Declaration of Sentiments that both honored the founding of the women's rights movement and set a course for its future.

Further Reading: *American History,* August 1998; Bacon, *Valiant Friend;* Stanton, *Eighty Years and More; Houston Chronicle,* July 19, 1998; *Post Standard,* July 30, 1998; Stanton, Anthony, and Gage, eds., *History of Woman Suffrage,* vol. 1.

settlement house movement

The settlement house movement began in England with the 1884 founding of the Toynbee Hall in East London. Its founders, Anglican priest Samuel A. Barnett and a number of Oxford University students, sought to bring university-educated people from privileged backgrounds into poor or working-class neighborhoods, where they could live side by side with those they wished to help. The Neighborhood Guild on the Lower East Side of New York City, founded by Stanton Coit in 1886, was the first American settlement house. Hull House, founded in 1889 by Jane ADDAMS and Ellen Gates Starr, was one of the best-known American settlement houses. The Henry Street Settlement, now a vibrant neighborhood center in

New York City, was founded in 1893 by Lillian WALD as an integral part of her effort to improve the health of that city's poor. By 1900 there were more than one hundred such settlement houses in the United States.

In addition to instructing poor and immigrant families in American middle-class values, America's settlement houses offered kindergartens and adult-education programs. Settlement house workers also worked to affect public policy concerning those they served. They lobbied legislators for an eight-hour workday for women and improved working conditions in the factories, supported the establishment of housing regulations in the tenements, and promoted juvenile courts.

At present, there are approximately 800 settlement houses in the United States. They are more frequently referred to as neighborhood centers than as settlement houses, and their staff members no longer reside on the grounds. Nevertheless, their work among the country's urban poor—which now frequently includes services to victims of DOMESTIC VIOLENCE, counseling for troubled teenagers, and geriatric programs—continues in the tradition established at the end of the nineteenth century.

Further Reading: Addams, *Twenty Years at Hull-House;* Chambers, *Seedtime of Reform;* Wald, *House on Henry Street.*

"Seven Sisters"

The name by which seven private liberal arts colleges—all originally founded in the nineteenth century for the education of women—are collectively known.

These colleges, which formalized their ties and gained the "Seven Sisters" appellation by establishing the Seven College Conference in 1926, are: Mount Holyoke (1836), Vassar (1861), Wellesley (1870), Smith (1871), Radcliffe (1879), Bryn Mawr (1880), and Barnard (1893).

Only OBERLIN, founded as a coeducational and multiracial college in 1833, granted undergraduate degrees to women when the first of the "Seven Sister" colleges was founded. (It also should be noted that, while MOUNT HOLYOKE COLLEGE was the first of these colleges to be founded, it did not complete its evolution into a full-fledged college until the 1890s.) Higher education for women was a controversial idea in the nineteenth century and, when propounded, was generally described as a means for women to better prepare themselves for future domestic responsibilities, such as rearing children. The Seven Sister colleges were no exception to this pattern; thus, their students were expected to master both their demanding academic subjects and the intricacies of a set of societal expectations now referred to as the "CULT OF TRUE WOMANHOOD." M[artha]. Carey Thomas, the outspoken president of Bryn Mawr from 1894 to 1922, was

the first leader of a Seven Sisters college to dispose of this sentimental veneer and actively encourage women's forthright pursuit of academic and professional excellence. The Seven Sister college have long been counted among the nation's top liberal arts colleges.

Private schools funded primarily by the tuition of well-off families and the generosity of similarly situated alumnae, the Seven Sister colleges, like other private colleges and universities, once attracted a fairly homogenous student population: drawn from middle- or upper-class Caucasian, Protestant families. Partly due to the fact that Barnard and Radcliffe were part of the originally all-male Ivy League universities, but also due to the elitist nature of all of these women's colleges, the Seven Sisters came to be viewed as a female parallel to the "Ivy League." Today, the colleges are enriched by a more broadly diverse student body.

During the 1960s and 1970s, with the emergence of the second wave of feminism, women's colleges in general began to fall into disfavor and a number, including Seven Sister Vassar in 1969, became coeducational. In 1999, Radcliffe College merged its undergraduate program with that of Harvard University and the college was recast as the Radcliffe Institute for Advanced Study. However, the 1990s have also seen a revival of interest in women's colleges. One catalyst was the release in 1992 of a study by the AMERICAN ASSOCIATION OF UNIVERSITY WOMEN entitled *How Schools Shortchange Girls: The AAUW Report.* This study concluded that girls are seriously shortchanged in coeducational settings. In addition, it has been widely noted that many of the decade's high-achieving women, including Hillary Rodham CLINTON and Madeleine ALBRIGHT, are graduates of Seven Sister colleges.

Further Reading: Horowitz, *Alma Mater;* Sadker and Sadker, *Failing at Fairness;* Solomon, *In the Company of Educated Women;* Thomas, *Education of Women;* ———, *College Women of the Present and Future;* ———, *Women's College and University Education;* Touchton, Davis, with Makosky, *Fact Book on Women in Higher Education;* Wellesley College Center for Research on Women, *How Schools Shortchange Girls;* Woody, *History of Women's Education in the United States.*

sexual harassment

The unwanted sexual advances, demands, or innuendoes directed toward women in the workplace, sexual harassment has been defined since the 1993 Supreme Court decision *HARRIS V. FORKLIFT SYSTEMS, INC.* as existing "so long as the [work] environment would reasonably be perceived, and is perceived, as hostile or abusive."

Feminist attorney Catharine Alice MACKINNON began, as soon as she graduated law school in 1977, to argue that

sexual harassment in the workplace was a violation of Title VII. Title VII of the CIVIL RIGHTS ACT OF 1964 made it "an unlawful employment practice for an employer . . . to discriminate against any individual with respect to his compensation, terms, conditions, or privileges of employment, because of such individual's race, color, religion, sex, or national origin." In 1980, the EQUAL EMPLOYMENT OPPORTUNITY COMMISSION, charged with enforcing Title VII, defined sex harassment as "[u]nwelcome sexual advances, requests for sexual favors, and other verbal or physical conduct of a sexual nature." *Quid pro quo* sexual harassment—a situation in which a promotion, raise, or bonus is promised in exchange for a woman's enduring the harassment without complaint—or conversely, where the loss of a job, suspension, or demotion is threatened as the result of complaint—was prohibited by the EEOC. In addition, "hostile environment" sexual harassment also was prohibited; this was defined as consisting of advances, requests, and conduct of a sexual nature having "the purpose or effect of unreasonably interfering with an individual's work performance or creating an intimidating, hostile, or offensive working environment." In 1986 the Supreme Court examined the issue in *MERITOR SAVINGS BANK, FSB V. VINSON,* a case in which MacKinnon acted as co-counsel. In a landmark ruling, the Supreme Court held "that a claim of hostile environment is actionable under Title VII."

In 1991 the issue of sexual harassment was bitterly debated in the media and in American homes when Anita HILL accused Supreme Court nominee Clarence Thomas of having subjected her to sexual harassment during his tenure as director of the EEOC. The Judiciary Committee's initial failure to investigate the charge prompted a number of women to run for political office and is credited with galvanizing angered female voters in 1992, the so-called YEAR OF THE WOMAN.

Between *Meritor* in 1986 and *Harris* in 1993, lower courts tended to find Title VII violation only in cases in which the victim had suffered demonstrable psychological damage and/or had become unable to work under the circumstances. Justice Sandra Day O'CONNOR, writing *Harris,* made it clear that Title VII protection of a woman's civil rights "comes into play before the harassing conduct leads to a nervous breakdown." The decision, which directed lower courts to use broad principles in defining sexual harassment, was hailed by many women's organizations and instantly characterized as too broad by business leaders. The Supreme Court's decision in *Oncale v. Sundowner* (1998) extended the same protection to same sex situations.

Further Reading: Boxer, *Strangers in the Senate;* Cary and Peratis, *Woman and the Law;* Goldstein, *Constitutional Rights of Women;* Greenhouse, "Court, 9–0, Makes Sex Harassment Easier to Prove"; Hoffman; "Plaintiffs' Lawyers Applaud Decision"; Margolies-Mezvinsky, *A Woman's Place . . .;* Morrison, ed., *Race-ing Justice, Engendering Power;* O'Connor, "Women and the Constitution," in *Women, Politics and the Constitution,* ed. Lynn; *Oncale v. Sundowner* (1998); Strebeigh, "Professor Catharine A. MacKinnon."

Sexual Politics (1970)

Published in 1970, Kate Millett's *Sexual Politics* is considered the first important work of literary criticism to emanate from the modern women's movement.

In her book, which began as a doctoral thesis, Millett denies the validity of commonly offered religious, philosophical, and psychological or scientific explanations for women's subservient situation, maintaining instead that women's oppression is crafted deliberately and politically and that much of men's cultural expression works to maintain the status quo. Millett traces women's history, from their status as marital chattel through various attempts at liberation, including efforts in Russia and Germany. She then explores the manner in which Freud's theories influenced reaction to women's demands, which frequently were viewed as stemming from jealousy. Turning to literature's part in the construct of "women's place," she explores the manner in which male authors tend to reinforce the age-old idea of women as property.

Millett's other books include *Token Learning* (1967); *The Prostitution Papers* (1971; rev. ed., 1976); *Flying* (1974); *Sita* (1977); *The Basement: Meditations on a Human Sacrifice* (1979); *Going to Iran* (1981).

Further Reading: Millet, *Sexual Politics.*

Shaw, Anna Howard (1847–1919) *suffragist, minister*

Anna Howard Shaw was born on February 14, 1847, in Newcastle-on-Tyne, England, to Nicolas Scott Shaw and her husband, Thomas Shaw. Thomas Shaw immigrated to America in 1850, and Nicolas Shaw and the children followed in 1851. The family lived first in New Bedford and then Lawrence, Massachusetts, but finally settled in Michigan.

Shaw had little formal education during her frontier childhood but nonetheless became the first ordained woman minister in the Methodist Protestant Church in 1880. She also graduated in 1886 from Boston University's Medical School. In 1885 Shaw entered the women's suffrage cause by joining the Massachusetts Woman Suffrage Association as lecturer and organizer. From 1888 to 1892 she held the position of superinten-

dent of the Franchise Department of the National Woman's Christian Temperance Union. She was active in both the AMERICAN WOMAN SUFFRAGE ASSOCIATION and the NATIONAL WOMAN SUFFRAGE ASSOCIATION even before the merger of the two groups in 1890. The year after the merger, Shaw became the national lecturer of the NATIONAL AMERICAN WOMAN SUFFRAGE ASSOCIATION (NAWSA). A powerful orator, she traveled extensively to participate in numerous campaigns for state suffrage. She also attended many congressional hearings. She was NAWSA's vice president from 1892 to 1904 and its president from 1904 to 1915.

Shaw served as chairman of the Woman's Committee of the U.S. Council of National Defense and in 1919 received the Distinguished Service Medal for services performed during World War I.

Anna Howard Shaw died in Moylan, Pennsylvania, on July 2, 1919.

Further Reading: Shaw, *Passages from speeches of Dr. Anna Howard Shaw;* ———, *Woman Suffrage as an Educator. An address before The Equal Franchise Society . . . January 13, 1910;* ———, "What the War Meant to Women"; Stanton, Anthony, and Gage, eds., *History of Woman Suffrage.*

Sheppard-Towner Maternity and Infancy Protection Act of 1921 (1921)

One of several pieces of federal legislation affecting women to be passed within the first few years following ratification of the NINETEENTH AMENDMENT (see the YEAR OF THE WOMAN for further discussion), the Sheppard-Towner Maternity and Infancy Protection Act of 1921 allocated $1,250,000 annually for the creation and operation of public health clinics for pregnant women, mothers, and babies.

Upon its introduction in May 1921, detractors characterized this federal legislation as "official meddling between mother and baby which would mean the abolition of the family" and "federal mid-wifery." However, at the urging of Harriet Taylor UPTON, the Republican party's national vice chairman, President Warren G. Harding lent his support to the legislation. In addition, female supporters of the act became what the *Journal of the American Medical Association* called "one of the strongest lobbies that has ever been seen in Washington," and *Good Housekeeping* magazine—never considered a radical publication—countered the antifamily charges with an editorial in favor of the act's passage entitled "Herod Is Not Dead."

As politicians' fear of ballot retaliation by the newly enfranchised sex decreased, so did their support of the legislation benefitting these constituents. (Again, see Year of the Woman). The Sheppard-Towner Maternity and Infancy Protection Act of 1921 expired on June 30, 1929.

Further Reading: Brown, *American Women in the 1920s;* Chafe, *American Woman;* Daniel, *American Women in the 20th Century.*

Silent Passage: Menopause, The (1992)

Published in 1992, Gail Sheehy's book *The Silent Passage: Menopause,* is an educational overview of what she terms a woman's "Second Adulthood."

Sheehy quotes research indicating that a healthy woman who passes her fiftieth birthday free of cancer and heart disease is likely to live into her ninth decade, and she points out that this is not something evolution has prepared women's bodies to expect. Concluding that women themselves "shall *have* to intervene—medically, hormonally, psychologically, spiritually . . ." to offset the effects of this evolutionary miscalculation, she furnishes the most up-to-date information available about hormone replacement therapy, Chinese medicine and natural remedies, the incidence of "prophylactic hysterectomy" (approximately one-third of American women have their wombs surgically removed, but only 11 percent of these operations are performed due to cancer), the impact of menopause on a woman's sex drive, and other considerations attendant to living up to one-third of one's life in a postmenopausal state.

In addition to offering medical information, Sheehy—in an effort to "normaliz[e] . . . a proud stage of life" and open discussion of what she found had been a taboo topic—candidly explores her own menopausal experience and the varied, volunteered experiences of other women. As she hoped, the book has sparked "a new camaraderie" among menopausal women and those soon to join them. Women have formed "fan clubs" to exchange information and support. (The groups are named for a discussion group in Sheehy's book, so called because one of its hot-flashing members told of requesting two restaurant menus: one in order to select a meal and the other for use as a fan.) One such group sent its motto to Sheehy, and she proudly reprinted it in the introduction to *The Silent Passage*'s 1993 expanded edition: "Women don't have hot flashes/they have power!"

Further Reading: Sheehy, *The Silent Passage*

"Slave's Appeal, A" (1860)

The second address of Elizabeth Cady STANTON to the New York State Legislature (February 18, 1860), this speech is credited with persuading that legislature to pass

AN ACT CONCERNING THE RIGHTS AND LIABILITIES OF HUSBAND AND WIFE.

Stanton began this speech by saying "There are certain natural rights as inalienable to civilization as are the rights of air and motion to the savage in the wilderness" and claiming that these rights were inseparable from each person's very being:

> [E]ach individual comes into this world with rights that are not transferable. He does not bring them like a pack on his back, that may be stolen from him, but they are a component part of himself . . . The individual may be put in the stocks, body and soul, he may be dwarfed, crippled, killed, but his rights no man can get; they live and die with him.

Before discussing woman's situation, she told the all-male legislature that they were blinded by self-interest to injustice that they themselves perpetuated. The injustices caused by others were easier to see and admit, she said. Thus, "some of you who have no slaves, can see the cruelty of his oppression; but who of you appreciate the galling humiliation, the refinements of degradation, to which women (the mothers, wives, sisters, and daughters of freemen) are subjected in this half of the nineteenth century?"

She continued to discuss woman's bondage in terms members of the New York State Legislature (and especially its antislavery members) might understand.

> Allow me . . . to call the attention of that party now so much interested in the slave of the Carolinas, to the similarity in his condition and that of the mothers, wives, and daughters of the Empire State. The negro has no name. His is Cuffy Douglass or Cuffy Brooks, just whose Cuffy he may chance to be. The woman has no name. She is Mrs. Richard Roe or Mrs. John Doe, just whose Mrs. she may chance to be. Cuffy has no right to earnings; he can not buy or sell or lay up anything that he can call his own. Mrs. Roe has no right to her earnings; she can neither buy nor sell, make contracts, nor lay up anything that she can call her own. Cuffy has no right to his children; they can be sold from him at any time; Mrs. Roe has no right to her children; they may be bound out to cancel a father's debts . . . The unborn child, even by the last will of the father, may be placed under the guardianship of a stranger and a foreigner. Cuffy has no legal existence; he is subject to restraint and moderate chastisement . . . Mrs. Roe has no legal existence; she has not the best right to her own person [a reference to a woman's legal obligation to accede to her husband's sexual advances]. The husband has the power to restrain, and administer moderate chastisement.
>
> Blackstone declares that the husband and wife are one, and learned commentators have decided that that one is the husband . . .

Women, Stanton claimed, suffered the same kind of discrimination suffered more visibly by blacks. In a free state such as New York, she thought women suffered the more severe discrimination. In illustration of this point, she contrasted the civil rights granted African-American men in New York State with the social privileges accorded its women. The free black male, she pointed out, could vote, own property, and preach in church. New York State women, she said, "may sit at the same table and eat with the white man." Asking which of the two, "social privileges or civil rights," was the more valuable to "citizens of a republic," she supplied an answer: "The latter, most certainly . . ."

She demanded women's suffrage and refuted the idea that men protected women by keeping them in a private, domestic sphere.

> But, say you, we would not have woman exposed to the grossness and vulgarity of public life, or encounter what she must at the polls. When you talk, gentlemen, of sheltering woman from the rough winds and revolting scenes of real life, you must be either talking for effect, or wholly ignorant of what the facts of life are. The man, whatever he is, is known to the woman . . . There are over forty thousand drunkards in this State. All these are bound by the ties of family to some woman. Allow but a mother and a wife to each, and you have over eighty thousand women. All these have seen their fathers, brothers, husbands, sons, in the lowest and most debased stages . . .

Whatever women might see in public life, she thought it would be an easier sight than "when, stepping from her chamber, she has beheld her loyal monarch, her lord and master—her legal representative—the protector of her property, her home, her children, and her person, down on his hands and knees slowly crawling up the stairs." With New York State marriage law giving any husband, at any time, the right to sexual intercourse with his wife, Stanton asked the legislators to pity woman, not at the polls, but "in her chamber—in her bed!"

Near the end of her speech, she returned from specific example to consideration of the principle of natural right:

> No, gentlemen, if there is but one woman in this State who feels the injustice of her position, she should not be denied her inalienable rights . . . Now do not think . . . we wish you to do a great many troublesome things for us . . . We ask no more than "Let us alone." In mercy, let us take care of ourselves, our property, our children, and our homes . . . There has been a great deal written and said about protection. We, as a class, are tired of one kind of protection, that which leaves us everything to do, to dare, to suffer, and strips us of all means of its accomplishment . . .

Undo what man did for us in the dark ages, and strike the words "white male" from all your constitutions, and then, with fair sailing, let us sink or swim, live or die, survive or perish together.

An Act Concerning the Rights and Liabilities of Husband and Wife was passed the next day. No action was taken on the question of women's suffrage.

Further Reading: Stanton, Anthony, and Gage, eds., *History of Woman Suffrage*, vol. 1.

Smith, Margaret Chase (1897–1995) *politician*
Born Margaret Madeline Chase on December 14, 1897, in Skowhegan, Maine, Margaret Chase Smith was the first woman to serve as both a congresswoman and a senator and the first woman to seek a major party's nomination for president.

She attended public schools until her 1916 graduation from high school. She held several jobs after high school, including employment as a teacher and at a Skowhegan newspaper, the *Independent Reporter*. She was president of the Maine Federation of Business and Professional Women's Clubs (see NATIONAL FEDERATION OF BUSINESS AND PROFESSIONAL WOMEN'S CLUBS) from 1926 to 1928. In May 1930 she and Clyde H. Smith were married.

Margaret Chase Smith served as a member of her state's Republican Committee from 1930 to 1936. When her husband was elected to Congress in 1936, Smith became his secretary. In April 1940 Clyde Smith died, and Margaret Chase Smith, following a special election held in June, completed his unexpired term. She was elected in September 1940 to a full term in the House; she would be reelected to three additional terms and serve until her successful bid for the Senate in 1948.

During Smith's eight-year tenure in the House, she was a member of the Naval Affairs Committee and of the Armed Services Committee. She was a strong advocate for the improvement of women's status in the armed forces and, as such, was central to the passage of the Women's Armed Services Integration Act of 1948. (See MILITARY SERVICE, AMERICAN WOMEN AND, for further discussion.)

On September 18, 1948, Smith was elected to the Senate. She was reelected to this office three additional times and served until her 1972 defeat by Representative William V. Hathaway. During her twenty-four years in the Senate, Smith was a member of many committees, including the Armed Forces, Rules, Government Operations, and Appropriations committees. On June 1, 1950, she became the first Republican publicly to castigate Senator Joseph R. McCarthy at a time when, as she herself later described it, "the then junior Senator from Wiscon-

sin had the Senate paralyzed with fear that he would purge any Senator that disagreed with him." Smith received the Chi Omega award for her anti-McCarthy declaration and other congressional contributions on January 5, 1954.

When Lucia Cormier (D) unsuccessfully challenged Smith in 1960, it was the first time that two female candidates opposed each other for election to a national office. Smith broke political ground once again on January 27, 1964, when she announced during a Women's National Press Club gathering that she would enter the New Hampshire and Illinois presidential primaries. In so doing, she became the first woman to seek a major party's nomination for president.

Smith received twenty-seven delegate votes at the Republican convention that July, finishing second to Senator Barry Goldwater, the Republican nominee, and returning to the Senate.

In July 1964 President Lyndon Johnson signed the CIVIL RIGHTS ACT OF 1964, which contained an antisex discrimination provision as part of Title VII. While Congresswoman Martha Griffiths had spearheaded support of the sex provision in the House, Smith had been a crucial advocate in the Senate.

In 1972 Smith failed to win reelection, and the Senate became an all-male body once again. Although she had not campaigned vigorously in the face of questions concerning her health and her age, seventy-five-year-old Smith said of her departure, "I hate to leave the Senate when there is no indication another qualified woman is coming in . . . If I leave and there's a long lapse, the next woman will have to rebuild entirely." (Between 1972 and 1992, the so-called YEAR OF THE WOMAN, only eight women were elected to the Senate.)

When the Women's Hall of Fame, located in Seneca Falls, New York, was dedicated in 1973, Margaret Chase Smith was one of the original twenty inductees. The Margaret Chase Smith Library in Skowhegan, Maine, was dedicated in August 1982, and Smith's papers and tapes are part of that library's collection.

Margaret Chase Smith died on May 29, 1995, in Skowhagen, Maine.

Further Reading: Boxer, *Strangers in the Senate;* Carabillo, et al., *Feminist Chronicles;* Clark, *Almanac of American Women in the 20th Century;* Davis, *Moving the Mountain;* McHenry, ed., *Famous American Women;* Read and Witlieb, *Book of Women's Firsts.*

Society for the Advancement of Women's Health Research

A coalition of women from the medical sciences and health fields based in Washington, D.C., and founded in

1990, the Society for the Advancement of Women's Health Research is dedicated to equalizing the inclusion of women with men in clinical health trials; increasing the amount of research on diseases and medical problems suffered primarily or exclusively by women; preparing a comprehensive agenda of women's health issues to be addressed in the future; and educating the rest of the medical community about inaccurate assumptions concerning the medical diagnosis and treatment of women who, as a group, may not have been equitably represented in studies of diseases and their various treatments.

The concerns of this organization are based on well-documented fact. In the area of heart disease, the number-one cause of death among women as well as men (and a disease that kills slightly more women than men each year), women were for many years deliberately excluded from research studies and clinical trials. For example, the Multiple Risk Factor Intervential Trial, conducted to ascertain risk factors and develop recommendations for their amelioration or control, studied 12,000 men and no women. The Physicians' Health Study, well known for providing evidence that some heart attacks can be prevented by small amounts of aspirin, also excluded women. (The Framingham Heart Study, begun in Massachusetts in 1948, is a notable exception to this pattern, having included women in equal numbers with men throughout its history.) Partly due to the fact that women have been absent from documented studies, only recently has it been realized that many women suffer diffused chest pain and nausea during the onset of a heart attack and not the concentrated pain in the middle of the chest and accompanying pain in the left arm experienced by men, which is—not coincidentally—described in medical textbooks. Two recent studies indicate that, even if a woman's heart disease or heart attack symptoms receive proper diagnosis, the treatment she receives is less aggressive than that administered to a man. For example, emergency-room physicians administer clot-dissolving medications to female heart attack victims with only 50 percent of the frequency with which they administer such drugs to male heart attack victims. (These drugs include streptokinase, TPA, and aspirin; they prevent some of the damage a heart attack usually inflicts on the body during the first hours of survival.)

Another example of unequal consideration of women's health concerns is that women's symptoms were originally omitted from the Centers for Disease Control (CDC) definition of AIDS. Kaposi's sarcoma, a cancer, afflicts many men who have AIDS, while women are more likely to suffer from cervical cancer or pelvic inflammatory disease. During a congressional hearing on the subject held June 6, 1991, witnesses testified that—due to the male-biased definition—women dying of AIDS were being denied the Social Security disability benefits routinely granted to male AIDS victims. (In 1992 the definition was changed to include these female symptoms.)

The Society for the Advancement of Women's Health Research is a strong supporter of the WOMEN'S HEALTH EQUITY ACT and of fair treatment of women's health issues in any future national health care reform legislation. In the meantime, the National Institutes of Health has announced a $625 million Women's Health Initiative, a study of more than 160,000 women to take place over fourteen years and intended to compile information on women and cancer, heart disease, osteoporosis, and other medical conditions.

The society publishes the *Journal of Women's Health* and has issued several reports, including *Towards a Women's Health Research Agenda: Findings of the Scientific Advisory Meeting; Women's Health Research Opportunities and Strategies for Change;* and *Towards a Woman's Health Research Agenda: Findings of the 1991 Women's Health Research Roundtables.* Phyllis Greenberger is currently the society's executive director.

Further Reading: "Asking Why Heart Treatments Fail in Women," *New York Times,* March 18, 1993; Brennan, ed., *Women's Information Directory;* Brody, "Personal Health"; Henig, "Are Women's Hearts Different?"; Hilts, "AIDS Definition Excludes Women, Congress Is Told"; Kolata, "Study Finds Bias in Way Women Are Evaluated for Heart Bypasses"; ———, "Study Says Women Fail to Receive Equal Treatment for Heart Disease"; Leary, "Study of Women's Health Criticized by Review Panel."

Sontag, Susan (1933–)
Born on January 28, 1933, in Tucson, Arizona, Susan Sontag is a novelist, filmmaker, and an influential critic and essayist.

Sontag's family moved to a California suburb when she was thirteen years old. She graduated from North Hollywood High School at the age of fifteen and began her college education at the University of California at Berkeley. After her freshman year, she transferred to the University of Chicago, from which she graduated with a B.A. degree in philosophy in 1951. She did her graduate work, in English and philosophy, at Harvard University, receiving her M.A. and completing all requirements for a Ph.D. except the dissertation.

With a grant from the AMERICAN ASSOCIATION OF UNIVERSITY WOMEN, Sontag studied at the University of Paris from 1957 to 1958. She then settled in New York, teaching philosophy, for one year each at the City College of New York and Sarah Lawrence and then for four years at Columbia University.

Sontag's first novel, *The Benefactor,* was published in 1963. It relates the life story of an aging European man

in an experimental, modernist format. Her criticism began to appear in magazines and literary journals in 1963 as well. One of these essays, "Notes on Camp," earned something of a celebrity status for its author when it was published in fall 1964 issue of *Partisan Review* and reported upon as news in the December 1964 issue of *Time* magazine.

Against Interpretation, and Other Essays, a collection of twenty-six essays published by Sontag between 1962 and 1965, including "Notes on Camp," was published in 1966. In *Against Interpretation,* as in later works, Sontag urges an evaluation of art based less on moral content or societal context and more on its success as a sensory experience.

In addition to *The Benefactor* and *Against Interpretation,* Sontag has published numerous other works, including the novels *Death Kit* (1967), *The Volcano Lover* (1992), and *In America* (2000); a collection of short stories, *I, etcetera* (1972); and the nonfiction *Styles of Radical Will* (1969), *Trip to Hanoi* (1969), *On Photography* (1977); *Illness as Metaphor* (1978); *Under the Sign of Saturn* (1980); and *A Susan Sontag Reader* (1982).

Sontag was president of PEN American Center, the writers' organization, in 1987, and has received many honors, including nomination for the National Book Award in 1966, for *Against Interpretation, and Other Essays;* the National Institute and American Academy award for literature in 1976; and the National Book Critics Circle prize for criticism in 1978, for *On Photography.*

Susan Sontag lives in New York City.

Further Reading: *Contemporary Authors,* vol. 25; *Current Biography,* 1969; Sontag, *The Benefactor;* ———, *Against Interpretation, and Other Essays;* ———, *Death Kit;* ———, *I, etcetera.;* ———, *Styles of Radical Will;* ———, *Trip to Hanoi;* ———, *On Photography;* ———, *Illness as Metaphor;* ———, *Under the Sign of Saturn;* ———, *Susan Sontag Reader;* ———, *Volcano Lover.*

Sophia Smith Collection

The oldest American primary-source archive of women's history, the Sophia Smith Collection was established at Smith College in 1942 and named after Sophia Smith, founder of that college, in 1946.

Originally a repository for the works of women writers, the collection now includes diaries, letters, manuscripts, organizational records, periodicals, photographs, audiovisual materials, and relevant books by both women and men. The collection spans 6,000 feet of shelving and several hundred years of history. It contains more than 300 manuscript collections, including the papers of Margaret SANGER and Gloria STEINEM; organizational records, such as minutes and correspondence, of more than sixty organizations, including PLANNED PARENTHOOD FEDERATION OF AMERICA; and approximately 600 periodical titles. The collection is especially strong in the areas of the women's suffrage, birth control, peace, and modern women's movements.

The Sophia Smith Collection, together with the Smith College Archives, sponsors two annual grant programs: the Caroline D. Bain Scholar-in-Residence Award, and the Margaret Storrs Grierson Scholars-in-Residence Awards (the latter named in honor of the first director of the Smith Collection). The college also has a Travel to Collections Fund to assist researchers with expenses associated with visiting the Sophia Smith Collection.

Further Reading: Sophia Smith Collection. Available online: http://www.smith.edu/libraries/ssc/home.html.

Stanton, Elizabeth Cady (1815–1902) *women's rights leader, suffragist*

The first woman to run for election to Congress and the founder of the organized women's movement in the United States, Stanton was born Elizabeth Cady on

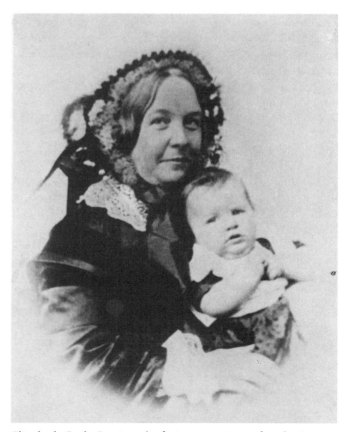

Elizabeth Cady Stanton, the first woman to run for election to Congress and the founder of the organized women's rights movement in the United States, with her daughter Harriot in 1856 (*Library of Congress*)

November 12, 1815, in Johnstown, New York, to Margaret Livingston Cady and Daniel Cady. She was educated first in a DAME SCHOOL and then at Emma WILLARD'S TROY FEMALE SEMINARY, from which she graduated in 1833. In 1840 she married Henry B. Stanton, with whom she had six children, Harriot Stanton BLATCH among them. She spent the first few years of her marriage reading law.

With Lucretia MOTT and several others, Stanton organized the SENECA FALLS CONVENTION in 1848, and she was the principal author of the women's movement's founding document, the DECLARATION OF RIGHTS AND SENTIMENTS. She met Susan B. ANTHONY in 1851, and the two quickly became close friends and working partners in the cause of women's rights.

In 1854 Stanton became the first woman to address the New York State Legislature, unsuccessfully urging that body to expand the New York State 1848 MARRIED WOMAN'S PROPERTY ACT. In February 1860 she again addressed the legislature. Her speech on that occasion, entitled "A SLAVE'S APPEAL," equated the legal situation of married women with that of slaves and was instrumental in convincing the legislature to pass AN ACT CONCERNING THE RIGHTS AND LIABILITIES OF HUSBAND AND WIFE on March 10, 1860.

During the Civil War, Cady Stanton and Anthony founded the NATIONAL WOMAN'S LOYAL LEAGUE to collect petitions in favor of the Thirteenth Amendment, outlawing slavery throughout the United States. After the war they split with their former abolitionist colleagues, refusing to support the FOURTEENTH and FIFTEENTH AMENDMENTS because neither one included women's suffrage. Stanton became the first woman to run for election to Congress in 1866. She founded the NATIONAL WOMAN SUFFRAGE ASSOCIATION (NWSA) with Anthony in 1869; she served as its president through most of its existence and for the two years after it merged with the AMERICAN WOMAN SUFFRAGE ASSOCIATION (AWSA) in 1890.

In 1895, in an effort to fight sexism at what she believed to be its source, she published *THE WOMAN'S BIBLE*. The book refuted, point by point, the common interpretation of the Bible as sanctioning women's subordination and was quite controversial.

Elizabeth Cady Stanton died in New York City on October 26, 1902.

Further Reading: Banner, *Elizabeth Cady Stanton;* Cullen-DuPont, *Elizabeth Cady Stanton;* Dubois, *Elizabeth Cady Stanton/Susan B. Anthony;* Frost and Cullen-DuPont, *Women's Suffrage in America;* Griffith, *In Her Own Right;* Stanton, *The Woman's Bible;* ———, *Eighty Years and More;* Stanton, Anthony, and Gage, eds., *History of Woman Suffrage;* Stanton and Blatch, *Elizabeth Cady Stanton.*

Stanton v. Stanton (1975)

The 1975 Supreme Court decision in this case struck down, on Fourteenth Amendment grounds, a Utah law requiring parental support for male children until age twenty-one while ending the required support of female children at age eighteen. Only Justice William H. Rehnquist dissented. The opinion, written by Justice Harry Blackmun, contains a sweeping invalidation of a law that was based largely on the idea that males are more in need of opportunities for higher education than females:

The test here . . . is whether the difference in sex between children warrants the distinction in the appellee's obligation to support that is drawn by the Utah statute. We conclude that it does not. It may be true as the Utah court observed and is argued here, that it is the man's primary responsibility to provide a home and that it is salutary for him to have education and training before he assumes that responsibility; that girls tend to mature earlier than boys; that females tend to marry earlier than males . . .

Notwithstanding the "old notions" to which the Utah court referred, we perceive nothing rational in the distinction drawn by [the statute] which, when related to the divorce decree, results in the appellee's liability for support for Sherri only to age 18 but for Rick to age 21 . . . A child, male or female, is still a child. No longer is the female destined solely for the home and the rearing of the family and only the male for the marketplace and the world of ideas. See *Taylor v. Louisiana.* Women's activities and responsibilities are increasing and expanding. Coeducation is a fact, not a rarity. The presence of women in business, in the professions, in government, and, indeed, in all walks of life where education is desirable, if not always a necessary antecedent, is apparent and a proper subject of judicial notice. If a specified age of minority is required for the boy in order to assure him parental support while he attains his education and training, so, too, it is for the girl. To distinguish between the two on educational grounds is to be self-serving: if the female is not to be supported so long as the male, she hardly can be expected to attend school as long as he does, and bringing her education to an end earlier coincides with the role-typing society has long imposed. And if any weight remains in this day in the claim of earlier maturity of the female, with a concomitant inference of absence of need for support beyond 18, we fail to perceive its unquestioned truth or its significance, particularly when marriage, as the statute provides, terminates minority for a person of either sex.

Further Reading: Cary and Peratis, *Woman and the Law;* Cushman, *Cases in Constitutional Law;* O'Connor, "Women and the Constitution," in *Women, Politics and the Constitution,* ed. Lynn; *Stanton v. Stanton,* 1975. 421 U.S. 7; *Taylor v. Louisiana,* 1975. 419 U.S. 522.

Stein, Gertrude (1874–1946) *writer*
Born on February 13, 1874, in Allegheny, Pennsylvania, to Amelia Keyster Stein and Daniel Stein, Gertrude Stein was the author of almost 600 novels, poems, biographies, essays, plays, opera librettos, and other literary works.

Stein's childhood was spent in Oakland, California, and punctuated by extensive stays in Austria and France. Both of her parents died while Stein was still a teenager, but an older brother, Leo, provided familial support.

Stein attended the Society for the Collegiate Instruction of Women (later Radcliffe College), from which she graduated in 1898. She then attended Johns Hopkins Medical School, where she was a brilliant but undisciplined student. In 1902 she left without a degree and moved to London with Leo; in 1903 the two moved to Paris, where they became important collectors of the work of Cézanne, Gauguin, Manet, Matisse, Picasso, and others. It was at this time that Stein met Alice B. Toklas. The two became lovers, began living together in 1909, and remained together until Stein's death, almost forty years later.

While some argue that Stein was more important as a champion of modern art—or even as a celebrity figure—than as a writer, she has always had a coterie of readers. (Among her admirers have been John Ashbery, Samuel Beckett, John Cage, and Edith Sitwell.) Interested as much in the sound of words as in their meanings, she created what she viewed as the written counterparts to the painters' abstractions. Most of her work was published in literary journals or by private arrangement, and a number of works were published years after completion or even posthumously.

Q. E. D., Stein's first full-length work, examines a lesbian love triangle; written in 1903, it was published under the title *Things as They Are* in 1950.

Between 1903 and 1911 Stein wrote *The Making of Americans; or, The History of a Family's Progress,* a thousand-page novel intended to provide a history of every American "who ever can or is or was or will be living," set in "a space of time that is always filled with moving." Published in 1925, the novel was considered inaccessible by many but praised as a masterpiece by Ernest Hemingway, among others.

In 1909, while *The Making of Americans* was in progress, Stein's *Three Lives* was published privately. The volume contains three stories, "The Good Anna," "The Gentle Lena," and "Melanctha," each of which rests on the concerns of an economically disadvantaged woman. "Melanctha" depicts, at least on its surface, a young mulatto woman's relationship with an African-American physician—Stein's empathetic rendering of African-American characters was considered groundbreaking at the time.

Stein's best-known work is perhaps *The Autobiography of Alice B. Toklas.* Published in 1933, the book is easily her most accessible work. Its subject is, famously, as much Stein as Toklas.

Among Stein's other works are *Tender Buttons* (1914), *Geography and Plays* (1922), *Composition as Explanation* (1926), *Operas and Plays* (1932), *Lectures in America* (1935), *The Geographical History of America; or, the Relation of Human Nature to the Human Mind* (1936), and *Wars I Have Seen* (1945). Her last major work was an opera about Susan B. ANTHONY, entitled *The Mother of Us All* (1945–46), for which Virgil Thompson composed the music.

As reported by Toklas, Stein's last conversation was a characteristic one. Regaining consciousness for just a few moments following surgery for advanced stomach cancer, Stein demanded to know "What is the answer?" Receiving no answer from those assembled, she said, "In that case, what is the question?" Before a response could be offered, she fell into a coma. Later that day, on July 19, 1946, and in Neuilly-sur-Seine, France, Gertrude Stein died.

Further Reading: Brinnin, *Third Rose;* Day, "Gertrude Stein," in *Notable American Writers,* ed. James, James, and Boyer; Faust, ed., *American Women Writers;* McHenry, ed., *Famous American Women;* Mellow, *Charmed Circle;* Showalter, Baechler, and Litz, eds. *Modern American Women Writers;* Stein, *Three Lives;* ———, *Autobiography of Alice B. Toklas;* ———, *Lectures in America;* ———, *Selected Writings of Gertrude Stein;* ———, *Fernhurst, Q. E. D. and Other Early Writings;* Weinstein, *Gertrude Stein and the Literature of the Modern Consciousness.*

Steinem, Gloria (1934–) *feminist, writer, publisher*
Called "the leading icon of American feminism" by *Time* magazine, Gloria Steinem was born on March 25, 1934, in Toledo, Ohio, to Ruth Nuneviller Steinem and Leo Steinem. She is also the granddaughter of feminist Pauline Steinem, who was a delegate to the International Council of Women (1908) and president of the Ohio Women's Suffrage Association (1908–11). Steinem's mother, who had once been a newspaper reporter, was an invalid during Steinem's childhood. Her parents divorced, and Steinem became her mother's caretaker. She attended school only sporadically in her first ten or twelve years and lived with her older sister, Susanne, during her last year of high school. When Steinem was admitted to Smith College in 1952, her mother sold the family's Toledo home in order to finance her daughter's education. Steinem majored in government and received her B.A. with honors in 1956.

Steinem began her writing career in 1960 but did not receive her first by-line until 1962, in *Esquire* magazine. The following year she wrote what became a widely read exposé of life as a "Playboy bunny" and immediately

became a frequent contributor to national women's magazines. When *New York* magazine was founded in 1968, Steinem was invited to become a contributing editor and soon had her own column, "The City Politic."

In 1968—for research purposes—Steinem attended a meeting of REDSTOCKINGS, a New York City feminist organization that later described its purpose as "publicly exposing the sexist foundation of all our [country's] institutions." She wrote an award-winning story and also joined the women's rights movement

In 1970 Steinem helped BETTY FRIEDAN organize the WOMEN'S STRIKE FOR EQUALITY. Two years later, *Ms.* magazine was founded with Steinem as its editor. Its first issue contained articles such as "Down With Sexist Upbringing" and a list of fifty noteworthy women—including Steinem—who publicly admitted to having abortions. The magazine eventually was sold for financial reasons and closed by its new, corporate publisher in 1990. It was resurrected that same year as an advertising-free, 100 percent reader-supported bimonthly, with Steinem as consulting editor. It had another corporate owner between 1996 and 1998, after which it again faced discontinuation. Steinem and other feminists responded by forming a nonprofit company, Liberty Media, to purchase the magazine. This latest incarnation of *Ms.* resumed publication in April 1999.

Steinem published *Outrageous Acts and Everyday Rebellions* in 1983, *Marilyn: Norma Jeane* in 1986, and *Revolution From Within: A Book of Self-Esteem* in 1992. She was a cofounder and board member of the Women's Action Alliance, a founding member of the Coalition of Labor Union Women, and is a member of the NATIONAL WOMEN'S POLITICAL CAUCUS' National Advisory Committee.

In a recent *Time* magazine interview, Steinem was asked why women should call themselves feminists. Her response? "[I]f you're a woman," she said with a laugh, "the only alternative is being a masochist."

Gloria Steinem is presently the chair of Liberty Media. She lives in New York City.

Further Reading: Associated Press, December 1, 1998; Attinger, "Steinem: Tying Politics to the Personal"; Gibbs, "War Against Feminism"; *Newsweek,* December 14, 1998; Steinem, *Revolution from Within;* ———, interview with Lenny Lopate, broadcast on WNYC on January 23, 1992.

Stewart, Maria W. Miller (1803–1879) *women's rights leader, abolitionist*
One of the earliest American women to speak publicly in favor of increased women's rights and abolition, Stewart was born Maria W. Miller in 1803 in Hartford, Connecticut, to African-American parents whose first names are

unknown. Orphaned at five, Maria grew up in the service of a local clergyman. She received no formal education but was allowed to read books in the clergyman's library. On August 10, 1826, she married James W. Stewart; she was widowed three years later.

Stewart made four public speeches at a time when only Frances Wright had previously dared to speak in public. When she spoke at the Franklin Hall in Boston on September 21, 1832, she exhorted her audience of free African-American women to do without every nonessential item in order to secure an education for their children and themselves. "Oh do not say, you cannot make anything of your children," she began, "but say, with the help of God, we will try . . . Let us make a mighty effort and arise. Let every female heart become united, and let us raise a fund ourselves; and at the end of one year and a half, we might be able to lay the corner-stone for the building of a High School . . ." Stewart, like Wright, met with criticism and ridicule for stepping out of what were considered feminine bounds. She answered her detractors:

> What if I am a woman; is not the God of ancient times the God of these modern days? Did he not raise up Deborah to be a mother and a judge in Israel? . . . If such women as are here described once existed, be no longer astonished then . . . that God at this eventful period shall raise up your own females to strive by their example, both in public and in private, to assist those who are endeavoring to stop the strong current of prejudice . . .

Stewart attracted little support, and on September 21, 1833, she made her "Farewell Address." In it she reported with evident regret, "I find it is not useful for me, as an individual, to try to make myself useful among my color in this city . . . I have made myself contemptible in the eyes of many."

Stewart's collected speeches were published by William Lloyd Garrison in 1835 as the *Productions of Mrs. Maria W. Stewart* and, in a second edition, published by Stewart herself in 1879, as *Meditations from the Pen of Mrs. Maria W. Stewart.*

Maria W. Miller Stewart died in Washington, D.C. on December 17, 1879.

Further Reading: Flexner, "Maria W. Miller Stewart," in *Notable American Women,* ed. James, James, and Boyer; ———, *Century of Struggle;* Sterling, *We Are Your Sisters.*

Stone, Lucy (1818–1893) *abolitionist, suffragist, founder of the American Woman Suffrage Association, supporter of women's rights*
Lucy Stone was born on August 13, 1818, on a farm just outside of West Brookfield, Massachusetts. She began to

think about women's rights while still a young girl. Her parents, Francis Stone and Hannah Matthews Stone, had nine children, seven of whom survived. Witnessing her mother's overwhelming domestic burdens filled Lucy with anger and pity—from the time she was twelve years old, she woke early enough to do some of her mother's chores before leaving for school.

Stone did not participate in other activities assigned to women, however. At the time, it was common for girls to join sewing circles. The garments they made were sold, and the monies received were made into contributions toward the tuition fees of young men studying to become ministers. (Since there was money involved, these sewing circles were required to have male treasurers.) Lucy Stone joined but decided she couldn't finish the shirt she'd begun—"Let these men with broader shoulders and stronger arms earn their own education," she said, "while we use our scantier opportunities to educate ourselves." Though frequently going hungry in the process, she attended OBERLIN COLLEGE and graduated with honors in 1847. She worked as a lecturer in the abolitionist movement, addressing threatening mobs and promiscuous audiences with a clear, sweet voice. But her equal concern for women was present from the start. As she wrote to her mother, "I expect to plead not only for the slave, but for suffering humanity everywhere. ESPECIALLY DO I MEAN TO LABOR FOR THE ELEVATION OF MY SEX."

The WORCESTER WOMEN'S RIGHTS CONVENTION of 1850 was the first she attended, and it marked the beginning of a long career devoted to the emancipation of women. When she and Henry Blackwell married in 1855, they incorporated a protest of the marriage laws into the ceremony. (See MARRIAGE PROTEST OF LUCY STONE AND HENRY BLACKWELL.) Lucy Stone kept her name, and Henry Blackwell joined her fight on behalf of women.

In 1858 Stone allowed her property to be seized rather than pay taxes to a government in which she was not represented. During the Civil War, she was a member of the NATIONAL WOMAN'S LOYAL LEAGUE; afterward, she was an officer of the AMERICAN EQUAL RIGHTS ASSOCIATION. When women's rights leaders divided across lines of support for and opposition to the FOURTEENTH and FIFTEENTH AMENDMENTS, Stone founded the AMERICAN WOMAN SUFFRAGE ASSOCIATION (1869) which supported both amendments despite the exclusion of women's suffrage and other rights. She also founded the WOMAN'S JOURNAL, endured great financial hardship to keep it in existence, and, with Mary Livermore, Henry Blackwell, and, eventually, her daughter Alice Stone BLACKWELL, acted as its editor. When the two factions of the women's rights movement merged their organizations, Stone became executive committee chairperson of the NATIONAL AMERICAN WOMAN SUFFRAGE ASSOCIATION.

Lucy Stone died in Boston on October 18, 1893.

Further Reading: Filler, "Lucy Stone," in *Notable American Women*, ed. James, James, and Boyer; Flexner, *Century of Struggle;* Lasser and Merrill, eds., *Friends and Sisters;* Stanton, Anthony, and Gage, eds., *History of Woman Suffrage*, vol. 1; Wheeler, ed., *Loving Warriors.*

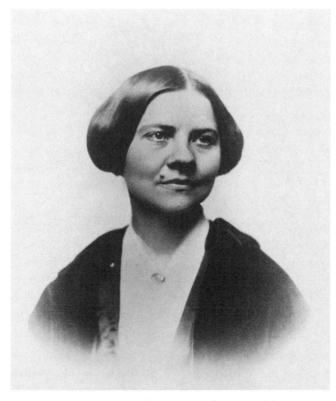

Lucy Stone, abolitionist, suffragist, and founder of the American Woman Suffrage Association (*Library of Congress*)

Stowe, Harriet Beecher (1811–1896) *writer, abolitionist*

The author of approximately three dozen works, including *Uncle Tom's Cabin*, Harriet Beecher Stowe was born Harriet Beecher on June 14, 1811, in Litchfield, Connecticut, to Roxana Foote Beecher and the prominent minister Lyman Beecher. When Harriet was four years old, her mother died; her sister Catharine BEECHER joined her father in caring for the younger children until Harriet Porter Beecher became Lyman's second wife and Harriet's stepmother.

Harriet was educated at a renowned girls school run by Sarah Pierce in Litchfield and then in Catharine Beecher's seminary in Hartford. She had published a sketch entitled "Uncle Lot" and a geography book

(under her sister Catharine's name) by the time she married Calvin Ellis Stowe, a theology professor and minister, on January 6, 1836. Between 1836 and 1840, Harriet Beecher Stowe bore four children, the first two of whom were twins. Although she wrote to a friend that she felt during this time like "a mere drudge with few ideas beyond babies and housekeeping," she continued to write and publish on a sporadic basis. *The Mayflower*, a collection of her stories, was published by Harper & Brothers in 1843. Her husband, supportive of her efforts and recognizing her talent, told her in 1842—just prior to the *Mayflower*'s publication—that "God has written it in His book that you must be a literary woman, and who are we that we should contend against God?" The time and energy for sustained writing was not soon available, however. Stowe's fifth child was not strong when born and nearly died, and Stowe herself did not recover from this pregnancy and delivery for several months. Her sixth child was born in the winter of 1849 but died during the summer. Stowe was pregnant for the seventh time when the family, prompted by Calvin Stowe's acceptance of a professorship at Bowdoin College, settled in Brunswick, Maine.

Following this move and the birth of her seventh child, this one healthy, Harriet Beecher Stowe seemed to regain her former energies, and it was during this time that *Uncle Tom's Cabin* originated. Stowe—and, indeed, her entire family—had long had strong antislavery sentiments. In 1849, during the summer of her infant son's illness and death, Stowe felt she added to her abolitionism the very personal and acutely painful knowledge of "what a poor slave mother may feel when her child is torn from her." This maternal empathy, combined with her outrage over the 1850 Fugitive Slave Law (which ordered the return of escaped slaves to their masters and made helping or harboring them a crime), inspired what was to become America's most famous antislavery novel. *Uncle Tom's Cabin* appeared in *The National Era* in serial form during 1851 and 1852. *Uncle Tom's Cabin, or Life Among the Lowly* was published in book form in 1852 and sold 350,000 copies in its first year. It so helped to galvanize the abolition movement that President Abraham Lincoln, upon meeting Harriet Beecher Stowe during the Civil War, reportedly exclaimed, "So you're the little woman who wrote the book that started this great war!"

Stowe's other books that center on abolitionist themes include *A Key to Uncle Tom's Cabin*, a collection of evidence to support the treatment of slaves depicted in the novel (1853), and another novel, *Dred: A Tale of the Great Dismal Swamp* (1856). Other novels, most notably *The Minister's Wooing* (1859), *Agnes of Sorrento* (1862), *The Pearl of Orr's Island* (1862), and *Oldtown Folks* (1869), depict women as vehicles of spiritual redemption. She also coauthored *The American Woman's Home* (1869) with her sister Catharine. *Poganuc People*, published in 1878 and perhaps the most autobiographical of Stowe's novels, was the author's final work.

Harriet Beecher Stowe died in Hartford, Connecticut on July 1, 1896.

Further Reading: Cross, "Harriet Beecher Stowe," in *Notable American Women*, ed. James, James, and Boyer; Faust, ed., *American Women Writers*; Gilbert and Gubar, eds., *Norton Anthology of Literature by Women*; Hedrick, *Harriet Beecher Stowe*; McHenry, ed., *Famous American Women*; Stowe, *Harriet Beecher Stowe*; Stowe, *Uncle Tom's Cabin*; ———, *Key to Uncle Tom's Cabin*; ———, *Household Papers and Stories*; Wilson, R. F., *Crusader in Crinoline*.

Strauder v. West Virginia (1880)

The 1880 Supreme Court decision in this case reconfirmed that an African American had the right to be tried by a jury open to black jurors and upheld West Virginia's law barring women from serving as jurors. The finding that states were entitled to "confine the selection to males" was not overturned until the Supreme Court's 1975 decision in *Taylor v. Louisiana*.

Further Reading: Cary and Peratis, *Woman and the Law*; Cushman, *Cases in Constitutional Law*; O'Connor, "Women and the Constitution," in *Women, Politics and the Constitution*, ed. Lynn; *Strauder v. West Virginia*, 1880. 100 U.S. 303; *Taylor v. Louisiana*, 1975. 419 U.S. 522.

Szold, Henrietta (1860–1945) *teacher, translator, editor, Jewish leader*

Born on December 21, 1860, in Baltimore, Maryland, to Sophia Schaar Szold and Benjamin Szold, Henrietta Szold became an important Zionist leader and founder of the Hadassah organization.

Benjamin Szold, a rabbi, educated his daughter according to the standards more customarily set for sons. Henrietta Szold graduated first in her class from Baltimore's Western Female High School in 1877, by which time, with her father's help, she had become fluent in German, French, and Hebrew and acquired a thorough knowledge of the Talmud, the authoritative body of Jewish tradition.

Szold became a teacher at Baltimore's exclusive school for girls, Misses Adams' School, a position she retained for fifteen years. At the same time, she taught religious classes at her father's synagogue. In 1889, responding to the needs of Jewish immigrants fleeing the pogroms that erupted in the Russian Empire following

the 1881 assassination of Czar Alexander II, Szold organized night classes to teach English and familiarize the newcomers with American history and customs. (Non-Jewish immigrants also were welcomed.) Her program was one of the first such efforts, and it served as a model for similar programs in other American cities.

In 1893 Szold became a member of what is believed to have been the first Zionist society in America, the Hebras Zion. In that year she also became the editorial secretary of the Jewish Publication Society. In that position, which she retained for twenty-three years, Szold was responsible for most of the translation and editing of Heinrich Graetz's five-volume *History of the Jews,* Moritz Lazarus' *The Ethics of Judaism,* Nahum Slouschz's *The Renascence of Hebrew Literature,* among other works. In 1899, Szold was largely responsible for the compilation and publication of the *Jewish Year Book;* from 1904 to 1908 she was the publication's sole editor.

In 1907 Szold joined the Hadassah Study Circle, a group that met to study Jewish history and explore Zionism. Traveling to Palestine in 1909, Szold became thoroughly convinced that a Jewish homeland should be created there. To work toward this end, in 1910 she became secretary of the Federation of American Zionists. In Palestine, Szold also had been moved by the plight of severely ill children without access to modern medical care. With other women from the Hadassah Study Circle, she founded in 1912 the Jewish women's voluntary organization HADASSAH, which immediately began to bring advanced medical care to people of all religious backgrounds in the region.

In order to relieve Szold of the necessity of earning her living, Zionist leaders—including, most notably, Justice Louis D. Brandeis and Judge Julian W. Mack—raised funds sufficient to provide her with a lifetime income. She resigned from the Jewish Publication Society in 1916 at the age of fifty-six and redoubled her efforts on behalf of Zionism.

In 1918 American Zionists met in Pittsburgh and joined together in one national organization, the Zionist Organization of America. Szold was named director of its education department. In the same year she was instrumental in organizing the American Zionist Medical Unit, which sent forty-four medical professionals and administrators, plus 400 tons of medical and other supplies, to Palestine under the auspices of Hadassah, the Zionist Organization of America, and the American Jewish Joint Distribution Committee.

Szold went to Palestine in 1920, where she served on the executive committee of the American Zionist Medical Unit. (The unit became the Hadassah Medical Organization in 1922.) There she organized and became the first president of Histadrut Nashim Ivriot (the League of Jewish Women), which brought women's philanthropic and welfare organizations throughout Palestine.

She returned to the United States in 1923, where she resumed the active management of Hadassah.

Szold resigned as Hadassah's president in 1926 and was named the organization's honorary president, a title she held until her death. The following year, at the age of sixty-seven, Szold attended a meeting of the World Zionist Organization in Basel and was named one of three members of the Palestine Zionist Executive Committee. She returned to Palestine to supervise the committee's department of health and education in 1927 and remained there for the rest of her life, except for 1930, which she spent in the United States, and a brief 1937 trip.

Szold was elected to serve on the Vaad Leumi, the executive committee of the Knesset Israel (the Palestinian Jewish National Assembly), from 1931 to 1933. From 1933 on she was particularly involved in projects designed to safeguard Jewish youth: In 1933 she became director of Hadassah's Youth Aliyah project, which helped 30,000 Jewish children escape from Germany between 1934 and 1948; on her eightieth birthday in 1940, she founded a child welfare and research institution, Lemaan ha-Yeled, which was later renamed Mosad Szold (the Szold Foundation) in her honor. She also was one of several prominent Zionists to press for a dual Jewish-Arab national identity for Palestine and empathy for Palestinian Arabs. (Hebrew University president Judah Magnes and philosopher Martin Buber were others.)

Szold received many honors, including the Jewish Institute of Religion's honorary degree, the Doctor of Hebrew Letters, in 1930 (the first time a woman was so honored) and Boston University's honorary degree of Doctor of Humanity, conferred in acknowledgment of a lifetime of service.

Henrietta Szold died on February 13, 1945, in the Hadassah-Hebrew University Hospital in Jerusalem.

Further Reading: Fineman, *Woman of Valor;* Herzberg, "Henrietta Szold," in *Notable American Women,* ed. James, James, and Boyer; McHenry, ed., *Famous American Women.*

T

Take Our Daughters to Work Day

An initiative of the Ms. Foundation for Women, the first Take Our Daughters to Work Day took place on April 28, 1993. On that date, mothers, fathers, or other "caring adults" took more than 1 million daughters along to work, hoping that the experience would better enable the girls to envision themselves as grown, productive women.

The idea was first suggested by Nell Merlino at the Ms. Foundation. It was formulated and announced as a New York area project, and organizers originally expected up to 500,000 participants. Word spread, however, and the foundation received between 300 and 400 inquiries a day during the three months prior to the event. On April 28 more than 1 million girls were welcomed by corporations in each of the fifty states, including ABC News, American Express, Chase Manhattan Bank, the Chicago Mercantile Exchange Center, the Ford Motor Co., Hewlett Packard, IBM, Inland Steel, NASA's Johnson Space Center, Merrill Lynch, NYNEX Corporation, the *New York Times,* Penguin USA, the Saturn Corporation, the U.S. Department of Health and Human Services, the U.S. Senate, and the United Nations.

Many corporations devised specific programs for their visitors. The publishing company Penguin USA, for example, asked its employees to register their daughters in advance. In anticipation of the day, each of the girls received a letter of welcome from Shelley Sadler, director of human resources, along with an agenda of the day's events. On April 28 the girls were welcomed by John Moore, Penguin's president and chief operating officer. Next the girls received an overview of the publishing industry, including an explanation of corporate structure; an explanation of the publishing process, facilitated by discussion of a specially prepared "flow chart"; and a panel discussion entitled "Working in the Publishing Industry," in which female employees offered insight into the requirements and rewards of their work.

An automobile manufacturing plant for Saturn Corporation located in Tennessee also participated. This company scheduled two Take Our Daughters to Work sessions in order to accommodate both day- and night-shift employees and their daughters. More than eighty girls participated, prompting one Saturn Corporation official to write to the foundation: "it was a tremendous success . . . We view this event as a positive step to emphasize diversity efforts within the organization, to support families to do the right things for their children, and to encourage career development for women long-term."

In addition to expanding the horizons of the girls themselves, Take Our Daughters to Work Day attracted nationwide media attention and prompted wide-scale debate of issues affecting girls.

In recent years, the day has also attracted some criticism from school boards and administrators who face disrupted attendance, as well as from parents who feel that boys are slighted on that day. However, a poll conducted in 1999 for Roper Starch Worldwide reveals that the day elicits largely positive responses: Eight in ten adults believe the day broadens girls' expectations; three in ten employed adults have brought a girl to work since the day's inception; and one-third of U.S. companies make accommodations for the day. Take Our Daughters to Work Day is now celebrated in England as well.

Further Reading: Chicago Tribune, April 6, 1997 and May 21, 1999; *Detroit News,* April 21, 1999; *The Guardian,* April 24, 1999; Sadler, letter to Ms. Deborah Greig, April 27, 1993 (courtesy Ms. Deborah Greig); Wilson, President of the Ms. Foundation for Women, letter to NOW membership, June 1993; *New York Newsday,* April 29, 1993; *New York Times,* April 29, 1993, p. 1; *USA Today,* April 29, 1993, p. 1; *Wall Street Journal,* April 29, 1993.

Tarbell, Ida (1857–1944) *writer, journalist, social reformer*

Born on November 5, 1857, in Erie County, Pennsylvania, to Esther Ann McCullough Tarbell and Franklin Sumner Tarbell, author and journalist Ida Tarbell was an early "muckraker"—one who used the written word to expose corruption.

Tarbell attended public schools in Titusville, Pennsylvania, and then Allegheny College, from which she graduated in 1880. She taught at the Poland (Ohio) Union Seminary for two years and then, in 1883, joined the staff of the *Chautauquan* magazine, where she worked for eight years.

Tarbell went to Paris in 1891, where she studied the part played by women in the French Revolution. While in France, Tarbell contributed articles to *Scribner's, McClure's,* and other American periodicals. She gained national recognition in the United States for her interviews with Alexandre Dumas, Louis Pasteur, and others, and was persuaded to return to America as a staff member of *McClure's* in 1894. Her articles for *McClure's* about Napoleon Bonaparte and Abraham Lincoln were collected and published in book form, in 1895 and 1900, respectively. Her work on Abraham Lincoln brought forward new evidence, since Tarbell was one of the earliest writers to try to present the facts, rather than the legends, of Lincoln's life. Other works from this time include the *Life of Madame Roland* (1896), which grew out of her investigation of women during the French Revolution, and, with Charles A. Dana, the *Recollections of the Civil War* (1898).

Tarbell's most famous work—and the work that perhaps had the most influence on her fellow journalists—was *The History of the Standard Oil Company,* published serially in *McClure's* beginning in 1902 and in book form in 1904. During her childhood, Tarbell had witnessed the effect of Standard Oil's consolidation of power on her county's independent producers, many of whom (including her father) went out of business. Although she was not the first writer to criticize Standard Oil (Henry D. Lloyd had published *Wealth Against Commonwealth* in 1894), she was the first to combine a carefully researched condemnation of the company's practices with an obviously heartfelt indignation. The book was an instant sensation.

Other reputable writers, including Upton Sinclair, Lincoln Steffens, and Ray Stannard Baker, had also begun turning their talents to expose corruption. They and Tarbell received the appellation by which they would ever after be known when an exasperated President Theodore Roosevelt likened them to the "Man with the Muckrake," in *Pilgrim's Progress.*

Baker, Tarbell, Steffens, and other writers purchased the *American Magazine* in 1906, which they edited on a cooperative basis until 1915, when they sold the magazine. Tarbell's *The Tariff in Our Times,* published in book form in 1911, originated as a series of articles for the *American Magazine.*

Despite Tarbell's reputation as an opponent of big business, she studied the methods of Henry Ford and Frederick W. Taylor and presented them as models worth emulating in *New Ideals in Business* (1916). She also wrote even-handed biographies of business leaders Elbert H. Gary (1925) and Owen D. Young (1932).

Tarbell was an active member of several committees and organizations, including the Woman's Committee of the United States Council of National Defense during World War I; President Woodrow Wilson's Industrial Conference in 1919; and President Warren G. Harding's Conference on Unemployment in 1921. Deeply interested in the peace movement, she was gratified to attend both the Paris Peace Conference and the Washington Naval Disarmament Conference as a journalist after World War I ended.

Tarbell, a strong supporter of the women's rights movement in her youth, seems to have altered her position once her own opportunity to become a mother had passed. In *The Business of Being a Woman,* she referred to marriage and maternity as "a business assigned by nature and society which was of more importance than public life." Her autobiography, *All in the Day's Work* (1939), also contains evidence that, in the end, she regretted focusing so exclusively on her career.

Ida Tarbell died on January 6, 1944, in Bridgeport, Connecticut.

Tarbell was inducted into the NATIONAL WOMEN'S HALL OF FAME in 2000.

Further Reading: Brady, *Ida Tarbell;* Chalmers, "Ida Tarbell," in *Notable American Women,* ed. James, James, and Boyer; Clark, *Almanac of American Women in the 20th Century;* Faust, ed., *American Women Writers;* McHenry, ed. *Famous American Women;* Tarbell, *Life of Abraham Lincoln;* ———, *History of the Standard Oil Company;* ———, *Tariff in Our Time;* ———, *Business of Being a Woman;* ———, *All in a Day's Work.*

Taussig, Helen Brooke (1898–1986) *physician, scientist*

Born on May 24, 1898, in Cambridge, Massachusetts, to Edith Guild Taussig and Frank William Taussig, physician, physiologist, and embryologist Helen Brooke Taussig helped devise the Blalock-Taussig surgical technique, the operation that has saved the lives of many thousands of infants since its introduction in 1945.

Taussig, whose father was a Harvard economics professor and whose mother was among Radcliffe's early

graduates, received her early education at the Cambridge School for Girls, from which she graduated in 1917. She began her college studies at Radcliffe, where she both excelled in her studies and became a tennis champion. Following her sophomore year, Taussig transferred to the University of California at Berkeley, from which she graduated in 1921.

Wishing to enter the field of public health, Taussig applied for admission to Harvard University. She was informed that only students who had studied medicine for two years were eligible for entry into Harvard's public health program and that the Harvard Medical School did not admit women. In an attempt to find a way around this barrier, Taussig asked for and gained admission as a "special student," permitted to study half the curricula on an informal basis. However, she soon lost patience with this approach and transferred to Boston University Medical School. There she began to specialize in the human heart and was advised by Dr. Alexander Swanson Begg, the school's dean, to complete her studies at Baltimore's Johns Hopkins Medical School. Taussig thereupon entered her third and final medical school. Prior to her graduation in 1927, she published her first paper on the human heart.

In 1928 Taussig became an Archibald fellow at Johns Hopkins Hospital's heart station and began an internship in pediatrics, which lasted until 1930. She was then named head of Johns Hopkins' pediatrics division, the Children's Heart Clinic of Harriet Lane Home. She remained at Johns Hopkins until her retirement in 1963, becoming associate professor of pediatrics in 1946 and becoming the first female full professor at Johns Hopkins in 1959. In another "first," Taussig was elected the first female president of the American Heart Association in 1965.

Taussig is best known for discovering that the pulmonary stenosis present and causing cyanosis in so-called blue babies (most of whom died shortly after birth) is caused by a leaky septum and an especially small and narrow artery leading from the heart to the lungs, and for devising a surgical strategy to aid these children, which she described as "the building of an artificial ductus arteriosus for children dying of anoxemia." Vascular surgeon Dr. Alfred Blalock and his assistants worked on dogs for eighteen months to perfect Taussig's suggested operation before operating on the first human child on November 9, 1944. As described in *Newsweek,* the operation was performed upon a sixteen-month-old baby girl. Although the child died nine months later, the second to receive the operation survived to become a normal, healthy child. Literally thousands of babies around the world have since been saved by the use of the Blalock-Taussig surgical procedure.

Taussig was also the central figure in America's avoidance, to a large degree, of the thalidomide-induced birth defects seen in Europe in the 1960s. Learning from a German student that the sleeping pill was becoming suspect, Taussig went to Germany in 1961 to conduct her own investigation. Upon her return to the United States, she successfully urged the Food and Drug Administration to ban the sale of thalidomide. She later testified before a Senate committee and helped to secure passage of more stringent laws regarding the testing and availability of drugs.

Taussig published *Congenital Malformations of the Heart* in 1947 and received numerous honors and awards, including the Women's National Press Club Award (1947); Chevalier, Legion d'Honneur (1947); American Heart Association's Award of Merit (1957); the Eleanor Roosevelt Achievement Award (1957); and the highest civilian honor an American president can confer, the Medal of Freedom, from President Lyndon B. Johnson in 1964. Asked in that year to comment upon her work, Taussig said simply, "Everybody enjoys feeling he can contribute. It is the greatest feeling in the world—whether one contributes to the family, community, or country."

Helen Brooke Taussig died in an automobile accident on May 20, 1986, near Kennett Square, Pennsylvania.

Further Reading: Clark, *Almanac of American Women in the 20th Century; Current Biography,* 1946, 1966, and 1986; McHenry, ed., *Famous American Women; New York Times,* May 22, 1986.

Taylor v. Louisiana (1975)

The 1975 Supreme Court decision in this case struck down a Louisiana statute exempting women from jury service. The challenge was brought by an African-American male who, once tried and convicted, claimed that Louisiana's law had violated his Sixth Amendment rights because it had resulted in a jury that was not "drawn from a cross-section of the community."

The decision, delivered by Justice Byron White, stated in part:

> . . . If it was ever the case that women were unqualified to sit on juries or were so situated that none of them should be required to perform jury service, that time has long since past. If at one time it could be held that Sixth Amendment juries must be drawn from a fair cross section of the community but that this requirement permitted the almost total exclusion of women, this is not the case today.

The decision referred to its own earlier view of female jury service in a footnote:

> . . . In *Hoyt v. Florida* [1961], the Court placed some emphasis on the notion, advanced by the State there and by Louisiana here in support of the rationality of

its statutory scheme, that "woman is still regarded as the center of the home and family life." Statistics compiled by the Department of Labor indicate that in October, 1974, 54.2% of all women between 18 and 64 were in the labor force . . . Additionally, in March, 1974, 45.7% of women with children under the age of 18 were in the labor force; with respect to families containing children between the ages of six and 17, 67.3% of mothers who were widowed, divorced, or separated were in the work force, while 51.2% of mothers whose husbands were present in the household were in the work force. Even in family units in which the husband was present and which contained a child under three years old, 31% of the mothers were in the work force . . . While these statistics perhaps speak more to the evolving nature of the structure of the family unit in American society than to the nature of the role played by women who happen to be members of a family unit, they certainly put to rest the suggestion that all women should be exempt from jury service based solely on their sex and the presumed role in the home.

Taylor v. Louisiana effectively overturned both *Hoyt v. Florida* and an earlier case involving female jury service, *Strauder v. West Virginia* (1880).

Further Reading: Cary and Peratis, *Woman and the Law;* Cushman, *Cases in Constitutional Law; Hoyt v. Florida,* 1961. 368 U.S. 57; O'Connor, "Women and the Constitution," in *Women, Politics and the Constitution,* ed. Lynn; *Strauder v. West Virginia,* 1880. 100 U.S. 303; *Taylor v. Louisiana,* 1975. 419 U.S. 522.

Title VII

See CIVIL RIGHTS ACT OF 1964.

Title IX of the Education Amendments of 1972 (1972)

Mandating that "No person in the United States shall, on the basis of sex, be excluded from participation in, be denied the benefits of, or be subjected to discrimination under any education program or activity receiving federal assistance," Title IX (Public Law 92-318) has improved the quality of many educational programs for women. It was sponsored by Rep. Patsy MINK.

Because the proposed act affected the funding of women's athletic programs and the establishment of athletic scholarships for women—as well as educational admissions, course placement, and campus housing—it was strenuously opposed by the National Collegiate Athletic Association, an organization of over 700 educational institutions with annual revenues of more than $10 million from activities such as televised college football and basketball games. Women's organizations such as the WOMEN'S

EQUITY ACTION LEAGUE, the NATIONAL ORGANIZATION FOR WOMEN, the NATIONAL WOMEN'S POLITICAL CAUCUS, the LEAGUE OF WOMEN VOTERS, the AMERICAN ASSOCIATION OF UNIVERSITY WOMEN, and the Girl Scouts were equally organized on behalf of Title IX, however, and the act passed in June 1972. Its most visible impact has perhaps been on female athletes: In 1970, only one in twenty-seven girls played high school sports; in 1999, that figure is one in three. At the college level, 37 percent of varsity athletes are female, and their opportunities after graduation are wider than ever before. The dominance of American women at the 1996 Olympic Games, the success of the Women's National Basketball Association, and the winning of the Women's World Cup by the U.S. women's soccer team in 1999, were widely hailed as a victories for Title IX as well as for the women athletes involved.

Title IX has had an equally large impact on other educational forefronts, such as women's admission to medical, law, and graduate schools.

In its earliest years, Title IX was interpreted in such a way that federal funding was withheld from an entire institution if any one of the institution's programs or activities discriminated against women. In 1984, however, the Supreme Court's ruling in *Grove City College v. Bell* permitted institutions to receive federal funds for their nondiscriminatory programs and prohibited the funding of only those specific programs or activities that discriminated against women. The Civil Rights Restoration Act of 1988 restored the original interpretation and also prohibited discrimination on the basis of age, disability, or race.

Most recently, the Supreme Court ruled on schools' liability for sexual harassment under Title IX. In a 1998 case, *Gebser v. Lago Vista Independent School District,* the Court ruled that schools could not be held liable for teacher harassment of students unless administrators capable of interceding knew of the harassment and made an "official decision" to ignore it. In 1999, in *Davis v. Monroe County Board of Education,* the Court specified that schools could be held liable for student-to-student harassment if administrators knew of severe and pervasive sexual harassment and failed to protect targeted students.

Further Reading: Associated Press, July 19, 1999; Davis, *Moving the Mountain; Davis v. Monroe County* 120 F.3d 1390, revised and remanded. Evans, *Born for Liberty; Gebser v. Lago Vista Independent School District,* 524 U.S. 274 (1998); *New York Times,* June 23, 1998 and May 25, 1999; Rix, ed., *American Woman 1990–91;* Sparhawk et al., *American Women in Sport, 1887–1987;* Wandersee, *American Women in the 1970s; USA Today,* October 11, 1995; U.S. Congress. House. *A resolution honoring the inaugural season of the United States women's professional basketball leagues.*

Triangle Shirtwaist Company Fire (1911)

A labor tragedy of horrific proportions, the Triangle Shirtwaist Company fire occurred on March 25, 1911, and killed 146 factory workers, most of whom were women, and mobilized wage-earning women and their supporters to demand women's suffrage.

Although the company's workers had gone on strike in 1909 in an attempt to improve their working conditions (see LABOR MOVEMENT, WOMEN'S PARTICIPATION IN), the factory had remained an unsafe place in which to work.

In 1811, when the fire broke out, there was no sprinkler system and the building's fire escapes were inadequate. Most unforgivable of all was the fact that the factory's doors were bolted from the outside, presumably to prevent the workers from taking unauthorized breaks.

Firefighters struggled to reach the desperate women who managed to make it to the ninth-floor fire escapes, but no ladder reached past the sixth floor. Many women fell to the sidewalk and died there; others died inside of burns or suffocation. That night, 146 corpses were laid out on the 26th Street pier. Two thousand people searched through the bodies for their relatives. After a week, seven women remained unidentified.

The outraged members of the INTERNATIONAL LADIES GARMENT WORKERS UNION and the New York Women's Trade Union League (see NATIONAL WOMEN'S TRADE UNION LEAGUE) began planning a proper funeral for the nameless women. Mayor William Jay Gaynor worried that the funeral would spark protest or even a riot, quickly had the women's bodies buried in a city plot.

The women's funeral procession took place as planned, with an empty hearse. April 5, 1911, was a cold, rainy day, but thousands of grieving New Yorkers marched behind the hearse while a half-million others lined the sidewalks to pay their respects.

The owners of the company, Max Blanck and Isaac Harris, were acquitted of manslaughter charges. Juror H. Houston Hierst explained the verdict by saying "I cannot see that anyone was responsible for the disaster. It seems to me to have been an act of the Almighty . . . I paid great attention to the witnesses while they were on the stand. I think the girls who worked there were not as intelligent as those in other walks of life and were therefore the more susceptible to panic."

Two years later, Max Blanck was charged once more for locking his female employees inside their work room. His fine was $20.

Funeral procession for the victims of the Triangle Shirtwaist Company Fire in 1911 (*Library of Congress*)

The fire strengthened the resolve of many suffragists. As Mary Ware DENNETT wrote in the WOMAN'S JOURNAL on April 1, 1911:

> Over and over again we suffragists insist that women are citizens and should be equally responsible with men, but a frightful shock like this makes us know it as we never knew it before. It is enough to silence forever the selfish addleheaded drivel of the antisuffragists who recently said at a legislative hearing that working women can safely trust their welfare to the "natural protectors." We might perhaps be willing to consign such [antisuffrage] women to the sort of protection, care and chivalry that is indicated by the men who allow 700 women to sit back to back, wedged in such close rows between machines that quick exit is an impossibility; a ten-story building with no outside fire escapes . . . with iron gates shutting off the staircase, and cigarette-smoking allowed in the midst of inflammable materials. But we are not willing to consign unwilling women or helpless young girls to any such tender mercies. And we claim in no uncertain voice that the time has come when women should have the one efficient tool with which to make for themselves decent and safe working conditions—the ballot.

Further Reading: Frost and Cullen-DuPont, *Women's Suffrage in America;* ———, *Women's Rights on Trial;* Kraditor, *Ideas of the Woman Suffrage Movement; People v. Harris,* 74 Misc. 353 NY (1911); Stein, *Triangle Fire;* Wertheimer, *We Were There; Woman's Journal,* April 1, 1911.

Troy Female Seminary, The
An institute of advanced learning for young women, and the first of its kind in America, the Troy Female Seminary was founded by Emma Hart WILLARD in 1821.

The citizens of Troy, New York, impressed by Willard's past accomplishments as an educator and her "Address to the Public; Particularly to the Members of the Legislature of New York, Proposing a Plan for Improving Female Education," agreed, through their Common Council, to raise money through a special tax for the erection of a school such as the one envisioned by Willard. Willard described Troy's efforts as follows: "that city has raised $4,000 by tax and another fund has been raised by subscription. They are now erecting a brick building 60′ x 40′, three stories from the basement; and the basement, raised 5′ about the ground, contains a dining room as well as a kitchen and a laundry."

Despite this evidence of support, there was widespread prejudice against the education of women at this time. No colleges were open to women, and the "female academies"—the only educational institutions open to

girls in their later teens—taught purely ornamental arts, such as embroidery, conversational French, and landscape painting. It was Willard's intent to give young women the equivalent of a college education, but she could not say so. Even the choice of the school's name was a conscious attempt to deflect attention from her motives. Willard recalled hearing "someone pray for 'our seminary of learning'" and realizing that "that word, while it is high as the highest, is also low as the lowest, and will not create a jealousy that we mean to intrude upon the province of men." Her school and those that followed in emulation, became known, then, not as female academies or colleges, but as "female seminaries."

At the Troy Female Seminary, young women were taught college courses such as science, mathematics, logic, literature, and history. (Among the textbooks used were some written by Emma Willard.) Most courses were taught without incident. Physiology, however, was an exception. "Mothers visiting a class at the Seminary . . . were so shocked at the sight of a pupil drawing a heart, arteries and veins on a blackboard to explain the circulation of the blood, that they left the room in shame and dismay." The human body was subsequently covered over with cardboard in all of the seminary's textbooks. Perhaps because she was willing to make compromises of this sort, Emma Willard's school stayed in business and flourished, counting among its graduates Elizabeth Cady STANTON and the niece and namesake of Mary Wollstonecraft. The school, in enlarged quarters, still exists in Troy. In 1895 it was renamed the Emma Willard School, in honor of its founder.

Further Reading: Flexner, *Century of Struggle;* Sage, *Emma Willard and Her Pupils.*

Truth, Sojourner (1797–1883) *abolitionist, women's rights supporter*
Originally named Isabella, Sojourner Truth was born in 1797 in Hurley, Ulster County, New York, to slaves, Elizabeth (or Betsey) and James, both owned by Charles Hardenbergh, a wealthy Dutch landowner. She was sold to a succession of owners before being purchased, in 1810, by John J. Dumont. She remained in the Dumont household, in New Paltz, New York, until 1827. During this time, she gave birth to her children, most of whom were sold away from her. (After New York State ordered the emancipation of slaves in 1828, Sojourner Truth and Quaker sympathizers successfully sued for the return of Truth's son Peter, illegally sold to an Alabama resident).

Truth ran away from Dumont in 1827 and was sheltered by Maria and Isaac Van Wagener, whose surname she used for a time. She moved to New York City in about 1829 and secured work as a domestic servant. Inspired by

mystical visions, she adopted the name Sojourner Truth in 1843 and became a traveling preacher.

Truth became an outspoken supporter of abolition and endorsed women's rights as well. At a woman's rights convention held on May 28 and 29, 1851, in Akron, Ohio, Elizabeth Cady STANTON, Susan B. ANTHONY, Lucy STONE, and Francis D. GAGE were heckled by a clergyman. He depicted women as frail and in need of chivalrous attention and, therefore, unfit for suffrage. Sojourner Truth retorted:

> That man over there says that women need to be helped into carriages, and lifted over ditches, and to have the best place everywhere. Nobody ever helps me into carriages, or over mud-puddles, or gives me any best place! And ain't I a woman? Look at me! I have ploughed, and planted, and gathered into barns, and no man could head me! And ain't I a woman? I could work as much and eat as much as a man—when I could get it—and bear the lash as well! And ain't I a woman? I have borne thirteen children, and seen almost all of them sold off into slavery, and when I cried out with my mother's grief, no one but Jesus heard me. And ain't I a woman? . . . That little man in black there, he says women can't have as much rights as men, because Christ wasn't a woman! Where did your Christ come from? . . . From God and a woman! Man had nothing to do with him.

Sojourner Truth died in Battle Creek, Michigan on November 26, 1883.

Further Reading: Frost and Cullen-DuPont, *Women's Suffrage in America;* Flexner, *Century of Struggle;* Redding, "Sojourner Truth," in *Notable American Women,* ed. James, James, and Boyer; Stanton, Anthony, and Gage, eds., *History of Women's Suffrage,* vol. 1.

Tubman, Harriet (ca. 1820–1913) *scout, spy, nurse, women's suffrage supporter*
Harriet Tubman was born in Dorchester County, Maryland, to Benjamin Ross and Harriet Greene, both slaves, in or about 1820. Named Araminta at birth, she later took her mother's name.

Growing up in slavery, Harriet worked throughout her childhood and never attended school. She performed her forced labors in an uncooperative manner and was abused as a result. When Harriet was thirteen, an angry overseer fractured her skull.

Still enslaved in Maryland in about 1844, Harriet married John Tubman, a free African American. She escaped alone to Philadelphia in 1849. Supporting herself with wages earned in hotel work, Tubman made about nineteen trips back to the South to rescue other slaves. Some of her trips were made with the assistance of the Underground Railroad, while other trips were made entirely alone. Her parents, six brothers and their families, and her sister and her children (scheduled for auction) were among the 60 to 300 slaves she is said to have freed. (Tubman's husband never joined her in the North. He died in 1867.) Tubman was an effective speaker at abolitionist conventions. She also conferred with John Brown and supported his raid upon Harper's Ferry, earning the accolade "General Tubman" from Brown. So notorious was Tubman among Maryland slaveholders that a $40,000 reward was offered for her capture.

When the Civil War began, Tubman volunteered to help the Union Army. She was issued a pass to travel without restriction on all Union transports and crossed Confederate lines to obtain what information she could from Southern blacks. In June 1863 she led Colonel James Montgomery of the 2nd South Carolina Volun-

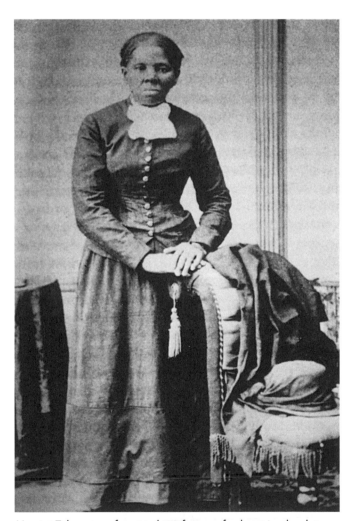

Harriet Tubman, a former slave famous for her trips back to the South to free other slaves, was a scout, spy, and nurse during the Civil War and an ardent supporter of women's suffrage. *(Library of Congress)*

teers on a successful raid up the Combahee River, an act that was praised on the front page of the *Boston Commonwealth:*

> Col. Montgomery and his gallant band of 800 black soldiers, under the guidance of a black woman, dashed into the enemies' country, struck a bold and effective blow, destroying millions of dollars worth of commissary stores, cotton and lordly dwellings, and striking terror to the heart of rebeldom, brought off near 800 slaves and thousands of dollars worth of property, without losing a man or receiving a scratch!

Tubman also served as a Union nurse and, after the war, as a nurse in a Virginia freedmen's hospital. In addition, she founded the Harriet Tubman Home for Indigent Aged Negroes, to care for African-American orphans and the elderly. She married one of her boarders, Nelson Davis, a Civil War veteran and former slave, on March 19, 1869.

When the women's movement split over support for the FOURTEENTH and FIFTEENTH AMENDMENTS, Tubman supported Elizabeth Cady STANTON and Susan B. ANTHONY, who refused to support the enfranchisement of African-American men when women of all races remained disfranchised.

Tubman continued to press for women's suffrage and other rights until the end of her life. She addressed a Rochester convention led by Susan B. Anthony in the 1880s and was honored with a party by the New England Woman Suffrage Association. At an 1896 meeting that brought the leaders of two generations of African-American women to Washington, D.C., Tubman helped to found the NATIONAL ASSOCIATION OF COLORED WOMEN. She joined a suffrage club in Geneva, New York, during the last years of her life. Asked why she believed women should have the ballot, she answered simply, "I suffered enough to believe it."

At the end of the Civil War, Tubman and leading citizens familiar with her work had petitioned Congress to render payment for her services. The requests were denied. Thirty years later, however, when Tubman had turned eighty and her second husband, Nelson Davis, had died, Tubman was granted a pension of $20 per month—in recognition of the wartime services of her late husband.

Harriet Tubman died in Auburn, New York on March 10, 1913.

Further Reading: Sterling, *We Are Your Sisters;* Flexner, *Century of Struggle;* Franklin, "Harriet Tubman," *Notable American Women,* James, James, and Boyer, ed.

U

Una, The

The first women's suffrage newspaper in America, *The Una* was founded by Paulina Wright Davis in 1853 and published in Providence, Rhode Island. Although it was in existence for only three years, it published works by some of the most notable leaders of the early women's rights movement, including Elizabeth Cady STANTON and Lucy STONE.

Further Reading: Flexner, *Century of Struggle;* Stanton, Anthony, and Gage, eds., *History of Women's Suffrage.*

Union of Needletrades, Industrial and Textile Employees (UNITE) (1995)

Formed in June 1995 by the merger of the INTERNATIONAL LADIES' GARMENT WORKERS UNION and the AMALGAMATED CLOTHING WORKERS UNION, the Union of Needletrades, Industrial and Textile Employees (UNITE) instantly became the country's fourth largest union of manufacturing employees. Jay Mazur, the former president of the International Ladies' Garment Workers Union, became UNITE's first president.

UNITE's mission statement envisions renewed, aggressive labor organizing in the United States and the building of a global labor movement. The union plans to press American companies to adopt some of the family-friendly policies more commonly seen in Europe, such as paid parental leave and generous vacation arrangements. "Other nations have taken the 'high road' with their employees and have managed to compete in a global economy," Mazur told delegates to the union's first convention. "Germany is a good example of a very competitive nation that puts the interests of its workforce and their families first. UNITE will nurture this approach in the United States." The union also stresses that a global labor movement is an equally high priority. As Mazur outlined, "[m]any American-based companies have become competitive by taking work out of this country and subcontracting it overseas, to nations where child labor is allowed, where sweatshops are the norm, and where workers have no rights. Until there is a global labor movement to counter these unconscionable actions, no worker is safe, and our standard of living is at risk."

In January 1999, UNITE and several other groups filed lawsuits against eighteen American companies alleging human rights abuses against Asian workers on the island of Saipan, a U.S. territory. The suits alleged that many of the Asian women who were recruited to work in Saipan had their passports confiscated and were subjected to inhuman working and living conditions. Those conditions were said to include rat-infested living quarters, threats and beatings for women who failed to meet production quotas, and forced abortions for pregnant workers. Plaintiffs claimed that mandatory twelve-hour days and seven-day work weeks were standard and that workers were frequently malnourished and dehydrated. The lawsuits, which were brought under the federal Racketeer Influenced and Corrupt Organizations Act, were settled in September 1999. The settling clothing manufacturers admitted no wrongdoing but agreed to pay a nonprofit group, Verite of Amherst, Massachusetts, to monitor working conditions under court supervision.

UNITE has 350,000 members and 1125 local groups. It maintains its headquarters in New York City.

Further Reading: *Associated Press,* January 13 and 14, 1999; *Boston Globe,* January 14, 1999; *Buffalo News,* July 9, 1995; Cleeland, "Four U.S. Retailers Settle Saipan Labor Suit"; *Denver Post,* February 21, 1995; Morrissey, "Will Merger Increase Union Presence In Mills?"; *Washington Post,* January 13 and 14, 1999.

United Nations Commission on the Status of Women

An intergovernmental forum created by the United Nations in 1947, the U.N. Commission on the Status of Women consisted of delegates from more than thirty countries by 1991. A U.S. delegate has been part of the commission since its inception. Among the commission's achievements have been the observance of INTERNATIONAL WOMEN'S YEAR, the U.N. Decade for Women (1976–85), and the CONVENTION ON THE ELIMINATION OF ALL FORMS OF DISCRIMINATION AGAINST WOMEN (1979).

Further Reading: Rix, ed., *American Woman 1990–91.*

United Nations Development Fund for Women

Founded by the U.N. General Assembly as the Voluntary Fund for the United Nations Decade for Women in 1976 following INTERNATIONAL WOMEN'S YEAR (1975), the United Nations Development Fund for Women (UNIFEM), as it was renamed in 1985, is an autonomous fund that works in association with the U.N. Development Programme to improve the lot of women around the world.

The fund assists education programs that benefit women in developing countries as well as rural women or female residents of inner-city areas of industrialized countries. Among other accomplishments, it has taught women modern food preservation techniques, instructed child care workers, assisted communities with the development of energy resources, and subsidized funds that make small business loans to women.

The United Nations Development Fund for Women publishes the semiannual *Development Review* in English, French, and Spanish. Noeleen Heyzer is the fund's current director.

Further Reading: Brennan, ed., *Women's Information Directory;* United Nations, *World's Women 1970–1990.*

United Nations Decade for Women: Equality, Development, Peace

An initiative of the U.N. Commission on the Status of Women, the United Nations Decade for Women: Equality, Development, Peace was observed from 1976 to 1985. The most tangible results of the decade were the 1979 CONVENTION ON THE ELIMINATION OF ALL FORMS OF DISCRIMINATION AGAINST WOMEN and two international women's conferences (one held in Copenhagen in 1980 and one held in Nairobi in 1985) and the "NAIROBI FORWARD-LOOKING STRATEGIES FOR THE ADVANCEMENT OF WOMEN," a document adopted at the 1985 Nairobi conference.

Further Reading: Davis, *Moving the Mountain;* Rix, ed., *American Woman 1990–91;* United Nations, *World's Women 1970–1990.*

United States v. Commonwealth of Virginia (1996)

The 1996 Supreme Court decision that prohibited the exclusion of women from state-supported schools, *United States v. Virginia* forced the country's last two all-male colleges—Virginia Military Institute (VMI) and The Citadel—to admit women or lose state funding, while reiterating and perhaps strengthening the judicial standard of review applied to claims of sexual discrimination.

In March 1990, the U.S. Department of Justice under President George Bush sued VMI after a female high school student complained that its all-male admission policy was discriminatory. (In the previous two years, inquiries from approximately 300 young women had been turned away by VMI's admissions department.) The United States claimed that VMI's admission policy discriminated against women and was not "substantially related to an important governmental objective."

The District Court considered VMI's 150-year history and the wish of the Virginia legislature in 1939 to produce "citizen-soldiers, educated and honorable men who are suited for leadership in civilian life and who can provide military leadership when necessary." The court also examined the "adversative" educational methods used by VMI. These methods "emphasize physical rigor, mental stress, absolute equality of treatment, absence of privacy, minute regulation of behavior, and indoctrination of values . . . designed to foster in VMI cadets doubts about previous beliefs and experiences and to instill in cadets new values . . . [in] a hostile, spartan environment." When it ruled in 1991, the District Court found that "diversity in education" was a legitimate state interest and that this interest was served both by VMI's "distinctive educational methods" and its male-only admissions policy. The Court upheld the college's exclusion of women, and the United States appealed.

The Fourth Circuit Court of Appeals ruled on October 5, 1992. Circuit Court judge Paul V. Niemerer, delivering the court's opinion, noted that the District Court opinion had referred to the Civil War. That opinion, he continued, praised the VMI cadets who courageously fought Union troops at New Market, Virginia, and described the current *U.S. v. Virginia* dispute as one where "the combatants have again confronted each other, but this time the venue is in court." He then gave a different meaning to that reference:

What was not said is that the outcome of each confrontation finds resolution in the Equal Protection Clause. When the Civil War was over, to assure the

abolition of slavery and the federal government's supervision over that policy, *all* states, north and south, yielded substantial sovereignty to the federal government in the ratification of the Fourteenth Amendment, and every state for the first time was expressly directed by federal authority not to deny any *person* within the state's jurisdiction "equal protection of the laws." The government now relies on this clause to attack VMI's admission policy.

The court found that the Fourteenth Amendment was violated and, problematically, that admitting women would destroy the uniqueness of the experience from which they were illegally barred. Reasoning that VMI's violation did not necessarily rest in its failure to admit women but certainly lay in its failure to provide equally unique leadership training for women, Niemeyer outlined possible remedies. Virginia, he wrote, "might properly decide to admit women to VMI and adjust the program to implement that choice, or it might establish parallel institutions or parallel programs, or it might abandon state support of VMI, leaving VMI the option to pursue its own policies as a private institution." He sent the case back to the District Court "to give to the commonwealth the responsibility to select a course it chooses, so long as the guarantees of the Fourteenth Amendment are satisfied."

VMI requested a hearing *en banc,* or by the full circuit court, which was denied. The state of Virginia and VMI subsequently established a state-funded military-style program for women at Mary Baldwin College, a private women's college in Staunton, Virginia. The federal court approved the program, and it began operations in the summer of 1995. The Clinton administration then appealed the federal circuit court ruling to the Supreme Court, which agreed to hear the case.

The Supreme Court had long viewed race, national origin, and religion as "inherently suspect" classifications for Fourteenth Amendment purposes—meaning that any legislation targeting these groups must meet the "strict scrutiny standard." This standard requires the law in question to serve a compelling state interest that cannot be served by any other means. To date, discrimination on the basis of sex has not been found inherently suspect by the Supreme Court. However, with CRAIG V. BOREN (1976), the Court adopted a "mid-level or heightened" scrutiny standard for such cases, requiring that laws discriminating against sex bear a substantial relationship to an important government interest.

The Court ruled seven to one on June 26, 1996, that VMI's admission policy was unconstitutional. The Court's opinion, written by Ruth Bader GINSBURG, who, as a young civil rights lawyer, had helped win the *Craig v. Boren* case, also addressed, and perhaps strengthened, the standard of scrutiny in sex discrimination cases. She repeated the Court's ruling in previous cases, writing that sex discrimination "must serve important governmental objectives" and be "substantially related to the achievement of those objectives." Then she added important specifics:

> The justification must be genuine, not hypothesized or invented post hoc in response to litigation. And it must not rely on overbroad generalizations about the different talents, capacities, or preferences of males and females. . . . "Inherent differences" between men and women, we have come to appreciate, remain cause for celebration, but not for denigration of the members of either sex or for artificial constraints on an individual's opportunity. Sex classifications may be used to compensate women "for particular economic disabilities [they have] suffered," to "promot[e] equal employment opportunity," and to advance full development of the talent and capacities of our nation's people. But such classifications may not be used, as they once were, to create or perpetuate the legal, social and economic inferiority of women.

Examining the facts of *U.S. v. Virginia* "against the review standard just described," the Court found that an all-male admission policy at a state-supported school violated the Fourteenth Amendment. The state goal of providing educational diversity, Ginsburg wrote, was not served by a plan that provided "a unique educational benefit only to males." Such a plan, she said, while "liberally" providing for "The state's sons. . . . makes no provisions whatever for her daughters. That is not equal protection." She also dismissed Virginia's argument that VMI's program would be "destroy[ed]" if women were included. This recalled the same "ancient and familiar fear" that had once barred women from the legal and other professions, she said, and was possibly equally misguided. "Women's successful entry into the federal military academies," she wrote, "and their participation in the nation's military forces, indicate that Virginia's fears for the future of VMI may not be solidly grounded."

Ginsburg called the new women's leadership program at Mary Baldwin College a "pale shadow" of VMI's own program. She acknowledged that not all women would benefit from the genuine VMI education but emphasized that "generalizations about the way women are, estimates of what is appropriate for most women, no longer justify denying opportunity to women whose talents and capacity place them outside the average description." She pointed out that VMI was for the select few of either sex, saying that Virginia had never tried to claim the college "suited most men."

The opinion mentioned many precedent-setting cases, but most central to the specific facts was MISSISSIPPI UNIVERSITY FOR WOMEN V. HOGAN, a 1982 ruling

stating that a state-supported nursing school could not exclude men. Justice Sandra Day O'CONNOR wrote that opinion, and it was widely reported that she shared a smile with Ginsburg when its application to *U.S. v. Virginia* was cited. Chief Justice William H. Rehnquist issued a concurring opinion, saying that he might have been persuaded by a truly equal parallel program and that he objected to the new legal terminology in the majority opinion. Justice Antonin Scalia dissented. (Justice Clarence Thomas did not take part because his son attended VMI).

In effect, the Court's decision forced the country's last two state-supported all-male colleges—The Citadel and Virginia Militray Institute—to admit women or forego state funding. Both colleges chose to admit women.

Further Reading: Frost-Knappman and Cullen-DuPont, *Women's Rights on Trial; New York Times,* April 4 and 24, 1991; June 18 and 19, 1991; August 13, 1992; October 6 and 14, 1992; November 19, 1992; September 26, 1993; October 13, 1993; June 1, 1995; December 27, 1995; January 18, 1996; and June 27, 28, and 29, 1996; July 1, 1996; *United States v. Commonwealth of Virginia; Washington Post,* July 14, 1996.

United Tailoresses Society
An early labor organization, founded and headed by Louise Mitchell and Lavinia Waight in New York City in 1825. Although the organization existed for just a short time, its members are credited with staging the first women's strike.

Further Reading: Flexner, *Century of Struggle;* Wertheimer, *We Were There.*

Unremunerated Work Act of 1993
Introduced by Representative Barbara-Rose Collins (D-MI) in February 1993 and cosponsored by nearly half the female Democratic members of the House, this bill, if passed, would have required that the Bureau of Labor Statistics include the value of women's unpaid household and volunteer work in the comprehensive gross domestic product.

As was pointed out in the United Nations' *The World's Women 1970–1990: Trends and Statistics,* "much of the work women do is still not considered to be of any economic value at all—and it is not even measured." The U.N.'s International Labor Office provides supporting statistics: Internationally, women perform two-thirds of the world's labor and yet are paid only 5 percent of the world's wages. The U.N. therefore asked that individual government statistics reflect the value of women's unpaid labor by 1995. The call for such reporting of women's unpaid labor was reiterated in 1995 at the U.N.'s Fourth World Conference on Women, in Beijing, China.

In recent years, the United States has begun to prepare for compliance with the U.N.'s request even though the Unremunerated Work Act has never been passed. In May 1996 and April 1998, the PRESIDENT'S INTERAGENCY COUNCIL ON WOMEN reported to the United Nations that the U.S. Department of Labor was developing plans to accurately estimate the value of unwaged work.

Other U.N. member countries have also submitted plans pertaining to unwaged work; to date, Trinidad and Tobago is the only country that has passed legislation changing its formula for GNP calculation.

Further Reading: Hochschild with Machung, *Second Shift;* Strasser, *Never Done;* Suh, "Economic Breakthrough,"; President's Interagency Council on Women, "U.S. Follow-Up to the U.N. Fourth World Conference"; ———, "Update to America's Commitment"; United Nations, *World's Women 1970–1990.*

Upton, Harriet Taylor (1853–1945) *suffragist, Republican party worker, writer*
Harriet Taylor Upton was born on December 17, 1853, in Ravenna, Ohio, to Harriet M. Frazer Taylor and Ezra Booth Taylor. Her father, a lawyer at the time of Harriet's birth, served in the House of Representatives (1880–93).

Upton grew up in an intellectually stimulating household. In her late teenage years and in her early twenties, she served as secretary of the WOMAN'S CHRISTIAN TEMPERANCE UNION but was a strong opponent of women's suffrage. When she began gathering information for an antisuffrage article, however, she could not find evidence that women were adequately represented without the vote, and she became a suffragist. In 1890 she joined the NATIONAL AMERICAN WOMAN SUFFRAGE ASSOCIATION (NAWSA). In 1894 she was elected treasurer of NAWSA, an office she held until 1910. From 1902 until 1910 she edited the monthly suffrage newspaper, *Progress.* She was a seemingly tireless member of the suffrage movement. She appeared before congressional hearings, edited reports of conventions, traveled extensively, organized annual conventions for the Ohio Suffrage Association, ran two unsuccessful campaigns for state suffrage in Ohio, and directed the successful 1916 campaign for municipal suffrage in Ohio. She was president of the Ohio Woman Suffrage Association for eighteen years (1899–1908 and 1911–20).

After ratification of the NINETEENTH AMENDMENT, Upton continued her involvement in politics. She was vice chairman of the Republican National Executive Committee for four years. Her last appointment was as liaison officer between the Ohio Department of Public Welfare and Ohio governor Myers Y. Cooper.

Upton wrote numerous political articles for newspapers and magazines that emphasized the role women had played in American history. She also published a children's book and two historical works, *A Twentieth Century History of Trumbull County, Ohio* (1909) and *History of the Western Reserve* (1910).

Harriet Taylor Upton died in Pasadena, California on November 2, 1945.

Further Reading: Frost and Cullen-DuPont, *Women's Suffrage in America; New York Times,* June 6, August 16, 1924; November 4, 1945; Stanton, Anthony, and Gage, eds., *History of Women's Suffrage,* vol. 6.

Van Duyn, Mona (1921–) *writer*

Born in 1921 in Waterloo, Iowa, poet Mona Van Duyn became the first woman to be named poet laureate of the United States.

During the 1940s, Van Duyn studied and taught at the University of Iowa Workshop. She is married to Jarvis Thruston, with whom she founded *Perspective, a Quarterly of Literature* in 1947. (Van Duyn was the magazine's coeditor from its founding until 1970.) The couple has lived in St. Louis since 1950.

Van Duyn has described her view of the arts as creations that "work invisibly" and "widen and deepen the human imagination." Her own work has been produced over five decades and includes the volumes *Valentines to the Wide World* (1959), *A Time of Bees* (1964), *To See, To Take* (1970), *Bedtime Stories* (1972), *Merciful Disguises* (1973), *Letter from a Father, and Other Poems* (1982), *Near Changes* (1990). *If It Be Not I: Collected Poems, 1959–1982,* was published in 1993.

Throughout her career, Van Duyn has enjoyed the respect of fellow poets and the praise of critics. In addition to the University of Iowa Writers' Workshop, Van Duyn has taught at the University of Louisville, Washington University, and at many well-regarded workshops for writers, such as Breadloaf. Van Duyn's appointment as poet laureate, for a one-year term, was made in May 1992. Her many other honors include *Poetry*'s Eunice Tietjens Award (1956) as well as its Harriet Monroe Award (1968); *Poetry Northwest*'s Helen Bullis Prize (1964), the Bollingen Prize (1970), the National Book Award (1971), and the Pulitzer Prize (1991).

Further Reading: *New York Times,* May 30, 1993; Van Duyn, *To See, To Take;* ———, *Merciful Disguises;* ———, *Near Changes;* ———, *Firefall;* ———, *If It Be Not I.*

Vaughan, Hester (trial of) (1868)

Convicted of the first-degree murder of her newborn infant and sentenced to death in 1868, Hester Vaughan prompted women's rights leaders to mount an effective protest against nineteenth-century women's exclusion from jury duty in America.

As Vaughan relayed it to her female sympathizers, she left her native England to marry her American fiancé. As it turned out, the man involved was already a husband and father, and he deserted Vaughan. Too ashamed to face her family, she became a housekeeper in Philadelphia. When she became pregnant as a result of a RAPE by a member of her employer's household, she rented a small room and began to support herself with odd sewing jobs. The record shows that Hester Vaughan, malnourished and alone, gave birth in an unheated room on February 8 or 9, 1868. Two days later she requested both a box for a dead baby and secrecy from another resident of the building.

Vaughan was arrested and tried for murder beginning June 30, 1868. The prosecution presented several witnesses; one, a physician, testified that he had found "several fractures of the skull, made apparently with some blunt instrument, and also clots of blood between the brain and skull." Another witness testified that the baby had cried. Vaughan's lawyer, a Mr. Guforth, was said in later reports to have failed to interview his client prior to the trial. He presented a character witness and his own views: "The death may have been caused by accident, for the prisoner was the only human being who saw the death and her lips were sealed by law." (The latter half of his argument may refer to the nineteenth-century belief that women were incompetent to serve as witnesses.)

Vaughan was convicted and sentenced to death. One of America's first female physicians, Susan A. Smith, M.D., heard of the case and visited Moyamensing Prison

to interview and examine Vaughan. At the conclusion of her investigation, she wrote to Governor John W. Geary of Pennsylvania to urge a pardon:

> [Vaughan] rented a third story room . . . from a family who understood very little English. She furnished this room, found herself in food and fuel for three months on twenty dollars. She was taken sick in this room at midnight on the 6th of February and lingered until Saturday morning, the eighth, when her child was born. She told me she was nearly frozen and fainted or went to sleep for a long time.
>
> You will please remember, sir, throughout this period of agony she was alone, without nourishment or fire, with her door unfastened.
>
> My professional opinion in Hester Vaughan's case is that [the] cold and want of attention produced painful and protracted labor—that the mother, in endeavoring to assist herself, injured the head of her child in its birth—that she either fainted or had a convulsion, and was insensible for a long time.

Although one witness had testified that cries were heard, Dr. Smith and another female physician, Clemence Lozier, both thought it was possible under such circumstances that the child had been stillborn.

Governor Geary did not grant the requested pardon, and Hester Vaughan's case was taken up by Elizabeth Cady STANTON, Susan B. ANTHONY, and other women's rights activists. While Stanton and Anthony found that Vaughan had been "condemned on insufficient evidence and inadequate defense," they championed her pardon on unexpected grounds: Pointing out that Vaughan had been arrested for allegedly breaking laws made by all-male legislators, prosecuted by a male district attorney, defended by a male lawyer, found guilty by an all-male jury, and sentenced to death by a male judge, Stanton and Anthony claimed that Vaughan had been denied "a trial by the jury of her peers." They called a protest meeting at Cooper [Union] Institute in New York City, where a petition drive was organized and the following resolution adopted:

> Whereas, The right of trial by a jury of one's peers is recognized by the governments of all civilized nations as the great palladium of rights, of justice, and equality to the citizen: therefore, Resolved, That this Association demand that in all civil and criminal cases, woman shall be tried by a jury of her peers; shall have a voice in making the law, in electing the judge who pronounces her sentence, and the sheriff who, in case of execution, performs for her that last dread act.

In their newspaper, the *REVOLUTION,* and in their speeches all across the United States, Stanton and Anthony asked women to consider Hester Vaughan's case with a "sense of . . . responsibility in making and executing the laws under which [our] daughters are to live." Governor Geary was deluged with petitions, letters, and poems on Vaughan's behalf. In the summer of 1869, he acquiesced to the women's demand and issued a pardon to Hester Vaughan—with the condition that she be returned to England with privately raised funds. Stanton and Anthony raised Vaughan's passage money. Her thank-you letter appeared in the August 19, 1869 issue of the *Revolution.*

Further Reading: Barry, *Susan B. Anthony;* Cullen-DuPont, "Hester Vaughan Trial," in *Great American Trials,* ed. Knappman; *New York Times,* December 4, 1868; *Philadelphia Inquirer,* July 1–2 and December 3–4, 1868; *Revolution,* December 10, 1868–August 19, 1869.

Violence Against Women Act (VAWA) (1994)

Signed into law by President Bill Clinton on September 13, 1994, the Violence Against Women Act (VAWA) mandates a unified judicial response to sexual crimes committed against women and provides funding ($1.6 billion over six years) for programs intended to decrease the incidence of such crimes. Joseph Biden (D-DE) proposed the act and introduced it in the Senate; Patricia SCHROEDER was its sponsor in the House of Representatives.

The act's provisions include: the creation of a national domestic violence hotline; more severe penalties for sex crimes; federal criminal penalties for anyone who crosses a state line to injure a spouse; mandatory arrest policies in cases of domestic violence; domestic violence education for police officers, prosecutors and judges; increased funding for battered women's shelters; the creation of a federal civil rights cause of action for victims of gender-motivated crimes of violence; new policies permitting battered immigrant spouses to petition for legal resident status; interstate enforcement of restraining orders; and prohibitions against gun ownership by anyone subject to a restraining order.

By the end of 1999, twelve federal courts had upheld VAWA as constitutional, and one—the Fourth Circuit Court in Richmond, Virginia—had ruled it unconstitutional. The Virginia case, *Brzonkala v. Virginia Polytechnic Institute & State University,* involved a female college student who brought a civil lawsuit against two students she claimed had raped her. Judge J. Michael Luttig ruled that the Violence Against Women Act, which permits rape victims to bring civil lawsuits whether or not the government presses criminal charges, was an impermissible federal intrusion into states' rights. (Criminal charges were not pressed because the college refused to refer the matter to the police.)

Brzonkala's lawyer, along with the U.S. Justice Department and the NOW Legal Education and Defense Fund, appealed to the Supreme Court, which agreed to hear the case. In May 2000, the Supreme Court ruling invalidated the VAWA provision that had permitted women to sue rapists in federal court.

Further Reading: Davis, *Moving the Mountain;* Gelhaus, "Constitutional Challenge to VAWA"; *Los Angeles Times,* June 22, 1999; *Ms.* magazine, January/February 1995, Symons, "Legislation for Women: The End of Gridlock?" *Executive Female* (May/June 1993).

Wages for Housework Campaign

Founded in 1972 and based in Los Angeles, the Wages for Housework Campaign works toward "the compensation of unwaged work women do." The group's definition of compensation includes not only wages but health benefits, Social Security credit for housework and child rearing, and access to child care. It proposes that homemaker wages come from monies presently spent on the military. While little progress has been made in securing wages for housework in the United States, the group was instrumental in persuading member nations of the United Nations to agree, in 1985, that women's unpaid work should be counted in each country's gross national product (GNP). The Wages for Housework Campaign has since pressured the United States to bring its GNP computations into compliance with the 1985 agreement and, as of 2000, the United States is preparing to do so. (See UNREMUNER-ATED WORK ACT OF 1993 for further discussion).

The Wages for Housework Campaign maintains a speakers' bureau and has published such titles as *The Global Kitchen*. It is currently headed by Margaret Prescod, a cofounder.

Further Reading: Brecher and Lippitt, *Women's Information Exchange National Directory;* Brennan, ed., *Women's Information Directory.*

Wald, Lillian (1867–1940) *nurse, founder of Visiting Nurse Service*

Born on March 10, 1867, in Cincinnati, Ohio, to Minnie Schwartz Wald and Max Wald, Lillian Wald became the founder of what is now the Visiting Nurse Service and indeed a founder of public health nursing.

Wald received her early education at Miss Cruttenden's English-French Boarding and Day School in Rochester, where her family had settled. She applied to Vassar when she was only sixteen years old and was denied admission on the basis of her age. At the age of twenty-one, moved by the "need of serious, definite work," she attended the New York Hospital's nursing school, from which she graduated in 1891.

During her first year as a nurse, Wald worked at the New York Juvenile Asylum; there she concluded that she had been insufficiently trained. She entered the Woman's Medical College in New York and, while a student there in 1893, held home nursing classes for Lower East Side families. In March she was called to the home of Mrs. Lipsky, one of her students; as she recounted, the experience redirected her life:

> The family . . . was neither criminal nor vicious. Although the husband was a cripple, one of those who stand on street corners exhibiting deformities to enlist compassion, and masking the begging of alms by a pretense at selling; although the family of seven shared their rooms with boarders . . . and although the sick woman lay on a wretched, unclean bed, soiled with a hemorrhage two days old, they were not degraded human beings, judged by any measure of moral values. In fact, it was very plain that they were sensitive to their condition, and when, at the end of my ministrations, they kissed my hands . . . it would have been some solace if by any conviction of the moral unworthiness of the family I could have defended myself as a part of a society which permitted such conditions to exist. Indeed, my subsequent acquaintance with them revealed the fact that, miserable as their state was, they were not without ideals for the family life, and for society, of which they were so unloved and unlovely a part.

Wald and a friend, Mary Brewster, moved into the Lower East Side, determined "to live in the neighborhood as nurses, identify ourselves with it socially, and . . .

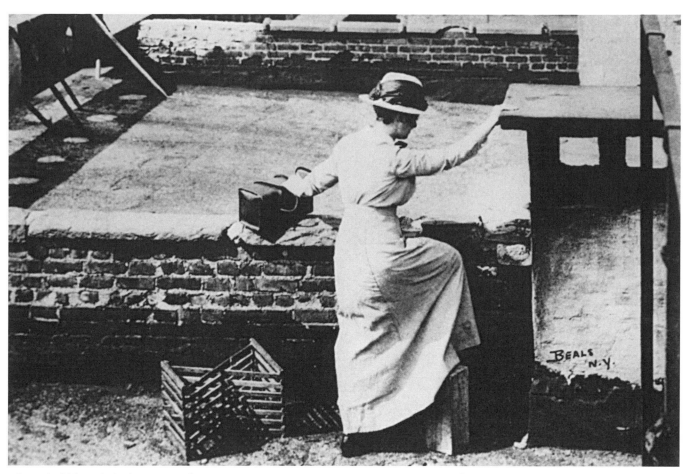

Lillian Wald founded what is now the Visiting Nurse Service. Here, a nurse crosses rooftops to visit a patient in 1908. (*Visiting Nurse Service of New York*)

contribute to it our citizenship." So began the field of public health nursing.

By 1895, with the financial assistance of Mrs. Solomon Loeb and her family, the "Nurses Settlement" was located in a building at 265 Henry Street. It was staffed by nine trained nurses and two other women, all of whom lived together in the settlement building. The Board of Health issued badges, certifying the nurses to make house calls under its authority and—perhaps equally important—enabling the nurses to have some authority when requesting the removal of health violations, such as trash from alleyways. The United Hebrew Charities' medical staff agreed to offer consultation and backup assistance to the nurses, who traveled from the home of one suffering person to another, from 8:30 A.M. to 5:00 P.M., seven days a week.

The family-style living arrangements of Wald's nurses began to be phased out as the service grew from the original nine to almost 100 by 1913. At the same time, as Wald tried to treat the "underlying social causes" of illness, the Henry Street Settlement became an important neighborhood resource for New York's Lower East Side residents. Its programs included educational endeavors such as kindergartens, nurses' training programs, and sewing, carpentry, music, dance, and art classes; clubs for boys, girls, men, young working women, and new mothers; and the establishment of two scholarship funds.

At Wald's direction, the nursing service volunteered to screen and treat students at a local high school in 1902. The program proved so beneficial that New York City created a nursing program to serve all of its public schools, thereby becoming the first city in the world to provide nursing care to its students. In 1911 she convinced the Metropolitan Life Insurance Company (now MetLife) to hire her nurses to care for ill policyholders. The experimental program so reduced anticipated death benefits that the company might otherwise have paid out that by 1916 the company made visiting nurse services available to 90 percent of its industrial policyholders, a population that was spread over 2,000 cities. This resulted in the first countrywide system of insurance coverage for medical care delivered in the home.

Wald also was committed to taking preventive health measures in the political arena. She viewed child labor as one of the underlying causes of illness and, with Florence KELLEY, organized the New York Child Labor Committee in 1902 and the National Child Labor Committee in 1904. Equally committed to preventing the exploitation of employed women, Wald was active in the NATIONAL WOMEN'S TRADE UNION LEAGUE.

In 1912 Wald became a founder and the first president of the National Organization for Public Health Nursing. In that same year, responding to suggestions made by Wald and Kelley, Congress created the United States Children's Bureau.

When the United States entered World War I, Wald joined the Council of National Defense as head of the home nursing committee. She was also the chairman of the Nurses' Emergency Council during the 1918 influenza epidemic.

Lillian Wald retired in 1933 and died on September 1, 1940, in Westport, Connecticut. In 1944 the institution she founded became two separate entities. The Henry Street Settlement, which retained the social and community service programs instituted by Wald, remains a vital resource center for New York City's Lower East Side. The Visiting Nurse Service of New York, as the spun-off nursing and medical care institution was named, currently serves over 17,000 New Yorkers (in homes throughout four of the city's five boroughs) each week.

Further Reading: Coss, ed. *Lillian D. Wald;* Daniels, *Always a Sister;* Denker, ed., *Healing at Home;* Duffus, *Lillian Wald;* Siegel, *Lillian Wald of Henry Street;* Wald, *House on Henry Street;* ———, *Windows on Henry Street.*

Walker, Alice Malsenior (1944–) *writer*

Born on February 9, 1944, in Eatonton, Georgia, to Millie Tallulah Grant Walker and Willie Lee Walker, Alice Walker is a poet and the author of numerous essays, short stories, and novels, including the Pulitzer Prize–winning *The Color Purple.*

Willie Lee Walker was a sharecropper and dairy farmer. Minnie Walker, who both assisted in the fields and worked as a maid, was a powerful inspiration to her daughter, teaching her that anything was possible if she set her mind to it.

Walker attended a shabby segregated school. Blind in one eye—one of her brothers accidentally shot her with a BB gun in 1952—she won a scholarship awarded to handicapped students by Spelman College, a black women's school. When Walker left for Spelman College and Atlanta in 1961, it was with bus fare donated by residents of Eatonton.

Walker's college years were extremely eventful ones. She became an active participant in the civil rights move-ment, attending demonstrations and violating some of Spelman's strict regulations regarding student behavior. Following her sophomore year, she received a scholarship offer from Sarah Lawrence College, in Bronxville, New York, where she transferred. Walker spent the summer of 1964 traveling through Africa; she returned to the United States pregnant and was distraught at the beginning of her junior year at Sarah Lawrence. Walker had an abortion and, in the emotion-filled week that followed, wrote the poems that would be published in 1968 in the volume *Once.*

In 1965 Walker graduated from Sarah Lawrence and worked briefly for the New York City Welfare Department. The following year she went to Mississippi "to be in the heart of the civil-rights movement"; there she met a young Jewish civil rights lawyer, Melvyn Rosenman Leventhal, whom she married on March 17, 1967. As Walker later described the union to Gloria STEINEM in a 1982 interview for *MS.* MAGAZINE, the couple expected to continue their voter-registration and other work while challenging the laws against intermarriage at the same time. Walker and Leventhal became the first legally married interracial couple in Jackson, Mississippi. They had one child, Rebecca Grant, and were divorced in 1976.

Once, the volume of poetry written during Walker's college days, was published to critical acclaim in 1968. Her first novel, *The Third Life of Grange Copeland,* was published to mixed reviews in 1970. It is the story of an African-American tenant farmer who abandons his wife, son, and the South for a new life in the North, only to return to make amends during the childhood of his orphaned granddaughter. Her second volume of poetry, *Revolutionary Petunias and Other Poems,* appeared in 1973, winning the Lillian Smith Award of the Southern Regional Council and a nomination for a National Book Award. Her first collection of short stories, *In Love and Trouble: Stories of Black Women,* was also published in 1973, winning the Richard and Hinda Rosenthal Award from the American Institute of Arts and Letters. Walker's third book to be published in 1973 was a biography for young readers, *Langston Hughes: American Poet.*

Walker became a contributing editor to *Ms.* magazine in 1974. Two more books were published in 1976: her second novel, *Meridian,* and her third volume of poetry, *Goodnight, Willie Lee, I'll See You in the Morning.* A second work on an African-American author—an anthology of Zora Neale HURSTON's work entitled *I Love Myself When I'm Laughing . . . and then Again When I Am Looking Mean and Impressive*—was published in 1979.

Walker's second collection of short stories, *You Can't Keep a Good Woman Down,* was published in 1981. Criticized for depicting black women more sympathetically than black men in these stories (as well as in previous works), Walker calmly replied in a 1970 interview for

Publishers Weekly that black women have been oppressed, an oppression often encouraged by black men.

The Color Purple (1982), Walker's third novel, further explores the gender relationships of African Americans by telling the story of Celie, a Southern African-American woman whose stepfather not only rapes and twice impregnates her, but forces her to give away her two children and marry a local widower. A tremendously redemptive tale by its end, *The Color Purple* won both the Pulitzer Prize for fiction and an American Book Award as well as a nomination for the National Book Critics Circle Award.

In 1983 Walker published a collection of essays, *In Search of Our Mothers' Gardens: Womanist Prose*. In it she gives several definitions of the term "womanist"—which she is credited with coining—the first among them, "A black feminist or feminist of color." Her fourth collection of poetry, *Horses Make a Landscape More Beautiful*, was published in 1984. In 1991, Walker's collected poetry was published in *Her Blue Body Everything We Know: Earthling Poems, 1965–1990 Complete*.

In the early 1990s, Walker turned her attention to the practice of FEMALE GENITAL MUTILATION, which she has addressed in her novel *Possessing the Secret of Joy* (1992) and in her nonfiction study *Warrior Marks: Female Genital Mutilation and the Sexual Blinding of Women*, with Pratibha Parmer (1993). *Anything We Love Can be Saved: A Writer's Activism* was published in 1997.

Further Reading: *Current Biography Yearbook*, 1984; Gilbert and Gubar, eds., *Norton Anthology of Literature by Women*; Hurston, *I Love Myself When I'm Laughing*; *Ms.* Magazine. June 1982; *New York Times*, April 16, 1983; *New York Times Magazine*, January 8, 1984; *Washington Post*, August 8, 1976; Showalter, Baechler, and Litz, eds., *Modern American Women Writers*; Walker, *Once*; ———, *Third Life of Grange Copeland*; ———, *Revolutionary Petunias and Other Poems*; ———, *Meridian*; ———, *Goodnight, Willie Lee, I'll See You in the Morning*; ———, *You Can't Keep a Good Woman Down*; ———, *Color Purple*; ———, *In Search of Our Mother's Gardens*; ———, *Horses Make a Landscape More Beautiful*; ———, *Her Blue Body Everything We Know*; ———, *Anything We Love Can Be Saved*; Walker and Parmer, *Warrior Marks*.

Warren, Mercy Otis (1728–1814) *poet, playwright, historian, Revolutionary War patriot*

Mercy Otis was born on September 14, 1728, in Barnstable, Massachusetts, to Mary Allyne Otis and James Otis. While tutors prepared her brothers for college, Mercy and her sisters received no formal education. Mercy nonetheless listened in on her brothers' lessons and was given access to her uncle's library. Mercy Otis married James Warren on November 14, 1754. The couple had five children.

Warren's husband served in the Massachusetts legislature, and Warren herself was a close friend of Abigail Adams and the sister of James Otis, a leader during the colonies' opposition to the Stamp Act of 1765. As colonial conflict escalated into revolution, Warren had an insider's view of events. Toward the end of the 1770s, she began writing her three-volume *History of the Rise, Progress and Termination of the American Revolution* (published in 1805). Before and possibly during the war, Warren wrote dramatic political satire. Her plays include: *The Adulateur* (published anonymously in the *Massachusetts Spy* [1772], it depicts Massachusetts governor Thomas Hutchinson as "Rapitio, the Bashaw [ruler] of Servia whose principal mission in life is to crush the ardent love of liberty in Servia's freeborn sons), *The Defeat* (published in the *Boston Gazette* [1773]), and *The Group* (1775). *The Blockheads* (1776) and *The Motley Assembly* (1779) are also tentatively attributed to her. Warren later wrote her criticism of the United States Constitution, *Observations on the New Constitution, and on the Federal Conventions* (1788), under the pseudonym "A Columbian Patriot." *Poems, Dramatic, and Miscellaneous* was published in 1790.

Mercy Otis Warren died in Plymouth, Massachusetts on October 19, 1814.

Further Reading: Etheridge, "Mercy Otis Warren," in *American Women Writers*, ed. Faust; Evans, *Born for Liberty*; Flexner, *Century of Struggle*; Freer, "Mercy Otis Warren," in *Notable American Women*, ed. James, James, and Boyer; McHenry, ed., *Famous American Women*; Rogers, *Meridian Anthology of Early American Women Writers*; Stanton, Anthony, and Gage, eds., *History of Woman Suffrage*, vol. 1; Warren, *History of the rise, progress and termination of the American Revolution*; Withey, *Dearest Friend*.

Weinberger v. Wiesenfeld (1975)

The 1975 Supreme Court decision in this case struck down, on FOURTEENTH AMENDMENT grounds, a provision of the Social Security Act that had prevented widowers from collecting survivors benefits on the same basis as widows.

The suit was brought by Stephen Wiesenfeld, whose wife, Paula, had died in childbirth. Wishing to remain at home to rear his newborn son, Wiesenfeld applied for Social Security survivor benefits, based on his wife Paula's contributions. The Social Security Administration denied the request, saying that such benefits were payable to widowed mothers but not to widowed fathers.

Ruth Bader GINSBURG, who would later serve on the Supreme Court, argued the case. She contended that the

Social Security Administration was guilty of sex discrimination against Stephen Wiesenfeld and also against Paula Wiesenfeld, whose participation in the Social Security program provided less of a benefit to her family than would a man's similar participation. The government argued in turn that widowed women were treated more favorably than widowed men in an effort to "compensate women and their beneficiaries as a group for the economic difficulties which still confront women who seek to support themselves and their families."

The majority opinion, written by Justice William J. Brennan, Jr., held that the Social Security Act was designed to "enable the surviving parent to remain at home to take care of a child" and that "It is no less important for a child to be cared for by its sole surviving parent when that parent is male rather than female." Quoting the majority opinion of the court in a prior Fourteenth Amendment women's rights case, *FRONTIERO V. RICHARDSON,* Justice Brennan concluded: "by providing dissimilar treatment for men and women who are similarly situated, the challenged section violates the [equal protection] Clause."

In its 1973 decision in *Califano v. Goldfarb* (also argued by Ruth Bader Ginsburg), the Court ruled that widowed men without dependent children were entitled to the same benefits as widowed women in the same position. In 1977, however, the Court, in *Califano v. Webster,* upheld a provision of the Social Security Act that treated men and women differently. Both men and women calculate their "average monthly wage" for Social Security purposes by using a formula that omits a number of their low-earning years. Women were permitted to omit more of their lower-earning years than men were, a policy that was challenged on Fourteenth Amendment grounds. In *Califano v. Webster,* the Court reasoned that this policy served an important governmental goal, namely the amelioration of the gap between women's and men's financial circumstances.

Further Reading: *Califano v. Goldfarb,* 1973. 430 U.S. 199; *Califano v. Webster,* 1977. 430 U.S. 313; Cary and Peratis, *Women and the Law;* Cushman, *Cases in Constitutional Law; Frontiero v. Richardson,* 1973. 411 U.S. 677; Mansbridge, *Why We Lost the ERA;* O'Connor, "Women and the Constitution," in *Women, Politics and the Constitution,* ed. Lynn; *Weinberger v. Wiesenfeld,* 1975. 420 U.S. 636.

Wells-Barnett, Ida Bell (1862–1931) *journalist, suffragist, African-American rights leader*
Ida Bell Wells-Barnett was born Ida Bell Wells on July 16, 1862, in Holly Springs, Mississippi, to Lizzie Bell and her husband, James Wells, both slaves at the time of her birth.

Wells-Barnett was educated in a local freedmen's school. When she was fourteen, both her parents and three of her siblings died of yellow fever. Adopting the longer skirts and upswept hair worn by older women, Wells-Barnett managed to find a job as a teacher and to support and raise the remaining children in Mississippi.

Moving to Memphis in 1884, she found another teaching position and continued her own education at Fisk University and Lemoyne Institute. Also in 1884 she was forcibly removed from a first-class car of the Chesapeake & Ohio Railroad, because of her race. Wells-Barnett filed a lawsuit against the railroad (the circuit court decided in her favor, but Tennessee's Supreme Court, in 1887, found in favor of the railroad), and she wrote an article about the incident. She then began writing for black newspapers under the pseudonym "Iola." When she publicly criticized the inferior education being offered to black children, she lost her job (1891). She married Ferdinand L. Barnett in 1895 and adopted a hyphenated surname, Wells-Barnett.

Wells-Barnett next directed all her energy toward her journalistic career. Before the year's end, she purchased a 33 percent interest in the *Memphis Free Speech* newspaper. In 1892 three of her friends were lynched. Wells-Barnett, by now half owner of the *Memphis Free Speech,* began a crusade against lynching. The articles she published on the subject so angered some readers that her newspaper offices were ransacked and demolished. Wells-Barnett left Memphis, touring the United States and England to lecture against lynching. She founded anti-lynching societies and black women's clubs wherever she visited. Her statistical study of lynchings over a three-year period, entitled *A Red Record,* was published in 1895.

Wells-Barnett helped to found the Alpha Suffrage Club (the first black woman's suffrage association), the Boston New Era Club, the NATIONAL ASSOCIATION OF COLORED WOMEN, and the National Association for the Advancement of Colored People. She served as secretary of the National Afro-American Council from 1892 to 1902 and sat as chairman of the Chicago Equal Rights League. As Chicago's black population increased, she organized a black women's organization to initiate long-term projects for that community. In 1910 she founded the Negro Fellowship League and, with her salary as a court probation officer, helped fund such projects as a community shelter and a recreation and employment center. She took part in the Washington, D.C. Suffrage Parade of 1913, marching in the Illinois section despite the NATIONAL AMERICAN WOMAN SUFFRAGE ASSOCIATION's request that she march as part of a separate black contingent. She marched without incident, in the Chicago Suffrage Parade of 1916.

Ida Bell Wells-Barnett died in Chicago on March 25, 1931.

Further Reading: Flexner, *Century of Struggle;* ———, "Ida Bell Wells-Barnett," *Notable American Women,* ed. James, James, and Boyer; Kraditor, *The Ideas of the Woman Suffrage Movement/1890–1920;* Sterling, *We Are Your Sisters; Black Women in the Nineteenth Century.*

Welty, Eudora (1909–) *writer*

Born on April 13, 1909, in Jackson, Mississippi, to Mary Chestina Andrews Welty and Christian Webb Welty, Eudora Welty became one of the South's most noted writers.

Welty studied at the Mississippi State College for Women from 1925 to 1927 and then transferred to the University of Wisconsin, from which she graduated in 1929. She then studied advertising at Columbia University for two years. In 1931 and upon her father's death, Welty returned to Jackson, where she found employment with radio station WJDX, several Jackson newspapers, and the Works Progress Authority.

The first of Welty's short stories to be published was "Death of a Traveling Salesman," which appeared in 1936 in *Manuscript.* Her first collection of short stories, *A Curtain of Green, and Other Stories,* was published in 1941. Containing such stories as "Why I Live at the P.O." and "Keela the Outcast Indian Maiden," it exhibited what would become the hallmarks of Welty's style: lyrically—even mythically—depicted lower- or lower-middle-class characters using entirely realistic dialogue, contributing to a richly conveyed sense of her stories' Southern setting. *The Wide Net, and Other Stories* was published in 1943; its title story concerns the adjustment of William Wallace Jamieson and his wife, Hazel, to the impending arrival of their first child. *The Golden Apples* was Welty's third collection of stories; published in 1949, it contains seven stories, all interwoven, of characters comprising three generations of the same family. Welty also published the collection *The Bride of Innisfallen* (1955) and a children's book entitled *The Shoe Bird* (1964). *The Collected Works of Eudora Welty,* published in 1980, brought together all but five of Welty's stories published prior to 1966 and two that had not appeared in any previous volume.

Welty also has published a number of novels, including *The Robber Bridegroom,* which was published in 1942 and adapted as a Broadway musical in 1975; *Delta Wedding,* which grew out of an earlier short story, "The Delta Cousins," and was published in 1946; and *The Ponder Heart,* which was published in 1954 and, like *The Robber Bridegroom,* was adapted for Broadway (1956).

Welty published the novels *Losing Battles* in 1970 and *The Optimist's Daughter* in 1972. *The Optimist's Daughter* was awarded the Pulitzer Prize, an honor many considered overdue. In 1978 she published a collection of reviews and essays entitled *The Eye of the Story.*

Welty offered insight into her development as a writer with the 1983 publication of *One Writer's Beginnings,* a book that originated in a series of lectures made at Harvard University during the spring of that year. Divided into three tellingly entitled chapters, "I. Listening," "II. Learning to See," and "III. Finding a Voice," *One Writer's Beginnings* is an evocative memoir of Welty's life and work, in which she concludes that memory "is the treasure most dearly regarded by me, in my life and in my work as a writer."

Eudora Welty lives in Jackson, Mississippi. In 2000, she was inducted into the NATIONAL WOMEN'S HALL OF FAME.

Further Reading: Faust, ed., *American Women Writers;* Gilbert and Gubar, eds., *Norton Anthology of Literature by Women;* McHenry, ed., *Famous American Women;* Showalter, Baechler, and Litz, eds., *Modern American Women Writers;* Waldron, *Eudora Welty;* Welty, *Delta Wedding;* ———, *The Optimist's Daughter;* ———, *Eye of the Story;* ———, *Collected Stories of Eudora Welty;* ———, *One Writer's Beginnings.*

Wharton, Edith Newbold Jones (1862–1937) *writer*

Born Edith Newbold Jones on January 24, 1862, in New York City, to Lucretia Rhinelander Jones and George Jones, Edith Wharton was a major American author of the early twentieth century.

Born into the monied upper class of nineteenth-century New York, Wharton was educated by governesses and traveled extensively throughout Europe during her youth. When she was sixteen, a volume of her poetry, entitled *Verses,* was privately published by her parents. She became engaged to Harry Stevens, but he broke the engagement in 1882, as the *Newport Daily News* recounted it, upon finding that "Miss Jones is an ambitious authoress, and it is said that, in the eyes of Mr. Stevens, ambition is a grievous fault." Wharton subsequently married a friend of her brother, Edward (Teddy) Wharton, on April 29, 1885. Although the marriage quickly proved unhappy, the couple moved together to Paris in 1907 and remained together until 1913. Upon her divorce, Wharton continued to live in Europe.

Wharton's earliest works included three story collections, *The Greater Inclination* (1899), *Crucial Instances* (1908), and *The Descent of Man, and Other Stories* (1904), as well as a historical novel, *The Valley of Decision,* published in 1902, and two books concerning the decorative arts (*The Decoration of Houses* [1897] and *Italian Villas, and Their Gardens* [1904]).

It was *The House of Mirth* published in 1905, though, that established Wharton as a leading literary figure. The novel, which bears a biblical title, explores the moral emptiness of New York's monied classes as it chronicles the life—and ultimate defeat of Lily Bart, a young woman taught to view marriage as the means to a wealthy end.

Wharton's other works include *Ethan Frome* (1911), the story of a man who, having fallen in love with his wife's cousin, arranges for their paired suicide and unwittingly sets up their survival as the handicapped dependents of his wife, Zeena Frome; *The Custom of the Country* (1913), a satiric look at marriage as the only occupation open to upper-class women; and *The Age of Innocence* (1920), a merciless exploration of the pain people exact from each other in an attempt to uphold a moribund social order.

Wharton was elected a member of the National Institute of Arts and Letters in 1930 and a member of the American Academy of Arts and Letters in 1934. Her autobiography, *A Backward Glance*, was published in 1934.

Edith Wharton died on August 11, 1937 in St. Brice-sous-forêt, France.

Further Reading: Auchincloss, "Edith Wharton," in *Notable American Women*, ed. James, James, and Boyer; Faust, ed., *American Women Writers;* Gilbert and Gubar, eds., *Norton Anthology of Literature by Women;* Lewis, *Edith Wharton;* McHenry, ed., *Famous American Women;* Showalter, Baechler, and Litz, eds., *Modern American Women Writers;* Wharton, *House of Mirth;* ———, *Ethan Frome;* ———, *Age of Innocence;* ———, *Backward Glance;* ———, *Best Short Stories of Edith Wharton.*

Wheatley, Phillis (ca. 1753–1784) *writer*

An African-American woman who became famous as a poet while enslaved, Phillis Wheatley was brought to America on a slave ship at about the age of seven (an approximation based upon the fact that she was in the process of losing her first teeth). Although she is believed to have been born in about 1753 or 1754 in what is now Senegal or Gambia to Moslem parents, there are no certain facts about her early life.

In 1761, she was purchased in Boston by John and Susannah Wheatley, who, quickly noting her intelligence, provided her with an education superior to that received by most white girls at the time. Although it was illegal to teach slaves to read, Wheatley was taught to read not only English but Latin. She started writing poetry at thirteen and began publishing her work in newspapers and magazines at the age of seventeen. She quickly became famous. She traveled to London as the guest of the Countess of Huntingdon in 1773 and was received in the homes of Boston's upper-class citizens. In 1776 she met with General George Washington following the publication of a poem addressed to him.

It is an indication of the negative, stereotyped ideas known to be held by Wheatley's potential white audience that her volume of poetry, *Poems on Various Subjects, Religious and Moral,* was published with a statement—signed by eighteen well-known and well-respected men, including John Hancock—vouching for the authenticity of Wheatley's authorship. (The book was published in London in 1774; it was not published in the United States until 1784.) Wheatley seems to have been treated like a favored pet by privileged people who wished to believe they offered her unfettered access to the world while keeping her enslaved. She was able to become America's first known black female poet in part because her poetry—filled with classical allusion and written in competent neoclassical couplets—emphasized Christian salvation and offended none of her white patrons.

Phillis Wheatley was freed after the deaths of her owners. In 1778 she married John Peters, a freedman who was later imprisoned for debt. Wheatley spent her last years in poverty. She bore three children; two died during Wheatley's lifetime, and the third died several hours after Wheatley on December 5, 1784. Wheatley and her child lie together in an unmarked grave in Massachusetts.

Further Reading: Bernikow, *World Split Open;* Faust, ed., *American Women Writers;* Gilbert and Gubar, eds., *Norton Anthology of Literature by Women;* Noble, *Beautiful, Also, Are the Souls of My Black Sisters;* Redding, "Phillis Wheatley," in *Notable American Women*, ed. James, James, and Boyer; Rogers, ed., *Meridian Anthology of Early American Women Writers;* Wheatley, *Poems on various subjects, religious and moral;* ———, *Poems of Phillis Wheatley.*

"wife sale"

A method of ending a marriage, practiced in colonial America. As practiced in England at least until 1880, this was an informal granting of a man's wife, marital obligations, and rights to another man in exchange for payment of money and/or goods such as alcohol. In England the transaction required a husband to bring his wife, with a halter around her neck, to a cattle market. There she was auctioned off with the other "mares" to the highest bidder. The same procedure—including the halter—sometimes was followed in colonial America. In some cases, however, wives were sold to their lovers or to members of their own families following a private agreement between husband and wife and in an effort to circumvent colonial

divorce law and proceedings. In places where wife sales occurred, neither the churches nor the courts interfered.

Further Reading: Salmon, *Women and the Law of Property in Early America;* Stanton, Anthony, and Gage, eds., *History of Woman Suffrage,* vol. 1.

Willard, Emma Hart (1787–1870)

Pioneering educator of young women and author of many text and history books, Willard was born Emma Hart on February 12, 1787, on a farm in Berlin, Connecticut, to Samuel and Lydia Hinsdale Hart. She was the sixteenth child born to her father and the ninth born to her mother, Samuel Hart's second wife.

Emma entered the Berlin Academy in 1802. By 1804 she was instructing the academy's youngest children. Her teaching career progressed rapidly, and in 1807 she became preceptress of the Female Academy at Middlebury, Vermont. At the time, all colleges were closed to women and "female academies" were the only institutions of learning open to girls in their later teens. Actually finishing schools, they offered a curriculum of ornamental activities; landscape painting, conversational French, and embroidery predominated.

On August 10, 1809, she married Dr. John Willard, a physician and a director of the Vermont State Bank. Upon her marriage, she did what was expected and left her position at the Female Academy. With her husband's encouragement—and the use of his books—she spent her days studying anatomy, geometry, and natural philosophy.

When John Willard experienced financial difficulties, Emma Willard turned some of the rooms in their large house into a boarding school for young women. This both alleviated the couple's financial difficulties and gave Willard the freedom to design an entirely new type of school for girls. She introduced college courses to her students, improvising where necessary. For example, she used homemade tools, such as cones, spheres, pyramids, and cylinders cut from fruits and vegetables, to teach geometry. She also continued to study on her own and relayed the newest of her acquired knowledge to her best students, grooming them to become teachers as well. The students learned and thrived. Satisfied with the results of her experiment, Willard invited the professors of nearby Middlebury College to audit her students' examinations. As Ezra Brainerd, president of that college in 1893, later admitted, his predecessors found "proof that 'the female mind' could apprehend the solid studies of the college course." However, when Willard asked, in turn, to attend the examinations of the young men at Middlebury College, she was refused permission. The college's then president, Davis, thought "it would not be a safe precedent, and that it would be unbecoming for her to attend."

Hoping to receive public funding for the education of women, Willard in 1819 forwarded "An Address to the Public; Particularly to the Members of the Legislature of New York, Proposing a Plan for Improving Female Education" to Governor DeWitt Clinton and members of the New York State Legislature. (Since 1795, New York State had used public monies for education.) Although she received a charter, she received no funding from the state. The citizens of Troy, New York, through their Common Council, offered to raise the money for her school, and the TROY FEMALE SEMINARY was opened in 1821. At the time, the education it offered was the most advanced education available to a young woman anywhere in America.

In 1822 Willard wrote, with William Channing Woodbridge, *A System of Universal Geography on the Principles of Comparison and Classification.* In 1828 she completed the first of her history texts, *Republic of America.* Her account of the American Revolution was applauded by no less an authority than General Lafayette, and it was the history text Daniel Webster, famous New England lawyer and senator, relied on: "I keep it near me as a book of reference, accurate in facts and dates," he

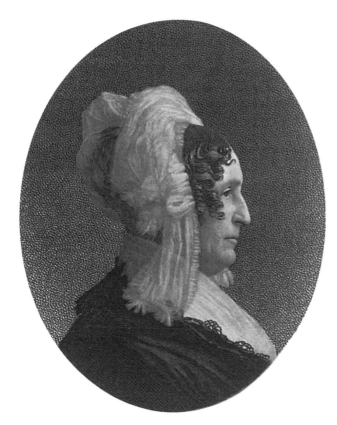

Emma Willard, the founder of America's first institute of advanced learning for women *(The Emma Willard School)*

said. Her other books include *A System of Universal History in Perspective* (1837); *A Treatise on the Motive Powers which Produce the Circulation of the Blood* (1846); and *Last Leaves of American History* (1849 enlarged ed., *Late American History: Containing a Full Account of the Courage, Conduct, and Success of John C. Fremont*, 1856).

Following the 1825 death of her husband, who had acted as the school's business manager, Emma Willard assumed responsibility for both curriculum and administrative matters. In 1838 she turned over the administration of her school to her son, John Hart Willard, and her daughter-in-law, Sarah Lucretia Hudson. She lived for a time in Connecticut, working to improve the quality of common schools there, but she returned to Troy in 1844. Willard spent the rest of her life working on behalf of women and education. She acted as teacher and adviser in Troy and traveled extensively, doing much to dispel prejudice against education for women. She died in Troy, New York on April 15, 1870. The Troy Female Seminary was renamed the Emma Willard School in honor of its founder in 1895.

Further Reading: Brainerd, "Life and Work in Middlebury, Vermont, of Emma Willard"; Flexner, *Century of Struggle;* Hardesty, "Emma Hart Willard," in *American Women Writers,* ed. Faust; Rudolph, "Emma Hart Willard," in *Notable American Women,* ed. James, James, and Boyer; Sage, *Emma Willard and Her Pupils;* Stanton, *Eighty Years and More;* Stanton, Anthony, and Gage, eds., *History of Woman Suffrage,* vol. 1.

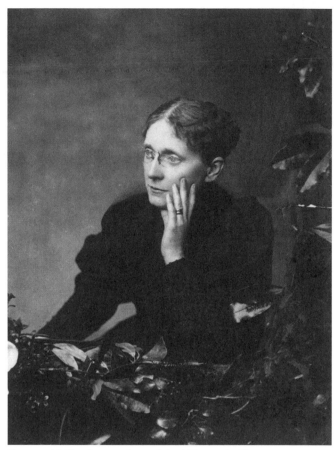

Frances Willard, president of the Woman's Christian Temperance Union from 1879 to 1898 (*Library of Congress*)

Willard, Frances Elizabeth Caroline (1839–1898)
suffragist, temperance leader

Frances Elizabeth Caroline Willard was born on September 28, 1839, in Churchville, New York, to Mary Thompson Hill Willard and Josiah Flint Willard.

Following her graduation from North-Western Female College in 1859, Willard began teaching. After working at a succession of schools, she became dean of women at Northwestern University in 1873. In 1874 she resigned her position at Northwestern and joined the growing crusade against liquor by becoming corresponding secretary of the National WOMAN'S CHRISTIAN TEMPERANCE UNION. In 1879 she became its president, a position she held until her death.

Willard also was a supporter of women's suffrage. Many women joined her temperance organization to work only toward banning alcohol. Willard, by pointing out to these women the political clout that could be gained by securing the vote, gained many converts for the suffrage cause.

She became influential in the Prohibition party and also in the Populist party but was disappointed in her wish to merge these two parties into a national reform party. In 1883 she organized the World's Woman's Christian Temperance Union and became its first president. She was elected president of the National Council of Women in 1888. She wrote many articles and several books, including *Woman and Temperance* (1883), the autobiographical *Glimpses of Fifty Years* (1889), *How to Win* (1886), and *A Great Mother* (1894). She coedited *A Woman of the Century* (1893) with Mary Livermore.

Frances E. Willard died in New York City on February 18, 1898. In 2000, Willard was inducted into the NATIONAL WOMEN'S HALL OF FAME.

Further Reading: Bordin, *Frances Willard;* Willard, *Glimpses of Fifty Years.*

Winnemucca, Sarah (Thocmetony) (ca. 1844–1891)
interpreter, peacemaker, activist

Born in about 1844 at Humboldt Sink in what later became Nevada, to Paiute chief Winnemucca II and a mother whose name has not survived, Sarah Winnemucca, or Thocmetony, which translates as "Shell-

Flower," became a mediator between her Native American people and the United States government.

Winnemucca's grandfather, Winnemucca I, is believed to have escorted Captain John C. Fremont safely across the Sierra Nevada to California during the winter of 1845–46. Winnemucca I, possibly because of this contact, took efforts to expose his granddaughter to settlers and their European cultures. By the time she was grown, Winnemucca spoke English and Spanish as well as three Native American languages. In addition, she merged Christian beliefs with her own traditional beliefs and took the name of Sarah.

In 1860 the numbers of settlers in Nevada began to increase, and fighting with the Paiute broke out. Although Winnemucca lost members of her own family in these battles, she acted as a negotiator and, from 1868 to 1871, was an interpreter at Nevada's Camp McDermitt. She relocated to the Malheur Reservation in Oregon in 1872 and, by 1875, was an interpreter for reservation agent Samuel Parrish. Parrish was replaced in 1876 with Major William V. Rinehart, whom Winnemucca judged to treat her people unfairly. Winnemucca reported Rinehart and promptly was dismissed as interpreter. She left the reservation. Many other Paiutes abandoned the reservation to join the Bannock tribe in Idaho. In 1878 the Bannock and the United States went to war, and Winnemucca volunteered to help the U.S. army. Learning that her father and some of his followers had been forced to side with the Bannock, she went without sleep to track the Bannock "through the roughest part of Idaho" and into Oregon. She engineered the escape of her father and other Paiutes unwilling to join the war and then returned to her army post with valuable information. She was General Oliver O. Howard's interpreter, scout, and guide until the end of the Bannock war.

In 1880 Winnemucca met with Secretary of the Interior Carl Schurz and President Rutherford B. Hayes and negotiated for a Paiute return to the Malheur Reservation and the granting of individual plots of land to Paiute tribe members. Although Hayes and Schurz agreed to Winnemucca's request, the order was not carried out by civilian agents, who claimed to fear that the Paiute would be killed while traveling back to their original reservation.

Winnemucca lectured extensively and further publicized the Paiute case by the sale of her privately printed *Life among the Piutes* (1883). On tour, she collected thousands of signatures to a petition requesting that the government fulfill its land allotment pledge. Congress passed a bill ordering such action in 1884, but the secretary of the interior refused to sign it.

Sarah Winnemucca died on October 16, 1891, in Monida, Montana, without seeing her hopes for her people realized.

Further Reading: Peabody, "Sarah Winnemucca's Practical Solution of the Indian Problem; Wilkins, "Sarah Winnemucca," in *Notable American Women,* ed. James, James, and Boyer.

Winning Plan, The (1916)

Carrie Chapman Catt's successful organizational strategy for what became the final phase of the struggle for women's suffrage, the "Winning Plan" was presented at a meeting of the Executive Council of the National American Woman Suffrage Association (NAWSA) following its 1916 convention. In secret, the officers of over thirty-six NAWSA state associations signed the compact pledging to "move on Congress with precision and a will . . . prepared to give their lives and their fortunes for success." According to Catt's plan, the NAWSA's national board would evaluate the feasibility of winning women's suffrage in the individual states, and the organization's resources and volunteers would be apportioned accordingly. Once a state had granted women's suffrage, its newly enfranchised female population would press for a women's suffrage amendment to the Constitution. If Congress passed such an amendment, it would then have to be ratified by thirty-six states (two-thirds of the states in the union). According to Catt's plan, women would have to become voters in at least that many states in order for legislators to support such a federal amendment or risk losing "the woman's vote."

Catt hoped to succeed by 1922. The Nineteenth Amendment was actually ratified in 1920—in part because women's participation in World War I pushed the issue of their participation in government to the forefront of the national agenda, but also because Catt's Winning Plan worked.

Further Reading: Flexner, *Century of Struggle;* Stanton, Anthony, and Gage, eds., *History of Woman Suffrage,* vol. 5.

Woman's Bible, The (1895, 1898)

Published by Elizabeth Cady STANTON in two volumes, the first of which appeared in 1895 and the second, in 1898, *The Woman's Bible* is a feminist reevaluation of the Old and New Testament. Stanton began the project because she had become convinced that discriminatory legal codes and exploitive social arrangements survived, in large part, because they had long been supported by religious authority. She was joined in the work by several other women, including Lillie Devereaux Blake, a great-great-granddaughter of Puritan preacher Jonathan Edwards.

Stanton begins her analysis with Genesis, where she finds evidence of a "Heavenly Mother and Father." As

she points out, Chapter 1, verses 26 to 28, refers to God as saying: "Let us make man in our image, and after our likeness: and let them have dominion . . . So God created man in his own image, in the image of God he created him; male and female created he them . . ." According to Stanton's reading, the plural possessive pronoun "our" indicates a plural God, and the creation of "male and female," as God describes it, "in our image," indicates "the existence of the feminine element in the Godhead, equal in power and glory with the masculine. The Heavenly Mother and Father!" She also examines the concluding verses, which read "And God blessed them, and God said unto them. Be fruitful, and multiply . . . and have dominion over the fish of the sea, and over the fowl of the air, and over every living thing that moveth upon the earth." Here, she notes, "equal dominion is given to woman over every living thing, but not one word is said giving man dominion over woman."

Turning her attention to the more frequently quoted story of creation found in Genesis, chapter 2, verses 21 to 25, Stanton describes the apple-eating Eve as a heroine. "[T]he unprejudiced reader must be impressed with the courage, the dignity, and the lofty ambition of the woman," she declares. "The tempter . . . did not try to tempt her . . . by brilliant jewels, rich dresses, worldly luxuries or pleasures, but with the promise of knowledge, with the wisdom of the Gods." Eve (whom Stanton describes as having spent the first part of her life "picking flowers and talking with Adam, [which] did not satisfy") does, according to Genesis, acquire knowledge for herself, Adam, and their descendants.

The book was widely read and just as widely condemned. The NATIONAL AMERICAN WOMAN SUFFRAGE ASSOCIATION (NAWSA), of which Elizabeth Cady Stanton had been a founder and a president, shocked her by introducing a resolution against "the so-called 'Woman's Bible'" at its January 1896 meeting. Susan B. ANTHONY, then president of the NAWSA, argued against the resolution:

> . . . When our platform becomes too narrow for people of all creeds and of no creed, I myself shall not stand upon it . . . Who can tell now whether Mrs. Stanton's commentaries may not prove a great help to woman's emancipation from old superstitions that have barred her way? Lucretia Mott at first thought Mrs. Stanton had injured the cause of all woman's other rights by insisting upon the demand for suffrage, but she had sense enough not to bring in a resolution against it . . . I shall be pained beyond expression if the delegates here are so narrow and illiberal as to adopt this resolution . . . I pray you, vote for religious liberty, without censorship or inquisition . . .

The resolution was passed over Anthony's objection. Stanton nonetheless published volume 2 of *The Woman's Bible* in 1898. Its analysis begins with the Old Testament Book of Joshua and concludes with the New Testament Book of Revelation. The full text of the NAWSA resolution is defiantly appended to volume 2, along with Anthony's speech in Stanton's defense.

The Woman's Bible now stands at the forefront of what has become a feminist theological tradition, as contemporary feminist theologians such as Mary Daly (*Beyond God the Father: Toward a Philosophy of Women's Liberation*, 1973) and Uta Ranke-Heinemann (*Eunuchs for the Kingdom of Heaven: The Catholic Church and Sexuality*, 1990) continue to explore the relationship between biblically sanctioned religious authority and women's position in the secular world.

Further Reading: Daly, *Beyond God the Father;* Ferraro, and Hussey, with O'Reilly, *No Turning Back;* Ranke-Heinemann, *Eunuchs for the Kingdom of Heaven;* Stanton, *Woman's Bible;* Stone, *When God Was a Woman.*

Woman's Christian Temperance Union

Founded in November 1874 in Cleveland, Ohio, this organization works to eliminate the consumption of alcohol. Under the direction of its first president, Annie Wittenmyer (1874–79), Woman's Christian Temperance Union (WCTU) members worked through education and public admonishment. The organization's next and most famous president, Frances E. WILLARD (1879–98), convinced many members that only the vote would give women the power to make social change, and the WCTU became a vocal lobbying force for women's suffrage.

When Prohibition was gained with the passage and ratification of the Eighteenth Amendment in 1919, the WCTU focused on "social purity" and child welfare issues. When the Eighteenth Amendment was repealed in 1933, the WCTU responded by returning to its earliest method of persuasion, education. The organization currently is dedicated to "education for total abstinence" and, coinciding with increased public attention to drunken driving and the need for healthier lifestyles, reports a recent influx of new members. Sarah F. Ward is its president.

Further Reading: Bordin, *Woman and Temperance;* Flexner, *Century of Struggle;* Willard, "Hints and Helps in Our Temperance Work"; ———, *Woman and Temperance; Glimpses of Fifty Years;* ———, "Address before the Second Biennial Convention"; ———, "Address before the Twenty-second Annual Meeting of the National Woman's Christian Temperance Union"; ———, "Ballot for the Home."

Woman's Journal, The

Founded by Lucy STONE and Henry Blackwell in 1870, *The Woman's Journal* was dedicated "to the interests of Woman—to her educational, industrial, legal and political Equality, and especially her right of Suffrage." It was the official magazine of the AMERICAN WOMAN SUFFRAGE ASSOCIATION until that organization in 1890 merged with the NATIONAL WOMAN SUFFRAGE ASSOCIATION and became the NATIONAL AMERICAN WOMAN SUFFRAGE ASSOCIATION. From that point until 1917, it was the official publication of the larger organization.

Edited by Stone, Blackwell, and Julia Ward HOWE during its first twenty-three years and by Alice Stone BLACKWELL following her mother's death in 1893, *The Woman's Journal* published announcements and reports of women's rights conventions; news relating to the progress of the struggle for women's suffrage in America; national and international news of interest to its readers; interviews with women's rights leaders; as well as fiction and poetry.

In 1917 *The Woman's Journal* was absorbed by the *Woman Citizen* along with a few other journals.

Further Reading: Catt and Shuler, *Woman Suffrage and Politics;* Flexner, *Century of Struggle;* Frost and Cullen-DuPont, *Women's Suffrage in America;* Hays, *Morning Star; The Woman's Journal,* Stone, Blackwell, and Howe, eds.

Woman's New York State Temperance Society

A New York State organization founded April 20–21, 1852, in Rochester. More than 500 women attended the organizing convention; Elizabeth Cady STANTON was elected president; Antoinette L. Brown, one of twelve vice presidents; Susan B. ANTHONY, one of two secretaries; and Amelia BLOOMER, corresponding secretary. During the organization's first year of existence, men were permitted to join, but not to vote or hold office. Many members objected to this policy as discriminatory, and men were granted equal membership rights the following year.

The organization had been founded in response to the refusal of existing temperance societies to admit women. (Abby Kelly had addressed one such organization, but "by favor and not by right.") At the founding convention, Stanton pointed out that women lacked more than the welcome of their male counterparts. Since women also lacked access to "the pulpit, the forum, the professor's chair, and the ballot-box," their new organization needed to find alternate means of wielding power and effecting change. The methods that legally and politically handicapped women might use were outlined, and they give a good idea of the limitations faced by women in mid-nineteenth-century America. Public education through "lectures, tracts, newspapers, and discussion" was possible, although it still required some courage for a woman to speak in public. Another possibility was the diversion of funds earned from sewing. Women and girls traditionally donated these monies toward the support of male theological students and other religious purposes. Claiming that "charity begins at home," Stanton suggested that Woman's State Temperance Society members "withdraw our mite" from religious service and the "building up of a theological aristocracy and gorgeous temples to the unknown God." Instead, she said, women should try to feed, clothe, and educate the "young men and women thrown alone upon the world," and thus help to prevent conditions which might lead to habitual drinking and drunkenness.

The society's most controversial action was the adoption of a resolution declaring: "That the woman who consents to live in the relation of wife with a confirmed drunkard, is, in so doing, recreant to the cause of humanity, and to the dignity of true womanhood." Amelia Bloomer endorsed it, saying

> Drunkenness is good ground for divorce, and every woman who is tied to a confirmed drunkard should sunder the ties; and if she do it not otherwise the law should compel it—especially if she have children . . . Can it be possible that the moral sense of a people is more shocked at the idea of a pure-minded, gentle woman sundering the ties which bind her to a loathsome mass of corruption, than it is to see her dragging out her days in misery, tied to his besotted and filthy carcass? . . .

Newspaper editors and members of the clergy *were* shocked, and the Woman's State Temperance Society's resolution was widely criticized in the press and from the pulpit.

The women were never fully accepted by the male-only temperance organizations. In June 1852 the Woman's State Temperance Society responded to a public call issued by a male-only temperance society, which requested that "Temperance associations of every name . . . send delegates." Anthony and Bloomer were elected to represent the Woman's State Temperance Society but, arriving in Syracuse, they were treated as the female delegates to the World Anti-Slavery Convention had been treated twelve years earlier. Women were not allowed to speak, and after the men argued about the suitability of women acting outside "their proper sphere—the domestic circle," they were refused a part in the convention. The following year, at the World's Temperance Convention held in New York City on May 12, 1853, the society's female delegates were again refused admission. Another such incident occurred in

September 1853 when Antoinette Brown was refused participation in a New York City temperance convention planned to coincide with the World's Fair and its attendant crowds. Horace Greeley summed up that convention's proceedings for *New York Tribune*'s readers on September 7, 1853:

> This convention has completed three of its four business sessions, and the results may be summed up as follows:
> First Day—Crowding a woman off the platform.
> Second Day—Gagging her.
> Third Day—Voting that she shall stay gagged. Having thus disposed of the main question, we presume the incidentals will be finished this morning.

Despite the lack of support they received from the male temperance societies, the Woman's State Temperance Society succeeded in bringing its message directly to the women of New York State. Susan B. Anthony, Antoinette Brown, and Amelia Bloomer traveled throughout the state, speaking about the hardships faced by the families of drunkards. Other women followed suit. At the society's first-anniversary meeting, Stanton was able to praise the large number of temperance women "who had never raised their voices in public one year ago" and who had "with so much self-reliance, dignity, and force, enter[ed] . . . such a field of labor, and so ably perform[ed] the work." In 1852, when the society held a meeting to protest their exclusion from the male societies' events, 3,000 people attended. Perhaps its greatest significance to the infant women's rights movement in America was its great success in demonstrating the difficulties women would encounter if they addressed isolated issues without insisting on the broadest possible emancipation. As Stanton explained in her 1853 address to the society's members, "We have been obliged to preach women's rights, because many, instead of listening to what we had to say on temperance, have questioned the right of a woman to speak on any subject . . ."

At the end of the nineteenth century, Frances E. WILLARD, president of the national (and much larger) WOMAN'S CHRISTIAN TEMPERANCE UNION, would find it necessary to point out the same connection.

Further Reading: Stanton, Anthony, and Gage, *History of Woman Suffrage*, vol. 1; Stanton and Blatch, *Elizabeth Cady Stanton*, vol. 2.

Woman's Peace Party

Begun in November 1914 by Crystal EASTMAN and Madeline Doty and expanded into a national organization in 1915 by Jane ADDAMS following a meeting of the INTERNATIONAL CONGRESS OF WOMEN at The Hague in that same year, the Woman's Peace Party (WPP) was the first all-female organization dedicated exclusively to the promotion of pacifism.

As early as the August 1914 outbreak of World War I in Europe, British suffragist Emmeline Pethick-Lawrence and Hungarian suffragist Rosika Schwimmer had requested that suffragist women in America work for peace. WPP responded by lobbying President Woodrow Wilson to mediate rather than join the war and by organizing women to oppose all war in principle. Carrie Chapman CATT, Florence KELLEY, Charlotte Perkins GILMAN, and some 25,000 other women joined the effort by the end of 1916.

When the United States entered World War I in 1917, the organization's leaders—hoping this might, after all, be the "war to end all wars"—put aside its public opposition and made plans for the postwar era. At a 1919 Women's Peace Conference in Zurich, women from sixteen countries agreed that the WPP would become the Women's International League for Peace and Freedom (WILFPF).

The Women's International League for Peace and Freedom continues to use the original slogan of the Woman's Peace Party: "Listen to the Women for a Change." Its current goals include the elimination of U.S. economic interference and military intervention abroad; universal disarmament; worldwide amnesty for those who refuse to serve in the armed forces; and the creation of "an economy that puts people before profits." Its international headquarters are in Geneva, Switzerland, and it has 130 branches in twenty-eight countries, including the United States. The U.S. section, based in Philadelphia, has 10,000 members, and currently is led by president Betty Burks.

Further Reading: Addams, Balch, and Hamilton, *Women at The Hague*; Brecher and Lippitt, *The Women's Information Exchange National Directory*; Brennan, ed., *Women's Information Directory*; Degen, *History of the Woman's Peace Party*; Wiltsher, *Most Dangerous Women*.

Women Against Pornography

Founded in 1979 by Susan Brownmiller, author of *AGAINST OUR WILL: MEN, WOMEN AND RAPE*, Robin MORGAN, and others, Women Against Pornography works to bring public opinion to the view that pornography is "about the degradation, objectification, and brutalization of women." Toward this end, it conducts a speakers' bureau, organizes protests, and conducts guided tours of the Times Square district in New York City.

Women Against Pornography publishes the *Women Against Pornography—Newsreport* two to four times each year. Based in New York City, it has 12,000 members.

Dorchen Leidholdt is the organization's current contact person.

Further Reading: Brecher and Lippitt, *Women's Information Exchange National Directory;* Brennan, ed., Women's Information Directory.

Women & Economics (1898)

Published by Charlotte Perkins GILMAN in 1898, this book—originally entitled *The Economic Factor Between Men and Women as a Factor in Social Evolution*—examines what Gilman calls the "sexuo-economic" relationship between men and women.

Beginning with the proposition that "The economic status of the human race in any nation, at any time, is governed mainly by the activities of the male: the female obtains her share in the racial advance only through him," Gilman then discredits the notion that women "earn their share" of their husbands' earnings as wives, homemakers, and mothers.

Discussing marriage and a woman's position as a partner to her husband within that institutionalized relationship, Gilman states

> Women consume economic goods. What economic product do they give in exchange for what they consume? The claim that marriage is a partnership, in which the two persons married produce wealth which neither of them, separately, could produce, will not bear examination. A man happy and comfortable can produce more than one unhappy and uncomfortable, but this is as true of a father or son as of a husband. To take from a man any of the conditions which make him happy and strong is to cripple his industry, generally speaking. But those relatives who make him happy are not therefore his business partners, and entitled to share in his income . . .

Gilman next disputes the common claim that a woman's homemaking services form the basis for a husband's support:

> If the wife is not, then, truly a business partner, in what way does she earn from her husband the food, clothing, and shelter she receives at his hands? By house service, it will be instantly replied. This is the general misty idea upon the subject—that women earn all they get, and more, by house service. Here we come to a very practical and definite economic ground . . . Their labor in the household has a genuine economic value.
>
> For a certain percentage of persons to serve other persons, in order that the ones so served may produce more, is a contribution not to be overlooked. The labor of women in the house, certainly, enables men to produce more wealth than they otherwise could;

and in this way women are economic factors in society. But so are horses. The labor of horses enables men to produce more wealth than they otherwise could. The horse is an economic factor in society. But the horse is not economically independent, nor is the woman . . .

Moreover, Gilman points out

> To take this ground and hold it honestly, wives, as earners through domestic service, are entitled to the wages of cooks, housemaids, nursemaids, seamstresses, or housekeepers, and to no more. This would of course reduce the spending money of the wives of the rich, and put it out of the power of the poor man to "support" a wife at all, unless, indeed, the poor man faced the situation fully, paid his wife her wages as house servant, and then she and he combined their funds in the support of their children. He would be keeping a servant: she would be helping keep the family. But nowhere on earth would there be a "rich woman" by these means. Even the highest class of private housekeeper, useful as her services are, does not accumulate a fortune.

Finally, Gilman tosses aside the idea that "motherhood is an exchangeable commodity given by women in exchange for clothes and food." This cannot be true, Gilman claims, because "the childless wife has as much money as the mother of many,—more, for the children of the latter consume what would otherwise be hers . . . Motherhood bears no [positive] relation to their economic status."

According to Gilman's analysis, "women's economic profit comes through the power of sex-attraction." Acknowledging that this is a form of prostitution, she continues:

> When we confront this fact boldly and plainly in the open market of vice, we are sick with horror. When we see the same economic relation made permanent, established by law, sanctioned and sanctified by religion, covered with flowers and incense and all accumulated sentiment, we think it innocent, lovely, and right. The transient trade we think evil. The bargain for life we think good. But the biological fact remains the same. In both cases the female gets her food from the male by virtue of her sex-relationship to him.

Gilman describes the need for change in this system of male-female relationship. As part of her argument, she outlines the overdevelopment of passive or "feminine" characteristics in young girls who must look to marriage as "the one road to fortune, to life," and the resulting impoverishment of female individuals and society as a whole.

She endorses the goals of the nineteenth-century women's movement and an end to women's subservience;

envisions that equality between men and women will lead to "a pure, lasting, monogamous sex-union . . . without bribe or purpose, without the manacles of economic dependence"; and predicts, in closing, that "When the mother of the race is free, we shall have a better world."

Further Reading: Gilman, *Women & Economics.*

Women and Madness

Published by feminist psychologist Phyllis Chesler in 1972, *Women and Madness* examines the psychological effects of sex roles assigned by society. Chesler argues that the generally accepted model of feminine behavior—a self-sacrificing compliance with stereotyped societal expectations—is inherently unhealthy. Conversely, she finds that an independent woman who is engaged in what should be viewed as a healthy struggle to avoid such compliance is often labeled—and even made to feel—"mad." See also Charlotte Perkins GILMAN.

Further Reading: Chesler, *Women and Madness.*

Women Involved in Farm Economics

Founded in 1976 and based in Shorter, Alabama, Women Involved in Farm Economics (WIFE) is dedicated to increasing the profitability of farming and to supporting the "family farm" as the cornerstone of food and fiber production in the United States.

The organization works with Congress and various governmental agencies on behalf of agricultural families and communities, and researches rural issues of particular concern to women. It also conducts various educational activities, such as the Ag in the Classroom program, to increase the general public's awareness of agriculture's contribution to the economic prosperity of the United States.

WIFE publishes the annual *Directory and Policy Summaries* and the monthly *Wifeline.* It has groups in 24 states and is currently headed by president Mary Ann Sheppard.

Further Reading: Brecher and Lippitt, *Women's Information Exchange National Directory;* Brennan, ed. *Women's Information Directory.*

Women of All Red Nations (WARN)

Women of All Red Nations (WARN), an organization of Native American Women from more than thirty Indian nations, was founded in September 1978 in Rapid City, South Dakota. Although its founders were inspired by the American Indian Movement (AIM) and that group's 1973 takeover at Wounded Knee, South Dakota, they pledged that their women's organization would have its own agenda. From the start, WARN leaders supported freedom for the peoples of all Native nations but placed special emphasis on issues important to women and their children: the elimination of the mass sterilizations imposed on Native women during the twentieth century; opposition to the forced surrender of Native-American children to government-run boarding schools or non-Native adoptive families, both of which were common before the 1978 Indian Child Welfare Act outlawed such practices; the operation of crisis centers to aid battered women and work with men to end domestic violence; and ensuring that future generations of Native children inherit lands now in possession of their elders.

WARN's headquarters are currently in Chicago, Illinois. Among its strongest leaders have been Lorelei Means and Madonna Gilbert.

Further Reading: Bataille, "Women of all Red Nations," and "Native American Women," in *Handbook of American Women's History,* ed. Zophy and Kavenik; Davis, *Moving the Mountain;* Conference on the Educational and Occupational Needs of American Indian Women; Qoyawayma, *No Turning Back.*

Women's Action Coalition

Founded in New York City in January 1992 by women angered by the treatment of Anita HILL during the Supreme Court confirmation hearings of Clarence Thomas in 1991, the Women's Action Coalition (WAC) is "an open alliance of women committed to direct action on issues affecting the rights of all women." Its goals include passage and ratification of the EQUAL RIGHTS AMENDMENT, "economic parity and representation for all women, and an end to homophobia, racism, religious prejudice and violence against women," as well as a recognition of "every women's right to health care and reproductive freedom."

The group is loosely organized in American, Canadian, and European cities, and it relies on a "telephone tree" to organize protests, demonstrations, and other "visible and remarkable resistance." A 1992 "WAC attack," as the *Village Voice* termed it, took place in Grand Central Station on the Friday prior to Mother's Day. Approximately 100 women marched to drums through the station, chanting

> Moms in a rage.
> We want a living wage.
> We took it to the court
> And still there's no support.

Other women unfurled a banner in front of the electronic arrivals and departures schedule board. They managed to hold their message, "It's Mother's Day. $30 Billion Owed Mothers in Child Support," for about five minutes before police removed them from the site.

WAC is nonhierarchal in structure and thus has no president or executive director. Its offices are in New York City's High School for the Humanities.

Further Reading: Brecher and Lippitt, eds., *Women's Information Exchange National Directory;* Brennan, ed. *Women's Information Directory;* Houppert, "Feminism in Your Face."

Women's Airforce Service Pilots (WASPS)

During World War II, 1,000 female pilots flew U.S. planes out of American air force bases in a paramilitary capacity. Originally they served in one of two separate organizations, the Women's Auxiliary Ferrying Squadron (WAFS), founded in September 1942 by Nancy Harkness

Jacqueline Cochran, aviator and director of the Women's Airforce Service Pilots, with Capt. Norman Edgar of the British Transport Auxiliary Service (*Library of Congress*)

Love, and the Women's Airforce Service Pilots (WASPS), founded almost concurrently by Jacqueline Cochran. On August 5, 1943, following orders of General Henry ("Hap") Arnold, chief of the Air Corps, the two organizations merged. Cochran was named director of the now larger WASPS. WASPS flew all types of military aircraft from factories to bases, tested and repaired planes, towed the targets upon which male students aimed their weapons, and taught flight and gunnery to male students. Although their flight accident rate was actually slightly better than that of their male counterparts, thirty-eight of these women died performing their duties.

Unlike the uniformed women who served as members of the WOMEN'S ARMY CORPS, the WOMEN'S RESERVES OF THE NAVY, the COAST GUARD WOMEN'S RESERVES, and the women's reserve of the MARINE CORPS, WASPS were members of civilian units. Thus, they received no veterans' benefits until 1977 when Congress, at the urging of Senator Barry Goldwater (R-AZ), finally bestowed veteran status upon them.

Further Reading: Weatherford, *American Women in World War II.*

Women's Army Corps (WACS)

Established as the Women's Auxiliary Army Corps (WAAC) on May 14, 1942, the Women's Army Corps (WACS) was the female component of the United States Army until 1978.

Representative Edith Nourse Rogers (R-MA) introduced the legislation creating the corps, and Oveta Culp Hobby was appointed director with the relative rank of major (later raised to colonel), a position she filled until July 1945. The Women's Auxiliary Army Corps was made a part of the regular army on July 1, 1943, and "Auxiliary" was thereafter dropped from its name. From that point on, its troops were permitted to serve overseas. During World War II, 140,000 women served as WACS, 17,000 of them abroad. African-American women served in segregated units. WACS worked in clerical, communications, supply, maintenance, and hospital positions, where they served as chemists, parachute packers, sheet metal workers, cartographers, weather forecasters, photographers, electricians, radio operators, and more. WACS and the military's other women's corps—the WOMEN'S RESERVE OF THE NAVY, the COAST GUARD WOMEN'S RESERVES, and the women's reserves of the MARINE CORPS—remained a regular part of the military until 1978, when all such units were abolished in favor of women's integration into the armed forces.

Further Reading: Clark, *Almanac of American Women in the 20th Century;* Weatherford, *American Women and World War II.*

Women's Bureau

Created pursuant to "An Act to establish in the Department of Labor a Bureau to be known as The Women's Bureau," enacted June 5, 1920, this government agency is authorized to "investigate and report upon all matters pertaining to the welfare of women in industry." Mary Anderson served as its first director.

Formed partly in response to the prompting of the American Federation of Labor and quickly endorsed by the NATIONAL WOMEN'S TRADE UNION LEAGUE, the Women's Bureau was originally a strong supporter of PROTECTIVE LABOR LEGISLATION and a vocal opponent of the EQUAL RIGHTS AMENDMENT. The bureau supported equal pay for equal work and the elimination of discriminatory hiring practices from its inception. (It supported, for example, the EQUAL PAY ACT, proposed in 1945 and finally passed in 1963.) It also compiled statistics that disproved the common belief that working for lower wages didn't really harm married women, since they supposedly worked for "pin money." As one bureau official summarized it, "What [married women] are working at such great cost to obtain is a chance for their children to have health and education, for their families to have a satisfactory home life." It nonetheless moved slowly to fully embrace the idea of financial independence for women. As late as 1964, a bureau report entitled *To Benefit Women at Work* set forth the following:

> It is not the policy of the Women's Bureau to encourage married women and mothers of young children to seek employment outside the home. Home and children are considered married women's most important responsibilities. But the fact is that married women *are* working outside their homes in increasing numbers . . . most often to add to the family income.

With the dismantling of protective legislation due to passage of Title VII of the CIVIL RIGHTS ACT OF 1964 and the 1969 appointment of Elizabeth B. Koontz as its director, the Women's Bureau entered a new era. Koontz, the first African American to head the bureau, felt that the bureau was too far removed from "the disparate philosophies of the women's movement." To celebrate the fiftieth anniversary of the bureau's founding, Koontz held a conference (June 10–12, 1970), which was attended by more than 1,000 female activists with a wide range of views. During the conference, the Women's Bureau and the Department of Labor announced their support for the Equal Rights Amendment.

As Koontz explained in October 1970, the Bureau's new mission would be "to keep abreast of and disseminate information on social changes in the labor market making particular note of the changing *aspirations* of women." The Women's Bureau continues to compile, evaluate, and publish such information and statistics.

Further Reading: Chafe, *American Woman;* Davis, *Moving the Mountain;* Hole and Levine, *Rebirth of Feminism.*

Women's Equality Day (1920)

First sponsored by the newly formed LEAGUE OF WOMEN VOTERS on August 26, 1920, Women's Equality Day celebrates the anniversary of the NINETEENTH AMENDMENT's ratification. The observance became an official one with a congressional resolution in 1971 and is marked each year by presidential proclamation.

Further Reading: Clinton, "Proclamation 7116—Women's Equality Day, 1998"; *Chicago Tribune,* August 24 and 27, 1999.

Women's Equity Action League

Founded in 1968 in Cleveland, Ohio, by Elizabeth Boyer, originally a member of the NATIONAL ORGANIZATION FOR WOMEN (NOW), the Women's Equity Action League (WEAL) was conceived as a "patient, determined and diplomatic" alternative to NOW. The organization avoided taking a position on abortion or other controversial issues in order to attract large numbers of moderate women willing to focus on a more limited agenda, including sex discrimination in education and employment.

In January 1970 WEAL backed Dr. Bernice Sandler in a discrimination lawsuit against the University of Maryland. Sandler charged that she had been discriminated against in terms of promotions. Since Title VII did not then apply to educational institutions, the suit—which became a class-action complaint against every American college and university—relied on Executive Order 11246, which banned government contractors from discriminating on the basis of race, color, religion, national origin, and, on amendment in 1968, sex. (See EXECUTIVE ORDER 11375.) The Department of Health, Education, and Welfare (HEW) received the complaints but failed to act until WEAL organized a national letter-writing campaign asking members of Congress to investigate HEW's lack of response. When HEW, under the resulting pressure, began investigating the hiring practices of educational institutions, many colleges and universities remedied their policies.

In 1974 WEAL was a major participant in another lawsuit against HEW. This time WEAL successfully sought HEW enforcement of TITLE IX OF THE EDUCATION AMENDMENTS OF 1972, which prohibited sex discrimination in any federally funded educational program or activity.

WEAL was also a strong supporter of the EQUAL RIGHTS AMENDMENT from its passage in 1972 to its demise in 1982.

Since 1972 WEAL has maintained offices in Washington, D.C., where it continues to offer legal support services, lobby for women's rights, and compile extensive research files on women's educational and economic experiences. Mary L. McCain is its current executive director.

Further Reading: Davis, *Moving the Mountain;* Hole and Levine, *Rebirth of Feminism.*

Women's Health Equity Act

A legislative package introduced by members of the CONGRESSIONAL CAUCUS FOR WOMEN'S ISSUES on July 26, 1990, the Women's Health Equity Act would have allocated $50 million to fund health research of particular concern to women, including contraception, infertility, breast and ovarian cancer, the transmission to and effect of AIDS on women and their children, and osteoporosis. The act also would have included Pap smear screening and mammography in the Medicaid program, assisted pregnant teenagers and young mothers with health care and other services, and offered increased access to screening and treatment for sexually transmitted diseases, the latter intended as a means of preventing infertility. Although the Women's Health Equity Act was not passed, many of its goals were met five years later, with the passage of WOMEN'S HEALTH RESEARCH AND PREVENTION AMENDMENTS OF 1998.

Further Reading: Congressional Caucus for Women's Issues in the 102nd Congress; "The Cochairs' Report," in *The American Woman 1992–1993;* ed. Ries and Stone.

Women's Health Research and Prevention Amendments of 1998 (1998)

Signed by President Bill Clinton in October 31, 1998, the Women's Health Research and Prevention Amendments of 1998 amended the Public Health Service Act to expand federal research on women's health issues and improve poor women's access to early screening programs for certain diseases. The bill's sponsors included Senator Bill Frist (R-TN) and cosponsors Senators Barbara Boxer (D-CA), Barbara Mikulski (D-MD), and Patty Murray (D-WA).

Specifically, the act provided for increased research on osteoporosis, Paget's disease, and related bone disorders; breast and ovarian cancers; and heart attacks, strokes, and other cardiovascular diseases in women. It also established a national program to educate health professionals and the general public about the problems associated with exposure to the drug diethylstilbestrol (DES, a drug once prescribed to prevent miscarriage, has had severe health consequences for some children born of those pregnancies; see DES ACTION, U.S.A. for discussion). These research programs will be administered by the National Institutes of Health.

The amendments also created a national breast and cervical cancer early detection program to provide screening services to low-income women.

Further Reading: Clinton, "Statement on Signing the Women's Health Research and Prevention Amendments of 1998"; U.S. Newswire, October 31, 1998; *Women's Health Research and Prevention Amendment of 1998.*

Women's Peace Union

Founded in 1921 as an outgrowth of the suffrage campaign in New York State and the WOMAN'S PEACE PARTY, the Women's Peace Union was a pacifist organization that was active between World Wars I and II.

Many of the organization's leaders and 2,000 members had been active in the campaign to secure women's suffrage through ratification of the NINETEENTH AMENDMENT. Once that goal was accomplished, they chose to use their new power as enfranchised citizens in a similar campaign for perpetual peace. They worked to secure another amendment to the U.S. Constitution, this one designed to prohibit war and the production and trade of war materiel. The amendment was introduced in Congress annually, from 1926 to 1939, by Senator Joseph Frazier (D-ND). Throughout these years, the union lobbied in Washington, D.C., for the amendment's passage. The organization participated in Senate hearings in 1927, 1930, 1934, and was present, through a representative, at the 1932 League of Nations Disarmament Conference in Geneva.

The Women's Peace Union lost support as fascism began to spread in Europe and public sentiment began to support U.S. intervention. It came to a halt—without officially dissolving—in 1941.

Further Reading: Alonso, *Women's Peace Union and the Outlawry of War.*

Women's Political Union

Founded by Harriet Stanton BLATCH to work for women's suffrage in 1907, this organization was originally named the Equality League of Self-Supporting Women. A core of successful professional women provided the bulk of the organization's operating budget so that other members, many of whom worked in factories,

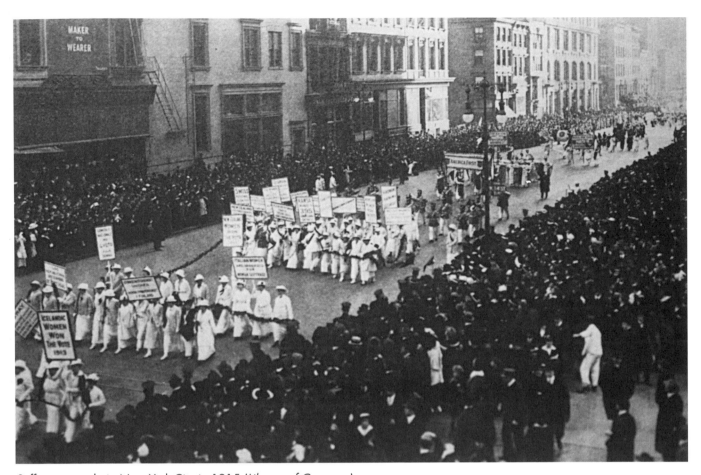

Suffrage parade in New York City in 1915 (*Library of Congress*)

could join by paying a one-time membership fee of just $.25. (The organization did not collect annual dues.) The name was changed to the Women's Political Union to accommodate those who, though not yet self-supporting, agreed with the organization's goals.

Members of the Women's Political Union traveled to Albany, New York, to address legislators on the subject of employed women's desire to gain suffrage in order to support those who endorsed work-safety and related legislation; distributed suffrage literature at polls; invited the famed English suffragist Emmeline Pankhurst to speak in America; and, perhaps most important, introduced the suffrage parade as a tactic in the suffrage and women's rights movement.

The first such suffrage parade was held in New York City on May 21, 1910. Thereafter—during the rest of the decade and until the Nineteenth Amendment was ratified in 1920—thousands of banner-bearing American women marched for suffrage.

Further Reading: Blatch and Lutz, *Challenging Years;* Flexner, *Century of Struggle;* Frost and Cullen-DuPont,

Women's Suffrage in America; U.S. Congress, Senate, *Suffrage Parade Hearings.*

Women's Prison Association

Founded in New York City in 1844 as the Female Department of the Prison Association of New York, the Women's Prison Association, as it became known in 1845, has worked throughout its history to improve conditions for women in prison and is especially noted for its efforts to aid them in the transition from prison to independence.

Abby Hopper Gibbons was the organization's original leader. Together with Josephine Shaw Lowell she tirelessly campaigned for separate women's prisons to be administered and staffed by women. (The first women's prison in the United States, New York's Mount Pleasant Female Prison, opened in 1834; prior to this, women were segregated within men's prisons and received few services or attempts at rehabilitation.) Two of the association's current programs—Hopper Home, a New York City halfway house, and Hopper Academy, an academic

and vocational training program for previously incarcerated women—are named in honor of Abby Hopper Gibbons. The association also conducts parenting classes and helps incarcerated mothers maintain their relationships with their children.

In addition to halfway homes and training programs, the Women's Prison Association provides group and individual counseling, parental skills programs, and a job assistance program. It is still headquartered in New York City, and Ann L. Jacobs is its current executive director.

Further Reading: Brecher and Lippitt, *Women's Information Directory;* Brennan, ed., *Women's Information Directory;* Freedeman, *Their Sisters' Keepers;* McKelvey, *American Prisons;* Rafter, *Partial Justice.*

Women's Reserve of the Navy

Established in June 1942, the Women's Reserve of the Navy was the female component of the Navy until 1978. Called WAVES, for Women Accepted for Volunteer Emergency Service, they were first headed by Commander Mildred McAfee. During World War II, 100,000 WAVES served. Banned from overseas service until the final months of the war, most of these women served in the United States. The first African-American woman was not accepted for enlistment until October 1944, when President Franklin D. Roosevelt ordered racial integration of the WAVES. Once admitted, however, African-American women worked and lived with the formerly all-white units. WAVES were pilot instructors, clerical workers, airplane mechanics, air-traffic controllers, parachute riggers, record keepers, and more.

The WAVES and the military's other women's corps—the WOMEN'S ARMY CORPS, the COAST GUARD WOMEN'S RESERVES, and the women's reserves of the MARINE CORPS—remained a regular part of the military until 1978, when all such units were abolished in favor of women's integration into the armed forces.

Further Reading: Clark, *Almanac of American Women in the 20th Century;* Weatherford, *American Women and World War II.*

The Women's Room (1977)

Published in 1977, Marilyn French's novel was hailed by a number of reviewers as the "major novel in the women's liberation movement."

The novel takes its title from the main character's crossing out of the "LADIES ROOM" sign on a bathroom door and her scrawling of a replacement legend, "THE WOMEN'S ROOM." Beginning with that first act of defiance, the novel describes the journey of a woman from her life as a 1950s housewife to her hard-earned life of independence in the early 1970s. Brutally honest in assessing the costs of both domestic entrapment and its escape, the book was widely read and discussed.

Marilyn French's other books include: *The Bleeding Heart* (1980), *Shakespeare's Division of Experience* (1981), *Beyond Power: On Women, Men and Morals* (1985), *Her Mother's Daughter* (1987), *The War Against Women* (1992), and *Our Father* (1994).

Further Reading: French, *Women's Room;* ———, *The War Against Women.*

Women's Strike for Equality

Organized under the auspices of the NATIONAL ORGANIZATION FOR WOMEN (NOW) by Betty FRIEDAN, Gloria STEINEM, and others, the Women's Strike for Equality was observed on August 26, 1970, the fiftieth anniversary of the Nineteenth Amendment's ratification.

At the time, NOW had only 3,000 or so members, divided among thirty cities. Friedan believed that this membership tally did not adequately reflect women's broad support for the women's movement. In her last address as NOW's president in March 1970, she called for a nationwide demonstration both to provide politicians and others with proof of women's support and to assure silently supportive women that they wouldn't be alone if they went public with their own desire for change.

Although many NOW leaders expressed reservations, fearing damage to the organization and the women's movement if few women answered the call, NOW rank and file voted to carry out Friedan's strike "of all women in America against the concrete conditions of their oppression." At the Des Moines press conference held to announce the strike, Friedan specifically asked that "telephone operators unplug their switchboards, the waitresses stop waiting, cleaning women stop cleaning and everyone who is doing a job for which a man would be paid more stop . . ." However, to facilitate partial participation for those worried about being fired if they actually took off an entire day, many lunchtime activities were organized for drop-in protesters.

On the day itself, even Friedan's hopes were exceeded. Women demonstrated in forty American cities and, in support, in France and the Netherlands. In New York City, elderly women who had marched last in suffrage parades took to the streets with the movement's youngest women. Some demonstrators carried signs urging bystanders, "Don't Cook Dinner—Starve a Rat Today." Despite NOW's failure to secure an official automobile ban, marchers effectively closed Fifth Avenue. As Friedan remembered later:

We came out of the park onto Fifth Avenue, and sure enough there were the police on horses, trying to shunt us off to the sidewalks. But there were so many women. I was walking between Judge Dorothy Kenyon, who in her eighties refused to ride in the car we'd provided for the suffrage veterans, and one of the young radicals in blue jeans. I took their hands and said to the women on each side, *take hands and stretch across the whole street.* And so we marched, in great swinging long lines, from sidewalk to sidewalk, and the police on their horses got out of our way.

As noted in Ethel Klein's *Gender Politics: From Consciousness to Mass Politics,* 80 percent of Americans polled following the strike were familiar with the women's movement and its demands.

Further Reading: Clark, *Almanac of American Women in the 20th Century;* Davis, *Moving the Mountain;* Friedan, *It Changed My Life;* Hole and Levine, *Rebirth of Feminism;* Klein, *Gender Politics;* New York Times, March 22, 1970 and August 27, 1970; Wandersee, *American Women in the 1970s.*

Women Strike for Peace

An international organization established in 1961 by Bella ABZUG and Dagmar Wilson, a peace activist who emphasized an end to the use of nuclear weapons, Women Strike for Peace had a strong American component. The group's most visible public action was its international demonstration held on November 1, 1961, in which 50,000 women in various countries participated. In the United States, 1,500 women marched to the Soviet Embassy in Washington, D.C., and to the White House, asking the first ladies of both countries, Nina Petrovna Khrushchev and Jacqueline Kennedy, to work toward world peace. The group's other demonstrations in the United States included an April 26, 1962, march of 3,000 members to the United Nations (U.N.) headquarters in New York City to protest U.S. atmospheric testing of nuclear weapons; a February 9, 1966, picketing of the White House by 1,500 members; a June 30, 1966, demonstration at the United States Mission to the U.N., followed by a meeting with Arthur J. Goldberg, U.S. Ambassador to the United Nations; a February 15, 1967, demonstration outside the Pentagon by 2,500 women condemning the "killing of innocent women and children in Vietnam"; a 1969 confrontation of 500 members with police outside the White House, resulting in the arrest of three women; and participation with other organizations, also in 1969, in a countrywide STOP-THE-DRAFT week demonstration.

In the early 1960s, the group's members also opposed McCarthyism and cheerfully gave irrelevant answers when called before the House Un-American Activities Committee. On December 4, 1964, Dagmar Wilson and another woman and member, Donna Allen, were charged with contempt of Congress at a closed session of the House Un-American Activities Committee.

In recent years, Women Strike for Peace has acted as a lobbying group in opposition to nuclear arms. It has a current membership of 5,000, publishes a monthly newsletter, *Women Strike for Peace—Legislative Alert,* and is headquartered in Washington, D.C. Edith Villastrigo is currently the organization's legislative director.

Further Reading: Brennan, ed., *Women's Information Directory;* Clark, *Almanac of American Women in the 20th Century;* Evans, *Born for Liberty.*

Women Work! The National Network for Women's Employment

Founded in California as the Alliance for Displaced Homemakers in 1974 by Tish Sommers and Laurie Shields and renamed the National Displaced Homemakers Network (1978), Women Work! The National Network for Women's Employment, as it has been known since 1993, is devoted to the "concerns of displaced homemakers—women whose principal job has been homemaking and who have lost their source of income because of divorce, separation, widowhood, disability or long-term unemployment of a spouse, or due to loss of eligibility for public assistance."

In 1975 Sommers and Shields organized the alliance to work toward the recognition of "homemaking and child-rearing . . . as a viable occupation . . ." The women viewed housework, child rearing, grocery shopping, entertainment related to a husband's career, and other contributions to domestic life as work that entitled married women to a share of family income and assets. Sommers, who had been divorced, and Shields, who had been widowed, argued that the end of a marriage—for whatever reason—not only inflicted personal pain but also ejected women from what had been, in a sense, their employment. Their alliance designed a work-training program for such displaced homemakers and successfully lobbied the California state legislature for passage of a bill to provide funding.

The alliance's first displaced homemaker's center was opened in Oakland, California, in 1976. It offered job training and counseling, sponsored self-help sessions, and maintained a referral service. Centers based on the Oakland model were opened shortly thereafter in Maryland and Iowa, and the alliance began to lobby the federal government for funding.

Phyllis SCHLAFLY, a chief opponent of the women's rights movement, objected to the centers as being dis-

ruptive to family units and described them as the tools of feminist propagandists in her newsletter, the *Eagle Forum*. Schlafly organized a letter-writing campaign against the proposed federal funding of such centers in 1977; perhaps due in part to Schlafly's influence, no such funding was granted. (However, individual centers were eligible to apply on an equal basis with other organizations for funding through the Comprehensive Employment Training Act [CETA].)

Despite this setback, the displaced homemaker movement, as Women Work! refers to it, continued to grow during the 1970s and 1980s: A national conference of displaced homemakers was held in Baltimore in 1978; the alliance, renaming itself the National Displaced Homemakers Network, became a national organization in 1979; and the PERKINS ACT, passed in 1984, set aside funds for the job training of displaced homemakers.

The passage of the DISPLACED HOMEMAKERS SELF-SUFFICIENCY ASSISTANCE ACT in 1990 was just one sign of growing support for displaced homemakers and Women Work! The National Network for Women's Employment among members of Congress. Congresswoman Lynn Woolsey (D-CA), one of the women elected in the 1992 so-called YEAR OF THE WOMAN, has publicly described herself as a former displaced homemaker who once had to rely on the country's welfare system for the survival of herself and her children; a vocal advocate of relevant legislation, she has recently introduced the Self-Sufficiency Standard Act to guarantee job training programs designed to lead women and men to "jobs that will pay them wages leading to longterm economic self-sufficiency." Eleven other senators and representatives—Senator Nancy Kassebaum and Representatives Patricia SCHROEDER (D-CO), Olympia Snowe (R-ME), Leslie Byrne (D-VA), Craig Washington (D-TX), Bill Goodling (R-PA), Norman Mineta (D-CA), Marcy Kaptur (D-OH), Major Owens (D-NY), Alcee Hastings (D-FL), and Pat Danner (D-MO)—participated in a Public Policy Forum at the organization's 1993 American Women Workers: Organizing for a Changing Economy Conference.

Twenty-seven states currently have legislation supporting displaced homemaker programs, and there are more than 1,000 displaced homemaker centers nationwide.

Women Work! The National Network for Women's Employment maintains its offices in Washington, D.C., and publishes *Network News: The Newsletter of Women Work! The National Network for Women's Employment* and *Transition Times.* Jill Miller, co-executive director, is the organization's current contact person.

Further Reading: Brennan, ed. *Women's Information Directory;* Davis, *Moving the Mountain; Network News; Transition Times.*

Woodhull, Victoria Claflin (1838–1927) *first woman to address the Judiciary Committee of the U.S. House of Representatives.*

Woodhull was born Victoria Claflin on September 23, 1838, in Homer, Ohio, to Roxanna Hummel Claflin and Reuben Buckman Claflin. Victoria had an unconventional childhood, spending several years as a psychic in her family's traveling medicine show. She received little formal education. At fifteen, in 1853, she married Canning Woodhull, from whom she was later divorced.

With the help of Cornelius Vanderbilt, Woodhull and her sister Tennessee Celeste Claflin (1845–1923) became the proprietors of Woodhull, Claflin & Company, a successful New York City brokerage house in 1870. In April of the same year, Woodhull declared herself a candidate for the U.S. presidency. She failed to win election and turned her attention to the women's suffrage movement.

Woodhull was familiar with attorney Francis Minor's argument that the FOURTEENTH AMENDMENT (guaranteeing citizenship and the rights of citizenship to all people born in the United States) could be interpreted as granting suffrage (one of the rights of citizenship) to American women. She won an invitation to address the Judiciary Committee of the House of Representatives on January 11, 1871. Woodhull presented a well-reasoned, thoroughly researched, and forceful speech based on Minor's contention. To the disappointment of the suffragists who had crowded into the committee room, the Judiciary Committee refused to agree that the Fourteenth Amendment conferred the right of suffrage upon women.

In addition to women's suffrage, Woodhull endorsed legalized prostitution, DRESS REFORM, and "free love," as sex without marriage was called in the nineteenth century. She also advocated fundamental change in marriage law and custom. These and other views were set forth in the *Woodhull & Claflin's Weekly,* a newspaper published by Victoria Woodhull and Tennessee Claflin from 1870 to 1876. (This paper was also the first U.S. publication to print a translation of Karl Marx's *Communist Manifesto.*)

Victoria Woodhull died in Tewkesbury, England on June 10, 1927.

Further Reading: Boydston, Kelley, and Margolis, eds., *Limits of Sisterhood;* Flexner, *Century of Struggle;* Frost and Cullen-DuPont, *History of Women's Suffrage;* Goldsmith, *Other Powers;* Griffith, *In Her Own Right;* Stanton, Anthony, and Gage, eds., *History of Woman Suffrage,* vol. 2; Woodhull, *Speech of the Principles of Social Freedom.*

Worcester Women's Rights Convention (1850)

Held in Worcester, Massachusetts, on October 23–24, 1850, and organized primarily by Paulina Wright Davis,

this was the first national women's rights convention. It drew more than 1,000 participants from Maine, New York, New Hampshire, Vermont, Pennsylvania, Connecticut, Rhode Island, Iowa, Ohio, and California, and from all parts of Massachusetts itself. The *New York Tribune* reported that only lack of space kept "many thousands more" from attending.

The convention began with news of Margaret FULLER. When plans for the convention had begun in May 1850, a letter was sent asking Fuller to return from Europe to assume a leadership role in the new American women's rights movement. Tragically, Fuller had drowned in a shipwreck en route to America in July, and all present at the convention were asked to join in mourning her loss.

A number of future leaders attended the Worcester Convention, among them Lucy STONE, Antoinette L. Brown (later Antoinette Brown BLACKWELL), Sojourner TRUTH, Clarina Irene Howard Nichols, and Harriot K. Hunt. Lucretia MOTT also attended, and Elizabeth Cady STANTON and others sent letters of support.

The Call of the Convention, signed by eighty-nine people from Massachusetts, Rhode Island, New York, Pennsylvania, Maryland, and Ohio, said that attendance was "your duty, if you are worthy of your age and country." Many subjects were discussed. Abbey H. Price spoke of women's limited educational and career opportunities and concluded that "the speediest solution of the vexed problem of prostitution was profitable work for the rising generation of girls." The issue of DRESS REFORM was raised in a letter from the European author Helene Marie Weber. Antoinette Brown addressed women's rights from a religious perspective, and Dr. Harriot Hunt discussed medical instruction for women.

By the end of the two days, seven resolutions were adopted. The first stated that "every human being of full age, and resident for a proper length of time on the soil of the nation, who is required to obey the law, is entitled to a voice in its enactment" and that all persons paying taxes to support a government are "entitled to a direct share in such government." The second stated that "women are clearly entitled to the right of suffrage, and to be considered eligible for office," that her failure to demand these rights was "a palpable recreancy to duty," and that men's denial of these rights, a "gross usurpation . . . no longer to be endured"; it further declared that any political party with "claims to represent the humanity, civilization, and progress of the age, is bound to inscribe on its banners, 'Equality before the law, without distinction of sex or color.'" The third resolution demanded that the word "male" (used to restrict rights of citizenship) "be stricken from every State Constitution." The fourth demanded equal property rights for husbands and wives. The fifth urged women to take full advantage of the limited educa-

tional and career opportunities available to them, until greater opportunities became available. The sixth declared that "every effort to educate woman, until you accord to her rights, and arouse her conscience by the weight of her responsibilities, is futile, and a waste of labor." The seventh and last read as follows:

> Resolved, That the cause we have met to advocate— the claim for woman of all her natural and civil rights—bids us remember the two millions of slave women at the South, the most grossly wronged and foully outraged of all women; and in every effort for an improvement in our civilization, we will bear in our heart of hearts the memory of the trampled womanhood of the plantation, and omit no effort to raise it to a share in the rights we claim for ourselves.

The convention received wide press coverage in the United States and was reported upon in England. Harriet Taylor, future wife of John Stuart Mill, upon reading of the Worcester Convention, began to write the essay "Enfranchisement of Women," which later appeared in the *Westminster and Foreign Quarterly Review*. In that essay, she credits American women with beginning an international woman's rights movement: "There are indications that the example of America will be followed," she wrote, "on this side of the Atlantic . . . On the 13th of February, 1851, a petition of women . . . was presented to the House of Lords . . ."

Further Reading: Flexner, *Century of Struggle;* Frost and Cullen-DuPont, *Women's Suffrage in America;* Stanton, Anthony, and Gage, eds., *History of Woman Suffrage,* vol. 1.

World Anti-Slavery Convention (1840)
Held on June 12, 1840, in London, this event was viewed by nineteenth-century feminists as the catalyst for the organized women's movement in America.

American women had been active in the antislavery movement from the beginning but had received inconsistent welcome. By the time of the London convention, the abolitionist movement had split in two—and one of the main dividing points was the position of women within each faction. Abolitionists aligned with William Lloyd Garrison permitted women to join their societies and to become speakers and officers. Abolitionists opposed to the Garrisonian faction thought the presence of women an "insane innovation" and refused them admission.

Garrison, for reasons other than his position on women's rights, was considered too extreme by many abolitionists—including many women. Refused admission to the all-male organizations opposing Garrison's, these women formed their own Female Anti-Slavery Societies.

Women, both Garrisonian and from the FEMALE ANTISLAVERY SOCIETIES, traveled from the United States to London as duly elected delegates of their abolitionist societies. Abby Southwick, Emily Winslow, and Ann Green Phillips went as delegates of Boston's American Female Anti-Slavery Society. Mary Grew, Elizabeth Neall, Sarah Pugh, Abbey Kimber, and Lucretia MOTT went from Philadelphia. Elizabeth Cady STANTON attended not as a delegate but in the company of her husband, Henry B. Stanton, who acted as secretary of the convention.

To the women's shock and lasting regret, they were denied participation in the World Anti-Slavery Convention. The debate about their merits began as soon as the convention opened, and it was frequently nasty and loud. Some of the male abolitionists defended their right to stay. Wendell Phillips, for example, said,

> We do not think it just or equitable . . . that, after the trouble, the sacrifice, the self-devotion of a part of those who leave their families . . . and occupations . . . to come three thousand miles to attend this World's Convention, they should be refused a place in its deliberations.

But most of the men argued that women were simply unfit for public life; one went so far as to say that women had "shrinking natures." Many of the men invoked religious sanctions to justify their opposition to women outside the home. Mary Grew's father, the Reverend Henry Grew, was present, and in his daughter's company he declared: "The reception of women as part of this Convention would, in the view of many, be . . . a violation . . . of the ordinance of Almighty God." To emphasize their point, many of the clergy started waving their Bibles overhead. This prompted abolitionist and Massachusetts state legislator George Bradburn to stand and shout with what Elizabeth Cady Stanton called "a voice of thunder": "Prove to me, gentlemen, that your Bible sanctions the slavery of woman—the complete subjugation of one-half of the race to the other—and I should feel that the best work I could do for humanity would be to make a grand bonfire of every Bible in the Universe!"

At no point during this discussion was a woman allowed to address those present. Only the men voted, and a majority voted against the participation of women in the convention. The female delegates were ordered to sit behind a curtain: They would be able to hear the proceedings but not to see them or to speak.

Behind this curtain it became apparent how small a sphere women occupied. "It is about time," Stanton recalled the women whispering, "some demand was made for new liberties for women." Before nightfall, Lucretia Mott and Elizabeth Cady Stanton made a vow. Back in America, they would hold a woman's rights convention. (For further information, see SENECA FALLS CONVENTION.)

Further Reading: Frost and Cullen-DuPont, *Women's Suffrage in America;* Grew, *Diary,* 1840; Stanton, *Eighty Years and More;* Stanton, Anthony, and Gage, eds., *History of Woman Suffrage,* vol. 1; Tolles, ed., *Slavery and "The Woman Question."*

Wright, Frances (1797–1852) *lecturer, writer, women's right supporter*

One of the first American women to lecture publicly, Fanny Wright, as she was called, was born on September 6, 1797, in Dundee, Scotland, to Camilla Campbell Wright and James Wright. Orphaned at the age of two, Wright was raised by various relatives. At twenty-one, for one year, she joined the household of her great-uncle, James Milne, a professor at Glasgow College. Through him she was given access to the college's library.

In 1819 Wright traveled to the United States. After a brief, unsuccessful stint as a playwright, she wrote an enthusiastic and well-received travel memoir, *Views of Society and Manners in America* (1821).

Wright settled permanently in the United States in 1825. Disgusted by slavery, she published "A Plan for the Gradual Abolition of Slavery in the United States without Danger of Loss to the Citizens of the South (1825)." In this pamphlet, Wright proposed that the government allow slaves to work on public lands to earn the funds with which to purchase their own freedom. Before the end of 1825, Wright—intending to demonstrate her plan—had purchased slaves and 640 acres in Tennessee. The experiment failed, and Wright moved for a time to Robert Dale Owen's utopian community in New Harmony, Indiana. She assisted Owen with the editing of his *New Harmony Gazette* and later published the New York City *Free Enquirer* with him.

Wright advocated the use of birth control, overhaul of nineteenth-century marriage laws, female education, and equal rights for women. She outlined her views in her *Address on the State of the Public Mind* (1829) and *Course of Popular Lectures* (1829 and 1836). Daring to speak and read from these works in public before "promiscuous" audiences (audiences composed of both men and women), Wright incensed the clergy and newspaper reporters of her day and inspired the women's rights leaders who followed.

Frances Wright died in Cincinnati on December 13, 1852.

Further Reading: Boyer, "Frances Wright," in *Notable American Women,* ed. James, James, and Boyer; Cott, ed., *Root of Bitterness;* Flexner, *Century of Struggle;* McHenry, ed., *Famous American Women;* Rossi, *Feminist Papers;* Schneir, ed., *Feminism;* Stanton, Anthony, and Gage, eds., *History of Woman Suffrage,* vol. 1.

Yalow, Rosalyn Sussman (1921–) *scientist, Nobel Prize winner*

Born on July 19, 1921, in the Bronx, New York City, to Clara Zipper Sussman and Simon Sussman, Rosalyn Yalow became the second woman to win the Nobel Prize for physiology or medicine.

Yalow attended public schools and received her B.S. from Hunter College in 1941, when she was just nineteen. She did her graduate work at the University of Illinois while serving as a teaching fellow in physics. In 1943 she and A. Aaron Yalow, a fellow physics student at the University of Illinois, were married. The couple had two children.

Yalow received her Ph.D. in physics in 1945 and returned to Hunter to lecture in physics from 1946 to 1950. Having become interested in finding beneficial medical uses for radioactive materials, Yalow also, in 1947, agreed to help with the creation of a radioisotope service in the Veteran's Administration (VA) hospital in the Bronx. Yalow worked on the VA project part time until 1950, when she left Hunter and became the Radioisotope Service's physicist and assistant head on a fulltime basis. Dr. Solomon A. Berson, who would become Yalow's research partner until his death in 1972, also joined the service in 1950.

Yalow and Berson devised a technique that they labeled radioimmunoassay (RIA), which uses radioactive isotopes to "tag" or label certain proteins, enzymes, or hormones in the body and thereby detect with incredible accuracy their exact amounts present in the body. Researchers using the RIA technique established in 1959 that poor processing of insulin, rather than a shortage of insulin, sometimes causes adult-onset diabetes. Since then RIA has been used, among other applications, to screen blood-donor supplies for the hepatitis virus and as a diagnostic tool in suspected cases of tuberculosis and certain forms of cancers.

In 1977 Yalow was awarded a half-share of the Nobel Prize for physiology or medicine (an honor she shared with Roger Guillemin and Andrew V. Schally, who had expanded the use of RIA during their research on hormones in the brain; Berson was not named because he had died). She was the second woman, following Gerty T. CORI, to win this prize and only the sixth woman to win any Nobel Prize in science. In her acceptance speech in Stockholm, Yalow spoke of her concern for all women and deplored the fact that many people undervalued women's potential.

Yalow's other honors include the Albert Lasker Prize for Medical Research, awarded in 1977 (she was the first woman to receive this prize), the Veterans Administration's Exceptional Service Award in 1975 and 1978; the Banting Medal, 1978; and the National Medal of Science, 1988. However, she refused to accept the Woman of the Year Award from the *Ladies' Home Journal* in 1979, explaining that she disapproved of gender-based awards. She is currently the Solomon A. Berson Distinguished Professor-at-Large at the Mount Sinai School of Medicine.

Further Reading: Clark, *Almanac of American Women in the 20th Century;* McHenry, ed., *Famous American Women;* Kent, "Winner Woman!"; Opfell, *Lady Laureates;* Yalow, Radioimmunoassay; ———, "Insulin-1133 Metabolism in Human Subjects"; ———, "Assay of Plasma Insulin in Human Subjects."

Year of the Woman

A phrase frequently used during election campaigns to predict the arrival of a gender-conscious voting pattern among women that, if employed, would elect large numbers of women or of male candidates sympathetic to women's issues. Incumbent male politicians in Congress

anticipated the power of women voters in the years immediately following the 1920 ratification of the Nineteenth Amendment. Partly to "win the woman's vote" and thus forestall the creation of an organized or (even militant) women's voting block, they passed legislation such as the SHEPPARD-TOWNER ACT of 1921 (appropriating funds for the improvement of maternal and infant health), the Packers and Stockyards bill of 1921 (strengthening consumer safeguards), the CABLE ACT of 1922 (allowing women to retain their U.S. citizenship if they married foreigners), and the Child Labor Amendment to the Constitution (passed by Congress in 1924 but never ratified by the states).

State politicians were equally accommodating to the wishes of newly enfranchised women. Virginia's female reformers requested and received a child placement bill and seventeen other family-friendly laws; Wisconsin passed an equal-rights bill; Montana and Michigan created equal-pay laws; and twenty states hurriedly passed laws permitting women to sit on juries.

An argument can be made that this flurry of activity ended because women *did not* organize to vote in a gender-conscious manner. In any event, the phrase "winning the woman's vote" quickly fell from use.

Over fifty years later, feminists began to predict the "Year of the Woman." Walter Mondale, hoping the feminists were correct in their prediction of a GENDER GAP, picked Geraldine FERRARO as his vice-presidential running mate in 1984. Mondale lost his presidential bid, and many newspaper editorialists and television journalists mocked the idea of a "gender gap" ever materializing among the electorate.

In 1992, however, the "Year of the Woman" finally seemed to arrive, ushered in by the Anita HILL/Clarence Thomas hearings. In the fall of 1991, when Clarence Thomas' Supreme Court confirmation hearings were being held, the Senate Judiciary Committee, in charge of the proceedings, received information that the attorney and professor Anita Hill, who had worked for Thomas during his tenure as director of the Equal Employment Opportunity Commission (EEOC), claimed to have been sexually harassed by him. The male members of the Judiciary Committee did not raise the issue during the public hearings, but the story leaked to the press.

Female members of the House of Representatives and the two female senators—livid that their male colleagues had deemed such a charge unimportant—demanded that the Judiciary Committee investigate Hill's charges. A new hearing was held, and Hill was questioned in sometimes scathing tones, especially by Republican senators. Thomas denied the charges and was confirmed by a small margin.

Many women, listening to male members of the Judiciary Committee question Hill, felt that men did not understand the impact of sex discrimination and harassment on women's lives. As a result, many women declared themselves candidates for election in 1992; other women, saying that men "just didn't get it," made record-breaking donations to the women's campaigns. Moreover, the Republican party—which had for the previous twelve years placated its right-wing, "pro-life" constituency at the expense of its feminist members' goals—faced public female defection: In a dramatic moment, nine Republican women spoke at the Democratic convention and announced that, because they were unhappy with the antichoice position of Republican President George Bush, they would vote for Democratic challenger Bill Clinton.

There were many factors involved in Bill Clinton's 1992 victory, and it is not possible to isolate the exact impact of votes based on "women's issues." In the Senate and House of Representatives, however, the arrival of the "Year of the Woman" is clear. Thanks to women's financial support and votes, the following women were newly elected to the House that year:

> Corrine Brown (D-FL 1993–)
> Leslie Byrne (D-VA 1993–1995)
> Maria Cantwell (D-WA 1993–1995)
> Eva Clayton (D-NC 1992–)
> Pat Danner (D-MO 1993–)
> Jennifer Dunn (R-WA 1993–)
> Karan English (D-AZ 1993–1995)
> Anna Eshoo (D-CA 1993–)
> Tillie Fowler (R-FL 1993–)
> Elizabeth Furse (D-OR 1993–1999)
> Jane Harman (D-CA 1993–1999)
> Eddie Bernice Johnson (D-TX 1993–)
> Blanche Lambert Lincoln (D-AR 1993–1997)
> Carolyn Maloney (D-NY 1993–)
> Marjorie Margolies-Mezvinsky (D-PA 1993–1995)
> Cynthia McKinney (D-GA 1993–)
> Carrie Meek (D-FL 1993–)
> Deborah Pryce (R-OH 1993–)
> Lucille Roybal-Allard (D-CA 1993–)
> Lynn Schenk (D-CA 1993–1995)
> Karen Shepherd (D-UT 1993–1995)
> Karen Thurman (D-FL 1993–)
> Nydia Velazquez (D-NY 1993–)
> Lynn Woolsey (D-CA 1993–)

Before the election, there had been 29 congresswomen; after the election, there were 48. (Five women from the previous term did not return to their seats.) Of the eleven new senators elected in 1992, four were women: Carol Moseley Braun (D-IL 1993–1999), who had the dual distinction of being the first African-American woman elected to the Senate; Barbara Boxer

(D-CA 1993–); Dianne Feinstein (D-CA 1993–); and Patty Murray (D-WA 1993–). They joined reelected incumbent Barbara Mikulski (D-MD 1987–) and Nancy Landon Kassebaum (R-KS 1978–1997), bringing the number of female senators to six. For a complete list of all the women who have served as U.S. Congressional Representatives and Senators. See Appendix No. 39.

Further Reading: Chafe, *American Woman;* Davis, *Moving the Mountain;* Faludi, *Backlash;* Kaiser, "Women of the Year"; *New York Times,* November 5, 1992.

Z

Zaharias, Mildred Ella Didrikson ("Babe")
(1911–1956)

Born Mildred Ella Didriksen to Norwegian immigrant parents Hannah Marie Olsen Didriksen and Ole Nicolene Didriksen on June 26, 1911, in Port Arthur, Texas, "Babe" Didrikson Zaharias was one of America's most outstanding athletes and a cofounder of the Ladies Professional Golf Association. (In adulthood, she changed the spelling of her surname.)

Encouraged in her athletic endeavors by her mother, who had been a skating and skiing champion in Norway, Mildred Didrikson played baseball with the neighborhood boys and became the star of her high school basketball team. She earned the nickname "Babe" from her childhood teammates, who enthusiastically compared her to Babe Ruth.

She secured a clerical position with the Employer's Casualty Program of Dallas in 1930. At a time when most colleges failed to provide women with athletic programs, many businesses, including Employer's Casualty, organized women's sports teams. Babe Didrikson attracted national attention as member of the Golden Cyclones, a semiprofessional basketball team sponsored by her employer. Twice leading her team to the finals and helping to secure it a national championship title, Babe Didrikson was named an All-American athlete on three separate occasions.

In the early 1930s, Didrikson also began to excel in track. By the time she competed in the Amateur Athletic Union Championships of 1932, where she won five of the eight events she entered, she had already beaten American, Olympic, and/or world records in baseball throw, broad jump, eighty-meter hurdles, high jump, and the javelin. She was restricted to entering three events in the 1932 Olympics, where she won gold medals in hurdles and the javelin and a silver medal for the high jump (she had tied the winner but was placed second because she didn't jump in a classical style).

In 1934, Didrikson turned professional and signed a contract with the House of David, a traveling baseball team. Considered by most sports commentators to be a better hitter and fielder than a pitcher, she was nonetheless invited in 1934 to pitch in exhibition games for several major league teams and caused a sensation when she struck out Joe DiMaggio.

Didrikson had begun to take golf lessons in 1932 and, in 1934, she entered the Fort Worth Women's Invitational. Although she lost in the first round of this tournament, she soon dominated the sport of women's golf. In 1938, in a Los Angeles men's golf tournament, she was paired with wrestler and sports promoter George Zaharias, whom she married at the end of the year. Susan Cayleff's recent biography depicts the Zaharias marriage as a happy one but also presents evidence that Babe Didrikson Zaharis, near the end of her life, was deeply in love with the female golfer Betty Dodd.

George Zaharias became his wife's manager. In order to be returned to amateur status, Babe Didrikson Zaharias refrained from competition for three years and refused to accept cash prizes for two more. Her amateur status was restored in 1944; over the next three years, she won seventeen consecutive amateur golf tournaments, including the 1947 British Women's Amateur Championship. In 1947, she turned professional once again. In January 1948, she became a cofounder, with Patty Berg, of the Ladies Professional Golf Association. She was the association's leading player from 1949 through 1951, winning the Women's Open in 1948 and 1950, and the Tampa Open in 1951.

In 1953, Babe Didrikson Zaharias was diagnosed with cancer of the rectum. Unusually for the era, she candidly discussed the cancer's symptoms and her fight against the disease. She also struggled to maintain her accustomed level of performance until the end of her life and inspired many when she succeeded: The year

following her colostomy, she won the United States Women's Open Title for the third time.

Babe Didrikson Zaharias won the All-American award in 1929; the Associated Press Woman Athlete of the Year award in 1932, 1945, 1946, 1947, and 1954, and the Associated Press Woman Athlete of the First Half of the Twentieth Century award in 1950. She died on September 27, 1956, in Galveston, Texas.

Further Reading: Cayleff, *The Life and Legend of Babe Didrikson Zaharias;* Gregorich, *Women at Play;* Norton, "Mildred Ella (Babe) Didrikson Zaharias," in *Notable American Women: The Modern Period,* Sicherman et al., eds.; Johnson and Williamson, *"Whatta-Gal": The Babe Didrikson Story;* Zaharias and Paxton, *This Life I've Led.*

Appendix: Documents

1. Constitution of the United States, with Amendments

2. Record of Margaret Brent's Request for Suffrage, 1647

3. An Act Concerning the Dowry of Widows, Connecticut, 1672

4. Blackstone's Commentaries, 1765

5. Edenton Resolution, 1774

6. Ladies Association of Philadelphia Broadside, 1780

7. Objections of a "Friend of the Ladies" to Women's Suffrage in New Jersey, 1802

8. From *The Married Lady's Companion, or Poor Man's Friend*, by Samuel K. Jennings, 1808

9. From "Appeal to Christian Women of the South," by Angelina Grimké, September 1836

10. From a Pastoral Letter of "the General Association of Massachusetts (Orthodox) to the Churches Under Their Care," 1837

11. Commonwealth of Massachusetts Report, House of Representatives, March 12, 1845, Concerning Request for Ten-Hour Workday Legislation

12. From *Treatise on Domestic Economy*, by Catharine E. Beecher, 1847

13. Married Woman's Property Act, New York, 1848

14. Declaration of Rights and Sentiments, Seneca Falls, July 19–20, 1848

15. "Ain't I a Woman?" Sojourner Truth's Reply to a Male Opponent of Women's Rights, 1851

16. Act Concerning the Rights and Liabilities of Husband and Wife, March 20, 1860

17. The Emancipation Address of the Woman's National Loyal League, Adopted May 15, 1863

18. Comstock Law, 1873

19. *Bradwell v. Illinois,* 83 U.S. 130 (1873)

20. From Hearings Before a Subcommittee of the Committee on the District of Columbia, United States Senate, 63rd Congress Under Senate Resolution 499 . . . To Investigate the Conduct of the District Police . . . in connection with the Woman's Suffrage Parade on March 3, 1913

21. Letter to the Commissioners of the District of Columbia Claiming Political Prisoner Status for Jailed Suffragettes, 1917

22. Equal Rights Amendment: Introduced, 1923; passed by Congress, 1972; failed to win ratification, 1982. With List of States and Years Ratified

23. President's Commission on the Status of Women, 1963

24. Title VII of the Civil Rights Act of 1964

25. From *Griswold v. Connecticut,* 381 U.S. 479 (1965)

26. National Organization for Women (NOW) Statement of Purpose, October 26, 1966

27. National Organization for Women Bill of Rights in 1968

28. National Organization for Women, Statement on Lesbian Rights, 1971

29. From *Reed v. Reed,* 404 U.S. 71 (1971)

30. From *Roe v. Wade,* 410 U.S. 113 (1973) and *Doe v. Bolton,* 410 U.S. 179 (1973)

31. Convention on the Elimination of All Forms of Discrimination Against Women, 1979

32. From *Meritor Savings Bank v. Mechelle Vinson,* 1986

33. From *Planned Parenthood v. Casey,* 1992

34. From *Harris v. Forklift,* 510 U.S. 17 (1993)

35. From Beijing Declaration and Platform for Action, 1995

36. From *United States v. Commonwealth of Virginia,* 518 U.S. 515 (1996)

37. *Oncale v. Sundowner Offshore Services,* 1998

38. 1998 Declaration of Sentiments of the National Organization for Women

39. List of Women Who Have Served as U.S. Congressional Representatives and U.S. Senators.

The Constitution of the United States

Preamble

We the People of the United States, in Order to form a more perfect Union, establish Justice, ensure domestic Tranquility, provide for the common defence, promote the general Welfare, and secure the Blessings of Liberty to ourselves and our Posterity, do ordain and establish this Constitution for the United States of America.

Article 1

Section 1. All legislative Powers herein granted shall be vested in a Congress of the United States, which shall consist of a Senate and House of Representatives.

Section 2. [1] The House of Representatives shall be composed of Members chosen every second Year by the People of the several States, and the Electors in each State shall have the Qualifications requisite for Electors of the most numerous Branch of the State Legislature.

[2] No Person shall be a Representative who shall not have attained to the Age of twenty five Years, and been seven Years a Citizen of the United States, and who shall not, when elected, be an Inhabitant of that State in which he shall be chosen.

[3] Representatives and direct Taxes shall be apportioned among the several States which may be included within this Union, according to their respective Numbers, which shall be determined by adding to the whole Number of free Persons, including those bound to Service for a Term of Years, and excluding Indians not taxed, three fifths of all other Persons. The actual Enumeration shall be made within three Years after the first Meeting of the Congress of the United States, and within every subsequent Term of ten Years, in such Manner as they shall by Law direct. The Number of Representatives shall not exceed one for every thirty Thousand, but each State shall have at Least one Representative; and until such enumeration shall be made, the State of New Hampshire shall be entitled to chuse three, Massachusetts eight, Rhode Island and Providence Plantations one, Connecticut five, New York six, New Jersey four, Pennsylvania eight, Delaware one, Maryland six, Virginia ten, North Carolina five, South Carolina five, and Georgia three.

[4] When vacancies happen in the Representation from any State, the Executive Authority thereof shall issue Writs of Election to fill such Vacancies.

[5] The House of Representatives shall chuse their Speaker and other Officers; and shall have the sole Power of Impeachment.

Section 3. [1] The Senate of the United States shall be composed of two Senators from each State, chosen by the Legislature thereof, for six Years; and each Senator shall have one Vote.

[2] Immediately after they shall be assembled in Consequence of the first Election, they shall be divided as equally as may be into three Classes. The Seats of the Senators of the first Class shall be vacated at the Expiration of the Second Year, of the second Class at the Expiration of the fourth Year, and of the third Class at the Expiration of the sixth Year, so that one third may be chosen every second Year; and if Vacancies happen by Resignation, or otherwise, during the Recess of the Legislature of any State, the Executive thereof may make temporary Appointments until the next Meeting of the Legislature, which shall then fill such Vacancies.

[3] No Person shall be a Senator who shall not have attained to the Age of thirty Years, and been nine Years a Citizen of the United States, and who shall not, when elected, be an Inhabitant of that State for which he shall be chosen.

[4] The Vice President of the United States shall be President of the Senate, but shall have no Vote, unless they be equally divided.

[5] The Senate shall chuse their other Officers, and also a President pro tempore, in the Absence of the Vice President, or when he shall exercise the Office of President of the United States.

[6] The Senate shall have the sole Power to try all Impeachments. When sitting for that Purpose, they shall be on Oath or Affirmation. When the President of the United States is tried, the Chief Justice shall preside: And no Person shall be convicted without the Concurrence of two thirds of the Members present.

[7] Judgment in Cases of Impeachment shall not extend further than to removal from Office, and disqualification to hold and employ any Office of honor, Trust, or Profit under the United States: but the Party convicted shall nevertheless be liable and subject to Indictment, Trial, Judgment, and Punishment, according to Law.

Section 4. [1] The Times, Places and Manner of holding Elections for Senators and Representatives, shall be prescribed in each State by the Legislature thereof; but the Congress may at any time by Law make or alter such Regulations, except as to the Places of chusing Senators.

[2] The Congress shall assemble at least once in every Year, and such Meeting shall be on the first Monday in December, unless they shall by Law appoint a different Day.

Section 5. [1] Each House shall be the Judge of the Elections, Returns, and Qualifications of its own Members, and a Majority of each shall constitute a Quorum to do Business; but a smaller Number may adjourn from day to day, and may be authorized to compel the Attendance of absent Members, in such Manner, and under such Penalties as each House may provide.

[2] Each House may determine the Rules of its Proceedings, punish its Members for disorderly Behav-

ior, and, with the Concurrence of two thirds, expel a Member.

[3] Each House shall keep a Journal of its Proceedings, and from time to time publish the same, excepting such Parts as may in their Judgment require Secrecy; and the Yeas and Nays of the Members of either House on any question shall, at the Desire of one fifth of those Present, be entered on the Journal.

[4] Neither House, during the Session of Congress, shall, without the Consent of the other, adjourn for more than three days, nor to any other Place than that in which the two Houses shall be sitting.

Section 6. [1] The Senators and Representatives shall receive a Compensation for their Services, to be ascertained by Law, and paid out of the Treasury of the United States. They shall in all Cases, except Treason, Felony and Breach of the Peace, be privileged from Arrest during their Attendance at the Session of their respective Houses, and in going to and returning from the same; and for any Speech and Debate in either House, they shall not be questioned in any other Place.

[2] No Senator or Representative shall, during the Time for which he was elected, be appointed to any civil Office under the Authority of the United States, which shall have been created, or the Emoluments whereof shall have been increased during such time; and no Person holding any Office under the United States, shall be a Member of either House during his Continuance in Office.

Section 7. [1] All Bills for raising Revenue shall originate in the House of Representatives; but the Senate may propose or concur with Amendments as on other Bills.

[2] Every Bill which shall have passed the House of Representatives and the Senate, shall, before it become a Law, be presented to the President of the United States; If he approve he shall sign it, but if not he shall return it, with his Objections to the House in which it shall have originated, who shall enter the Objections at large on their Journal, and proceed to reconsider it. If after such Reconsideration two thirds of that House shall agree to pass the Bill, it shall be sent together with the Objections, to the other House, by which it shall likewise be reconsidered, and if approved by two thirds of that House, it shall become a Law. But in all such Cases the Votes of both Houses shall be determined by Yeas and Nays, and the Names of the Persons voting for and against the Bill shall be entered on the Journal of each House respectively. If any Bill shall not be returned by the President within ten Days (Sundays excepted) after it shall have been presented to him, the Same shall be a Law, in like Manner as if he had signed it, unless the Congress by their Adjournment prevent its Return in which Case it shall not be a Law.

[3] Every Order, Resolution, or Vote, to Which the Concurrence of the Senate and House of Representatives may be necessary (except on a question of Adjournment) shall be presented to the President of the United States; and before the Same shall take Effect, shall be approved by him, or being disaproved by him, shall be repassed by two thirds of the Senate and House of Representatives, according to the Rules and Limitations prescribed in the Case of a Bill.

Section 8. [1] The Congress shall have Power To lay and collect Taxes, Duties, Imposts and Excises, to pay the Debts and provide for the common Defence and general Welfare of the United States; but all Duties, Imposts and Excises shall be uniform throughout the United States;

[2] To borrow money on the credit of the United States;

[3] To regulate Commerce with foreign Nations, and among the several States, and with the Indian Tribes;

[4] To establish an uniform Rule of Naturalization, and uniform Laws on the subject of Bankruptcies throughout the United States;

[5] To coin Money, regulate the Value thereof, and of foreign Coin, and fix the Standard of Weights and Measures;

[6] To provide for the Punishment of counterfeiting the Securities and current Coin of the United States;

[7] To Establish Post Offices and Post Roads;

[8] To promote the Progress of Science and useful Arts, by securing for limited Times to Authors and Inventors the exclusive Right to their respective Writings and Discoveries;

[9] To constitute Tribunals inferior to the supreme Court;

[10] To define and punish Piracies and Felonies committed on the high Seas, and Offenses against the Law of Nations;

[11] To declare War, grant Letters of Marque and Reprisal, and make Rules concerning Captures on Land and Water;

[12] To raise and support Armies, but no Appropriation of Money to that Use shall be for a longer Term than two Years;

[13] To provide and maintain a Navy;

[14] To make Rules for the Government and Regulation of the land and naval Forces;

[15] To provide for calling forth the Militia to execute the Laws of the Union, suppress Insurrections and repel Invasions;

[16] To provide for organizing, arming, and disciplining, the Militia, and for governing such Part of them as may be employed in the Service of the United States, reserving to the States respectively, the Appointment of the Officers, and the Authority of training the Militia according to the discipline prescribed by Congress;

[17] To exercise exclusive Legislation in all Cases whatsoever, over such District (not exceeding ten Miles

square) as may, by Cession of particular States, and the Acceptance of Congress, become the Seat of the Government of the United States, and to exercise like Authority over all Places purchased by the Consent of the Legislature of the State in which the Same shall be, for the Erection of Forts, Magazines, Arsenals, dock-Yards, and other needful Buildings;—And

[18] To make all Laws which shall be necessary and proper for carrying into Execution the foregoing Powers, and all other Powers vested by this Constitution in the Government of the United States, or in any Department or Officer thereof.

Section 9. [1] The Migration or Importation of Such Persons as any of the States now existing shall think proper to admit, shall not be prohibited by the Congress prior to the Year one thousand eight hundred and eight, but a Tax or duty may be imposed on such importation, not exceeding ten dollars for each Person.

[2] The privilege of the Writ of Habeas Corpus shall not be suspended, unless when in Cases of Rebellion or Invasion the public Safety may require it.

[3] No Bill of Attainder or ex post facto Law shall be passed.

[4] No Capitation, or other direct, Tax shall be laid, unless in Proportion to the Census or Enumeration herein before directed to be taken.

[5] No Tax or Duty shall be laid on Articles exported from any State.

[6] No Preference shall be given by any Regulation of Commerce or Revenue to the Ports of one State over those of another: nor shall Vessels bound to, or from, one State be obliged to enter, clear, or pay Duties in another.

[7] No money shall be drawn from the Treasury, but in Consequence of Appropriations made by Law; and a regular Statement and Account of the Receipts and Expenditures of all public Money shall be published from time to time.

[8] No Title of Nobility shall be granted by the United States; And no Person holding any Office of Profit or Trust under them, shall, without the Consent of the Congress, accept of any present, Emolument, Office, or Title, of any kind whatever, from any King, Prince, or foreign State.

Section 10. [1] No State shall enter into any Treaty, Alliance, or Confederation; grant Letters of Marque and Reprisal; coin Money; emit Bills of Credit; make any Things but gold and silver Coin a Tender in Payment of Debts; pass any Bill of Attainder, ex post facto Law, or Law impairing the Obligation of Contracts, or grant any Title of Nobility.

[2] No State shall, without the Consent of the Congress, lay any Imposts or Duties on Imports or Exports, except what may be absolutely necessary for executing its inspection Laws: and the net Produce of all Duties and Imposts, laid by any State on Imports or Exports, shall be for the Use of the Treasury of the United States; and all such Laws shall be subject to the Revision and Controul of the Congress.

[3] No State shall, without the Consent of Congress, lay any Duty of Tonnage, keep Troops, or Ships of War in time of Peace, enter into any Agreement or Compact with another State or with a foreign Power, or engage in War, unless actually invaded, or in such imminent Danger as will not admit of delay.

Article 2

Section 1. [1] The executive Power shall be vested in a President of the United States of America. He shall hold his Office during the Term of four Years, and, together with the Vice President, chosen for the same Term, be elected, as follows:

[2] Each State shall appoint, in such Manner as the Legislature thereof may direct, a Number of Electors, equal to the whole Number of Senators and Representatives to which the State may be entitled in the Congress; but no Senator or Representative, or Person holding an Office of Trust or Profit under the United States, shall be appointed an Elector.

[3] The Electors shall meet in their respective States, and vote by Ballot for two Persons, of whom one at least shall not be an Inhabitant of the same State with themselves. And they shall make a List of all the Persons voted for, and of the number of Votes for each; which List they shall sign and certify, and transmit sealed to the Seat of the Government of the United States, directed to the President of the Senate. The President of the Senate shall, in the Presence of the Senate and House of Representatives, open all the Certificates, and the Votes shall then be counted. The Person having the greatest Number of Votes shall be the President, if such Number be a Majority of the whole Number of Electors appointed; and if there be more than one who have such Majority, and have an equal Number of Votes, then the House of Representatives shall immediately chuse by Ballot one of them for President; and if no Person have a Majority, then from the five highest on the List the said House shall in like Manner chuse the President. But in chusing the President, the Votes shall be taken by States the Representation from each State having one Vote; A quorum for this Purpose shall consist of a Member or Members from two thirds of the States, and a Majority of all the States shall be necessary to a Choice. In every Case, after the Choice of the President, the Person having the greater Number of Votes of the Electors shall be the Vice President. But if there should remain two or more who have equal Votes, the Senate shall chuse from them by Ballot the Vice President.

[4] The Congress may determine the Time of chusing the Electors, and the Day on which they shall give their Votes; which Day shall be the same throughout the United States.

[5] No person except a natural born Citizen, or a Citizen of the United States, at the time of the Adoption of this Constitution, shall be eligible to the Office of President; neither shall any Person be eligible to that Office who shall not have attained to the Age of thirty five Years, and been fourteen Years a Resident within the United States.

[6] In case of the removal of the President from Office, or of his Death, Resignation or Inability to discharge the Powers and Duties of the said Office, the Same shall devolve on the Vice President, and the Congress may by Law provide for the Case of Removal, Death, Resignation or Inability, both of the President and Vice President, declaring what Officer shall then act as President, and such Officer shall act accordingly, until the Disability be removed, or a President shall be elected.

[7] The President shall, at stated Times, receive for his Services, a Compensation, which shall neither be increased nor diminished during the Period for which he shall have been elected, and he shall not receive within that Period any other Emolument from the United States, or any of them.

[8] Before he enter on the Execution of his Office, he shall take the following Oath or Affirmation: "I do solemnly swear (or affirm) that I will faithfully execute the Office of President of the United States, and will to the best of my Ability, preserve, protect and defend the Constitution of the United States."

Section 2. [1] The President shall be Commander in Chief of the Army and Navy of the United States, and of the militia of the several States, when called into the actual Service of the United States; he may require the Opinion, in writing, of the principal Officer in each of the Executive Departments, upon any Subject relating to the Duties of their respective Offices, and he shall have Power to grant Reprieves and Pardons for Offenses against the United States, except in Cases of Impeachment.

[2] He shall have Power, by and with the Advice and Consent of the Senate to make Treaties, provided two thirds of the Senators present concur; and he shall nominate, and by and with the Advice and Consent of the Senate, shall appoint Ambassadors, other public Ministers and Consuls, Judges of the supreme Court, and all other Officers of the United States, whose Appointments are not herein otherwise provided for, and which shall be established by Law; but the Congress may by Law vest the Appointment of such inferior Officers, as they think proper, in the President alone, in the Courts of Law, or in the Heads of Departments.

[3] The President shall have Power to fill up all Vacancies that may happen during the Recess of the Senate, by granting Commissions which shall expire at the End of their next Session.

Section 3. He shall from time to time give to the Congress Information of the State of the Union, and recommend to their Consideration such Measures as he shall judge necessary and expedient; he may, on extraordinary Ocasions, convene both Houses, or either of them, and in Case of Disagreement between them, with Respect to the Time of Adjournment, he may, on extraordinary Occasions, convene both Houses, or either of them, and in and other public Ministers; he shall take Care that the Laws be faithfully executed, and shall Commission all the Officers of the United States.

Section 4. The President, Vice President and all civil Officers of the United States, shall be removed from Office on Impeachment for, and Conviction of, Treason, Bribery, or other high Crimes and Misdemeanors.

Article 3

Section 1. The judicial Power of the United States, shall be vested in one supreme Court, and in such inferior Courts as the Congress may from time to time ordain and establish. The Judges, both of the supreme and inferior Courts, shall hold their Offices during good Behaviour, and shall, at stated Times, receive for their Services a Compensation, which shall not be diminished during their Continuance in Office.

Section 2. [1] The judicial Power shall extend to all Cases, in Law and Equity, arising under this Constitution, the Laws of the United States, and Treaties made, or which shall be made, under their Authority;—to all Cases affecting Ambassadors, other public Ministers and Consuls;—to all Cases of admiralty and maritime Jurisdiction;—to Controversies to which the United States shall be a Party;—to Controversies between two or more States;—between Citizens of the same State claiming Lands under the Grants of different States, and between a State, or the Citizens thereof, and foreign States, Citizens or Subjects.

[2] In all Cases affecting Ambassadors, other public Ministers and Consuls, and those in which a State shall be a Party, the Supreme Court shall have original Jurisdiction. In all the other Cases before mentioned, the supreme Court shall have appellate Jurisdiction, both as to Law and Fact, with such Exceptions, and under such Regulations as the Congress shall make.

[3] The trial of all Crime, except in Cases of Impeachment, shall be by Jury; and such Trial shall be held in the State where the said Crimes shall have been committed; but when not committed within any State, the Trial shall be at such Place or Places as the Congress may by Law have directed.

Section 3. [1] Treason against the United States, shall consist only in levying War against them, or, in adhering to their Enemies, giving them Aid and Comfort. No Person shall be convicted of Treason unless on the Testimony of two Witnesses to the same overt Act, or on Confession in open Court.

[2] The Congress shall have Power to declare the Punishment of Treason, but no Attainder of Treason shall work Corruption of Blood, or Forfeiture except during the Life of the Person attainted.

Article 4

Section 1. Full Faith and Credit shall be given in each State to the public Acts, Records, and judicial Proceedings of every other State. And the Congress may by general Laws prescribe the Manner in which such Acts, Records and Proceedings shall be proved, and the Effect thereof.

Section 2. [1] The Citizens of each State shall be entitled to all Privileges and Immunities of Citizens in the several States.

[2] A Person charged in any State with Treason, Felony, or other Crime, who shall flee from Justice, and be found in another State, shall on demand of the executive Authority of the State from which he fled, be delivered up, to be removed to the State having Jurisdiction of the Crime.

[3] No Person held to Service or Labour in one State, under the Laws thereof, escaping into another, shall, in Consequence of any Law or Regulation therein, be discharged from such Service or Labour, but shall be delivered up on Claim of the Party to whom such Service or Labour may be due.

Section 3. [1] New States may be admitted by the Congress into this Union; but no new State shall be formed or erected within the Jurisdiction of any other State; nor any State be formed by the Junction of two or more States, or Parts of States, without the Consent of the Legislatures of the States concerned as well as of the Congress.

[2] The Congress shall have Power to dispose of and make all needful Rules and Regulations respecting the Territory or other Property belonging to the United States; and nothing in this Constitution shall be so construed as to Prejudice any Claims of the United States, or of any particular State.

Section 4. The United States shall guarantee to every State in this Union a Republican Form of Government, and shall protect each of them against Invasion; and on Application of the Legislature, or of the Executive (when the Legislature cannot be convened) against domestic Violence.

Article 5

The Congress, whenever two thirds of both Houses shall deem it necessary, shall propose Amendments to this Constitution, or, on the Application of the Legislatures of two thirds of the several States, shall call a Convention for proposing Amendments, which, in either Case, shall be valid to all Intents and Purposes, as part of this Constitution, when ratified by the Legislatures of three fourths of the several States, or by Conventions in three fourths thereof, as the one or the other Mode of Ratification may be proposed by the Congress; Provided that no Amendment which may be made prior to the Year One thousand eight hundred and eight shall in any Manner affect the first and fourth Clauses in the Ninth Section of the first Article; and that no State, without its Consent, shall be deprived of its equal Suffrage in the Senate.

Article 6

[1] All Debts contracted and Engagements entered into, before the Adoption of this Constitution shall be as valid against the United States under this Constitution, as under the Confederation.

[2] This Constitution, and the Laws of the United States which shall be made in Pursuance thereof; and all Treaties made, or which shall be made under the Authority of the United States, shall be the supreme Law of the Land; and the Judges in every State shall be bound thereby, any Things in the Constitution or Laws of any State to the Contrary notwithstanding.

[3] The Senators and Representatives before mentioned, and the Members of the several State Legislatures, and all executive and judicial Officers, both of the United States and of the several States, shall be bound by Oath or Affirmation, to support this Constitution; but no religious Test shall ever be required as a Qualification to any Office or public Trust under the United States.

Article 7

The Ratification of the Conventions of nine States shall be sufficient for the Establishment of this Constitution between the States so ratifying the Same.

ARTICLES IN ADDITION TO, AND AMENDMENT OF, THE CONSTITUTION OF THE UNITED STATES OF AMERICA, PROPOSED BY CONGRESS, AND RATIFIED BY THE LEGISLATURES OF THE SEVERAL STATES PURSUANT TO THE FIFTH ARTICLE OF THE ORIGINAL CONSTITUTION.

Amendment I [1791]

Congress shall make no law respecting an establishment of religion, or prohibiting the free exercise thereof; or abridging the freedom of speech, or of the press; or the right of the people peaceably to assemble, and to petition the Government for a redress of grievances.

Amendment II [1791]

A well regulated Militia, being necessary to the security of a free State, the right of the people to keep and bear Arms, shall not be infringed.

Amendment III [1791]

No Soldier shall, in time of peace be quartered in any house, without the consent of the Owner, nor in time of war, but in a manner to be prescribed by law.

Amendment IV [1791]

The right of the people to be secure in their persons, houses, papers, and effects, against unreasonable searches and seizures, shall not be violated, and no Warrants shall issue, but upon probable cause, supported by Oath or affirmation, and particularly describing the place to be searched, and the persons or things to be seized.

Amendment V [1791]

No person shall be held to answer for a capital, or otherwise infamous crime, unless on a presentment or indictment of a Grand Jury, except in cases arising in the land or naval forces, or in the Militia, when in actual service in time of War or public danger; nor shall any person be subject for the same offence to be twice put in jeopardy of life or limb; nor shall be compelled in any criminal case to be a witness against himself, nor be deprived of life, liberty, or property, without due process of law; nor shall private property be taken for public use, without just compensation.

Amendment VI [1791]

In all criminal prosecutions, the accused shall enjoy the right to a speedy and public trial, by an impartial jury of the State and district wherein the crime shall have been committed, which district shall have been previously ascertained by law, and to be informed of the nature and cause of the accusation; to be confronted with the witnesses against him; to have compulsory process for obtaining witnesses in his favor, and to have the Assistance of Counsel for his defence.

Amendment VII [1791]

In Suits at common law, where the value in controversy shall exceed twenty dollars, the right of trial by jury shall be preserved, and no fact tried by jury, shall be otherwise reexamined in any Court of the United States, than according to the rules of the common law.

Amendment VIII [1791]

Excessive bail shall not be required, nor excessive fines imposed, nor cruel and unusual punishments inflicted.

Amendment IX [1791]

The enumeration in the Constitution, of certain rights, shall not be construed to deny or disparage others retained by the people.

Amendment X [1791]

The powers not delegated to the United States by the Constitution, nor prohibited by it to the States, are reserved to the States respectively, or to the people.

Amendment XI [1798]

The Judicial power of the United States shall not be construed to extend to any suit in law or equity, commenced or prosecuted against one of the United States by Citizens of another State, or by Citizens or Subjects of any Foreign State.

Amendment XII [1804]

The Electors shall meet in their respective states and vote by ballot for President and Vice-President, one of whom, at least, shall not be an inhabitant of the same state with themselves; they shall name in their ballots the person voted for as President, and in distinct ballots the person voted for as Vice-President, and they shall make distinct lists of all persons voted for as President, and of all persons voted for as Vice-President, and of the number of votes for each, which lists they shall sign and certify, and transmit sealed to the seat of the government of the United States, directed to the President of the Senate;—The President of the Senate shall, in the presence of the Senate and House of Representatives, open all the certificates and the votes shall then be counted;—The person having the greatest number of votes for President, shall be the President, if such number be a majority of the whole number of Electors appointed; and if no person have such majority, then from the persons having the highest numbers not exceeding three on the list of those voted for as President, the House of Representatives shall choose immediately, by ballot, the President. But in choosing the President, the votes shall be taken by states, the representation from each state having one vote; a quorum for this purpose shall consist of a member or members from two-thirds of the States, and a majority of all the states shall be necessary to a choice. And if the House of Representatives shall not choose a President whenever the right of choice shall devolve upon them before the fourth day of March next following, then the Vice-President shall act as President, as in the case of the death or other constitutional disability of the President.—The person having the greatest number of votes as Vice-President, shall be the Vice-President, if such number be a majority of the whole number of Electors appointed, and if no person have a majority, then from

the two highest numbers on the list, the Senate shall choose the Vice-President; a quorum for the purpose shall consist of two-thirds of the whole number of Senators, and a majority of the whole number shall be necessary to a choice. But no person constitutionally ineligible to the office of President shall be eligible to that of Vice-President of the United States.

Amendment XIII [1865]

Section 1. Neither slavery nor involuntary servitude, except as a punishment for crime whereof the party shall have been duly convicted, shall exist within the United States, or any place subject to their jurisdiction.

Section 2. Congress shall have power to enforce this article by appropriate legislation.

Amendment XIV [1868]

Section 1. All persons born or naturalized in the United States, and subject to the jurisdiction thereof, are citizens of the United States and of the State wherein they reside. No State shall make or enforce any law which shall abridge the privileges or immunities of citizens of the United States; nor shall any State deprive any person of life, liberty, or property, without due process of law; nor deny to any person within its jurisdiction the equal protection of the laws.

Section 2. Representatives shall be apportioned among the several States according to their respective numbers, counting the whole number of persons in each State, excluding Indians not taxed. But when the right to vote at any election for the choice of electors for President and Vice President of the United States, Representatives in Congress, the Executive and Judicial officers of a State, or the members of the Legislature thereof, is denied to any of the male inhabitants of such State, being twenty-one years of age, and citizens of the United States, or in any way abridged, except for participation in rebellion, or other crime, the basis of representation therein shall be reduced in the proportion which the number of such male citizens shall bear to the whole number of male citizens twenty-one years of age in such State.

Section 3. No person shall be a Senator or Representative in Congress, or elector of President and Vice President, or hold any office, civil or military, under the United States, or under any State, who having previously taken an oath, as a member of Congress, or as an officer of the United States, or as a member of any State legislature, or as an executive or judicial officer of any State, to support the Constitution of the United States, shall have engaged in insurrection or rebellion against the same, or given aid or comfort to the enemies thereof. But Congress may by a vote of two-thirds of each House, remove such disability.

Section 4. The validity of the public debt of the United States, authorized by law, including debts incurred for payment of pensions and bounties for services in suppressing insurrection or rebellion, shall not be questioned. But neither the United States nor any State shall assume or pay any debt or obligation incurred in aid of insurrection or rebellion against the United States, or any claim for the loss or emancipation of any slave; but all such debts, obligations and claims shall be held illegal and void.

Section 5. The Congress shall have power to enforce, by appropriate legislation, the provisions of this article.

Amendment XV [1870]

Section 1. The right of citizens of the United States to vote shall not be denied or abridged by the United States or by any State on account of race, color, or previous condition of servitude.

Section 2. The Congress shall have power to enforce this article by appropriate legislation.

Amendment XVI [1913]

The Congress shall have power to lay and collect taxes on incomes, from whatever source derived, without apportionment among the several States, and without regard to any census or enumeration.

Amendment XVII [1914]

[1] The Senate of the United States shall be composed of two Senators from each State, elected by the people thereof, for six years; and each Senator shall have one vote. The electors in each State shall have the qualifications requisite for electors of the most numerous branch of the State legislatures.

[2] When vacancies happen in the representation of any State in the Senate, the executive authority of such State shall issue writs of election to fill such vacancies: *Provided,* That the legislature of any State may empower the executive thereof to make temporary appointments until the people fill the vacancies by election as the legislature may direct.

[3] This amendment shall not be so construed as to affect the election or term of any Senator chosen before it becomes valid as part of the Constitution.

Amendment XVIII [1919]

Section 1. After one year from the ratification of this article the manufacture, sale, or transportation of intoxicating liquors within, the importation thereof into, or the exportation thereof from the United States and all territory subject to the jurisdiction thereof for beverage purposes is hereby prohibited.

Section 2. The Congress and the several States shall have concurrent power to enforce this article by appropriate legislation.

Section 3. This article shall be inoperative unless it shall have been ratified as an amendment to the Constitution by the legislatures of the several States, as provided in the Constitution, within seven years from the date of the submission hereof to the States by the Congress.

Amendment XIX [1920]

[1] The right of citizens of the United States to vote shall not be denied or abridged by the United States or by any State on account of sex.

[2] Congress shall have power to enforce this article by appropriate legislation.

Amendment XX [1933]

Section 1. The terms of the President and Vice President shall end at noon on the 20th day of January, and the terms of Senators and Representatives at noon on the 3d day of January, of the years in which such terms would have ended if this article had not been ratified; and the terms of their successors shall then begin.

Section 2. The Congress shall assemble at least once in every year, and such meeting shall begin at noon on the 3d day of January, unless they shall by law appoint a different day.

Section 3. If, at the time fixed for the beginning of the term of the President, the President elect shall have died, the Vice President elect shall become President. If the President shall not have been chosen before the time fixed for the beginning of his term, or if the President elect shall have failed to qualify, then the Vice President elect shall act as President until a President shall have qualified; and the Congress may by law provide for the case wherein neither a President elect nor a Vice President elect shall have qualified, declaring who shall then act as President, or the manner in which one who is to act shall be selected, and such person shall act accordingly until a President or Vice President shall have qualified.

Section 4. The Congress may by law provide for the case of the death of any of the persons from whom the House of Representatives may choose a President whenever the right of choice shall have devolved upon them, and for the case of the death of any of the persons from whom the Senate may choose a Vice President whenever the right of choice shall have devolved upon them.

Section 5. Sections 1 and 2 shall take effect on the 15th day of October following the ratification of this article.

Section 6. This article shall be inoperative unless it shall have been ratified as an amendment to the Constitu-

tion by the legislatures of three-fourths of the several States within seven years from the date of its submission.

Amendment XXI [1933]

Section 1. The eighteenth article of amendment to the Constitution of the United States is hereby repealed.

Section 2. The transportation or importation into any State, Territory, or possession of the United States for delivery or use therein of intoxicating liquors, in violation of the laws thereof, is hereby prohibited.

Section 3. This article shall be inoperative unless it shall have been ratified as an amendment to the Constitution by conventions in the several States, as provided in the Constitution, within seven years from the date of the submission hereof to the States by the Congress.

Amendment XXII [1951]

Section 1. No person shall be elected to the office of the President more than twice, and no person who has held the office of President, or acted as President, for more than two years of a term to which some other person was elected President shall be elected to the office of President more than once. But this Article shall not apply to any person holding the office of President when this Article was proposed by the Congress, and shall not prevent any person who may be holding the office of President, or acting as President, during the term within which this Article becomes operative from holding the office of President or acting as President during the remainder of such term.

Section 2. This article shall be inoperative unless it shall have been ratified as an amendment to the Constitution by the legislatures of three-fourths of the several States within seven years from the date of its submission to the States by the Congress.

Amendment XXIII [1961]

Section 1. The District constituting the seat of Government of the United States shall appoint in such manner as the Congress may direct:

A number of electors of President and Vice President equal to the whole number of Senators and Representatives in Congress to which the District would be entitled if it were a State, but in no event more than the least populous state; they shall be in addition to those appointed by the states, but they shall be considered, for the purposes of the election of President and Vice President, to be electors appointed by a state; and they shall meet in the District and perform such duties as provided by the twelfth article of amendment.

Section 2. The Congress shall have power to enforce this article by appropriate legislation.

Amendment XXIV [1964]

Section 1. The right of citizens of the United States to vote in any primary or other election for President or Vice President, for electors for President or Vice President, or for Senator or Representative in Congress, shall not be denied or abridged by the United States or any State by reason of failure to pay any poll tax or other tax.

Section 2. The Congress shall have power to enforce this article by appropriate legislation.

Amendment XXV [1967]

Section 1. In case of the removal of the President from office or of his death or resignation, the Vice President shall become President.

Section 2. Whenever there is a vacancy in the office of the Vice President, the President shall nominate a Vice President who shall take office upon confirmation by a majority vote of both Houses of Congress.

Section 3. Whenever the President transmits to the President pro tempore of the Senate and the Speaker of the House of Representatives his written declaration that he is unable to discharge the powers and duties of his office, and until he transmits to them a written declaration to the contrary, such powers and duties shall be discharged by the Vice President as Acting President.

Section 4. Whenever the Vice President and a majority of either the principal officers of the executive departments or of such other body as Congress may by law provide, transmit to the President pro tempore of the Senate and the Speaker of the House of Representatives their written declaration that the President is unable to discharge the powers and duties of his office, the Vice President shall immediately assume the powers and duties of the office as Acting President.

Thereafter, when the President transmits to the President pro tempore of the Senate and the Speaker of the House of Representatives his written declaration that no inability exists, he shall resume the powers and duties of his office unless the Vice President and a majority of either the principal officers of the executive department or of such other body as Congress may by law provide, transmit within four days to the President pro tempore of the Senate and the Speaker of the House of Representatives their written declaration that the President is unable to discharge the powers and duties of his office. Thereupon Congress shall decide the issue, assembling within forty-eight hours for that purpose if not in session. If the Congress, within twenty-one days after receipt of the latter written declaration, or, if Congress is not in session, within twenty-one days after Congress is required to assemble, determines by two-thirds vote of both Houses that the President is unable to discharge the powers and duties of his office, the Vice President shall continue to discharge the same as Acting President; otherwise, the President shall resume the powers and duties of his office.

Amendment XXVI [1971]

Section 1. The right of citizens of the United States, who are eighteen years of age or older, to vote shall not be denied or abridged by the United States or by any State on account of age.

Section 2. The Congress shall have power to enforce this article by appropriate legislation.

Record of Margaret Brent's Request for Suffrage, 1647

Came Mistress Margarett Brent and requested to have vote in the house for her self, and voice also for that [because] at the last Court 3rd Jan. it was ordered that the said Mistress Brent was to be looked upon and received as his Lordship's Attorney. The Governor denied that the said Mistress Brent should have any vote in the house. And the said Mistress Brent protested against all proceedings in this present Assembly, unless she may be present and vote as aforesaid.

. . .

To Lord Baltimore] Great and many have been the miseries, calamities and other Sufferings which your Poor distressed People, Inhabitants of this Province have sustained and undergone here since the beginning of that Heinous Rebellion . . . for two years continued . . . during all which time your Honour cannot be ignorant what pains and travail your Friends underwent in aiding your dear Brother for the subduing of those Rebels and after again in conserving the Province for your Lordship. . . . As for Mistress Brent's undertaking and meddling with your Lordship's Estate here (whether she procured it with her own and others importunity or no) we do Verily Believe and in Conscience report that it was better for the Colony's safety at that time in her hands than in any man's else in the whole Province after your brother's death. [F]or the Soldiers would never have treated any other with that Civility and respect and, though they were even ready at several times to run into mutiny, yet she still pacified them, till at the last things were brought to that strait that she must be admitted and declared your Lordship's Attorney by an order of Court . . . or else all must go to ruin Again, and then the second mischief had been doubtless far greater than the former. . . . We conceive from that time she rather deserved favour and thanks from your Honour for her so much Concurring to the public safety, than to be justly liable to all those bitter invectives you have been pleased to Express against her.

An Act Concerning the Dowry of Widows, Connecticut, 1672

That there may be suitable provision made for the maintenance and comfortable support of widows, after the decease of their husbands, Be it enacted . . . that every married woman, living with her husband in this state, or absent elsewhere from him with his consent, or through his mere default, or by inevitable providence; or in case of divorce where she is the innocent party, that shall not before marriage be estated by way of jointure in some houses, lands, tenements or hereditaments for term of life . . . shall immediately upon, and after the death of her husband, have right, title and interest by way of dower, in and unto one third part of the real estate of her said deceased husband, in houses and lands which he stood possessed of in his own right, at the time of his decease, to be to her during her natural life: the remainder of the estate shall be disposed of according to the will of the deceased. . . .

And for the more easy, and speedy ascertaining such rights of dower, It is further enacted, That upon the death of any man possessed of any real estate . . . which his widow . . . hath a right of dower in, if the person, or persons that by law have a right to inherit said estate, do not within sixty days next after the death of such husband, by three sufficient freeholders of the same county; to be appointed by the judge of probate . . . and sworn for that purpose, set out, and ascertain such right of dower, that then such widow may make her complaint to the judge of probate . . . which judge shall decree, and order that such woman's dowry shall be set out, and ascertained by three sufficient freeholders of the county . . . and upon approbation thereof by said judge, such dower shall remain fixed and certain. . . .

And every widow so endowed . . . shall maintain all such houses, buildings, fences, and inclosures as shall be assigned, and set out to her for her dowry; and shall leave the same in good and sufficient repair.

Blackstone's Commentaries, 1765

By marriage, the husband and wife are one person in law: that is, the very being or legal existence of the woman is suspended during the marriage, or at least is incorporated and consolidated into that of the husband; under whose wing, protection, and *cover*, she performs every thing; and is therefore called in our law-French a *feme-covert, foemina viro co-operta;* is said to be *covert-baron,* or under the protection and influence of her husband, her *baron,* or lord; and her condition during her marriage is called her *coverture.* Upon this principle, of a union of person in husband and wife, depend almost all the legal rights, duties, and disabilities, that either of them acquire by the marriage. I speak not at present of the rights of property, but of such as are merely *personal*. For this reason, a man cannot grant anything to his wife, or enter into covenant with her: for the grant would be to suppose her separate existence; and to covenant with her, would be only to covenant with himself: and therefore it is also generally true, that all compacts made between husband and wife, when single, are voided by the intermarriage. A woman indeed may be attorney for her husband; for that implies no separation from, but is rather a representation of, her lord. And a husband may also bequeath any thing to his wife by will; for that cannot take effect till the coverture is determined by his death. The husband is bound to provide his wife with necessaries by law, as much as himself; and, if she contracts debts for them, he is obliged to pay them; but for anything besides necessaries he is not chargeable. Also if a wife elopes, and lives with another man, the husband is not chargeable even for necessaries; at least if the person who furnishes them is sufficiently apprized of her elopement. If the wife be indebted before marriage, the husband is bound afterwards to pay the debt; for he has adopted her and her circumstances together. If the wife be injured in her person or her property, she can bring no action for redress without her husband's concurrence, and in his name, as well as her own; neither can she be sued without making the husband a defendant. There is indeed one case where the wife shall sue and be sued as a feme sole, viz. where the husband has abjured the realm, or is banished, for then he is dead in law; and the husband being thus disabled to sue for or defend the wife, it would be most unreasonable if she had no remedy, or could make no defence at all. In criminal prosecutions, it is true, the wife may be indicted and punished separately; for the union is only a civil union. But in trials of any sort they are not allowed to be evidence for, or against, each other: partly because it is impossible their testimony should be indifferent, but principally because of the union of person. . . .

But though our law in general considers man and wife as one person, yet there are some instances in which she is separately considered; as inferior to him and acting by his compulsion. And therefore all deeds executed, and acts done, by her, during her coverture, are void; except it be a fine, or the like manner of record, in which case she must be solely and secretly examined, to learn if her act be voluntary. She cannot by will devise lands to her husband, unless under special circumstances; for at the time of making it she is supposed to be under his coercion. And in some felonies, and other inferior crimes, committed by her, through constraint of her husband, the law excuses her: but this extends not to treason or murder.

The husband also, by the old law, might give his wife moderate correction. For, as he is to answer for her misbehaviour, the law thought it reasonable to intrust him with this power of restraining her, by domestic chastisement, in the same moderation that a man is allowed to correct his apprentices or children; for whom the master or parent is also liable in some cases to answer. But this power of correction was confined within reasonable bounds, and the husband was prohibited from using any violence to his wife. . . . But with us, in the politer reign of Charles the second, this power of correction began to be doubted; and a wife may now have security of the peace against her husband; or, in return, a husband against his wife. Yet the lower rank of people, who were always fond of the old common law, still claim and exert their ancient privilege: and the courts of law will still permit a husband to restrain a wife of her liberty, in case of any gross misbehaviour.

These are the chief legal effects of marriage during the coverture; upon which we may observe, that even the disabilities which the wife lies under are for the most part intended for her protection and benefit: so great a favourite is the female sex of the laws of England.

Edenton Resolution, 1774

Edenton, North Carolina, October 25, 1774

The provincial deputies of North Carolina, having resolved not to drink any more tea, nor wear any more British cloth, etc., many ladies of this province have determined to give a memorable proof of their patriotism, and have accordingly entered into the following honorable and spirited association. . . .

"As we cannot be indifferent on any occasion that appears nearly to affect the peace and happiness of our country, and as it has been thought necessary, for the public good, to enter into several particular resolves by a meeting of members deputed from the whole province, it is a duty which we owe, not only to our near and dear connections, who have concurred in them, but to ourselves, who are essentially interested in their welfare, to do everything, as far as lies in our power, to testify our sincere adherence to the same; and we do therefore accordingly subscribe this paper as a witness of our fixed intention and solemn determination to do so: (51 signatures).

Ladies Association of Philadelphia, Broadside, 1780

. . . Our ambition is kindled by the fame of those heroines of antiquity, who have rendered their sex illustrious, and have proved to the universe, that, if the weakness of our Constitution, if opinion and manners did not forbid us to match to glory by the same paths as the Men, we should at least equal, and sometimes surpass them in our love for the public good. I glory in all that which my sex has done great and commendable. I call to mind with enthusiasm and with admiration, all those acts of courage, of constancy and patriotism, which history has transmitted to us: The people favoured by Heaven, preserved from destruction by the virtues, the zeal and the resolution of Deborah, of Judith, of Esther! The fortitude of the mother of the Macchabees, in giving up her sons to die before her eyes: Rome saved from the fury of a victorious enemy by the efforts of Volumnia, and other Roman Ladies: So many famous sieges where the Women have been seen forgetting the weakness of their sex, building new walls, digging trenches with their feeble hands, furnishing arms to their defenders, they themselves darting the missile weapons on the enemy, resigning the ornaments of their apparel, and their fortune, to fill the public treasury, and to hasten the deliverance of their country; burying themselves under its ruins, throwing themselves into the flames rather than submit to the disgrace of humiliation before a proud enemy.

Born for liberty, disdaining to bear the irons of a tyrannic Government, we associate ourselves to the grandeur of those Sovereigns, cherished and revered, who have held with so much splendour the scepter of the greatest States, The Batildas, the Elizabeths, the Maries, the Catharines, who have extended the empire of liberty, and contented to reign by sweetness and justice, have broken the chains of slavery, forged by tyrants in times of ignorance and barbarity. . . .

. . . We are at least certain, that he cannot be a good citizen who will not applaud our efforts for the relief of the armies which defend our lives, our possessions, our liberty? The situation of our soldiery has been represented to me; the evils inseparable from war, and the firm and generous spirit which has enabled them to support these. But it has been said, that they may apprehend, that, in the course of a long war, the view of their distresses may be lost, and their services be forgotten. Forgotten! never; I can answer in the name of all my sex. Brave Americans, your disinterestedness, your courage, and your constancy will always be dear to America, as long as she shall preserve her virtue.

We know that at a distance from the theatre of war, if we enjoy any tranquility it is the fruit of your watchings, your labours, your dangers. If I live happy in the midst of my family; if my husband cultivates his field, and reaps his harvest in peace; if surrounded with my children, I myself nourish the youngest, and press it to my bosom, without being affraid of seeing myself separated from it, by a ferocious enemy; if the house in which we dwell; if our barns, our orchards are safe at the present time from the hands of those incendiaries, it is to you that we owe it. And shall we hesitate to evidence to you our gratitude? Shall we hesitate

to wear a cloathing more simple; hair dressed less elegant, while at the price of this small privation, we shall deserve your benedictions. Who, amongst us, will not renounce with the highest pleasure, those vain ornaments, when she shall consider that the valiant defenders of American will be able to draw some advantage from the money which she may have laid out in these. . . .The time is arrived to display the same sentiments which animated us at the beginning of the Revolution, when we renounced the use of teas, however agreeable to our taste, rather than receive them from our persecutors; when we made it appear to them that we placed former necessaries in the rank of superfluities, when our liberty was interested; when our republican and laborious hands spun the flax, prepared the linen intended for the use of our soldiers; when [as] exiles and fugitives we supported with courage all the evils which are the concomitants of war. Let us not lose a moment; let us be engaged to offer the homage of our gratitude at the altar of military valour, and you, our brave deliverers, while mercenary slaves combat to cause you to share with them, the irons with which they are loaded, receive with a free hand our offering, the purest which can be presented to your virtue, By AN AMERICAN WOMAN.

Objections of a "Friend of the Ladies" to Women's Suffrage in New Jersey, 1802

For the True American:

Among the striking scenes which our election presents to the disinterested observer, none is more amusing than the sight of whole wagon loads of those "privileged fair", who for the lucky circumstance of being possessed of 50 pounds, and of being disengaged at the age of 21, are entitled to vote.

What a blissful week has the preceding one been for them! How respectfully attentive each young Federalist and Republican has been to the fair elector! How ready to offer them his horses, his carriages, to drag them in triumph to the election ground! Oh sweet week! Why do you not last the whole year round!

However pleasing these reflections may be to the Ladies it must be owned that the inconvenience attending the practice far outweighs the benefits derived from it. We may well be allowed to answer, without being accused of detraction, that those votes are rarely, if ever unbiased. Timid and pliant, unskilled in politics, unacquainted with all the real merits of the several candidates, and almost always placed under the dependence or care of a father, uncle or brother &c, they will of course be directed or persuaded by them. And the man who brings his two daughters, his mother and his aunt to the elections, really gives five votes instead of one. How will an obedient daughter dare to vote against the sentiments of her father and how can a fair one refuse her lover, who on his knees beseeches her by her beauty, by his passion, to give her vote to Lambert or Anderson!

When our Legislature passed the act by which the females are entitled to share in our elections they were not aware of its inconveniences, and acted from a principle of justice, deeming it right that every free person who pays a tax should have a vote. But from the moment when party spirit began to rear its hideous head the female vote became its passive tools, and the ill consequences of their admission have increased yearly. This year their number arose to an alarming height; in some townships I am told they made up almost one fourth of the total number of votes, and we cannot blame the apprehensions of an old farmer who feared that the next election would be entirely left to the ladies.

This defect in our Constitution certainly deserves the notice of our Government, and if not attended to may in a few years cause the most fatal confusion; for until it is amended, each party will of course muster all its female champions, from an apprehension that its antagonists will do the same.

Let not our fair conclude that I wish to see them deprived of their rights. Let them rather consider that female reserve and delicacy are incompatible with the duties of a free elector, that a female politician is often subject of ridicule and they will recognize in the writer of this a sincere

Friend to the Ladies.
Dated Oct. 18, 1802.

From *The Married Lady's Companion, or Poor Man's Friend*, by Samuel K. Jennings, 1808

1. As it is your great wish and interest, to enjoy much of your husband's company and conversation, it will be important to acquaint yourself with his temper, his inclination, and his manner, that you may render your house, your person, and your disposition quite agreeable to him. By observing with accuracy, and guarding your words and actions with prudence, you may quickly succeed according to your wishes.

2. Here perhaps you ask, why so much pains necessary on my part? I will answer your question candidly. Your choice in forming the connexion, was at best a passive one. Could you have acted the part of a courtier and made choice of a man whose disposition might have corresponded precisely with yours, there would have been less to do afterwards. But under present circumstances, it is your interest to adapt yourself to your husband, whatever may be his peculiarities. Again, nature has made man the stronger, the consent of mankind has given him supe-

riority over his wife, his inclination is, to claim his natural and acquired rights. He of course expects from you a degree of condescension, and he feels himself the more confident of the propriety of his claim, when he is informed, that St. Paul adds his authority to its support. "Wives submit yourselves unto your own husbands, as unto the Lord, for the husband is the head of his wife."

3. In obedience then to this precept of the gospel, to the laws of custom and of nature, you ought to cultivate a cheerful and happy submission. "The way of virtue is the way of happiness." The truth of this maxim will be verified to you in your conformity to this duty. By such submission, you will secure to yourself the advantages of a willing obedience on the part of your husband to the counter part of Paul's command, "Husbands love your wives as your own flesh," &c.

4. The great attention and submission practised by most men in time of courtship are well calculated to raise in the female mind, false expectation of an uniform continuance of the same officiousness after marriage. For the honey moon you may not be disappointed. But the charge of a family will soon teach any man, that he has something more to do than live a life of courtship. The discharge of his duty as a father, a friend, and a citizen, will gradually divert him in some degree from that punctilious attention to your person, with which you are so highly pleased.

5. Should you begin to discover this change, be careful to conduct yourself with discretion. By no means upbraid him, nor suffer jealousy to take possession of your breast. If you once admit this passion, it may terminate in your ruin. It will lead you to consider every seeming inattention, as a proof of his want of affection. You will conclude, *he is tired of his toy and is looking out for another.* This thought, once admitted, will have an infatuating influence over your mind. Not only your actions will express your suspicion, but you will unguardedly speak it out, perhaps in terms of reproach.—Your good husband, stabbed to the very heart, may possibly with eyes full of tears clasp you in his arms and assure you of his love. But all will be vain, jealousy once admitted contaminates the soul. He will scarcely turn his back, before the old impression will revive.

His tears and entreaties will be considered as evidence of his guilt, and you will wretchedly settle upon this conclusion. *"I am disagreeable, he is gone to caress the happy fair one whose company is preferred."*

6. As you regard your own bliss, speedily check all thoughts of this kind, as soon as they arise in your mind. If indulged, they will have a baneful effect upon your temper, and spread a gloom over your countenance, so as to strip you of every charm. Your husband, repelled from time to time, will at length become indifferent, and leaving you to languish in your distress, he will seek for amusement where it may be found. And thus you will bring upon yourself the very evil, against which you would make your mistaken defence.

7. If you have already proved the truth of these reflections by sad experience, I know you are ready to excuse yourself, because the whole proceeded from the most sincere affection. But you should consider that the anxiety and distress which are so often depicted in your countenance, might, with equal propriety, lead your companion to doubt the sincerity of your love. And for any thing you know to the contrary, a suspicion of this kind is at the bottom of the whole mischief. Do not act like stubborn children, rejecting that happiness which is entirely in your own power.

8. If he do not come in, the very hour or day that you expect him, instead of accusing him with neglect, be the considerate woman, and take into view the various and unavoidable delays with which he must meet in transacting his business. And be assured, for I speak from experience, that in many instances he sacrifices his most sincere wishes to be with you, for what he considers necessary for the present. He is bound to provide for you and your children. In easy circumstances there is most satisfaction, and he feels a strong desire to secure this foundation for your future happiness. Receive him then with gladness as often as he comes in, shew him that you are happy in his company, and let the preparations made for his reception prove to him that he holds a considerable share in your thoughts and affections when he is absent. Such conduct will endear you to his heart, and secure to you all the attention and regard you so ardently desire.

9. Do not suppose, that my plan implies that the husband has nothing to do. So far from this he is bound "To love and cherish his wife, as his own flesh." But I repeat it, this obligation seems, in a great degree, to rest on the condition of a loving and cheerful submission on the part of the wife. Here again perhaps you object and say, "Why not the husband, first shew a little condescension as well as the wife?" I answer for these plain reasons. It is not his disposition; it is not the custom but with the henpecked; it is not his duty; it is not implied in the marriage contract; it is not required by law or gospel.

10. I presume you are not one of those ladies who indulge a mean opinion of their companions, and are indeed ashamed of them. This can happen in no case where there is not a want of information and judgment. If you stooped in marrying him, do not indulge the thought, that you added to his respectability. Never tell him "you lifted him out of the ashes." For it will be hard for you to extricate yourself from this difficulty. "If you stooped of necessity, because you could get no one else, the obligation is on your own side. If you stooped of choice, who ought to be blamed but yourself? Besides it will be well to remember that when you became his wife,

he became your head, and your supposed superiority was buried in that voluntary act.

There are women in the world, who arrogate to themselves superior skill in the management of an estate, suppose they have great judgment in the value of property, and therefore wrest every thing out of the hands of their husbands, and convert the poor men into perfect cyphers. I hold the disposition and conduct of such women in great contempt, and I pity the *poor inoffensive creature of a man,* who can submit to be so degraded. *Yet it must be acknowledged, that where the man falls into the hands of a termagant,* he may find it *necessary to purchase peace on any terms.*

Men and women appear to best advantage each in their own proper station. Had it been my lot, to have taken one of those *manlike ladies,* whenever there happened to be company at my house, I should have made it my business, to brush the floor, rub the furniture, wash the tea equipage, scold the maids, talk about the kitchen and dairy, &c. and apologize as I proceeded, by giving intimation, that I had made an exchange of provinces with my good wife, by way of mutual accommodation.

Such conduct would at least shew, how awkwardly a man appears in acting the part of a woman, and of course would lead a woman of common sense to conclude, that she could not appear to much better advantage, when engaged in the capacity of a man.

If it were to save appearances only, the husband ought at least to *seem* to be the head. And therefore if you are determined to rule him, adopt the following plan. "When any article of property is to be bought or sold, take him aside, teach him the price to be given or received, point out the kind of payment, the time when to be paid, &c. &c. let the whole business be properly adjusted, and then let the poor fellow go forward and seem to act like a man." It is shocking to every man of sense, to see a woman interfere publicly, fly into a passion, and declare *point blank* the thing shall not be. Indeed if she had the true spirit of a woman, she would blush to acknowledge herself the wife of such a dastardly man as would submit to such treatment.

From "Appeal to the Christian Women of the South," by Angelina Grimké

September 1836

I have thus, I think, clearly proved to you seven propositions, viz.: First, that slavery is contrary to the declaration of our independence. Second, that it is contrary to the first charter of human rights given to Adam, and renewed to Noah. Third, that the fact of slavery having been the subject of prophecy, furnishes *no* excuse whatever to slave dealers. Fourth, that no such system existed under the patriarchal dispensation. Fifth, that *slavery never* existed under the Jewish dispensation; but so far otherwise, that every servant was placed under the *protection of law,* and care taken not only to prevent all *involuntary* servitude, but all *voluntary perpetual* bondage. Sixth, that slavery in America reduces a *man* to a *thing,* a "chattel personal," *robs him of all* his rights as a *human being,* fetters both his mind and body, and protects the *master* in the most unnatural and unreasonable power, whilst it *throws him out* of the protection of law. Seventh, that slavery is contrary to the example and precepts of our holy and merciful Redeemer, and of his apostles.

But perhaps you will be ready to query, why appeal to *women* on this subject? *We* do not make the laws which perpetuate slavery. *No* legislative power is vested in *us; we* can do nothing to overthrow the system, even if we wished to do so. To this I reply, I know you do not make the laws, but I also know that *you are the wives and mothers, the sisters and daughters of those who do;* and if you really suppose *you* can do nothing to overthrow slavery, you are greatly mistaken. You can do much in every way: four things I will name. 1st. You can read on this subject. 2d. You can pray over this subject. 3d. You can speak on this subject. 4th. You can *act* on this subject. I have not placed reading before praying because I regard it more important, but because, in order to pray aright, we must understand what we are praying for; it is only then we can "pray with the understanding and the spirit also."

1. Read then on the subject of slavery. Search the Scriptures daily, whether the things I have told you are true. Other books and papers might be a great help to you in this investigation, but they are not necessary, and it is hardly probable that your Committees of Vigilance will allow you to have the other. The *Bible* then is the book I want you to read in the spirit of inquiry, and the spirit of prayer. Even the enemies of Abolitionists, acknowledged that their doctrines are drawn from it. In the great mob in Boston, last autumn, when the books and papers of the Anti-Slavery Society, were thrown out of the windows of their office, one individual laid hold of the Bible and was about tossing it out to the ground, when another reminded him that it was the Bible he had in his hand. *"O! 'tis all one,"* he replied, and out went the sacred volume, along with the rest. We thank him for the acknowledgment. Yes, *"it is all one,"* for our books and papers are mostly commentaries on the Bible, and the Declaration. Read the *Bible* then, it contains the words of Jesus, and they are spirit and life. Judge for yourself whether *he sanctioned* such a system of oppression and crime.

2. Pray over this subject. When you have entered into your closets, and shut to the doors, then pray to your father, who seeth in secret, that he would open your eyes to see whether slavery is *sinful,* and if it is, that he

would enable you to bear a faithful, open and unshrinking testimony against it, and to do whatsoever your hand find to do, leaving the consequences entirely to him, who still says to us whenever we try to reason away duty from the fear of consequences, *What is that to thee, follow thou me.* Pray also for that poor slave, that he may be kept patient and submissive under his hard lot, until God is pleased to open the door of freedom to him without violence or bloodshed. Pray too for the master that his heart may be softened, and he made willing to acknowledge, as Joseph's brethren did, "Verily we are guilty concerning our brother," before he will be compelled to add in consequence of Divine judgment, "therefore is all this evil come upon us." Pray also for all your brethren and sisters who are laboring in the righteous cause of Emancipation in the Northern States, England and the world. There is great encouragement for prayer in these words of our Lord. "Whatsoever ye shall ask the Father *in my name,* he *will give* it to you"—Pray then without ceasing, in the closet and the social circle.

3. Speak on this subject. It is through the tongue, the pen, and the press, that truth is principally propagated. Speak then to your relatives, your friends, your acquaintances on the subject of slavery; be not afraid if you are conscientiously convinced it is *sinful,* to say so openly, but calmly, and to let your sentiments be known. If you are served by the slaves of others, try to ameliorate their condition as much as possible; never aggravate their faults, and thus add fuel to the fire of anger already kindled, in a master and mistress's bosom, remember their extreme ignorance, and consider them as your Heavenly Father does the *less* culpable on this account, even when they do wrong things. Discountenance *all* cruelty to them, all starvation, all corporal chastisement; these may brutalize and *break* their spirits, but will never bend them to willing, cheerful obedience. If possible, see that they are comfortably and *seasonably* fed, whether in the house or the field; it is unreasonable and cruel to expect slaves to wait for their breakfast until eleven o'clock, when they rise at five or six. Do all you can, to induce their owners to clothe them well, and to allow them many little indulgences which would contribute to their comfort. Above all, try to persuade your husband, father, brothers and sons, that *slavery is a crime against God and man,* and that it is a great sin to keep *human beings* in such abject ignorance; to deny them the privilege of learning to read and write. The Catholics are universally condemned, for denying the Bible to the common people, but, *slaveholders must not* blame them, for *they* are doing the *very same thing,* and for the very same reason, neither of these systems can bear the light which bursts from the pages of that Holy Book. And lastly, endeavour to inculcate submission on the part of the slaves, but whilst doing this be faithful in pleading the cause of the oppressed.

"Will *you* behold unheeding,
 Life's holiest feelings crushed,
Where *woman's* heart is bleeding,
 Shall *woman's* voice be hushed?"

4. Act on this subject. Some of you *own* slaves yourselves. *If* you believe slavery is *sinful,* set them at liberty, "undo the heavy burdens and let the oppresed go free." If they wish to remain with you, pay them wages, if not let them leave you. Should they remain, teach them, and have them taught the common branches of an English education; they have minds and those minds, *ought to be improved.* So precious a talent as intellect, never was given to be wrapt in a napkin and buried in the earth. It is the *duty* of all, as far as they can, to improve their own mental faculties, because we are commanded to love God with *all our minds,* as well as with all our hearts, and we commit a great sin, if we *forbid or prevent* that cultivation of the mind in others, which would enable them to perform this duty. Teach your servants then to read &c, and encourage them to believe it is their *duty* to learn, if it were only that they might read the Bible.

But some of you will say, we can neither free our slaves nor teach them to read, for the laws of our state forbid it. Be not surprised when I say such wicked laws *ought to be no barrier* in the way of your duty, and I appeal to the Bible to prove this position. What was the conduct of Shiphrah and Puah, when the king of Egypt issued his cruel mandate, with regard to the Hebrew children? "*They* feared *God,* and did *not* as the King of Egypt commanded them, but saved the men children alive." Did these *women* do right in disobeying that monarch? "*Therefore* (says the sacred text,) *God dealt well* with them, and made them houses" Ex. i. What was the conduct of Shadrach, Meshach, and Abednego, when Nebuchadnezzar set up a golden image in the plain of Dura, and commanded all people, nations, and languages to fall down and worship it? "Be it known, unto thee, (said these faithful *Jews*) O king, that *we will not* serve thy gods, nor worship the image which thou hast set up." Did these men *do right in disobeying the law* of their sovereign? Let their miraculous deliverance from the burning fiery furnace, answer; Dan. iii. . . .

But some of you may say, if we do free our slaves, they will be taken up and sold, therefore there will be no use in doing it. Peter and John might just as well have said, we will not preach the gospel, for if we do, we shall be taken up and put in prison, therefore there will be no use in our preaching. *Consequences,* my friends, belong no more to *you,* than they did to these apostles. Duty is ours and events are God's. If you think slavery is sinful, all *you* have to do is to set your slaves at liberty, do all you can to protect them, and in humble faith and fervent prayer, commend them to your common Father. He can

take care of them; but if for wise purposes he sees fit to allow them to be sold, this will afford you an opportunity of testifying openly, wherever you go, against the crime of *manstealing*. Such an act will be *clear robbery,* and if exposed, might, under the Divine direction, do the cause of Emancipation more good, than any thing that could happen, for, "He makes even the wrath of man to praise him, and the remainder of wrath he will restrain."

I know that this doctrine of obeying *God,* rather than man, will be considered as dangerous, and heretical by many, but I am not afraid openly to avow it, because it is the doctrine of the Bible; but I would not be understood to advocate resistance to any law however oppressive if, in obeying it, I was not obliged to commit *sin*. If for instance, there was a law, which imposed imprisonment or a fine upon me if I manumitted a slave, I would on no account resist that law, I would set the slave free, and then go to prison or pay the fine. If a law commands me to sin I will break it; if it calls me to *suffer,* I will let it take its course *unresistingly*. The doctrine of blind obedience and unqualified submission to *any human* power, whether civil or ecclesiastical, is the doctrine of despotism, and ought to have no place among Republicans and Christians.

But you will perhaps say, such a course of conduct would inevitably expose us to great suffering. Yes! my christian friends, I believe it would, but this will *not* excuse you or any one else for the neglect of *duty*. If Prophets and Apostles, Martyrs, and Reformers had not been willing to suffer for the truth's sake, where would the world have been now? If they had said, we cannot speak the truth, we cannot do what we believe is right, because the *laws of our country or public opinion are against us,* where would our holy religion have been now? . . .

But you may say we are *women,* how can our hearts endure persecution? And why not? Have not women stood up in all the dignity and strength of moral courage to be the leaders of the people, and to bear a faithful testimony for the truth whenever the providence of God has called them to do so? Are there no *women* in that noble army of martyrs who are now singing the song of Moses and the Lamb? Who led out the women of Israel from the house of bondage, striking the timbrel, and singing the song of deliverance on the banks of that sea whose waters stood up like walls of crystal to open a passage for their escape? It was a *woman:* Miriam, the prophetess, the sister of Moses and Aaron. Who went up with BArak to Kadesh to fight against Jabin, King of Canaan, into whose hand Israel had been sold because of their iniquities? It was a *woman!* Deborah, the wife of Lapidoth, the judge, as well as the prophetess of that backsliding people; Judges iv, 9. Into whose hands was Sisera, the captain of Jabin's host delivered? Into the hands of a *woman*. Jael the wife of Heber! Judges vi, 21. Who dared to *speak the truth* concerning those judgments which were coming

upon Judea, when Josiah, alarmed at finding that his people "had not kept the word of the Lord to do after all that was written in the book of the Law," sent to enquire of the Lord concerning these things? It was a *woman*. Huldah the prophetess, the wife of Shallum; 2, Chron. xxxiv, 22. Who was chosen to deliver the whole Jewish nation from that murderous decree of Persia's King, which wicked Haman had obtained by calumny and fraud? It was a *woman;* Esther the Queen; yes, weak and trembling *woman* was the instrument appointed by God, to reverse the bloody mandate of the eastern monarch, and save the *whole visible church* from destruction. What human voice first proclaimed to Mary that she should be the mother of our Lord? It was a *woman!* Elizabeth, the wife of Zacharias; Luke i, 42, 43. Who united with the good old Simeon in giving thanks publicly in the temple, when the child, Jesus, was presented there by his parents, "and spake of him to all them that looked for redemption in Jerusalem?" It was a *woman!* Anna the prophetess. Who first proclaimed Christ as the true Messiah in the streets of Samaria, once the capital of the ten tribes? It was a *woman!* Who ministered to the Son of God whilst on earth, a despised and persecuted Reformer, in the humble garb of a carpenter? They were *women!* Who followed the rejected King of Israel, as his fainting footsteps trod the road to Calvary? "A great company of people and of *women;*" and it is remarkable that to *them alone,* he turned and addressed the pathetic language, "Daughters of Jerusalem, weep not for me, but weep for yourselves and your children." Ah! who sent unto the Roman Governor when he was set down on the judgment seat, saying unto him, "Have thou nothing to do with that just man, for I have suffered many things this day in a dream because of him?" It was a *woman!* the wife of Pilate. Although "*he knew* that for envy the Jews had delivered Christ," yet *he* consented to surrender the Son of God into the hands of a brutal soldiery, after having himself scourged his naked body. Had the *wife* of Pilate sat upon that judgment seat, what would have been the result of the trial of this "just person?" . . .

And what, I would ask in conclusion, have *women* done for the great and glorious cause of Emancipation? Who wrote that pamphlet which moved the heart of Wilberforce to pray over the wrongs, and his tongue to plead the cause of the oppressed African? It was a *woman,* Elizabeth Heyrick. Who labored assiduously to keep the sufferings of the slave continually before the British public? They were *women*. And how did they do it? By their needles, paint brushes and pens, by speaking the truth, and petitioning Parliament for the abolition of slavery. And what was the effect of their labors? Read it in the Emancipation bill of Great Britain. Read it, in the present state of her West India Colonies. Read it, in the impulse which has been given to the cause of freedom, in the United States of

America. Have English women then done so much for the negro, and shall American women do nothing? Oh no! Already are there sixty female Anti-Slavery Societies in operation. These are doing just what the English women did, telling the story of the colored man's wrongs, praying for his deliverance, and presenting his kneeling image constantly before the public eye on bags and needle-books, card-racks, pen-wipers, pin-cushions, &c. Even the children of the north are inscribing on their handy work, "May the points of our needles prick the slaveholder's conscience." Some of the reports of these Societies exhibit not only considerable talent, but a deep sense of religious duty, and a determination to persevere through evil as well as good report, until every scourge, and every shackle, is buried under the feet of the manumitted slave.

The Ladies' Anti-Slavery Society of Boston was called last fall, to a severe trial of their faith and constancy. They were mobbed by "the gentlemen of property and standing," in that city at their anniversary meeting, and their lives were jeoparded by an infuriated crowd; but their conduct on that occasion did credit to our sex, and affords a full assurance that they will *never* abandon the cause of the slave. The pamphlet, Right and Wrong in Boston, issued by them in which a particular account is given of that "mob of broad cloth in broad day," does equal credit to the head and the heart of her who wrote it. I wish my Southern sisters could read it; they would then understand that the women of the North have engaged in this work from a sense of *religious duty,* and that nothing will ever induce them to take their hands from it until it is fully accomplished. They feel no hostility to you, no bitterness nor wrath; they rather sympathize in your trials and difficulties; but they well know that the first thing to be done to help you, is to pour in the light of truth on your minds, to urge you to reflection, and pray over the subject. This is all *they* can do for you, *you* must work out your own deliverance with fear and trembling, and with the direction and blessing of God, *you can do it.* Northern women may labor to produce a correct public opinion as the North, but if Southern women sit down in listless indifference and criminal idleness, public opinion cannot be rectified and purified at the South. It is manifest to every reflecting mind, that slavery must be abolished; the era in which we live, and the light which is overspreading the whole world on this subject, clearly show that the time cannot be distant when it will be done. Now there are only two ways in which it can be effected, by moral power or physical force, and it is for *you* to choose which of these you prefer. Slavery always has, and always will produce insurrections wherever it exists, because it is a violation of the natural order of things, and no human power can much longer perpetuate it . . .

The *women of the South can overthrow* this horrible system of oppression and cruelty, licentiousness and wrong. Such appeals to your legislatures would be irresistible, for there is something in the heart of man which *will bend under moral suasion.* There is a swift witness for truth in his bosom, which *will respond to truth* when it is uttered with calmness and dignity. If you could obtain but six signatures to such a petition in only one state, I would say send up that petition, and be not in the least discouraged by the scoffs and jeers of the heartless, or the resolution of the house to lay it on the table. It will be a great thing if the subject can be introduced into your legislatures in any way, even by *women,* and *they* will be the most likely to introduce it there in the best possible manner, as a matter of *morals* and *religion,* not of expediency or politics. You may petition, too, the different ecclesiastical bodies of the slave states. Slavery must be attacked with the whole power of truth and the sword of the spirit. You must take it up on *Christian* ground, and fight against it with Christian weapons, whilst your feet are shod with the preparation of the gospel of peace. And *you are now* loudly called upon by the cries of the widow and the orphan, to arise and gird yourselves for this great moral conflict, with the whole armour of righteousness upon the right hand and on the left.

From a Pastoral Letter of "The General Association of Massachusetts (Orthodox) to the Churches Under Their Care"

1837

III. We invite your attention to the dangers which at present seem to threaten the female character with widespread and permanent injury.

The appropriate duties and influence of woman are clearly stated in the New Testament. Those duties and that influence are unobtrusive and private, but the source of mighty power. When the mild, dependent, softening influence of woman upon the sternness of man's opinions is fully exercised, society feels the effects of it in a thousand forms. The power of woman is her dependence, flowing from the consciousness of that weakness which God has given her for her protection, (!) and which keeps her in those departments of life that form the character of individuals, and of the nation. There are social influences which females use in promoting piety and the great objects of Christian benevolence which we can not too highly commend.

We appreciate the unostentatious prayers and efforts of woman in advancing the cause of religion at home and abroad; in Sabbath-schools; in leading religious inquirers to the pastors (!) for instruction; and in all such associated effort as becomes the modesty of her sex: and earnestly hope that she may abound more and more in these labors of piety and love. But when she assumes the place and tone

of man as a public reformer, our care and protection of her seem unnecessary; we put ourselves in self-defence (!) against her; she yields the power which God has given her for her protection, and her character becomes unnatural. If the vine, whose strength and beauty is to lean upon the trellis-work, and half conceal its clusters, thinks to assume the independence and the overshadowing nature of the elm, it will not only cease to bear fruit, but fall in shame and dishonor into the dust. We can not, therefore, but regret the mistaken conduct of those who encourage females to bear an obtrusive and ostentatious part in measures of reform, and countenance any of that sex who so far forget themselves as to itinerate in the character of public lecturers and teachers. We especially deplore the intimate acquaintance and promiscuous conversation of females with regard to things which ought not to be named; by which that modesty and delicacy which is the charm of domestic life, and which constitutes the true influence of woman in society, is consumed, and the way opened, as we apprehend, for degeneracy and ruin.

We say these things not to discourage proper influences against sin, but to secure such reformation (!) as we believe is Scriptural, and will be permanent.

Commonwealth of Massachusetts Report, House of Representatives, March 12, 1845, Concerning Request for Ten-Hour Workday Legislation

March 12, 1845

The Special Committee to which was referred sundry petitions relating to the hours of labor, have considered the same and submit the following

REPORT

The first petition which was referred to your committee, came from the city of Lowell and was signed by Mr. John Quincy Adams Thayer, and eight hundred and fifty others, "peaceable, industrious, hard working men and women of Lowell." The petitioners declare that they are confined to "from thirteen to fourteen hours per day in unhealthy apartments," and are thereby "hastening through pain, disease and privation, down to a premature grave." They therefore ask the Legislature "to pass a law providing that ten hours shall constitute a day's work," and that no corporation or private citizen "shall be allowed, except in cases of emergency, to employ one set of hands more than ten hours per day."

The second petition came from the town of Fall River, and is signed by John Gregory and four hundred and eighty-eight others. These petitions ask for the passage of a law to constitute "ten hours a day's work in *all corporations* created by the Legislature."

The third petition signed by Samuel W. Clark and five hundred others, citizens of Andover, is in precisely the same words as the one from Fall River.

The fourth petition is from Lowell, and is signed by James Carle and three hundred others. The petitioners ask for the enactment of a law making ten hours a day's work, where no specific agreement is entered into between the parties.

The whole number of names on the several petitions is 2,139, of which 1,152 are from Lowell. A very large proportion of the Lowell petitioners are females. Nearly one half of the Andover petitioners are females. The petition from Fall River is signed exclusively by males.

In view of the number and respectability of the petitioners who had brought their grievances before the Legislature, the Committee asked for and obtained leave of the House to send for "persons and papers," in order that they might enter into an examination of the Legislature as a basis for legislative action, should any be deemed necessary.

On the 13th of February, the Committee held a session to hear the petitioners from the city of Lowell. Six of the female and three of the male petitioners were present, and gave in their testimony.

The first petitioner who testified was *Eliza R. Hemmingway.* She had worked 2 years and 9 months in the Lowell Factories; 2 years in the Middlesex, and 9 months in the Hamilton Corporations. Her employment is weaving,—works by the piece. The Hamilton Mill manufactures cotton fabrics. The Middlesex, woollen fabrics. She is now at work in the Middlesex Mills, and attends one loom. Her wages average from $16 to $23 a month exclusive of board. She complained of the hours for labor being too many, and the time for meals too limited. In the summer season, the work is commenced at 5 o'clock, A.M., and continued till 7 o'clock, P.M., with half an hour for breakfast and three quarters of an hour for dinner. During eight months of the year, but half an hour is allowed for dinner. The air in the room she considered not to be wholesome. There were 293 small lamps and 61 large lamps lighted in the room in which she worked when evening work is required. These lamps are also lighted sometimes in the morning.—About 130 females, 11 men, and 12 children (between the ages of 11 and 14,) work in the room with her. She thought the children enjoyed about as good health as children generally do. The children work but 9 months out of 12. The other 3 months they must attend school. Thinks that there is no day when there are less than six of the females out of the mill from sickness. Has known as many as thirty. She, herself, is out quite often, on account of sickness. There was more sickness in the Summer than in Winter months; though in the Summer, lamps are not lighted. She thought there was a general desire among the females to

work but ten hours, regardless of the pay. Most of the girls are from the country, who work in the Lowell Mills. The average time which they remain there is about three years. She knew one girl who had worked there 14 years. Her health was poor when she left. Miss Hemmingway said her health was better where she now worked, than it was when she worked on the Hamilton Corporation.

She knew of one girl who last winter went into the mill at half past 4 o'clock, A.M. and worked till half past 7 o'clock P.M. She did so to make more money. She earned from $25 to $30 per month. There is always a large number of girls at the gate wishing to get in before the bell rings. On the Middlesex Corporation one fourth part of the females go onto the mill before they are obliged to. They do this to make more wages. A large number come to Lowell to make money to aid their parents who are poor. She knew of many cases where married women came to Lowell and worked in the mills to assist their husbands to pay for their farms. The moral character of the operatives is good. There was only one American female in the room with her who could not write her name.

Miss Sarah G. Bagley said she had worked in the Lowell Mills eight years and a half,—six years and a half on the Hamilton Corporation, and two years on the Middlesex. She is a weaver, and works by the piece. She worked in the mills three years before her health began to fail. She is a native of New Hampshire, and went home six weeks during the summer. Last year she was out of the mill a third of the time. She thinks the health of the operatives is not so good as the health of females who do house-work or millinery business. The chief evil, so far as health is concerned, is the shortness of time allowed for meals. The next evil is the length of time employed—not giving them time to cultivate their minds. She spoke of the high moral and intellectual character of the girls. That many were engaged as teachers in the Sunday schools. That many attended the lectures of the Lowell Institute; and she thought, if more time was allowed, that more lectures would be given and more girls attend. She thought that the girls generally were favorable to the ten hour system. She had presented a petition, same as the one before the Committee, to 132 girls, most of whom said that they would prefer to work but ten hours. In a pecuniary point of view, it would be better, as their health would be improved. They would have more time for sewing. Their intellectual, moral and religious habits would also be benefited by the change.

Miss Bagley said, in addition to her labor in the mills, she had kept evening school during the winter months, for four years, and thought that this extra labor must have injured her health.

Miss Judith Payne testified that she came to Lowell 16 years ago, and worked a year and a half in the Merrimack Cotton Mills, left there on account of ill health, and remained out over seven years. She was sick most of the time she was out. Seven years ago she went to work in the Boott Mills, and has remained there ever since; works by the pieces. She has lost, during the last seven years, about one year from ill health. She is a weaver, and attends three looms. Last pay-day she drew $14.66 for five weeks work; this was exclusive of board. She was absent during the five weeks but half a day. She says there is a very general feeling in favor of the ten hour system among the operatives. She attributes her ill health to the long hours of labor, the shortness of time for meals, and the bad air of the mills. She had never spoken to Mr. French, the agent, or to the overseer of her room, in relation to these matters. She could not say that more operatives died in Lowell than other people.

Miss Olive J. Clark.—She is employed on the Lawrence Corporation; has been there five years; makes about $1.62 $1/_2$ per week, exclusive of board. She has been home to New Hampshire to school. Her health never was good. The work is not laborious; can sit down about a quarter of the time. About fifty girls work in the spinning-room with her, three of whom signed the petition. She is in favor of the ten hour system, and thinks that the long hours had an effect upon her health. She is kindly treated by her employers. There is hardly a week in which there is not some one out on account of sickness. Thinks the air is bad, on account of the small particles of cotton which fly about. She has never spoken with the agent or overseer about working only ten hours.

Miss Celicia Phillips has worked four years in Lowell. Her testimony was similar to that given by Miss Clark.

Miss Elizabeth Rowe has worked in Lowell 16 months, all the time on the Lawrence Corporation, came from Maine, she is a weaver, works by the piece, runs four looms. "My health," she says, "has been very good indeed since I worked there, averaged three dollars a week since I have been there besides my board; have heard very little about the hours of labor being too long." She consented to have her name put on the petition because Miss Phillips asked her to. She would prefer to work only ten hours. Between 50 and 60 work in the room with her. Her room is better ventilated and more healthy than most others. Girls who wish to attend lectures can go out before the bell rings; my overseer lets them go, also Saturdays they go out before the bell rings. It was her wish to attend 4 looms. She has a sister who has worked in the mill 7 years. Her health is very good. Don't known that she has ever been out on account of sickness. The general health of the operatives is good. Have never spoken to my employers about the work being too hard, or the hours too long. Don't know any one who has been hastened to a premature grave by factory labor. I never attended any of the lectures in Lowell on the ten hour system. Nearly all the female operatives

in Lowell work by the piece; and of the petitioners who appeared before the Committee, Miss Hemmingway, Miss Bagby, Miss Payne and Miss Rowe work by the piece, and Miss Clark and Miss Phillips by the week.

Mr. Gilman Gale, a member of the city council, and who keeps a provision store, testified that the short time allowed for meals he thought the greatest evil. He spoke highly of the character of the operatives and of the agents; also of the boarding houses and the public schools. He had two children in the mills who enjoyed good health. The mills are kept as clean and as well ventilated as it is possible for them to be.

Mr. Herman Abbott had worked in the Lawrence Corporation 13 years. Never heard much complaint among the girls about the long hours, never heard the subject spoken of in the mills. Does not think it would be satisfactory to the girls to work only ten hours, if their wages were to be reduced in proportion. Forty-two girls work in the room with him. The girls often get back to the gate before the bell rings.

Mr. John Quincy Adams Thayer, has lived in Lowell 4 years, "works at physical labor in the summer season, and mental labor in the winter." Has worked in the big machine shop 24 months, off and on; never worked in a cotton or woollen mill. Thinks that the mechanics in the machine shop are not so healthy as in other shops; nor so intelligent as the other classes in Lowell. He drafted the petition. Has heard many complain of the long hours.

Your Committee have not been able to give the petitions from the other towns in this State a hearing. We believed that the whole case was covered by the petition from Lowell, and to the consideration of that petition we have given our undivided attention, and we have come to the conclusion *unanimously,* that legislation is not necessary at the present time, and for the following reasons:—

1st. That a law limiting the hours of labor, if enacted at all, should be of a general nature. That it should apply to individuals or copartnerships as well as to corporations. Because, if it is wrong to labor more than ten hours in a corporation, it is also wrong when applied to individual employers, and your Committee are not aware that more complaint can justly be made against incorporated companies in regard to the hours of labor, than can be against individuals or copartnerships. But it will be said in reply to this, that corporations are the creatures of the Legislature, and therefore the Legislature can control them in this, as in other matters. This to a certain extent is true, but your Committee go farther than this, and say, that not only are corporations subject to the control of the Legislature but individuals are also, and if it should ever appear that the public morals, the physical condition, or the social well-being of society were endangered, from this cause or from any cause, then it would be in the

power and would be the duty of the Legislature to interpose its prerogative to avert the evil.

2d. Your Committee believe that the factory system, as it is called, is not more injurious to health than other kinds of indoor labor. That a law which would compel all of the factories in Massachusetts to run their machinery but ten hours out of the 24, while those in Maine, New Hampshire, Rhode Island and other States in the Union, were not restricted at all, the effect would be to close the gate of every mill in the State. It would be the same as closing our mills one day in every week, and although Massachusetts capital, enterprise, and industry are willing to compete on fair terms with the same of other States, and, if needs be, with European nations, yet it is easy to perceive that we could not compete with our sister States, much less with foreign countries, if a restriction of this nature was put upon our manufactories.

3d. It would be impossible to legislate to restrict the hours of labor, without affecting very materially the question of wages; and that is a matter which experience has taught us can be much better regulated by the parties themselves than by the Legislature. Labor in Massachusetts is a very different commodity from what it is in foreign countries. Here labor is on an equality with capital, and indeed controls it, and so it ever will be while free education and free constitutions exist. And although we may find fault, and say, that labor works too many hours, and labor is too severely tasked, yet if we attempt by legislation to enter within its orbit and interfere with its plans, we will be told to keep clear and to mind our own business. Labor is intelligent enough to make its own bargains, and look out for its own interests without any interference from us; and your Committee want no better proof to convince them that Massachusetts men and Massachusetts women, are equal to this, and will take care of themselves better than we can take care of them, than we had from the intelligent and virtuous men and women who appeared in support of this petition, before the Committee.

4th. The Committee do not wish to be understood as conveying the impression, that there are no abuses in the present system of labor; we think there are abuses; we think that many improvements may be made, and we believe will be made, by which labor will not be so severely tasked as it now is. We think that it would be better if the hours for labor were less,—if more time was allowed for meals, if more attention was paid to ventilation and pure air in our manufactories, and work shops, and many other matters. We acknowledge all this, but we say, the remedy is not with us. We look for it in the progressive improvement in art and science, in a higher appreciation of man's destiny, in a less love for money, and a more ardent love for social happiness and intellectual superiority. Your Committee, therefore, while they

agree with the petitioners in their desire to lessen the burthens imposed upon labor, differ only as is the means by which these burthens are sought to be removed.

It would be an interesting inquiry were we permitted to enter upon it, to give a brief history of the rise and progress of the factory system in Massachusetts, to speak of its small beginnings, and show its magnificent results. Labor has made it what it is, and labor will continue to improve upon it.

Your Committee, in conclusion, respectfully ask to be discharged from the further consideration of the matters referred to them, and that the petitions be referred to the next General Court.

For the Committee,
Wm. Schouler, Chairman

From *Treatise on Domestic Economy,* by Catharine E. Beecher, 1847

. . . who shall take the higher, and who the subordinate, stations in social and civil life? This matter, in the case of parents and children, is decided by the Creator. He has given children to the control of parents, as their superiors, and to them they remain subordinate, to a certain age, or so long as they are members of their household. And parents can delegate such a portion of their authority to teachers and employers, as the interests of their children require.

In most other cases, in a truly democratic state, each individual is allowed to choose for himself, who shall take the position of his superior. No woman is forced to obey any husband but the one she chooses for herself; nor is she obliged to take a husband, if she prefers to remain single. So every domestic, and every artisan or laborer, after passing from parental control, can choose the employer to whom he is to accord obedience, or, if he prefers to relinquish certain advantages, he can remain without taking a subordinate place to any employer.

Each subject, also, has equal power with every other, to decide who shall be his superior as a ruler. The weakest, the poorest, the most illiterate, has the same opportunity to determine this question, as the richest, the most learned, and the most exalted.

And the various privileges that wealth secures, are equally open to all classes. Every man may aim at riches, unimpeded by any law or institution which secures peculiar privileges to a favored class, at the expense of another. Every law, and every institution, is tested by examining whether it secures equal advantages to all; and, if the people become convinced that any regulation sacrifices the good of the majority to the interests of the smaller number, they have power to abolish it. . . .

The tendencies of democratic institutions, in reference to the rights and interests of the female sex, have been fully developed in the United States; and it is in this aspect, that the subject is one of peculiar interest to American women. In this Country, it is established, both by opinion and by practice, that woman has an equal interest in all social and civil concerns; and that no domestic, civil, or political, institution, is right, which sacrifices her interest to promote that of the other sex. But in order to secure her the more firmly in all these privileges, it is decided, that, in the domestic relation, she take a subordinate station, and that, in civil and political concerns, her interests be intrusted to the other sex, without her taking any part in voting, or in making and administering laws. . . .

It appears, then, that it is in America, alone, that women are raised to an equality with the other sex; and that, both in theory and practice, their interests are regarded as of equal value. They are made subordinate in station, only where a regard to their best interests demands it, while, as if in compensation for this, by custom and courtesy, they are always treated as superiors. Universally, in this Country, through every class of society, precedence is given to woman, in all the comforts, conveniences, and courtesies, of life.

In civil and political affairs, American women take no interest or concern, except so far as they sympathize with their family and personal friends; but in all cases, in which they do feel a concern, their opinions and feelings have a consideration, equal, or even superior, to that of the other sex.

In matters pertaining to the education of their children, in the selection and support of a clergyman, in all benevolent enterprises, and in all questions relating to morals or manners, they have a superior influence. In such concerns, it would be impossible to carry a point, contrary to their judgement and feelings; while an enterprise, sustained by them, will seldom fail of success.

If those who are bewailing themselves over the fancied wrongs and injuries of women in this Nation, could only see things as they are, they would know, that, whatever remnants of a barbarous or aristocratic age may remain in our civil institutions, in reference to the interests of women, it is only because they are ignorant of them, or do not use their influence to have them rectified; for it is very certain that there is nothing reasonable, which American women would unite in asking, that would not readily be bestowed. . . .

The preceding remarks, then, illustrate the position, that the democratic institutions of this Country are in reality no other than the principles of Christianity carried into operation, and that they tend to place woman in her true position in society, as having equal rights with the other sex; and that, in fact, they have secured

to American women a lofty and fortunate position, which, as yet, has been attained by the women of no other nation. . . .

The success of democratic institutions, as is conceded by all, depends upon the intellectual and moral character of the mass of the people. If they are intelligent and virtuous, democracy is a blessing; but if they are ignorant and wicked, it is only a curse, and as much more dreadful than any other form of civil government, as a thousand tyrants are more to be dreaded than one. It is equally conceded, that the formation of the moral and intellectual character of the young is committed mainly to the female hand. The mother forms the character of the future man; the sister bends the fibres that are hereafter to be the forest tree; the wife sways the heart, whose energies may turn for good or for evil the destinies of a nation. Let the women of a country be made virtuous and intelligent, and the men will certainly be the same. The proper education of a man decides the welfare of an individual; but educate a woman, and the interests of a whole family are secured.

If this be so, as none will deny, then to American women, more than to any others on earth, is committed the exalted privilege of extending over the world those blessed influences, which are to renovate degraded man, and "clothe all climes with beauty."

No American woman, then, has any occasion for feeling that hers is an humble or insignificant lot. . . .

Married Woman's Property Act, New York

1848

The People of the State of New York, represented in Senate and Assembly, do enact as follows:

I The real and personal property of any female who may hereafter marry, and which she shall own at the time of her marriage, and the rents, issues and profits thereof, shall not be subject to the disposal of her husband nor be liable for his debts and shall continue her sole and separate property as if she were a single female.

II The real and personal property and the rents, issues and profits thereof of any female now married shall not be subject to the disposal of her husband; but shall be her sole and separate property as if she were a single female except so far as the same may be liable for the debts of her husband heretofore contracted.

III It shall be lawful for any married female to receive by gift, grant device or bequest, from any person other than her husband and to hold to her sole and separate use, as if she were a single female, real and personal property and the rents, issues and profits thereof, and the same shall not be subject to the disposal of her husband, nor be liable for his debts.

IV All contracts made between persons in contemplation of marriage shall remain in full force after such marriage takes place.

Declaration of Rights and Sentiments, Seneca Falls

July 19–20, 1848

DECLARATION OF SENTIMENTS

When, in the course of human events, it becomes necessary for one portion of the family of man to assume among the people of the earth a position different from that which they have hitherto occupied, but one to which the laws of nature and of nature's God entitle them, a decent respect to the opinions of mankind requires that they should declare the causes that impel them to such a course.

We hold these truths to be self-evident: that all men and women are created equal; that they are endowed by their Creator with certain inalienable rights; that among these are life, liberty, and the pursuit of happiness; that to secure these rights governments are instituted, deriving their just powers from the consent of the governed. Whenever any form of government becomes destructive of these ends, it is the right of those who suffer from it to refuse allegiance to it, and to insist upon the institution of a new government, laying its foundation on such principles and organizing its powers in such form, as to them shall seem most likely to effect their safety and happiness. Prudence, indeed, will dictate that governments long established should not be changed for light and transient causes; and, accordingly, all experience has shown that mankind are more disposed to suffer, while evils are sufferable, than to right themselves by abolishing the forms to which they were accustomed. But when a long train of abuses and usurpations, pursuing invariably the same object, evinces a design to reduce them under absolute despotism, it is their duty to throw off such government and to provide new guards for their future security. Such has been the patient sufferance of the women under this government, and such is now the necessity which constrains them to demand the equal station to which they are entitled.

The history of mankind is a history of repeated injuries and usurpations on the part of man toward woman, having in direct object the establishment of an absolute tyranny over here. To prove this, let facts be submitted to a candid world.

He has never permitted her to exercise her inalienable right to the elective franchise.

He has compelled her to submit to laws in the formation of which she had no voice.

He has withheld from her rights which are given to the most ignorant and degraded men, both natives and foreigners.

Having deprived her of this first right of a citizen, the elective franchise, thereby leaving her without representation in the halls of legislation, he has oppressed her on all sides.

He has made her, if married, in the eye of the law, civilly dead.

He has taken from her all rights in property, even to the wages she earns.

He has made her, morally, an irresponsible being, as she can commit many crimes with impunity, provided they be done in the presence of her husband. In the covenant of marriage, she is compelled to promise obedience to her husband, he becoming, to all intents and purposes, her master—the law giving him power to deprive her of her liberty and to administer chastisement.

He has so framed the laws of divorce, as to what shall be the proper causes and, in case of separation, to whom the guardianship of the children shall be given, as to be wholly regardless of the happiness of women—the law, in all cases, going upon a false supposition of the supremacy of man and giving all power into his hands.

After depriving her of all rights as a married woman, if single and the owner of property, he has taxed her to support a government which recognizes her only when her property can be made profitable to it.

He has monopolized nearly all the profitable employments, and from those she is permitted to follow, she receives but a scanty remuneration. He closes against her all the avenues to wealth and distinction which he considers most honorable to himself. As a teacher of theology, medicine, or law, she is not known.

He has denied her the facilities for obtaining a thorough education, all colleges being closed against her.

He allows her in church, as well as state, but a subordinate position, claiming apostolic authority for her exclusion from the ministry, and, with some exceptions, from any public participation in the affairs of the church.

He has created a false public sentiment by giving to the world a different code of morals for men and women, by which moral delinquencies which exclude women from society are not only tolerated but deemed of little account in man.

He has usurped the prerogative of Jehovah himself, claiming it as his right to assign for her a sphere of action, when that belongs to her conscience and to her God.

He has endeavored, in every way that he could, to destroy her confidence in her own powers, to lessen her self-respect, and to make her willing to lead a dependent and abject life.

Now, in view of this entire disfranchisement of one-half the people of this country, their social and religious degradation, in view of the unjust laws above mentioned, and because women do feel themselves aggrieved, oppressed, and fraudulently deprived of their most sacred rights we insist that they have immediate admission to all the rights and privileges which belong to them as citizens of the United States.

In entering upon the great work before us, we anticipate no small amount of misconception, misrepresentation, and ridicule; but we shall use every instrumentality within our power to effect our object. We shall employ agents, circulate tracts, petition the state and national legislatures, and endeavor to enlist the pulpit and the press in our behalf. We hope this Convention will be followed by a series of conventions embracing every part of the country.

RESOLUTIONS

Whereas, the great precept of nature is conceded to be that "man shall pursue his own true and substantial happiness." Blackstone in his *Commentaries* remarks that this law of nature, being coeval with mankind and dictated by God himself, is, of course, superior in obligation to any other. It is binding over all the globe, in all countries and at all times; no human laws are of any validity if contrary to this, and such of them as are valid derive all their force, and all their validity, and all their authority, mediately and immediately, from this original; therefore,

Resolved, That such laws as conflict, in any way, with the true and substantial happiness of woman, are contrary to the great precept of nature and of no validity, for this is "superior in obligation to any other."

Resolved, that all laws which prevent woman from occupying such a station in society as her conscience shall dictate, or which place her in a position inferior to that of man, are contrary to the great precept of nature and therefore of no force or authority.

Resolved, that woman is man's equal, was intended to be so by the Creator, and the highest good of the race demands that she should be recognized as such.

Resolved, that the women of this country ought to be enlightened in regard to the laws under which they live, that they may no longer publish their degradation by declaring themselves satisfied with their present position, nor their ignorance, by asserting that they have all the rights they want.

Resolved, that inasmuch as man, while claiming for himself intellectual superiority, does accord to woman moral superiority, it is preeminently his duty to encourage her to speak and teach, as she has an opportunity, in all religious assemblies.

Resolved, that the same amount of virtue, delicacy, and refinement of behavior that is required of woman in

the social state should also be required of man, and the same transgressions should be visited with equal severity on both man and woman.

Resolved, that the objection of indelicacy and impropriety, which is so often brought against woman when she addresses a public audience, comes with a very ill grace from those who encourage, by their attendance, her appearance on the stage, in the concert, or in feats of the circus.

Resolved, that woman has too long rested satisfied in the circumscribed limits which corrupt customs and a perverted application of the Scriptures have marked out for her, and that it is time she should move in the enlarged sphere which her great Creator has assigned her.

Resolved, that it is the duty of the women on this country to secure to themselves their sacred right to the elective franchise.

Resolved, that the equality of human rights results necessarily from the fact of the identity of the race in capabilities and responsibilities.

Resolved, that the speedy success of our cause depends upon the zealous and untiring efforts of both men and women for the overthrow of the monopoly of the pulpit, and for the securing to woman an equal participation with men in the various trades, professions, and commerce.

Resolved, therefore, that, being invested of the Creator with the same capabilities and the same consciousness of responsibility for their exercise, it is demonstrably the right and duty of woman, equally with man, to promote every righteous cause by every righteous means; and especially in regard to the great subjects of morals and religion, it is self-evidently her right to participate with her brother in teaching them, both in private and in public, by writing and by speaking, by any instrumentalities proper to be used, and in any assemblies proper to be held; and this being a self-evident truth growing out of the divinely implanted principles of human nature, any custom or authority adverse to it, whether modern or wearing the hoary sanction of antiquity, is to be regarded as a self-evident falsehood and at war with mankind.

"Ain't I a Woman?" Sojourner Truth's Reply to a Male Opponent of Women's Rights, 1851

"Wall, chilern, whar dar is so much racket dar must be somethin' out o' kilter. I tink dat 'twixt de niggers of de Souf and de womin at de Norf, all talkin' 'bout rights, de white men will be in a fix pretty soon. But what's all dis here talkin' 'bout?

"Dat man ober dar say dat womin needs to be helped into carriages, and lifted ober ditches, and to hab de best place everywhar. Nobody eber helps me into carriages, or ober mud-puddles, or gibs me any best place!" And raising herself to her full height, and her voice to a pitch like rolling thunder, she asked, "And a'n't I a woman? Look at me! Look at my arm! (and she bared her right arm to the shoulder, showing her tremendous muscular power). I have ploughed, and planted, and gathered into barns, and no man could head me! And a'n't I a woman? I could work as much and eat as much as a man—when I could get it—and bear de lash as well! And a'n't I a woman? I have borne thirteen chilern, and seen 'em mos' all sold off to slavery, and when I cried out with my mother's grief, none but Jesus heard me! And a'n't I a woman?

"Den dey talks 'bout dis ting in de head; what dis dey call it?" ("Intellect," whispered some one near.) "Dat's it, honey. What's dat got to do wid womin's rights or nigger's rights? If my cup won't hold but a pint, and yourn holds a quart, wouldn't ye be mean not to let me have my little half-measure full?" . . .

"Den dat little man in black dar, he say women can't have as much rights as men, 'cause Christ wan't a woman! Whar did your Christ come from?" . . .

From God and a woman! Man had nothin' to do wid Him." . . .

"If de fust woman God ever made was strong enough to turn de world upside down all alone, dese women togedder (and she glanced her eye over the platform) ought to be able to turn it back, and get it right side up again! And now dey is asking to do it, de men better let 'em." . . .

"'Bleeged to ye for hearin' on me, and now ole Sojourner han't got nothin' more to say."

Act Concerning the Rights and Liabilities of Husband and Wife

March 20, 1860

The People of the State of New York, represented in Senate and Assembly, do enact as follows:

Section 1. The property, both real and personal, which any married woman now owns, as her sole and separate property; that which comes to her by descent, devise, bequest, gift, or grant; that which she acquires by her trade, business, labor, or services, carried on or performed on her sole or separate account; that which a woman married in this State owns at the time of her marriage, and the rents, issues, and proceeds of all such property, shall notwithstanding her marriage, be and remain her sole and separate property, and may be used, collected, and invested by her in her own name, and shall not be subject to the interference or control of her husband, or liable for his debts, except such debts as may have been contracted for the support of herself or her children, by her as his agent.

§2. A married woman may bargain, sell, assign, and transfer her separate personal property, and carry on any trade or business, and perform any labor or services on her sole and separate account, and the earnings of any married woman from her trade, business, labor, or services shall be her sole and separate property, and may be used or invested by her in her own name.

§3. Any married woman possessed of real estate as her separate property may bargain, sell, and convey such property, and enter into any contract in reference to the same; but no such conveyance or contract shall be valid without the assent, in writing, of her husband, except as hereinafter provided.

§4. In case any married woman possessed of separate real property, as aforesaid, may desire to sell or convey the same, or to make any contract in relation thereto, and shall be unable to procure the assent of her husband as in the preceding section provided, in consequence of his refusal, absence, insanity, or other disability, such married woman may apply to the County Court in the county where she shall at the time reside, for leave to make such sale, conveyance, or contract, without the assent of her husband.

§5. Such application may be made by petition, verified by her, and setting forth the grounds of such application. If the husband be a resident of the county and not under disability from insanity or other cause, a copy of said petition shall be served upon him, with a notice of the time when the same will be presented to the said court, at least ten days before such application. In all other cases, the County Court to which such application shall be made, shall, in its discretion, determine whether any notice shall be given, and if any, the mode and manner of giving it.

§6. If it shall satisfactorily appear to such court, upon application, that the husband of such applicant has willfully abandoned his said wife, and lives separate and apart from her, or that he is insane, or imprisoned as a convict in any state prison, or that he is an habitual drunkard, or that he is in any way disabled from making a contract, or that he refuses to give his consent without good cause therefore, then such court shall cause an order to be entered upon its records, authorizing such married woman to sell and convey her real estate, or contract in regard thereto without the assent of her husband, with the same effect as though such conveyance or contract had been made with his assent.

§7. Any married woman may, while married, sue and be sued in all matters having relation to her property, which may be her sole and separate property, or which may hereafter come to her by descent, devise, bequest, or the gift of any person except her husband, in the same manner as if she were sole. And any married woman may bring and maintain an action in her own name, for dam-ages against any person or body corporate, for any injury to her person or character, the same as if she were sole; and the money received upon the settlement of any such action, or recovered upon a judgment, shall be her sole and separate property.

§8. No bargain or contract made by any married woman, in respect to her sole and separate property, or any property which may hereafter come to her by descent, devise, bequest, or gift of any person except her husband, and no bargain or contract entered into by any married woman in or about the carrying on of any trade or business under the statutes of this State, shall be binding upon her husband, or render him or his property in any way liable therefor.

§9. Every married woman is hereby constituted and declared to be the joint guardian of her children, with her husband, with equal powers, rights, and duties in regard to them, with the husband.

§10. At the decease of husband or wife, leaving no minor child or children, the survivor shall hold, possess, and enjoy a life estate in one-third of all the real estate of which the husband or wife died seized.

§11. At the decease of the husband or wife intestate, leaving minor child or children, the survivor shall hold, possess, and enjoy all the real estate of which the husband or wife died seized, and all the rents, issues, and profits thereof during the minority of the youngest child, and one-third thereof during his or her natural life.

The Emancipation Address of the Woman's National Loyal League

Adopted **May 15, 1863**
The Loyal Women of the Country to Abraham Lincoln, President of the United States.

Having heard many complaints of the want of enthusiasm among Northern women in the war, we deemed it fitting to call a National Convention. From every free State, we have received the most hearty responses of interest in each onward step of the Government as it approaches the idea of a true republic. From the letters received, and the numbers assembled here to-day, we can with confidence address you in the name of the loyal women of the North.

We come not to criticise or complain. Not for ourselves or our friends do we ask redress of specific grievances, or posts of honor or emolument. We speak from no considerations of mere material gain; but, inspired by true patriotism, in this dark hour of our nation's destiny, we come to pledge the loyal women of the Republic to freedom and our country. We come to strengthen you with earnest words of sympathy and encouragement. We come to thank you for your proclamation, in which the

nineteenth century seems to echo back the Declaration of Seventy-six. Our fathers had a vision of the sublime idea of liberty, equality, and fraternity; but they failed to climb the heights that with anointed eyes they saw. To us, their children, belongs the work to build up the living reality of what they conceived and uttered.

It is not our mission to criticise the past. Nations, like individuals, must blunder and repent. It is not wise to waste one energy in vain regret, but from each failure rise up with renewed conscience and courage for nobler action. The follies and faults of yesterday we cast aside as the old garments we have outgrown. Born anew to freedom, slave creeds and codes and constitutions must now all pass away. "For men do not put new wine into old bottles, else the bottles break, and the wine runneth out, and the bottles perish; but they put new wine into new bottles, and both are preserved."

Our special thanks are due to you, that by your Proclamation two millions of women are freed from the foulest bondage humanity ever suffered. Slavery for man is bad enough, but the refinements of cruelty must ever fall on the mothers of the oppressed race, defrauded of all the rights of the family relation, and violated in the most holy instincts of their nature. A mother's life is bound up in that of her child. There center all her hopes and ambition. But the slavemother, in her degradation, rejoices not in the future promise of her daughter, for she knows by experience what her sad fate must be. No pen can describe the unutterable agony of that mother whose past, present, and future are all wrapped in darkness; who knows the crown of thorns she wears must press her daughter's brow: who knows that the wine-press she now treads, unwatched, those tender feet must tread alone. For, by the law of slavery, "the child follows the condition of the mother."

By your act, the family, that great conservator of national virtue and strength, has been restored to millions of humble homes, around whose altars coming generations shall magnify and bless the name of Abraham Lincoln. By a mere stroke of the pen you have emancipated millions from a condition of wholesale concubinage. We now ask you to finish the work by declaring that nowhere under our national flag shall the motherhood of any race plead in vain for justice and protection. So long as one slave breathes in this Republic, we drag the chain with him. God has so linked the race, man to man, that all must rise or fall together. Our history exemplifies this law. It was not enough that we at the North abolished slavery for ourselves, declared freedom of speech and the press, built up churches, colleges, and free schools, studied the science of morals, government, and economy, dignified labor, amassed wealth, whitened the sea with our commerce, and commanded the respect and admiration of the nations of the earth, so long as the South, by the natural proclivities of slavery, was sapping the very foundations of our national life . . .

You are the first President ever borne on the shoulders of freedom into the position you now fill. Your predecessors owed their elevation to the slave oligarchy, and in serving slavery they did but obey their masters. In your election, Northern freemen threw off the yoke. And with you rests the responsibility that our necks shall never bow again. At no time in the annals of the nation has there been a more auspicious moment to retrieve the one false step of the fathers in the concessions to slavery. The Constitution has been repudiated, and the compact broken by the Southern traitors now in arms. The firing of the first gun on Sumter released the North from all constitutional obligations to slavery. It left the Government, for the first time in our history, free to carry out the Declaration of our Revolutionary fathers, and made us in fact what we have ever claimed to be, a nation of freemen.

"The Union as it was"—a compromise between barbarism and civilization—can never be restored, for the opposing principles of freedom and slavery can not exist together. Liberty is life, and every form of government yet tried proves that slavery is death. In obedience to this law, our Republic, divided and distracted by the collisions of caste and class, is tottering to its base, and can only be reconstructed on the sure foundations of impartial freedom to all men. The war in which we are involved is not the result of party or accident, but a forward step in the progress of the race never to be retraced. Revolution is no time for temporizing or diplomacy. In a radical upheaving, the people demand eternal principles to stand upon.

Northern power and loyalty can never be measured until the purpose of the war be liberty to man; for a lasting enthusiasm is ever based on a grand idea, and unity of action demands a definite end. At this time our greatest need is not in men or money, valiant generals or brilliant victories, but in a consistent policy, based on the principle that "all governments derive their just powers from the consent of the governed." And the nation waits for you to say that there is no power under our declaration of rights, nor under any laws, human or divine, by which *free* men can be made slaves; and therefore that your pledge to the slaves is irrevocable, and shall be redeemed.

It if be true, as it is said, that Northern women lack enthusiasm in this war, the fault rests with those who have confused and confounded its policy. The page of history glows with incidents of self-sacrifice by woman in the hour of her country's danger. Fear not that the daughters of this Republic will count any sacrifice too great to insure the triumph of freedom. Let the men who wield the nation's power be wise, brave, and magnanimous, and its women will be prompt to meet the duties of the hour with devotion and heroism.

When Fremont on the Western breeze proclaimed a day of jubilee to the bondmen within our gates, the women of the nation echoed back a loud Amen. When Hunter freed a million men, and gave them arms to fight our battles, justice and mercy crowned that act, and tyrants stood appalled. When Butler, in the chief city of the Southern despotism, hung a traitor, we felt a glow of pride; for that one act proved that we had a Government, and one man brave enough to administer its laws. And when Burnside would banish Vallandigham to the Dry Tortugas, let the sentence be approved, and the nation will ring with plaudits. Your Proclamation gives you immortality. Be just, and share your glory with men like these who wait to execute your will.

In behalf of the Women's National Loyal League,

ELIZABETH CADY STANTON, *President.*
SUSAN B. ANTHONY, *Secretary.*

Comstock Law, 1873

Be it enacted . . . That whoever, within the District of Columbia or any of the Territories of the United States . . . shall sell . . . or shall offer to sell, or to lend, or to give away, or in any manner to exhibit, or shall otherwise publish or offer to publish in any manner, or shall have in his possession, for any such purpose or purposes, any obscene book, pamphlet, paper, writing, advertisement, circular, print, picture, drawing or other representation, figure, or image on or of paper or other material, or any cast, instrument, or other article of an immoral nature, or any drug or medicine, or any article whatever, for the prevention of conception, or for causing unlawful abortion, or shall advertize the same for sale, or shall write or print, or cause to be written or printed, any card, circular, book, pamphlet, advertisement, or notice of any kind, stating when, where, how, or of whom, or by what means, any of the articles in this section . . . can be purchased or obtained, or shall manufacture, draw, or print, or in any wise make any of such articles, shall be deemed guilty of a misdemeanor, and on conviction thereof in any court of the United States . . . he shall be imprisoned at hard labor in the penitentiary for not less than six months nor more than five years for each offense, or fined not less than one hundred dollars nor more than two thousand dollars, with costs of court. . . .

Decision of the Supreme Court, *Bradwell v. Illinois*

1873

Mr. Justice Miller delivered the opinion of the court:
The claim that, under the 14th Amendment of the Constitution, which declares that no state shall make or enforce any law which shall abridge the privileges and immunities of citizens of the United States, and the statute law of Illinois, or the common law prevailing in that state, can no longer be set up as a barrier against the right of females to pursue any lawful employment for a livelihood (the practice of law included), assumes that it is one of the privileges and immunities of women as citizens to engage in any and every profession, occupation or employment in civil life.

It certainly cannot be affirmed, as a historical fact, that this has ever been established as one of the fundamental privileges and immunities of the sex. On the contrary, the civil law, as well as nature herself, has always recognized a wide difference in the respective spheres and destinies of man and woman. Man is, or should be woman's protector and defender. The natural and proper timidity and delicacy which belongs to the female sex evidently unfits it for many of the occupations of civil life. The constitution of the family organization, which is founded in the divine ordinance, as well as in the nature of things, indicates the domestic sphere as that which properly belongs to the domain and functions of womanhood. The harmony, not to say identity, of interests and views which belong or should belong to the family institution, is repugnant to the idea of a woman adopting a distinct and independent career from that of her husband. So firmly fixed was this sentiment in the founders of the common law that it became a maxim of that system of jurisprudence that a woman had no legal existence separate from her husband, who was regarded as her head and representative in the social state. . . .

The paramount destiny and mission of woman are to fulfill the noble and benign offices of wife and mother. This is the law of the Creator. And the rules of civil society must be adapted to the general constitution of things, and cannot be based upon exceptional cases.

The humane movements of modern society, which have for their object the multiplication of avenues for woman's advancement, and of occupations adapted to her condition and sex, have my heartiest concurrence. But I am not prepared to say that it is one of her fundamental rights and privileges to be admitted into every office and position, including those which require highly special qualifications and demanding special responsibilities. In the nature of things it is not every citizen of every age, sex, and condition that is qualified for every calling and position. It is the prerogative of the legislator to prescribe regulations founded on nature, reason, and experience for the due admission of qualified persons to professions and callings demanding special skill and confidence. This fairly belongs to the police power of the state; and, in my opinion, in view of the peculiar characteristics, destiny, and mission of

woman, it is within the province of the legislature to ordain what offices, positions, and callings shall be filled and discharged by men, and shall receive the benefit of those energies and responsibilities, and that decision and firmness which are presumed to predominate in the sterner sex.

For these reasons I think that the laws of Illinois now complained of are not obnoxious to the charge of abridging any of the privileges and immunities of citizens of the United States.

From Hearings Before a Subcommittee of the Committee on the District of Columbia, United States Senate, 63rd Congress under Senate Resolution 499 . . . To Investigate the Conduct of the District Police . . . in connection with the Woman's Suffrage Parade on March 3, 1913

Wesley L. Jones, CHAIRMAN. The committee will come to order. The resolution under which the committee is acting reads as follows:

Resolved; That the Committee on the District of Columbia, by subcommittee or otherwise, be, and it is hereby, authorized and directed to investigate the conduct of the District police and police department of the District of Columbia in connection with the Women's Suffrage parade on March third, nineteen hundred and thirteen, and ascertain whether said police or police department was negligent in protecting the participants in said parade from interference, insult, and indignity, and submit its report and recommendations as soon as possible, and said committee shall have authority to summon witnesses, administer oaths, and take testimony. . . .

Testimony of Miss Julia C. Lathrop, Chief of the Children's Bureau, Washington, D. C.

The witness was duly sworn by the chairman.

The CHAIRMAN. Give your full name to the stenographer.

Miss LATHROP. Julia C. Lathrop.

The CHAIRMAN. Where do you live?

Miss LATHROP. At the present time, in Washington.

The CHAIRMAN. Do you have any official position?

Miss LATHROP. I am the chief of the Children's Bureau.

The CHAIRMAN. Were you on Pennsylvania Avenue on the 3d of March last?

Miss LATHROP. I was.

The CHAIRMAN. You were in the procession?

Miss LATHROP. I was.

The CHAIRMAN. What part of the procession were you in?

Miss LATHROP. I was marching with the Government employees.

The CHAIRMAN. In the front or the middle of the procession?

Miss LATHROP. Directly behind the Government employees' banner.

The CHAIRMAN. I do not know what position that occupied in the parade.

Miss LATHROP. I confess I hardly know myself, but I should say it was well in the earlier part of the parade.

The CHAIRMAN. Toward the front?

Miss LATHROP. Yes, sir. . . .

The CHAIRMAN. You will just proceed, Miss Lathrop, and describe what happened during that parade so far as you know.

MISS LATHROP. We came down on to the Avenue, and were delayed occasionally as we came down to the Avenue, but from that time on we were frequently stopped for varying periods, and we found on either side a very closely packed mass of people who crowded in more and more. We were, however, in our section enabled to maintain a marching front of four, although they were pressed as closely as they could possibly be, and I should think the people on the right—I confess I do not know what happened on the left—were from 12 to 18 inches from us all the way along. There was constant comment, rather frivolous, and sometimes rather coarse. . . .

THE CHAIRMAN. At about what point were you first discommoded?

Miss LATHROP. I do not think I could say very positively. I should say beyond Seventh Street it grew constantly denser and denser.

The CHHAIRMAN. After you reached Seventh Street and from there on?

Miss LATHROP. Yes.

The CHAIRMAN. That is, on the Avenue?

Miss LATHROP. Yes.

The CHAIRMAN. Were you enabled to march four abreast all the way up the Avenue?

Miss LATHROP. Yes; we were halted many times, not being able to go at all. When we marched our section was able to march four abreast.

The CHAIRMAN. Did you see many policemen?

Miss LATHROP. Not many—some.

The CHAIRMAN. Can you give us any idea as to how many policemen there were along the line from the Peace Monument to Seventh Street, for instance?

Miss LATHROP. No, Mr. Chairman; I could not make an estimate. My recollection would be that—I am not impressed with the recollection of many. I saw an occasional policeman and an occasional man in citizen's clothes with a star.

The CHAIRMAN. Were there any mounted policemen?

Miss LATHROP. I saw none.

The CHAIRMAN. You saw no mounted policemen all down the Avenue?

Miss LATHROP. I recall none.

The CHAIRMAN. What were the policemen that you saw doing toward attempting to keep the crowd away from the line of march?

Miss LATHROP. For the most part they were doing nothing. One or two were making some futile attempts to put their arms out and thrust the crowd back.

The CHAIRMAN. Did you notice any of the policemen who were apparently making no efforts toward keeping the crowd away from the line of procession?

Miss LATHROP. Yes, sir.

The CHAIRMAN. What proportion of the policemen were apparently doing nothing?

Miss LATHROP. I should say that none of them were really doing anything actively. . . .

Testimony of Mrs. Cordelia Powell Odenheimer, Jessup, MD.

The witness was duly sworn by the chairman.

The CHAIRMAN. What is your name?

Mrs. ODENHEIMER. Mrs. Cordelia Powell Odenheimer.

The CHAIRMAN. Where do you live?

Mrs. ODENHEIMER. Jessup, Md.

The CHAIRMAN. Were you in the parade on the 3d of March?

Mrs. ODENHEIMER. I was not. I was a witness of the parade or pageant. . . .

The CHAIRMAN. You may just describe how the condition was.

Mrs. ODENHEIMER. When I got to Ninth Street there were two points I want to bring out about the police. When I reached Ninth Street I had had no trouble, but just as I crossed over there was quite a file of young men, black and white, with hands on each other's shoulders, going from side to side. They made the most insulting remarks to the women. They tore a woman's suffrage badge from off my coat and nearly knocked me down. When I managed to get up the crowd was very dense. A woman cried out—she was crying—that they had torn two children away from her.

The CHAIRMAN. This was about what time in the afternoon?

Mrs. ODENHEIMER. This was about—I should say it would be a quarter after 2.

The CHAIRMAN. It was before 4 o'clock, before the procession came along?

Mrs. ODENHEIMER. Oh, yes; before the pageant started. When I got to my seat, and this woman was calling, to show you how easy it would have been for the

police, I looked around, saw no police, and I braced myself against the crowd and I called out, "Is there not a man here with enough of the spark of manhood in him to at least protect children?" Two men pushed forward, broke the line of the mob, and made a passageway. There were no policemen around whatever.

Letter to the Commissioners of the District of Columbia Claiming Political Prisoner Status for Jailed Suffragettes

1917

To the Commissioners of the District of Columbia:

As political prisoners, we, the undersigned, refuse to work while in prison. We have taken this stand as a matter of principle after careful consideration, and from it we shall not recede.

This action is a necessary protest against an unjust sentence. In reminding President Wilson of his preelection promises toward woman suffrage we were exercising the right of peaceful petition, guaranteed by the Constitution of the United States, which declares peaceful picketing is legal in the District of Columbia. That we are unjustly sentenced has been well recognized—when President Wilson pardoned the first group of suffragists who had been given sixty days in the workhouse, and again when Judge Mullowny suspended sentence for the last group of picketers. We wish to point out the inconsistency and injustice of our sentences—some of us have been given sixty days, a later group thirty days, and another group a suspended sentence for exactly the same action.

Conscious, therefore, of having acted in accordance with the highest standards of citizenship, we ask the Commissioners of the District to grant us the rights due political prisoners. We ask that we no longer be segregated and confined under locks and bars in small groups, but permitted to see each other, and that Miss Lucy Burns, who is in full sympathy with this letter, be released from solitary confinement in another building and given back to us.

We ask exemption from prison work, that our legal right to consult counsel be recognized, to have food sent to us from outside, to supply ourselves with writing material for as much correspondence as we may need, to receive books, letters, newspapers, our relatives and friends.

Our united demand for political treatment has been delayed, because on entering the workhouse we found conditions so very bad that before we could ask that the suffragists be treated as political prisoners, it was necessary to make a stand for the ordinary rights of human beings for all the inmates. Although this has not been accomplished we now wish to bring the important question of the status of political prisoners to the attention of

the commissioners, who, we are informed, have full authority to make what regulations they please for the District prison and workhouse.

The Commissioners are requested to send us a written reply so that we may be sure this protest has reached them.

Signed by,

Mary Winsor, Lucy Branham, Ernestine Hara, Hilda Blumberg, Maud Malone, Pauline F. Adams, Eleanor A. Calnan, Edith Ainge, Annie Arneil, Dorothy J. Bartlett, Margaret Fotheringham.

Equal Rights Amendment: Introduced 1923; passed by Congress, 1972; failed to win ratification, 1982. With list of states that ratified.

Section 1. Equality of rights under the law shall not be denied or abridged by the United States or by any State on account of sex.

Section 2. The Congress shall have the power to enforce, by appropriate legislation, the provisions of this article.

Section 3. This amendment shall take effect two years after the date of ratification.

ERA: States and Years Ratified

1972
Alaska
California
Colorado
Delaware
Hawaii
Idaho
Iowa
Kansas
Kentucky
Maryland
Massachusetts
Michigan
Nebraska
New Hampshire
New Jersey
New York
Pennsylvania
Rhode Island
Tennessee
Texas
West Virginia

1973
Connecticut
Minnesota

New Mexico
Oregon
South Dakota
Vermont
Washington
Wisconsin
Wyoming

1974
Montana
Ohio

1975
Maine
North Dakota

1977
Indiana

President's Commission on the Status of Women, 1963

Recommendations

Education and Counseling

Means of acquiring or continuing education must be available to every adult at whatever point he or she broke off traditional formal schooling. The structure of adult education must be drastically revised. It must provide practicable and accessible opportunities, developed with regard for the needs of women, to complete elementary and secondary school and to continue education beyond high school. Vocational training, adapted to the nation's growing requirement for skilled and highly educated manpower, should be included at all of these educational levels. Where needed and appropriate, financial support should be provided by local, state, and federal governments and by private groups and foundations.

In a democracy offering broad and everchanging choices, where ultimate decisions are made by individuals, skilled counseling is an essential part of education. Public and private agencies should join in strengthening counseling resources. States and school districts should raise their standards for state employment service counselors and school guidance counselors. Institutions offering counseling education should provide both course content and ample supervised experience in the counseling of females as well as males, adults as well as adolescents.

The education of girls and women for their responsibilities in home and community should be thoroughly reexamined with a view to discovering more effective approaches, with experimentation in content and timing,

and under auspices including school systems, private organizations, and the mass media.

Home and Community

For the benefit of children, mothers, and society, child-care services should be available for children of families at all economic levels. Proper standards of child care must be maintained, whether services are in homes or in centers. Costs should be met by fees scaled to parents' ability to pay, contributions from voluntary agencies, and public appropriations.

Tax deductions for child-care expenses of working mothers should be kept commensurate with the median income of couples when both husband and wife are engaged in substantial employment. The present limitation on their joint income, above which deductions are not allowable, should be raised. Additional deductions, of lesser amounts, should be allowed for children beyond the first. The 11-year age limit for child-care deductions should be raised.

Family services under public and private auspices to help families avoid or overcome breakdown or dependency and establish a soundly based homelife, and professionally supervised homemaker services to meet emergency or other special needs should be strengthened, extended, or established where lacking.

Community programs under public and private auspices should make comprehensive provisions for health and rehabilitation services, including easily accessable maternal and child health services, accompanied by education to encourage their use.

Volunteers' services should be made more effective through coordinated and imaginative planning among agencies and organizations for recruitment, training, placement, and supervision, and their numbers augmented through tapping the large reservoir of additional potential among youth, retired people, members of minority groups, and women not now in volunteer activities.

Women in Employment

Equal opportunity for women in hiring, training, and promotion should be the governing principle in private employment. An Executive order should state this principle and advance its application to work done under federal contracts.

At present, federal systems of manpower utilization discourage part-time employment. Many able women, including highly trained professionals, who are not free for full-time employment, can work part time. The Civil Service Commission and the Bureau of the Budget should facilitate the imaginative and prudent use of such personnel throughout the government service.

Labor Standards

The federal Fair Labor Standards Act, including premium pay for overtime, should be extended to employment subject to federal jurisdiction but now uncovered, such as work in hotels, motels, restaurants, and laundries, in additional retail establishments, in agriculture, and in nonprofit organizations.

State legislation, applicable to both men and women, should be enacted, or strengthened and extended to all types of employment, to provide minimum-wage levels approximating the minimum under federal law and to require premium pay at the rate of at least time and a half for overtime.

The normal workday and workweek at this moment of history should be not more than 8 hours a day and 40 hours a week. The best way to discourage excessive hours for all workers is by broad and effective minimum-wage coverage, both federal and state, providing overtime of at least time and a half the regular rate for all hours in excess of 8 a day or 40 a week.

Until such time as this goal is attained, state legislation limiting maximum hours of work for women should be maintained, strengthened, and expanded. Provisions for flexibility under proper safeguards should allow additional hours of work when there is a demonstrated need. During this interim period, efforts should continuously and simultaneously be made to require premium rates of pay for all hours in excess of 8 a day or 40 a week.

State laws should establish the principle of equal pay for comparable work.

State laws should protect the right of all workers to join unions of their own choosing and to bargain collectively.

Security of Basic Income

A widow's benefit under the federal old-age insurance system should be equal to the amount that her husband would have received at the same age had he lived. This objective should be approached as rapidly as may be financially feasible.

The coverage of the unemployment-insurance system should be extended. Small establishments and nonprofit organizations should be covered now through federal action, and state and local government employees through state action. Practicable means of covering at least some household workers and agricultural workers should be actively explored.

Paid maternity leave or comparable insurance benefits should be provided for women workers; employers, unions, and governments should explore the best means of accomplishing this purpose.

Women Under the Law

Early and definitive court pronouncement, particularly by the United States Supreme Court, is urgently needed

with regard to the validity under the Fifth and Fourteenth Amendments of laws and official practices discriminating against women, to the end that the principle of equality become firmly established in constitutional doctrine.

Accordingly, interested groups should give high priority to bringing under court review cases involving laws and practices which discriminate against women.

The United States should assert leadership, particularly in the United Nations, in securing equality of rights for women as part of the effort to define and assure human rights; should participate actively in the formulation of international declarations, principles, and conventions to improve the status of women throughout the world; and should demonstrate its sincere concern for women's equal rights by becoming a party to appropriate conventions.

Appropriate action, including enactment of legislation where necessary, should be taken to achieve equal jury service in the states.

State legislatures, and other groups concerned with the improvement of state statutes affecting family law and personal and property rights of married women, including the National Conference of Commissioners on Uniform State Laws, the Council of State Governments, the American Law Institute, and state Commissions on the Status of Women, should move to eliminate laws which impose legal disabilities on women.

Women as Citizens

Women should be encouraged to seek elective and appointive posts at local, state, and national levels and in all three branches of government.

Public office should be held according to ability, experience, and effort, without special preferences or discriminations based on sex. Increasing consideration should continually be given to the appointment of women of demonstrated ability and political sensitivity to policy-making positions.

Continuing Leadership

To further the objectives proposed in this report, an Executive order should:

1. Designate a Cabinet officer to be responsible for assuring that the resources and activities of the federal government bearing upon the Commission's recommendations are directed to carrying them out, and for making periodic progress reports to the President.
2. Designate the heads of other agencies involved in those activities to serve, under the chairmanship of the designated Cabinet officer, as an interdepartmental committee to assure proper coordination and action.
3. Establish a citizens committee, advisory to the interdepartmental committee and with its secretariat from the designated Cabinet officer, to meet periodically to evaluate progress made, provide counsel, and serve as a means for suggesting and stimulating action.

Members of the Commission

The names of the men and women appointed to the Commission, and the posts they occupied at the time of their appointment, were:

Eleanor Roosevelt, *Chairman (deceased)*

Esther Peterson, *Executive Vice Chairman,* Assistant Secretary of Labor

Dr. Richard A. Lester, *Vice Chairman,* Chairman, Department of Economics, Princeton University.

The Attorney General, Honorable Robert F. Kennedy

The Secretary of Agriculture, Honorable Orville L. Freeman

The Secretary of Commerce, Honorable Luther H. Hodges

The Secretary of Labor, Honorable Arthur J. Goldberg, Honorable W. Willard Wirtz

The Secretary of Health, Education, and Welfare, Honorable Abraham A. Ribicoff, Honorable Anthony L. Celebrezze

Honorable George D. Aiken, United States Senate

Honorable Maurine B. Neuberger, United States Senate

Honorable Edith Green, United States House of Representatives

Honorable Jessica M. Weis *(deceased),* United States House of Representatives

The Chairman of the Civil Service Commission, Honorable John W. Macy, Jr.

Macon Boddy, Henrietta, Tex.

Dr. Mary I. Bunting, President, Radcliffe College

Mary E. Callahan, Member, Executive Board, International Union of Electrical, Radio and Machine Workers

Dr. Henry David, President, New School for Social Research

Dorothy Height, President, National Council of Negro Women, Inc.

Margaret Hickey, Public Affairs Editor, *Ladies' Home Journal*

Viola H. Hymes, President, National Council of Jewish Women, Inc.

Margaret J. Mealey, Executive Director, National Council of Catholic Women

Norman E. Nicholson, Administrative Assistant, Kaiser Industries Corp., Oakland, Calif.

Marguerite Rawalt, Attorney; past president: Federal Bar Association, National Association of Women Lawyers, National Federation of Business and Professional Women's Clubs, Inc.

William F. Schnitzler, Secretary-Treasurer, American Federation of Labor and Congress of Industrial Organizations

Dr. Caroline F. Ware, Vienna, Va.

Dr. Cynthia C. Wedel, Assistant General Secretary for Program, National Council of the Churches of Christ in the United States of America

Title VII of the Civil Rights Act of 1964

Sec. 703. (a) It shall be an unlawful employment practice for an employer—

(1) to fail or refuse to hire or to discharge any individual, or otherwise to discriminate against any individual with respect to his compensation, terms, conditions, or privileges of employment, because of such individual's race, color, religion, sex, or national origin; or

(2) to limit, segregate, or classify his employees in any way which would deprive or tend to deprive any individual of employment opportunities or otherwise adversely affect his status as an employee, because of such individual's race, color, religion, sex, or national origin.

(b) It shall be an unlawful employment practice for an employment agency to fail or refuse to refer for employment, or otherwise to discriminate against, any individual because of his race, color, religion, sex, or national origin, or to classify or refer for employment any individual on the basis of his race, color, religion, sex, or national origin.

(c) It shall be an unlawful employment practice for a labor organization—

(1) to exclude or to expel from its membership, or otherwise to discriminate against, any individual because of his race, color, religion, sex, or national origin;

(2) to limit, segregate, or classify its membership, or to classify or fail or refuse to refer for employment any individual, in any way which would deprive or tend to deprive any individual of employment opportunities, or would limit such employment opportunities or otherwise adversely affect his status as an employee or as an applicant for employment, because of such individual's race, color, religion, sex, or national origin; or

(3) to cause or attempt to cause an employer to discriminate against an individual in violation of this section. . . .

(e) Notwithstanding any other provision of this title, (1) it shall not be an unlawful employment practice for an employer to hire and employ employees, for an employment agency to classify, or refer for employment any individual, for a labor organization to classify its membership or to classify or refer for employment any individual, or for an employer, labor organization, or joint labor-management committee controlling apprenticeship or other training or retraining programs to admit or employ any individual in any such program, on the basis of his religion, sex, or national origin in those certain instances where religion, sex, or national origin is a bona fide occupational qualification reasonably necessary to the normal operation of that particular business or enterprise. . . .

Sec. 705. (a) There is hereby created a Commission to be known as the Equal Employment Opportunity Commission, which shall be composed of five members, not more than three of whom shall be members of the same political party, who shall be appointed by the President by and with the advice and consent of the Senate. . . .

(g) The Commission shall have power—

(1) to cooperate with and, with their consent, utilize regional, State, local, and other agencies, both public and private, and individuals; . . .

(3) to furnish to persons subject to this title such technical assistance as they may request to further their compliance with this title or an order issued thereunder;

(4) upon the request of (i) any employer, whose employees or some of them, or (ii) any labor organization, whose members or some of them, refuse or threaten to refuse to cooperate in effectuating the provisions of this title, to assist in such effectuation by conciliation or such other remedial action as is provided by this title;

(5) to make such technical studies as are appropriate to effectuate the purposes and policies of this title and to make the results of such studies available to the public;

(6) to refer matters to the Attorney General with recommendations for intervention in a civil action brought by an aggrieved party under section 706, or for the institution of a civil action by the Attorney General under section 707, and to advise, consult, and assist the Attorney General on such matters. . . .

From *Griswold v. Connecticut*, 381 U.S. 479 (1965)

MR. JUSTICE DOUGLAS delivered the opinion of the Court.

We think that appellants have standing to raise the constitutional rights of the married people with whom they had a professional relationship. . . . Certainly the accessory should have standing to assert that the offense which he is charged with assisting is not, or cannot constitutionally be, a crime. . . .

Coming to the merits, we are met with a wide range of questions that implicate the Due Process Clause of the Fifth Amendment. Overtones of some arguments suggest that *Lochner v. New York*, 198 U.S. 45, should be our guide. But we decline that invitation as we did in *West Coast Hotel Co. v. Parrish*, 300 U.S. 379; *Olsen v. Nebraska*, 313 U.S. 236; *Lincoln Union v. Northwestern Co.*, 335 U.S. 525; *Williamson v. Lee Optical Co.*, 348 U.S. 483;

Giboney v. Empire Storage Co., 336 U.S. 490. We do not sit as a superlegislature to determine the wisdom, need, and propriety of laws that touch economic problems, business affairs, or social conditions. This law, however, operates directly on an intimate relation of husband and wife and their physician's role in one aspect of that relation.

The association of people is not mentioned in the Constitution nor in the Bill of Rights. The right to educate a child in a school of the parent's choice—whether public or private or parochial—is also not mentioned. Nor is the right to study any particular subject or any foreign language. Yet the First Amendment has been construed to include certain of those rights.

By *Pierce v. Society of Sisters,* the right to educate one's children as one chooses is made applicable to the State by the force of the First and Fourteenth Amendments. By *Meyer v. Nebraska,* the same dignity is given the right to study the German language in a private school. In other words, the State may not, consistently with the spirit of the First Amendment, contract the spectrum of available knowledge. The right of freedom of speech and press includes not only the right to utter or to print, but the right to distribute, the right to receive, the right to read (*Martin v. Struthers,* 319 U.S. 141, 143) and freedom of inquiry, freedom of thought, and freedom to teach (*see Wieman v. Updegraff,* 344 U.S. 183, 195)—indeed the freedom of the entire university community. *Sweezy v. New Hampshire,* 354 U.S. 234, 249–50, 261–63; *Barenblatt v. United States,* 360 U.S. 109, 112; *Baggett v. Bullitt,* 377 U.S. 360, 369. Without those peripheral rights the specific rights would be less secure. And so we reaffirm the principle of the *Pierce* and the *Meyer* cases.

In *NAACP v. Alabama,* 357 U.S. 449, 462, we protected the "freedom to associate and privacy in one's associations," noting that freedom of association was a peripheral First Amendment right. . . . In other words, the First Amendment has a penumbra where privacy is protected from governmental intrusion. In like context, we have protected forms of "association" that are not political in the customary sense but pertain to the social, legal, and economic benefit of the members. *NAACP v. Button,* 371 U.S. 415, 430–31. . . .

Those cases involved more than the "right of assembly"—a right that extends to all irrespective of their race or ideology. *De Jonge v. Oregon,* 299 U.S. 353. The right of "association," like the right of belief (*Board of Education v. Barnette,* 319 U.S. 624), is more than the right to attend a meeting; it includes the right to express one's attitudes or philosophies by membership in a group or by affiliation with it or by other lawful means. Association in that context is a form of expression of opinion; and while it is not expressly included in the First Amendment its existence is necessary in making the express guarantees fully meaningful.

The foregoing cases suggest that specific guarantees in the Bill of Rights have penumbras, formed by emanations from those guarantees that help give them life and substance. Various guarantees create *zones* of privacy. The right of association contained in the penumbra of the First Amendment is one, as we have seen. The Third Amendment in its prohibition against the quartering of soldiers "in any house" in time of peace without the consent of the owner is another facet of that privacy. The Fourth Amendment explicitly affirms the "right of the people to be secure in their persons, houses, papers, and effects, against unreasonable searches and seizures." The Fifth Amendment in its Self-Incrimination Clause enables the citizen to create a zone of privacy which government may not force him to surrender to his detriment. The Ninth Amendment provides: "The enumeration in the Constitution, of certain rights, shall not be construed to deny or disparage others retained by the people."

The Fourth and Fifth Amendments were described in *Boyd v. United States,* 116 U.S. 616, 630, as protection against all governmental invasions "of the sanctity of a man's home and the privacies of life."* We recently referred in *Mapp v. Ohio,* 367 U.S. 643, 656, to the Fourth Amendment as creating a "right to privacy, no less important than any other right carefully and particularly reserved to the people."

We have had many controversies over these penumbral rights of "privacy and repose." *See, e.g., Breard v. Alexandria,* 341 U.S. 622, 626, 644; *Public Utilities Comm'n v. Pollak,* 343 U.S. 451; *Monroe v. Pape,* 365 U.S. 167; *Lanza v. New York,* 370 U.S. 139; *Frank v. Maryland,* 359 U.S. 360; *Skinner v. Oklahoma,* 316 U.S. 535, 541. These cases bear witness that the right of privacy which presses for recognition here is a legitimate one.

The present case, then, concerns a relationship lying within the zone of privacy created by several fundamental constitutional guarantees. And it concerns a law which, in forbidding the use of contraceptives rather than regulating their manufacture or sale, seeks to achieve its goals by means having a maximum destructive impact upon that relationship. Such a law cannot stand in light of the familiar principle, so often applied by this Court, that a "governmental purpose to control or prevent activities

* This Court, in a series of decisions, has held that the Fourteenth Amendment absorbs and applies to the States those specifics of the first eight amendments which express fundamental personal rights. The language and history of the Ninth Amendment reveal that the Framers of the Constitution believed that there are additional fundamental rights, protected from governmental infringement, which exist alongside those fundamental rights specifically mentioned in the first eight constitutional amendments.

constitutionally subject to state regulation may not be achieved by means which sweep unnecessarily broadly and thereby invade the area of protected freedoms." *NAACP v. Alabama*, 377 U.S. 288, 307. Would we allow the police to search the sacred precincts of marital bedrooms for telltale signs of the use of contraceptives? The very idea is repulsive to the notions of a privacy surrounding the marriage relationship.

We deal with the right of privacy older than the Bill of Rights—older than our political parties, older than our school system. Marriage is a coming together for better or for worse, hopefully enduring, and intimate to the degree of being sacred. It is an association that promotes a way of life, not causes; a harmony in living, not political faiths; a bilateral loyalty, not commercial or social projects. Yet it is an association for as noble a purpose as any involved in our prior decisions.

Reversed.

MR. JUSTICE GOLDBERG, whom THE CHIEF JUSTICE and MR. JUSTICE BRENNAN join, concurring.

I agree with the Court that Connecticut's birth-control law unconstitutionally intrudes upon the right of marital privacy, and I join in its opinion and judgment. Although I have not accepted the view that "due process" as used in the Fourteenth Amendment incorporates all of the first eight Amendments, I do agree that the concept of liberty protects those personal rights that are fundamental, and is not confined to the specific terms of the Bill of Rights. My conclusion that the concept of liberty is not so restricted and that it embraces the right of marital privacy though that right is not mentioned explicitly in the Constitution is supported both by numerous decisions of this Court, referred to in the Court's opinion, and by the language and history of the Ninth Amendment. In reaching the conclusion that the right of marital privacy is protected, as being within the protected penumbra of specific guarantees of the Bill of Rights, the Court refers to the Ninth Amendment, *ante*. I add these words to emphasize the relevance of that Amendment to the Court's holding.

The Court stated many years ago that the Due Process Clause protects those liberties that are "so rooted in the traditions and conscience of our people as to be ranked as fundamental." *Snyder v. Massachusetts*, 291 U.S. 97, 105. . . . And, in *Meyer v. Nebraska*, 262 U.S. 390, 399, the Court, referring to the Fourteenth Amendment, stated:

> While this Court has not attempted to define with exactness the liberty thus guaranteed, the term has received much consideration and some of the included things have been definitely stated. Without doubt, it denotes not merely freedom from bodily restraint but also [for example,] the right . . . to marry, establish a home and bring up children. . . .

This Court, in a series of decisions, has held that the Fourteenth Amendment absorbs and applies to the States those specifics of the first eight amendments which express fundamental personal rights. The language and history of the Ninth Amendment reveal that the Framers of the Constitution believed that there are additional fundamental rights, protected from governmental infringement, which exist alongside those fundamental rights specifically mentioned in the first eight constitutional amendments.

The Ninth Amendment reads, "The enumeration in the Constitution, of certain rights, shall not be construed to deny or disparage others retained by the people." . . . To hold that a right so basic and fundamental and so deep-rooted in our society as the right of privacy in marriage may be infringed because that right is not guaranteed in so many words by the first eight amendments to the Constitution is to ignore the Ninth Amendment and to give it no effect whatsoever. Moreover, a judicial construction that this fundamental right is not protected by the Constitution because it is not mentioned in explicit terms by one of the first eight amendments or elsewhere in the Constitution would violate the Ninth Amendment, which specifically states that "[t]he enumeration in the Constitution, of certain rights, shall not be *construed* to deny or disparage others retained by the people." (Emphasis added.) . . . [T]he Ninth Amendment shows a belief of the Constitution's authors that fundamental rights exist that are not expressly enumerated in the first eight amendments and an intent that the list of rights included there not be deemed exhaustive . . . [and] that other fundamental personal rights should not be denied . . . protection or disparaged in any other way simply because they are not specifically listed in the first eight constitutional amendments. . . . I do not see how this broadens the authority of the Court; rather it serves to support what this Court has been doing in protecting fundamental rights.

Nor am I turning somersaults with history in arguing that the Ninth Amendment is relevant in a case dealing with a *State's* infringement of a fundamental right. While the Ninth Amendment—and indeed the entire Bill of Rights—originally concerned restrictions upon *federal* power, the subsequently enacted Fourteenth Amendment prohibits the States as well from abridging fundamental personal liberties. And, the Ninth Amendment, in indicating that not all such liberties are specifically mentioned in the first eight amendments, is surely relevant in showing the existence of other fundamental personal rights, now protected from state, as well as federal, infringement.

In determining which rights are fundamental, judges are not left at large to decide cases in light of their personal and private notions. Rather, they must look to the "traditions and [collective] conscience of our people" to determine whether a principle is "so rooted [there] . . . as to be ranked as fundamental." *Snyder v. Massachusetts*, 291 U.S. 97, 105. The inquiry is whether a right involved "is of such a character that it cannot be denied without violating those 'fundamental principles of liberty and justice which lie at the base of all our civil and political institutions'. . . ." *Powell v. Alabama*, 287 U.S. 45, 65. . . .

The Connecticut statutes here involved deal with a particularly important and sensitive area of privacy—that of the marital relation and the marital home. This Court recognized in *Meyer v. Nebraska, supra*, that the right "to marry, establish a home and bring up children" was an essential part of the liberty guaranteed by the Fourteenth Amendment, 262 U.S., at 399. In *Pierce v. Society of Sisters*, 268 U.S. 510, the Court held unconstitutional an Oregon Act which forbade parents from sending their children to private schools because such an act "unreasonably interferes with the liberty of parents and guardians to direct the upbringing and education of children under their control." 268 U.S., at 534–35. As this Court said in *Prince v. Massachusetts*, 321 U.S. 158, at 166, the *Meyer* and *Pierce* decisions "have respected the private realm of family life which the state cannot enter." . . .

The logic of the dissents would sanction federal or state legislation that seems to me even more plainly unconstitutional than the statute before us. Surely the Government, absent a showing of a compelling subordinating state interest, could not decree that all husbands and wives must be sterilized after two children have been born to them. Yet by their reasoning such an invasion of marital privacy would not be subject to constitutional challenge because, while it might be "silly," no provision of the Constitution specifically prevents the Government from curtailing the marital right to bear children and raise a family. While it may shock some of my Brethren that the Court today holds that the Constitution protects the right of marital privacy, in my view it is far more shocking to believe that the personal liberty guaranteed by the Constitution does not include protection against such totalitarian limitation of family size, which is at complete variance with our constitutional concepts. Yet, if upon a showing of a slender basis of rationality, a law outlawing voluntary birth control by married persons is valid, then, by the same reasoning, a law requiring compulsory birth control also would seem to be valid. In my view, however, both types of law would unjustifiably intrude upon rights of marital privacy which are constitutionally protected. . . .

MR. JUSTICE HARLAN, concurring in the judgment.

I fully agree with the judgment of reversal, but find myself unable to join the Court's opinion. The reason is that it seems to me to evince an approach to this case very much like that taken by my Brothers BLACK and STEWART in dissent, namely: The Due Process Clause of the Fourteenth Amendment does not touch this Connecticut statute unless the enactment is found to violate some right assured by the letter or penumbra of the Bill of Rights. . . .

In my view, the proper constitutional inquiry in this case is whether this Connecticut statute infringes the Due Process Clause of the Fourteenth Amendment because the enactment violates basic values "implicit in the concept of ordered liberty," *Palko v. Connecticut*, 302 U.S. 319, 325. For reasons stated at length in my dissenting opinion in *Poe v. Ullman*, I believe that it does.

[In *Poe*, J. HARLAN said, in part:

Certainly the safeguarding of the home does not follow merely from the sanctity of property rights. The home derives its pre-eminence as the seat of family life. And the integrity of that life is something so fundamental that it has been found to draw to its protection the principles of more than one explicitly granted Constitution right. . . . Of this whole "private realm of family life" it is difficult to imagine what is more private or more intimate than a husband and wife's marital relations. . . .

Adultery, homosexuality and the like are sexual intimacies which the State forbids . . . but the intimacy of husband and wife is necessarily an essential and accepted feature of the institution of marriage, an institution which the State not only must allow, but which always and in every age it has fostered and protected. It is one thing when the State exerts its power either to forbid extra-marital sexuality . . . or to say who may marry, but it is quite another when, having acknowledged a marriage and the intimacies inherent in it, it undertakes to regulate by means of the criminal law the details of that intimacy.]

MR. JUSTICE WHITE, concurring in the judgment.

In my view the Connecticut law as applied to married couples deprives them of "liberty" without due process of law, as that concept is used in the Fourteenth Amendment. I therefore concur in the judgment of the Court reversing these convictions under Connecticut's aiding and abetting statute.

It would be unduly repetitious, and belaboring the obvious, to expound on the impact of this statute on the liberty guaranteed by the Fourteenth Amendment against arbitrary or capricious denials or on the nature of this liberty. Suffice it to say that this is not the first time this Court has had occasion to articulate that the liberty entitled to protection under the Fourteenth Amendment includes the right "to marry, establish a home and bring up children," *Meyer v. Nebraska*, 262 U.S. 390, 399, and "the liberty . . . to direct the upbringing and education

of children," *Pierce v. Society of Sisters,* 268 U.S. 510, 534–35, and that these are among "the basic civil rights of man." *Skinner v. Oklahoma,* 316 U.S. 535, 541. These decisions affirm that there is a "realm of family life which the state cannot enter" without substantial justification. *Prince v. Massachusetts,* 321 U.S. 158, 166. Surely the right invoked in this case, to be free of regulation of the intimacies of the marriage relationship, "come[s] to this Court with a momentum for respect lacking when appeal is made to liberties which derive merely from shifting economic arrangements." *Kovacs v. Cooper,* 336 U.S. 77, 95 (opinion of Frankfurter, J.).

The Connecticut anti-contraceptive statute deals rather substantially with this relationship. For it forbids all married persons the right to use birth-control devices, regardless of whether their use is dictated by considerations of family planning, health, or indeed even of life itself. In my view, a statute with these effects bears a substantial burden of justification when attacked under the Fourteenth Amendment. *Yick Wo v. Hopkins,* 118 U.S. 356; *Skinner v. Oklahoma,* 316 U.S. 535; *Schware v. Board of Bar Examiners,* 353 U.S. 232; *McLaughlin v. Florida,* 379 U.S. 184, 192.

An examination of the justification offered, however, cannot be avoided by saying that the Connecticut anti-use statute invades a protected area of privacy and association or that it demeans the marriage relationship. The nature of the right invaded is pertinent, to be sure, for statutes regulating sensitive areas of liberty do, under the cases of this Court, require "strict scrutiny," *Skinner v. Oklahoma,* 316 U.S. 535, 541, and "must be viewed in the light of less drastic means for achieving the same basic purpose." *Shelton v. Tucker,* 364 U.S. 479, 488. "Where there is a significant encroachment upon personal liberty, the State may prevail only upon showing a subordinating interest which is compelling." *Bates v. Little Rock,* 361 U.S. 516, 524. *See also McLaughlin v. Florida,* 379 U.S. 184. But such statutes, if reasonably necessary for the effectuation of a legitimate and substantial state interest, and not arbitrary or capricious in application, are not invalid under the Due Process Clause. *Zemel v. Rusk,* 381 U.S. 1. . . . [The] State claims but one justification for its anti-use statute. There is no serious contention that Connecticut thinks the use of artificial or external methods of contraception immoral or unwise in itself, or that the anti-use statute is founded upon any policy of promoting population expansion. Rather, the statute is said to serve the State's policy against all forms of promiscuous or illicit sexual relationships, be they premarital or extramarital, concededly a permissible and legitimate legislative goal.

Without taking issue with the premise that the fear of conception operates as a deterrent to such relationships in addition to the criminal proscriptions Connecticut has against such conduct, I wholly fail to see how the ban on the use of contraceptives by married couples in any

way reinforces the State's ban on illicit sexual relationships. . . . Perhaps the theory is that the flat ban on use prevents married people from possessing contraceptives and without the ready availability of such devices for use in the marital relationship, there will be no or less temptation to use them in extramarital ones. This reasoning rests on the premise that married people will comply with the ban in regard to their marital relationship, notwithstanding total nonenforcement in this context and apparent nonenforcibility, but will not comply with criminal statutes prohibiting extramarital affairs and the anti-use statute in respect to illicit sexual relationships, a premise whose validity has not been demonstrated and whose intrinsic validity is not very evident. At most the broad ban is of marginal utility to the declared objective. A statute limiting its prohibition on use to persons engaging in the prohibited relationship would serve the end posited by Connecticut in the same way, and with the same effectiveness or ineffectiveness, as the broad anti-use statue under attack in this case. I find nothing in this record justifying the sweeping scope of this statue, with its telling effect on the freedoms of married persons, and therefore conclude that it deprives such persons of liberty without due process of law.

National Organization for Women (NOW) Statement of Purpose

(Adopted at the organizing conference in Washington, D.C., October 29, 1966)

We, men and women, who hereby constitute ourselves as the National Organization for Women, believe that the time has come for a new movement toward true equality for all women in America, and toward a fully equal partnership of the sexes, as part of the world-wide revolution of human rights now taking place within and beyond our national borders.

The purpose of NOW is to take action to bring women into full participation in the mainstream of American society now, exercising all the privileges and responsibilities thereof in truly equal partnership with men.

We believe the time has come to move beyond the abstract argument, discussion and symposia over the status and special nature of women which has raged in America in recent years; the time has come to confront, with concrete action, the conditions that now prevent women from enjoying the equality of opportunity and freedom of which is their right, as individual Americans, and as human beings.

NOW is dedicated to the proposition that women, first and foremost, are human beings, who, like all other people in our society, must have the chance to develop their fullest human potential. We believe that women can achieve such equality only by accepting to the full the

challenges and responsibilities they share with all other people in our society, as part of the decision-making mainstream of American political, economic and social life.

We organize to initiate or support action, nationally, or in any part of this nation, by individuals or organizations, to break through the silken curtain of prejudice and discrimination against women in government, industry, the professions, the churches, the political parties, the judiciary, the labor unions, in education, science, medicine, law, religion and every other field of importance in American society. Enormous changes taking place in our society make it both possible and urgently necessary to advance the unfinished revolution of women toward true equality, now. With a life span lengthened to nearly 75 years it is no longer either necessary or possible for women to devote the greater part of their lives to childrearing; yet childbearing and rearing which continues to be a most important part of most women's lives—still is used to justify barring women from equal professional and economic participation and advance.

Today's technology has reduced most of the productive chores which women once performed in the home and in mass-production industries based upon routine unskilled labor. This same technology has virtually eliminated the quality of muscular strength as a criterion for filling most jobs, while intensifying American industry's need for creative intelligence. In view of this new industrial revolution created by automation in the midtwentieth century, women can and must participate in old and new fields of society in full equality—or become permanent outsiders.

Despite all the talk about the status of American women in recent years, the actual position of women in the United States has declined, and is declining, to an alarming degree throughout the 1950's and '60s. Although 46.4% of all American women between the ages of 18 and 65 now work outside the home, the overwhelming majority—75%—are in routine clerical, sales, or factory jobs, or they are household workers, cleaning women, hospital attendants. About two-thirds of Negro women workers are in the lowest paid service occupations. Working women are becoming increasingly—not less—concentrated on the bottom of the job ladder. As a consequence full-time women workers today earn on the average only 60% of what men earn, and that wage gap has been increasing over the past twenty-five years in every major industry group. In 1964, of all women with a yearly income, 89% earned under $5,000 a year; half of all full-time year round women workers earned less than $3,690; only 1.4% of full-time year round women workers had an annual income of $10,000 or more.

Further, with higher education increasingly essential in today's society, too few women are entering and finishing college or going on to graduate or professional school. Today, women earn only one in three of the B.A.'s and M.A.'s granted, and one in ten of the Ph.D.'s.

In all the professions considered of importance to society, and in the executive ranks of industry and government, women are losing ground. Where they are present it is only a token handful. Women comprise less than 1% of federal judges; less than 4% of all lawyers; 7% of doctors. Yet women represent 51% of the U.S. population. And, increasingly men are replacing women in the top positions in secondary and elementary schools, in social work, and in libraries—once thought to be women's fields.

Official pronouncements of the advance in the status of women hide not only the reality of this dangerous decline, but the fact that nothing is being done to stop it. The excellent reports of the President's Commission on the Status of Women and of the State Commissions have not been fully implemented. Such Commissions have power only to advise. They have no power to enforce their recommendations; nor have they the freedom to organize American women and men to press for action on them. The reports of these commissions have, however created a basis upon which it is now possible to build.

Discrimination in employment on the basis of sex is now prohibited by federal law, in Title VII of the Civil Rights Act of 1964. But although nearly one-third of the cases brought before the Equal Employment Opportunity Commission during the first year dealt with sex discrimination and the proportion is increasing dramatically, the Commission has not made clear its intention to enforce the law with the same seriousness on behalf of women as of other victims of discrimination. Many of these cases were Negro women, who are the victims of the double discrimination of race and sex. Until now, too few women's organizations and official spokesmen have been willing to speak out against these dangers facing women. Too many women have been restrained by the fear of being called "feminist."

There is no civil rights movement to speak for women, as there has been for Negroes and other victims of discrimination. The National Organization for Women must therefore begin to speak.

WE BELIEVE that the power of American law, and the protection guaranteed by the U.S. Constitution to the civil rights of all individuals, must be effectively applied and enforced to isolate and remove patterns of sex discrimination, to ensure equality of opportunity in employment and education, and equality of civil and political rights and responsibilities on behalf of women, as well as for Negroes and other deprived groups.

We realize that women's problems are linked to many broader questions of social justice; their solution will require concerted action by many groups. Therefore,

convinced that human rights for all are indivisible, we expect to give active support to the common cause of equal rights for all those who suffer discrimination and deprivation, and we call upon other organizations committed to such goals to support our efforts toward equality for women.

WE DO NOT ACCEPT the token appointment of a few women to high-level positions in government and industry as a substitute for a serious continuing effort to recruit and advance women according to their individual abilities. To this end, we urge American government and industry to mobilize the same resources of ingenuity and command with which they have solved problems of far greater difficulty than those now impeding the progress of women.

WE BELIEVE that this nation has a capacity at least as great as other nations, to innovate new social institutions which will enable women to enjoy true equality of opportunity and responsibility in society, without conflict with their responsibilities as mothers and homemakers. In such innovations, America does not lead the Western world, but lags by decades behind many European countries. We do not accept the traditional assumption that a woman has to choose between marriage and motherhood, on the one hand, and serious participation in industry or the professions on the other. We question the present expectation that all normal women will retire from job or profession for 10 or 15 years, to devote their full time to raising children, only to reenter the job market at a relatively minor level. This in itself, is a deterrent to the aspirations of women, to their acceptance into management or professional training courses, and to the very possibility of equality of opportunity or real choice, for all but a few women. Above all, we reject the assumption that these problems are the unique responsibility of each individual woman, rather than a basic social dilemma which society must solve. True equality of opportunity and freedom of choice for women requires such practical, and possible innovations as a nationwide network of child-care centers which will make it unnecessary for women to retire completely from society until their children are grown, and national programs to provide retraining for women who have chosen to care for their own children full-time.

WE BELIEVE that it is as essential for every girl to be educated to her full potential of human ability as it is for every boy—with the knowledge that such education is the key to effective participation in today's economy and that, for a girl as for boy, education can only be serious where there is expectation that it be used in society. We believe that American educators are capable of devising means of imparting such expectations to girl students. Moreover, we consider the decline in the proportion of women receiving higher and professional education to be evidence of discrimination. This discrimination may take the form of quotas against the admission of women to colleges, and professional schools; lack of encouragement by parents, counselors and educators; denial of loans or fellowships; or the traditional or arbitrary procedures in graduate and professional training geared in terms of men, which inadvertently discriminate against women. We believe that the same serious attention must be given to high school dropouts who are girls as to boys.

WE REJECT the current assumptions that a man must carry the sole burden of supporting himself, his wife, and family, and that a woman is automatically entitled to lifelong support by a man upon her marriage, or that marriage, home and family are primarily woman's world and responsibility—hers to dominate—his to support. We believe that a true partnership between the sexes demands a different concept of marriage an equitable sharing of the responsibilities of home and children and of the economic burdens of their support. We believe that proper recognition should be given to the economic and social value of homemaking and child-care. To these ends we will seek to open a reexamination of laws and mores governing marriage and divorce, for we believe that the current state of "half-equality" between the sexes discriminates against both men and women, and is the cause of much unnecessary hostility between the sexes.

WE BELIEVE that women must now exercise their political rights and responsibility as American citizens. They must refuse to be segregated on the basis of sex into separate-and-not-equal ladies auxiliaries in the political parties, and they must demand representation according to their numbers in the regularly constituted part committees—at local, state, and national levels—and in the informal power structure, participating fully in the selection of candidates and political decision-making, and running for office themselves.

IN THE INTERESTS OF THE HUMAN DIGNITY OF WOMEN, we will protest, and endeavor to change, the false image of women now prevalent in the mass media, and in the texts, ceremonies, laws, and practices of our major social institutions. Such images perpetuate contempt for women by society and by women for themselves. We are similarly opposed to all policies and practices—in church, state, college, factory, or office—which, in the guise of protectiveness, not only deny opportunities but also foster in women self-denigration, dependence, and evasion of responsibility, undermine their confidence in their own abilities and foster contempt for women.

NOW WILL HOLD ITSELF INDEPENDENT OF ANY POLITICAL PARTY in order to mobilize the political power of all women and men intent on our goals. We will strive to ensure that no party, candidate, president, senator, governor, congressman, or any public official who betrays or ignores the principle of full

equality between the sexes is elected or appointed to office. If it is necessary to mobilize the votes of men and women who believe in our cause, in order to win for women the final right to be fully free and equal human beings, we so commit ourselves.

WE BELIEVE THAT women will do most to create a new image of women by acting now, and by speaking out in behalf of their own equality, freedom, and human dignity—not in pleas for special privilege, nor in enmity toward men, who are also victims of the current, half-equality between the sexes—but in an active, self-respecting partnership with men. By so doing, women will develop confidence in their own ability to determine actively, in partnership with men, the conditions of their life, their choices, their future and their society.

National Organization for Women Bill of Rights in 1968

(Adopted at the 1967 National Conference)
I. Equal Rights Constitutional Amendment
II. Enforce Law Banning Sex Discrimination in Employment
III. Maternity Leave Rights in Employment and in Social Security Benefits
IV. Tax Deduction for Home and Child Care Expenses for Working Parents
V. Child Day Care Centers
VI. Equal and Unsegregated Education
VII. Equal Job Training Opportunities and Allowances for Women in Poverty
VIII. The Right of Women to Control their Reproductive Lives

We Demand:

I. That the United States Congress immediately pass the Equal Rights Amendment to the Constitution to provide that "Equality of rights under the law shall not be denied or abridged by the United States or by any State on account of sex" and that such then be immediately ratified by the several States.

II. That equal employment opportunity be guaranteed to all women, as well as men by insisting that the Equal Employment Opportunity Commission enforce the prohibitions against sex discrimination in employment under Title VII of the Civil Rights Act of 1964 with the same vigor as it enforces the prohibitions against racial discrimination.

III. That women be protected by law to insure their rights to return to their jobs within a reasonable time after childbirth without loss of seniority or other accrued

benefits and be paid maternity leave as a form of social security and/or employee benefit.

IV. Immediate revision of tax laws to permit the deduction of home and child care expenses for working parents.

V. That child care facilities be established by law on the same basis as parks, libraries and public schools adequate to the needs of children, from the pre-school years through adolescence, as a community resource to be used by all citizens from all income levels.

VI. That the right of women to be educated to their full potential equally with men be secured by Federal and State legislation, eliminating all discrimination and segregation by sex, written and unwritten, at all levels of education including college, graduate and professional schools, loans and fellowships and Federal and State training programs, such as the job Corps.

VII. The right of women in poverty to secure job training, housing and family allowances on equal terms with men, but without prejudice to a parent's right to remain at home to care for his or her children; revision of welfare legislation and poverty programs which deny women dignity, privacy and self respect.

VIII. The right of women to control their own reproductive lives by removing from penal codes the laws limiting access to contraceptive information and devices and laws governing abortion.

National Organization for Women, Statement on Lesbian Rights (1971)

WHEREAS the first wave of feminist anger in this Country recognized the fundamental issue of women's liberation as "the most sacred right of all—a woman's right to her own person." This is the right that NOW reaffirmed a century later when it took up the banner and dedicated itself to changing those conditions in society, the laws, the practices, the attitudes—that prevented women from realizing their full human potential. Recognizing that a woman cannot reach this potential if she is denied the basic right to control her own body, NOW has demanded the dissemination of birth control information and contraceptives and the repeal of all laws against abortion. It has stopped short, however, of clarifying its position on every woman's right to define—and express—her own sexuality, to choose her own lifestyle. Specifically, NOW has been silent on the issue of lesbianism. Yet no other woman suffers more abuse and discrimination for the right to be her own person than does the lesbian, and

WHEREAS, the lesbian is doubly oppressed, both as a woman and as a homosexual, she must face the injustices

and degradation common to all women, plus endure additional social, economic, legal, and psychological abuse as well. In education and employment, the lesbian confronts more than discrimination or tokenism. She can be arbitrarily rejected or dismissed from many professions, even those—such as teaching—traditionally relegated to women. Married women are denied equality under laws that decree men as head of the household, but a wife is nonetheless allowed some legal protection. A lesbian, however, who shares her home with another woman—regardless of her income or responsibilities— forgoes all the economic and legal compensations granted to the married woman, including the tax deductions, insurance benefits, inheritance rights, etc., and

WHEREAS, this prejudice against the lesbian is manifested in the courts as well, and

WHEREAS, most divorced women are conceded the right to their children, a lesbian is automatically presumed unfit for motherhood, and can have her children taken from her, and

WHEREAS, these are but a few of the laws and practices in our society that reflect irrational assumptions about lesbians. Just as the false and demeaning image of all women provides the rationale to keep them subjugated, so does the distorted stereotype of the lesbian sanction her persecution. Not only is she assumed to be unstable or sick or immoral; but because she defines herself independently of men, the lesbian is considered unnatural, incomplete, not quite a woman—as though the essence of womanhood were to be identified with men. Obviously, this *Playboy* image of the lesbian reduces her to an abject sexual object, deprived of the most basic civil and human rights due every person, and

WHEREAS, because she is so oppressed and so exploited, the lesbian has been referred to as "the rage of all women condensed to the point of explosion." This rage found a natural outlet in the women's liberation movement that seemed to view women in a new way and promised a new pride and sisterhood for every woman in search of equality and independence. Lesbians became active in NOW and in other groups, fighting for all the feminist goals, including child care centers and abortion repeal. As a result of their activism in the movement, lesbians—as did all feminists— reached a new consciousness, a new sense of their worth and dignity as women and human beings. They began to rebel against the intolerance of a society that condemned their lifestyle, but instead of finding support from their sisters, lesbians discovered that NOW and other liberation groups reflected some of the same prejudices and policies of the sexist society they were striving to change, and

WHEREAS, lesbians were never excluded from NOW, but we have been evasive or apologetic about their presence within the organization. Afraid of alienating public support, we have often treated lesbians as the step-sisters of the movement, allowed to work with us, but then expected to hide in the upstairs closet when company comes. Lesbians are now telling us that this attitude is no longer acceptable. Asking women to disguise their identities so they will not "embarrass" the group is an intolerable form of oppression, like asking black women to join us in white face. Furthermore, this discrimination is inconsistent with NOW's stated goal to "recognize our sisterhood" and to help women "overcome self-degradation." If this pledge is to be anything more than idle rhetoric, NOW must reassess the priorities that sacrifice principle to "image," and

WHEREAS, some members of NOW object that the lesbian question is too controversial to confront right now, that we will weaken the movement by alienating potential and current members who are comfortable with NOW's "respectable" image. The same argument, that women would be frightened away, was raised a few years ago when NOW took a bold stand on the controversial abortion issue. The argument did not prove prophetic then, and we do not believe it is valid now. We are, after all, a reform movement, with revolutionary goals. The D.A.R. can be "respectable," but as Susan B. Anthony pointed out:

> "Cautious, careful people always casting about to preserve their reputation or social standards, can never bring about a reform . . ."

WHEREAS, it is encouraging to note that feminists are not so easily frightened. Since the resolution supporting lesbians was passed in Los Angeles NOW two months ago, the chapter has increased, not decreased, in membership. If a few cautious, careful people scurried away, the loss was imperceptible. And we are stronger now because many women feel more relaxed and are freer to work with us towards NOW goals, and

WHEREAS, another objection to the resolution contends that lesbian oppression is simply not "relevant" to the concerns of NOW; "the movement will be weakened or even destroyed" if we diffuse our energies on non-feminist issues. This is a curious argument, since all one has to do is read the NOW Bill of Rights to find that we have pledged support to the cause of "equal rights for all those who suffer discrimination and deprivation;" further, we have recognized a "common oppression that affects all women." If lesbians are women, and if lesbians suffer discrimination and deprivation, then the conclusion is inescapable: their oppression is not only relevant, but an integral part of the women's liberation movement, and

WHEREAS, we are affected by society's prejudices against the lesbian, whether we acknowledge it or not; as feminists we are all subject to lesbian-baiting by opponents who use the tactic of labeling us the worst thing they can think of, "lesbians," in order to divide and discredit the movement and bring women to heel. Even within NOW, regrettably, this tactic is employed by some members who conjure up the sexist-image of lesbians and shout "lavender menace" at anyone who opposes their views. NOW is inevitably weakened by these attempts to undermine the spirit and efforts of its members; we can no longer afford to ignore the problem; and

WHEREAS, the resolution does not mean that we are changing our emphasis and concentrating on specific lesbian issues, however. We have not been asked, nor do we intend, to diffuse our energies in any way. The resolution, in itself, is an action—the first step towards breaking down the barriers between women that have kept them weak and suppressed. We are giving notice that we recognize our sisterhood with all women and that we are fighting for every woman's "sacred right to her own person." As feminists, we can do no less;

THEREFORE, BE IT RESOLVED: That NOW recognizes the double oppression of women who are lesbians, and

BE IT FURTHER RESOLVED: That a woman's right to her own person includes the right to define and express her own sexuality and to choose her own lifestyle, and

BE IT FURTHER RESOLVED: That NOW acknowledge the oppression of lesbians as a legitimate concern of feminism.

From *Reed v. Reed,* 404 U.S. 71 (1971)

MR. CHIEF JUSTICE BURGER delivered the opinion of the Court.

. . . Having examined the record and considered the briefs and oral arguments of the parties, we have concluded that the arbitrary preference established in favor of males by §15–314 of the Idaho Code cannot stand in the face of the Fourteenth Amendment's command that no state deny the equal protection of the laws to any person within its jurisdiction.

Idaho does not, of course, deny letters of administration to women altogether. Indeed, under §15–312, a woman whose spouse dies intestate has a preference over a son, father, brother, or any other male relative of the decedent. Moreover, we can judicially notice that in this country, presumably due to the greater longevity of women, a large proportion of estates, both intestate and under wills of decedents, are administered by surviving widows.

Section 15–314 is restricted in its operation to those situations where competing applications for letters of administration have been filed by both male and female members of the same entitlement class established by §15-312. In such situations, §15-314 provides that different treatment be accorded to the applicants on the basis of their sex; it thus establishes a classification subject to scrutiny under the Equal Protection Clause.

In applying that clause, this Court has consistently recognized that the Fourteenth Amendment does not deny to States the power to treat different classes of persons in different ways. *Barbier v. Connolly,* 113 U.S. 27 (1885); *Lindsley v. Natural Carbonic Gas Co.,* 220 U.S. 61 (1911); *Railway Express Agency v. New York,* 336 U.S. 106 (1949); *McDonald v. Board of Election Commissioners,* 394 U.S. 802 (1969). The Equal Protection Clause of that amendment does, however, deny to States the power to legislate that different treatment be accorded to persons placed by a statute into different classes on the basis of criteria wholly unrelated to the objective of that statute. A classification "must be reasonable, not arbitrary, and must rest upon some ground of difference having a fair and substantial relation to the object of the legislation, so that all persons similarly circumstanced shall be treated alike." *Royster Guano Co. v. Virginia,* 253 U.S. 412, 415 (1920). The question presented by this case, then, is whether a difference in the sex of competing applicants for letters of administration bears a rational relationship to a state objective that is sought to be advanced by the operation of §15–312 and 15–314.

In upholding the latter section, the Idaho Supreme Court concluded that its objective was to eliminate one area of controversy when two or more persons, equally entitled under §15–312, seek letters of administration and thereby present the probate court "with the issue of which one should be named." The court also concluded that where such persons are not of the same sex, the elimination of females from consideration "is neither an illogical nor arbitrary method devised by the legislature to resolve an issue that would otherwise require a hearing as to the relative merits . . . of the two or more petitioning relatives. . . ." 93 Idaho, at 514, 465 P.2d, at 638.

Clearly the objective of reducing the workload on probate courts by eliminating one class of contests is not without some legitimacy. The crucial question, however, is whether §15–314 advances that objective in a manner consistent with the command of the Equal Protection Clause. We hold that it does not. To give a mandatory preference to members of either sex over members of the other, merely to accomplish the elimination of hearings on the merits, is to make the very kind of arbitrary legislative choice forbidden by the Equal Protection Clause of the Fourteenth Amendment; and whatever may be said as to the positive values of avoiding intrafamily con-

troversy, the choice in this context may not lawfully be mandated solely on the basis of sex.

We note finally that if §15–314 is viewed merely as a modifying appendage to §15–312 and as aimed at the same objective, its constitutionality is not thereby saved. The objective of §15–312 clearly is to establish degrees of entitlement of various classes of persons in accordance with their varying degrees and kinds of relationship to the intestate. Regardless of their sex, persons within any one of the enumerated classes of that section are similarly situated with respect to that objective. By providing dissimilar treatment for men and women who are thus similarly situated, the challenged section violates the Equal Protection Clause. *Royster Guano Co. v. Virginia, supra.*

The judgment of the Idaho Supreme Court is reversed and the case remanded for further proceedings not inconsistent with this opinion.

Reversed and remanded.

From *Roe v. Wade,* 410 U.S. 113 (1973) and *Doe v. Bolton,* 410 U.S. 179 (1973)

MR. JUSTICE BLACKMUN delivered the opinion of the Court [for *Roe v. Wade*].

. . .

We forthwith acknowledge our awareness of the sensitive and emotional nature of the abortion controversy, of the vigorous opposing views, even among physicians, and of the deep and seemingly absolute convictions that the subject inspires. One's philosophy, one's experiences, one's religious training, one's attitudes toward life and family and their values, and the moral standards one establishes and seeks to observe, are all likely to influence and to color one's thinking and conclusions about abortion.

In addition, population growth, pollution, poverty, and racial overtones tend to complicate and not to simplify the problem.

Our task, of course, is to resolve the issue by constitutional measurement, free of emotion and of predilection. We seek earnestly to do this, and, because we do, we have inquired into, and in this opinion place some emphasis upon, medical and medical-legal history and what that history reveals about man's attitudes toward the abortion procedure over the centuries. . . .

V

The principal thrust of appellant's attack on the Texas statutes is that they improperly invade a right, said to be possessed by the pregnant woman, to choose to terminate her pregnancy. Appellant would discover this right in the concept of personal "liberty" embodied in the Fourteenth Amendment's Due Process Clause; or in personal, mari-

tal, familial, and sexual privacy said to be protected by the Bill of Rights or its penumbras, *see Griswold v. Connecticut,* 381 U.S. 479 (1965); *Eisenstadt v. Baird,* 405 U.S. 438 (1972); *id.* at 460 (WHITE, J., concurring in result); or among those rights reserved to the people by the Ninth Amendment, *Griswold v. Connecticut,* 381 U.S. at 486 (Goldberg, J., concurring). Before addressing this claim, we feel it desirable briefly to survey, in several aspects, the history of abortion, for such insight as that history may afford us, and then to examine the state purposes and interests behind the criminal abortion laws.

VI

It perhaps is not generally appreciated that the restrictive criminal abortion laws in effect in a majority of States today are of relatively recent vintage. Those laws, generally proscribing abortion or its attempt at any time during pregnancy except when necessary to preserve that pregnant woman's life, are not of ancient or even of common-law origin. Instead, they derive from statutory changes effected, for the most part, in the latter half of the nineteenth century.

1. *Ancient attitudes.* These are not capable of precise determination. . . . [A]bortion was practiced in Greek times as well as in the Roman Era,[9] and . . . "it was resorted to without scruple."[10] . . . If abortion was prosecuted in some places, it seems to have been based on a concept of a violation of the father's right to his offspring. Ancient religion did not bar abortion.[12]

2. *The Hippocratic Oath.* What then of the famous Oath that has stood so long as the ethical guide of the medical profession and that bears the name of the great Greek (460?–377? B.C.), who has been described as the Father of Medicine . . . ? The Oath was not uncontested even in Hippocrates' day; only the Pythagorean school of philosophers frowned upon the related act of suicide. Most Greek thinkers, on the other hand, commended abortion, at least prior to viability. *See* Plato, *Republic,* V, 461; Aristotle, *Politics,* VII, 1335b 25. For the Pythagoreans, however, it was a matter of dogma. For them the embryo was animate from the moment of

[9]J. Ricci, *The Genealogy of Gynaecology,* 52, 84, 113, 149, (2d ed. 1950) (hereinafter Ricci); L. Lader, *Abortion* 75–77 (1966) (hereinafter Lader); K. Niswander, *Medical Abortion Practices in the United States in Abortion and the Law* 37, 38–40 (D. Smith ed. 1967); G. Williams, *The Sanctity of Life and the Criminal Law* 148 (1957) (hereinafter Williams); J. Noonan, "An Almost Absolute Value in History," in *The Morality of Abortion* 1, 3–7 (J. Noonaned. 1970) (hereinafter Noonan); Quay *Justifiable Abortion—Medical and Legal Foundations* (pt. 2), 49 Geo. L. J. 395, 406–42 (1961) (hereinafter Quay).
[10]L. Edelstein, *The Hippocratic Oath* 10 (1943) (hereinafter Edelstein).
[12]Edelstein 13–14.

conception, and abortion meant destruction of a living being. The abortion clause of the Oath, therefore, "echoes Pythagorean doctrines," and "[i]n no other stratum of Greek opinion were such views held or proposed in the same spirit of uncompromising austerity."[17] . . . But with the end of antiquity a decided change took place. Resistance against suicide and against abortion became common. The Oath came to be popular. The emerging teachings of Christianity were in agreement with the Pythagorean ethic. The Oath "became the nucleus of all medical ethics" and "was applauded as the embodiment of truth."[19] . . .

This . . . enables us to understand, in historical context, a long-accepted and revered statement of medical ethics.

3. *The common law.* It is undisputed that at common law, abortion performed *before* "quickening"—the first recognizable movement of the fetus *in utero,* appearing usually from the 16th to the 18th week of pregnancy—was not an indictable offense. . . . Christian theology and the canon law came to fix the point of animation at 40 days for a male and 80 days for a female, a view that persisted until the 19th century, [but] there was otherwise little agreement about the precise time of formation or animation. There was agreement, however, that prior to this point the fetus was to be regarded as part of the mother, and its destruction, therefore, was not homicide. Due to continued uncertainty about the precise time when animation occurred, to the lack of any empirical basis for the 40–80-day view, and perhaps to Aquinas' definition of movement as one of the two first principles of life, Bracton focused upon quickening as the critical point. The significance of quickening was echoed by later common-law scholars and found its way into the received common law in this country.

Whether abortion of a *quick* fetus was a felony at common law, or even a lesser crime, is still disputed. . . . A recent review of the common-law precedents argues . . . that those precedents contradict Coke and that even post-quickening abortion was never established as a common-law crime.[26] . . . [I]t now appear[s] doubtful that abortion was ever firmly established as a common-law crime even with respect to the destruction of a quick fetus.

4. *The English statutory law.* England's first criminal abortion statute. Lord Ellenborough's Act, 43 Geo. 3, ch. 58, came in 1803. It made abortion of a quick fetus, §1, a capital crime, but in §2 it provided lesser penalties for the felony of abortion before quickening, and thus preserved the "quickening" distinction. . . . [Court traces British abortion law up to the present. As of 1967 British law was similar to the Georgia statute treated in *Doe v. Bolton.*—Au.]

5. *The American law.* In this country, the law in effect in all but a few States until mid-nineteenth century was the pre-existing English common law. Connecticut, the first State to enact abortion legislation, adopted in 1821 that part of Lord Ellenborough's Act that related to a woman "quick with child." The death penalty was not imposed. Abortion before quickening was made a crime in that State only in 1860. In 1828, New York enacted legislation that, in two respects, was to serve as a model for early antiabortion statutes. First, while barring destruction of an unquickened fetus as well as a quick fetus, it made the former only a misdemeanor, but the latter second-degree manslaughter. Second, it incorporated a concept of therapeutic abortion by providing that an abortion was excused if it "shall have been necessary to preserve the life of such mother, or shall have been advised by two physicians to be necessary for such purpose." By 1840, when Texas had received the common law, only eight American States had statutes dealing with abortion. It was not until after the War Between the States that legislation began generally to replace the common law. Most of those initial statutes dealt severely with abortion after quickening but were lenient with it before quickening. Most punished attempts equally with completed abortions. While many statutes included the exception for an abortion thought by one or more physicians to be necessary to save the mother's life, that provision soon disappeared and the typical law required that the procedure actually be necessary for that purpose.

Gradually, in the middle and late nineteenth century the quickening distinction disappeared from the statutory law of most States and the degree of the offense and the penalties were increased. By the end of the 1950s, a large majority of the jurisdictions banned abortion, however and whenever performed, unless done to save or preserve the life of the mother. . . . In the past several years, however, a trend toward liberalization of abortion statutes has resulted in adoption, by about one-third of the States, of less stringent laws, most of them patterned after the ALI Model Penal Code. . . .

It is thus apparent that at common law, at the time of the adoption of our Constitution, and throughout the major portion of the nineteenth century, abortion was viewed with less disfavor than under most American statutes currently in effect. Phrasing it another way, a woman enjoyed a substantially broader right to terminate a pregnancy than she does in most States today. At least with respect to the early stage of pregnancy, and very

[17] *Id.* at 18; Lader 76.

[19] *Id.* at 64.

[26] Means, *The Phoenix of Abortional Freedom: Is a Penumbral or Ninth-Amendment Right About to Arise from the Nineteenth-Century Legislative Ashes of a Fourteenth-Century Common-Law Liberty?,* 17 N.Y.L.F. 335 (1971) (hereinafter Means II). . . .

possibly without such a limitation, the opportunity to make this choice was present in this country well into the nineteenth century. Even later, the law continued for some time to treat less punitively an abortion procured in early pregnancy.

6. *The position of the American Medical Association.* [Court recapitulates AMA committee reports of 1857 and 1871 condemning abortion and calling "the attention of the clergy of all denominations to the perverted views of morality entertained by a large class of females—aye, and men also, on this important question," He then describes the liberalization of AMA positions in 1967 and 1970.]

7. *The position of the American Public Health Association.* In October 1970, the Executive Board of the APHA adopted Standards for Abortion Services. These [urged that:]

> Rapid and simple abortion referral must be readily available through state and local public health departments, medical societies, or other nonprofit organizations. . . . (Recommended Standards for Abortion Services, 61 Am. J. Pub. Health 396 [1971].)

. . . It was said that at present abortions should be performed by physicians or osteopaths who are licensed to practice and who have "adequate training." *Id.* at 398.

8. *The position of the American Bar Association.* At its meeting in February 1972 the ABA House of Delegates approved, with 17 opposing votes, the Uniform Abortion Act. . . . We set forth the Act in full in the margin.[40] . . .

VII

Three reasons have been advanced to explain historically the enactment of criminal abortion laws in the nineteenth century and to justify their continued existence.

It has been argued occasionally that these laws were the product of a Victorian social concern to discourage illicit sexual conduct. Texas, however, does not advance this justification in the present case, and it appears that no court or commentator has taken the argument seriously. The appellants and *amici* contend, moreover, that this is not a proper state purpose at all and suggest that, if it were, the Texas statutes are overbroad in protecting it since the law fails to distinguish between married and unwed mothers.

A second reason is concerned with abortion as a medical procedure. When most criminal abortion laws were first enacted, the procedure was a hazardous one for the woman. This was particularly true prior to the development of antisepsis. Antiseptic techniques . . . were not generally accepted and employed until about the turn of the century. Abortion mortality was high. Even after 1900, and perhaps until as late as the development of antibiotics in the 1940s, standard modern techniques

such as dilation and curettage were not nearly so safe as they are today. Thus, it has been argued that a State's real concern in enacting a criminal abortion law was to protect the pregnant woman, that is, to restrain her from submitting to a procedure that placed her life in serious jeopardy.

Modern medical techniques have altered this situation. Appellants and various *amici* refer to medical data indicating that abortion in early pregnancy, that is, prior to the end of the first trimester, although not without its risk, is now relatively safe. Mortality rates for women undergoing early abortions, where the procedure is legal, appear to be as low or lower than the rates for normal childbirth. Consequently, any interest of the State in protecting the woman from an inherently hazardous procedure, except when it would be equally dangerous for her to forgo it, has largely disappeared. Of course, important state interests in the areas of health and medical standards do remain. The State has a legitimate interest in seeing to it that abortion, like any other medical procedure, is performed under circumstances that insure maximum safety for the patient. This interest obviously extends at least to

[40] "UNIFORM ABORTION ACT"

"SECTION 1. [*Abortion Defined: When Authorized.*]

"(a) 'Abortion' means the termination of human pregnancy with an intention other than to produce a live birth or to remove a dead fetus.

"(b) An abortion may be performed in this state only if it is performed:

"(1) by a physician licensed to practice medicine [or osteopathy] in this state or by a physician practicing medicine [or osteopathy] in the employ of the government of the United States or of this state, [and the abortion is performed [in the physician's office or in a medical clinic, or] in a hospital approved by the [Department of Health] or operated by the United States, this state, or any department, agency, or political subdivision of either;] or by a female upon herself upon the advice of the physician, and

"(2) within [20] weeks after the commencement of the pregnancy [or after [20] weeks only if the physician has reasonable cause to believe (i) there is a substantial risk that continuance of the pregnancy would endanger the life of the mother or would gravely impair the physical or mental health of the mother, (ii) that child would be born with grave physical or mental defect, or (iii) that the pregnancy resulted from rape or incest, or illicit intercourse with a girl under the age of 16 years].

"SECTION 2. [*Penalty.*] Any person who performs or procures an abortion other than authorized by this Act is guilty of a [felony] and, upon conviction thereof, may be sentenced to pay a fine not exceeding [$1,000] or to imprisonment [in the state penitentiary] not exceeding [5 years], or both.

"SECTION 3. [*Uniformity of Interpretation.*] This act shall be construed to effectuate its general purpose to make uniform the law with respect to the subject of this Act among those state which enact it.

"SECTION 4. [*Short Title.*] This act may be cited as the Uniform Abortion Act.

"SECTION 5. [*Severability.*] If any provision of this Act or the application thereof to any person or circumstance is held invalid, the invalidity does not affect other provisions or applications of this Act which can be given effect without the invalid provision or application, and to this end the provisions of this Act are severable.

the performing physician and his staff, to the facilities involved, to the availability of after-care, and to adequate provision for any complication or emergency that might arise. . . . Moreover, the risk to the woman increases as her pregnancy continues. Thus, the State retains a definite interest in protecting the woman's own health and safety when an abortion is proposed at a late stage of pregnancy.

The third reason is the State's interest—some phrase it in terms of duty—in protecting prenatal life. Some of the argument for this justification rests on the theory that a new human life is present from the moment of conception. The State's interest and general obligation to protect life then extends, it is argued, to prenatal life. Only when the life of the pregnant mother herself is at stake, balanced against the life she carries within her, should the interest of the embryo or fetus not prevail. Logically, of course, a legitimate state interest in this area need not stand or fall on acceptance of the belief that life begins at conception or at some other point prior to live birth. In assessing the State's interest, recognition may be given to the less rigid claim that as long as at least *potential* life is involved, the State may assert interests beyond the protection of the pregnant woman alone.

Parties challenging state abortion laws have sharply disputed in some courts the contention that a purpose of these laws, when enacted, was to protect prenatal life. . . . [and] they claim that most state laws were designed solely to protect the woman. Because medical advances have lessened this concern, at least with respect to abortion in early pregnancy, they argue that with respect to such abortions the laws can no longer be justified by any state interest. There is some scholarly support for this view of original purpose. The few state courts called upon to interpret their laws in the late nineteenth and early twentieth centuries did focus on the State's interest in protecting the woman's health rather than in preserving the embryo and fetus. Proponents of this view point out that in many States, including Texas, by statute or judicial interpretation, the pregnant woman herself could not be prosecuted for self-abortion or for cooperating in an abortion performed upon her by another. They claim that adoption of the "quickening" distinction through received common law and state statutes tacitly recognizes the greater health hazards inherent in the late abortion and impliedly repudiates the theory that life begins at conception. . . .

VIII

The Constitution does not explicitly mention any right of privacy. In a line of decisions, however, going back perhaps as far as *Union Pacific R. Co. v. Botsford,* 141 U.S. 250, 251 (1891), the Court has recognized that a right of personal privacy, or a guarantee of certain areas or zones of privacy, does exist under the Constitution. In varying contexts, the Court or individual Justices have, indeed, found at least the roots of that right in the First Amendment, *Stanley v. Georgia,* 394 U.S. 557, 564 (1969); in the Fourth and Fifth Amendments, *Terry v. Ohio,* 392 U.S. 1, 8–9 (1968), *Katz v. United States,* 389 U.S. 347, 350 (1967), *Boyd v. United States,* 116 U.S. 616 (1886), *see Olmstead v. United States,* 277 U.S. 438, 478 (1928) (Brandeis, J., dissenting); in the penumbras of the Bill of Rights, *Griswold v. Connecticut,* 381 U.S., at 484–885: in the Ninth Amendment, *id.* at 486 (Goldberg, J., concurring); or in the concept of liberty guaranteed by the first section of the Fourteenth Amendment, *see Meyer v. Nebraska,* 262 U.S. 390, 399 (1923). These decisions made it clear that only personal rights that can be deemed "fundamental" or "implicit in the concept of ordered liberty," *Palko v. Connecticut,* 302 U.S. 319, 325 (1937), are included in this guarantee of personal privacy. They also make it clear that the right has some extension to activities relating to marriage, *Loving v. Virginia,* 388 U.S. 1, 12 (1967); procreation, *Skinner v. Oklahoma,* 316 U.S. 535, 541–42 (1942); contraception, *Eisenstadt v. Baird,* 405 U.S., at 453–54; *id.* at 460, 463–65 (WHITE, J., concurring in result); family relationships, *Prince v. Massachusetts,* 321 U.S. 158, 166 (1944); and child rearing and education, *Pierce v. Society of Sisters,* 268 U.S. 510, 535 (1925), *Meyer v. Nebraska, supra.*

This right of privacy, whether it be founded in the Fourteenth Amendment's concept of personal liberty and restrictions upon state action, as we feel it is, or, as the District Court determined, in the Ninth Amendment's reservation of rights to the people, is broad enough to encompass a woman's decision whether or not to terminate her pregnancy. The detriment that the State would impose upon the pregnant woman by denying this choice altogether is apparent. Specific and direct harm medically diagnosable even in early pregnancy may be involved. Maternity, or additional offspring, may force upon the woman a distressful life and future. Psychological harm may be imminent. Mental and physical health may be taxed by child care. There is also the distress, for all concerned, associated with the unwanted child, and there is the problem of bringing a child into a family already unable, psychologically and otherwise, to care for it. In other cases, as in this one, the additional difficulties and continuing stigma of unwed motherhood may be involved. All these are factors the woman and her responsible physician necessarily will consider in consultation.

On the basis of elements such as these, appellant and some *amici* argue that the woman's right is absolute and that she is entitled to terminate her pregnancy at whatever time, in whatever way, and for whatever reason she alone chooses. With this we do not agree. Appellant's arguments that Texas either has no valid interest at all in regulating the abortion decision, or no interest strong enough to

support any limitation upon the woman's sole determination, are unpersuasive. The Court's decisions recognizing a right of privacy also acknowledge that some regulation in areas protected by that right is appropriate. As noted above, a State may properly assert important interests in safeguarding health, in maintaining medical standards, and in protecting potential life. At some point in pregnancy, these respective interests become sufficiently compelling to sustain regulation of the factors that govern the abortion decisions. The privacy right involved, therefore, cannot be said to be absolute. In fact, it is not clear to us that the claim asserted by some *amici* that one has an unlimited right to do with one's body as one pleases bears a close relationship to the right of privacy previously articulated in the Court's decisions. The Court has refused to recognize an unlimited right of this kind in the past. *Jacobson v. Massachusetts,* 197 U.S. 11 (1905) (vaccination); *Buck v. Bell,* 274 U.S. 200 (1927) (sterilization).

We, therefore, conclude that the right of personal privacy includes the abortion decision, but that this right is not unqualified and must be considered against important state interests in regulation. . . . [This] right, nonetheless, is not absolute and is subject to some limitations; and . . . at some point the state interests as to protection of health, medical standards, and prenatal life, become dominant. . . .

Where certain "fundamental rights" are involved, the Court has held that regulation limiting these rights may be justified only by a "compelling state interest," *Kramer v. Union Free School District,* 395 U.S. 621, 627 (1969); *Shapiro v. Thompson,* 394 U.S. 618, 634 (1969); *Sherbert v. Verner,* 374 U.S. 398, 406 (1963); and that legislative enactments must be narrowly drawn to express only the legitimate state interests at stake. *Griswold v. Connecticut,* 381 U.S., at 485; *Aptheker v. Secretary of State,* 378 U.S. 500, 508 (1964); *Cantwell v. Connecticut,* 310 U.S. 296, 307–8 (1940); *see Eisenstadt v. Baird,* 405 U.S., at 460, 463–64 (WHITE, J., concurring in result).

In the recent abortion cases, . . . courts have recognized these principles. Those striking down state laws have generally scrutinized the State's interests in protecting health and potential life, and have concluded that neither interest justified broad limitations on the reasons for which a physician and his pregnant patient might decide that she should have an abortion in the early stages of pregnancy. Courts sustaining state laws have held that the State's determinations to protect health or prenatal life are dominant and constitutionally justifiable.

IX

The District Court held that the appellee failed to meet his burden of demonstrating that the Texas statute's infringement upon Roe's rights was necessary to support a compelling state interest, and that, although the appellee presented "several compelling justifications for state presence in the area of abortions," the statutes outstripped these justifications and swept "far beyond any areas of compelling state interest." 314 F. Supp., at 1222–23. Appellant and appellee both contest that holding. Appellant, as has been indicated, claims an absolute right that bars any state imposition of criminal penalties in the area. Appellee argues that the State's determination to recognize and protect prenatal life from and after conception constitutes a compelling state interest. As noted above, we do not agree fully with either formulation.

A. The appellee and certain *amici* argue that the fetus is a "person" within the language and meaning of the Fourteenth Amendment. In support of this, they outline at length and in detail the well-known facts of fetal development. If this suggestion of personhood is established, the appellant's case, of course, collapses, for the fetus' right to life would then be guaranteed specifically by the Amendment . . . [but] no case [can] be cited that holds that a fetus is a person within the meaning of the Fourteenth Amendment.

The Constitution does not define "person" in so many words. Section 1 of the Fourteenth Amendment contains three references to "person." The first, in defining "citizens," speaks of "persons born or naturalized in the United States." . . . "Person" is used in other places in the Constitution. . . . But in nearly all these instances, the use of the word is such that it has application only postnatally. None indicates, with any assurance, that it has any possible pre-natal application.

All this, together with our observation, *supra*, that throughout the major portion of the nineteenth century prevailing legal abortion practices were far freer than they are today, persuades us that the word "person," as used in the Fourteenth Amendment, does not include the unborn. This is in accord with the results reached in those few cases where the issue has been squarely presented. [He cites seven lower court cases and one Supreme Court case of indirect reference, *U.S. v. Vuitch* 402 U.S. 62 (1971).—Au.]

B. The pregnant woman cannot be isolated in her privacy. She carries an embryo and, later, a fetus. . . . The situation therefore is inherently different from marital intimacy, or bedroom possession of obscene material, or marriage, or procreation, or education, with which *Eisenstadt* and *Griswold, Stanley, Loving, Skinner,* and *Pierce* and *Meyer* were respectively concerned. As we have intimated above, it is reasonable and appropriate for a State to decide that at some point in time another interest, that of health of the mother or that of potential human life, becomes significantly involved. The woman's privacy is no longer sole and any right of privacy she possesses must be measured accordingly.

Texas urges that, apart from the Fourteenth Amendment, life begins at conception and is present throughout

pregnancy, and that, therefore, the State has a compelling interest in protecting that life from and after conception. We need not resolve the difficult question of when life begins. When those trained in the respective disciplines of medicine, philosophy, and theology are unable to arrive at any consensus, the judiciary, at this point in the development of man's knowledge, is not in a position to speculate as to the answer.

It should be sufficient to note briefly the wide divergence of thinking on this most sensitive and difficult question. There has always been strong support for the view that life does not begin until live birth. This was the belief of the Stoics. It appears to be the predominant, though not the unanimous, attitude of the Jewish faith. It may be taken to represent also the position of a large segment of the Protestant community, insofar as that can be ascertained; organized groups that have taken a formal position on the abortion issue have generally regarded abortion as a matter for the conscience of the individual and her family. As we have noted, the common law found greater significance in quickening. Physicians and their scientific colleagues have regarded that event with less interest and have tended to focus either upon conception, upon live birth, or upon the interim point at which the fetus becomes "viable," that is, potentially able to live outside the mother's womb, albeit with artificial aid. Viability is usually placed at about seven months (28 weeks) but may occur earlier, even at 24 weeks. . . . [The Roman Catholic Church] would recognize the existence of life from the moment of conception. . . . As one brief *amicus* discloses, this is a view strongly held by many non-Catholics as well, and by many physicians. Substantial problems for precise definition of this view are posed, however, by new embryological data that purport to indicate that conception is a "process" over time, rather than an event, and by new medical techniques such as menstrual extraction, the "morning-after" pill, implantation of embryos, artificial insemination, and even artificial wombs.

In areas other than criminal abortion, the law has been reluctant to endorse any theory that life, as we recognize it, begins before live birth or to accord legal rights to the unborn except in narrowly defined situations and except when the rights are contingent upon live birth. For example, the traditional rule of tort law denied recovery for prenatal injuries even though the child was born alive. That rule has been changed in almost every jurisdiction. In most States, recovery is said to be permitted only if the fetus is viable, or at least quick, when the injuries were sustained, though few courts have squarely so held. In a recent development, generally opposed by the commentators, some States permit the parents of a stillborn child to maintain an action for wrongful death because of prenatal injuries. Such an action, however, would appear to be one to vindicate the parents' interest and is thus consistent with the view that the fetus, at most, represents only the potentiality of life. . . .

X

In view of all this, we do not agree that, by adopting one theory of life, Texas may override the rights of the pregnant woman that are at stake. We repeat, however, that the State does have an important and legitimate interest in preserving and protecting the health of the pregnant woman, whether she be a resident of the State or a nonresident who seeks medical consultation and treatment there, and that it has still *another* important and legitimate interest in protecting the potentiality of human life. These interests are separate and distinct. Each grows in substantiality as the woman approaches term and, at a point during pregnancy, each becomes "compelling."

With respect the State's important and legitimate interest in the health of the mother, the "compelling" point, in the light of present medical knowledge, is at approximately the end of the first trimester. This is so because of the now-established medical fact, referred to above, that until the end of the first trimester mortality in abortion may be less than mortality in normal childbirth. It follows that, from and after this point, a State may regulate the abortion procedure to the extent that the regulation reasonably relates to the preservation and protection of maternal health. Examples of permissible state regulation in this area are requirements as to the qualifications of the person who is to perform the abortion; as to the licensure of that person; as to the facility in which the procedure is to be performed, that, that is, whether it must be a hospital or may be a clinic or some other place of less-than-hospital status; as to the licensing of the facility; and the like.

This means, on the other hand, that, for the period of pregnancy prior to this "compelling" point, the attending physician, in consultation with his patient, is free to determine, without regulation by the State, that, in his medical judgment, the patient's pregnancy should be terminated. If that decision is reached, the judgment may be effectuated by an abortion free of interference by the State.

With respect to the State's important and legitimate interest in potential life, the "compelling" point is at viability. This is so because the fetus then presumably has the capability of meaningful life outside the mother's womb. State regulation protective of fetal life after viability thus has both logical and biological justifications. If the State is interested in protecting fetal life after viability, it may go so far as to proscribe abortion during that period, except when it is necessary to preserve the life or health of the mother.

Measured against these standards, Article 1196 of the Texas Penal Code, in restricting legal abortions to

those "procured or attempted by medical advice for the purpose of saving the life of the mother," sweeps too broadly. The statute made no distinction between abortions performed early in pregnancy and those performed later, and it limits to a single reason, "saving" the mother's life, the legal justification for the procedure. The statute, therefore, cannot survive the constitutional attack made upon it here. . . .

XI

To summarize and to repeat:

1. A state criminal abortion statute of the current Texas type, that excepts from criminality only a *life-saving* procedure on behalf of the mother, without regard to pregnancy stage and without recognition of the other interests involved, is violative of the Due Process Clause of the Fourteenth Amendment.

(a) For the stage prior to approximately the end of the first trimester, the abortion decision and its effectuation must be left to the medical judgment of the pregnant woman's attending physician.

(b) For the stage subsequent to approximately the end of the first trimester, the State, in promoting its interest in the health of the mother, may, if it chooses, regulate the abortion procedure in ways that are reasonably related to maternal health.

(c) For the stage subsequent to viability, the State in promoting its interest in the potentiality of human life may, if it chooses, regulate, and even proscribe, abortion except where it is necessary, in appropriate medical judgment, for the preservation of the life or health of the mother.

2. The State may define the term "physician," as it has been employed in the preceding paragraphs of this part XI of this opinion, to mean only a physician currently licensed by the State, and may proscribe any abortion by a person who is not a physician as so defined.

In *Doe v. Bolton, post,* procedural requirements contained in one of the modern abortion statutes are considered. That opinion and this one, of course, are to be read together. . . .

MR. JUSTICE BLACKMUN delivered the opinion of the Court [for *Doe v. Bolton*].

. . .

IV

The appellants attack on several grounds those portions of the Georgia abortion statutes that remain after the District Court decision: undue restriction of a right to personal and marital privacy; vagueness; deprivation of substantive and procedural due process; improper restriction to Georgia residents; and denial of equal protection.

A. *Roe v. Wade, supra,* sets forth our conclusion that a pregnant woman does not have an absolute constitutional right to an abortion on her demand. What is said there is applicable here and need not be repeated.

B. . . . Appellants argue that the statutes do not adequately protect the woman's right. This is so because it would be physically and emotionally damaging to Doe to bring a child into her poor, "fatherless" family, and because advances in medicine and medical techniques have made it safer for a woman to have a medically induced abortion than for her to bear a child. Thus, "a statute that requires a woman to carry an unwanted pregnancy to term infringes not only on a fundamental right of privacy but on the right to life itself."

The appellants recognize that a century ago medical knowledge was not so advanced as it is today, that the techniques of antisepsis were not known, and that any abortion procedure was dangerous for the woman. To restrict the legality of the abortion to the situation where it was deemed necessary, in medical judgment, for the preservation of the woman's life was only a natural conclusion in the exercise of the legislative judgment of that time. . . .

C. Appellants argue that §26–1202(a) of the Georgia statutes, as it has been left by the District Court's decision, is unconstitutionally vague. This argument centers on the proposition that, with the District Court's having struck down the statutorily specified reasons, it still remains a crime for a physician to perform an abortion except when, at §26–1202(a) reads, it is "based upon his best clinical judgment that an abortion is necessary." The appellants contend that the word "necessary" does not warn the physician of what conduct is proscribed; that the statute is wholly without objective standards and is subject to diverse interpretation; and that doctors will choose to err on the side of caution and will be arbitrary.

The net result of the District Court's decision is that the abortion determination, so far as the physician is concerned, is made in the exercise of his professional, that is, his "best clinical," judgment in the light of all the attendant circumstances. He is not now restricted to the three situations originally specified. Instead, he may range farther afield wherever his medical judgment, properly and professionally exercised, so dictates and directs him. . . .

[We conclude] that the term "health" present[s] no problem of vagueness. "Indeed, whether a particular operation is necessary for a patient's physical or mental health is a judgment that physicians are obviously called upon to make routinely whenever surgery is considered." *United States v. Vuitch,* 402 U.S. 62, 72 (1971).

We agree with the District Court, 319 F. Supp., at 1058, that the medical judgment may be exercised in the light of all factors—physical, emotional, psychological, familial, and the woman's age—relevant to the well-being of the patient. All these factors may relate to health. This allows the attending physician the room he needs to

make his best medical judgment. And it is room that operates for the benefit, not the disadvantage, of the pregnant woman.

D. The appellants next argue that the District Court should have declared unconstitutional three procedural demands of the Georgia statute: (1) that the abortion be performed in a hospital accredited by the Joint Commission on Accreditation of Hospitals:[11] (2) that the procedure be approved by the hospital staff abortion committee; and (3) that the performing physician's judgment be confirmed by the independent examinations of the patient by two other licensed physicians. The appellants attack these provisions not only on the ground that they unduly restrict the woman's right of privacy, but also on procedural due process and equal protection grounds. The physician-appellants also argue that, by subjecting a doctor's individual medical judgment to committee approval and to confirming consultations, the statute impermissibly restricts the physician's right to practice his profession and deprives him of due process.

1. *JCAH accreditation.* . . . In Georgia, there is no restriction on the performance of non-abortion surgery in a hospital not yet accredited by the JCAH [Joint Commission on the Accreditation of Hospitals] so long as other requirements imposed by the State, such as licensing of the hospital and of the operating surgeon, are met.

We hold that the JCAH-accreditation requirement does not withstand constitutional scrutiny in the present context. It is a requirement that simply is not "based on differences that are reasonably related to the purposes of the Act in which it is found." *Morey v. Doud,* 354 U.S. 457, 465 (1957).

This is not to say that Georgia may not or should not, from and after the end of the first trimester, adopt standards for licensing all facilities where abortions may be performed so long as those standards are legitimately related to the objective the State seeks to accomplish. The appellants contend that such a relationship would be lacking even in a lesser requirement that an abortion be performed in a licensed hospital, as opposed to a facility, such as a clinic, that may be required by the State to possess all the staffing and services necessary to perform an abortion safely (including those adequate to handle serious complications or other emergency, or arrangements with a nearby hospital to provide such services). Appellants and various *amici* have presented us with a mass of data purporting to demonstrate that some facilities other than hospitals are entirely adequate to perform abortions if they possess these qualifications. The State, on the other hand, has not presented persuasive data to show that only hospitals meet its acknowledged interest in

insuring the quality of the operation and the full protection of the patient. We feel compelled to agree with appellants that the State must show more than it has in order to prove that only the full resources of a licensed hospital, rather than those of some other appropriately licensed institution, satisfy these health interests. We hold that the hospital requirement of the Georgia law, because it fails to exclude the first trimester of pregnancy, *see Roe v. Wade, ante,* is also invalid. . . .

2. *Committee approval.* The second aspect of the appellants' procedural attack relates to the hospital abortion committee. . . . Viewing the Georgia statute as a whole, we see no constitutionally justifiable pertinence in the structure for the advance approval. . . . We are not cited to any other surgical procedure made subject to committee approval as a matter of state criminal law. The woman's right to receive medical care in accordance with her licensed physician's best judgment and the physician's right to administer it are substantially limited by this statutorily imposed overview.

3. *Two-doctor concurrence.* Appellants' attack centers on the . . . required confirmation by two Georgia-licensed physicians in addition to the recommendation of the pregnant woman's own consultant (making under the statute, a total of six physicians involved, including the three on the hospital's abortion committee). We conclude that this provision, too, must fall.

The statute's emphasis, as has been repetitively noted, is on the attending physician's "best clinical judgment that an abortion is necessary." . . . Again, no other voluntary medical or surgical procedure for which Georgia requires confirmation by two other physicians has been cited to us. If a physician is licensed by the State, he is recognized by the State as capable of exercising acceptable clinical judgment. If he fails in this, professional censure and deprivation of his license are available remedies. Required acquiescence by copractitioners has no rational connection with a patient's need and unduly infringes on the physician's right to practice. . . .

E. The appellants attack the residency requirement of the Georgia law . . . as violative of the right to travel stressed in *Shapiro v. Thompson,* 394 U.S. 618, 629–31 (1969), and other cases. A requirement of this kind, of course, could be deemed to have some relationship to the availability of post-procedure medical care for the aborted patient.

Nevertheless, we do not uphold the constitutionality of the residence requirement. It is not based on any policy of preserving state-supported facilities for Georgia residents, for the bar also applies to private hospitals and to privately retained physicians. There is no intimation, either, that Georgia facilities are utilized to capacity in caring for Georgia residents. Just as the Privileges and Immunities Clause, Const. art. IV, §2, protects persons

[11]We were advised at reargument, Tr. of Oral Rearg. 10, that only 54 of Georgia's 159 counties have a JCAH-accredited hospital.

who enter other States to ply their trade, *Ward v. Maryland,* 12 Wall. 418, 430 (1871); *Blake v. McClung,* 172 U.S. 239, 248–56 (1898), so must it protect persons who enter Georgia seeking the medical services that are available there. *See Toomer v. Witsell,* 334 U.S. 385, 396–97 (1948). A contrary holding would mean that a State could limit to its own residents the general medical care available within its borders. This we could not approve. . . .

V

In summary, we hold that the JCAH-accredited hospital provision and the requirements as to approval by the hospital abortion committee, as to confirmation by two independent physicians, and as to residence in Georgia are all violative of the Fourteenth Amendment. . . .

MR. JUSTICE STEWART, concurring [in *Roe v. Wade*].

In 1963, this Court, in *Ferguson v. Skrupa,* 372 U.S. 726, purported to sound the death knell for the doctrine of substantive due process, a doctrine under which many state laws had in the past been held to violate the Fourteenth Amendment. As Mr. Justice Black's opinion for the court in *Skrupa* put it: "We have returned to the original constitutional proposition that courts do not substitute their social and economic beliefs for the judgment of legislative bodies, who are elected to pass laws." *Id.* at 730.[1]

Barely two years later, in *Griswold v. Connecticut,* 381 U.S. 479, the Court held a Connecticut birth control law unconstitutional. In view of what had been so recently said in *Skrupa,* the Court's opinion in *Griswold* understandably did its best to avoid reliance on the Due Process Clause of the Fourteenth Amendment as the ground for decision. Yet, the Connecticut law did not violate any provision of the Bill of Rights, nor any specific provision of the Constitution.[2] So it was clear to me then, and it is equally clear to me now, that the *Griswold* decision can be rationally understood only as a holding that the Connecticut statute substantively invaded the "liberty" that is protected by the Due Process Clause of the Fourteenth Amendment. As so understood, *Griswold*

stands as one in a long line of pre-*Skrupa* cases decided under the doctrine of substantive due process, and I now accept it as such. . . . The Constitution nowhere mentions a specific right of personal choice in matters of marriage and family life, but the "liberty" protected by the Due Process Clause of the Fourteenth Amendment covers more than those freedoms explicitly named in the Bill of Rights. *See Schware v. Board of Bar Examiners,* 353 U.S. 232, 238–39; *Pierce v. Society of Sisters,* 268 U.S. 510, 534–35; *Meyer v. Nebraska,* 262 U.S. 390, 399–400. *Cf. Shapiro v. Thompson,* 394 U.S. 618, 629–30; *United States v. Guest,* 383 U.S. 745, 757–58; *Carrington v. Rash,* 380 U.S. 89, 96; *Aptheker v. Secretary of State,* 378 U.S. 500, 505; *Kent v. Dulles,* 357 U.S. 116, 127; *Bolling v. Sharpe,* 347 U.S. 497, 499–500; *Truax v. Raich,* 239 U.S. 33, 41.

As Mr. Justice Harlan once wrote:

[T]he full scope of the liberty guaranteed by the Due Process Clause cannot be found in or limited by the precise terms of the specific guarantees elsewhere provided in the Constitution. This "liberty" is not a series of isolated points pricked out in terms of the taking of property; the freedom of speech, press, and religion; the right to keep and bear arms; the freedom from unreasonable searches and seizures; and so on. It is a rational continuum which, broadly speaking, includes a freedom from all substantial arbitrary impositions and purposeless restraints . . . and which also recognizes, what a reasonable and sensitive judgment must, that certain interests require particularly careful scrutiny of the state needs asserted to justify their abridgment. (*Poe v. Ullman,* 367 U.S. 497, 543 [opinion dissenting from dismissal of appeal] [citations omitted].

In the words of Mr. Justice Frankfurter, "Great concepts like . . . 'liberty' . . . were purposely left to gather meaning from experience. For they relate to the whole domain of social and economic fact, and the statesmen who founded this Nation knew too well that only a stagnant society remains unchanged." *National Mutual Ins. Co. v. Tidewater Transfer Co.,* 337 U.S. 582, 646 (dissenting opinion).

Several decisions of this Court make clear that freedom of personal choice in matters of marriage and family life is one of the liberties protected by the Due Process Clause of the Fourteenth Amendment. *Loving v. Virginia,* 388 U.S. 1, 12; *Griswold v. Connecticut; Pierce v. Society of Sisters; Meyer v. Nebraska. See also Prince v. Massachusetts,* 321 U.S. 158, 166; *Skinner v. Oklahoma,* 316 U.S. 535, 541. As recently as last Term, in *Eisenstadt v. Baird,* 405 U.S. 438, 453, we recognized "the right of the *individual,* married or single to be free from unwarranted governmental intrusion into matters so

[1]Only Mr. Justice Harlan failed to join the Court's opinion, 372 U.S., at 733.

[2]There is no constitutional right of privacy, as such. "[The Fourth] Amendment protects individual privacy against certain kinds of governmental intrusion, but its protections go further, and often have nothing to do with privacy at all. Other provisions of the Constitution protect personal privacy from other forms of governmental invasions, But the protection of a person's *general* right to privacy—his right to be let alone by other people—is, like the protection of his property and of his very life, left largely to the law of the individual States." *Katz v. United States,* 389 U.S. 347, 350–51 (footnotes omitted).

fundamentally affecting a person as the decision whether to bear or beget a child." That right necessarily includes the right of a woman to decide whether or not to terminate her pregnancy. "Certainly the interests of a woman in giving of her physical and emotional self during pregnancy and the interests that will be affected throughout her life by the birth and raising of a child are of a far greater degree of significance and personal intimacy than the right to send a child to private school protected in *Pierce v. Society of Sisters,* or the right to teach a foreign language protected in *Meyer v. Nebraska,*" *Abele v. Markle,* 351 F. Supp. 224, 227 (Conn. 1972).

Clearly, therefore, the Court today is correct in holding that the right asserted by Jane Roe is embraced within the personal liberty protected by the Due Process Clause of the Fourteenth Amendment.

It is evident that the Texas abortion statute infringes that right directly. Indeed, it is difficult to imagine a more complete abridgment of a constitutional freedom than that worked by the inflexible criminal statute now in force in Texas. The question then becomes whether the state interests advanced to justify this abridgment can survive the "particularly careful scrutiny" that the Fourteenth Amendment here requires.

The asserted state interests are protection of the health and safety of the pregnant woman, and protection of the potential future human life within her. These are legitimate objectives, amply sufficient to permit a State to regulate abortions as it does other surgical procedures, and perhaps sufficient to permit a State to regulate abortions more stringently or even to prohibit them in the late stages of pregnancy. But such legislation is not before us, and I think the Court today has thoroughly demonstrated that these state interests cannot constitutionally support the broad abridgment of personal liberty worked by the existing Texas law. Accordingly, I join the Court's opinion holding that the law is invalid under the Due Process Clause of the Fourteenth Amendment.

MR. CHIEF JUSTICE BURGER, concurring [for both *Roe* and *Doe*].

I agree that, under the Fourteenth Amendment to the Constitution, the abortion statutes of Georgia and Texas impermissibly limit the performance of abortions necessary to protect the health of pregnant women, using the term health in its broadest medical context. *See United States v. Vuitch,* 402 U.S. 62, 71–72 (1971). I am somewhat troubled that the Court has taken notice of various scientific and medical data in reaching its conclusion; however, I do not believe that the Court has exceeded the scope of judicial notice accepted in other contexts.

In oral argument, counsel for the State of Texas informed the Court that early abortion procedures were routinely permitted in certain cases, such as nonconsensual pregnancies resulting from rape and incest. In the face of a rigid and narrow statute, such as that of Texas, no one in these circumstances should be placed in a posture of dependence on a prosecutorial policy or prosecutorial discretion. Of course, States must have broad power, within the limits indicated in the opinion, to regulate the subject of abortions, but where the consequences of state intervention are so severe, uncertainty must be avoided as much as possible. For my part, I would be inclined to allow a State to require the certification of two physicians to support an abortion, but the Court holds otherwise. I do not believe that such a procedure is unduly burdensome, as are the complex steps of the Georgia statutes, which require as many as six doctors and the use of a hospital certified by the JCAH.

I do not read the Court's holdings today as having the sweeping consequences attributed to them by the dissenting Justices; the dissenting views discount the reality that the vast majority of physicians observe the standards of their profession, and act only on the basis of carefully deliberated medical judgments relating to life and health. Plainly, the Court today rejects any claim that the Constitution requires abortions on demand.

MR. JUSTICE DOUGLAS, concurring [for both *Roe* and *Doe*].

While I join the opinion of the Court, I add a few words.

I

The questions presented in the present cases . . . involved the right or privacy, one aspect of which we considered in *Griswold v. Connecticut,* 381 U.S. 479, 484, when we held that various guarantees in the Bill of Rights create zones of privacy.[2]

The Ninth Amendment obviously does not create federally enforceable rights. It merely says, "The enumeration in the Constitution, of certain rights, shall not be construed to deny or disparage others retained by the

[2]There is no mention of privacy in our bill of Rights but our decisions have recognized it as one of the fundamental values those amendments were designed to protect. The fountainhead case is *Boyd v. United States,* 116 U.S. 616, holding that a federal statue which authorized a courts in tax cases to require a taxpayer to produce this records or to concede the Government's allegations offended the Fourth and Fifth Amendments. Mr. Justice Bradley, for the Court, found that the measure unduly intruded into the "sanctity of a man's home and privacies of life," *Id.* at 630. Prior to *Boyd,* in *Kilbourn v. Thompson,* 103 U.S. 168, 190, Mr. Justice Miller held for the Court that neither House of Congress "possesses the general power of making inquiry into the private affairs of the citizen." . . .

people." But a catalogue of these rights includes customary, traditional, and time-honored rights, amenities, privileges, and immunities that come within the sweep of "the Blessings of Liberty" mentioned in the preamble to the Constitution. Many of them, in my view, come within the meaning of the term "liberty" as used in the Fourteen Amendment.

First is the autonomous control over the development and expression of one's intellect, interests, tastes, and personality.

These are rights protected by the First Amendment and, in my view, they are absolute, permitting of no exceptions. The right to remain silent as respects one's own beliefs. . . . the privacy of first-class mail, . . . these aspects of the right of privacy are rights "retained by the people" in the meaning of the Ninth Amendment.

Second is freedom of choice in the basic decisions of one's life respecting marriage, divorce, procreation, contraception, and the education and upbringing of children.

These rights, unlike those protected by the First Amendment, are subject to some control by the police power. Thus, the Fourth Amendment speaks only of "unreasonable searches and seizures" and of "probable cause." These rights are "fundamental," and we have held that in order to support legislative action the statute must be narrowly and precisely drawn and that a "compelling state interest" must be shown in support of the limitation. *E.g., Kramer v. Union Free School District; Shapiro v. Thompson; Carrington v. Rash; Sherbert v. Verner; NAACP v. Alabama.*

The liberty to marry a person of one's own choosing, *Loving v. Virginia;* the right of procreation, *Skinner v. Oklahoma;* the liberty to direct the education of one's children, *Pierce v. Society of Sisters,* and the privacy of the marital relation, *Griswold v. Connecticut,* are in this category.[4] . . .

[4]My Brother STEWART, writing in *Roe v. Wade,* says that our decision in *Griswald* reintroduced substantive due process that had been rejected in *Ferguson v. Skrupa,* 372 U.S. 376. *Skrupa* involved legislation governing a business enterprise; and the Court in that case, as had Mr. Justice Holmes on earlier occasions, rejected the idea that "liberty" within the meaning of the Due Process Clause of the Fourteenth Amendment was vessel to be filled with one's personal choices of values, whether drawn from the *laissez faire* school, from the socialistic school, or from the technocrats. *Griswald* involved legislation touching on the marital relation and involving the conviction of a licensed physician for giving married people information concerning contraception. There is nothing specific in the Bill of Rights that covers that item. Nor is there anything in the Bill of Rights that in terms protects the right of association or the privacy in one's association. Yet we found those rights in the periphery of the First Amendment, *NAACP v. Alabama,* 357 U.S. 449, 462. Other peripheral rights are the rights to educate one's children as one chooses, *Pierce v. Society of Sisters,* 268 U.S. 510, and the right to study the German language, *Meyer v. Nebraska,* 262 U.S. 390. These decisions, with all respect, have nothing to do with substantive due process. One may think they are not peripheral to other rights that are expressed in the Bill of Rights. But that is not enough to bring into play the protection of substantive due process. . . .

This right of privacy was called by Mr. Justice Brandeis the right "to be let alone." *Olmstead v. United States,* 277 U.S. 438, 478 (dissenting opinion). That right includes the privilege of an individual to plan his own affairs, for, "'outside areas of plainly harmful conduct, every American is left to shape his own life as he thinks best, do what he pleases, go where he pleases.'" *Kent v. Dulles,* 357 U.S. 116, 126.

Third is the freedom to care for one's health and person, freedom from bodily restraint or compulsion, freedom to walk, stroll, or loaf.

These rights, though fundamental, are likewise subject to regulation on a showing of "compelling state interest." We stated in *Papachristou v. City of Jacksonville,* 405 U.S. 156, 164, that walking, strolling, and wandering "are historically part of the amenities of life as we have known them." As stated in *Jacobson v. Massachusetts,* 197 U.S. 11, 29:

> There is, of course, a sphere within which the individual may assert the supremacy of his own will and rightfully dispute the authority of any human government, especially of any free government existing under a written constitution, to interfere with the exercise of that will.

In *Union Pacific R. Co. v. Botsford,* 141 U.S. 250, 252, the Court said, "the inviolability of the person is as much invaded by a compulsory stripping and exposure as by a blow." . . .

The Georgian statute is at war with the clear message of these cases—that a woman is free to make the basic decision whether to bear an unwanted child. Elaborate argument is hardly necessary to demonstrate that childbirth may deprive a woman of her preferred lifestyle and force upon her a radically different and undesired future. For example, rejected applicants under the Georgia statute are required to endure the discomforts of pregnancy; to incur the pain, higher mortality rate, and aftereffects of childbirth; to abandon educational plans; to sustain loss of income; to forgo the satisfactions of careers; to tax further mental and physical health in providing child care; and, in some cases, to bear the lifelong stigma of unwed motherhood, a badge which may haunt, if not deter, later legitimate family relationships.

II

Such reasoning is, however, only the beginning of the problem. The State has interests to protect. Vaccinations to prevent epidemics are one example, as *Jacobson,* holds. The Court held that compulsory sterilization of imbeciles afflicted with hereditary forms of insanity or imbecility is another. *Buck v. Bell,* 274 U.S. 200. Abortion affects another. While childbirth endangers the lives of some women, voluntary abortion at any time and

place regardless of medical standards would impinge on a rightful concern of society. The woman's health is part of that concern; as if the life of the fetus after quickening. These concerns justify the State in treating the procedure as a medical one.

One difficulty is that this statute as construed and applied apparently does not give full sweep to the "psychological as well as physical well-being" of women patients which saved the concept "health" from being void for vagueness in *United States v. Vuitch*, 402 U.S., at 72. But, apart from that, Georgia's enactment has a constitutional infirmity because, as stated by the District Court, it "limits the numbers of reasons for which an abortion may be sought. . . . Such an action unduly restricts a decision sheltered by the Constitutional right to privacy." 319 F. Supp., at 1056.

The vicissitudes of life produce pregnancies which may be unwanted, or which may impair "health" in the broad *Vuitch* sense of the term, or . . . in the full setting of the case may create such suffering, dislocations, misery, or tragedy as to make an early abortion the only civilized step to take. . . .

There is no doubt that the State may require abortions to be performed by qualified medical personnel. The legitimate objective of preserving the mother's health clearly supports such laws. Their impact upon the woman's privacy is minimal. But the Georgia statute outlaws virtually all such operations—even in the earliest stages of pregnancy. In light of modern medical evidence suggesting that an early abortion is safer healthwise than childbirth itself, it cannot be seriously urged that so comprehensive a ban is aimed at protecting the woman's health. Rather, this expansive proscription of all abortions along the temporal spectrum can rest only on a public goal of preserving both embryonic and fetal life.

The present statute has struck the balance between the woman's and the State's interests wholly in favor of the latter. I am not prepared to hold that a State may equate, as Georgia has done, all phases of maturation preceding birth. We held in *Griswold* that the states may not preclude spouses from attempting to avoid the joinder of sperm and egg. If this is true, it is difficult to perceive any overriding public necessity which might attach precisely at the moment of conception. . . .

In summary, the enactment is overbroad. It is not closely correlated to the aim of preserving prenatal life. In fact, it permits its destruction in several cases, including pregnancies resulting from sex acts in which females are below the statutory age of consent. At the same time, however, the measure broadly proscribes aborting other pregnancies which may cause severe mental disorders. Additionally, the statute is overbroad because it equates the value of embryonic life immediately after conception with the worth of life immediately before birth.

III

The right to privacy has no more conspicuous place than in the physician-patient relationship, unless it can be in the priest-penitent relationship. . . .

The right to seek advice on one's health and the right to place reliance on the physician of one's choice are basic to Fourteenth Amendment values. We deal with fundamental rights and liberties, which, as already noted, can be contained or controlled only by discretely drawn legislation that preserves the "liberty" and regulates only those phrases of the problem of compelling legislative concern. The imposition by the State of group controls over the physician-patient relationship is not made on any medical procedure apart from abortion, no matter how dangerous the medical step may be. The oversight imposed on the physician and patient in abortion cases denies them their "liberty," *viz.*, their right of privacy, without any compelling, discernible state interest. . .

Convention on the Elimination of All Forms of Discrimination Against Women

[Adopted and opened for signature, ratification, and accession by the U.N. General Assembly resolution 34/180 of 18 December 1979]

The States Parties to the present Convention,

Noting that the Charter of the United Nations reaffirms faith in fundamental human rights, in the dignity and worth of the human person and in the equal rights of men and women,

Noting that the Universal Declaration of Human Rights affirms the principle of the inadmissibility of discrimination and proclaims that all human beings are born free and equal in dignity and rights and that everyone is entitled to all the rights and freedoms set forth therein, without distinction of any kind, including distinction based on sex.

Noting that the States Parties to the International Covenants on Human Rights have the obligation to ensure the equal right of men and women to enjoy all economic, social, cultural, civil and political rights,

Considering the international conventions concluded under the auspices of the United Nations and the specialized agencies promoting equality of rights of men and women,

Noting also the resolutions, declarations and recommendations adopted by the United Nations and the specialized agencies promoting equality of rights of men and women,

Concerned, however, that despite these various instruments extensive discrimination against women continues to exist,

Recalling that discrimination against women violates the principles of equality of rights and respect for human dignity, is an obstacle to the participation of women, on equal terms with men, in the political, social, economic and cultural life of their countries, hampers the growth of the prosperity of society and the family and makes more difficult the full development of the potentialities of women in the service of their countries and of humanity,

Concerned that in situations of poverty women have the least access to food, health, education, training and opportunities for employment and other needs,

Convinced that the establishment of the new international economic order based on equity and justice will contribute significantly towards the promotion of equality between men and women,

Emphasizing that the eradication of *apartheid*, all forms of racism, racial discrimination, colonialism, neo-colonialism, aggression, foreign occupation and domination and interference in the internal affairs of States is essential to the full enjoyment of the rights of men and women,

Affirming that the strengthening of international peace and security, the relaxation of international tension, mutual co-operation among all States irrespective of their social and economic systems, general and complete disarmament, in particular nuclear disarmament under strict and effective international control, the affirmation of the principles of justice, equality and mutual benefit in relations among countries and the realization of the right of peoples under alien and colonial domination and foreign occupation to self-determination and independence, as well as respect for national sovereignty and territorial integrity, will promote social progress and development and as a consequence will contribute to the attainment of full equality between men and women,

Convinced that the full and complete development of a country, the welfare of the world and the cause of peace require the maximum participation of women on equal terms with men in all fields,

Bearing in mind the great contribution of women to the welfare of the family and to the development of society, so far not fully recognized, the social significance of maternity and the role of both parents in the family and in the upbringing of children, and aware that the role of women in procreation should not be a basis for discrimination but that the upbringing of children requires a sharing of responsibility between men and women and society as a whole,

Aware that a change in the traditional role of men as well as the role of women in society and in the family is needed to achieve full equality between men and women,

Determined to implement the principles set forth in the Declaration on the Elimination of Discrimination Against Women and, for that purpose, to adopt the measures required for the elimination of such discrimination in all forms and manifestations,

Have agreed on the following:

PART I

Article 1

For the purposes of the present Convention, the term "discrimination against women" shall mean any distinction, exclusion or restriction made on the basis of sex which has the effect or purpose of impairing or nullifying the recognition, enjoyment or exercise by women, irrespective of their marital status, on a basis of equality of men and women, of human rights and fundamental freedoms in the political, economic, social, cultural, civil or any other field.

Article 2

States Parties condemn discrimination against women in all its forms, agree to pursue by all appropriate means and without delay a policy of eliminating discrimination against women and, to this end, undertake:

(a) To embody the principle of the quality of men and women in their national constitutions or other appropriate legislation if not yet incorporated therein and to ensure, through law and other appropriate means, the practical realization of this principle;

(b) To adopt appropriate legislative and other measures, including sanctions where appropriate, prohibiting all discriminations against women.

(c) To establish legal protection of the rights of women on an equal basis with men and to ensure through competent national tribunals and other public institutions the effective protection of women against any act of discrimination;

(d) To refrain from engaging in any act or practice of discrimination against women and to ensure that public authorities and institutions shall act in conformity with this obligation;

(e) To take all appropriate measures to eliminate discrimination against women by any person, organization or enterprise;

(f) To take all appropriate measures, including legislation, to modify or abolish existing laws, regulations, customs and practices which constitute discrimination against women;

(g) To repeal all national penal provisions which constitute discrimination against women.

Article 3

States Parties shall take in all fields, in particular in the political, social, economic and cultural fields, all appropriate measures, including legislation, to ensure the full development and advancement of women, for the purpose of guaranteeing them the exercise and enjoyment of human rights and fundamental freedoms on a basis of equality with men.

Article 4

1. Adoption by States Parties of temporary special measures aimed at accelerating *de facto* equality between men and women shall not be considered discrimination as defined in the present Convention, but shall in no way entail as a consequence the maintenance of unequal or separate standards; these measures shall be discontinued when the objectives of equality of opportunity and treatment have been achieved.

2. Adoption by States Parties of special measures, including those measures contained in the present Convention, aimed at protecting maternity shall not be considered discriminatory.

Article 5

States Parties shall take all appropriate measures:

(a) To modify the social and cultural patterns of conduct of men and women, with a view to achieving the elimination of prejudices and customary and all other practices which are based on the idea of the inferiority or the superiority of either of the sexes or on stereotyped roles for men and women;

(b) To ensure that family education includes a proper understanding of maternity as a social function and the recognition of the common responsibility of men and women in the upbringing and development of their children, it being understood that the interest of the children is the primordial consideration in all cases.

Article 6

States Parties shall take all appropriate measures including legislation, to suppress all forms of traffic in women and exploitation of prostitution of women.

PART II

Article 7

States Parties shall take all appropriate measures to eliminate discrimination against women in the political and public life of the country and, in particular, shall ensure to women, on equal terms with men, the right:

(a) To vote in all elections and public referenda and to be eligible for election to all publicly elected bodies;

(b) To participate in the formulation of government policy and the implementation thereof and to hold public office and perform all public functions at all levels of government;

(c) To participate in non-governmental organizations and associations concerned with the public and political life of the country.

Article 8

States Parties shall take all appropriate measures to ensure to women, on equal terms with men and without any discrimination, the opportunity to represent their Governments at the international level and to participate in the work of international organizations.

Article 9

1. States Parties shall grant women equal rights with men to acquire, change or retain their nationality. They shall ensure in particular that neither marriage to an alien nor change of nationality by the husband during marriage shall automatically change the nationality of the wife, render her stateless or force upon her the nationality of the husband.

2. States Parties shall grant women equal rights with men with respect to the nationality of their children.

PART III

Article 10

States Parties shall take all appropriate measures to eliminate discrimination against women in order to ensure to them equal rights with men in the field of education and in particular to ensure, on a basis of equality of men and women:

(a) The same conditions for career and vocational guidance, for access to studies and for the achievement of diplomas in educational establishments of all categories in rural as well as in urban areas; this equality shall be ensured in pre-school, general, technical, professional and higher education, as well as in all types of vocational training;

(b) Access to the same curricula, the same examination, teaching staff with qualifications of the same standard and school premises and equipment of the same quality;

(c) The elimination of any stereotyped concept of the roles of men and women at all levels and in all forms of educations by encouraging coeducation and other types of

education which will help to achieve this aim and, in particular, by the revision of textbooks and school programmes and the adaptation of teaching methods.

(d) The same opportunities to benefit from scholarships and other study grants;

(e) The same opportunities for access to programmes of continuing education, including adult and functional literacy programmes, particularly those aimed at reducing at the earliest possible time, any gap in education existing between men and women;

(f) The reduction of female student drop-out rates and the organization of programmes for girls and women who have left school prematurely;

(g) The same opportunities to participate actively in sports and physical education;

(h) Access to specific educational information to help to ensure the health and well-being of families, including information and advice on family planning.

Article 11

1. States Parties shall take all appropriate measures to eliminate discrimination against women in the field of employment in order to ensure, on a basis of equality of men and women, the same rights, in particular:

(a) The right to work as an inalienable right of all human beings;

(b) The right to the same employment opportunities, including the application of the same criteria for selection in matters of employment;

(c) The right to free choice of profession and employment, the right to promotion, job security and all benefits and conditions of service and the right to receive vocational training and retraining, including apprenticeships, advanced vocational training and recurrent training;

(d) The right to equal remuneration, including benefits and to equal treatment in respect of work of equal value, as well as equality of treatment in the evaluation of the quality of work;

(e) The right to social security; particularly in cases of retirement, unemployment, sickness, invalidity and old age and other incapacity to work, as well as the right to paid leave;

(f) The right to protection of health and to safety in working conditions, including the safeguarding of the function of reproduction.

2. In order to prevent discrimination against women on the grounds of marriage or maternity and to ensure their effective right to work, States Parties shall take appropriate measures:

(a) To prohibit, subject to the imposition of sanctions, dismissal on the grounds of pregnancy or of maternity leave and discrimination in dismissals on the basis of marital status;

(b) To introduce maternity leave with pay or with comparable social benefits without loss of former employment, seniority or social allowances;

(c) To encourage the provision of the necessary supporting social services to enable parents to combine family obligations with work responsibilities and participation in public life, in particular through promoting the establishment and development of a network of child-care facilities;

(d) To provide special protection to women during pregnancy in types of work proved to be harmful to them.

3. Protective legislation relating to matters covered in this article shall be reviewed periodically in light of scientific and technological knowledge and shall be revised, repealed or extended as necessary.

Article 12

1. States Parties shall take all appropriate means to eliminate discrimination against women in the field of health care in order to ensure, on a basis of equality of men and women, access to health care services, including those related to family planning.

2. Notwithstanding the provisions of paragraph 1 of this Article, States Parties shall ensure to women appropriate services in connexion with pregnancy, confinement and the postnatal period, granting free services where necessary, as well as adequate nutrition during pregnancy and lactation.

Article 13

States Parties shall take all appropriate measures to eliminate discrimination against women in other areas of economic and social life in order to ensure, on a basis of equality of men and women, the same rights, in particular:

(a) The right to family benefits;

(b) The right to bank loans, mortgages and other forms of financial credit;

(c) The right to participate in recreational activities, sports and all aspects of cultural life.

Article 14

1. States Parties shall take into account the particular problems faced by rural women and the significant roles which rural women play in the economic survival of their families, including their work in the non-monetized

sectors of the economy, and shall take all appropriate measures to ensure the application of the provisions of the present Convention to women in rural areas.

2. States Parties shall take all appropriate measures to eliminate discrimination against women in rural areas in order to ensure, on a basis of equality of men and women, that they participate in and benefit from rural development and, in particular, shall ensure to such women the right:

(a) To participate in the elaboration and implementation of development planning at all levels;

(b) To have access to adequate health care facilities, including information, counselling and services in family planning;

(c) To benefit directly from social security programmes;

(d) To obtain all types of training and education, formal and non-formal, including that relating to functional literacy, as well as *inter alia,* the benefit of all community and extension services, in order to increase their technical proficiency;

(e) To organize self-help groups and co-operatives in order to obtain equal access to economic opportunities through employment or self-employment;

(f) To participate in all community activities;

(g) To have access to agricultural credit and loans, marketing facilities, appropriate technology and equal treatment in land and agrarian reform as well as in land resettlement schemes;

(h) To enjoy adequate living conditions, particularly in relation to housing, sanitation, electricity and water supply, transport and communications.

PART IV

Article 15

1. States Parties shall accord to women equality with men before the law.

2. States Parties shall accord to women, in civil matters, a legal capacity identical to that of men and the same opportunities to exercise that capacity. In particular, they shall give women equal rights to conclude contracts and to administer property and shall treat them equally in all stages of procedure in courts and tribunals.

3. States Parties agree that all contracts and all other private instruments of any kind with a legal effect which is directed at restricting the legal capacity of women shall be deemed null and void.

4. States Parties shall accord to men and women the same rights with regard to the law relating to the move-

ment of persons and the freedom to choose their residence and domicile.

Article 16

1. States Parties shall take all appropriate measures to eliminate discrimination against women in all matters relating to marriage and family relations and in particular shall ensure, on a basis of equality of men and women:

(a) The same right to enter into marriage;

(b) The same right freely to choose a spouse and to enter into marriage only with their free and full consent;

(c) The same rights and responsibilities during marriage and at its dissolution;

(d) The same rights and responsibilities as parents, irrespective of their marital status, in matters relating to their children; in all cases the interests of the children shall be paramount;

(e) The same rights to decide freely and responsibly on the number and spacing of their children and to have access to the information, education and means to enable them to exercise these rights;

(f) The same rights and responsibilities with regard to guardianship, wardship, trusteeship and adoption of children, or similar institutions where these concepts exist in national legislation; in all cases the interests of the children shall be paramount;

(g) The same personal rights as husband and wife, including the right to choose a family name, a profession and an occupation;

(h) The same rights for both spouses in respect of the ownership, acquisition, management, administration, enjoyment and disposition of property, whether free of charge or for a valuable consideration.

2. The betrothal and the marriage of a child shall have no legal effect, and all necessary action, including legislation, shall be taken to specify a minimum age for marriage and to make the registration of marriages in an official registry compulsory.

PART V

Article 17

1. For the purpose of considering the progress made in the implementation of the present Convention, there shall be established a Committee on the Elimination of Discrimination Against Women (hereinafter referred to as the Committee) consisting, at the time of entry into force of the Convention, of eighteen and after ratification of or accession to the Convention by the thirty-fifth State Party, of twenty-three experts of high moral stand-

ing and competence in the field covered by the convention. The experts shall be elected to States Parties from among their nationals and shall serve in their personal capacity, consideration being given to equitable geographical distribution and to the representation of the different forms of civilization as well as the principal legal systems.

2. The members of the Committee shall be elected by secret ballot from a list of persons nominated by States Parties. Each State Party may nominate one person from among its own nationals.

3. The initial election shall be held six months after the date of the entry into force of the present Convention. At least three months before the date of each election the Secretary-General of the United Nations shall address a letter to the States Parties inviting them to submit their nominations within two months. The Secretary-General shall prepare a list in alphabetical order of all persons thus nominated, indicating the States Parties which have nominated them, and shall submit it to the States Parties.

4. Elections of the members of the Committee shall be held at a meeting of States Parties convened by the Secretary-General at United Nations Headquarters. At that meeting, for which two-thirds of the States Parties shall constitute a quorum, the persons elected to the Committee shall be those nominees who obtain the largest number of votes and an absolute majority of the votes of the representatives of States Parties present and voting.

5. The members of the Committee shall be elected for a term of four years. However, the terms of nine of the members elected at the first election shall expire at the end of two years; immediately after the first election the names of these nine members shall be chosen by lot by the Chairman of the Committee.

From *Meritor Savings Bank, FSB v. Vinson,* 54 U.S.L.W. 4703 (1986)

JUSTICE REHNQUIST delivered the opinion of the Court.

This case presents important questions concerning claims of workplace "sexual harassment" brought under Title VII of the Civil Rights Act of 1964, 78 Stat. 253, as amended, 42 U.S.C. §2000e *et seq.*

I

In 1974, respondent Mechelle Vinson met Sidney Taylor, a vice president of what is now petitioner Meritor Savings Bank (the bank) and manager of one of its branch offices. . . . With Taylor as her supervisor, respondent started as a teller-trainee, and thereafter was promoted to teller, head teller, and assistant branch manager. She worked at the same branch for four years, and it is undisputed that her advancement there was based on merit alone. In September 1978, respondent notified Taylor that she was taking sick leave for an indefinite period. On November 1, 1978, the bank discharged her for excessive use of that leave.

Respondent brought this action against Taylor and the bank, claiming that during her four years at the bank she had "constantly been subjected to sexual harassment" by Taylor in violation of Title VII. She sought injunctive relief, compensatory and punitive damages against Taylor and the bank, and attorney's fees.

At the 11-day bench trial, the parties presented conflicting testimony about Taylor's behavior during respondent's employment. Respondent testified that during her probationary period as a teller-trainee, Taylor treated her in a fatherly way and made no sexual advances. Shortly thereafter, however, he invited her out to dinner and, during the course of the meal, suggested that they go to a motel to have sexual relations. At first she refused, but out of what she described as fear of losing her job she eventually agreed. According to respondent, Taylor thereafter made repeated demands upon her for sexual favors, usually at the branch, both during and after business hours; she estimated that over the next several years she had intercourse with him some 40 or 50 times. In addition, respondent testified that Taylor fondled her in front of other employees, followed her into the women's restroom when she went there alone, exposed himself to her, and even forcibly raped her on several occasions. These activities ceased after 1977, respondent stated, when she started going with a steady boyfriend.

Respondent also testified that Taylor touched and fondled other women employees of the bank, and she attempted to call witnesses to support this charge. But while some supporting testimony apparently was admitted without objection, the District Court did not allow her "to present wholesale evidence of a pattern and practice relating to sexual advances to other female employees in her case in chief, but advised her that she might well be able to present such evidence in rebuttal to the defendants' cases." *Vinson v. Taylor,* 23 F.E.P. Cases 37, 38–39, n.1 (D. D.C. 1980). Respondent did not offer such evidence in rebuttal. Finally, respondent testified that because she was afraid of Taylor she never reported his harassment to any of his supervisors and never attempted to use the bank's complaint procedure.

Taylor denied respondent's allegations of sexual activity, testifying that he never fondled her, never made suggestive remarks to her, never engaged in sexual intercourse with her and never asked her to do so. He

contended instead that respondent made her accusations in response to a business-related dispute. The bank also denied respondent's allegations and asserted that any sexual harassment by Taylor was unknown to the bank and engaged in without its consent or approval.

The District Court denied relief, but did not resolve the conflicting testimony about the existence of a sexual relationship between respondent and Taylor. It found instead that

> If [respondent] and Taylor did engage in an intimate or sexual relationship during the time of [respondent's] employment with [the bank], that relationship was a voluntary one having nothing to do with her continued employment at [the bank] or her advancement or promotions at that institution. (*Id.* at 42 [footnote omitted].)

The court ultimately found that respondent "was not the victim of sexual harassment and was not the victim of sexual discrimination" while employed at the bank. *Id.* 43.

. . .

The Court of Appeals for the District of Columbia Circuit reversed. 753 F.2d 141 (1985). . . . [T]he court stated that a violation of Title VII may be predicated on either of two types of sexual harassment: harassment that involves the conditioning of concrete employment benefits on sexual favors, and harassment that, while not affecting economic benefits, creates a hostile or offensive working environment. The court drew additional support for this position from the Equal Employment Opportunity Commission's Guidelines on Discrimination Because of Sex, 29 C.F.S. §1604.11(a) (1985), which set out these two types of sexual harassment claims. Believing that "Vinson's grievance was clearly of the [hostile environment] type," 753 F.2d, at 145, and that the District Court had not considered whether a violation of this type had occurred, the court concluded that a remand was necessary.

The court further concluded that the District Court's finding that any sexual relationship between respondent and Taylor "was a voluntary one" did not obviate the need for a remand. "[U]ncertain as to precisely what the [district] court meant" by this finding, the Court of Appeals held that if the evidence otherwise showed that "Taylor made Vinson's toleration of sexual harassment a condition of her employment," her voluntariness "had no materiality whatsoever." 753 F.2d, at 146. The court then surmised that the District Court's finding of voluntariness might have been based on "the voluminous testimony regarding respondent's dress and personal fantasies," testimony that the Court of Appeals believed "had no place in this litigation." 753 F.2d, at 146, n.36.

As to the bank's liability, the Court of Appeals held that an employer is absolutely liable for sexual harassment practiced by supervisory personnel, whether or not the employer knew or should have known about the misconduct. The court relied chiefly on Title VII's definition of "employer" to include "any agent of such a person." 42 U.S.C. §2000e(b), as well as on the EEOC guidelines. The court held that a supervisor is an "agent" of his employer for Title VII purposes, even if he lacks authority to hire, fire, or promote, since "the mere existence—or even the appearance—of a significant degree of influence in vital job decisions gives any supervisor the opportunity to impose on employees." 753 F.2d, at 150.

In accordance with the foregoing, the Court of Appeals reversed the judgment of the District Court and remanded the case for further proceedings. . . . We . . . now affirm but for different reasons.

II

Title VII of the Civil Rights Act of 1964 makes it "an unlawful employment practice for an employer . . . to discriminate against any individual with respect to his compensation, terms, conditions, or privileges of employment, because of such individual's race, color, religion, sex, or national origin." 42 U.S.C. §2000e–2 (a)(1). . . .

Respondent argues, and the Court of Appeals held, that unwelcome sexual advances that create an offensive or hostile working environment violate Title VII. Without question, when a supervisor sexually harasses a subordinate because of the subordinate's sex, that supervisor "discriminate[s]" on the basis of sex. Petitioner apparently does not challenge this proposition. It contends instead that in prohibiting discrimination with respect to "compensation, terms, conditions, or privileges" of employment, Congress was concerned with what petitioner describes as "tangible loss" of "an economic character," not "purely psychological aspects of the workplace environment." . . .

We reject petitioner's view. First, the language of Title VII is not limited to "economic" or "tangible" discrimination. The phrase "terms, conditions, or privileges of employment" evinces a congressional intent "to strike at the entire spectrum of disparate treatment of men and women" in employment. *Los Angeles Department of Water and Power v. Manhart,* 435 U.S. 702, 707, n.13 (1978). . . .

Second, in 1980 the EEOC issued guidelines specifying that "sexual harassment," as there defined, is a form of sex discrimination prohibited by Title VII. As an "administrative interpretation of the Act by the enforcing agency," *Griggs v. Duke Power Co.,* 401 U.S. 424, 433–34 (1971), these guidelines, "'while not controlling upon the courts by reason of their authority, do constitute a body of experience and informed judgment to which courts and litigants may properly resort for guidance,'" *General Electric Co. v. Gilbert,* 429 U.S. 125, 141–42 (1976). . . .

In defining "sexual harassment," the guidelines first describe the kinds of workplace conduct that may be actionable under Title VII. These include "[u]nwelcome sexual advances, requests for sexual favors, and other verbal or physical conduct of a sexual nature." 29 C.F.R. §1604.11(a) (1985). Relevant to the charges at issue in this case, the guidelines provide that such sexual misconduct constitutes prohibited "sexual harassment," whether or not it is directly linked to the grant or denial of an economic *quid pro quo,* where "such conduct has the purpose or effect of unreasonably interfering with an individual's work performance or creating an intimidating, hostile, or offensive working environment." §1604.11(a)(3).

In concluding that so-called "hostile environment" (*i.e.,* non *quid pro quo*) harassment violates Title VII, the EEOC drew upon a substantial body of judicial decisions and EEOC precedent holding that Title VII affords employees the right to work in an environment free from discriminatory intimidation, ridicule, and insult. *See generally* 45 Fed. Reg. 74676 (1980). *Rogers v. EEOC,* 454 F.2d 234 (5th Cir. 1971), *cert. denied,* 406 U.S. 957 (1972), was apparently the first case to recognize a cause of action based upon a discriminatory work environment. In *Rogers,* the . . . court explained that an employee's protections under Title VII extend beyond the economic aspects of employment:

> . . . One can readily envision working environments so heavily polluted with discrimination as to destroy completely the emotional and psychological stability of minority group workers. . . . (454 F.2d, at 238.)

Courts applied this principle to harassment based on race, *e.g., Firefighters Institute for Racial Equality v. St. Louis,* 549 F.2d 506, 514–15 (8th Cir.) (1977); *Gray v. Greyhound Lines, East,* 545 F.2d 169, 176 (1976), religion, *e.g., Compston v. Borden, Inc.,* 424 F. Supp. 157 (S.D. Ohio 1976), and national origin, *e.g., Cariddi v. Kansas City Chiefs Football Club,* 568 F.2d 87, 88 (8th Cir. 1977). Nothing in Title VII suggests that a hostile environment based on discriminatory *sexual* harassment should not be likewise prohibited. The guidelines thus appropriately drew from, and were fully consistent with, the existing caselaw.

Since the guidelines were issued, courts have uniformly held, and we agree, that a plaintiff may establish a violation of Title VII by proving that discrimination based on sex has created a hostile or abusive work environment. As the Court of Appeals for the Eleventh Circuit wrote in *Henson v. Dundee,* 682 F.2d 897, 902 (1982):

> Sexual harassment which creates a hostile or offensive environment for members of one sex is every bit the

arbitrary barrier to sexual equality at the workplace that racial harassment is to racial equality. Surely, a requirement that a man or woman run a guantlet of sexual abuse in return for the privilege of being allowed to work and make a living can be as demeaning and disconcerting as the harshest of racial epithets.

Of course, as the courts in both *Rogers* and *Henson* recognized, not all workplace conduct that may be described as "harassment" affects a "term, condition, or privilege" of employment within the meaning of Title VII. . . . For sexual harassment to be actionable, it must be sufficiently severe or pervasive "to alter the conditions of [the victim's] employment and create an abusive working environment." *Henson, supra,* at 904. Respondent's allegations in this case—which include not only pervasive harassment but also criminal conduct of the most serious nature—are plainly sufficient to state a claim for "hostile environment" sexual harassment. Since it appears that the District Court made its findings without ever considering the "hostile environment" theory of sexual harassment, the Court of Appeals' decision to remand was correct.

Second, the District Court's conclusion that no actionable harassment occurred might have rested on its earlier "finding" that "[i]f [respondent] and Taylor did engage in an intimate or sexual relationship . . ., that relationship was a voluntary one." 23 F.E.P. cases, at 42. But the fact that sex-related conduct was "voluntary," in the sense that the complainant was not forced to participate against her will, is not a defense to a sexual harassment suit brought under Title VII. The gravamen of any sexual harassment claim is that the alleged sexual advances were "unwelcome." 29 C.F.R. §1604.11(a) (1985). While the question whether particular conduct was indeed unwelcome presents difficult problems of proof and turns largely on credibility determinations committed to the trier of fact, the District Court in this case erroneously focused on the "voluntariness" of respondent's participation in the claimed sexual episodes. The correct inquiry is whether respondent by her conduct indicated that the alleged sexual advances were unwelcome, not whether her actual participation in sexual intercourse was voluntary.

Petitioner contends that even if this case must be remanded to the District Court, the Court of Appeals erred in one of the terms of its remand. Specifically, the Court of Appeals stated that testimony about respondent's "dress and personal fantasies," 753 F.2d, at 146, n.36, which the District Court apparently admitted into evidence, "had no place in this litigation." *Id.* The apparent ground for this conclusion was that respondent's voluntariness *vel non* in submitting to Taylor's advances was immaterial to her sexual harassment claim. While "voluntariness" in the sense of consent is not a defense to such a

claim, it does not follow that a complainant's sexually provocative speech or dress is irrelevant as a matter of law in determining whether he or she found particular sexual advances unwelcome. To the contrary, such evidence is obviously relevant. The EEOC guidelines emphasize that the trier of fact must determine the existence of sexual harassment in light of "the record as a whole" and "the totality of circumstances, such as the nature of the sexual advances and the context in which the alleged incidents occurred." 29 C.F.R. §1604.11(b) (1985). Respondent's claim that any marginal relevance of the evidence in question was outweighed by the potential for unfair prejudice is the sort of argument properly addressed to the District Court. In this case the District Court concluded that the evidence should be admitted, and the Court of Appeals' contrary conclusion was based upon the erroneous, categorical view that testimony about provocative dress and publicly expressed sexual fantasies "had no place in this litigation." 753 F.2d, at 146, n.36. While the District Court must carefully weigh the applicable considerations in deciding whether to admit evidence of this kind, there is no *per se* rule against its admissibility.

III

Although the District Court concluded that respondent had not proved a violation of Title VII, it nevertheless went on to consider the question of the bank's liability. Finding that "the bank was without notice" of Taylor's alleged conduct, and that notice to Taylor was not the equivalent of notice to the bank, the court concluded that the bank therefore could not be held liable for Taylor's alleged actions. The Court of Appeals took the opposite view, holding that an employer is strictly liable for a hostile environment created by a supervisor's sexual advances, even though the employer neither knew nor reasonably could have known of the alleged misconduct. The court held that a supervisor, whether or not he possesses the authority to hire, fire, or promote, is necessarily an "agent" of his employer for all Title VII purposes, since "even the appearance" of such authority may enable him to impose himself on his subordinates.

. . .

Petitioner argues that respondent's failure to use its established grievance procedure, or to otherwise put it on notice of the alleged misconduct, insulates petitioner from liability for Taylor's wrongdoing. A contrary rule would be unfair, petitioner argues, since in a hostile environment harassment case the employer often will have no reason to know about, or opportunity to cure, the alleged wrongdoing.

The EEOC, in its brief as *amicus curiae,* contends . . . that where a supervisor exercises the authority actually delegated to him by his employer, by making or threatening to make decisions affecting the employment status of his subordinates, such actions are properly imputed to the employer whose delegation of authority empowered the supervisor to undertake them. Brief for United States and Equal Employment Opportunity Commission as *Amicus Curiae* 22. Thus, the courts have consistently held employers liable for the discriminatory discharges of employees by supervisory personnel, whether or not the employer knew, should have known, or approved of the supervisor's actions.

The EEOC suggests that when a sexual harassment claim rests exclusively on a "hostile environment" theory, however, the usual basis for a finding of agency will often disappear. In that case, the EEOC believes, agency principles lead to

> a rule that asks whether a victim of sexual harassment had reasonably available an avenue of complaint regarding such harassment, and, if available and utilized, whether that procedure was reasonably responsive to the employee's complaint. If the employer has an expressed policy against sexual harassment and has implemented a procedure specifically designed to resolve sexual harassment claims, and if the victim does not take advantage of that procedure, the employer should be shielded from liability absent actual knowledge of the sexually hostile environment (obtained, *e.g.,* by the filing of a charge with the EEOC or a comparable state agency). In all other cases, the employer will be liable if it has actual knowledge of the harassment or if, considering all the facts of the case, the victim in question had no reasonably available avenue for making his or her complaint known to appropriate management officials. (Brief for United States and Equal Opportunity Employment Commission as *Amici Curiae,* 26.)

As respondent points out, this suggested rule is in some tension with the EEOC guidelines, which hold an employer liable for the acts of its agents without regard to notice. 29 C.F.R. §1604.11(c) (1985). The guidelines do require, however, an "examin[ation of] the circumstances of the particular employment relationship and the job [f]unctions performed by the individual in determining whether an individual acts in either a supervisory or agency capacity." *Id.*

This debate over the appropriate standard for employer liability has a rather abstract quality about it given the state of the record in this case. We do not know at this stage whether Taylor made any sexual advances toward respondent at all, let alone whether those advances were unwelcome, whether they were sufficiently pervasive to constitute a condition of employment, or whether they were "so pervasive and so long continuing . . . that the employer must have become conscious of [them]," *Taylor v. Jones,* 653 F.2d 1193, 1197–99 (8th Cir. 1981)

We therefore decline the parties' invitation to issue a definitive rule on employer liability, but we do agree with the EEOC that Congress wanted courts to look to agency principles for guidance in this area. While such common-law principles may not be transferable in all their particulars to Title VII, Congress' decision to define "employer" to include any "agent" of an employer, 42 U.S.C. §2000e(b), surely evinces an intent to place some limits on the acts of employees for which employers under Title VII are to be held responsible. For this reason, we hold that the Court of Appeals erred in concluding that employers are always automatically liable for sexual harassment by their supervisors. For the same reason, absence of notice to an employer does not necessarily insulate that employer from liability.

Finally, we reject petitioner's view that the mere existence of a grievance procedure and a policy against discrimination, coupled with respondent's failure to invoke that procedure, must insulate petitioner from liability. While those facts are plainly relevant, the situation before us demonstrates why they are not necessarily dispositive. Petitioner's general nondiscrimination policy did not address sexual harassment in particular, and thus did not alert employees to their employer's interest in correcting that form of discrimination. Moreover, the bank's grievance procedure apparently required an employee to complain first to her supervisor, in this case Taylor. Since Taylor was the alleged perpetrator, it is not altogether surprising that respondent failed to invoke the procedure and report her grievance to him.

. . .

IV

In sum, we hold that a claim of "hostile environment" sex discrimination is actionable under Title VII, that the District Court's findings were insufficient to dispose of respondent's hostile environment claim, and that the District Court did not err in admitting testimony about respondent's sexually provocative speech and dress. As to employer liability, we conclude that the Court of Appeals was wrong to entirely disregard agency principles and impose absolute liability on employers for the acts of their supervisors, regardless of the circumstances of a particular case.

Accordingly, the judgment of the Court of Appeals reversing the judgment of the District Court is affirmed, and the case is remanded for further proceedings consistent with this opinion.

It is so ordered.

JUSTICE STEVENS, concurring.

Because I do not see any inconsistency between the two opinions, and because I believe the question of statutory construction that JUSTICE MARSHALL has answered is fairly presented by the record, I join both the Court's opinion and JUSTICE MARSHALL'S opinion.

JUSTICE MARSHALL, with whom JUSTICE BRENNAN, JUSTICE BLACKMUN, and JUSTICE STEVENS join, concurring in the judgment.

I fully agree with the Court's conclusion that workplace sexual harassment is illegal, and violates Title VII. Part III of the Court's opinion, however, leaves open the circumstances in which an employer is responsible under Title VII for such conduct. Because I believe that question to be properly before us, I write separately.

The issue the Court declines to resolve is addressed in the EEOC Guidelines on Discrimination Because of Sex, which are entitled to great deference. *See Griggs v. Duke Power Co.,* 401 U.S. 424, 433–34 (1971). The Guidelines explain:

> Applying general Title VII principles, an employer . . . is responsible for its acts and those of its agents and supervisory employees with respect to sexual harassment regardless of whether the specific acts complained of were authorized or even forbidden by the employer and regardless of whether the employer knew or should have known of their occurrence. The Commission will examine the circumstances of the particular employment relationship and the job functions performed by the individual in determining whether an individual acts in either a supervisory or agency capacity.
>
> With respect to conduct between fellow employees, an employer is responsible for acts of sexual harassment in the workplace where the employer (or its agents or supervisory employees) knows or should have known of the conduct, unless it can show that it took immediate and appropriate corrective action. (29 C.F.R. §1604.11[c], [d] [1985].

. . . I would adopt the standard set out by the Commission.

An employer can act only through individual supervisors and employees; discrimination is rarely carried out pursuant to a formal vote of a corporation's board of directors. Although an employer may sometimes adopt company-wide discriminatory policies violative of Title VII, acts that may constitute Title VII violations are generally effected through the actions of individuals, and often an individual may take such a step even in defiance of company policy. Nonetheless, Title VII remedies, such as reinstatement and backpay, generally run against the employer as an entity. The question thus arises as to the circumstances under which an employer will be held liable under Title VII for the acts of its employees.

The answer supplied by general Title VII law, like that supplied by federal labor law, is that the act of a

supervisory employee or agent is imputed to the employer. Thus, for example, when a supervisor discriminatorily fires or refuses to promote a black employee, that act is, without more, considered the act of the employer. The courts do not stop to consider whether the employer otherwise had "notice" of the action. . . . Following that approach, every Court of Appeals that has considered the issue has held that sexual harassment by supervisory personnel is automatically imputed to the employer when the harassment results in tangible job detriment to the subordinate employee. [Citations omitted.]

The brief filed by the Solicitor General on behalf of the EEOC in this case suggests that a different rule should apply when a supervisor's harassment "merely" results in a discriminatory work environment. The Solicitor General . . . , departing from the EEOC Guidelines,. . . argues that the case of a supervisor merely creating a discriminatory work environment is different because the supervisor "is not exercising, or threatening to exercise, actual or apparent authority to make personnel decisions affecting the victim." In the latter situation, he concludes, some further notice requirement should therefore be necessary.

The Solicitor General's position is untenable. A supervisor's responsibilities do not begin and end with the power to hire, fire, and discipline employees, or with the power to recommend such actions. Rather, a supervisor is charged with the day-to-day supervision of the work environment and with ensuring a safe, productive, workplace. There is no reason why abuse of the latter authority should have different consequences than abuse of the former. In both cases it is the authority vested in the supervisor by the employer that enables him to commit the wrong: it is precisely because the supervisor is understood to be clothed with the employer's authority that he is able to impose unwelcome sexual conduct on subordinates. There is therefore no justification for a special rule, to be applied *only* in "hostile environment" cases, that sexual harassment does not create employer liability until the employee suffering the discrimination notifies other supervisors. . . .

Agency principles and the goals of Title VII law make appropriate some limitation on the liability of employers for the acts of supervisors. Where, for example, a supervisor has no authority over an employee, because the two work in wholly different parts of the employer's business, it may be improper to find strict employer liability. *See* 29 C.F.R. §1604.11(c) (1985). Those considerations, however, do not justify the creation of a special "notice" rule in hostile environment cases.

Further, nothing would be gained by crafting such a rule. In the "pure" hostile environment case, where an employee files an EEOC complaint alleging sexual harassment in the workplace, the employee seeks not money damages but injunctive relief. *See Bundy v. Jackson*, 641 F.2d 934, 936, n.12 (1981). Under Title VII, the EEOC must notify an employer of charges made against it within 10 days after receipt of the complaint. 42 U.S.C. §2000e–5(b). If the charges appear to be based on "reasonable cause," the EEOC must attempt to eliminate the offending practice through "informal methods of conference, conciliation, and persuasion." An employer whose internal procedures assertedly would have redressed the discrimination can avoid injunctive relief by employing these procedures after receiving notice of the complaint or during the conciliation period. Where a complaint, on the other hand, seeks backpay on the theory that a hostile work environment effected a constructive termination, the existence of an internal complaint procedure may be a factor in determining not the employer's liability but the remedies available against it. Where a complainant without good reason bypassed an internal complaint procedure she knew to be effective, a court may be reluctant to find constructive termination and thus to award reinstatement or backpay.

I therefore reject the Solicitor General's position. I would apply in this case the same rules we apply in all other Title VII cases, and hold that sexual harassment by a supervisor of an employee under his supervision, leading to a discriminatory work environment, should be imputed to the employer for Title VII purposes regardless of whether the employee gave "notice" of the offense.

From *Planned Parenthood v. Casey*, 1992

From the Decision By Justices O'Connor, Kennedy and Souter

Liberty finds no refuge in a jurisprudence of doubt. Yet 19 years after our holding that the Constitution protects a woman's right to terminate her pregnancy in its early stages, *Roe v. Wade*, 410 U.S. 113 (1973), that definition of liberty is still questioned. Joining the respondents as amicus curiae, the United States, as it has done in five other cases in the last decade, again asks us to overrule *Roe*.

At issue in these cases are five provisions of the Pennsylvania Abortion Control Act of 1982 as amended in 1988 and 1989. The Act requires that a woman seeking an abortion give her informed consent prior to the abortion procedure, and specifies that she be provided with certain information at least 24 hours before the abortion is performed. For a minor to obtain an abortion, the Act requires the informed consent of one of her parents, but provides for a judicial bypass option if the minor does not wish to or cannot obtain a parent's consent. Another pro-

vision of the Act requires that, unless certain exceptions apply, a married woman seeking an abortion must sign a statement indicating that she has notified her husband of her intended abortion. The Act exempts compliance with these three requirements in the event of a "medical emergency," which is defined in Sections 3203 of the Act. In addition to the above provisions regulating the performance of abortions, the Act imposes certain reporting requirements on facilities that provide abortion services.

Before any of these provisions took effect, the petitioners, who are five abortion clinics and one physician representing himself as well as a class of physicians who provide abortion services, brought this suit seeking declaratory and injunctive relief. Each provision was challenged as unconstitutional on its face. The District Court entered a preliminary injunction against the enforcement of the regulations, and, after a 3-day bench trial, held all the provisions at issue here unconstitutional, entering a permanent injunction against Pennsylvania's enforcement of them. The Court of Appeals for the Third Circuit affirmed in part and reversed in part, upholding all of the regulations except for the husband notification requirement. . . .

And at oral argument in this Court, the attorney for the parties challenging the statute took the position that none of the enactments can be upheld without overruling *Roe v. Wade.* We disagree with that analysis; but we acknowledge that our decisions after *Roe* cast doubt upon the meaning and reach of its holding. Further, the Chief Justice admits that he would overrule the central holding of *Roe* and adopt the rational relationship test as the sole criterion of constitutionality. State and Federal courts as well as legislatures throughout the union must have guidance as they seek to address this subject in conformance with the Constitution. Given these premises, we find it imperative to review once more the principles that define the rights of the woman and the legitimate authority of the state respecting the termination of pregnancies by abortion procedures.

After considering the fundamental constitutional questions resolved by *Roe,* principles of institutional integrity, and the rule of stare decisis, we are led to conclude this: the essential holding of *Roe v. Wade* should be retained and once again reaffirmed.

It must be stated at the outset and with clarity that *Roe's* essential holding, the holding we reaffirm, has three parts. First is a recognition of the right of the woman to choose to have an abortion before viability and to obtain it without undue interference from the State. Before viability, the state's interests are not strong enough to support a prohibition of abortion or the imposition of a substantial obstacle to the woman's effective right to elect the procedure. Second is a confirmation of the state's power to restrict abortions after fetal viability, if the law contains exceptions for pregnancies which endanger a woman's life or health. And third is the principle that the state has legitimate interests from the outset of the pregnancy in protecting the health of the woman and the life of the fetus that may become a child. These principles do not contradict one another; and we adhere to each.

. . .

Men and women of good conscience can disagree, and we suppose some always shall disagree, about the profound moral and spiritual implications of terminating a pregnancy, even in its earliest stage. Some of us as individuals find abortion offensive to our most basic principles of morality, but that cannot control our decision. Our obligation is to define the liberty of all, not to mandate our own moral code. The underlying constitutional issue is whether the state can resolve these philosophic questions in such a definitive way that a woman lacks all choice in the matter, except perhaps in those rare circumstances in which the pregnancy is itself a danger to her own life or health, or is the result of rape or incest.

It is conventional constitutional doctrine that where reasonable people disagree the Government can adopt one position or the other. That theorem, however, assumes a state of affairs in which the choice does not intrude upon a protected liberty. Thus, while some people might disagree about whether or not the flag should be saluted, or disagree about the proposition that it may not be defiled, we have ruled that a state may not compel or enforce one view or the other.

Our cases recognize "the right of the individual, married or single, to be free from unwarranted governmental intrusion into matters so fundamentally affecting a person as the decision whether to bear or beget a child." *Eisenstadt v. Baird.* Our precedents "have respected the private realm of family life which the state cannot enter." *Prince v. Massachusetts.* These matters, involving the most intimate and personal choices a person may make in a lifetime, choices central to personal dignity and autonomy, are central to the liberty protected by the Fourteenth Amendment. At the heart of liberty is the right to define one's own concept of existence, of meaning, of the universe, and of the mystery of human life. Beliefs about these matters could not define the attributes of personhood were they formed under compulsion of the State.

These considerations begin our analysis of the woman's interest in terminating her pregnancy but cannot end it, for this reason: though the abortion decision may originate within the zone of conscience and belief, it is more than a philosophic exercise. Abortion is a unique act. It is an act fraught with consequences for others: for the woman who must live with the implications of her decision; for the persons who perform and assist in the procedure; for the spouse, family, and society which must

confront the knowledge that these procedures exist, procedures some deem nothing short of an act of violence against innocent human life; and; depending on one's beliefs, for the life or potential life that is aborted. Though abortion is conduct, it does not follow that the State is entitled to proscribe it in all instances. That is because the liberty of the woman is at stake in a sense unique to the human condition and so unique to the law. The mother who carries a child to full term is subject to anxieties, to physical constraints, to pain that only she must bear.

. . .

Although *Roe* has engendered opposition, it has in no sense proven "unworkable," representing as it does a simple limitation beyond which a state law is unenforceable.

. . .

But to do this would be simply to refuse to face the fact that for two decades of economic and social developments, people have organized intimate relationships and made choices that define their views of themselves and their places in society, in reliance on the availability of abortion in the event that contraception should fail. The ability of women to participate equally in the economic and social life of the nation has been facilitated by their ability to control their reproductive lives. The Constitution serves human values, and while the effect of reliance on *Roe* cannot be exactly measured, neither can the certain cost of overruling *Roe* for people who have ordered their thinking and living around that case be dismissed.

No evolution of legal principle has left *Roe's* doctrinal footings weaker than they were in 1973. No development of constitutional law since the case was decided has implicitly or explicitly left *Roe* behind as a mere survivor of obsolete constitutional thinking.

. . .

We have seen how time has overtaken some of *Roe's* factual assumptions: advances in maternal health care allow for abortions safe to the mother later in pregnancy than was true in 1973, and advances in neonatal care have advanced viability to a point somewhat earlier. But these facts go only to the scheme of time limits on the realization of competing interests, and the divergences from the factual premises of 1973 have no bearing on the validity of *Roe's* central holding, that viability marks the earliest point at which the state's interest in fetal life is constitutionally adequate to justify a legislative ban on nontherapeutic abortions.

The soundness or unsoundness of that constitutional judgment in no sense turns on whether viability occurs at approximately 28 weeks, as was usual at the time of *Roe*, at 23 to 24 weeks, as it sometimes does today, or at some moment even slightly earlier in pregnancy, as it may if fetal respiratory capacity can somehow be enhanced in the future. Whenever it may occur, the attainment of viability may continue to serve as the critical fact, just as it has done since *Roe* was decided; which is to say that no change in *Roe's* factual underpinning has left its central holding obsolete, and none supports an argument for overruling it.

The sum of the precedential inquiry to this point shows *Roe's* underpinnings unweakened in any way affecting its central holding. While it has engendered disapproval, it has not been unworkable. An entire generation has come of age free to assume *Roe's* concept of liberty in defining the capacity of women to act in society, and to make reproductive decisions; no erosion of principle going to liberty or personal autonomy has left *Roe's* central holding a doctrinal remnant; *Roe* portends no developments at odds with other precedent for the analysis of personal liberty; and no changes of fact have rendered viability more or less appropriate as the point at which the balance of interests tips. . . .

. . .

Our analysis would not be complete, however, without explaining why overruling *Roe's* central holding would not only reach an unjustifiable result under principles of stare decisis, but would seriously weaken the Court's capacity to exercise the judicial power and to function as the Supreme Court of a nation dedicated to the rule of law. . . .

The root of American Governmental power is revealed most clearly in the instance of the power conferred by the Constitution upon the Judiciary of the United States and specifically upon this Court. As Americans of each succeeding generation are rightly told, the Court cannot buy support for its decisions by spending money and, except to a minor degree, it cannot independently coerce obedience to its decrees. The Court's power lies, rather, in its legitimacy, a product of substance and perception that shows itself in the people's acceptance of the judiciary as fit to determine what the nation's law means and to declare what it demands.

The underlying substance of this legitimacy is of course the warrant for the Court's decisions in the Constitution and the lesser sources of legal principle on which the Court draws. That substance is expressed in the Court's opinions, and our contemporary understanding is such that a decision without principled justification would be no judicial act at all. But even when justification is furnished by apposite legal principle, something more is required. Because not every conscientious claim of principled justification will be accepted as such, the justification claimed must be beyond dispute.

The Court must take care to speak and act in ways that allow people to accept its decisions on the terms the Court claims for them, as grounded truly in principle, not as compromises with social and political pressures having, as such, no bearing on the principled choices that

the Court is obliged to make. Thus, the Court's legitimacy depends on making legally principled decisions under circumstances in which their principled character is sufficiently plausible to be accepted by the nation.

The need for principled action to be perceived as such is implicated to some degree whenever this, or any other appellate court, overrules a prior case. This is not to say, of course, that this Court cannot give a perfectly satisfactory explanation in most cases. People understand that some of the Constitution's language is hard to fathom and that the Court's Justices are sometimes able to perceive significant facts or to understand principles of law that eluded their predecessors and that justify departures from existing decisions. However upsetting it may be to those most directly affected when one judicially derived rule replaces another, the country can accept some correction of error without necessarily questioning the legitimacy of the Court.

In two circumstances, however, the Court would almost certainly fail to receive the benefit of the doubt in overruling prior cases. There is, first, a point beyond which frequent overruling would overtax the country's belief in the Court's good faith. Despite the variety of reasons that may inform and justify a decision to overrule, we cannot forget that such a decision is usually perceived (and perceived correctly) as, at the least, a statement that a prior decision was wrong. There is a limit to the amount of error that can plausibly be imputed to prior courts. If that limit should be exceeded, disturbance of prior rulings would be taken as evidence that justifiable re-examination of principle had given way to drives for particular results in the short term. The legitimacy of the Court would fade with the frequency of its vacillation.

That first circumstance can be described as hypothetical; the second is to the point here and now. Where, in the performance of its judicial duties, the Court decides a case in such a way as to resolve the sort of intensely divisive controversy reflected in *Roe* and those rare, comparable cases, its decision has a dimension that the resolution of the normal case does not carry. It is the dimension present whenever the Court's interpretation of the Constitution calls the contending sides of a national controversy to end their national division by accepting a common mandate rooted in the Constitution.

The Court is not asked to do this very often, having thus addressed the nation only twice in our lifetime, in the decisions of *Brown* and *Roe*. But when the Court does act in this way, its decision requires an equally rare precedential force to counter the inevitable efforts to overturn it and to thwart its implementation. Some of those efforts may be mere unprincipled emotional reactions; others may proceed from principles worthy of profound respect.

But whatever the premises of opposition may be, only the most convincing justification under accepted standards of precedent could suffice to demonstrate that a later decision overruling the first was anything but a surrender to political pressure, and an unjustified repudiation of the principle on which the Court staked its authority in the first instance. So to overrule under fire in the absence of the most compelling reason to re-examine a watershed decision would subvert the Court's legitimacy beyond any serious question.

. . .

The Court's duty in the present case is clear. In 1973, it confronted the already-divisive issue of governmental power to limit personal choice to undergo abortion, for which it provided a new resolution based on the due process guaranteed by the Fourteenth Amendment. Whether or not a new social consensus is developing on that issue, its divisiveness is no less today than in 1973, and pressure to overrule the decision, like pressure to retain it, has grown only more intense. A decision to overrule *Roe's* essential holding under the existing circumstances would address error, if error there was, at the cost of both profound and unnecessary damage to the Court's legitimacy, and to the nation's commitment to the rule of law. It is therefore imperative to adhere to the essence of *Roe's* original decision, and we do so today.

From what we have said so far it follows that it is a constitutional liberty of the woman to have some freedom to terminate her pregnancy. We conclude that the basic decision in *Roe* was based on a constitutional analysis which we cannot now repudiate. The woman's liberty is not so unlimited, however, that from the outset the State cannot show its concern for the life of the unborn, and at a later point in fetal development the state's interest in life has sufficient force so that the right of the woman to terminate the pregnancy can be restricted.

. . .

Yet it must be remembered that *Roe v. Wade* speaks with clarity in establishing not only the woman's liberty but also the state's "important and legitimate interest in potential life." That portion of the decision in *Roe* has been given too little acknowledgement and implementation by the Court in its subsequent cases.

Those cases decided that any regulation touching upon the abortion decision must survive strict scrutiny, to be sustained only if drawn in narrow terms to further a compelling state interest. Not all of the cases decided under that formulation can be reconciled with the holding in Roe itself that the state has legitimate interests in the health of the woman and in protecting the potential life within her.

In resolving this tension, we choose to rely upon *Roe,* as against the later cases.

. . .

Some guiding principles should emerge. What is at stake is the woman's right to make the ultimate decision, not a right to be insulated from all others in doing so.

Regulations which do no more than create a structural mechanism by which the state, or the parent or guardian of a minor, may express profound respect for the life of the unborn are permitted, if they are not a substantial obstacle to the woman's exercise of the right to choose. Unless it has that effect on her right of choice, a state measure designed to persuade her to choose childbirth over abortion will be upheld if reasonably related to that goal.

Regulations designed to foster the health of a woman seeking an abortion are valid if they do not constitute an undue burden. That is to be expected in the application of any legal standard which must accommodate life's complexity. We do not expect it to be otherwise with respect to the undue burden standard. We give this summary:

(a) To protect the central right recognized by *Roe v. Wade* while at the same time accommodating the state's profound interest in potential life, we will employ the undue burden analysis as explained in this opinion. An undue burden exists, and therefore a provision of law is invalid, if its purpose or effect is to place a substantial obstacle in the path of a woman seeking an abortion before the fetus attains viability.

(b) We reject the rigid trimester framework of *Roe v. Wade.* To promote the state's profound interest in potential life, throughout pregnancy the state may take measures to ensure that the woman's choice is informed, and measures designed to advance this interest will not be invalidated as long as their purpose is to persuade the woman to choose childbirth over abortion. These measures must not be an undue burden on the right.

(c) As with any medical procedure, the state may enact regulations to further the health or safety of a woman seeking an abortion. Unnecessary health regulations that have the purpose or effect of presenting a substantial obstacle to a woman seeking an abortion impose an undue burden on the right.

(d) Our adoption of the undue burden analysis does not disturb the central holding of *Roe v. Wade,* and we reaffirm that holding. Regardless of whether exceptions are made for particular circumstances, a State may not prohibit any woman from making the ultimate decision to terminate her pregnancy before viability.

(e) We also reaffirm *Roe's* holding that "subsequent to viability, the State in promoting its interest in the potentiality of human life may, if it chooses, regulate, and even proscribe, abortion except where it is necessary, in appropriate medical judgment, for the preservation of the life or health of the mother." *Roe v. Wade,* 410 U.S., at 164 165.

By Justice Stevens Concurring in part and dissenting in part

The portions of the Court's opinion that I have joined are more important than those with which I disagree. I shall therefore first comment on significant areas of agreement and then explain the limited character of my disagreement.

The Court is unquestionably correct in concluding that the doctrine of stare decisis has controlling significance in a case of this kind, notwithstanding an individual justice's concerns about the merits. The central holding of *Roe v. Wade,* has been a "part of our law" for almost two decades. It was a natural sequel to the protection of individual liberty established in *Griswold v. Connecticut,* The societal costs of overruling *Roe* at this late date would be enormous. *Roe* is an integral part of a correct understanding of both the concept of liberty and the basic equality of men and women.

. . .

I also accept what is implicit in the Court's analysis, namely, a reaffirmation of *Roe's* explanation of why the state's obligation to protect the life or health of the mother must take precedence over any duty to the unborn. The Court in *Roe* carefully considered, and rejected, the state's argument "that the fetus is a 'person' within the language and meaning of the Fourteenth Amendment."

After analyzing the usage of "person" in the Constitution, the Court concluded that that word "has application only postnatally." Commenting on the contingent property interests of the unborn that are generally represented by guardians ad litem, the Court noted: "Perfection of the interests involved, again, has generally been contingent upon live birth. In short, the unborn have never been recognized in the law as persons in the whole sense." Accordingly, an abortion is not "the termination of life entitled to Fourteenth Amendment protection."

From this holding, there was no dissent, indeed, no member of the Court has ever questioned this fundamental proposition. Thus, as a matter of Federal constitutional law, a developing organism that is not yet a "person" does not have what is sometimes described as a "right to life." This has been and, by the Court's holding today, remains a fundamental premise of our constitutional law governing reproductive autonomy.

By Justice Blackmun Concurring in part and dissenting in part

Three years ago, in *Webster v. Reproductive Health Serv.,* four members of this Court appeared poised to "cas(t) into darkness the hopes and visions of every woman in this country" who had come to believe that the Constitution guaranteed her the right to reproductive choice. All that remained between the promise of *Roe* and the darkness of the plurality was a single, flickering flame. Decisions since *Webster* gave little reason to hope that this flame would cast much light. But now, just when so many expected the darkness to fall, the flame has grown bright.

I do not underestimate the significance of today's joint opinion. Yet I remain steadfast in my belief that the right to reproductive choice is entitled to the full protection afforded by this Court before *Webster*. And I fear for the darkness as four Justices anxiously await the single vote necessary to extinguish the light.

Make no mistake, the joint opinion of Justices O'Connor, Kennedy, and Souter is an act of personal courage and constitutional principle. In contrast to previous decisions in which Justices O'Connor and Kennedy postponed reconsideration of *Roe v. Wade,* the authors of the joint opinion today join Justice Stevens and me in concluding that "the essential holding of *Roe* should be retained and once again reaffirmed."

In brief, five members of this Court today recognize that "the Constitution protects a woman's right to terminate her pregnancy in its early stages." A fervent view of individual liberty and the force of stare decisis have led the Court to this conclusion.

. . .

At long last, the Chief Justice admits it. Gone are the contentions that the issue need not be (or has not been) considered. There, on the first page, for all to see, is what was expected: "We believe that *Roe* was wrongly decided, and that it can and should be overruled consistently with our traditional approach to stare decisis in constitutional cases." If there is much reason to applaud the advances made by the joint opinion today, there is far more to fear from the Chief Justice's opinion.

The Chief Justice's criticism of *Roe* follows from his stunted conception of individual liberty. While recognizing that the Due Process Clause protects more than simple physical liberty, he then goes on to construe this Court's personal-liberty cases as establishing only a laundry list of particular rights, rather than a principled account of how these particular rights are grounded in a more general right of privacy.

. . .

Under the Chief Justice's standard, states can ban abortion if that ban is rationally related to a legitimate state interest a standard which the United States calls "deferential, but not toothless." Yet when pressed at oral argument to describe the teeth, the best protection that the Solicitor General could offer to women was that a prohibition, enforced by criminal penalties, with no exception for the life of the mother, "could raise very serious questions." Perhaps, the Solicitor General offered, the failure to include an exemption for the life of the mother would be "arbitrary and capricious."

If, as the Chief Justice contends, the undue burden test is made out of whole cloth, the so called "arbitrary and capricious" limit is the Solicitor General's "new clothes."

Even if it is somehow "irrational" for a state to require a woman to risk her life for her child, what protection is offered for women who become pregnant through rape or incest? Is there anything arbitrary or capricious about a state's prohibiting the sins of the father from being visited upon his offspring?

But, we are reassured, there is always the protection of the democratic process. While there is much to be praised about our democracy, our country since its founding has recognized that there are certain fundamental liberties that are not to be left to the whims of an election. A woman's right to reproductive choice is one of those fundamental liberties. Accordingly, that liberty need not seek refuge at the ballot box.

In one sense, the Court's approach is worlds apart from that of the Chief Justice and Justice Scalia. And yet, in another sense, the distance between the two approaches is short—the distance is but a single vote. I am 83 years old. I cannot remain on this Court forever, and when I do step down, the confirmation process for my successor well may focus on the issue before us today. That, I regret, may be exactly where the choice between the two worlds will be made.

From *Harris v. Forklift*, 1993

By Justice O'Connor, For the Court

In this case we consider the definition of a discriminatorily "abusive work environment" (also known as a "hostile work environment") under Title VII of the Civil Rights Act of 1964.

Teresa Harris worked as a manager at Forklift Systems, Inc., an equipment rental company, from April 1985 until October 1987. Charles Hardy was Forklift's president.

The magistrate found that, throughout Harris's time at Forklift, Hardy often insulted her because of her gender and often made her the target of unwanted sexual innuendos. Hardy told Harris on several occasions, in the presence of other employees, "You're a woman, what do you know" and, "We need a man as the rental manager;" at least once, he told her she was "a dumb ass woman." Again in front of others, he suggested that the two of them "go to the Holiday Inn to negotiate (Harris's) raise." Hardy occasionally asked Harris and other female employees to get coins from his front pants pocket. He threw objects on the ground in front of Harris and other women, and asked them to pick the objects up. He made sexual innuendos about Harris's and other women's clothing.

In mid-August 1987, Harris complained to Hardy about his conduct. Hardy said he was surprised that

Harris was offended, claimed he was only joking, and apologized. He also promised he would stop, and based on this assurance Harris stayed on the job. But in early September, Hardy began anew: While Harris was arranging a deal with one of Forklift's customers, he asked her, again in front of other employees, "What did you do, promise the guy . . . some (sex) Saturday night?" On Oct. 1, Harris collected her paycheck and quit.

Harris then sued Forklift, claiming that Hardy's conduct had created an abusive work environment for her because of her gender. The United States District Court for the Middle District of Tennessee, adopting the report and recommendation of the magistrate, found this to be "a close case," but held that Hardy's conduct did not create an abusive environment. The court found that some of Hardy's comments "offended (Harris), and would offend the reasonable woman," but that they were not "so severe as to be expected to seriously affect (Harris's) psychological well-being. A reasonable woman manager under like circumstances would have been offended by Hardy, but his conduct would not have risen to the level of interfering with that person's work performance.

"Neither do I believe that (Harris) was subjectively so offended that she suffered injury. . . .Although Hardy may at times have genuinely offended (Harris), I do not believe that he created a working environment so poisoned as to be intimidating or abusive to (Harris)."

Conflict Among Circuits

In focusing on the employee's psychological well-being, the District Court was following Circuit precedent. See *Rabidue v. Osceola Refining Co.* (CA6 1986). The United States Court of Appeals for the Sixth Circuit affirmed in a brief unpublished decision.

We granted certiorari, to resolve a conflict among the circuits on whether conduct, to be actionable as "abusive work environment" harassment (no quid pro quo harassment issue is present here), must "seriously affect (an employee's) psychological well-being" or lead the plaintiff to "suffe(r) injury." . . .

Title VII of the Civil Rights Act of 1964 makes it "an unlawful employment practice for an employer . . . to discriminate against any individual with respect to his compensation, terms, conditions, or privileges of employment, because of such individual's race, color, religion, sex, or national origin." As we made clear in *Meritor Savings Bank v. Vinson,* (1986), this language "is not limited to 'economic' or 'tangible' discrimination. The phrase 'terms, conditions, or privileges of employment' evinces a Congressional intent 'to strike at the entire spectrum of disparate treatment of men and women' in employment," which includes requiring people to work in a discriminatorily hostile or abusive envi-

ronment. When the workplace is permeated with "discriminatory intimidation, ridicule, and insult," that is "sufficiently severe or pervasive to alter the conditions of the victim's employment and create an abusive working environment," Title VII is violated.

This standard, which we reaffirm today, takes a middle path between making actionable any conduct that is merely offensive and requiring the conduct to cause a tangible psychological injury. As we pointed out in *Meritor,* "mere utterance of an . . . epithet which engenders offensive feelings in a employee," does not sufficiently affect the conditions of employment to implicate Title VII. Conduct that is not severe or pervasive enough to create an objectively hostile or abusive work environment, an environment that a reasonable person would find hostile or abusive, is beyond Title VII's purview. Likewise, if the victim does not subjectively perceive the environment to be abusive, the conduct has not actually altered the conditions of the victim's employment, and there is no Title VII violation.

Effects on Performance

But Title VII comes into play before the harassing conduct leads to a nervous breakdown. A discriminatorily abusive work environment, even one that does not seriously affect employees' psychological well-being, can and often will detract from employees' job performance, discourage employees from remaining on the job, or keep them from advancing in their careers. Moreover, even without regard to these tangible effects, the very fact that the discriminatory conduct was so severe or pervasive that it created a work environment abusive to employees because of their race, gender, religion, or national origin offends Title VII's broad rule of workplace equality. The appalling conduct alleged in Meritor, and the reference in that case to environments "'so heavily polluted with discrimination as to destroy completely the emotional and psychological stability of minority group workers,'" merely present some especially egregious examples of harassment. They do not mark the boundary of what is actionable.

We therefore believe the District Court erred in relying on whether the conduct "seriously affect(ed) plaintiff's psychological well-being" or led her to "suffe(r) injury." Such an inquiry may needlessly focus the factfinder's attention on concrete psychological harm, an element Title VII does not require. Certainly Title VII bars conduct that would seriously affect a reasonable person's psychological well-being, but the statute is not limited to such conduct. So long as the environment would reasonably be perceived, and is perceived, as hostile or abusive, there is no need for it also to be psychologically injurious.

This is not, and by its nature cannot be, a mathematically precise test. We need not answer today all the potential questions it raises, nor specifically address the E.E.O.C.'s new regulations on this subject. But we can say that whether an environment is "hostile" or "abusive" can be determined only by looking at all the circumstances. These may include the frequency of the discriminatory conduct; its severity; whether it is physically threatening or humiliating, or a mere offensive utterance; and whether it unreasonably interferes with an employee's work performance. The effect on the employee's psychological well-being is, of course, relevant to determining whether the plaintiff actually found the environment abusive. But while psychological harm, like any other relevant factor, may be taken into account, no single factor is required.

. . .

By Justice Scalia, Concurring

Meritor Savings Bank v. Vinson, held that Title VII prohibits sexual harassment that takes the form of a hostile work environment. The Court stated that sexual harassment is actionable if it is "sufficiently severe or pervasive 'to alter the conditions of (the victim's) employment and create an abusive work environment.'" Today's opinion elaborates that the challenged conduct must be severe or pervasive enough "to create an objectively hostile or abusive work environment, an environment that a reasonable person would find hostile or abusive." Ante, at 4.

"Abusive" (or "hostile," which in this context I take to mean the same thing) does not seem to me a very clear standard and I do not think clarity is at all increased by adding the adverb "objectively" or by appealing to a "reasonable person's" notion of what the vague word means. Today's opinion does list a number of factors that contribute to abusiveness, but since it neither says how much of each is necessary (an impossible task) nor identifies any single factor as determinative, it thereby adds little certitude. As a practical matter, today's holding lets virtually unguided juries decide whether sex-related conduct engaged in (or permitted by) an employer is egregious enough to warrant an award of damages.

One might say that what constitutes "negligence" (a traditional jury question) is not much more clear and certain than what constitutes "abusiveness." Perhaps so. But the class of plaintiffs seeking to recover for negligence is limited to those who have suffered harm, whereas under this statute "abusiveness" is to be the test of whether legal harm has been suffered, opening more expansive vistas of litigation.

Be that as it may, I know of no alternative to the course the Court today has taken. . . .

By Justice Ginsburg, Concurring

Today the Court reaffirms the holding of *Meritor Savings Bank v. Vinson*, "(A) plaintiff may establish a violation of Title VII by proving that discrimination based on sex has created a hostile or abusive work environment." The critical issue, Title VII's text indicates, is whether members of one sex are exposed to disadvantageous terms or conditions of employment to which members of the other sex are not exposed. As the Equal Employment Opportunity Commission emphasized, see Brief for United States and Equal Employment Opportunity Commission as amici curiae, the adjudicator's inquiry should center, dominantly, on whether the discriminatory conduct has unreasonably interfered with the plaintiff's work performance. To show such interference, "the plaintiff need not prove that his or her tangible productivity has declined as a result of the harassment." It suffices to prove that a reasonable person subjected to the discriminatory conduct would find, as the plaintiff did, that the harassment so altered working conditions as to "ma(k)e it more difficult to do the job."

Davis concerned race-based discrimination, but that difference does not alter the analysis; except in the rare case in which a bona fide occupational qualification is shown, see *Automobile Workers v. Johnson Controls, Inc.*, Title VII declares discriminatory practices based on race, gender, religion, or national origin equally unlawful. (Footnote 1)

. . .

Footnote 1. Indeed, even under the Court's equal protection jurisprudence, which requires an exceedingly persuasive justification for a gender-based classification, *Kirchberg v. Feenstra* (1981), it remains an open question whether classifications based upon gender are inherently suspect. See *Mississippi Univ. for Women v. Hogan*, (1982).

From the *Beijing Declaration and Platform for Action*, 1995

Declaration

1. We, the Governments participating in the Fourth World Conference on Women,

2. Gathered here in Beijing in September 1995, the year of the fiftieth anniversary of the founding of the United Nations,

3. Determined to advance the goals of equality, development and peace for all women everywhere in the interest of all humanity,

4. Acknowledging the voices of all women everywhere and taking note of the diversity of women and their roles and circumstances, honouring the women who paved the way and inspired by the hope present in the world's youth,

5. Recognize that the status of women has advanced in some important respects in the past decade but that progress has been uneven, inequalities between women and men have persisted and major obstacles remain, with serious consequences for the well-being of all people,

6. Also recognize that this situation is exacerbated by the increasing poverty that is affecting the lives of the majority of the world's people, in particular women and children, with origins in both the national and international domains,

7. Dedicate ourselves unreservedly to addressing these constraints and obstacles and thus enhancing further the advancement and empowerment of women all over the world, and agree that this requires urgent action in the spirit of determination, hope, cooperation and solidarity, now and to carry us forward into the next century.

We reaffirm our commitment to:

8. The equal rights and inherent human dignity of women and men. . . .

9. Ensure the full implementation of the human rights of women and of the girl child as an inalienable, integral and indivisible part of all human rights and fundamental freedoms. . . .

11. Achieve the full and effective implementation of the Nairobi Forward-looking Strategies for the Advancement of Women;

12. The empowerment and advancement of women, including the right to freedom of thought, conscience, religion and belief, thus contributing to the moral, ethical, spiritual and intellectual needs of women and men, individually or in community with others and thereby guaranteeing them the possibility of realizing their full potential in society and shaping their lives in accordance with their own aspirations.

We are convinced that:

13. Women's empowerment and their full participation on the basis of equality in all spheres of society, including participation in the decision-making process and access to power, are fundamental for the achievement of equality, development and peace;

14. Women's rights are human rights;

15. Equal rights, opportunities and access to resources, equal sharing of responsibilities for the family by men and women, and a harmonious partnership between them are critical to their well-being and that of their families as well as to the consolidation of democracy;

16. Eradication of poverty based on sustained economic growth, social development, environmental protection and social justice requires the involvement of women in economic and social development, equal opportunities and the full and equal participation of women and men as agents and beneficiaries of people-centered sustainable development;

17. The explicit recognition and reaffirmation of the right of all women to control all aspects of their health, in particular their own fertility, is basic to their empowerment;

18. Local, national, regional and global peace is attainable and is inextricably linked with the advancement of women, who are a fundamental force for leadership, conflict resolution and the promotion of lasting peace at all levels;

19. It is essential to design, implement and monitor, with the full participation of women, effective, efficient and mutually reinforcing gender-sensitive policies and programmes, including development policies and programmes, at all levels that will foster the empowerment and advancement of women;

20. The participation and contribution of all actors of civil society, particularly women's groups and networks and other non-governmental organizations and community-based organizations, with full respect for their autonomy, in cooperation with Governments, are important to the effective implementation and follow-up of the Platform for Action;

21. The implementation of the Platform for Action requires commitment from Governments and the international community. By making national and international commitments for action, including those made at the Conference, Governments and the international community recognize the need to take priority action for the empowerment and advancement of women.

We are determined to:

22. Intensify efforts and actions to achieve the goals of the Nairobi Forward-looking Strategies for the Advancement of Women by the end of this century;

23. Ensure the full enjoyment by women and the girl child of all human rights and fundamental freedoms and take effective action against violations of these rights and freedoms;

24. Take all necessary measures to eliminate all forms of discrimination against women and the girl child and remove all obstacles to gender equality and the advancement and empowerment of women;

25. Encourage men to participate fully in all actions towards equality;

26. Promote women's economic independence, including employment, and eradicate the persistent and increasing burden of poverty on women by addressing the structural causes of poverty through changes in economic structures, ensuring equal access for all women, including those in rural areas, as vital development agents, to productive resources, opportunities and public services;

27. Promote people-centered sustainable development, including sustained economic growth, through the provision of basic education, life-long education, literacy and training, and primary health care for girls and women;

28. Take positive steps to ensure peace for the advancement of women and, recognizing the leading role that women have played in the peace movement, work actively towards general and complete disarmament under strict and effective international control, and . . . the prevention of the proliferation of nuclear weapons in all its aspects;

29. Prevent and eliminate all forms of violence against women and girls;

30. Ensure equal access to and equal treatment of women and men in education and health care and enhance women's sexual and reproductive health as well as education;

31. Promote and protect all human rights of women and girls;

32. Intensify efforts to ensure equal enjoyment of all human rights and fundamental freedoms for all women and girls who face multiple barriers to their empowerment and advancement because of such factors as their race, age, language, ethnicity, culture, religion, or disability, or because they are indigenous people;

33. Ensure respect for international law, including humanitarian law, in order to protect women and girls in particular;

34. Develop the fullest potential of girls and women of all ages, ensure their full and equal participation in building a better world for all and enhance their role in the development process.

We are determined to:

35. Ensure women's equal access to economic resources, including land, credit, science and technology, vocational training, information, communication and markets, as a means to further the advancement and empowerment of women and girls, including through the enhancement of their capacities to enjoy the benefits of equal access to these resources, interalia, by means of international cooperation;

36. Ensure the success of the Platform for Action, which will require a strong commitment on the part of Governments, international organizations and institutions at all levels. We are deeply convinced that economic development, social development and environmental protection are interdependent and mutually reinforcing components of sustainable development, which is the framework for our efforts to achieve a higher quality of life for all people. Equitable social development that recognizes empowering the poor, particularly women living in poverty, to utilize environmental resources sustainably is a necessary foundation for sustainable development. We also recognize that broad-based and sustained economic growth in the context of sustainable development is necessary to sustain social development and social justice. The success of the Platform for Action will also require adequate mobilization of resources at the national and international levels as well as new and additional resources to the developing countries from all available funding mechanisms . . . for the advancement of women; financial resources to strengthen the capacity of national, subregional, regional and international institutions; a commitment to equal rights, equal responsibilities and equal opportunities and to the equal participation of women and men in all national, regional and international bodies and policy-making processes; and the establishment or strengthening of mechanisms at all levels for accountability to the world's women;

37. Ensure also the success of the Platform for Action in countries with economies in transition, which will require continued international cooperation and assistance;

38. We hereby adopt and commit ourselves as Governments to implement the following Platform for Action, ensuring that a gender perspective is reflected in all our policies and programmes. . . .

Mission Statement

1. The Platform for Action is an agenda for women's empowerment. It aims at accelerating the implementation of the Nairobi Forward-looking Strategies for the Advancement of Women and at removing all the obstacles to women's active participation in all spheres of public and private life through a full and equal share in economic, social, cultural and political decision-making. This means that the principle of shared power and responsibility should be established between women and men at home, in the workplace and in the wider national and international communities. Equality between women and men is a matter of human rights and a condition for social justice and is also a necessary and fundamental prerequisite for equality, development and peace. A transformed partnership based on equality between women and men is a condition for people-centered sustainable development. A sustained and long-term commitment is essential, so that women and men can work together for themselves, for their children and for society to meet the challenges of the twenty-first century.

2. The Platform for Action reaffirms the fundamental principle . . . that the human rights of women and of the girl child are an inalienable, integral and indivisible part of universal human rights. As an agenda for action, the Platform seeks to promote and protect the full enjoyment of all human rights and the fundamental freedoms of all women throughout their life cycle. . . .

44. To this end, Governments, the international community and civil society, including non-governmental organizations and the private sector, are called upon to take strategic action in the following critical areas of concern:

- The persistent and increasing burden of poverty on women
- Inequalities and inadequacies in and unequal access to education and training
- Inequalities and inadequacies in and unequal access to health care and related services
- Violence against women
- The effects of armed or other kinds of conflict on women, including those living under foreign occupation
- Inequality in economic structures and policies, in all forms of productive activities and in access to resources
- Inequality between men and women in the sharing of power and decision-making at all levels
- Insufficient mechanisms at all levels to promote the advancement of women
- Lack of respect for and inadequate promotion and protection of the human rights of women
- Stereotyping of women and inequality in women's access to and participation in all communication systems, especially in the media
- Gender inequalities in the management of natural resources and in the safeguarding of the environment
- Persistent discrimination against and violation of the rights of the girl child.

From *United States v. Commonwealth of Virginia,* 1996

Justice Ginsburg delivered the opinion of the Court.

Founded in 1839, VMI is today the sole single sex school among Virginia's 15 public institutions of higher learning. VMI's distinctive mission is to produce "citizen soldiers," men prepared for leadership in civilian life and in military service. VMI pursues this mission through pervasive training of a kind not available anywhere else in Virginia. Assigning prime place to character development, VMI uses an "adversative method" modeled on English public schools and once characteristic of military instruction. VMI constantly endeavors to instill physical and mental discipline in its cadets and impart to them a strong moral code. The school's graduates leave VMI with heightened comprehension of their capacity to deal with duress and stress, and a large sense of accomplishment for completing the hazardous course.

VMI has notably succeeded in its mission to produce leaders; among its alumni are military generals, Members of Congress, and business executives. The school's alumni overwhelmingly perceive that their VMI training helped them to realize their personal goals. . . .

Neither the goal of producing citizen soldiers nor VMI's implementing methodology is inherently unsuitable to women. And the school's impressive record in producing leaders has made admission desirable to some women. Nevertheless, Virginia has elected to preserve exclusively for men the advantages and opportunities a VMI education affords. . . .

In 1990, prompted by a complaint filed with the Attorney General by a female high school student seeking admission to VMI, the United States sued the Commonwealth of Virginia and VMI, alleging that VMI's exclusively male admission policy violated the Equal Protection Clause of the Fourteenth Amendment. Id., at 1408. . . . Trial of the action consumed six days and involved an array of expert witnesses on each side. Ibid.

In the two years preceding the lawsuit, the District Court noted, VMI had received inquiries from 347 women, but had responded to none of them. Id., at 1436. "[S]ome women, at least," the court said, "would want to attend the school if they had the opportunity." Id., at 1414. The court further recognized that, with recruitment, VMI could "achieve at least 10% female enrollment"—"a sufficient 'critical mass' to provide the female cadets with a positive educational experience." Id., at 1437–1438. And it was also established that "some women are capable of all of the individual activities required of VMI cadets." Id., at 1412. In addition, experts agreed that if VMI admitted women, "the VMI ROTC experience would become a better training program from the perspective of the armed forces, because it would provide training in dealing with a mixed gender army." Id., at 1441.

The District Court ruled in favor of VMI, however, and rejected the equal protection challenge pressed by the United States. . . .

The District Court reasoned that education in "a single gender environment, be it male or female," yields substantial benefits. 766 F. Supp., at 1415. VMI's school for men brought diversity to an otherwise coeducational Virginia system, and that diversity was "enhanced by VMI's unique method of instruction." Ibid. If single gender education for males ranks as an important governmental objective, it becomes obvious, the District Court concluded, that the only means of achieving the objective "is to exclude women from the all male institution—VMI." Ibid. . . .

The Court of Appeals for the Fourth Circuit disagreed and vacated the District Court's judgment. The appellate court held: "The Commonwealth of Virginia has not. . . advanced any state policy by which it can justify its determination, under an announced policy of diversity, to afford VMI's unique type of program to men and not to women." 976 F. 2d 890, 892 (1992). . . .

. . . The Court of Appeals, however, accepted the District Court's finding that "at least these three aspects of VMI's program—physical training, the absence of privacy, and the adversative approach—would be materially

affected by coeducation." Id., at 896–897. Remanding the case, the appeals court assigned to Virginia, in the first instance, responsibility for selecting a remedial course. The court suggested these options for the State: Admit women to VMI; establish parallel institutions or programs; or abandon state support, leaving VMI free to pursue its policies as a private institution. Id., at 900. . . .

In response to the Fourth Circuit's ruling, Virginia proposed a parallel program for women: Virginia Women's Institute for Leadership (VWIL). The 4 year, state sponsored undergraduate program would be located at Mary Baldwin College, a private liberal arts school for women, and would be open, initially, to about 25 to 30 students. Although VWIL would share VMI's mission—to produce "citizen soldiers"—the VWIL program would differ, as does Mary Baldwin College, from VMI in academic offerings, methods of education, and financial resources. See 852 F. Supp. 471, 476–477 (WD Va. 0994).

VWIL students would participate in ROTC programs and a newly established, "largely ceremonial" Virginia Corps of Cadets, id., at 1234, but the VWIL House would not have a military format, 852 F. Supp., at 477, and VWIL would not require its students to eat meals together or to wear uniforms during the school day, id., at 495. In lieu of VMI's adversative method, the VWIL Task Force favored "a cooperative method which reinforces self esteem." Id., at 476. In addition to the standard bachelor of arts program offered at Mary Baldwin, VWIL students would take courses in leadership, complete an off campus leadership externship, participate in community service projects, and assist in arranging a speaker series. See 44 F. 3d, at 1234.

Virginia represented that it will provide equal financial support for in state VWIL students and VMI cadets [852 F. Supp., at 483]. . . . The VMI Alumni Association has developed a network of employers interested in hiring VMI graduates. The Association has agreed to open its network to VWIL graduates, id., at 499, but those graduates will not have the advantage afforded by a VMI degree.

Virginia returned to the District Court seeking approval of its proposed remedial plan, and the court decided the plan met the requirements of the Equal Protection Clause. . . . The court anticipated that the two schools would "achieve substantially similar outcomes." Ibid. It concluded: "If VMI marches to the beat of a drum, then Mary Baldwin marches to the melody of a fife and when the march is over, both will have arrived at the same destination." Id., at 484.

A divided Court of Appeals affirmed the District Court's judgment. 44 F. 3d 1229 (CA4 1995)

"[P]roviding the option of a single gender college education may be considered a legitimate and important aspect of a public system of higher education," the appeals court observed. . . . Moreover, the court continued, the adversative method vital to a VMI education "has never been tolerated in a sexually heterogeneous environment." Ibid. The method itself "was not designed to exclude women," the court noted, but women could not be accommodated in the VMI program, the court believed, for female participation in VMI's adversative training "would destroy . . . any sense of decency that still permeates the relationship between the sexes." Ibid.

Having determined, deferentially, the legitimacy of Virginia's purpose, the court considered the question of means. Exclusion of "men at Mary Baldwin College and women at VMI," the court said, was essential to Virginia's purpose, for without such exclusion, the State could not "accomplish [its] objective of providing single gender education." Ibid.

Although the appeals court recognized that the VWIL degree "lacks the historical benefit and prestige" of a VMI degree, it nevertheless found the educational opportunities at the two schools "sufficiently comparable." Id., at 1241.

Senior Circuit Judge Phillips dissented. . . .

. . . [H]e thought it evident that the proposed VWIL program, in comparison to VMI, fell "far short . . . from providing substantially equal tangible and intangible educational benefits to men and women." Ibid.

The Fourth Circuit denied rehearing en banc. 52 F. 3d 90 (1995). Circuit Judge Motz, joined by Circuit Judges Hall, Murnaghan, and Michael, filed a dissenting opinion. . . .

. . . [T]his case present two ultimate issues. First, does Virginia's exclusion of women from the educational opportunities provided by VMI . . . deny to women "capable of all of the individual activities required of VMI cadets," 766F. Supp., at 1412, the equal protection of the laws guaranteed by the Fourteenth Amendment? Second, if VMI's "unique" situation, id., at 1413—as Virginia's sole single sex public institution of higher education—offends the Constitution's equal protection principle, what is the remedial requirement?

We note, once again, the core instruction of this Court's pathmarking decisions in *J. E. B. v. Alabama ex rel.* T. B., 511 U.S. 127, . . . and *Mississippi Univ. for Women*, 458 U. S., at 724 (internal quotation marks omitted): Parties who seek to defend gender based government action must demonstrate an "exceedingly persuasive justification" for that action. . . .

In 1971, for the first time in our Nation's history, this Court ruled in favor of a woman who complained that her State had denied her the equal protection of its

laws. *Reed v. Reed,* 404 U.S. 71, 73 (holding unconstitutional Idaho Code prescription that, among " 'several persons claiming and equally entitled to administer [a decedent's estate], males must be preferred to females'"). Since *Reed,* the Court has repeatedly recognized that neither federal nor state government acts compatibly with the equal protection principle when a law or official policy denies to women, simply because they are women, full citizenship stature—equal opportunity to aspire, achieve, participate in and contribute to society based on their individual talents and capacities. . . .

Without equating gender classifications, for all purposes, to classifications based on race or national origin, . . . the Court, in post-*Reed* decisions, has carefully inspected official action that closes a door or denies opportunity to women (or to men). . . . To summarize the Court's current directions for cases of official classification based on gender: Focusing on the differential treatment or denial of opportunity for which relief is sought, the reviewing court must determine whether the proffered justification is "exceedingly persuasive." The burden of justification is demanding and it rests entirely on the State. See *Mississippi Univ. for Women,* 458 U. S., at 724. The State must show "at least that the [challenged] classification serves 'important governmental objectives and that the discriminatory means employed' are 'substantially related to the achievement of those objectives.'" Ibid. (quoting *Wengler v. Druggists Mutual Ins. Co.,* 446 U.S. 142, 150 (1980)). The justification must be genuine, not hypothesized or invented post hoc in response to litigation. And it must not rely on overbroad generalizations about the different talents, capacities, or preferences of males and females. See *Weinberger v. Wiesenfeld,* 420 U.S. 636, 643, 648 (1975); *Califano v. Goldfarb,* 430 U.S. 199, 223–224 (1977) (Stevens, J., concurring in judgment).

The heightened review standard our precedent establishes does not make sex a proscribed classification. Supposed "inherent differences" are no longer accepted as a ground for race or national origin classifications. See *Loving v. Virginia,* 388 U.S. 1 (1967). Physical differences between men and women, however, are enduring: "[T]he two sexes are not fungible; a community made up exclusively of one [sex] is different from a community composed of both." *Ballard v. United States,* 329 U.S. 187, 193 (1946).

"Inherent differences" between men and women, we have come to appreciate, remain cause for celebration, but not for denigration of the members of either sex or for artificial constraints on an individual's opportunity. Sex classifications may be used to compensate women "for particular economic disabilities [they have] suffered," *Califano v. Webster,* 430 U.S. 313, 320 (1977) (per curiam), to "promot[e] equal employment opportunity,"

see *California Federal Sav. & Loan Assn. v. Guerra,* 479 U.S. 272, 289 (1987), to advance full development of the talent and capacities of our Nation's people. [n.7] But such classifications may not be used, as they once were, see *Goesaert,* 335 U. S., at 467, to create or perpetuate the legal, social, and economic inferiority of women.

Measuring the record in this case against the review standard just described, we conclude that Virginia has shown no "exceedingly persuasive justification" for excluding all women from the citizen soldier training afforded by VMI. We therefore affirm the Fourth Circuit's initial judgment, which held that Virginia had violated the Fourteenth Amendment's Equal Protection Clause. Because the remedy proffered by Virginia—the Mary Baldwin VWIL program—does not cure the constitutional violation, i.e., it does not provide equal opportunity, we reverse the Fourth Circuit's final judgment in this case.

. . . Virginia . . . asserts two justifications in defense of VMI's exclusion of women. First, the Commonwealth contends, "single sex education provides important educational benefits," . . . and the option of single sex education contributes to "diversity in educational approaches" . . . Second, the Commonwealth argues, "the unique VMI method of character development and leadership training," the school's adversative approach, would have to be modified were VMI to admit women. Id., at 33–36. We consider these two justifications in turn.

Single sex education affords pedagogical benefits to at least some students, Virginia emphasizes, and that reality is uncontested in this litigation . . . Similarly, it is not disputed that diversity among public educational institutions can serve the public good. But Virginia has not shown that VMI was established, or has been maintained, with a view to diversifying, by its categorical exclusion of women, educational opportunities within the State.

Mississippi Univ. for Women is immediately in point. There the State asserted, in justification of its exclusion of men from a nursing school, that it was engaging in "educational affirmative action" by "compensat[ing] for discrimination against women." 458 U. S., at 727. Undertaking a "searching analysis," id., at 728, the Court found no close resemblance between "the alleged objective" and "the actual purpose underlying the discriminatory classification," id., at 730. Pursuing a similar inquiry here, we reach the same conclusion. . . .

. . . [W]e find no persuasive evidence in this record that VMI's male only admission policy "is in furtherance of a state policy of 'diversity.' " See 976 F. 2d, at 899. . . . A purpose genuinely to advance an array of educational options, as the Court of Appeals recognized, is not served by VMI's historic and constant plan—a plan to "affor[d] a unique educational benefit only to males." Ibid. However "liberally" this plan serves the State's

sons, it makes no provision whatever for her daughters. That is not equal protection.

Virginia next argues that VMI's adversative method of training provides educational benefits that cannot be made available, unmodified, to women. Alterations to accommodate women would necessarily be "radical," so "drastic," Virginia asserts, as to transform, indeed "destroy," VMI's program. . . . Neither sex would be favored by the transformation, Virginia maintains: Men would be deprived of the unique opportunity currently available to them; women would not gain that opportunity because their participation would "eliminat[e] the very aspects of [the] program that distinguish [VMI] from . . . other institutions of higher education in Virginia." . . .

. . . [I]t is uncontested that women's admission would require accommodations, primarily in arranging housing assignments and physical training programs for female cadets. . . . It is also undisputed, however, that "the VMI methodology could be used to educate women." 852 F. Supp., at 481. . . . The parties, furthermore, agree that "some women can meet the physical standards [VMI] now impose[s] on men." 976 F. 2d, at 896. In sum, as the Court of Appeals stated, "neither the goal of producing citizen soldiers," VMI's raison d'être, "nor VMI's implementing methodology is inherently unsuitable to women." Id., at 899.

In support of its initial judgment for Virginia, a judgment rejecting all equal protection objections presented by the United States, the District Court made "findings" on "gender based developmental differences." 766 F. Supp., at 1434–1435. These "findings" restate the opinions of Virginia's expert witnesses, opinions about typically male or typically female "tendencies." Id., at 1434. For example, "[m]ales tend to need an atmosphere of adversativeness," while "[f]emales tend to thrive in a cooperative atmosphere." Ibid. . . .

The United States does not challenge any expert witness estimation on average capacities or preferences of men and women. Instead, the United States emphasizes that time and again since this Court's turning point decision in Reed v. Reed, 404 U.S. 71 (1971), we have cautioned reviewing courts to take a "hard look" at generalizations or "tendencies" of the kind pressed by Virginia, and relied upon by the District Court. . . . State actors controlling gates to opportunity, we have instructed, may not exclude qualified individuals based on "fixed notions concerning the roles and abilities of males and females." . . .

It may be assumed, for purposes of this decision, that most women would not choose VMI's adversative method. . . . The issue, however, is not whether "women—or men—should be forced to attend VMI"; rather, the question is whether the State can constitutionally deny to women who have the will and capacity, the

training and attendant opportunities that VMI uniquely affords. . . .

The notion that admission of women would downgrade VMI's stature, destroy the adversative system and, with it, even the school, is a judgment hardly proved, a prediction hardly different from other "self-fulfilling prophec[ies]," see Mississippi Univ. for Women, 458 U. S., at 730, once routinely used to deny rights or opportunities. When women first sought admission to the bar and access to legal education, concerns of the same order were expressed. . . .

Medical faculties similarly resisted men and women as partners in the study of medicine. . . .

Women's successful entry into the federal military academies, and their participation in the Nation's military forces, indicate that Virginia's fears for the future of VMI may not be solidly grounded. . . .

Virginia and VMI trained their argument on "means" rather than "end," and thus misperceived our precedent. Single sex education at VMI serves an "important governmental objective," they maintained, and exclusion of women is not only "substantially related," it is essential to that objective. By this notably circular argument, the "straightforward" test Mississippi Univ. for Women described, see 458 U. S., at 724–725, was bent and bowed.

The State's misunderstanding and, in turn, the District Court's, is apparent from VMI's mission: to produce "citizen soldiers," individuals

" 'imbued with love of learning, confident in the functions and attitudes of leadership, possessing a high sense of public service, advocates of the American democracy and free enterprise system, and ready . . . to defend their country in time of national peril.' " 766 F. Supp., at 1425 (quoting Mission Study Committee of the VMI Board of Visitors, Report, May 16, 1986).

Surely that goal is great enough to accommodate women, who today count as citizens in our American democracy equal in stature to men. Just as surely, the State's great goal is not substantially advanced by women's categorical exclusion, in total disregard of their individual merit, from the State's premier "citizen soldier" corps. Virginia, in sum, "has fallen far short of establishing the 'exceedingly persuasive justification,' " Mississippi Univ. for Women, 458 U. S., at 731, that must be the solid base for any gender defined classification.

In the second phase of the litigation, Virginia presented its remedial plan—maintain VMI as a male-only college and create VWIL as a separate program for women. The plan met [with] approval.

Virginia chose not to eliminate, but to leave untouched, VMI's exclusionary policy. For women only, however, Virginia proposed a separate program, different

in kind from VMI and unequal in tangible and intangible facilities. . . .

Virginia maintains that . . . methodological differences are "justified pedagogically," based on "important differences between men and women in learning and developmental needs," "psychological and sociological differences" Virginia describes as "real" and "not stereotypes."

As earlier stated, generalizations about "the way women are," estimates of what is appropriate for most women, no longer justify denying opportunity to women whose talent and capacity place them outside the average description. Notably, Virginia never asserted that VMI's method of education suits most men. It is also revealing that Virginia accounted for its failure to make the VWIL experience "the entirely militaristic experience of VMI" on the ground that VWIL "is planned for women who do not necessarily expect to pursue military careers." 852 F. Supp., at 478. By that reasoning, VMI's "entirely militaristic" program would be inappropriate for men in general or as a group, for "[o]nly about 15% of VMI cadets enter career military service." See 766 F. Supp., at 1432.

In contrast to the generalizations about women on which Virginia rests, we note again these dispositive realities: VMI's "implementing methodology" is not "inherently unsuitable to women," 976 F. 2d, at 899; "some women . . . do well under [the] adversarial model," 766 F. Supp., at 1434 (internal quotation marks omitted); "some women, at least, would want to attend [VMI] if they had the opportunity," id., at 1414; "some women are capable of all of the individual activities required of VMI cadets," id., at 1412, and "can meet the physical standards [VMI] now impose[s] on men," 976 F. 2d, at 896. It is on behalf of these women that the United States has instituted this suit, and it is for them that a remedy must be crafted, a remedy that will end their exclusion from a state supplied educational opportunity for which they are fit, a decree that will "bar like discrimination in the future." *Louisiana*, 380 U. S., at 154.

In myriad respects other than military training, VWIL does not qualify as VMI's equal. VWIL's student body, faculty, course offerings, and facilities hardly match VMI's. Nor can the VWIL graduate anticipate the benefits associated with VMI's 157-year history, the school's prestige, and its influential alumni network.

Virginia, in sum, while maintaining VMI for men only, has failed to provide any "comparable single gender women's institution." Id., at 1241. Instead, the Commonwealth has created a VWIL program fairly appraised as a "pale shadow" of VMI in terms of the range of curricular choices and faculty stature, funding, prestige, alumni support and influence. See id., at 1250 (Phillips, J., dissenting).

Virginia's VWIL solution is reminiscent of the remedy Texas proposed 50 years ago, in response to a state

trial court's 1946 ruling that, given the equal protection guarantee, African Americans could not be denied a legal education at a state facility. See *Sweatt v. Painter*, 339 U.S. 629 (1950). Reluctant to admit African Americans to its flagship University of Texas Law School, the State set up a separate school for Herman Sweatt and other black law students. Id., at 632. As originally opened, the new school had no independent faculty or library, and it lacked accreditation. Id., at 633. Nevertheless, the state trial and appellate courts were satisfied that the new school offered Sweatt opportunities for the study of law "substantially equivalent to those offered by the State to white students at the University of Texas." Id., at 632 (internal quotation marks omitted).

Before this Court considered the case, the new school had gained "a faculty of five full time professors; a student body of 23; a library of some 16,500 volumes serviced by a full time staff; a practice court and legal aid association; and one alumnus who ha[d] become a member of the Texas Bar." Id., at 633. This Court contrasted resources at the new school with those at the school from which Sweatt had been excluded. The University of Texas Law School had a full time faculty of 16, a student body of 850, a library containing over 65,000 volumes, scholarship funds, a law review, and moot court facilities. Id., at 632-633.

More important than the tangible features, the Court emphasized, are "those qualities which are incapable of objective measurement but which make for greatness" in a school, including "reputation of the faculty, experience of the administration, position and influence of the alumni, standing in the community, traditions and prestige." Id., at 634. Facing the marked differences reported in the Sweatt opinion, the Court unanimously ruled that Texas had not shown "substantial equality in the [separate] educational opportunities" the State offered. Id., at 633. Accordingly, the Court held, the Equal Protection Clause required Texas to admit African Americans to the University of Texas Law School. Id., at 636. In line with Sweatt, we rule here that Virginia has not shown substantial equality in the separate educational opportunities the State supports at VWIL and VMI.

When Virginia tendered its VWIL plan, the Fourth Circuit did not inquire whether the proposed remedy, approved by the District Court, placed women denied the VMI advantage in "the position they would have occupied in the absence of [discrimination]." . . .

The Fourth Circuit plainly erred. . . . Valuable as VWIL may prove for students who seek the program offered, Virginia's remedy affords no cure at all for the opportunities and advantages withheld from women who want a VMI education and can make the grade. . . . In sum, Virginia's remedy does not match the constitutional violation; the State has shown no "exceedingly

persuasive justification" for withholding from women qualified for the experience premier training of the kind VMI affords.

VMI . . . offers an educational opportunity no other Virginia institution provides, and the school's "prestige"—associated with its success in developing "citizen soldiers"—is unequaled. Virginia has closed this facility to its daughters and, instead, has devised for them a "parallel program," with a faculty less impressively credentialed and less well paid, more limited course offerings, fewer opportunities for military training and for scientific specialization. Cf. Sweatt, 339 U. S., at 633. VMI, beyond question, "possesses to a far greater degree" than the VWIL program "those qualities which are incapable of objective measurement but which make for greatness in a . . . school," including "position and influence of the alumni, standing in the community, traditions and prestige." Id., at 634. Women seeking and fit for a VMI quality education cannot be offered anything less, under the State's obligation to afford them genuinely equal protection.

A prime part of the history of our Constitution, historian Richard Morris recounted, is the story of the extension of constitutional rights and protections to people once ignored or excluded. [n.21] VMI's story continued as our comprehension of "We the People" expanded. See supra, at 29, n. 16. There is no reason to believe that the admission of women capable of all the activities required of VMI cadets would destroy the Institute rather than enhance its capacity to serve the "more perfect Union."

. . .

For the reasons stated, the initial judgment of the Court of Appeals, 976 F. 2d 890 (CA4 1992), is affirmed, the final judgment of the Court of Appeals, 44 F. 3d 1229 (CA4 1995), is reversed, and the case is remanded for further proceedings consistent with this opinion.

It is so ordered.

Oncale v. Sundowner Offshore Services, 1998

Justice Scalia delivered the opinion of the Court.

This case presents the question whether workplace harassment can violate Title VII's prohibition against "discriminat[ion] . . . because of . . . sex," 42 U.S.C. § 2000e-2(a)(1), when the harasser and the harassed employee are of the same sex.

I

The District Court having granted summary judgment for respondent, we must assume the facts to be as alleged by petitioner Joseph Oncale. The precise details are irrelevant to the legal point we must decide, and in the interest of both brevity and dignity we shall describe them only generally. In late October 1991, Oncale was working for respondent Sundowner Offshore Services on a Chevron U. S. A., Inc., oil platform in the Gulf of Mexico. He was employed as a roustabout on an eight-man crew which included respondents John Lyons, Danny Pippen, and Brandon Johnson. Lyons, the crane operator, and Pippen, the driller, had supervisory authority, App. 41, 77, 43. On several occasions, Oncale was forcibly subjected to sex-related, humiliating actions against him by Lyons, Pippen, and Johnson in the presence of the rest of the crew. Pippen and Lyons also physically assulted Oncale in a sexual manner, and Lyons threatened him with rape.

Oncale's complaints to supervisory personnel produced no remedial action; in fact, the company's Safety Compliance Clerk, Valent Hohen, told Oncale that Lyons and Pippen "picked [on] him all the time too," and called him a name suggesting homosexuality. Id., at 77. Oncale eventually quit—asking that his pink slip reflect that he "voluntarily left due to sexual harassment and verbal abuse." Id., at 79. When asked at his deposition why he left Sundowner, Oncale stated "I felt that if I didn't leave my job, that I would be raped or forced to have sex." Id., at 71.

Oncale filed a complaint against Sundowner in the United States District Court for the Eastern District of Louisiana, alleging that he was discriminated against in his employment because of his sex. Relying on the Fifth Circuit's decision in *Garcia v. Elf Atochem North America*, 28 F.3d 446, 451—452 (CA5 1994), the district court held that "Mr. Oncale, a male, has no cause of action under Title VII for harassment by male co-workers." App. 106. On appeal, a panel of the Fifth Circuit concluded that Garcia was binding Circuit precedent, and affirmed. 83 F. 3d 118 (1996). We granted certiorari. . .

II

Title VII of the Civil Rights Act of 1964 provides, in relevant part, that "[i]t shall be an unlawful employment practice for an employer ... to discriminate against any individual with respect to his compensation, terms, conditions, or privileges of employment, because of such individual's race, color, religion, sex, or national origin." 78 Stat. 255, as amended, 42 U.S.C. § 2000e—2(a)(1). We have held that this not only covers "terms" and "conditions" in the narrow contractual sense, but "evinces a congressional intent to strike at the entire spectrum of disparate treatment of men and women in employment." *Meritor Savings Bank, FSB v. Vinson*, 477 U.S. 57, 64 (1986) (citations and internal quotation marks omitted). "When the workplace is permeated with discriminatory

intimidation, ridicule, and insult that is sufficiently severe or pervasive to alter the conditions of the victim's employment and create an abusive working environment, Title VII is violated." *Harris v. Forklift Systems, Inc.,* 510 U.S. 17, 21 (1993) (citations and internal quotation marks omitted).

Title VII's prohibition of discrimination "because of . . . sex" protects men as well as women, *Newport News Shipbuilding & Dry Dock Co. v. EEOC,* 462 U.S. 669, 682 (1983), and in the related context of racial discrimination in the workplace we have rejected any conclusive presumption that an employer will not discriminate against members of his own race. "Because of the many facets of human motivation, it would be unwise to presume as a matter of law that human beings of one definable group will not discriminate against other members of that group." *Castaneda v. Partida,* 430 U.S. 482, 499 (1977). See also id., at 515–516 n. 6 (Powell, J., joined by Burger, C. J., and Rehnquist, J., dissenting). In *Johnson v. Transportation Agency, Santa Clara Cty.,* 480 U.S. 616 (1987), a male employee claimed that his employer discriminated against him because of his sex when it preferred a female employee for promotion. Although we ultimately rejected the claim on other grounds, we did not consider it significant that the supervisor who made that decision was also a man. See id., at 624–625. If our precedents leave any doubt on the question, we hold today that nothing in Title VII necessarily bars a claim of discrimination "because of . . . sex" merely because the plaintiff and the defendant (or the person charged with acting on behalf of the defendant) are of the same sex.

Courts have had little trouble with that principle in cases like Johnson, where an employee claims to have been passed over for a job or promotion. But when the issue arises in the context of a "hostile environment" sexual harassment claim, the state and federal courts have taken a bewildering variety of stances. Some, like the Fifth Circuit in this case, have held that same-sex sexual harassment claims are never cognizable under Title VII. See also, e.g., *Goluszek v. H. P. Smith,* 697 F. Supp. 1452 (ND Ill. 1988). Other decisions say that such claims are actionable only if the plaintiff can prove that the harasser is homosexual (and thus presumably motivated by sexual desire). Compare *McWilliams v. Fairfax County Board of Supervisors,* 72 F.3d 1191 (CA4 1996), with *Wrightson v. Pizza Hut of America,* 99 F.3d 138 (CA4 1996). Still others suggest that workplace harassment that is sexual in content is always actionable, regardless of the harasser's sex, sexual orientation, or motivations. See *Doe v. Belleville,* 119 F.3d 563 (CA7 1997).

We see no justification in the statutory language or our precedents for a categorical rule excluding same-sex harassment claims from the coverage of Title VII. As some courts have observed, male-on-male sexual harass-

ment in the workplace was assuredly not the principal evil Congress was concerned with when it enacted Title VII. But statutory prohibitions often go beyond the principal evil to cover reasonably comparable evils, and it is ultimately the provisions of our laws rather than the principal concerns of our legislators by which we are governed. Title VII prohibits "discriminat[ion] . . . because of . . . sex" in the "terms" or "conditions" of employment. Our holding that this includes sexual harassment must extend to sexual harassment of any kind that meets the statutory requirements.

Respondents and their amici contend that recognizing liability for same-sex harassment will transform Title VII into a general civility code for the American workplace. But that risk is no greater for same-sex than for opposite-sex harassment, and is adequately met by careful attention to the requirements of the statute. Title VII does not prohibit all verbal or physical harassment in the workplace; it is directed only at "discriminat[ion] . . . because of . . . sex." We have never held that workplace harassment, even harassment between men and women, is automatically discrimination because of sex merely because the words used have sexual content or connotations. "The critical issue, Title VII's text indicates, is whether members of one sex are exposed to disadvantageous terms or conditions of employment to which members of the other sex are not exposed." *Harris,* supra, at 25 (Ginsburg, J., concurring).

Courts and juries have found the inference of discrimination easy to draw in most male-female sexual harassment situations, because the challenged conduct typically involves explicit or implicit proposals of sexual activity; it is reasonable to assume those proposals would not have been made to someone of the same sex. The same chain of inference would be available to a plaintiff alleging same-sex harassment, if there were credible evidence that the harasser was homosexual. But harassing conduct need not be motivated by sexual desire to support an inference of discrimination on the basis of sex. A trier of fact might reasonably find such discrimination, for example, if a female victim is harassed in such sex-specific and derogatory terms by another woman as to make it clear that the harasser is motivated by general hostility to the presence of women in the workplace. A same-sex harassment plaintiff may also, of course, offer direct comparative evidence about how the alleged harasser treated members of both sexes in a mixed-sex workplace. Whatever evidentiary route the plaintiff chooses to follow, he or she must always prove that the conduct at issue was not merely tinged with offensive sexual connotations, but actually constituted "discrimina[tion] . . . because of . . . sex."

And there is another requirement that prevents Title VII from expanding into a general civility code: As we

emphasized in *Meritor and Harris,* the statute does not reach genuine but innocuous differences in the ways men and women routinely interact with members of the same sex and of the opposite sex. The prohibition of harassment on the basis of sex requires neither asexuality nor androgyny in the workplace; it forbids only behavior so objectively offensive as to alter the "conditions" of the victim's employment. "Conduct that is not severe or pervasive enough to create an objectively hostile or abusive work environment—an environment that a reasonable person would find hostile or abusive—is beyond Title VII's purview." *Harris,* 510 U.S., at 21, citing *Meritor,* 477 U.S. at 67. We have always regarded that requirement as crucial, and as sufficient to ensure that courts and juries do not mistake ordinary socializing in the workplace—such as male-on-male horseplay or intersexual flirtation—for discriminatory "conditions of employment."

We have emphasized, moreover, that the objective severity of harassment should be judged from the perspective of a reasonable person in the plaintiff's position, considering "all the circumstances." *Harris,* supra, at 23. In same-sex (as in all) harassment cases, that inquiry requires careful consideration of the social context in which particular behavior occurs and is experienced by its target. A professional football player's working environment is not severely or pervasively abusive, for example, if the coach smacks him on the buttocks as he heads onto the field—even if the same behavior would reasonably be experienced as abusive by the coach's secretary (male or female) back at the office. The real social impact of workplace behavior often depends on a constellation of surrounding circumstances, expectations, and relationships which are not fully captured by a simple recitation of the words used or the physical acts performed. Common sense, and an appropriate sensitivity to social context, will enable courts and juries to distinguish between simple teasing or roughhousing among members of the same sex, and conduct which a reasonable person in the plaintiff's position would find severely hostile or abusive.

III

Because we conclude that sex discrimination consisting of same-sex sexual harassment is actionable under Title VII, the judgment of the Court of Appeals for the Fifth Circuit is reversed, and the case is remanded for further proceedings consistent with this opinion.

1998 Declaration of Sentiments of the National Organization for Women, July 12, 1998

On this twelfth day of July, 1998, the delegates of the National Organization for Women gather in convention on the one hundred and fiftieth year of the women's rights movement.

We bring passion, anger, hope, love and perseverance to create this vision for the future:

> We envision a world where women's equality and women's empowerment to determine our own destinies is a reality;
> We envision a world where women have equal representation in all decision-making structures of our societies;
> We envision a world where social and economic justice exist, where all people have the food, housing, clothing, health care and education they need;
> We envision a world where there is recognition and respect for each person's intrinsic worth as well as the rich diversity of the various groups among us;
> We envision a world where non-violence is the established order;
> We envision a world where patriarchal culture and male dominance no longer oppress us or our earth;
> We envision a world where women and girls are heard, valued and respected.

Our movement, encompassing many issues and many strategies, directs our love for humanity into action that spans the world and unites women. But our future requires us to know our past.

One hundred fifty years ago the women's rights movement grew out of the fight to abolish slavery. Angered by their exclusion from leadership and public speaking at abolitionist conventions and inspired by the power of the Iroquois women, a small dedicated group of women and men built a movement. After its inception, the movement was fractured by race. Our history is full of struggle against common bonds of oppression and a painful reality of separation. Nevertheless, these activists created a political force that achieved revolutionary change. They won property rights for married women; opened the doors of higher education for women; and garnered suffrage in 1920.

In 1923, on the seventy-fifth anniversary of the historic Seneca Falls convention, feminists led the demand for constitutional equality for women to win full justice under the law in order to end economic, educational, and political inequality.

Our foremothers—the first wave of feminists—ran underground railroads, lobbied, marched, and picketed. They were jailed and force fed, lynched and raped. But they prevailed. They started with a handful of activists, and today, the feminist movement involves millions of people every day.

Standing on their shoulders, we launched the National Organization for Women in 1966, the largest and

strongest organization of feminists in the world today. A devoutly grassroots, action-oriented organization, we have sued, boycotted, picketed, lobbied, demonstrated, marched, and engaged in non-violent civil disobedience. We have won in the courts and in the legislatures; and we have negotiated with the largest corporations in the world, winning unparalleled rights for women.

The National Organization for Women and our modern day movement have profoundly changed the lives of women, men and children. We have raised public consciousness about the plight of women to such an extent that today the majority of people support equality for women.

In the past 32 years, women have advanced farther than in any previous generation. Yet still we do not have full equality.

We have moved more feminists than ever before into positions of power in all of the institutions that shape our society. We have achieved some measure of power to effect change in these institutions from within; yet still we are far from full equality in decision-making. We demand an equal share of power in our families and religions, in law, science and technology, the arts and humanities, sports, education, the trades and professions, labor and management, the media, corporations and small businesses as well as government. In no sphere of life should women be silenced, underrepresented, or devalued.

Today, we reaffirm our demand for Constitutional equality for women and girls. Simultaneously, we are working with sister organizations to develop and pass a national women's equality act for the twenty-first century. And we participate in and advance a global movement for women and demand that the United States join the overwhelming majority of nations of the world in ratifying the United Nations Convention on the Elimination of All Forms of Discrimination Against Women without reservations, declarations, or understandings that would weaken this commitment.

We reaffirm our commitment to the power of grassroots activism, to a multi-issue, multi-tactical strategy.

We are committed to a feminist ideology and reaffirm our historic commitment to gaining equality for women, assuring safe, legal and accessible abortion and full reproductive freedom, combating racism, stopping violence against women, ending bigotry and discrimination based on sexual orientation and on color, ethnicity, national origin, economic status, age, disability, size, childbearing capacity or choices, or parental or marital status.

We will not trade off the rights of one woman for the advancement of another. We will not be divided. We will unite with all women who seek freedom and join hands with all of the great movements of our time and all time, seeking equality, empowerment and justice.

We commit to continue the mentoring, training, and leadership development of young and new activists of all ages who will continue our struggle. We will work to invoke enthusiasm for our goals and to expand ownership in this movement for current and future generations.

We commit to continue building a mass movement where we are leaders, not followers, of public opinion. We will continue to move feminist ideals into the mainstream thought, and we will build our media and new technology capabilities to control our own image and message.

How long and hard a struggle it was to win the right for women to vote. Today, we fight the same reactionary forces: the perversion of religion to subjugate women; corporate greed that seeks to exploit women and children as a cheap labor force; and their apologists in public office who seek to do through law what terrorists seek to accomplish through bullets and bombs. We will not submit, nor will we be intimidated. But we will keep moving forward.

Those who carried the struggle for women's suffrage through to its end were not there at the start; those who started the struggle did not live to see the victory. Like those strong feminist activists, we will not let ourselves be dispirited or discouraged. Even when progress seems most elusive, we will maintain our conviction that the work itself is important. For it is the work that enriches our lives; it is the work that unites us; it is the work that will propel us into the next century. We know that our struggle has made a difference, and we reaffirm our faith that it will continue to make a difference for women's lives.

Today, we dedicate ourselves to the sheer joy of moving forward and fighting back.

Chronological List of Women Who Have Served as U.S. Congressional Representatives and U.S. Senators

Congressional Representatives

Notes: Those marked with an asterisk served or serve as delegates; those marked with two asterisks later served the U.S. Senate as well.

Jeannette Rankin (R-MT, 1917–19 and 1941–43)
Alice Mary Robertson (R-OK, 1921–23)
Winnifred Sprague Mason Huck (R-IL, 1922–23)
Mae Ella Nolan (R-CA, 1923–25)
Florence Prag Kahn (R-CA, 1925–37)
Mary Teresa Norton (D-NJ, 1925–51)
Edith Nourse Rogers (R-MA, 1925–60)
Katherine Gudger Langley (R-KY, 1927–37)
Pearl Peden Oldfield (D-AR, 1929–31)
Ruth Hannah McCormick (R-IL, 1929–31)
Ruth Bryan Owen (D-FL, 1929–33)
Ruth Sears Baker Pratt (R-NY, 1929–33)
Effiegene Locke Wingo (D-AR, 1930–33)

Willa McCord Blake Eslick (D-TN, 1932–33)
Virginia Ellis Jenckes (D-IN, 1933–39)
Kathryn Ellen O'Loughlin (McCarthy) (D-KS, 1933–35)
Isabella Selmes Greenway (D-AZ, 1933–37)
Marian Williams Clarke (R-NY, 1933–35)
Caroline Love Goodwin O'Day (D-NY, 1937–39)
Nan Wood Honeyman (D-OR, 1937–39)
Elizabeth Hawley Gasque (D-SC, 1938–39)
Jessie Sumner (R-IL, 1939–47)
Clara Gooding McMillan (D-SC, 1939–41)
Frances Payne Bolton (R-OH, 1940–69)
Margaret Chase Smith (R-ME, 1940–49)**
Florence Reville Gibbs (D-GA, 1940–41)
Katharine Edgar Byron (D-MD, 1941–43)
Veronica Grace Boland (D-PA, 1942–43)
Clare Boothe Luce (R-CT, 1943–47)
Winifred Claire Stanley (R-NY, 1943–45)
Willa Lybrand Fulmer (D-SC, 1944–45)
Emily Taft Douglas (D-IL, 1945–47)
Helen Gahagan Douglas (D-CA, 1945–51)
Chase Going Woodhouse (D-CT, 1945–47 and 1949–51)
Helen Douglas Mankin (D-GA, 1946–47)
Eliza Jane Pratt (D-NC, 1946–47)
Georgia Lee Lusk (D-NM, 1947–49)
Katharine Price Collier St. George (R-NY, 1947–65)
Reva Zilpha Beck Bosone (D-UT, 1949–53)
Cecil Murray Harden (R-IN, 1949–59)
Edna Flannery Kelly (D-NY, 1949–69)
Marguerite Stitt Church (R-IL, 1951–63)
Ruth Thompson (R-MI, 1951–57)
Maude Elizabeth Kee (D-WV, 1951–65)
Vera Daerr Buchanan (D-PA, 1951–55)
Gracis Bowers Pfost (D-ID, 1953–63)
Leonor Kretzer Sullivan (D-MO, 1953–77)
Mary Elizabeth Pruett Farrington (R-HI, 1954–57)*
Iris Faircloth Blitch (D-GA, 1955–63)
Edith Starrett Green (D-OR, 1955–74)
Martha Wright Griffiths (D-MI, 1955–74)
Coya Gjesdal Knutson (D-MN, 1955–59)
Kathryn Elizabeth Granahan (D-PA, 1956–63)
Florence Price Dwyer (R-NJ, 1957–73)
Catherine Dean May (R-WA, 1959–71)
Edna Oakes Simpson (R-IL, 1959–61)
Jessica McCullough Weis (R-NY, 1959–63)
Julia Butler Hansen (D-WA, 1960–74)
Catherine Dorris Norrell (D-AR, 1961–63)
Louise Goff Reece (R-TN, 1961–63)
Corrine Boyd Riley (D-SC, 1962–63)
Charlotte Thompson Reid (R-IL, 1963–71)
Irene Bailey Baker (R-TN, 1964–65)
Patsy Takemoto Mink (D-HI, 1965–77 and 1990–)

Lera Millard Thomas (D-TX, 1966–67)
Margaret M. Heckler (R-MA, 1967–83)
Shirley Anita Chisholm (D-NY, 1969–83)
Bella Savitsky Abzug (D-NY, 1971–77)
Ella Tambussi Grasso (D-CT, 1971–75)
Louise Day Hicks (D-MA, 1971–73)
Elizabeth Bullock Andrews (D-AL, 1972–73)
Yvonne Brathwaite Burke (D-CA, 1973–79)
Marjorie Sewell Holt (R-MD, 1973–87)
Elizabeth Holtzman (D-NY, 1973–81)
Barbara Charline Jordan (D-TX, 1973–79)
Patricia Scott Schroeder (D-CO, 1973–97)
Corinne Claiborne (Lindy) Boggs (D-LA, 1973–91)
Cardiss Collins (D-IL, 1973–97)
Millicent Hammond Fenwck (R-NJ, 1975–83)
Martha Elizabeth Keys (D-KS, 1975–79)
Marilyn Laird Lloyd (D-TN, 1975–95)
Helen Stevenson Meyner (D-NJ, 1975–79)
Virginia Dodd Smith (R-NE, 1975–91)
Gladys Noon Spellman (D-MD, 1975–81)
Shirley Neil Pettis (R-CA, 1975–79)
Barbara Ann Mikulski (D-MD, 1977–87)**
Mary Rose Oakar (D-OH, 1977–93)
Beverly Barton Butcher Byron (D-MD, 1979–93)
Geraldine Ann Ferraro (D-NY, 1979–85)
Olympia Jean Snowe (R-ME, 1979–95)**
Bobbi Fiedler (R-CA, 1981–87)
Lynn Morely Martin (R-IL, 1981–91)
Margaret Scafati Roukema (R-NJ, 1981–)
Claudine Schneider (R-RI, 1981–91)
Barbara Bailey Kennelly (D-CT, 1982–99)
Jean Spencer Ashbrook (R-OH, 1982–83)
Katie Beatrice Hall (D-IN, 1982–85)
Barbara Boxer (D-CA, 1983–93)**
Nancy Lee Johnson (R-CT, 1983–)
Marcia Carolyn (Marcy) Kaptur (D-OH, 1983–)
Barbara Farrell Vucanovich (R-NV, 1983–97)
Sala Burton (D-CA, 1983–87)
Helen Delich Bentley (R-MD, 1985–95)
Jan Meyers (R-KS, 1985–97)
Catherine S. Long (D-LA, 1985–87)
Constance A. Morella (R-MD, 1987–)
Elizabeth J. Patterson (D-SC, 1987–93)
Patricia Fukuda Saiki (R-HI, 1987–91)
Louise McIntosh Slaughter (D-NY, 1987–)
Nancy Pelosi (D-CA, 1987–)
Nita M. Lowey (D-NY, 1989–)
Jolene Unsoeld (D-WA, 1989–95)
Jill Long (D-IN, 1989–95)
Ileana Ros-Lehtinen (R-FL, 1989–)
Susan Molinari (R-NY, 1990–97)
Barbara-Rose Collins (D-MI, 1991–97)
Rosa L. DeLauro (D-CT, 1991–)
Joan Kelly Horn (D-MO, 1991–93)

Eleanor Holmes Norton (D-DC, 1991–)*
Maxine Waters (D-CA, 1991–)
Eva Clayton (D-NC, 1992–)
Corrine Brown (D-FL, 1993–)
Leslie Byrne (D-VA, 1993–95)
Maria Cantwell (D-WA, 1993–95)
Pat Danner (D-MO, 1993-)
Jennifer Dunn (R-WA, 1993–)
Karan English (D-AZ, 1993–95)
Anna G. Eshoo (D-CA, 1993–)
Tillie Fowler (R-FL, 1993–)
Elizabeth Furse (D-OR, 1993–99)
Jane Harman (D-CA, 1993–99)
Eddie Bernice Johnson (D-TX, 1993–)
Blanche Lambert Lincoln (D-AR, 1993–97)**
Carolyn B. Maloney (D-NY, 1993–)
Marjorie Margolies-Mezvinsky (D-PA, 1993–95)
Cynthia McKinney (D-GA, 1993–)
Carrie P. Meek (D-FL, 1993–)
Deborah Pryce (R-OH, 1993–)
Lucille Roybal-Allard (D-CA, 1993–)
Lynn Schenk (D-CA, 1993–95)
Karen Shepherd (D-UT, 1993–95)
Karen Thurman (D-FL, 1993–)
Nydia M. Velazquez, (D-NY, 1993–)
Lynn Woolsey (D-CA, 1993–)
Helen Chenoweth (R-ID, 1995–)
Barbara Cubin (R-WY, 1995–)
Enid Greene (Waldholtz) (R-UT, 1995–97)
Sheila Jackson-Lee (D-TX, 1995–)
Sue Kelly (R-NY, 1995–)
Zoe Lofgren (D-CA, 1995–)
Karen McCarthy (D-MO, 1995–)
Sue Myrick (R-NC, 1995–)
Lynn Rivers (D-MI, 1995–)
Andrea Seastrand (R-CA, 1995–97)
Linda Smith (R-WA, 1995–99)
Juanita Millender-McDonald (D-CA, 1996–)
JoAnn Emerson (R-MO, 1996–)
Julia Carson (D-IN, 1997–)
Donna MC Christensen (D-VI, 1997–)*
Diana DeGette (D-CO, 1997–)
Kay Granger (R-TX, 1997–)
Darlene Hooley (D-OR, 1997–)
Carolyn Cheeks Kilpatrick (D-MI, 1997–)
Carolyn McCarthy (D-NY, 1997–)
Anne Northup (R-KY, 1997–)
Loretta Sanchez (D-CA, 1997–)
Debbie Stabenow (D-MI, 1997–01)
Ellen Tauscher (D-CA, 1997–)

Lois Capps (D-CA, 1998–)
Mary Bono (R-CA, 1998–)
Barbara Lee (D-CA, 1998–)
Heather Wilson (R-NM, 1998–)
Tammy Baldwin (D-WI, 1999–)
Shelley Berkley (D-NV, 1999–)
Judith Borg Biggert (R-IL, 1999–)
Stephanie Tubbs Jones (D-OH, 1999–)
Grace Napolitano (D-CA, 1999–)
Janice Schakowsky (D-IL, 1999–)
Shelly Capit (R-WV, 2001–)
Jo Ann Davis (D-CA, 2001–)
Melissa Hart (R-PA, 2001–)
Betty Mccollum (D-MA, 2001–)

Senators:

Rebecca Latimer Felton (D-GA, 1922)
Hattie Wyatt Caraway (D-AK, 1931–45)
Rose McConnell Long (D-LA, 1936–37)
Dixie Bibb Graves (D-AL, 1937–38)
Gladys Pyle (R-SD, 1938–39)
Vera Cahalan Bushfield (R-SD, 1948)
Margaret Chase Smith (R-ME, 1949–73)
Eva Kelley Bowring (R-NE, 1954)
Hazel Hempel Abel (R-NE, 1954)
Maurine Brown Neuberger (D-OR, 1960–67)
Elaine S. Edwards (D-LA, 1972)
Muriel Humphrey (D-Minnesota, 1978)
Maryon Allen (D-Alabama, 1978)
Nancy Landon Kassebaum (R-KA, 1978–97)
Paula Hawkins (R-FL, 1981–87)
Barbara Mikulski (D-MD, 1987–)
Jocelyn Burdick (D-ND, 1992)
Dianne Feinstein (D-CA, 1993–)
Barbara Boxer (D-CA, 1993–)
Carol Moseley-Braun (D-IL, 1993-1999)
Patty Murray (D-WA, 1993–)
Kay Bailey Hutchison (R-TX, 1993–)
Olympia Jean Snowe (R-ME, 1995–)
Sheila Frahm (R-KS, 1996)
Mary Landrieu (D-LA, 1997–)
Susan Collins (R-ME, 1997–)
Blanche Lambert Lincoln (D-AK, 1999–)
Hillary Rodham Clinton (D-NY, 2001–)
Deborah Stabenow (D-Michigan, 2001–)
Maria E. Cantwell (D-WA, 2001–)
Jean Carnahan (D-Missouri, 2001–)

Sources: Office of the Clerk, U.S. House of Representatives, and the Senate Historical Office

Bibliography

Abbott, Rebecca Phillips, Director of Administration for the National Museum of Women in the Arts, 1994 letter to prospective members.

Abraham, Henry J. *The Judicial Process,* 4th ed. New York: Oxford University Press, 1980.

Abzug, Bella. November 29, 1994 radio interview, "New York Beat," WNYC.

Abzug, Bella, with Mim Keller. *Gender Gap: Bella Abzug's Guide to Political Power.* Boston: Houghton Mifflin, 1984.

Addams, Jane. *Newer Ideals of Peace.* New York: Macmillan, 1907. Woodbridge, Conn.: Research Publications, microfilm.

———. *Twenty Years at Hull-House.* 1910, rpt. New York: NAL Penguin, Inc., 1981.

———. "Why Women Should Vote." New York: National American Woman Suffrage Association, 1912. Woodbridge, Conn.: Research Publications, microfilm.

Addams, Jane, Emily G. Balch, and Alice Hamilton. *Women at The Hague: The International Congress of Women and Its Results.* New York: Macmillan, 1915; rpt. New York: Garland, 1972.

Adelman, Joseph. *Famous Women.* New York: Lonow, 1926.

Adkins v. Childrens Hospital of District of Columbia, 43 S. Ct. 394 (1923).

Alcott, Louisa May. *Little Women.* 1868, rpt., New York: M. A. Donohue & Co., n.d.

———. *Little Men.* Boston: Roberts Brothers, 1871.

———. *Work: A Story of Experience.* 1873, rpt., New York: Schocken Books, 1977.

———. *Eight Cousins.* Boston: Roberts Brothers, 1875.

———. *Rose in Bloom.* Boston: Roberts Brothers, 1876.

———. *Jo's Boys.* Boston: Roberts Brothers, 1886.

———. *Jack and Jill: A Village Story.* 1880, rpt., New York: Little, Brown, and Company, 1928.

———. *Louisa May Alcott Unmasked: Collected Thrillers.* Boston: Northeastern University Press, 1995.

———. *The Inheritance.* Joel Myerson and Daniel Shealy, eds. New York: Dutton Books, 1997.

———. *A Long Fatal Love Chase.* New York: Macmillan Reference Library, 1997.

———. *Alternative Alcott (The American Women Writers Series).* Elaine Showalter, ed. New Brunswick, N.J.: Rutgers University Press, 1998.

Alonso, Harriet Hyman. *The Woman's Peace Union and the Outlawry of War, 1921–1942.* Knoxville: University of Tennessee Press, 1989.

Altman, Lawrence K. "Gertrude Elion, Drug Developer, Dies at 81," *New York Times,* February 23, 1999.

"American Academy of Pediatrics Statement on Female Genital Mutilation," *American Family Physician,* October 1, 1998.

American Association of University Women. *How Girls Shortchange Girls: The AAUW Report: A Study of Major Findings on Girls and Education.* New York: Marlowe & Co., 1995.

———. *Gender Gaps: Where Schools Still Fail Our Children.* New York: Marlowe & Co., 1998.

American History, August 1998.

Ammer, Christine. *Unsung: A History of Women in American Music.* Westport, Conn.: Greenwood, 1979.

Angelou, Maya. *I Know Why the Caged Bird Sings.* New York: Random House, 1970.

———. *Singing' and Swingin' and Gettin' Merry like Christmas.* New York: Bantam, 1977.

———. *The Heart of a Woman.* New York: Random House, 1981.

———. *All God's Children Need Traveling Shoes.* New York: Random House, 1986.

———. "On the Pulse of Morning," New York: Random House, 1993.

Anthony, Susan B. and Ida Husted Harper, eds. *History of Woman Suffrage,* vol. 4, 1902, rpt. Salem, N.H.: Ayer, 1985.

Apfel, Roberta J., and Susan M. Fisher. *To Do No Harm: DES and the Dilemmas of Modern Medicine.* New Haven, Conn.: Yale University Press, 1984.

Architectural Record, June 1998.

Architecture, November 1998.

Archives of Maryland, vol. 1. *Assembly Proceedings,* January-March 1647–48. Baltimore: Maryland Historical Society, 1883.

Arendt, Hannah. *The Origins of Totalitarianism.* 3 vols. New York: Harcourt Brace, 1951.

———. *On Revolution.* New York: Harcourt Brace, 1958.

———. *The Human Condition.* Chicago: University of Chicago Press, 1958.

———. *On Violence.* New York: Faber, 1962.

———. *The Life of the Mind.* New York: Harcourt Brace, 1977.

Armitage, Merle. *Martha Graham: The Early Years.* New York: Da Capo Press, 1937.

Art in America, November 1998.

Arvey, Verna. "Outstanding Achievements of Negro Composers." *Etude* (1942).

Asals, Frederick. *Flannery O'Connor: The Imagination of Extremity.* Athens: University of Georgia Press, 1982.

Ashe, Samuel A'Court. *History of North Carolina,* vol. 1. Greensboro, NC: Charles L. Van Neppen, 1908.

"Asking Why Heart Treatments Fail in Women," *New York Times,* March 18, 1993.

Asnes, Marion. "Birth Control Over 30." *Working Woman,* July 1994.

Associated Press, December 11, 1996; October 11, 1997; November 13, 1997; March 11 and 31, 1998; June 26, 1998; September 2, 1998; December 1, 1998; April 20, 1999; January 13, 14, and 22, 1999; March 16 and 20, 1999; April 17 and 26, 1999; June 25, 1999; July 12, 14, and 19, 1999.

Attinger, Joelle. "Steinem: Tying Politics to the Personal." *Time* 139, no. 10 (March 9, 1992).

Automobile Workers v. Johnson Controls, Inc., 409 U.S. 187 (1991).

Avery, Myrta Lockett. *A Virginia Girl in the Civil War, 1861–1865.* New York: D. Appleton, 1908.

Aviation Week & Space Technology, March 9, 1998.

Bachus, Jean L. *Letters from Amelia: An Intimate Portrait of Amelia Earhart.* Boston: Beacon, 1982.

Bacon, Margaret Hope. *Valiant Friend: The Life of Lucretia Mott.* New York: Walker, 1980.

Baker, Peter. "President Quietly Signs Law Aimed at Gay Marriages," *The Washington Post,* September 22, 1996.

Banner, Lois. *Elizabeth Cady Stanton: A Radical for Women's Rights.* Boston: Little, Brown & Co., 1980.

———. *American Beauty.* New York: Knopf, 1983.

Barnes, Gilbert H., and Dwight L. Dumond, eds. *Letters of Theodore Dwight Weld, Angelina Grimké Weld and Sarah Grimké, 1822–1844.* Gloucester, Mass.: Peter Smith/American Historical Association, 1965.

Baron, Robert C., ed. *Soul of America: Documenting Our Past, 1942–1974.* Golden, Colo.: Fulcrum, Inc., 1989.

Barringer, Felicity. "Banning of Women at Military College Is Upheld." *New York Times,* June 18, 1991.

Barrow, Anne Llewellyn. *Witchcraze: A New History of the European Witch Hunts.* San Francisco: Pandora/HarperSanFrancisco, 1994.

Barry, Kathleen. *Susan B. Anthony: A Biography of a Singular Feminist.* New York: New York University Press, 1988.

Barter, Judith A. *Mary Cassatt: Modern Woman.* New York: Art Institute of Chicago/Abrams, 1988.

Barton, Clara Harlowe. *The Red Cross, a History of this Remarkable International Movement in the Interest of Humanity . . . Washington, D.C.: American National Red Cross, c. 1898.* Woodbridge, Conn.: Research Publications, microfilm.

———. *The Story of My Childhood.* New York: The Baker & Taylor Co., 1907. Woodbridge, Conn.: Research Publications, microfilm.

Bates, Ernest Sutherland, and John Dittemore. *Mary Baker Eddy: The Truth and the Tradition.* New York: Knopf, 1932.

Bateson, Mary Catherine. *With a Daughter's Eye.* New York: Washington Square Press, 1984.

Beard, Charles, and Mary Beard. *A Basic History of the United States.* New York: New Home Library, 1944.

Beard, Mary. *On Understanding Women.* New York: Grosset & Dunlap, 1931.

———. *Woman as a Force in History: A Study in Traditions and Realities.* New York: Collier, 1946.

———. *The Force of Women in Japanese History.* Washington, D.C.: Public Affairs Press, 1953.

Beck, Melinda with Ray Wilkinson, Bill Turque and Clara Bingham. "Our Women in the Desert: Sharing the Duty—and Danger—in a 'Mom's War,'" *Newsweek,* September 10, 1992.

Beecher, Catharine Esther. "An essay on the education of female teachers, written at the request of the American lyceum and communicated at their annual meeting, New York, May 8th, 1835." New York: Van Nostrand & Dwight, 1835. Woodbridge, Conn.: Research Publications, microfilm.

———. "An essay on slavery and abolitionism, with reference to the duty of American females." Philadelphia: H. Perkins, 1837. Woodbridge, Conn.: Research Publications, microfilm.

———. *The Duty of American Women to Their Country.* New York: Harper & Brothers, 1845. Woodbridge, Conn.: Research Publications, microfilm.

———. *The Evils Suffered by American Women and American Children: the Causes and the Remedy.* New York: Harper & Brothers, 1846. Woodbridge, Conn.: Research Publications, microfilm.

———. *A Treatise on Domestic Economy for the Use of Young Ladies at Home and at School.* Revised edition. New York: Harper & Brothers, 1850. Woodbridge, Conn.: Research Publications, microfilm.

———. *Something for Women Better Than the Ballot.* New York: D. Appleton & Co., 1869. Woodbridge, Conn.: Research Publications, microfilm.

———. *Woman's Profession as Mother and Teacher with Views in Opposition to Woman Suffrage.* New York: Maclean, Gibson & Co., 1872. Woodbridge, Conn.: Research Publications, microfilm.

———. "Female Education," in *The American Journal of Education,* 2 (1927): 9. Woodbridge, Conn.: Research Publications, microfilm.

Belford, Barbara. *Brilliant Bylines: A Biographical Anthology of Notable Newspaperwomen in America.* New York: Columbia University Press, 1986.

Bendavid, Naftali. "Keeping a High Profile: Reno's Tenure as Attorney General Marked by Turbulence," *Houston Chronicle,* August 15, 1999.

Benedict, Ruth. *Patterns of Culture.* Boston: Houghton Mifflin, 1934.

———. *Race, Science and Politics.* New York: Viking, 1940.

———. *The Chrysanthemum and the Sword.* Houghton Mifflin, 1946.

Benton, Josiah H., Jr. "What Women Did for the War, and What the War Did For Women." Memorial Day speech before the Soldier's Club, Wellesley, Mass., May 30, 1894. Woodbridge, Conn.: Research Publications, microfilm.

Berke, Richard L. "Clinton Picks Miami Woman, Veteran State Prosecutor, to be His Attorney General." *New York Times,* February 12, 1993.

———. "Centrist Role Cited: Appeals Judge Has Ruled for Abortion Rights, but Criticizes Roe." *New York Times,* June 15, 1993.

Berkon, Susan Fondiler, and Jane Holtz Kay. "Marion Mahony Griffin, Architect." *Feminist Art Journal* (Spring 1975).

Bernikow, Louise, ed. *The World Split Open: Four Centuries of Women Poets in England and America, 1552–1950.* New York: Vintage Books, 1974.

Beveridge, Albert Jeremiah. "A Tribute to the American Woman, Frances E. Willard. In the United States Senate, February 17, 1905, on the occasion of the unveiling of the Willard Statue in the U.S. Capitol."

Indianapolis, Levey Bros. Co., 1905. Woodbridge, Conn.: Research Publications, microfilm.

Birmingham, Stephen. *The Grandes Dames.* New York: Simon & Schuster 1982.

Bishop, Elizabeth. *The Collected Prose.* Robert Giroux, ed. New York: Farrar, Straus & Giroux, 1984.

———. *The Complete Poems of Elizabeth Bishop, 1927–1979.* New York: Farrar, Straus and Giroux, 1984.

———. *One Art: Letters.* Edited by Robert Giroux. New York: Farrar, Straus & Giroux, 1994.

Bishop, Katherine, "Scant Success for California Efforts to Put Women in Construction Jobs," *New York Times,* February 15, 1991.

Blackman, Ann. *Seasons of Her Life: A Biography of Madeleine Korbel Albright.* New York: Scribner, 1998.

Blackwell, Alice Stone. *Lucy Stone: Pioneer of Woman's Rights.* Detroit: Grand River Books, 1971; first published, 1930.

Blackwell, Antoinette Louisa Brown. *Sex Injustice.* An Address delivered at the twenty-first annual meeting of the American Purity Alliance. New York: American Purity Alliance [n.d.] Woodbridge, Conn.: Research Publications, microfilm.

———. *The Sexes Throughout Nature.* New York: G. P. Putnam's Sons, 1875. Woodbridge, Conn.: Research Publications, microfilm.

———. *The Physical Basis of Immortality.* New York: G. P. Putnam & Sons, 1876. Woodbridge, Conn.: Research Publications, microfilm.

———. *The Philosophy of Individuality; or, the One and the Many.* New York: Putnam & Sons, 1893. Woodbridge, Conn.: Research Publications, microfilm.

———. *The Social Side of Mind and Action . . .* New York: The Neale Pub. Co., 1915. Woodbridge, Conn.: Research Publications, microfilm.

Blackwell, Elizabeth. *The Laws of Life With Specific Reference to the Physical Education of Girls.* New York: G. P. Putnam, 1852. Woodbridge, Conn.: Research Publications, microfilm.

———. *Address on the Medical Education of Women.* New York: Baptist & Taylor, Book and Job Printers, 1864. Woodbridge, Conn.: Research Publications, microfilm.

———. *Counsel to Parents on the Moral Education of Their Children.* New York: Brentano's Literary Emporium, 1878. Woodbridge, Conn.: Research Publications, microfilm.

———. *The Religion of Health.* Edinburgh and Glasgow, J. Menzies & Co., 1878. Woodbridge, Conn.: Research Publications, microfilm.

———. *The Influence of Women in the Profession of Medicine.* Address given at the . . . London School of

Medicine for Women. Baltimore, 1890. Woodbridge, Conn.: Research Publications, microfilm.

———. *The Human Element in Sex: Being a Medical Inquiry Into the Relation of Sexual Physiology to Christian Morality.* New Edition, London: J. & A. Churchill, 1894. Woodbridge, Conn.: Research Publications, microfilm.

———. *Pioneer Work in Opening the Medical Profession to Women: Autobiographical Sketches.* Hastings, England: K. Barry, 1895. Woodbridge, Conn.: Research Publications, microfilm.

Blackwell, Elizabeth, and Emily Blackwell. *Medicine as a Profession for Women.* New York: W. H. Tinson, 1860. Woodbridge, Conn.: Research Publications, microfilm.

Blair, Karen J. *The Clubwoman as Feminist: True Womanhood Redefined, 1868–1914.* New York: Holmes & Meier, 1980.

Blakely, Mary Kay. "Remembering Jane," *New York Times Magazine,* September 23, 1990.

Blanchard, Paula. *Margaret Fuller: From Transcendentalism to Revolution.* New York: Addison-Wesley Publishing Company, 1987.

Blatch, Harriot Stanton, and Alma Lutz. *Challenging Years: The Memoirs of Harriot Stanton Blatch.* New York: Putnam, 1940.

Block, Adrienne Fried. *Amy Beach, Passionate Victorian: The Life and Work of an American Composer, 1867–1944.* New York: Oxford University Press, 1999.

Block, Adrienne Fried, and Carol Neuls-Bates, eds. *Women in American Music.* Westport, Conn.: Greenwood, 1979.

Blumberg, Dorothy Rose. *Florence Kelley: The Making of a Social Pioneer.* New York: A. M. Kelly, 1966.

Bly, Nellie. (Elizabeth Cochrane Seaman). Interview of Susan B. Anthony, *The Woman's Journal,* February 22, 1895.

Board of Directors of Rotary International v. Rotary Club of Duarte, 481 U.S. 537 (1987).

Boggs, Lindy. *Washington Through a Purple Veil: Memoirs of a Southern Woman.* New York: Harcourt Brace, 1994.

Bok, Edward William. "Real opponents to the suffrage movement . . . are the women themselves whose peculiar field of work lies outside of politics . . ." New York: New York Association Opposed to Woman Suffrage, 1909. Woodbridge, Conn.: Research Publications, microfilm.

Bomann, Mieke H. "Projects Recognizes Women in History," *Times Union* (Albany), March 14, 1999.

Bonnin, Gertrude S. *Old Indian Legends.* 1901, rpt., Lincoln: University of Nebraska Press, 1985.

———. *American Indian Stories.* 1921, rpt., Lincoln: University of Nebraska Press, 1985.

Bordin, Ruth. *Woman and Temperance: The Quest for Power and Liberty, 1873–1900.* Philadelphia: Temple University Press, 1981.

———. *Frances Willard: A Biography.* Chapel Hill: University of North Carolina Press, 1986.

Boston Authors Club. "Birthday Tributes to Mrs. Julia Ward Howe, May 27, 1905." Boston: Press of Winthrop B. Jones, 1905. Woodbridge, Conn.: Research Publications, microfilm.

Boston Globe, November 14, 1996; March 4, 1997; January 14, 1999; May 28, 1999.

Boston Women's Health Book Collective, The. *Our Bodies, Ourselves.* New York: Simon & Schuster, 1976.

———. *The New Our Bodies, Ourselves.* New York: Simon & Schuster, 1984.

———. *Our Bodies, Ourselves: A Book by and for Women, 25th Anniversary Edition.* New York: Simon & Schuster, 1996.

———. *Our Bodies, Ourselves for the New Century: A Book for and by Women.* New York: Simon & Schuster, 1998.

Boxer, Barbara with Nicole Boxer. *Strangers in the Senate: Politics and the New Revolution of Women in America.* Washington, D.C.: National Press Books, 1994.

Boydston, Jeanne, Mary Kelley, and Anne Margolis, eds. *The Limits of Sisterhood: The Beecher Sisters on Women's Rights and Woman's Sphere.* Chapel Hill: University of North Carolina Press, 1988.

Boyer, Dave. "Senate Panel to Probe Justice Department," *The Nation,* September 24, 1999.

Boyle, Richard J. *American Impressionists.* Boston: New York Graphic Society, 1971.

Bradstreet, Anne Dudley. *The Works of Anne Bradstreet in Prose and Verse,* ed. John Harvard Ellis. Charleston: A. E. Cutter, 1867. Woodbridge, Conn.: Research Publications, microfilm.

Bradwell v. State of Illinois, 83 U.S. 130 (1873).

Brady, Kathleen. *Ida Tarbell: Portrait of a Muckraker.* New York: Putnam, 1984.

Brainerd, Ezra. "Life and Work in Middlebury, Vermont, of Emma Willard," address read at Rutland, Vt., before the Congressional Club, September 26, 1893, printed New York: Evening Post Printing House [n.d.].

Brecher, Deborah and Jill Lippitt. *The Women's Information Exchange National Directory.* New York: Avon Books, 1994.

Breckinridge, Mary. *Wide Neighborhoods: The Story of the Frontier Nursing Service.* 1952.

Breeskin, Adelyn D. *Mary Cassatt, Catalogue raisonne of the Oils, Pastels, Watercolors and Drawings.* Washington, D.C.: Smithsonian Institution, 1970.

———. *Mary Cassatt: A Catalogue Raisonne of the Graphic Works,* rev'd ed. Washington, D.C.: Smithsonian Institution, 1980.

Brennan, Shawn, ed. *Women's Information Directory.* Detroit: Gale Research, 1993.

Brinnin, John Malcolm. *The Third Rose: Gertrude Stein and Her World.* Boston: Little, Brown, 1959.

Brody, Jane E. "Personal Health. The Leading Killer of Women: Heart Disease." *New York Times,* November 10, 1993.

Bronson, Minnie, "Woman Suffrage and Child Labor Legislation . . ." New York: National Association Opposed to Woman Suffrage, 1914. Woodbridge, Conn.: Research Publications, microfilm.

Brooks, H. Allen. *The Prairie School: Frank Lloyd Wright and His Midwest Contemporaries.* New York: W. W. Norton, 1972.

Brooks, Paul. *The House of Life: Rachel Carson at Work.* Boston: Houghton Mifflin, 1972.

Brooks-Pazmany, Kathleen. *United States Women in Aviation 1919–1929.* Washington, D.C.: Smithsonian Institution, 1983.

Brown, Dorothy M. *American Women in the 1920s: Setting a Course.* Boston: Twayne Publishers, 1987.

Brown, Hallie Q. *Homespun Heroines and Other Women of Distinction.* 1926, rpt., New York: Oxford University Press, 1988.

Brown, Henry Billings. "Woman Suffrage: a paper read by ex-justice Brown . . . before the Ladies Congressional Club of Washington, D.C., April 1910." Boston: Massachusetts Association Opposed to the Further Extension of Suffrage to Women, 1910. Woodbridge, Conn.: Research Publications, microfilm.

Brownmiller, Susan. *Shirley Chisholm, A Biography.* Garden City, N.Y.: Doubleday, 1971.

———. *Against Our Will: Men, Women and Rape.* 1975. New York: Bantam, 1976.

———. *In Our Time: Memoir of a Revolution.* New York: Dial, 1999.

Bruce, H. Addington. *Women in the Making of America,* rev. ed. Boston: Little, Brown, 1928.

Bryant, Anne L. Executive Director of American Association of University Women. October 1991 letter to prospective members.

Buck, Pearl. *The Good Earth.* 1931. Reprint, Garden City, N.Y.: International Collectors Library, n.d.

———. *The Mother.* New York: The John Day Company, 1934.

———. *This Proud Heart.* New York: The John Day Company, 1938.

———. *Pavilion of Women.* New York: The John Day Company, 1946.

———. *Peony.* New York: The John Day Company, 1948.

———. *Imperial Woman.* 1956. New York: Pocket Books, 1973.

———. *Command the Morning.* 1959. New York: Pocket Books, 1960.

Buck v. Bell, 274 U.S. 200 (1927).

Buffalo News, July 9, 1995; July 29, 1998.

Bullough, Vern L., and Bonnie Bullough. *Contraception: A Guide to Birth Control Methods.* Buffalo, N.Y.: Prometheus, 1990.

Burlington Industries, Inc. v. Ellerth, 118 S. Ct. 2257 (1998).

Califano v. Goldfarb. 1973. 430 U.S. 199.

Califano v. Webster. 1977. 430 U.S. 313.

Cammermeyer, Margarethe with Chris Fisher. *Serving in Silence.* New York: Viking, 1994.

Carabillo, Toni, Judith Meuli, and June Bundy Csida. *Feminist Chronicles, 1953–1993.* Los Angeles: Women's Graphics, 1993.

Carelli, Richard. "Court Calls Job Hazard Policies Sex Bias," *San Francisco Examiner,* March 20, 1991.

Carreau, Mark. "Shuttle Puts Down in Rare Night Landing," *Houston Chronicle,* July 28, 1999.

Carson, Rachel. *Under the Sea Wind.* Boston: Houghton Mifflin, 1941.

———. *The Sea Around Us.* New York: Oxford University Press, 1951.

———. *The Edge of the Sea.* Boston: Houghton Mifflin, 1955.

———. *Silent Spring.* Boston: Houghton Mifflin, 1962.

Carter, Bill. "A Quiet Woman's Story With a Loud Message," *New York Times,* February 2, 1995.

Cary, Eve, and Kathleen Willert Peratis. *Woman and the Law.* Skokie, Ill.: National Textbook Co. in conjunction with the American Civil Liberties Union, 1977.

Cary, Richard, ed. *Sarah Orne Jewett.* New York: Twayne, 1962.

———. *Appreciation of Sarah Orne Jewett: 29 Interpretive Essays.* Waterville, Me.: Colby College Press, 1973.

Castro, Ida B. "Enforcement Guidance: Vicarious Employer Liability for Unlawful Harassment by Supervisors." Washington, D.C.: Equal Employment Opportunity Commission, 1999.

Caswell, Mary S. "Address in Opposition to Woman Suffrage." Boston: Massachusetts Association Opposed to the Further Extension of Suffrage to Women, 1913. Woodbridge, Conn.: Research Publications, microfilm.

Cather, Willa. *The Novels and Stories of Willa Cather.* (13 vols.) Boston: Houghton Mifflin, 1937–41.

———. *The Old Sleeping Beauty and Others.* New York: Knopf, 1948.

———. *On Writing.* New York: Knopf, 1949.

———. *The Kingdom of Art: Willa Cather's First Principles and Critical Statements, 1893–1896,* ed. Bernice Slote. Lincoln: University of Nebraska Press, 1966.

Catt, Carrie Chapman. Papers. Manuscript and Archives Division, New York Public Library.

———. "The Winning Policy." New York: National American Woman Suffrage Association, 1916. Microfilm.

Catt, Carrie Chapman, and Nettie Rogers Shuler. *Woman Suffrage and Politics.* New York: Scribner, 1923.

Cayleff, Susan E. *Babe: The Life and Legend of Babe Didrikson Zaharias.* Chicago: University of Illinois Press, 1995.

Chadwick, Whitney. *Women, Art and Society.* London: Thames and London, 1990.

Chafe, William Henry. *The American Woman: Her Changing Social, Economic, and Political Roles, 1920–1970.* New York: Oxford University Press, 1972; rpt. 1981.

Chambers, Clarke A. *Seedtime of Reform.* Minneapolis: University of Minnesota Press, 1963.

Cheney, Ednah Dow. *Louisa May Alcott: Her Life, Letters and Journals.* Boston: Roberts Brothers, 1889.

Chesler, Ellen. *Woman of Valor: Margaret Sanger and the Birth Control Movement in America.* New York: Simon & Schuster, 1992.

Chesler, Phyllis. *Women and Madness.* Garden City, N.Y.: Doubleday, 1972.

———. *Sacred Bond: The Legacy of Baby M.* New York: Times Books, 1988.

Chesnut, Mary. *Mary Chestnut's Civil War,* ed. C. Vann Woodward. New Haven, Conn.: Yale University Press, 1981.

Chicago, Judy. *Through the Flower: My Struggle as a Woman Artist,* intro. Anais Nin. Garden City, N.Y.: Doubleday, 1975, 1977.

———. *The Dinner Party: A Symbol of Our Heritage.* Garden City, N.Y.: Anchor, 1979.

———. *Embroidering Our Heritage: The Dinner Party Needlework.* Garden City, N.Y.: Doubleday, 1980.

———. *The Birth Project.* Garden City, N.Y.: Doubleday, 1985.

———. *Holocaust Project: From Darkness Into Light.* With Photography by Donald Woodman. New York: Penguin Books USA, 1993.

———. Lecture at Congregation Beth Elohim, Brooklyn, New York, April 25, 1994.

———. *Beyond the Flower: The Autobiography of a Feminist Artist.* New York: Viking, 1996.

Chicago Times Herald. March 19, 1898.

Chicago Tribune, March 19, 1898; October 3, 1983; May 14, 1986; January 20, 1988; April 6, 1997; May 21, August 24 and 27, 1999.

Chopin, Kate. *The Complete Works of Kate Chopin,* ed., with an introduction by Per Seyersted; foreword by Edmund Wilson. Baton Rouge: Louisiana State University Press, 1970.

———. *The Awakening: An Authoritative Text, Contexts, Criticism,* ed. Margaret Culley, New York: Norton, 1976.

Christian Science Monitor, April 9, 1969; January 25, 1972; December 23, 1998.

Chu, Jonathan M. *Neighbors, Friends, or Madmen: The Puritan Adjustment to Quakerism in Seventeenth-Century Massachusetts Bay.* Westport, Conn.: Greenwood Press, 1985.

"Citadel Plans Appeal of Ruling on Woman," *New York Times,* August 18, 1993.

Clark, Ella E., and Margot Edmonds. *Sacagawea of the Lewis and Clark Expedition,* Berkeley: University of California Press, 1980.

Clark, Judith Freeman. *Almanac of American Women in the 20th Century.* New York: Prentice-Hall Press, 1987.

Cleeland, Nancy. "Four U.S. Retailers Settle Saipan Labor Suit," *Los Angeles Times,* August 10, 1999.

Clinton, Catherine. *The Other Civil War: American Women in the Nineteenth Century.* New York: Hill and Wang, 1984.

Clinton v. Jones, 520 U.S. 681, 1997.

Clinton, William J. "Proclamation 7116—Women's Equality Day, 1998." *Weekly Compilation of Presidential Documents.* Washington, August 24, 1998. Available on-line. URL: http://www.nypl.org/branch/resources/eproquest.html.

———. "Statement on Signing the Women's Health Research and Prevention Amendments of 1998." *Weekly Compilation of Presidential Documents.* Washington, November 9, 1998. Available on-line. URL: http://www.nypl.org/branch/resources/eproquest.html.

Cloud, Stanley W. "Standing Tall: The Capital Is all Agog at New Attorney General's Outspoken Honesty," *Time* 141, no. 19 (May 10, 1993).

Cohen, Tom. "Albright Encounters Cheers, Jeers in Kosovo," *The Atlanta Journal-Constitution,* July 30, 1999.

Coles, Robert. *Dorothy Day: A Radical Devotion.* Reading, Mass.: A Merloyd Lawrence Book/Addison-Wesley Publishing, 1987.

Compion, Nardi Reed. *Ann the Word: The Life of Mother Ann Lee.* Boston: Little Brown, 1976.

Conference on the Educational and Occupational Needs of Women. Washington, D.C.: National Insitute of Education, 1980.

"Congressional Caucus for Women's Issues, 106th Congress." Available on-line. URL: http://www.house.gov./maloney/wcaucus.html.

Conn, Peter. *Pearl S. Buck: A Cultural Biography.* New York: Cambridge University Press, 1966.

Contemporary Authors. Detroit: Gale Research, published annually.

Cook, Alison. "Lone Star: Ann Richards Is that Rarest of Political Creatures—A Popular Governor. Maybe

Too Popular for Her Own Good." *New York Times Magazine*, February 7, 1993.

Cook, Blanche Wiesen. *Eleanor Roosevelt, Volume One: 1884–1933*. New York: Viking, 1992.

Cooper, Jane Roberta. *Reading Adrienne Rich: Reviews and Re-Visions, 1951–1981*. Ann Arbor: University of Michigan Press, 1984.

Corry, John. "Madeleine's War," *The American Spectator*, July 1999.

Coss, Clare, ed. *Lillian D. Wald, Progressive Activist*. New York: The Feminist Press, City University of New York, 1989.

Cott, Nancy F. *The Bonds of Womanhood: "Woman's Sphere" in New England, 1789–1835*. New Haven, Conn.: Yale University Press, 1977.

Cott, Nancy F., ed. *Root of Bitterness: Documents of the Social History of American Women*. New York: E. P. Dutton & Co., Inc., 1972.

Countryman, Vern, ed. *The Douglas Opinions*. New York: Random House, 1977.

"Country Reports on Human Rights Practices for 1997," Submitted to the Committee on Foreign Relations, U.S. Senate and the Committee on International Relations, U.S. House of Representatives by the Department of State, January 1998.

Craig v. Boren. 1976. 429 U.S. 190.

Crocker, Hannah Mather. "Observations on the real rights of women, with their appropriate duties, agreeable to Scripture, reason and common sense." Boston, Printed for the author, 1818. Woodbridge, Conn.: Research Publications, microfilm.

Cullen-DuPont, Kathryn. *Elizabeth Cady Stanton and Women's Liberty*. New York: Facts On File, 1992.

Current Biography Yearbook. New York: H. W. Wilson Company, published annually.

Cushman, Robert F. *Cases in Constitutional Law*, 6th ed. Englewood Cliffs, N.Y.: Prentice-Hall, 1984.

Daly, Mary, *Beyond God the Father: Toward a Philosophy of Women's Liberation*. Boston: Beacon Press, 1973.

Dance Magazine. October 1971; September 1972; November 1974; and June 1974.

Daniels, D. G. *Always a Sister: The Feminism of Lillian D. Wald*. New York: The Feminist Press, City University of New York, 1989.

Dannett, Sylvia G. L. *She Rode With the Generals: The True and Incredible Story of Sarah Emma Seeyle, alias Franklin Thompson*. New York: Thomas Nelson and Sons, 1960.

Dao, James. "Albany Set to Require Arrest in Domestic Violence Cases." *New York Times*, June 22, 1994.

Dash, Joan. *Summoned to Jerusalem: The Life of Henrietta Szold*. New York: Harper & Row, 1979.

"Date Rape: The Story of an Epidemic and Those Who Deny It." *Ms.*, October, 1985.

Davis, Flora. *Moving the Mountain: The Women's Movement in America Since 1960*. New York: Simon & Schuster, 1991.

Davis v. Monroe County 120 F.3d 1390, reversed and remanded.

Day, Dorothy. *The Long Loneliness*. New York: Harper, 1952.

———. *The Selected Writings of Dorothy Day*. Ed. and intr. by Robert Ellsberg. New York: Alfred A. Knopf, 1983.

Defense of Marriage Act of 1996, Public Law 104-33.

Degen, Marie Louise. *The History of the Woman's Peace Party*. Baltimore: Johns Hopkins University Press, 1939; rpt. New York: Garland, 1972.

De Mille, Agnes. *Dance to the Piper*, 1951. Reprint, New York: Da Capo Press, 1980.

———. *And Promenade Home*, 1956. Reprint: New York: Da Capo Press, Inc. 1980.

———. *America Dances*. New York: Macmillan, 1980.

———. *Martha: The Life and Work of Martha Graham*. New York: Random House, 1991.

Denker, Ellen Paul, ed. *Healing at Home: Visiting Nurse Service of New York, 1893–1993*. New York: Visiting Nurse Service of New York, 1993.

Dennett, Mary Ware. *The Real Point*. New York: National Woman Suffrage Publishing Co., 1918.

———. Letter to Alice Park, May 17, 1925. Sophia Smith Collection, Smith College.

———. *Birth Control Laws*. New York: F. H. Hitchcock, 1926.

———. *The Prosecution of Mary Ware Dennett for Obscenity*. New York: ACLU, 1929.

———. *Who's Obscene?* New York: Vanguard, 1930.

———. *The Sex Education of Children: A Book for Parents*. New York: Vanguard, 1931.

Denver Post, February 21, 1995; December 26, 1998; July 30, 1999.

Desti, Mary. *Isadora Duncan's End*. London: Victor Gollancz, 1929.

Detroit News, March 6, 1993; October 22, 1997; April 21, 1999.

Deutsch, Claudia H., "Getting Women Down to the Site," *New York Times*, March 11, 1990.

Dick, Auguste. *Emmy Noether, 1882–1935*. Boston: Birkhauser, 1981.

Dickinson, Emily. *The Complete Poems of Emily Dickinson*, ed. Thomas H. Johnson. Boston: Little, Brown and Company, 1960.

———. *Letters*, ed. Thomas H. Johnson. (3 vols.) Cambridge, Mass.: Belknap Press of Harvard University Press, 1965.

Dilberto, Gioia. *A Useful Woman: The Early Life of Jane Addams*. New York: Scribner, 1998.

Dinnon, Richard. *Rebel in Paradise: A Biography of Emma Goldman.* Chicago: University of Chicago Press, 1961.

Dix, Dorothea Lynde, *The Garland of Flora.* Boston: S. G. Goodrich and Co., and Carter and Hendee, 1829. Woodbridge, Conn.: Research Publications, microfilm.

———. *Remarks on Prisons and Prison Discipline in the United States.* Boston: Munroe & Francis, 1845. Woodbridge, Conn.: Research Publications, microfilm.

Dobbs, Michael. *Madeleine Albright: A Twentieth-Century Odyssey.* New York: Henry Holt, 1999.

Dove, Rita. *The Yellow House on the Corner,* 1980. rpt., Pittsburgh: Carnegie-Mellon University Press, 1989.

———. *Museum.* Pittsburgh: Carnegie-Mellon University Press, 1983.

———. *Fifth Sunday.* Charlottesville: University Press of Virginia, 1985.

———. *Thomas and Beulah.* Pittsburgh: Carnegie-Mellon University Press, 1986.

———. *Grace Notes.* New York: W. W. Norton & Company, 1989.

———. *Through the Ivory Gate.* New York: Vintage Books, 1992.

———. *Mother Love.* New York: W. W. Norton, 1995.

———. *The Darker Face of the Earth.* Brownsville, Ore.: Story Line Press, 1996.

———. *On the Bus With Rosa Parks.* New York: W. W. Norton, 1999

———. "The Torchbearer: Rosa Parks," *Time* magazine, June 14, 1999.

Drogin, Bob. "Albright Welcomed as Hero in Kosovo but Visit Also Includes Gunshot, Jeering Crowd," *Times-Picayune* (New Orleans), July 30, 1999.

Dublin, Thomas. *Transforming Women's Work: New England Lives in the Industrial Revolution.* New York: Cornell University, 1994.

DuBois, Ellen Carol. *Elizabeth Cady Stanton/Susan B. Anthony: Correspondence, Writings, Speeches.* New York: Schocken, 1981.

Duffus, R. L. *Lillian Wald: Neighbor and Crusader.* New York: Macmillan, 1938.

Duffy, Clinton T. with Al Hirshberg. *Sex and Crime.* New York: Doubleday, 1965.

Duncan, Irma. *Duncan Dancer: An Autobiography.* Middletown, Conn.: Wesleyan University Press, 1965.

Duncan, Isadora. *My Life.* New York: Boni and Liveright, 1927.

Dungee, Ron. "SBA Salutes Women's History Month," *Sentinel* (Los Angeles), March 19, 1998.

Duniway, Abigail Scott. *Path Breaking: An Autobiographical History of the Equal Suffrage Movement in Pacific Coast States.* Portland, Ore.: James, Kerbs & Abbot, 1914.

Dunn, Marcia. "Woman to Lead Shuttle Crew," *Detroit News,* June 25, 1999.

———. "First Female Shuttle Commander Has Already Risen Far," *The Atlanta Journal-Constitution,* July 18, 1999.

———. "And She's Off . . . !!! America's First Female Spaceflight Commander Flies Into History After Two Scrubs, Takeoff Scare," *The Atlanta Journal-Constitution,* July 23, 1999.

———. "Message from Space: 'Reach for the Stars,'" *Boston Globe,* July 25, 1999.

———. "From One Woman to Another: Ride Offers Wisdom to Female Commander," *Denver Post,* July 26, 1999.

———. "Shuttle Flight Ends in Triumph Despite Fuel Leak," *Buffalo News,* July 28, 1999.

Dwight, Eleanor. *Edith Wharton: An Extraordinary Life.* New York: Abrams, 1994.

Dworkin, Andrea. *Woman Hating.* New York: E. P. Dutton, 1974.

———. *Pornography: Men Possessing Women.* New York: Putnam, 1981.

———. *Right-Wing Women: The Politics of Domesticated Females.* New York: Putnam, 1983.

———. *Intercourse.* New York: Free Press, 1987.

———. *Mercy.* New York: Four Walls Eight Windows, 1991.

———. *Life and Death.* New York: Free Press, 1997.

Dye, Nancy Schrom. *As Equals and Sisters.* Columbia: University of Missouri Press, 1980.

Dyer, William. *Mary Dyer, Quaker. Two Letters of William Dyer of Rhode Island.* 1659–1660.

Earhart, Amelia. *Twenty Hours Forty Minutes: Our Flight in the Friendship.* New York: Putnam, 1928.

———. *The Fun of It: Random Records of My Own Flying and of Women in Aviation.* 1932. Reprint. Detroit: Gale Research, 1975.

Eastman, Crystal. *Crystal Eastman on Women and Revolution,* ed. Blanche Wiesen Cook, Chicago: Charles H. Kerr Publishing Company, 1978.

Economist, The, August 22, 1998 (U.S.); February 13, 1999 (London).

Eddy, Mary Baker. *Science and Health: With a Key to the Scriptures.* Boston: First Church of Christ, Scientist, 1975.

Edmonds, S. Emma E. *Nurse and Spy in the Union Army: Comprising the Adventures and Experiences of a Woman in Hospitals, Camps, and Battle-Fields.* Hartford, Conn.: W. S. Williams & Co., 1865.

Edwards, Julia. *Women of the World: The Great Foreign Correspondents.* New York: Ivy Books, 1989.

Ehrenreich, Barbara, and Deidre English. *For Her Own Good: 150 Years of the Experts' Advice to Women.* New York: Doubleday, 1989.

Eisenstadt v. Baird, 92 S. Ct. 1029 (1972).

Eisler, Benita, ed., *The Lowell Offering: Writings by New England Mill Women (1840–1845)*. New York: Lippincott, 1977.

Elasser, Glenn. "O'Connor Makes Mark as a Key Influence on Court," *Denver Post*, September 7, 1997.

Elie, Paul. *The Patron Saint of Paradox,"* in *The New York Times Magazine*, November 8, 1998.

Ellesberg, Robert, ed. *By Little and By Little: The Selected Writings of Dorothy Day*. New York: Knopf, 1983.

Ellet, Elizabeth F. *The Women of the American Revolution*, vol. 1. New York: Baker & Scribner, 1848; rpt. New York: Arno, 1974.

Elshtain, Jean Bethke. *Women and War*. New York: Basic Books, 1987.

Emily's List. Available on-line. URL: http://www. emilyslist.org. August 17, 1999.

Encyclopedia of World Biography. Vols. 1–18. Detroit: Gale Research, 1998.

Estrada, Richard. "How Much is Owed to Latin Japanese-Americans?" *Chicago Tribune*, March 18, 1977.

Evans, Sara M. *Born for Liberty: A History of Women in America*. New York: The Free Press, 1989.

Executive Female (May/June 1993).

Fairstein, Linda A. *Sexual Violence: Our War Against Rape*. New York: William Morrow and Company, 1993.

Faludi, Susan. *Backlash: The Undeclared War Against American Women*. New York: Crown Publishers, 1991.

Faragher v. City of Boca Raton, 524 U.S. 775 (1998).

Farrant, Margaret. *Sarah Orne Jewett*. Minneapolis: University of Minnesota Press, 1966.

Faust, Langdon Lynne, ed. *American Women Writers: A Critical Reference Guide from Colonial Times to the Present*, abridged ed. New York: Ungar, 1988.

Faux, Marian. *Roe v. Wade*. New York: Macmillan, 1988.

———. *Crusaders: Voices from the Abortion Front*. New York: Birch Lane Press, 1990.

"Female Pilots Recall Bullets," *New York Times*, February 9, 1990.

Feminist Majority. Available on-line: URL: http://www. feminist.org. August 18, 1999.

Fenichell, Stephen, and Lawrence S. Charfoos. *Daughters at Risk: A Personal DES History*. New York: Doubleday, 1981.

Ferraro, Barbara, and Patricia Hussey with Jane O'Reilly. *No Turning Back: Two Nuns' Battle with the Vatican over Women's Right to Choose*. New York: Ivy Books (Ballantine), 1990.

Ferraro, Geraldine. *Changing History: Women, Power and Politics*. Mt. Kisco, N.Y.: Moyer Bell, 1993.

Ferraro, Geraldine and Catherine Whitney. *Framing a Life: A Family Memoir*. New York: Simon & Schuster, 1998.

Ferraro, Geraldine, with Linda Bird Francke. *Ferraro: My Story*. New York: Bantam, 1985.

Fetherling, Dale. *Mother Jones: The Miners' Angel*. Carbondale: Southern University Press, 1974.

Field, Vera B. *Constantina: A Study of the Life and Works of Judith Sargent Murray*. University of Maine Studies, 2nd Ser., no. 17 (Orono, Maine, 1933).

Fineman, Irving. *Woman of Valor*. New York: Simon & Schuster, 1961.

Finley, Ruth. *The Lady of Godey's*. Philadelphia: Lippincott, 1931.

Fish, Dexter. "Zitkala Sa: The Evolution of a Writer." *American Indian Quarterly*, August 1979.

Fletcher, Robert. *History of Oberlin College*. Salem, N.H.: Ayer, 1997.

Flexner, Eleanor. *Century of Struggle: The Woman's Rights Movement in the United States*. 1959. Rev. ed. Cambridge, Mass.: The Belknap Press of Harvard University Press, 1975.

Flynn, Elizabeth Gurley. *The Rebel Girl: An Autobiography*. (first published as *I Speak My Own Piece*, 1955) Rev. ed. New York: International Publishers, 1973.

Foner, Eric, and John A. Garraty, eds. *The Reader's Companion to American History*. Boston: Houghton Mifflin, 1991.

Foner, Philip S. *Women and the American Labor Movement: From Colonial Times to the Eve of World War One*. New York: Free Press, 1979.

———. *Women and the American Labor Movement: From World War One to the Present*. New York: Free Press, 1980.

Foner, Philip S., ed. *The Factory Girls*. Chicago: University of Illinois Press, 1977.

Forest, Jim. *Love Is the Measure: A Biography of Dorothy Day*. New York: Paulist Press, 1986.

Fortune 500 Business and Professional Women's Club: *Fortune 500 Report* 1, no. 1, (February 1980).

Fort Worth Star-Telegram, September 23, 1996.

Fossey, Dian. *Gorillas in the Mist*. Boston: Houghton Mifflin, 1983.

Foster, Frances Smith. *A Brighter Coming Day: A Frances Ellen Watkins Reader*. New York: The Feminist Press, 1990.

Fowler, Robert B. *Carrie Catt: Feminist Politician*. Boston: Northeastern University Press, 1986.

Fox-Genovese, Elizabeth. *Feminism Without Illusions: A Critique of Individualism*. Chapel Hill: The University of North Carolina Press, 1991.

Francke, Linda Bird. *Ground Zero: The Gender Wars in the Military*. New York: Simon & Schuster, 1997.

Frankenthaler, Helen. *Helen Frankenthaler: Paintings*, exhibition catalog, Corcoran Gallery of Art, Washington, D.C., 1975.

Freedeman, Estelle B. *Their Sisters' Keepers: Women's Prison Reform in America, 1830–1930*. Ann Arbor: University of Michigan Press, 1981.

"French Abortion Pill Will Be Tested in U.S.," *New York Times,* March 18, 1993.

French, Marilyn. *The Woman's Room.* New York: Summit, 1977.

———. *The War Against Women.* New York: Summit Books, 1992.

Frey, Jennifer. "Dream Lives Another Day for Players' Making Mets' Cut," *New York Times,* February 2, 1995, B16.

Friedan, Betty. *The Feminine Mystique.* 1963, rpt. New York: Dell Publishing Co., 1974.

———. *It Changed My Life: Writings on the Women's Movement.* New York: Dell Publishing Co., 1977.

———. *The Second Stage.* New York: Summit Books, 1981.

———. *The Fountain of Age.* New York: Simon & Schuster, 1993.

———. *Beyond Gender: The New Politics of Work and Gender.* Baltimore: John Hopkins University Press, 1997.

———. *Life So Far.* New York: Simon & Schuster, 2000.

Frontiero v. Richardson. 1973. 411 U.S. 677.

Frost, Elizabeth, and Kathryn Cullen-DuPont. *Women's Suffrage in America: An Eyewitness History.* New York: Facts On File, 1992.

Frost-Knappman, Elizabeth, and Kathryn Cullen-DuPont. *Women's Rights on Trial: 101 Historic Trials from Anne Hutchinson to the Virginia Military Institute Cadets.* Detroit: Gale Research, 1997.

Garrow, David J. *Liberty and Sexuality: The Right to Privacy and the Making of Roe v. Wade.* New York: Macmillan, 1994.

———. "A Deadly, Dying Fringe." *New York Times* op-ed page, January 9, 1995.

Gartner, Carol B. *Rachel Carson.* New York: Frederick Ungar, 1983.

Gelhaus, Lisa. "Constitutional Challenge to VAWA Raises Ire," in *Trial* (Washington), June 1999.

Gerdts, William H. *The White Marmorean Flock: Nineteenth Century American Women Neoclassical Sculptors.* Poughkeepsie, N.Y.: Vassar College Art Gallery, 1972.

Gibbs, Nancy. "How to Revive a Revolution: From Two Vantages Comes a Shared View About Bucking the Backlash." *Time* magazine, March 9, 1992.

———. "The War Against Feminism." *Time* 139, no. 10 (March 9, 1992).

———. "Truth, Justice and the Reno Way." *Time* 142, no. 2 (July 12, 1993).

Gifis, Steven H. *Law Dictionary,* 3rd ed. New York: Barron's Education Series, 1991.

Gilbert, Sandra M., and Susan Gubar, eds. *The Norton Anthology of Literature by Women.* New York: W. W. Norton & Company, 1985.

Gilligan, Carol. *In a Different Voice: Essays on Psychological Theory and Women's Development.* Cambridge, Mass.: Harvard University Press, 1982.

Gilligan, Carol, with Lyn Mikel Brown. *Meeting at the Crossroads: Women's Psychology and Girls' Development.* Cambridge, Mass.: Harvard University Press, 1992.

Gilligan, Carol, with Nona P. Lyons and Trudy J. Hanmer. *Making Connections: The Relational Worlds of Adolescent Girls at Emma Willard School.* Cambridge, Mass.: Harvard University Press, 1991.

Gilligan, Carol, with Janie Victoria Ward, Jill McLean Taylor, and Betty Bardige. *Mapping the Moral Domain: A Contribution of Women's Thinking to Psychological Theory and Education.* Cambridge, Mass.: Harvard University Press, 1989.

Gilman, Charlotte Perkins. *Women & Economics: The Economic Factor Between Men and Women as a Factor in Social Evolution,* ed. Carl Degler. Boston: Small, Maybard & Company, 1898. Rpt. New York: Harper & Row, 1966.

———. *Concerning Children.* Boston: Small, Maynard & Co., 1901. Woodbridge, Conn.: Research Publications, microfilm.

———. *The Home; Its Work and Influence.* New York: McClure, Phillips & Co., 1903. Woodbridge, Conn.: Research Publications, microfilm.

———. *Human Work.* New York: McClure, Phillips & Co., 1904. Woodbridge, Conn.: Research Publications, microfilm.

———. *The Man-Made World; or, Our Androcentric Culture.* New York: Charlton Co., 1911. Woodbridge, Conn.: Research Publications, microfilm.

———. *Herland.* 1915. Rpt., New York: Pantheon, 1979.

———. *His Religion and Hers: The Faith of Our Fathers and the Work of Our Mothers.* New York: Appleton-Century, 1923.

———. *The Living of Charlotte Perkins Gilman.* New York: Appleton-Century, 1935.

———. *The Yellow Wallpaper and Other Writings by Charlotte Perkins Gilman.* With an introduction by Lynne Sharon Schwartz. New York: Bantam, 1989.

Glazer, Randi. "Women's Hall of Fame Adds 35," *Her New York,* October 8, 1993.

Glimcher, Arnold. *Louise Nevelson.* New York: Dutton, 1979.

Godey's Lady's Book On-line." Available on-line. URL: http://www.history.rochester.edu/godeys. August 25, 1999.

Goerner, Fred. *The Search for Amelia Earhart: A Biography.* Garden City, N.Y.: Doubleday, 1966.

Goesaert v. Cleary. 1948. 335 U.S. 464.

Goldman, Emma. *Anarchism and Other Essays.* New York: Mother Earth Publishing Association, 3rd rev. ed., 1917. Woodbridge, Conn.: Research Publications, microfilm.

————. *My Disillusionment in Russia.* 1922. Rpt., New York: Thomas Y. Crowell, 1970.

————. *Living My Life.* (2 vols.) New York: Alfred A. Knopf, 1931. Rpt., New York: Dover Publications, 1970.

————. *The Traffic in Women and Other Essays on Feminism,* with a biography by Alix Kates Shulman. Albion, Calif.: Times Change Press, 1970.

Goldmark, Josephine. *Impatient Crusader: Florence Kelley's Life Story.* Urbana, University of Illinois Press, 1953.

Goldsmith, Barbara. *Other Powers: The Age of Suffrage, Spiritualism, & the Scandalous Victoria Woodhull.* New York: Alfred A. Knopf, 1998.

Goldstein, Leslie Friedman. *The Constitutional Rights of Women: Cases in Law and Social Change.* 1979. New ed., updated and revised. Madison: University of Wisconsin Press, 1989.

Goldstein, Michael. "Few Leagues of Their Own," *Business Week,* January 18, 1999.

Goodwin, Doris Kearns. *No Ordinary Time. Franklin and Eleanor Roosevelt: The Home Front in World War II.* New York: Simon & Schuster, 1994.

Gordon, Barbara. "Will She Be a Force for Change? Attorney General Janet Reno Talks About Children, Crime Prevention and Politics," *Parade: The Sunday Newspaper Magazine,* May 2, 1993.

Gordon, Linda. *Woman's Body, Woman's Right: A Social History of Birth Control in America.* New York: Grossman, 1976.

Gragg, Larry. "Under an Evil Hand." *American History Illustrated* (March–April 1992).

Graham, Martha. *Blood Memory: An Autobiography.* New York: Doubleday, 1991.

Graham, Shirley. "Spirituals to Symphonies." *Etude* (November 1936).

Greenhouse, Linda. "Surprising Decision: Majority Issues Warning on White House Effort to Overrun Roe," *New York Times,* June 30, 1992.

————. "A Telling Court Opinion," *New York Times,* July 1, 1992.

————. "Supreme Court Roundup: Justices to Rule if Racketeering Law Protects Abortion Clinics From Protests," *New York Times,* June 15, 1993.

————. "Court, 9-0, Makes Sex Harassment Easier to Prove: A Standard Is Set," *New York Times,* November 10, 1993.

Gregorich, Barbara. *Women at Play: The Story of Women in Baseball.* New York: Harcourt Brace & Company, 1993.

Grew, Mary. *Diary, 1840.* Woodbridge, Conn.: Research Publications, microfilm.

Griffith, Elisabeth. *In Her Own Right: The Life of Elizabeth Cady Stanton.* New York: Oxford University Press, 1984.

Grimes, William. "Toni Morrison is '93 Winner of Nobel Prize in Literature." *New York Times,* October 8, 1993.

Grimké, Angelina Emily. *Appeal to the Christian Women of the South,* rev. and cor. New York, 1836. Woodbridge, Conn.: Research Publications, microfilm.

————. *Letters to Catharine E. Beecher in Reply to an Essay on Slavery and Abolitionism, Addressed to A. E. Grimké.* Rev. by the author. Boston: Printed by I. Knapp, 1838. Woodbridge, Conn.: Research Publications, microfilm.

————. *Letter from Angelina Grimké Weld, to the Woman's Rights Convention, held at Syracuse, Sept., 1852.* Syracuse: Masters' print, 1852[?]. Woodbridge, Conn.: Research Publications, microfilm.

Grimké, Sarah Moore. *An Epistle to the Clergy of the Southern States.* New York, 1836. Woodbridge, Conn.: Research Publications, microfilm.

Griswold v. Connecticut, 85 S. Ct. 1678 (1965).

Guardian, The (Manchester, England), April 24, 1999.

Guernsey, Alfred H., and Henry M. Adlen, eds. *Harpers Pictorial History of the Civil War.* New York: Fairfax Press, 1866.

Gula, Kasha Linville. "Eva Hesse: No Explanation." *Ms.* magazine (April 1973).

Hadas, Pamela W. *Letters on the Equality of the Sexes and the Condition of Women, Addressed to Mary S. Parker, President of the Boston Female Anti-Slavery Society.* Boston: I. Knapp, 1838. Woodbridge, Conn.: Research Publications, microfilm.

————. *Marianne Moore: Poet of Affection.* Syracuse, N.Y.: Syracuse University Press, 1977.

Hale, Nancy. *Mary Cassatt.* Garden City, N.Y. Doubleday, 1975.

Hale, Sarah Josepha. *The Good Housekeeper; or, the Way to Live Well and be Well While We Live.* Boston: Weeks, Jordan, 1839. Woodbridge, Conn.: Research Publications, microfilm.

————. *Boarding Out: A Tale of Domestic Life.* New York: Harper & Brothers, 1855. Woodbridge, Conn.: Research Publications, microfilm.

————. *Woman's Record; or, Sketches of all Distinguished Women From the Creation to A.D. 1854.* Second ed., revised. New York: Harper & Brothers, Publishers, 1855. Woodbridge, Conn.: Research Publications, microfilm.

Hall, Donald. *Marianne Moore: The Animal and the Cage.* Winter Park, Fla.: Pegasus, 1970.

Hall, Jacqueline Dowd. *Revolt Against Chivalry: Jesse Daniel Ames and the Women's Campaign Against Lynching.* New York: Columbia University Press, 1979.

Hall, Mary Harrington. "An American Mother and the Nobel Prize—A Cinderella Story in Science." *McCall's* (July 1964).

Hansen, Chadwick. *Witchcraft at Salem*. New York: George Braziller, 1969.

Hardesty, Von and Dominick Pisano. *Black Wings: The American Black in Aviation*. Washington, D.C.: National Air and Space Museum, 1984.

Harlan, Louis B. *Booker T. Washington: The Making of a Black Leader* (2 vols.). New York: Oxford University Press, 1972, 1984.

Harper, Frances Ellen Watkins. *Sketches of Southern Life*. Philadelphia: Ferguson Bros. & Co., 1893. Woodbridge, Conn.: Research Publications, microfilm.

Harper, Ida Husted. *The Life and Work of Susan B. Anthony*, vols. 1–3. Indianapolis: Hollenbeck Press, 1898. rpt. Salem, N.H.: Ayer Company, Publishers, 1983.

Harper, Ida Husted, ed. *History of Woman Suffrage*, vols. 5 and 6, 1922, rpt. Salem, N.H.: Ayer, 1985.

Harris, Ann Sutherland, and Linda Nochlin. *Women Artists: 1550–1950*. New York: Alfred A. Knopf, 1989.

Harris v. Forklift Systems, Inc. 510 U.S. 17 (1993).

Hartmann, Susan M. *American Women in the 1940s: The Home Front and Beyond*. Boston: Twayne Publishers, 1982.

Haskins, James. *Fighting Shirley Chisholm*. New York: Dial, 1975.

Hays, Eleanor Rice. *Morning Star: A Biography of Lucy Stone, 1810–1893*. New York: Harcourt, Brace & World, 1961.

Heartney, Eleanor. *Distillations of Landscape: The Sculptures of Maya Lin,"* Art in America, September 1998.

Hedrick, Joan D. *Harriet Beecher Stowe: A Life*. New York: Oxford University Press, 1994.

Hellman, Lillian. *An Unfinished Woman*. Boston: Little, Brown, 1969.

———. *Collected Plays*. Boston: Little, Brown, 1972.

———. *Pentimento: A Book of Portraits*. Boston: Little, Brown, 1973.

———. *Scoundrel Time*. Boston: Little, Brown, 1976.

———. *Maybe*. Boston: Little, Brown, 1980.

Hemenway, Robert. *Zora Neale Hurston: A Literary Biography*. Foreword by Alice Walker. Urbana: University of Illinois Press, 1977.

Henig, Robin Marantz. "Are Women's Hearts Different?" *New York Times Magazine*, October 3, 1993.

"Her Own Woman." *Time* 109 (January 3, 1977).

Hicks, Nancy. *The Honorable Shirley Chisholm: Congresswoman From Brooklyn*. New York: Lion Books, 1971.

Hilts, Philip J. "AIDS Definition Excludes Women, Congress Is Told." *New York Times*, June 7, 1991.

———. "When Medical Reliability Adds Political Sensitivity." *New York Times*, May 17, 1994.

Hochschild, Arlie, with Anne Machung. *The Second Shift*. New York: Avon Books, 1989.

Hoffman, Jan, "Plaintiffs' Lawyers Applaud Decision," *New York Times*, November 10, 1993.

Hoffman, Mark S., ed. *The World Almanac and Book of Facts: 1992*. New York: Pharos Books, 1991.

Hole, Judith and Ellen Levine. *Rebirth of Feminism*. New York: Quadrangle/The New York Times Book Co., 1971.

Holt, Rackham. *Mary McLeod Bethune: A Biography*. Garden City, N.Y.: Doubleday, 1964.

Hooker, Isabella Beecher. *Womanhood: Its Sanctities and Fidelities*. Boston: Lee and Shepard, 1874. Woodbridge, Conn.: Research Publications, microfilm.

———. *The Constitutional Rights of the Women of the United States*. An address before the International Council of Women, Washington, D.C., March 30, 1888. Washington D.C.[?]: Fowler & Miller Co., c. 1888. Woodbridge, Conn.: Research Publications, microfilm.

Horney, Karen. *The Neurotic Personality of Our Time*. New York: Norton, 1937.

———. *New Ways in Psychoanalysis*. New York: Norton, 1939.

———. *Our Inner Conflicts: A Constructive Theory of Neurosis*. New York: Norton, 1945.

Horowitz, Helen Lefkowitz. *Alma Mater: Design and Experience in the Women's Colleges from their Nineteenth Century Beginnings to the 1930s*. New York: Knopf, 1984.

Hosmer, Harriet. *Letters and Memories*, ed. Cornelia Carr. New York: Moffat, Yard, 1912.

Houppert, Karen. "Feminism in Your Face: The Women's Action Coalition Confronts Sexism in the Media, the Courts, and on the Streets," *Village Voice*, June 9, 1992.

Houston Chronicle, October 12, 1995; July 19, 1998; October 12, 1998; December 2, 1998; January 3, 15, and 23, 1999.

Howard, Jane. *Margaret Mead: A Life*. New York: Simon & Schuster, 1984.

Howe, Julia Ward. *Margaret Fuller*. Boston, Roberts Brothers, 1883. Woodbridge, Conn.: Research Publications, microfilm.

———. *Reminiscences, 1819–1899*. Boston: Houghton, Mifflin and Co., 1899. Woodbridge, Conn.: Research Publications, microfilm.

———. *Mrs. Howe on Equal Rights . . . An Address . . . at the 38th Annual Convention of the National American Woman Suffrage Association, at Baltimore, Md., February 12, 1906* [n.p., n.d.] Woodbridge, Conn.: Research Publications, microfilm.

———. *Woman and the Suffrage,* [n.p., c. 1909]. Woodbridge, Conn.: Research Publications, microfilm.

————. *Julia Ward Howe and the Woman Suffrage Movement; a Selection from Her Speeches, and Essays, with introduction and notes by her daughter, Florence Howe Hall.* Boston: D. Estes & Co., 1913. Woodbridge, Conn.: Research Publications, microfilm.

Hoyt v. Florida. 1961. 368 U.S. 57.

Huerta, Dolores. "The 21st Century Party Holds Founding Meetings," *National NOW Times,* August 1992.

Hughes, Rupert. *Music Lovers' Encyclopedia.* 1903. Revised by Taylor, Deems and Russell Kerr. New York: Doubleday & Company, 1954.

Hurston, Zora Neale. *Their Eyes Were Watching God.* Foreword by Sherley Ane Williams. Urbana: University of Illinois Press, 1978.

————. *I Love Myself When I'm Laughing . . . and then again When I'm Looking Mean and Impressive: A Zora Neale Hurston Reader,* ed. Alice Walker. New York: Feminist Press, 1979.

Huxtable, Ada Louise. *Will They Ever Finish Bruckner Boulevard?* New York: Macmillan, 1970.

————. *The Tall Building Artistically Reconsidered: The Search for a Skyscraper Style.* New York: Pantheon, 1984.

————. *Goodbye History, Hello Hamburger: An Anthology of Architectural Delights and Disasters.* Foreword by John B. Oakes. Washington, D.C.: Preservation Press, 1986.

————. *The Unreal America: Architecture and Illusion.* New York: Free Press, 1997.

Ingrassia, Michele, and Melinda Beck, with reporting by Ginny Carroll, Nina Archer Biddle, Karen Springen, Patrick Rogers, John McCormick, Jeanne Gordon, Allison Samuels and Mary Hager. "Patterns of Abuse." *Newsweek,* July 4, 1994.

International Alliance of Women, Constitution. Resolution adopted at London Convention, April 26th to May 1st inclusive, 1909. Woodbridge, Conn.: Research Publications, microfilm.

International Congress for Women. London, 1899. "The International Congress of Women of 1899," ed. Countess of Aberdeen. London: T. F. Unwin, 1900. Woodbridge, Conn.: Research Publications, microfilm.

————. "Report of the International Congress of Women held in Toronto, Canada, June 24–30, 1909." Toronto: G. Parker & Sons, 1910. Woodbridge, Conn.: Research Publications, microfilm.

————. "What is the International Council of Women?" and other questions. With answers by its president. Berlin: Langenscheidtsche Buchdruckerei, 1912. Woodbridge, Conn.: Research Publications, microfilm.

Irwin, Inez Hayes. *The Story of Alice Paul and the National Woman's Party.* Fairfax, Va.: Denlinger's Publishers, 1964.

Isaacson, Walter. "Madeleine's War," *Time,* May 17, 1999.

Jackson, Robert. "Patsy Mink Holds Many Political Firsts," *Rocky Mountain News,* May 12, 1997.

Jacob, H. E. *The World of Emma Lazarus.* New York: Schocken, 1949.

James, Edward T., Janet Wilson James, and Paul S. Boyer, eds. *Notable American Women 1607–1950: A Biographical Dictionary.* Cambridge, Mass.: The Belknap Press of Harvard University Press, 1971.

James, Janet W., ed. *Women in American Religion.* Philadelphia: University of Pennsylvania Press, 1980.

Janofsky, Michael. "V.M.I.'s Partner in Leadership Training for Women." *New York Times,* February 1, 1995.

Jaworski, Leon. *The Right and the Power: The Prosecution of Watergate.* 1976. New York: Pocket Books, 1977.

Jennings, Samuel K. *The Married Lady's Companion, or Poor Man's Friend,* rev. 2nd ed. New York: Lorenzo Dow, 1808.

Jewett, Sarah Orne. *A Country Doctor.* Boston, Houghton Mifflin, 1884.

————. *The Country of the Pointed Firs.* Boston: Houghton Mifflin, 1896.

Johnson Kirk. "Politics' Old-Girl Network State: Connecticut Has Long Tradition of Female Political Success." *New York Times,* March 8, 1993.

Johnson v. Transportation Agency. 1987. 197 S. Ct. 1442.

Johnson, William O., and Nancy P. Williamson. *"Whatta-Gal": The Babe Didrikson Story.* Boston: Little, Brown & Company, 1975.

Jones, Mary Harris. *The Autobiography of Mother Jones.* Chicago: Charles Kerr, 1925.

————. *Mother Jones Speaks: Collected Writings and Speeches,* Philip S. Foner, ed. New York: Anchor Foundation, 1983.

Jones, Wanda K., et al. "Female Genital Mutilation/Female Circumcision: Who Is at Risk in the U.S.?" *Public Health Reports,* U.S. Department of Health and Human Services, September 19, 1997.

Jordan, Barbara. Letter, 1993, to potential supporters of the Teaching Tolerance Project.

Juhaza, Suzanne. *Feminist Critics Read Emily Dickinson.* Bloomington: Indiana University Press, 1983.

————. *The Undiscovered Continent: Emily Dickinson and the Space of the Mind.* Bloomington: Indiana University Press, 1983.

Kaiser, Charles. "Women of the Year: Twenty-four New Congresswomen Prepare to Take on Washington." *Vogue* (February 1993).

Kaledin, Eugenia. *American Women in the 1950s: Mothers and More.* Boston: Twayne Publishers, 1984.

Kantrowitz, Barbara, and Pat Wingert. "The Norplant Debate: In Baltimore and a Dozen States, a Birth-Control Device Raises a Hard Issue: Should Poor Women Be Urged—or Forced—Not to Have More Kids?" *Newsweek,* February 15, 1993.

Kaplan, Laura. *The Story of Jane: The Legendary Underground Feminist Abortion Service.* Chicago: University of Chicago Press, 1995.

Karlsen, Carol. *The Devil in the Shape of a Woman: Witchcraft in Colonial New England.* New York: W. W. Norton, 1987.

Keller, Evelyn Fox. *A Feeling for the Organism: The Life and Work of Barbara McClintock.* San Francisco: W. H. Freeman & Company, 1983.

Keller, Helen. "Optimism, an essay." New York: T. Y. Crowell, 1903.

———. *The Story of My Life, with her letters.* New York: Doubleday, 1903.

———. *The World I Live in.* New York: Century, c. 1909.

———. "The Modern Woman." (Printed in the Congressional Record, September 17, 1913). Washington, 1913.

Kelley, Florence. *Some Ethical Gains through Legislation.* New York: Macmillan, 1905.

———. "Women in Trade Unions." New York: [np], 1906.

———. "Woman Suffrage: Its Relation to Working Women and Children." Warren, Ohio: [np], 1906.

———. "Twenty-five Years of the Consumers' League Movement." 1915. Woodbridge, Conn.: Research Publications, 1983. microfilm.

———. "What Women Might Do with the Ballot. The Abolition of Child Labor." New York: National American Woman Suffrage Association, 1915.

———. "Women in Industry; the eight hour day and rest at night, upheld by the United States Supreme Court." New York: National Consumers League, 1916.

———. "Wage Earning Women in War Time; the Textile Industry." New York: National Consumers League, 1919.

Kendall, Phoebe. *Maria Mitchell: Her Life, Letters, and Journals.* Boston: Lee & Shepard, 1896.

Kennedy, David. *Birth Control in America: The Career of Margaret Sanger.* New Haven, Conn.: Yale University Press, 1970.

Kent, Lelitia. "Winner Woman!" *Vogue* (January 1978).

Kerber, Linda K. *Women of the Republic: Intellect and Ideology in Revolutionary America.* Chapel Hill: University of North Carolina Press, 1980.

Kerber, Linda K., and Jane DeHart Mathews, eds., *Women's America: Refocusing the Past.* New York: Oxford University Press, 1982.

Kessler-Harris, Alice. *Out to Work: A History of Wage-Earning Women in the United States.* New York: Oxford University Press, 1982.

Keyes, Claire. *The Aesthetics of Power: The Poetry of Adrienne Rich.* Athens: University of Georgia Press, 1986.

Kilborn, Peter T. "Labor Dept. Wants to Take on Job Bias in the Executive Suite." *New York Times,* July 30, 1990.

———. "Putting Up Office Tower, Women Break Sex Barrier," *New York Times,* August 25, 1990.

King, M. L., Jr. *Stride Toward Freedom: The Montgomery Story.* New York: Harper, 1958.

Kingston, Maxine Hong. *The Woman Warrior: Memoirs of a Girlhood Among Ghosts.* New York: Knopf, 1976.

———. *China Men.* New York: Knopf, 1980.

———. *Tripmaster Monkey: His Fake Book.* New York: Knopf, 1989.

Kirchberg v. Feenstra. 1981. 450 U.S. 455.

Kirkpatrick, Jeane J. *The New Presidential Elite: Men and Women in National Politics.* New York: Russell Sage Foundation, 1976.

———. *Dismantling the Parties: Reflections on Party Reform and Party Decomposition.* Washington, D.C.: American Enterprise Institute, 1978.

Kistner, Robert W. *The Pill: Facts and Fallacies About Today's Oral Contraceptives.* 1969. New York: Dell Publishing, 1970.

Klein, Ethel. *Gender Politics: From Consciousness to Mass Politics.* Cambridge, Mass.: Harvard University Press, 1984.

Knappman, Edward, ed. *Great American Trials.* Detroit: Gale Research, 1993.

Knowlton, Charles. *Fruits of Philosophy, or, the Private Companion of Young Married People.* Reprinted from the American ed. 2d ed. London, J. Watson [18—], Woodbridge, Conn.: Research Publications, microfilm.

Kolata, Gina. "Study Finds Bias in Way Women Are Evaluated for Heart Bypasses." *New York Times,* April 16, 1990.

———. "Studies Say Women Fail to Receive Equal Treatment for Heart Disease." *New York Times,* July 25, 1991.

Korb, Lawrence J. "A Woman's Place Is in the Pentagon." *New York Times,* Op-Ed page, August 9, 1993.

Kraditor, Aileen S. *The Ideas of the Woman Suffrage Movement, 1890–1920.* New York: Norton, 1981.

Kunin, Madeline. *Living a Political Life: One of America's First Woman Governors Tells Her Story.* New York: Alfred A. Knopf, 1994.

Lader, Lawrence. *The Margaret Sanger Story and the Fight for Birth Control.* Garden City, N.Y.: Doubleday, 1955.

Lange, Dorothea. Farm Security Administration photographs, Library of Congress.

Langway, Lynn, and Rich Thomas. "The Cabinet: First Lady of Commerce." *Newsweek* 89 (February 7, 1977).

Lanker, Brian. *I Dream a World: Portraits of Black Women Who Changed America*. New York: Stewart, Tabori & Chang, 1989.

Larcom, Lucy. *A New England Girlhood*. Boston: Northeastern University Press, 1986; first published, 1889.

Lash, Joseph P. *Eleanor and Franklin*. New York: Norton, 1971.

———. *Eleanor: The Years Alone*. New York: Norton, 1972.

———. *Love, Eleanor Roosevelt and Her Friends*. Garden City, N.Y.: Doubleday, 1982.

Lasser, Carol, and Marlene Deahl Merrill, eds. *Friends and Sisters: Letters between Lucy Stone and Antoinette Brown Blackwell, 1846–93*. Urbana: University of Illinois Press, 1987.

Lear, Linda. *Rachel Carson: Witness for Nature*. New York: Henry Holt & Company, 1997.

Leary, Warren E. "Female Condom Approved for Market." *New York Times,* May 11, 1993.

———. "Maker of Abortion Pill Reaches Licensing Pact With U.S. Group," *New York Times,* May 25, 1993.

———. "Broader Uses Seen for Abortion Pill," *New York Times,* September 9, 1993.

———. "Study of Women's Health Criticized by Review Panel." *New York Times,* November 23, 1993.

Lee, Hermione. *Willa Cather: Double Lives*. New York: Vintage Books, 1989.

Legal Information Institute. "U.S. Supreme Court, 1998–1999." *Supreme Court Collection*. Available on-line. URL: http://supct.law.cornell.edu/supct. August 25, 1999.

Lemons, J. Stanley. War Relocation Authority photographs, National Archives.

———. *The Woman Citizen*. Urbana: University of Illinois Press, 1973.

Leonard, Eugene Andruss, Sophia Drinker, and Miriam Young Holden. *The American Woman in Colonial and Revolutionary Times, 1765–1800*. Philadelphia: University of Pennsylvania Press, 1962.

Lerner, Gerda. *The Grimké Sisters from South Carolina: Pioneers for Woman's Rights and Abolition*. New York: Schocken Books, 1967.

Lewin, Tamar. "Plans for Abortion Pill Stalled in U.S." *New York Times,* October 17, 1993.

———. "Courts Struggle Over How Much Force It Takes to Be a Rape," *New York Times,* June 3, 1994.

Lewis, Neil A. "Rejected as a Clerk, Chosen as a Justice." *New York Times,* June 15, 1993.

———. "High Court Nominee Is Rated Highly by the Bar Association." July 14, 1993.

Lewis, R. W. B. *Edith Wharton*. New York: Harper & Row, 1975.

Lewis, Ted. "Flood of Talent Buoys WNBA's Third Season," *Times-Picayune* (New Orleans), June 10, 1999.

Lifton, Robert Jay, ed. *The Woman in America*. Boston: Beacon Press, 1964.

Liliuokalani. *Hawaii's Story, by Hawaii's Queen, Liliuokalani*. Boston: Lee and Shepard, 1898. Woodbridge, Conn.: Research Publications, microfilm.

Lindlaw, Scott. "Gore Attacks Online Stalking: Justice Department Report Calls for Updated State, Federal Laws," *The Washington Post,* September 17, 1999.

Lisle, Laurie. *Portrait of an Artist: A Biography of Georgia O'Keeffe*. Albuquerque: University of New Mexico Press, 1986.

Livermore, Mary. *My Story of the War: A Woman's Narrative or Four Years Personal Experience as Nurse in the Union Army, and in Relief Work at Home, in Hospitals, Camps, and at the Front . . . 1887. Rpt., Williamstown, Mass.: Corner House Publishes, 1978.

Loder, David E. and Lisa W. Clark. "In Gestational Surrogacies, All Parties Bear Risk." *Trial,* August 1997.

Logan, Mary Simmerson. *The Part Taken by Women in American History*. 1912. Rpt., New York: Arno, 1972.

Los Angeles Department of Water v. Marie Manhart, 98 S. Ct. 1370 (1978).

Los Angeles Times, July 24, 1977; April 11 and 30, 1996; July 11, 1997; January 30, 1998; March 5, 1999; June 22, 1999.

Lovejoy, Esther Pohl. *Certain Samaritans,* 2nd ed. New York: Macmillan, 1933.

Lunardini, Christine A. *From Equal Suffrage to Equal Rights: Alice Paul and the National Woman's Party, 1910–1928*. New York: New York University Press, 1986.

Lyall, Sarah. "Book Notes: Rediscovered Novels [Frances Ellen Watkins Harper]." *New York Times,* February 2, 1994.

Lynn, Naomi B., ed. *Women, Politics and the Constitution*. New York: Haworth Press, 1990.

McCandless, Byron. *The Story of the American Flag."* National Geographic Magazine (October 1917).

McCorvey, Norma with Andy Meisler. *I am ROE: My Life, Roe v. Wade, and Freedom of Choice*. New York: HarperCollins, 1994.

MacDougall, Allan Ross. *Isadora: A Revolutionary in Art and Love*. New York: Thomas Nelson & Sons, 1960.

McHenry, Robert, ed. *Famous American Women: A Biographical Dictionary from Colonial Times to the Present*. New York: Dover Publications, 1980, rpt. 1983.

McKelvey, Blake. *American Prisons: A History of Good Intentions*. Montclair, N.J.: Patterson Smith, 1977.

MacKinnon, Catharine A. *Sexual Harassment of Working Women*. New Haven, Conn.: Yale University Press, 1979.

———. *Feminism Unmodified: A Discourse on Life and Law*. Cambridge, Mass.: Harvard University Press, 1987.

———. *Toward a Feminist Theory of the State*. Cambridge, Mass.: Harvard University Press, 1989.

———. *Only Words*. Cambridge, Mass.: Harvard University Press, 1993.

MacKinnon, Catharine A. and Andrea Dworkin. *In Harm's Way: The Pornography Civil Rights Hearings*. Cambridge, Mass.: Harvard University Press, 1998.

McLarin, Kimberly L. "An Outsider Wins Office: Christine Todd Whitman." *New York Times,* November 3, 1993.

Magriel, Paul, ed. *Isadora Duncan*. New York: Henry Holt & Co., 1947.

Malcolm, Ellen, letter to prospective contributors to Emily's List, March 18, 1994.

Malcolm, Janet. *The Silent Woman: Sylvia Plath & Ted Hughes*. New York: Knopf, 1994.

"Male Bastion Finding Fewer Good Men," *New York Times,* October 20, 1993.

Manegold, Catherine S. "Appeals Panel Hears Case on Citadel's Ban on Women," *New York Times,* January 31, 1995.

Mankiller, Wilma and Michael Wallis. *Mankiller: A Chief and Her People*. New York: St. Martin's Press, 1993.

Mansbridge, Jane J. *Why We Lost the ERA*. Chicago: University of Chicago Press, 1986.

Margolick, David. "Trial by Adversity Shapes Jurist's Outlook: Ruth Ginsburg, Her Life and Her Law." *New York Times,* June 25, 1993.

Margolis-Mezvinsky, Marjorie. *A Woman's Place: The Women Who Changed the Face of Congress*. New York: Crown, 1994.

Marshall, Carolyn, "An Excuse for Workplace Hazard," *The Nation,* April 25, 1987.

Martin, George. *Madam Secretary: Frances Perkins*. Boston: Houghton Mifflin, 1976.

Martin, Wendy. *An American Triptych: Anne Bradstreet, Emily Dickinson, and Adrienne Rich*. Chapel Hill: University of North Carolina Press, 1984.

Marzolf, Marion. *Up From the Footnote: A History of Women Journalists*. New York: Hastings House, 1977.

Mathis, Nancy. "President Signs GOP Bill on Gay Marriages," *Houston Chronicle,* September 22, 1996.

Matter of Baby M, 537 A.2d 1127 (NJ) 1988.

Matthews, Nancy Mowell. *Mary Cassatt: A Life*. New York: Villard Books, 1994.

Matthieson, F. O. *Sarah Orne Jewett*. Boston: Houghton Mifflin, 1920.

May, Antoinette. *Witness to War: A Biography of Marguerite Higgins*. New York: Beaufort Books, 1983.

May, John R. *The Pruning Word: The Parables of Flannery O'Connor*. Baton Rouge: Louisiana State University Press, 1976.

Maya Lin: A Strong Clear Vision. Dir. Freida Lee Mock. Video recording, 1997.

Mayer, Jane and Jill Abramson. *Strange Justice: The Selling of Clarence Thomas*. Boston: Houghton Mifflin, 1994.

Mead, Margaret. *Coming of Age in Samoa*. 1928. Rpt., New York: William Morrow, 1971.

———. *Sex and Temperament in Three Primitive Societies*. 1935. Rpt., New York: William Morrow, 1963.

———. *Male & Female: A Study of the Sexes in a Changing World*. 1949. Rpt., New York: William Morrow, 1975.

———. "Ruth Fulton Benedict, 1887–1948," *American Anthropologist* 51 (1949).

———. *An Anthropologist at Work: The Writings of Ruth Benedict*. 1966, rpt., Westport, Conn: Greenwood, 1977.

———. *Blackberry Winter*. New York: Washington Square Press, 1972.

Mellow, James R. *Charmed Circle: Gertrude Stein and Company*. New York: Praeger, 1974.

Meltzer, Milton. *Dorothea Lange: A Photographer's Life*. New York: Farrar, Straus & Giroux, 1978.

Meritor Savings Bank, FSB v. Vinson. 1986. 196. S. Ct. 2399.

Meroney, John. "The Real Maya Angelou," in *The American Spectator,* March 1993.

Merriam, Eve. *Emma Lazarus: Woman with a Torch*. New York: Citadel, 1956.

Milkman, Ruth, ed. *Women, Work & Protest: A Century of U.S. Women's Labor History*. Boston: Routledge & Kegan Paul, 1985.

Miller, Brett C. *Elizabeth Bishop: Life and the Memory of It*. Berkeley: University of California Press, 1993.

Miller, Greg. "Man Pleads Guilty to Using Net to Solicit Rape," *Los Angeles Times,* April 29, 1999.

Miller, Greg and Davan Maharaj, "Chilling Cyber-Stalking Case Illustrates New Breed of Crime," *Los Angeles Times,* January 23, 1999.

Miller, Jay, ed. *Mourning Dove: A Salishaw Autobiography*. Lincoln: University of Nebraska Press, 1990.

Miller, William. *A Harsh and Dreadful Love: Dorothy Day and the Catholic Worker Movement*. Garden City, N.Y.: Doubleday, 1974.

———. *Dorothy Day: A Biography*. San Francisco: Harper & Row, 1982.

Millet, Kate. *Sexual Politics.* New York: Doubleday, 1970.

Miniclier, Kit. "Homesteader's Story Told in Women's History Month," *Denver Post,* March 20, 1999.

Minor v. Happersett, 88 U.S. 162 (1875).

Mississippi University for Women v. Hogan. 1982. 458 U.S. 718.

Molotsky, Irwin. "Rita Dove Named Next Poet Laureate; First Black in Post." *New York Times,* May 19, 1993.

Money 22, no. 6 (June 1993).

Moore, Frank. *Women of the War.* Hartford, Conn.: S. S. Scranton & Co., 1866.

Morgan, Edmund S. *The Puritan Dilemma: The Story of John Winthrop.* Boston: Little, Brown, 1958.

Morgan, Robin, ed. *Sisterhood Is Powerful: An Anthology of Writings from the Women's Liberation Movement.* New York: Vintage, 1970.

———. *Lady of the Beasts.* New York: Random House, 1976.

———. *Monster: Poems.* New York: Random House, 1976.

———. *Going Too Far: The Persnal Chronicle of a Feminist.* New York: Vintage, 1978.

——— (contributing editor). *Sisterhood Is Global: The International Women's Movement Anthology.* New York: Anchor, 1985.

———. *The Demon Lover: On the Sexuality of Terrorism.* New York: Norton, 1989.

———. *Upstairs in the Garden.* New York: W. W. Norton, 1990.

———. *The Mer-Child.* New York: Feminist Press at The City University of New York, 1991.

———. *The Word of a Woman.* New York: W. W. Norton, 1992.

———. *A Hot January: Poems 1996–1999.* New York: W. W. Norton, 1999.

Morganthau, Tom with Carroll Bogert, John Bary and Gregory Visticia. "The Military Fights the Gender Wars," *Time* magazine, November 14, 1994.

Morris, George. *Hunter Seat Equitation,* 3rd ed. New York: Doubleday, 1990.

Morrison, Toni. *The Bluest Eye.* New York: Holt, 1969.

———. *Sula.* New York: Knopf, 1973.

———. *Song of Solomon.* New York: Knopf, 1977.

———. *Tar Baby.* New York: Knopf, 1977.

———. *Beloved.* New York: Knopf, 1987.

———. *Jazz.* New York, Knopf, 1992.

———. *Playing in the Dark: Whiteness and the Literary Imagination.* Cambridge, Mass.: Harvard University Press, 1992.

———. *Conversations with Toni Morrison.* Jackson, MS: University Press of Mississippi, 1994.

———. *The Nobel Lecture in Literature, 1993.* New York: Knopf, 1994.

———. *Paradise.* New York: Alfred A. Knopf, 1998.

Morrison, Toni, ed. *Race-ing Justice, En-Gendering Power: Essays on Anita Hill, Clarence Thomas, and the Construction of Social Reality.* New York: Pantheon, 1992.

Morrissey, James A. *"Will Merger Increase Union Presence in Mills?" Textile World,* May 1995.

Mosse, Julia, and Josephine Heation. *The Fertility and Contraception Book.* Winchester, Mass.: Faber and Faber, 1991.

Mossiker, Frances. *Pocahontas: The Life and Legend.* New York: Knopf, 1977.

Mott, Frank Luther. *A History of American Women's Magazines.* 3 vols. New York: Appleton, 1930.

Mott, Lucretia. *A Sermon to the Medical Students, Delivered at Cherry Street Meeting House, Philadelphia, on First-day evening, second month 11th, 1849.* Philadelphia: Merrihew and Thompson, 1849. Woodbridge, Conn.: Research Publications, microfilm.

———. *Discourse on Woman. Delivered at the Assembly Buildings, December 17, 1849. Being a Full Phonographic Report, Revised by the Author.* Philadelphia: T. B. Peterson, 1850. Woodbridge, Conn.: Research Publications, microfilm.

Mount Holyoke College. "General view of the principles and designs of the Mount Holyoke Female Seminary," n.d., 1837? Woodbridge, Conn.: Research Publications, microfilm.

———. *Female Education. Tendencies of the principles embraced, and the system adopted in the Mount Holyoke Female Seminary.* South Hadley, Mass.: 1837. Woodbridge, Conn.: Research Publications, microfilm.

———. *Historical Sketch of Mount Holyoke Seminary.* Founded at South Hadley, Mass., in 1837. Prepared in compliance with an invitation from the Commissioner of Education, representing the Department of the Interior in Matters relating to the National Centennial of 1876. Springfield, Mass.: Clark W. Bryan & Co., Printers, 1876. Woodbridge, Conn.: Research Publications, microfilm.

———. *Memorial. Twenty-fifth anniversary of the Mt. Holyoke Female Seminary.* Published for the seminary. South Hadley, Mass. [Springfield, Mass., S. Bowles & Co.], 1862. Woodbridge, Conn.: Research Publications, microfilm.

Mourning Dove. *Cogewa: The Half-Blood.* 1927. Reprint, Lincoln: University of Nebraska Press, 1990.

———. Coyote Stories. 1933. Reprint, Lincoln: University of Nebraska Press, 1990.

Moynihan, Rugh Barnes, Cynthia Russett, and Laurie Crumpacker, eds. *Second to None: A Documentary*

History of American Women, vol. 1. Lincoln: University of Nebraska Press, 1993.

Ms. Foundation for Women, 20th Birthday Party invitation.

Ms. magazine, January 1983; January 1988; May/June, 1993.

Munsterberg, Hugo. *A History of Women Artists.* New York: C. N. Potter Crown, 1975.

Nation, August 8, 1928.

Nation, Carry. *The Use and Need of the Life of Carry A. Nation, Written by Herself,* rev. ed. Topeka: F. M. Stevens & Sons, 1905.

National Abortion and Reproductive Rights Action League. Available on-line. URL: http://www.naral.org.

National Conference of Puerto Rican Women, Inc., brochure and mission statement, March 1972.

National Consumers League. Available on-line: URL: http://www.fraud.org.

National Displaced Homemaker Network, *Transition Times,* 5, no. 1 (Spring 1993).

National Law Journal, March 22, 1999.

National NOW Times 24, no. 6 (August 1992).

National Observer, May 11, 1970.

National Women's History Project. *Women's History Resources.* Windsor, Calif.: National Women's History Project, 1991.

National Women's History Project. (Site includes "March is National Women's History Month" page.) Available on-line: URL: http://www.nwhp.org.

Navarro, Mireya. "A Condom for Women Is Winning Favor." *New York Times,* December 15, 1993.

Nekola, Charlotte, and Paula Rabinowitz, eds. *Writing Red: An Anthology of American Women Writers, 1930–1940.*

Nelan, Bruce W. "Annie Get Your Gun: Under New Pentagon Rules, Females will be Permitted to Fly Combat Planes and Serve on Warships at Sea," *Time* 141, no. 19 (May 10, 1993).

Network News: The Newsletter of Women Work! The National Network for Women's Employment 16, no. 4 (Winter 1993).

Neuborne, Helen (Executive Director of NOW's Legal Defense and Education Fund). June 1993 letter.

New York Newsday, July 13, 1992; January 19 and 22, 1993; April 29, 1993.

New York Sunday News, November 22, 1970.

New York Times, July 29, 1928; May 4, 1935; January 27, 1938; December 5, 1952; February 8, 1953; October 27, 1961; November 3, 4, 11, 13, and 25, 1961; December 2 and 9, 1961; January 3 and 13, 1962; October 20, 1962; January 18, 1963; May 17 and 19, 1963; May 12, 1964; December 9, 1964; March 30 and 31, 1965; June 8, 9, 10, 13, and 15, 1965; March 22, 1970; May 7 and 30, 1970; August 27, 1970; December 18, 1970; June 4, 1973; October 5, 1973; March 25, 1974; February 6, 1972; May 1, 1981; June 19, 1983; July 1, 1984; December 15, 1985; May 22, 1986; May 28, 1987; October 10 and 14, 1987; April 18, 1988; February 24, 1989; February 9, 1990; June 26, 1990; April 4 and 24, 1991; June 18 and 19, 1991; November 18, 1991; January 22, 1992; June 30, 1992; August 13, 1992; October 6 and 14, 1992; October 28, 1992; November 19, 1992; January 15 and 18, 1993; March 10, 18 and 22, 1993; April 29, 1993; June 15, 16, 22, 23, 1993; August 18, 1993; September 26, 1993; October 13, 1993; October 20 and 23, 1993; November 17, 1993; January 13, 1994; March 25, 1994; February 10, 1995; March 15, 1995; June 1, 1995; December 8 and 27, 1995; January 18, 1996; April 15 and 25, 1996; May 2, 1996; June 27, 28, and 29, 1996; July 1, 1996; October 12, 1996; December 2, 1997; March 17, 1998; May 14, 1998; June 16, 1998; November 12, 1998; April 13 and 19, 1999; June 16, 1999; July 21, 1999.

New York *World Journal Tribune* mag., March 12, 1967.

Newsweek, June 13, 1983; October 24, 1983; September 21, 1992; December 28, 1992; December 14, 1998.

Niebuhr, Gustave. "Anti-Abortion Tactics Debated by Nation's Christian Leaders," *New York Times,* January 9, 1995.

Nitchie, George W. *Marianne Moore: An Introduction to the Poetry.* New York: Columbia University Press, 1969.

Noble, Barbara Presley. "Helping a Union Find Its Way: The Media Strategy Behind the Flight Attendants' Improbable Success," *New York Times,* December 12, 1993.

Noble, Jean. *Beautiful, Also, Are the Souls of My Black Sisters: A History of the Black Woman in America.* Englewood Cliffs, N.J.: Prentice-Hall, 1978.

Nordheimer, Jon. "Women's Role in Combat: The War Resumes," *New York Times,* May 26, 1991.

Norton, Mary Beth. *Liberty's Daughters: The Revolutionary Experience of American Women, 1750–1800.* Boston: Little, Brown, 1980.

O'Brien, Sharon. *Willa Cather: The Emerging Voice.* New York: Oxford University Press, 1987.

O'Connor, Flannery. *Wise Blood.* New York: Harcourt Brace, 1952.

———. *A Good Man Is Hard to Find.* New York: Harcourt Brace, 1955.

———. *The Violent Bear It Away.* New York: Farrar, Straus & Giroux, 1960.

———. *Everything that Rises Must Converge.* New York: Farrar, Straus & Giroux, 1965.

———. *The Habit of Being: Letters of Flannery O'Connor,* ed. Sally Fitzgerald. New York: Farrar, Straus & Giroux, 1969.

———. *Collected Works by Flannery O'Connor,* ed. Mary Jo Salter. New York: Library of America, 1989.

Ohrn, Karin Becker. *Dorothea Lange and the Documentary Tradition.* Baton Rouge: Louisiana State University Press, 1980.

O'Keeffe, Georgia. *Georgia O'Keeffe.* New York: Viking, 1976.

———. *Georgia O'Keeffe: Art and Letters.* Exhibition catalog for *Georgia O'Keeffe: 1887–1986.* Washington, D.C.; National Gallery of Art, 1987.

Olendorf, Donna. *Contemporary Authors: A Bio-Bibliographical Guide to Current Writers . . . Detroit: Gale Research, published annually.*

Oncale v. Sundowner Offshore Services, Inc., 523 U.S. 75 (1998).

O'Neil, William L. *Everyone Was Brave: The Rise and Fall of Feminism in America.* Chicago: Quadrangle, 1969.

Opera News, March 18, 1972.

Opfell, Olga S. *The Lady Laureates.* New York: Scarecrow Press, 1978.

Orenstein, Peggy, in association with the American Association of University Women. *Schoolgirls: Young Women, Self-Esteem, and the Confidence Gap.* Garden City, N.Y.: Doubleday, 1994.

Orr v. Orr. 1979. 440 U.S. 268.

Osen, Lynn M. *Women in Mathematics.* Cambridge, Mass.: MIT Press, 1974.

Ossoli, Margaret Fuller. *Summer on the Lakes.* New York: Charles S. Francis & Co., 1844. Woodbridge, Conn.: Research Publications, microfilm.

———. *Papers on Literature and Art.* New York: Wiley & Putnam, 1846. Woodbridge, Conn.: Research Publications, microfilm.

———. *Memoirs of Margaret Fuller Ossoli.* Boston: Phillips, Sampson and Co., 1852. Woodbridge, Conn.: Research Publications, microfilm.

———. *Woman in the Nineteenth Century and Kindred Papers Relating to the Sphere, Condition and Duties, of Woman.* 1855. Rpt., New York: W. W. Norton & Company, 1971.

———. *At Home and Abroad; or, Things and Thought in America and Europe,* ed. Arthur B. Fuller, 2d ed. Boston: Crosby, Nichols, and Co., 1856. Woodbridge, Conn.: Research Publications, microfilm.

———. *Life Without and Life Within; or, Reviews, Narratives, Essays, and Poems,* ed. Arthur B. Fuller. Boston: Brown, Taggard and Chase, c. 1859. Woodbridge, Conn.: Research Publications, microfilm.

———. *Love Letters of Margaret Fuller, 1845–1846.* New York: D. Appleton, 1903. Woodbridge, Conn.: Research Publications, microfilm.

Paglia, Camille. *Sexual Personae: Art and Decadence from Nefertiti to Emily Dickinson.* New Haven: Yale University Press, 1990.

———. *Sex, Art, and American Culture: Essays.* New York: Vintage Books, 1992.

———. *Vamps and Tramps: New Essays.* New York: Vintage Books, 1994.

Palmer, Laura. "The Nurses of Vietnam, Still Wounded." *New York Times Magazine,* November 7, 1993.

Papashvily, Helen Waite. *All the Happy Endings: A Study of the Domestic Novel in America, the Women Who Wrote It, the Women Who Read It, in the Nineteenth Century.* New York: Harper, 1956.

Paris, Bernard J. *Karen Horney: A Psychoanalysist's Search for Self-Understanding.* New Haven, Conn.: Yale University Press, 1994.

Parton, James. *Fanny Fern: A Memorial Volume. Containing her Select Writings and a Memoir,* with illustrations by Arthur Lumley. New York: G. W. Carleton & Co., 1874. Woodbridge, Conn.: Research Publications, microfilm.

Parton, Sara Payson Willis. *Ruth Hall: A Domestic Tale of the Present Time.* [By Fanny Fern, pseud.] New York: Mason Brothers, 1855. Woodbridge, Conn.: Research Publications, microfilm.

Paul, Alice. *Conversations with Alice Paul: Woman Suffrage and the Equal Rights Amendment.* An Interview Conducted by Amelia Fry. Berkeley: Bankroft Library, Regional Oral History Office, University of California, c. 1976.

Payne, Elizabeth Ann. *Reform, Labor, and Feminism: Margaret Dreier Robbins and the Women's Trade Union League.* Urbana: University of Illinois Press, 1988.

Payne, Karen, ed. *Between Ourselves: Letters Between Mothers and Daughters.* Boston: Houghton Mifflin, 1983.

Peabody, Elizabeth Palmer. *Sarah Winnemucca's Practical Solution of the Indian Problem.* Cambridge, Mass.: J. Wilson & Son, 1886.

Peck, Mary Gray. *Carrie Chapman Catt, A Biography.* New York: Wilson, 1944.

Peel, Robert. *Mary Baker Eddy: The Years of Discovery.* New York: Holt, Rinehart and Winston, 1966.

———. *Mary Baker Eddy: The Years of Trial.* New York: Holt, Rinehart and Winston, 1971.

———. *Mary Baker Eddy: The Years of Authority.* New York: Holt, Rinehart and Winston, 1977.

People magazine, January 25, 1993; May 10, 1993.

People v. Harris, 74 Misc. 353 N.Y. (1911).

Perkins, Frances. *The Roosevelt I Knew.* New York: Viking, 1946.

Petchesky, Rosalind Pollack. *Abortion and Woman's Choice.* Boston: Northeastern University Press, 1984, revised 1990.

Phelps, Timothy M., "Abortion Rules Eased," *New York Newsday,* January 22, 1993.

Philadelphia Inquirer, July 1–2 and December 3–4, 1868; March 28, 1999.

Piehl, Mel. *Breaking Bread: The Catholic Worker and the Origin of Catholic Radicalism in America.* Philadelphia: Temple University Press, 1982.

Planned Parenthood of New York City, *Annual Report,* 1998.

Plath, Sylvia. *The Bell Jar.* New York: Harper, 1971.

———. *The Collected Poems.* New York: Harper, 1981.

Plimpton, George, ed. *Writers at Work,* 6th series. New York: Viking Penguin, 1984.

Population Council, Inc. *Guide to Effective Counseling: Norplant Subdermal Implants.* New York: The Population Council, 1989.

Population Information Program, Johns Hopkins University, *Population Reports: Injectables and Implants.* March–April, 1987 (Series K, No. 3).

Post-Standard (Syracuse), July 30, 1998.

President's Commission on the Status of Women. *American Women.* Washington, D.C.: U.S. Government Printing Office, 1963.

President's Interagency Council on Women. "U.S. Follow-Up to the U.N. Fourth Conference on Women, Beijing, September 4–15, 1995 and on U.S. Implementation of the Beijing Platform for Action," Women Watch: The UN Internet Gateway on the Advancement and Empowerment of Women, March 1999. Available on-line. URL: http://www.un.org/womenwatch/followup/national/natplans.htm.

———. "Update to America's Commitment: Federal Programs Benefitting Women and New Initiatives as Follow-Up to the UN Fourth Conference on Women, April 1998 Supplement," Women Watch: The UN Internet Gateway on the Advancement and Empowerment of Women, March 1999. Available on-line. URL: http://www.un.org/womenwatch/followup/national/natplans.htm.

Prose, Francine. "Carol Gilligan Studies Girls Growing Up: Confident at 11, Confused at 16." *New York Times Magazine,* January 7, 1990.

Public Law 104-208. Omnibus Consolidated Appropriations Act, 1997. Volume 110, Title V, Section 579 and Title VI, Sections 644, 645, and 658, *U.S. Statutes at Large,* 104th Congress (1996).

Purdum, Todd S. "Leaders Back Ferraro's Bid for Senate," *New York Times,* May 29, 1992.

———. "Abrams, in Tight Senate Vote, Appears to Edge Out Ferraro," *New York Times,* September 16, 1992.

———. "Ferraro, Looking Back and Ahead," *New York Times,* November 6, 1992.

Putnam, George Palmer. *Soaring Wings.* New York: Harcourt Brace, 1939.

Qoyawayma, Polingaysi (Elizabeth Q. White), as told to Vada F. Carlson. *No Turning Back.* Albuquerque: University of New Mexico Press, 1964.

Quattlebaum, Mary. "Girls Have a Blast Visiting the Past," *The Washington Post,* March 12, 1999.

Quill, The (Chicago), November 1997.

Quindlen, Anna, "Public & Private: Going Nowhere," *New York Times,* June 23, 1993.

Rafter, Nicole Hahn. *Partial Justice: Women in State Prisons, 1800–1935.* Boston: Northeastern University Press, 1985.

Ralston, Jeannie. "Women's Work: The Gulf War Exploded Myths About Females in Combat, but Their Fight to Fight Rages On." *Life* magazine, May 1991.

Rampersad, Arnold. *The Art & Imagination of W. E. B. Dubois.* Cambridge, Mass.: Harvard University Press, 1976.

Ranke-Heinemann, Uta. *Eunuchs for the Kingdom of Heaven: The Catholic Church and Sexuality.* New York: Doubleday, 1990.

Rankin, Bill. "Police Union Unsure if It Will Appeal Domestic-Violence Gun Ban," *The Atlanta Journal-Constitution,* August 8, 1997.

Rankin, Daniel S. *Kate Chopin and her Creole Stories.* Philadelphia: University of Pennsylvania Press, 1932.

Raum, Tom. "Kosovo Albanians Hail Albright as Liberator," *The Atlanta Journal-Constitution,* July 29, 1999.

Raymon, Graham, "War Heroines: Memorial Honors Women Vietnam Vets." *New York Newsday,* September 17, 1993.

Read, Phyllis J., and Bernard L. Witlieb. *The Book of Women's Firsts.* New York: Random House, 1992.

Redbook, November 1973.

Reed, James. *From Public Vice to Private Virtue: The Birth Control Movement and American Society Since 1830.* Princeton: Princeton University Press, 1978.

Reed v. Reed. 1971. 404 U.S. 71.

Reno, Janet. Interview with Elaine Shannon, published in *Time* magazine, July 12, 1993.

Reuters, September 13, 1996; March 3, 1997; May 28, 1997; October 24, 1997; December 18, 1997; October 2, 1998; February 26, 1999.

Revolution, December 10, 1868–August 19, 1869.

"Rhine Maidens, The," *Newsweek,* March 10, 1945.

Rich, Adrienne. *A Change of World.* New Haven: Yale University Press, 1951.

———. *The Diamond Cutters and Other Poems.* New York: Harper, 1955.

———. *Snapshots of a Daughter-in-Law: Poems, 1954–1962.* New York: Harper & Row, 1963.

———. *Necessities of Life: Poems, 1962–1965.* New York: Norton, 1966.

———. *A Wild Patience Has Taken Me This Far: Poems 1978–1981.* New York: Norton, 1971.

———. *Diving Into the Wreck: Poems, 1971–1972.* New York: Norton, 1973.

———. *Poems: Selected and New, 1950–1974.* New York: Norton, 1975.

———. *Of Woman Born.* New York: Norton, 1976.

———. *On Lies, Secrets, and Silence: Selected Prose 1966–1978.* New York: Norton, 1979.

———. *The Fact of a Doorframe: Poems Selected and New, 1950–1984.* New York: Norton, 1984.

———. *Your Native Land, Your Life.* New York: Norton, 1986.

———. *Blood, Bread, and Poetry: Selected Prose, 1979–1985.* New York: Norton, 1987.

———. *What is Found There: Notebooks on Poetry and Politics.* New York: W. W. Norton, 1993.

———. *What Is Found There: Notebooks on Poetry and Politics.* New York: Norton, 1994.

———. *Midnight Salvage: Poems 1995–1998.* New York: W. W. Norton, 1999.

Rich, Doris. *Amelia Earhart: A Biography.* Washington, D.C.: Smithsonian Institution, 1989.

Riederman, Sarah R. and Elton T. Gustafson. *Portraits of Nobel Laureates in Medicine and Physiology.* London: Abelard-Schuman, 1953.

Ries, Paula and Anne J. Stone, eds. *The American Woman 1992–1993: A Status Report.* New York: W. W. Norton & Company, 1992.

Rinehart, Mary Roberts. *My Story.* New York: Rinehart & Co., 1948.

Rittenhouse, Mignon. *The Amazing Nellie Bly.* New York: E. P. Dutton, 1956.

Rix, Sara E., ed. *The American Woman 1990–91: A Status Report.* New York: W. W. Norton & Company, 1990.

Robb, Inez. *Don't Just Stand There.* New York: David McKay, 1962.

Roberts, Barbara. March 1994 letter to prospective contributors to Emily's List.

Roberts v. Jaycees. 1984. 468 U.S. 609.

Robertson, Nan. *The Girls in the Balcony: Women, Men and the New York Times.* New York: Fawcett Columbine, 1922.

Robichaud, Todd D. "Defense of Marriage Act—Or Attack on Family?" *National Law Journal,* September 30, 1996.

Robinson, Harriet. *Loom and Spindle: Or Life Among the Early Mill Girls.* Kailua, Hawaii: Press Pacifica, 1976; first published, 1898.

Robinson, Louis. "Women Lawmakers on the Move," *Ebony,* October 1971.

Robinson, Roxana. *Georgia O'Keeffe: A Life.* New York: Harper & Row, 1989.

Roe v. Wade, 410 U.S. 113 (1973).

Rogers, Katharine M., ed. *The Merian Anthology of Early American Women Writers: From Anne Bradstreet to Louisa May Alcott, 1650–1865.* New York: New American Library, 1991.

Rogers, Mary Beth. *Barbara Jordan: American Hero.* New York: Bantam Books, 1998.

Roiphe, Katie. *The Morning After: Sex, Fear, and Feminism.* Boston and New York: Little Brown, 1993.

Roosevelt, Eleanor. *It's Up to the Women.* New York: Stokes, 1933.

———. *The Autobiography of Eleanor Roosevelt.* New York: Harper, 1971.

———. *My Day: Her Acclaimed Columns, 1936–1945,* ed. Martha Gellhorn. New York: Pharos Books, 1989.

———. *My Day: Her Acclaimed Columns, 1945–1952,* ed. David Emblidge. New York: Pharos Books, 1990.

Rosemont, Franklin, ed. *Isadora Speaks.* San Francisco: City Lights Books, 1981.

Rosenthal, A. M. "The Torture Continues." *New York Times,* July 27, 1992.

———. "Female Genital Torture." *New York Times,* November 12, 1993.

Ross, Ishbel. *Ladies of the Press: The Story of Women in Journalism by an Insider.* New York: Harper and Brothers, 1936.

———. *Rebel Rose: Life of Rose O'Neal Greenhow, Confederate Spy.* New York: Harper & Brothers, 1954.

Rossi, Alice A. *The Feminist Papers: From Adams to de Beauvoir.* Boston: Northeastern University Press, 1988.

Rosten, Leo. *Religions of America: Ferment and Faith in an Age of Crisis.* New York: Simon and Schuster, 1975.

Rother, Larry. "Tough 'Front Line Warrior': Janet Reno." *New York Times,* February 12, 1993.

———. "Era of Female Combat Pilots Opens With Shrugs and Glee." *New York Times,* April 19, 1993.

Roudebush, Jay. *Mary Cassatt.* New York: Crown, 1979.

Rowan, Victoria C. "Maya Lin Finds Inspiration in the Architecture of Nature," *Architectural Record,* September 1998.

Rozell, Mark J. and Clyde Wilcox. "The Clinton Scandal in Retrospect," *Political Science & Politics,* September 1999.

Rubenstein, Charlotte Streifer. *American Women Artists from Early Indian Times to the Present.* Boston: G. K. Hall, 1982.

Russell, Diana E. H., and Nicole Van de Ven. *Crimes Against Women: Proceedings of the International Tribunal.* Millbrae, Calif.: Les Femmes, 1976.

Sack, Kevin, "New York Is Urged to Outlaw Surrogate Parenting for Pay," *New York Times,* May 15, 1992.

Sadker, Myra and David Sadker. *Failing at Fairness: How America's Schools Cheat Girls.* New York: Charles Scribner's Sons, 1994.

Sadler, Shelley, director of Human Resources, Penguin USA, Letter to Ms. Deborah Greig, April 27, 1993 (courtesy Ms. Deborah Greig).

Sage, Mrs. Russell. *Emma Willard and Her Pupils for Fifty Years of Troy Female Seminary: 1822–1872.*

St. Denis, Ruth. *An Unfinished Life.* New York: Harper & Brothers, 1939.

St. Louis Post-Dispatch. November 28, 1999.

Salmon, Marylynn. *Women and the Law of Property in Early America.* Chapel Hill: University of North Carolina Press, 1986.

"Same-Sex Marriage: Federal and State Authority," *Congressional Digest,* November 1996.

Sanger, Margaret. "Family Limitation," 5th ed. revised. New York: [n.d.]; Woodbridge, Conn.: Research Publications, microfilm.

———. *Woman the New Race.* New York: 1920.

———. *My Fight for Birth Control.* 1931, rpt., Elmsford, N.Y.: Maxwell, 1969.

———. *An Autobiography.* 1938. Rpt., foreword by Kathryn Cullen-DuPont. New York: Cooper Square Press, 1999.

Santa Clara Pueblo v. Martinez. 1978. 436 U.S. 49.

Schappes, Morris, ed. *Emma Lazarus: Selections from Her Poetry and Prose.* New York: Cooperative Book League, 1944.

Schilpp, Madeline Golden and Sharon M. Murphy. *Great Women of the Press.* Carbondale: Southern Illinois University Press, 1983.

Schlafly, Phyllis. *The Power of the Positive Woman.* New York: Jove/HJB, 1978.

Schmitt, Eric. "Senate Votes to Remove Ban on Women as Combat Pilots." *New York Times,* August 8, 1991.

———. "Pentagon Plans to Allow Combat Flights by Women; Seeks to Drop Warship Ban." *New York Times,* April 28, 1993.

———. "A Belated Salute to the Women Who Served: Memorial Is Dedicated to Forgotten Corps of Vietnam Veterans." *New York Times,* November 12, 1993.

———. "Aspin Moves to Open Many Military Jobs to Women." *New York Times,* January 14, 1994.

Schneir, Miriam, ed. *Feminism: The Essential Historical Writings.* New York: Vintage Books, 1972.

Schroeder, Patricia. Interview with Charles Bierbauer, "Newsmaker Saturday," CNN, June 25, 1994.

———. *24 Years of House Work . . . and the Place is Still a Mess.* 1998. Rpt. Kansas City, Mo.: Andrews & McMeel, 1999.

Schultz, Duane. *A History of Modern Psychology.* New York: Academic Press, 1975.

Schultz, J. W. *The Bird Woman: Sacajawea, Guide of Lewis and Clark.* New York: Gordon Press, 1977.

Schwartz, Felice N. "Management Women and the New Facts of Life," *Harvard Business Review,* January/February 1989.

———. "The 'Mommy Track' Isn't Anti-Woman," *New York Times,* March 22, 1989.

Sciolino, Elaine. "Battle Lines Are Shifting on Women in War." *New York Times,* January 5, 1990.

———. "Female P.O.W. Is Abused, Kindling Debate." *New York Times,* June 29, 1992.

Seelye, Katharine Q. "Accord Opens Way for Abortion Pill in U.S. in Two Years: Patent Rights Given Up." *New York Times,* May 17, 1994.

Sewall, Richard B. *The Life of Emily Dickinson.* ———, rpt. Cambridge, Mass.: Harvard University Press, 1994.

Shabecoff, Philip. "Report of Woman's Role Is Called into Question." *New York Times,* January 8, 1990.

Shaw, Anna Howard. "Woman Suffrage as an Educator. An address before the Equal Franchise Society . . . January 13, 1910." New York: Equal Franchise Society [1910?]

———. *Passages from Speeches of Dr. Anna Howard Shaw.* New York: National Woman Suffrage Publishing Co., 1915.

———. "What the War Meant to Women." Speech delivered during 1919. New York: League to Enforce Peace, 1919.

Sheehy, Gail. *The Silent Passage: Menopause.* New York: Pocket Books, 1992.

Shelton, Suzanne. *Divine Dancer: A Biography of Ruth St. Denis.* New York: Doubleday & Co., 1981.

Shilts, Randy. *Conduct Unbecoming: Gays and Lesbians in the U.S. Military.* New York: Fawcett Columbine, 1993.

Showalter, Elaine, Lea Baechler, and A. Walton Litz, eds. *Modern American Women Writers: Profiles of Their Lives and Works—From the 1870s to the Present.* New York: Collier Books, 1993.

Shuger, Scott. "Kindest Cut: The Story of My Vasectomy." *The New Republic,* October 14, 1991.

Shulman, Alix Kates, ed. *Red Emma Speaks: Selected Writings and Speeches by Emma Goldman.* New York: Random House, 1972.

Shurtleff, Nathaniel B., ed. *Records of the Governor and Company of the Massachusetts Bay in New England.* Boston: From the Press of William White, Printer to the Commonwealth, 1854.

Sicherman, Barbara, and Carol Hurd Green, with Ilene Kantrov and Harriette Walker, eds. *Notable American Women: The Modern Period. A Biographical Dictionary.*

Cambridge, Mass.: The Belknap Press of Harvard University Press, 1980.

Siegel, Beatrice. *Lillian Wald of Henry Street.* New York: Macmillan, 1983.

Sigaud, Louis A. *Belle Boyd: Confederate Spy.* Richmond, Va.: The Dietz Press, 1944.

Simons, Marlise. "France Jails Woman for Daughters' Circumcisions." *New York Times,* January 11, 1993.

Slaughter-House Cases. 1872. 83 U.S. 16 Wall. 36.

Smith, Christopher H. "1997 State Department Report on Human Rights Practices," Congressional testimony, February 3, 1998.

Smith, Claire. "Concerns Are Voiced on Effects of Title IX," *New York Times,* February 3, 1995.

Smith, Dinitia. "Love Is Strange: The Crusading Feminist and the Repentant Womanizer." *New York,* March 22, 1993.

Smith, J. David, and K. Ray Nelson, *The Sterilization of Carrie Buck: Was She Feebleminded or Society's Pawn.* Far Hills, N.J.: New Horizon Press, 1989.

Smith Rosenberg, Carroll. *Disorderly Conduct: Vision of Gender in Victorian America.* New York: Oxford University Press, 1985.

Smolowe, Jill. "When Violence Hits Home." *Time,* July 4, 1994.

Solomon, Barbara H., ed. *American Wives: Thirty Short Stories by Women.* New York: New American Library, 1986.

Solomon, Barbara Miller. *In the Company of Educated Women: A History of Women and Higher Education in America.* New Haven: Yale University Press, 1985.

Solomon, Hannah Greenbaum. *Fabric of My Life; The Story of a Social Pioneer.* 1946; rpt, New York: Bloch, 1974.

Somerville, Sean. "Sponsors Defend English-As-Official-Language Proposals," *Gannett News Service,* October 18, 1995.

Sontag, Susan. *The Benefactor.* New York: Farrar, Straus, 1963.

———. *Against Interpretation, and Other Essays.* New York: Farrar, Straus, 1966.

———. *Death Kit.* New York: Farrar, Straus, 1967.

———. *Styles of Radical Will.* New York: Farrar, Straus, 1969.

———. *Trip to Hanoi.* New York: Farrar, Straus, 1969.

———. *On Photography.* New York: Farrar, Straus, 1977.

———. *I, etcetera.* New York: Farrar, Straus, 1978.

———. *Illness as Metaphor.* New York: Farrar, Straus, 1978.

———. *Under the Sign of Saturn.* New York: Farrar, Straus, 1980.

———. *A Susan Sontag Reader.* Introduction by Elizabeth Hardwick. New York: Farrar, Straus, 1982.

———. *The Volcano Lover.* New York: Farrar, Straus, 1992.

———. *In America.* Farrar, Straus, 2000.

Sparhawk, Rita M., Mary E. Leslie, Phyllis T. Turbow, and Zina R. Rose, *American Women in Sport, 1887–1987: A 100-Year Chronology.* Metuchen, N.J.: Scarecrow Press, 1989.

Spingarn, Joel E., Papers. New York Public Library.

Spitzer, Kirk. "Gay and Lesbian Group Gives Hawaii Delegation Top Marks," *Gannett News Service,* September 27, 1996.

Spruill, Julia Cherry. *Women's Life and Work in the Southern Colonies.* New York: W. W. Norton & Company, 1972.

Squire, Susan, "Whatever Happened to Baby M?" *Redbook,* January 1994.

Stanton, Elizabeth Cady. *The Woman's Bible.* 1895 and 1896; rpt. Salem, N.H.: Ayer Company, Publishers, 1988.

———. *Eighty Years and More: Reminiscences 1815–1897.* 1898; rpt. New York: Schocken Books, 1971.

Stanton, Elizabeth Cady, Susan B. Anthony and Matilda Joslyn Gage, eds. *History of Woman Suffrage.* 6 vols., 1881–1922. Rpt., Salem, N.H.: Ayer Company, Publishers, 1985.

Stanton, Theodore, and Harriot Stanton Blatch. *Elizabeth Cady Stanton: As Revealed in Her Letters, Diary, and Reminiscences, vols. 1 and 2.* New York: Arno Press and the New York Times, 1969; first published 1895.

Stanton v. Stanton. 1975. 421 U.S. 7.

Starkey, Marion L. *The Devil in Massachusetts, a Modern Enquiry into the Salem Witch Trials.* Garden City, N.Y.: Doubleday, 1949, 1969.

Steegmuller, Francis, ed. *Your Isadora.* New York: Random House, 1974.

Stein, Gertrude. *Three Lives.* New York: Grafton, 1910.

———. *The Autobiography of Alice B. Toklas.* New York: Harcourt Brace, 1933.

———. *Lectures in America.* New York: Random House, 1934.

———. *Selected Writings of Gertrude Stein,* ed., with an introduction, by Carl Van Vechten. New York: Random House, 1946, 1962.

———. *Fernhurst, Q.E.D. and Other Early Writings,* ed. Leon Katz. New York: Liveright, 1971.

Stein, Judith E. "Space and Place," *Art in America,* December 1994.

Stein, Leon. *The Triangle Fire.* New York: Caroll and Graf, 1962.

Steinberg, Ronnie. *Wages and Hours: Labor and Reform in Twentieth-Century America.* New Brunswick, N.J.: Rutgers University Press, 1982.

Steinem, Gloria. *Revolution From Within: A Book of Self-Esteem.* Boston: Little, Brown, 1992.

———. Interview with Lenny Lopate, broadcast on WNYC on January 23, 1992.

Sterling, Dorothy, ed. *We Are Your Sisters: Black Women in the Nineteenth Century.* New York: Norton, 1984.

Stern, Madeline B. *We The Women: Career Firsts of Nineteenth Century America.* Lincoln: University of Nebraska Press, 1962.

Stevens, Doris. *Jailed for Freedom.* 1920. Rpt. Salem, N.H.: Ayer Company, 1990.

Stimson, Julia C. *Finding Themselves: The Letters of an American Army Chief Nurse in a British Hospital in France.* New York: Macmillan, 1918; Woodbridge, Conn.: Research Publications, microfilm.

Stodelle, Ernestine. *Deep Song: The Dance Story of Martha Graham.* New York: Schirmer Books, 1984.

Stone, Merlin. *When God Was a Woman.* New York: Harcourt Brace Jovanovich, 1976.

Stowe, Charles Edward. *Harriet Beecher Stowe; the story of her life, by her son Charles Edward Stowe, and her grandson, Lyman Beecher . . .* Boston: Houghton Mifflin and Company, 1896. Woodbridge, Conn.: Research Publications, microfilm.

Stowe, Harriet Beecher. *Uncle Tom's Cabin.* 1852. Rpt., New York: Books, Inc. [n.d.].

———. *The Key to Uncle Tom's Cabin.* 1854 ed. Rpt. (American Negro: His History and Literature Ser., No. 1.) New York: Arno Press, 1968.

———. *Household Papers and Stories.* Boston: Houghton Mifflin and Company, 1896; Woodbridge, Conn.: Research Publications, microfilm.

Strane, Susan. *A Whole-Souled Woman: Prudence Crandall and the Education of Black Women.* New York: W. W. Norton, 1990.

Strasser, Susan. *Never Done: A History of American Housework.* New York: Pantheon Books, 1982.

Strauder v. West Virginia. 1880. 100 U.S. 303.

Strebeigh, Fred. "Defining the Law on the Feminist Frontier." *New York Times Magazine,* October 6, 1991.

Suh, Mary. "Economic Breakthrough: Making Unpaid Labor Count." *Ms.* magazine 3, no. 6 (May/June 1993).

"The Supreme Court: Retaining the Constitutional Right to Abortion, Excerpts from the Justices' Decision in the Pennsylvania Case," *New York Times,* June 30, 1992.

Sweet, Frederick A. *Miss Mary Cassatt, Impressionist From Pennsylvania.* Norman: University of Oklahoma Press, 1966.

Symons, Joanne L., "Legislation for Women: The End of Gridlock?" *Executive Female,* May/June 1993.

Talbot, Margaret. "The Little White Bombshell," *New York Times Magazine,* July 11, 1999.

Tan, Amy. *The Joy Luck Club.* New York: G. P. Putnam's Sons, 1989.

Tanner, Leslie B. *Voices From Women's Liberation.* New York: New American Library, 1970.

Tarbell, Ida. *The Life of Abraham Lincoln.* New York: Doubleday & McClure, 1900.

———. *The History of the Standard Oil Company.* New York: McClure, Phillips, 1904.

———. *The Tariff in Our Time.* New York: Macmillan, 1911.

———. *The Business of Being a Woman.* New York: Macmillan, 1912.

———. *All in a Day's Work.* New York: Macmillan, 1939.

Taylor v. Louisiana. 1975. 419 U.S. 522.

Tebbell, John W. *American Dynasty: Story of the Maccormicks, Medills, & Pattersons.* 1947. Rpt., Westport, Conn.: Greenwood, 1968.

Terry, Walter. *Isadora Duncan: Her Life, Her Art, Her Legacy.* New York: Dodd, Mead & Co., 1963.

———. *The "More Living Life" of Ruth St. Denis.* New York: Dodd, Mead & Co., 1969.

Thomas, M. Carey. *Education of Women.* Albany, New York: J. B. Lyon Company, 1900.

———. "The College Women of the Present and Future." [no city]: McClure's Syndicate, 1901.

———. "Women's College and University Education: Address delivered at the college evening of the National American Women Suffrage Association, Buffalo, October 17, 1908. Woodbridge, Conn.: Research Publications, 1983, microfilm.

Thomas, Robert McG., Jr. "Dottie Green, a Baseball Pioneer in Women's League, Dies at 71," *New York Times,* October 28, 1992.

Tiffany, Francis. *Life of Dorothea Lynde Dix.* Boston: Houghton Mifflin & Co., 1981; Woodbridge, Conn.: Research Publications, microfilm.

Time, February 3, 1958; August 31, 1962; March 31, 1967; June 13, 1983; October 24, 1983; March 10, 1986; April 17, 1989; January 13, September 14 and December 14, 1992; May 10, 1993.

Times Union (Albany). November 28, 1997; February 27 and April 1, 1998.

Tolles, Frederick B., ed. *Slavery and "The Woman Question": Lucretia Mott's Diary on Her Visit to Great Britain to Attend the World's Anti-Slavery Convention of 1840.* Haverford: Friends' Historical Association (Suppl. 23 to the *Journal of the Friends Historical Society*), 1952.

Touchton, Judith G. and Lynn Davis, with the assistance of Vivian Parker Makosky. *Fact Book on Women in Higher Education.* New York: Macmillan, 1991.

Transition Times 5, no. 1 (Spring 1993).

Tufts, Eleanor. *Our Hidden Heritage: Five Centuries of Women Artists.* New York: Paddington Press, 1974.

———. *American Women Artists 1830–1930*. Washington, D.C.: The National Museum of Women in the Arts, 1987.

Tuttle, Lisa. *Encyclopedia of Feminism*. New York: Facts On File, 1986.

United Nations. *Convention for the Suppression of Traffic in Persons and of the Exploitation of the Prostitution of Others*. 1949.

———. *Supplementary Convention on the Abolition of Slavery, the Slave Trade, and Institutions and Practices Similar to Slavery*. 1956.

———. *The Forward-Looking Strategies for the Advancement of Women*. New York: United Nations, 1985.

———. *The World's Women 1970–1990: Trends and Statistics*. New York: United Nations Publication, 1991.

———. *Beijing Declaration and Platform for Action*. New York: United Nations, 1995.

United States v. Commonwealth of Virginia et al., 518 U.S. 515 (1996).

Upham, Charles W. *Salem Witchcraft*. Williamstown, Mass.: Corner House Publishers, 1971.

Upjohn Company, The Advertisement for Depo-Provera. *Working Woman* (December 1993).

USA Today, April 29, 1993; October 11, 1995; December 17, 1996; June 30, 1997; April 12, 1999; August 11, 1999.

U.S. Congress, House of Representatives. Debate on sex amendment to Title VII. *Congressional Record,* 88th Congress, 2nd session, February 8, 1964, 110 pt. 2:2577–84.

———. (Congresswoman Martha Griffiths speaking about the EEOC.) *Congressional Record,* 89th Congress, 2nd session, June 20, 1966, 112:13689–94.

———. A resolution honoring the inaugural season of the United States women's professional basketball season. 105th Cong., 1st session., 1997. H.Res. 173.

U.S. Congress, Senate, Subcommittee of the Committee on the District of Columbia. *Suffrage Parade Hearings*. 63d Congress, special sess. Washington, D.C.: Government Printing Office, 1913.

U.S. Department of Labor, Women's Bureau. *A Working Woman's Guide to Her Job Rights,* 1988.

U.S. Department of State, "Afghanistan Country Report on Human Rights Practices for 1998." Washington, D.C.: Bureau of Democracy, Human Rights and Labor, February 26, 1999.

U.S. General Accounting Office. "Equal Employment Opportunity: EEOC and State Agencies Did Not Fully Investigate Discrimination Charges," October 1988.

U.S. News and World Report, February 17, 1986; November 6, 1989; August 30, 1999.

U.S. Newswire, October 31, 1998; May 19, 1999; June 3, 1999.

Van Duyn, Mona. *To See, To Take*. New York: Atheneum, 1970.

———. *Merciful Disguises: Published and Unpublished Poems*. New York: Atheneum, 1973.

———. *Letters from a Father, and Other Poems*. New York: Atheneum, 1982.

———. *Near Changes: Poems*. New York: Alfred A. Knopf, 1990.

———. *Firefall: Poems*. New York: Knopf, 1993.

———. *If It Be Not I: Collected Poems, 1959–1982*. New York: Knopf, 1993.

Van Gelder, Lawrence. "Booknotes," *New York Times,* January 11, 1995.

Van Vooris, Jacqueline. *Carrie Chapman Catt, A Public Life*. New York: Feminist Press, 1987.

"Virginia Military Institute to Establish Courses at Women's Colleges," *New York Times,* September 26, 1993.

Vogel, Dan. *Emma Lazarus*. Boston: G. K. Hall, 1980.

Von Drehle, David. "The Quiet Revolutionary: Ruth Bader Ginsburg's Odyssey from Convention to Crusade." *Washington Post National Weekly Edition* 10, no. 39 (July 26–August 1, 1993).

———. "A Trailblazer's Step-by-Step Assault on the Status Quo." *Washington Post National Weekly Edition* 10, no. 39 (July 26–August 1, 1993).

Wald, Lillian. *The House on Henry Street*. New York: Henry Holt and Company, 1915.

———. *Windows on Henry Street*. Boston: Little, Brown, and Company, 1934.

Waldron, Ann. *Eudora Welty: A Writer's Life*. New York: Doubleday, 1998.

Walker, Alice. *Once*. New York: Harcourt Brace, 1968.

———. *The Third Life of Grange Copeland*. New York: Harcourt Brace, 1970.

———. *In Love and Trouble: Stories of Black Women*. New York: Harcourt Brace, 1973.

———. *Revolutionary Petunias and Other Poems*. New York: Harcourt Brace, 1973.

———. "In Search of Zora Neale Hurston," *Ms.* magazine (March 1975).

———. *Meridian*. New York: Harcourt Brace, 1976.

———. *Goodnight, Willie Lee, I'll See You in the Morning*. New York: Dial, 1979.

———. *You Can't Keep a Good Woman Down*. New York: Harcourt Brace, 1981.

———. *The Color Purple*. New York: Harcourt Brace Jovanovich, 1982.

———. *In Search of Our Mother's Gardens*. New York: Harcourt Brace, 1983.

———. *Horses Make a Landscape More Beautiful*. New York: Harcourt Brace, 1984.

———. *Possessing the Secret of Joy*. New York: Jovanovich, Inc., 1992.

———. Interview with Ray Suarez on "Talk of the Nation," WNYC-AM, November 9, 1993.

———. *Her Blue Body Everything We Know: Earthling Poems, 1965–1990 Complete.* San Diego: Harcourt Brace, 1991.

———. *Anything We Love Can Be Saved: A Writer's Activism.* New York: Random House, 1997.

Walker, Alice, and Pratibha Parmer. *Warrior Marks: Female Genital Mutilation and the Sexual Blinding of Women.* New York: Harcourt Brace Jovanovich, 1993.

Wall Street Journal, April 29, 1993.

Wandersee, Winifred. *American Women in the 1970s: On the Move.* Boston: Twayne Publishers, 1988.

Ware, Susan. *American Women in the 1930s: Holding Their Own.* Boston: Twayne Publishers, 1982.

Warren, Mercy Otis. *History of the Rise, Progress and Termination of the American Revolution: Interspersed with Biographical, Political and Moral Observations.* Boston: Manning and Loring for E. Larkin, 1805. Woodbridge, Conn.: Research Publications, microfilm.

Washington Post, October 22, 1972; March 17, 1996; April 24 and 30, 1996; May 2 and 3, 1996; July 14, 1996; September 11, 1996; October 20, 1996; November 7, 1996; February 24, 1997; March 25, 1997; September 10, 1997; November 15, 1997; December 16, 1997; February 25, 1998; March 5, 1998; April 1, 2, and 28, 1998; June 12 and 27, 1998; August 6, 1998; November 30, 1998; December 7, 1998; January 13 and 14, 1999; July 21, 1999.

Weatherford, Doris. *American Women and World War II.* New York: Facts On File, 1990.

Weinberger v. Wiesenfeld. 1975. 420 U.S. 636.

Weinstein, Norman. *Gertrude Stein and the Literature of the Modern Consciousness.* New York: Ungar, 1970.

Wellesley College Center for Research on Women, *How Schools Shortchange Girls: The AAUW Report.* Washington, D.C.: American Association of University Women Educational Foundation, 1992.

Wells, Seth. *Testimonies of Life, Character, Revelation and Doctrine of Our Blessed Mother Ann Lee.* Hancock, Mass.: The United Society, 1816.

Welter, Barbara, "The Cult of True Womanhood: 1820–1860," *American Quarterly* 18 (Summer 1966).

———. *Dimity Convictions: The American Woman in the Nineteenth Century.* Athens: Ohio University Press, 1976.

Welty, Eudora. *Delta Wedding.* New York: Harcourt Brace, 1946.

———. *The Optimist's Daughter.* New York: Random House, 1972.

———. *The Eye of the Story: Selected Essays and Reviews.* New York: Random House, 1978.

———. *The Collected Stories of Eudora Welty.* New York: Harcourt Brace Jovanovich, 1980.

———. *One Writer's Beginnings.* 1983. New York: Warner Books, 1985.

Wertheimer, Barbara Mayer. *We Were There: The Story of Working Women in America.* New York: Pantheon Books, 1977.

Wexler, Alice. *Emma Goldman in America* (Originally published as *Emma Goldman: An Intimate Life*). Boston: Beacon Press, 1984.

Wharton, Edith. *House of Mirth.* New York: Scribner, 1905.

———. *Ethan Frome.* New York: Scribner, 1911.

———. *The Age of Innocence.* New York: Appleton, 1920.

———. *A Backward Glance.* New York: Appleton-Century, 1934.

———. *The Best Short Stories of Edith Wharton,* intro. by Wayne Andrews. New York: Scribner, 1958.

Wheatley, Phillis. *Poems on various subjects, religious and moral.* London: A. Bell, 1773. Woodbridge, Conn.: Research Publications, microfilm.

———. *The Poems of Phillis Wheatley,* ed. Julian D. Mason, Jr. Chapel Hill: University of North Carolina Press, 1966.

Wheeler, Leslie, ed. *Loving Warriors: Selected Letters of Lucy Stone and Henry B. Blackwell, 1853–1893.* New York: Dial Press, 1981.

Whitehead, Mary Beth with Loretta Schwartz-Nobel. *A Mother's Story: The Truth About the Baby M Case.* New York: St. Martin's Press, 1989.

Who's Who in America. Published annually.

Wilbur, Sybil. *The Life of Mary Baker Eddy.* New York: Concord, 1908.

Wilcox, H. K. W. "National Standards and Emblems." *Harper's Monthly* (July 1873).

Willard, Frances E. "Hints and Helps in Our Temperance Work." New York: National Temperance Society and Publication House, 1875. Woodbridge, Conn.: Research Publications, microfilm.

———. *Woman and Temperance; or, The Work and Workers of the Woman's Christian Temperance Union.* Hartford, Conn.: Park Pub. Co., 1883. Woodbridge, Conn.: Research Publications, microfilm.

———. *Glimpses of Fifty Years: The Autobiography of an American Woman.* Chicago: Worth Publishing, 1889.

———. "Address before the Second Biennial Convention of the World's Woman's Christian Temperance Union, and the Twentieth Annual Convention of the National Woman's Christian Temperance Union, by

their president . . ." World's Columbian Exposition, Chicago . . . October 1893. Woodbridge, Conn.: Research Publications, microfilm.

———. "Address before the Twenty-Second Annual Meeting of the National Woman's Christian Temperance Union," Baltimore, Md., October 18–23, 1895. Chicago: Woman's Temperance Pub. Assn., [1895]. Woodbridge, Conn.: Research Publications, microfilm.

———. "The Ballot for the Home." Boston: *The Woman's Journal,* 1898. Woodbridge, Conn.: Research Publications, microfilm.

Willard, Frances E. and Mary Livermore, eds. *A Woman of the Century: Fourteen Hundred Biographical Sketches.* Buffalo, N.Y.: C. W. Moulton, 1893.

Willentz, June. *Women Veterans: America's Forgotten Heroines.* New York: Continuum, 1983.

Wilson, Marie C. President of the Ms. Foundation for Women. Letter of June 1993.

Wilson, Robert F. *Crusader in Crinoline: The Life of Harriet Beecher Stowe.* 1941. Rpt., Westport, Conn.: Greenwood Press, 1972.

Wiltsher, Ann. *Most Dangerous Women: Feminist Peace Campaigners of the Great War.* Boston: Pandora, 1985.

Winthrop, John. *Winthrop's Journal, "History of New England," 1630–1649* (2 vols.). New York: Charles Scribner's Sons, 1908.

Withey, Lynne. *Dearest Friend: A Life of Abigail Adams.* New York: The Free Press, 1981.

Wolf, Naomi. *Fire With Fire: The New Female Power and How to Use It.* New York: Fawcett Columbine, 1993.

"Woman Registers at Citadel, Then Is Barred," *New York Times,* January 13, 1994.

"Women's Christian Temperance Union." A report on "All Things Considered," broadcast on WNYC on April 21, 1991.

Women's Health Research and Prevention Amendments of 1998, Public Law 105–340.

Woman's Journal, The. 1870–1917. Woodbridge, Conn.: Research Publications, microfilm. Lucy Stone, Henry Blackwell and Julia Ward Howe, eds. 1870–1893; Alice Stone Blackwell, ed. 1893–1917.

Women in Military Service for America Memorial Foundation, Inc., May 5, 1999. Available on-line. URL: http://www.womensmemorial.org. Women's Health Research and Prevention Act of 1998, Public Law 105–40. Available on-line. URL: http//thomas.loc.gov.

"Women Work! The National Network for Women's Employment," *Network News,* 16, no. 4 (Winter 1993).

Wood, Mary Louise, and Martha McWilliams. *The National Museum of Women in the Arts.* New York: Abrams, 1987.

Woodhull, Victoria. *A Speech of the Principles of Social Freedom, delivered in Steinway Hall, Monday, November 20, 1871 and Music Hall, Wednesday, January 3, 1872.* London: Blackfriars Printers, 1894. Woodbridge, Conn.: Research Publications, microfilm.

Woodress, James. *Willa Cather. A Literary Life.* Lincoln: University of Nebraska Press, 1987.

Woodward, Grace Steele. *Pocahontas.* Norman: University of Oklahoma Press, 1969.

Woody, Thomas. *History of Women's Education in the United States.* 2 vols. New York: Octagon Books P.A., 1966.

Wright, Helen. *Sweeper in the Sky: The Life of Maria Mitchell, First Woman Astronomer in America.* New York: Macmillan, 1949.

Wright, William. *Lillian Hellman: The Image, the Woman.* New York: Simon & Schuster, 1986.

Yalow, Rosalyn. "Insulin-1133 Metabolism in Human Subjects: Demonstration of Insulin Binding Globulin in the Circulation of Insulin Treated Subjects," *Journal of Clinical Investigation,* Volume 35, 1956, pp. 170–90.

———. "Assay of Plasma Insulin in Human Subjects by Immunological Methods," *Nature,* Volume 184, 1959, pp. 1648–49.

———. *Radioimmunoassay: Methodology and Applications in Physiology and in Clinical Studies.* 1974. Rpt. New York: Wiley, 1983.

Young Women's Christian Associations. U.S. National Board. Bureau of Immigration and the Foreign-Born. *Foreign Born Women and Girls.* New York: 1920. Woodbridge, Conn.: Research Publications, microfilm.

Zaharias, Babe Didrikson, and Harry Paxton. *This Life I've Led.* New York: A. S. Barnes, 1955.

Zinsser, William. "I Realized Her Tears Were Becoming Part of the Memorial," *Smithsonian,* September 1991.

Zophy, Angela Howard, and Frances M. Kavenik, eds. *Handbook of American Women's History.* New York: Garland Publishing, 1990.

Index

Boldface page numbers denote main entries; *italic* page numbers indicate illustrations.